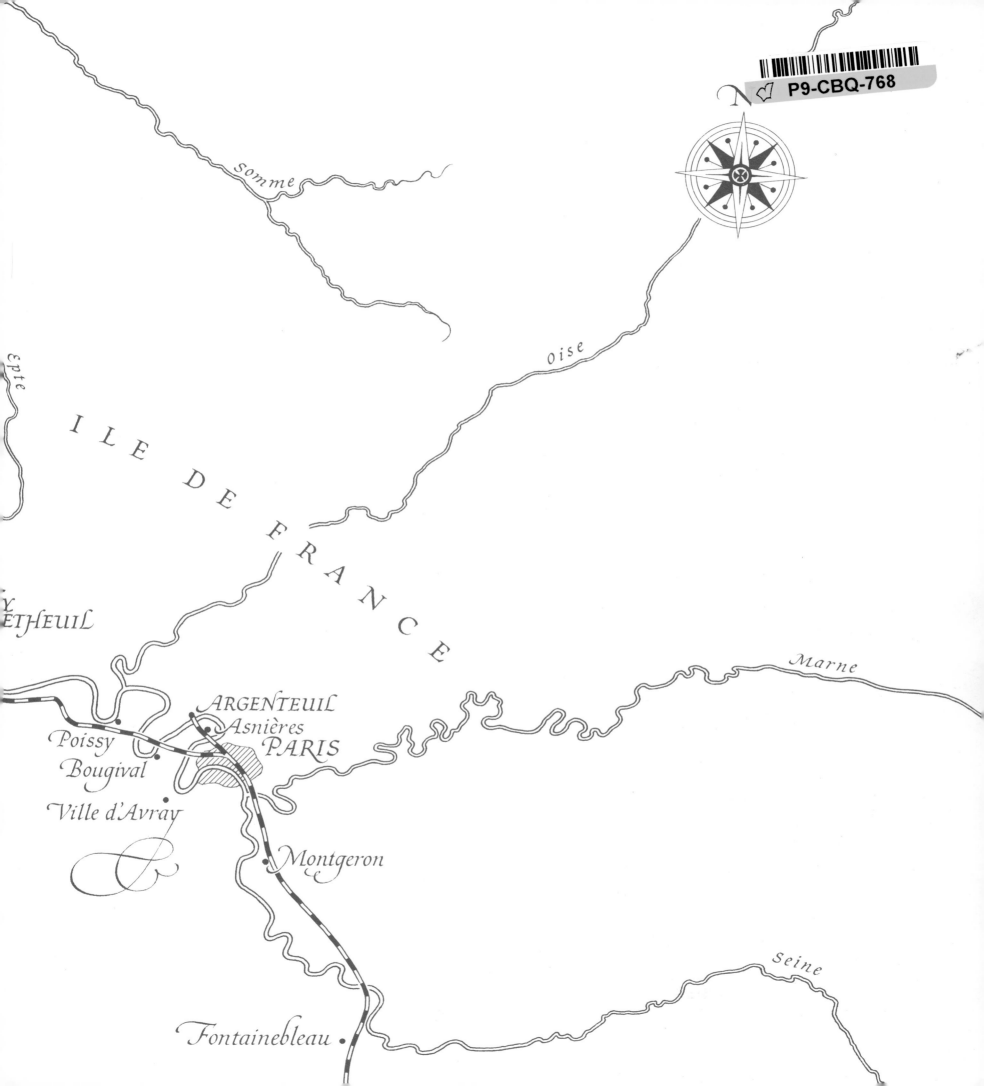

N

Somme

Oise

epte

ILE DE FRANCE

Marne

ÉTHEUIL

ARGENTEUIL
Asnières
PARIS

Poissy
Bougival

Ville d'Avray

Montgeron

Seine

Fontainebleau

# Claude Monet
## LIFE AND WORK

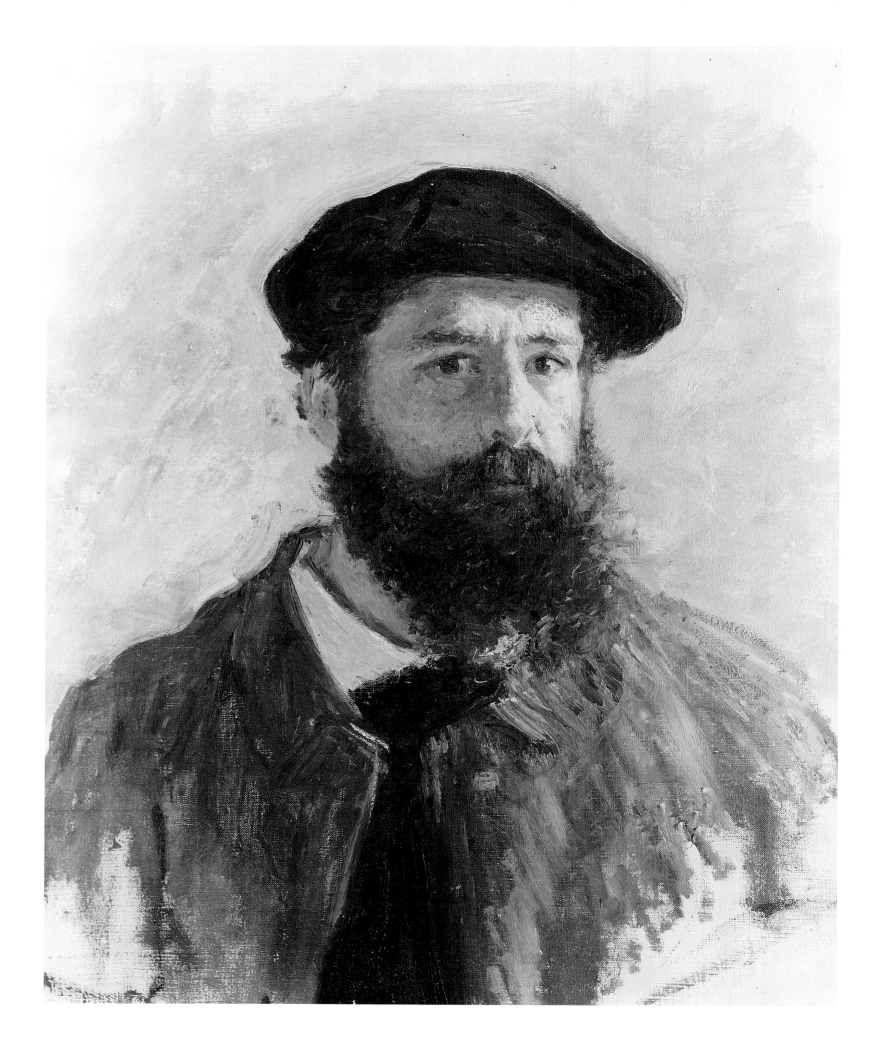

VIRGINIA SPATE

# Claude Monet
## LIFE AND WORK

With over 300 illustrations, 135 in colour

RIZZOLI
NEW YORK

*To G.F. with love*

*Frontispiece: Self-portrait (W.1078), 1886, 56 × 46 (22 × 18)*

First published in the United States of America in 1992 by
Rizzoli International Publications, Inc.
300 Park Avenue South, New York, NY 10010

Copyright © 1992 Thames and Hudson Ltd, London

LC 92–50137
ISBN 0–8478–1571–4

Printed and bound in Singapore by C.S. Graphics

# Contents

# *Preface*

WHEN I BEGAN THIS BOOK OVER A DECADE AGO, MONET STUDIES WERE NOT the growth industry they have since become. In the intervening years, books, exhibition catalogues, conference papers, articles, collections of his recipes and lavishly illustrated souvenirs of his garden have poured from the presses, at the same time as manufacturers have produced thousands of reproductions, postcards, T-shirts, jigsaw puzzles, calendars and replicas of his dinner plates. The most ambitious publication was the Wildenstein monument to Monet, a five-volume *catalogue raisonné* without whose cornucopias of information my book would have long been completed. Thinking only of those who have written on the painter in these years, who have ensured that Monet can never again be regarded either as a formalist or a simple-minded recorder of nature and whose names have regularly punctuated my labours, names that come readily to mind include those of T.J. Clark, Crow, Forge, Herbert, House, Isaacson, Levine, Moffett, Shiff, Stuckey, Tucker and Varnedoe. As always happens, many of their works were published too late for me to make real use of them, but I owe them all a great deal. In the same period I have, both eagerly and uneasily, been aware of the many disciplines which have recently been transforming our own. And yet every book has its own momentum, and mine has been less responsive to this transformation than I would have wished.

The genesis of one's ideas is obscure, and one may remember only the excitement rather than the detail of past intellectual encounters. The book did, however, have its origin in lectures I gave in Cambridge in the 1970s, whose themes were developed over endless cups of coffee with Paul Joannides, who sharpened my ideas on nineteenth-century painting, even as we disagreed enjoyably on many aspects of it. I owe a great deal to discussions with Richard Brettell, Anthea Callen, T.J. Clark, Carol Duncan, John Golding, Robert L. Herbert, Joel Isaacson, Christopher Lloyd, Linda Nochlin, Robert Ratcliffe, Griselda Pollock, MaryAnne Stevens, Nancy Underhill, Frank Whitford, and to Margaret Walters who read an early draft. I give special thanks to John House for the many hours we spent looking at paintings. In France, I owe a particular debt for hospitality, help and encouragement to Michel Laclotte, Michel Hoog, Claire Joyes and Jean-Marie Toulgouat, Hélène Toussaint and Jacques Villain. I am particularly grateful to David Bromfield who has shared his research on Monet and Japanese art with me, and to Pat Mainardi who not only housed me for many weeks, but was endlessly generous with ideas.

My book was begun before I returned to Australia from England in 1979. Although the logistics of studying French art have been made more difficult by this move, I have been compensated by being able to work at the Power Institute of Fine Arts of Sydney University. I have been constantly challenged by the spirit of critical enquiry which characterizes the work of my colleagues, as well as by my exacting, lively and responsive students. Teaching in a landscape unmediated by Monet, and in a society distant in most senses from French culture has,

to say the least, been a stimulus to my attempts to restore plenitude of meaning to the painting shaped by French landscape, society and history.

I must thank Sydney University which awarded me leave and grants to continue my research in Paris. I also thank the staff of many museums and libraries, in particular those museums that have allowed me to reproduce their works. Whenever possible, I discuss paintings in public collections – since I hope that those who read this book can test my words against pictures to which access is relatively easy. I do, however, thank the private collectors whose works have been reproduced. I owe a particular debt to the Fondation Wildenstein and the Galerie Durand-Ruel for help with photographs and documentary material.

My book – seemingly the last to be written largely by hand – has had so many typists and operators of word-processors in three countries that I cannot thank them here individually, as I do in my mind. I would, however, like to express my gratitude to Myra Katz for smoothing away a multitude of problems, and to Jill Beaulieu, Donna Brien, Anita Callaway, Belinda Altmann, Philippa Bateman and Vera Schuster who helped me with documentation.

There is one omission from this book which I particularly regret — that of the role of Monet's friends in the creation of his art. Impressionism was shaped by long-lasting friendships, and to isolate Monet as I have done is to deprive his work of a vital part of its meaning. My work too has been shaped by friends. Apart from those in the practice of art history named above, I should name Lynn Barnett and Penelope Pollitt, who have given me support and encouragement over the years. The role of Irma Pick in shaping my ideas will be obvious to her. I must also thank my family for its support. If I have had to retreat from both friends and family into the long silence of desk or library to complete my work, this book is nevertheless theirs.

Finally, I owe a particular debt of gratitude to my publishers, Thames and Hudson, in particular to Nikos Stangos for his enthusiasm and long patience. I cannot sufficiently thank Catharine Carver who edited the text with tact, sensitivity and precision.

Reaching the end of this long labour, I must ask myself if I have got any closer to understanding Monet's painting. If the comparison were not impertinent, I would be tempted to think of him painting reflections in water moved by invisible currents, stirred by the breeze, lit by an unseen, changing sky. His painting is there, within the grasp of eye, mind and heart, yet as I have sought to give my sense to it, it changes, dissolves and frees itself from any final definition.

V.S.

Begun by the Seine and finished by the
Southern Ocean, April 1989

In the captions all works are by Monet, oil on canvas, unless specified otherwise. Dimensions are in centimetres followed by inches.

# Introduction

*Monet is only an eye . . .*
CÉZANNE[1]

THE IMPLICATIONS OF MONET'S LIFE-LONG DETERMINATION TO REPRESENT certain aspects of the visible world as truthfully as he could have rarely been examined. What was the meaning of his radical restriction of the range of pictorial expression to that which lay before his eyes at a particular moment, a moment with no past and no future? What of his struggle to see the external world 'without knowing' what he saw, refusing to make any connections, or to show any relationships that he could not see, and depicting not only nature but human beings as if they were no more than the source of visual sensations? Within the beauty of Monet's paintings there lies a bleak objectivity which suggests that when painting he cut himself off from any emotional identification with what he was representing, and which perhaps explains his perpetual return to certain themes as if seeking some way to grasp their being – a desire which, like that of Narcissus, was always denied. Indeed, this very detachment may also explain why Monet used the external world to create images which, while appearing true to that world, transform it into a place of sensual plenitude, an ideal protective closure against the losses brought by time.

Soon after Monet's death his closest friend, Georges Clemenceau, recounted a conversation in which Monet had said that his mode of seeing was

the obsession, the joy, the torment of my days, to the extent that one day, seated at the bedside of a dead woman [his first wife] who had been and still was very dear to me, I surprised myself with my eyes fixed on her tragic forehead, in the act of mechanically observing the succession, the encroachment of fading colours which death was imposing on the immobile face. . . . That's what I had come to. It's quite natural to wish to reproduce the last image of one who is about to leave us forever. But even before I had the idea of recording the features to which I was deeply attached, my bodily organism reacted in the first place to the shocks of colour, and in spite of myself my reflexes drew me into an unconscious process in which the daily round of my life was resumed. Just like an animal on a treadmill . . .[2]

No one has described more poignantly how Monet's mode of representation depended on a mechanical recording of visual 'shocks' which preclude emotional identification with the object of sight. In no other painting was Monet's obsessive desire to capture a reality at the moment when it is 'about to leave us forever' more profoundly exemplified than in *Camille Monet on her death-bed*. This is so tenuous an image of a face that it is impossible to consider it in terms of personality, of its history, of its past. It is there, yet, as it dissolves into drifting skeins of paint, it is on the point of not being there. It was a private painting, registering a private loss. Today it hangs in a museum as an image, a sign, 'Monet's dead wife'. Is there any way in which the painting can be recuperated from that banal identification?

The processes by which Monet realized his images of the external world are visible in the paintings, in the brushstrokes themselves and in the complex, multivalent structures which they form: they bear the imprint of this detached 'mechanical' observation, this apprehension of the external world as a succession of momentary shocks of colour, each of which is threatened with loss by the inexorable movement of time.[3]

Monet conceived his paintings as the expression of his unique perceptions – they would be, he wrote early in his career, 'the expression of what I personally will have felt'[4] – and they were indeed not so much literal images of the external world as images embodying his processes of shaping it into his own. The years in which Monet was becoming conscious of his world saw those transformations of social relations and

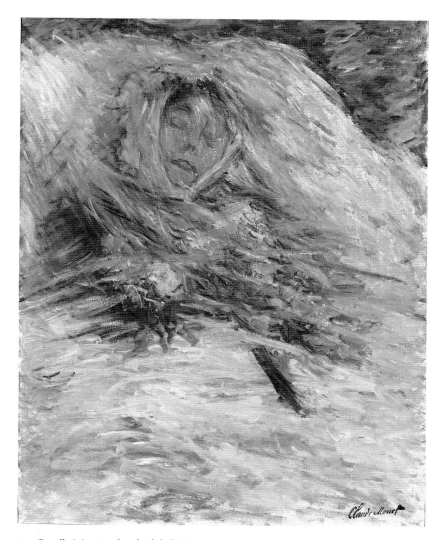

1   *Camille Monet on her death-bed* (W.543), 1879, 90 × 68 (35 × 26½)

of the environment which changed France from a largely pre-industrial society to a free-enterprise capitalist one. His youth and early years as a painter were passed under the Second Empire, when the 'euphoria of high profits' and vast capital works, like the transformation of Paris and the expansion of the railways, encouraged intense financial speculation and feverish dreams of riches. Paris lured tens of thousands of rural immigrants by the promise of work, wealth and a fuller life, by the dazzling spectacles of urban life, and by the fantastic multiplication of goods. In this increasingly mobile society, the struggle to attain secure social position was intense, and the display of signs of success crucial. Intimate knowledge of one's fellows was increasingly superseded by the fascinated scrutiny of the signs of social status, by the relations of sight which are invoked by images like Daumier's 'The New Paris' of 1862.[5]

Modern urban life has generally been characterized in terms of loss: the loss of some dreamed commonality to a fragmented individualism; the loss of affective social relationships to the fetishized relationships of the world of commodities; the loss of collective memory and shared tradition; the loss of a sense of the person in the unknowable crowd; the loss of continuity of consciousness under a bombardment of mechanically-produced stimuli of ever-increasing speed and intensity. 'He is an "I" with an insatiable appetite for the "non-I",' Baudelaire wrote of the painter of modern life, 'at every instant rendering it . . . in pictures more living than life itself which is always unstable and fugitive.'[6]

Monet's contemporaries feared that their society was threatened by loss and disintegration and that all its values – including those of art – were being transformed into monetary ones, particularly since financial speculation was changing wealth from its knowable basis in property to something invisible, fictive. Yet at the same time this society promised escape from the slavery of need, and the good life for all, and contemporaries were as much exhilarated by its possibilities as they were fearful of its consequences. This ambivalence was central to Zola's novel about finance in the Second Empire, *L'Argent* (1890), which concludes:

money was, until this day, the manure from which the humanity of the future was growing; money, poisonous and destructive, was the yeast of all social growth, the

necessary compost for the great works which would make existence easier. . . . over so many crushed victims, over all that abominable suffering which every step forward costs mankind, is there not something superior, good, just, definitive, towards which we are going without knowing it, and which fills the heart with the obstinate need of life and hope?[7]

Within two decades of his being a student, Monet's paintings were to be absorbed into the cycle of speculation which may have shaped their exteriority, and may eventually have influenced his strange multiplication of works on a single subject.

Unlike Zola who located the realization of the bourgeois vision of the inevitable progress of free-enterprise capitalism towards social harmony, justice and plenitude in the future, Monet located the good life in the present in paintings which presented the desired as real. 'Dream infuses them', Armand Silvestre wrote of Impressionist paintings in 1873, 'and, completely impregnated by them, it flees towards loved landscapes which they recall all the more surely because the reality of their appearance is there most striking.'[8] The subject-matter of Monet's 'loved landscapes' is intensely, exclusively pleasurable. Generally located in cultivated nature, they represent a self-contained world where the loveliness of flowers, foliage, sunlight and water offers an alternative to the manufactured world. It is a world almost without work, where the comfortably-off middle classes enjoy themselves, boating, promenading beside a river, walking through flowery fields, sitting on sunlit beaches, in flowery gardens, in intimate domestic interiors, or bustling along modern boulevards. It also shows the pleasurable objects of their sight – the countryside, the seaside, the gardens of the Île de France and Normandy and, after the early 1880s, more distant tourist sites – all seen from the view of a leisured visitor.

Monet's art was centred on his own family, which was for him, as for the bourgeois male in general, the locus of individual self-realization, the refuge from an alienating public sphere. Although almost all Monet's models were female, his figure paintings were in no way erotic. Desire was not for him, as it was for Renoir, synonymous with the female body, but with a domesticated, feminized, bourgeois nature in which there were traces of his own childhood, which was of course irretrievably lost, but which he sought to restore, transformed into a

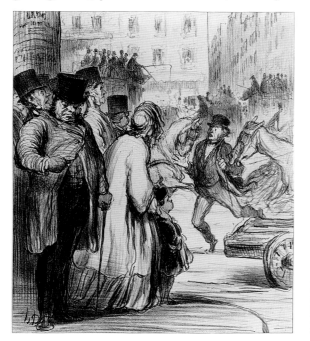

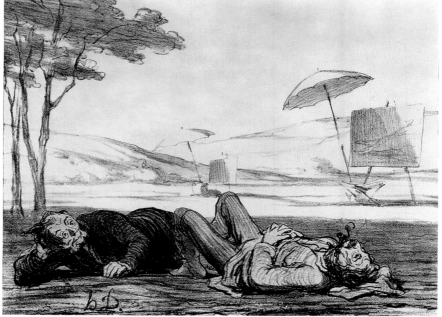

2   Honoré Daumier, 'The New Paris', lithograph in *Le Boulevard*, 6 April 1862

3   Honoré Daumier, 'Landscapists at work', lithograph in *Le Boulevard*, 17 August 1862

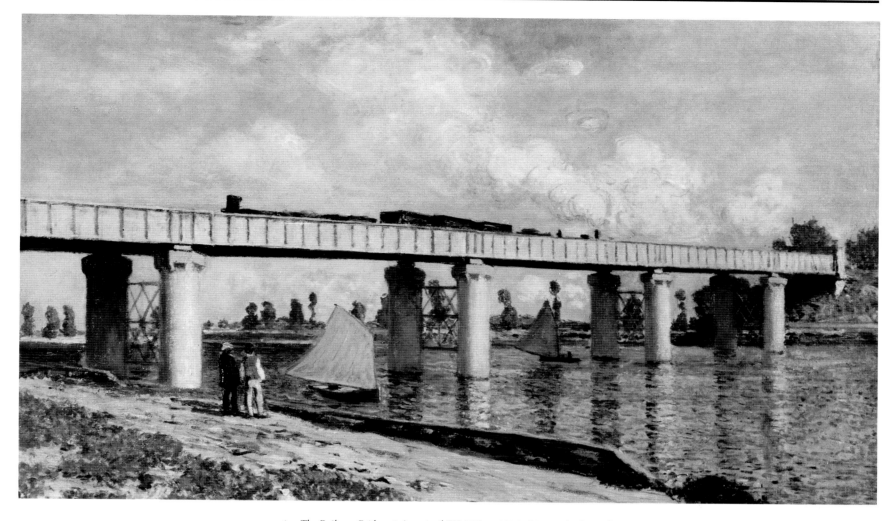

4    *The Railway Bridge at Argenteuil* (W.279), c. 1873, 60 × 99 (23½ × 38½)

higher sensuous wholeness. Through his painting, Monet enclosed his family in gardens made of veils of foliage and flowers, or in the familial countryside, represented more as a bourgeois pleasure garden than as a working landscape. The family, then, played a crucial role in creating a modern landscape painting.

Yet despite Monet's almost total exclusion of any subject-matter which could threaten his construction of an ideal, protected world, this world was undermined from within by the rigour of his modern 'seeing'. Zola, the most perceptive of the early commentators on Monet, claimed in 1868 that his paintings of the country were shaped by urban experience,[9] and this was, I believe, shown in the way in which he attempted to represent figures and their environment, both city and country, as pure objects of sight, inaccessible to other modes of experience. It is possible to show how Monet's painting expressed the alienation of object-relationships; how it exalted the moment of individual self-realization as opposed to shared social experience; how it was shaped by the fragmentation of time integral to capitalism and by the practice of financial speculation. It was not, however, a literal reflection of such orders of experience, and it shows that pure 'object-seeing' was neither simple nor total, particularly since his painting could not and cannot impose these modes of experience on the spectator.

The simultaneous play of loss and reparation can be seen with particular clarity in Monet's representation of time, which was related to

a concept central to the discourse of the modern, that of the destruction of traditional temporal experience by modern time-keeping. Daumier represented the different modes of time in two lithographs published in 1862, 'The New Paris' and the 'Landscapists at work'. The new city is shown as shaped by the modern compulsion for speed which absorbs the individual into the undifferentiated mass or can even threaten physical disintegration. The businessman's focus on his watch indicates it as the generator of the time which directs life in the modern city. This is mechanical time: the time which measures the moments and arrests temporal continuities; the time which regulates the industrial world. The lithograph of the pleinairist painters figures natural time: the continuous time of the sun and the seasons; the time which had shaped the pre-industrial work of peasant and artisan, and which would continue to shape the work of the landscape painter which Daumier characterized in terms of freedom and pleasure. While earlier nineteenth-century landscapes were formed by the notion and the experience of continuous time, Monet's paintings enact the conflict between these different modes of time, which were figured quite explicitly in the theme of the river and the theme of the train, the one characterized by nature's continuity, the other regulated by mechanical time. The train was, however, the means by which ordinary people reached the dreamed freedoms of the river, and were transported back to their city lives. Moreover, both themes were perceived by an eye conditioned by

modern urban experience, which sought to see 'mechanically' in terms of the 'shocks of colour' into which the motif fragmented. If there was in this mode of seeing something of the 'moment' of camera vision, this moment coexisted with other temporal experiences in such a way that it is endowed with a fragile, wavering continuity. Monet may have grasped the motif instantaneously, but the structures of his paintings show a long and complex process of seeking the appropriate marks of paint with which to construct his fictitious image of immediacy.

In one sense, then, Monet's paintings deny the continuity of natural time, as if he arrested it at the instant of the perceptual 'shock', detached from those which had preceded and would succeed it: a wave flung up as spray a moment before it falls or a cloud of steam just before it dissipates. His paintings enact unrepeatable conjunctions: a gleam of light catches wind-filled sails in the moment the yacht turns, just as the sails slacken, and clouds break up the light; a ripple underwater 'holds' the sun's light before the coming wind ruffles the water surface and it disappears – forever? Monet's compulsion to grasp that which is on the point of disappearing led him in the 1890s to those sequences of paintings in which he tried to record every variation of light on a motif, and which resulted in an astonishing procedure in which he might paint only two or three strokes before the light changed, and then had to race to another, already commenced, work which might resemble the new 'moment' of light. The fracturing of consciousness inherent in this procedure was closely connected with Monet's fragmentation of the objective world into coruscating particles of colour, as if his desire to get closer and closer to the object resulted in its near-disintegration and, as was written in 1909, 'Of the visible world there remains only . . . this eddy of radiant atoms.'[10]

A painting by Monet reveals itself as composed of dense webs of coloured marks which enact momentary apprehensions and which coalesce temporarily into an image – a lasting image – of the transient intersection of multiple perceptions. A spectator can grasp the painting-as-instant in a similar moment of apprehension, yet the paint structure also allows the possibility of experiencing the processes of creation in time. Until his last works, however, most of his contemporaries tended to see Monet's paintings primarily in terms of the 'moment' suggested by a sketch. Moreover, this moment was often seen in terms suggested by a caricaturist's mockery of Monet's speed of execution in the phrase 'Time is money',[11] which neatly insinuated a current preoccupation with the contaminating effects of modern business practice and manufacturing production into what was held to be the timeless, sacrosanct realm of art.

In fact, work scarcely figured in Monet's created world; it existed only by implication as the corollary of leisure, so making the summer weekend endless. With one extraordinary exception – the machine-like *Men unloading coal* of 1875 – almost the only figures depicted as working are the painters themselves. Thus painting suggests a paradigm for work as pleasure, work as freedom, work as a mode of individual self-realization (a notion treated with satirical affection in Daumier's 'Landscapists at work').

Despite Monet's avowed dedication to the concept of truth to the visible world, he embodied his truths in structures which were profoundly his own and which can be seen in clumsy or partial form in even his earliest paintings and drawings. It was as if his process of finding truth was accomplished by finding his own intimate form within a motif which he struggled to see as if it were entirely detached from him. This helps explain the extraordinary continuities in Monet's work:

as soon as he began painting, he dedicated himself to the direct experience of the motif, to painting outdoors, to effects of light, and his first surviving works show the water and reflections that he was still painting nearly seventy years later.

Monet was a very effective producer of his own history, abetted by his close friends, the critics Octave Mirbeau and Gustave Geffroy, and other journalists. He began constructing the heroic narrative of the self-created artist in the 1860s, and developed it in the new genre, the artist interview, from 1880 until the end of his life. Interview after interview projected his career in terms of a dynamic, self-directed evolution which persists in every monograph written both during his lifetime and after it, so persistent and driven a narrative that it is difficult to escape it. This book has certainly not done so. The impulse which shaped Monet's construction of his own history was also the impulse according to which he shaped his own work as a single-minded individual exploring 'effects of light and colour' which he, like Cézanne, called his 'research'.

Monet's story is also exemplary in its account of the sacrifices he made to be true to his art, of his extreme poverty, and of the way in which ridicule and opprobrium were followed by success, the confusion of his enemies and recognition as the greatest landscape painter of his day, if not of all time. Of course, Monet did stick to his vision of art and did suffer poverty and ridicule when he had the skills to succeed in more conventional styles, but such is the force of the epic of the misunderstood genius that it submerges the fact that Monet was early recognized as a leading painter of his generation, that he did earn a considerable amount well within a decade of being a student, and could have lived comfortably through the 1870s had he not been something of a spendthrift.

Despite (or perhaps because of) this early use of the press to promote the self-image of the artist, despite a well-documented life (presented with almost fanatical inclusiveness in Wildenstein's biography and catalogue), despite the survival of over 2,000 paintings and over 2,500 of his letters, despite the letters, articles and memoirs of friends, despite all that is known of Monet, he seems curiously absent from his own story. Renoir wrote to Monet, embarrassed that he had accepted a Légion d'honneur when Monet resolutely opposed such distinctions:

You, you follow an admirable line of conduct, I've never known the day before what I'll do the next day. You must know me better than I do myself, since I very probably know you better than you do. . . . Let's not speak of it any more, and long live love!

Unfortunately Renoir never spoke much about his knowledge of Monet, saying only to his son Jean that Monet was born a *'grand seigneur'*, and acknowledging that the other painter inspired him with courage whenever he despaired.[12]

Yet, despite his tenacity and strength of will, Monet was profoundly, even neurotically, self-doubting, and seems to have needed strong friends, such as Mirbeau and Clemenceau, upon whom he was curiously dependent, endlessly calling on their (sometimes ferocious) good sense and humour to persuade him to persevere in the face of his agonizing doubts as to whether he could realize what he sought – when he would almost undoubtedly have persevered in any case. A related pattern can be seen in his curious attitudes to money: one so often finds him begging pitiful sums from friends in years when he was earning more than many urban professionals, that one comes to wonder whether he needed to be in debt. He was obsessed with money, chronically mean,

but a huge spender, and, even when he was very rich, irrationally fearful of losing everything.[13] Monet also needed a family, partly as subject for his painting, partly to provide the ideal conditions for his work; he had to endow this family with the bourgeois comforts which he found necessary, and which shaped his art as something domestic, familiar, so that it might seem to secure his world against the threats to which life – his personal life in that modernizing society – was subject, and against the disintegration to which his 'modern' mode of seeing led him.

We also know that Monet participated in – or was a spectator of – both the high culture and popular entertainment of the day, and even while living at Giverny and fulminating happily against Paris, visited the city regularly to keep in touch with friends, both writers and artists, attending exhibitions, the theatre and even wrestling matches. His abiding love was boating on the river, and yet, after the turn of the century, he gave himself with great enthusiasm to the exhilarations of the motor car and even went to motor races. As one would expect of someone whose close friends included Mirbeau and Mallarmé, Monet was well read, knowing the works of Tolstoy, Baudelaire, Gautier, Flaubert, the Goncourts, Zola, Huysmans, Jules Renard and Maeterlinck. But we know almost nothing of his attitudes to what he read – except that the *Journals* of his 'dear Delacroix' were his favourite reading.[14]

Indeed, what is striking in his 2,685 surviving letters is how little they say about his ideas. They reveal the fanatical exactitude with which he approached effects of light, the sheer amount of labour that went into his painting, the endless struggle against weather. Into these dominant obsessions were woven his concerns for his companion and future wife, Alice Hoschedé, and for his children and hers, together with exhibition strategies and other matters to do with the sale of his paintings. There is scarcely a hint as to why he painted or what he was seeking beyond fidelity to certain effects of light. Compared with Pissarro's letters, Monet's display a notable absence of ideas; while Pissarro commented on social, political and artistic events, on books he was reading and exhibitions he had seen, as well as on the role and nature of art in capitalist and in a future socialist society, Monet's indicate an absolute self-concern, or rather an exclusive concern for his painting and for the conditions in which he could develop and sell it.[15]

It thus remains a mystery why this most bourgeois of artists should have included among his closest friends the radicals Mirbeau and Geffroy, or why he should have been numbered among the friends of some of the most gifted writers of his day, from Zola to Mallarmé. Of course, many intellectuals were attracted by the lure of 'genius'; moreover, aided by Alice and later by Blanche Hoschedé-Monet, he created a home and garden which abundant testimony shows was simply a delight to visit. Monet seems to have had a gift for inspiring friendship, yet there is little in his letters which suggests real feeling for others, except for Alice and the children of their first marriages. The loving husband and father was a domestic tyrant at whose rages – most extreme when he felt his painting was going badly – his family would tremble, and who, as he himself recognized, made the life of his stepdaughter/daughter-in-law, Blanche, a misery when she gave up her own painting to look after him in the last twelve years of his life (he also left her entirely unprovided for).[16] The genial host and valued friend was a man who would treat his friends shabbily and opportunistically, testing their patience to its extreme limits. Indeed, the arrival of one of his querulous, woeful, demanding, even begging letters must have made the recipient's heart sink. Nevertheless, there is the testimony of Maurice Rollinat, the melancholic poet:

Don't try to disparage yourself; you are simultaneously the absolute type of the sincere artist and the best man we have known. You always have a sympathetic word, a good smile and a kind look, even when you are most tired or most preoccupied.

While Rodin wrote, obviously in response to some concern of Monet's:

Preoccupied as we both are by our pursuit of nature, the expression of friendship suffers, but the same sentiment of fraternity, the same love of art, have made us friends for always.... At our age, my dear friend, it would be so hard to lose a friend or to see him indifferent, that I too suffer from that thought.[17]

If one considers Monet's figure paintings, paintings of family and friends, they suggest, by comparison with those of Renoir, Morisot and even Pissarro, no sense of identification with his subject. Bigot wrote in 1877, 'No intimate sentiment . . . no personal vision . . . Behind this eye and this hand one searches in vain for a thought and a soul', while Gillet commented in 1909, 'Beneath the eternal smile of his work, one does not sufficiently feel the life of his model. He lacks sympathy.'[18] Despite intimacy with his subjects and despite the beauties with which he surrounded them, his paintings suggest the detachment with which Degas approached his figures, rather than Renoir's projection of desire into his images of fellow beings.

Monet had a life rich in friendship and family relationships, yet beside his death-bed a volume of Baudelaire was left open at the page of 'The Stranger':

Tell me, enigmatical man, whom do you love best, your father, your mother, your sister, or your brother?
I have neither father, nor mother, nor sister, nor brother.
Your friends?
You use a word whose meaning I have never known.
Your country?
I don't know in what latitude it lies.
Beauty?
I could indeed love her, Goddess and Immortal.
Gold?
I hate it as you hate God.
Then, what do you love, extraordinary stranger?
I love the clouds . . . the clouds that pass . . . up there . . . up there . . . the wonderful clouds![19]

As one would expect of an admirer of Manet, Monet was early concerned with the self-conscious pictorial experimentation of modernism. He explored endless variations on the ways in which touches of colour create form, insisting in his practice on the abstraction of the marks used to signify aspects of the visible world. These practices should not be seen as formalist, despite the fact that Monet's efficient creation of his own history lent itself to being appropriated in the myth of modernism as a single evolution towards pure form. Monet's exploration of form was a means both of expressing his unique vision and of securing the joys of family, friendship and nature as eternal, exclusive, totalizing. He and his critic friends believed that his paintings were beautiful because they were true to the laws of nature, and beauty thus became a sign for the truth of his painted world.

Although in the 1860s and 1870s Monet's work did attract a significant group of patrons, it failed to find an audience which could sustain his necessarily precarious vision of the desired life. Those who attacked his painting were less hostile to its subject-matter – the bourgeois good life which potential audiences enjoyed or might hope to enjoy – than to the demand that they participate actively in the reading of the marks which he used to create his images of the real, and which embodied his detachment at the heart of intimate pleasures. It was perhaps the failure of Monet's images of the modern to find a sustaining

audience that created the conditions for his development of a modernist art which would appeal to two élites, the artistic avant-garde and modernizing professionals and entrepreneurs in France and, above all, in the United States. In the 1880s and 1890s Monet became more sophisticated in aesthetic experimentation and exhibition strategies, and his art simultaneously became more luxuriant. His paintings were less often representations of ordinary pleasurable experiences, than embodiments of heightened perceptual states which contemporaries could celebrate in terms of poetic or mystic experience. The sheer sensuousness of the paintings obscures Monet's detachment from the *objects* of his representation – a detachment that lasted at least as long as he was painting them, and that was necessary for his atomization of the external world, and inherent in modernism. Seen primarily as sensuous objects, Monet's paintings were, however, most often seen as depictions of lovely scenery and charming scenes, and were immediately absorbed into a spiral in which their consumption as luxury objects shaped their increasing preciosity.

Monet's education in Realism shaped his mode of representation, which denied traditional forms of constructing narrative relationships between figures and denied traditional associative content in his landscapes. His lifelong commitment to truth to visible reality did not, however, require the documentation of contemporary society in all its forms, as Zola demanded of Impressionism, and, in this sense, Monet's was perhaps the extreme form of positivism in implying that one could know only one's family and friends and the patch of nature and the interiors which they inhabited. Truth to visible reality did not presuppose literal exactitude. Monet's colours are not those of nature and he frequently made changes to the motif in the interests of the overall harmony of the painting, for, to him, truth lay not in detail, but in the grasp of the harmonic relationships of nature.[20]

Monet used signs connoting the processes of being true to nature to construct a fictitious world of unblemished ease and beauty; he painted scenes of delectable happiness on the river when he was 'without a sou'; he represented his family secure in a comfortably furnished interior when his financial situation was so precarious that this existence was by no means assured; he painted industrializing, polluted Argenteuil as a place of pure visual delights, and ignored those contradictions which Maupassant made explicit in his recollection of life on the Seine:

Ah, the promenades along the flowery banks, my friends, the frogs dreaming on water-lily leaves, and the water irises . . . amidst tall, fine grasses which suddenly opened before me a page of a Japanese album behind a willow when a kingfisher fled before me like a blue flame . . . .
I have memories of sunrises, dawn mists . . . wandering, floating vapours . . . lit by pinks which would ravish the heart, as the first rays of the sun stole over the fields . . . .
And all this, symbol of the eternal illusion, borne for me on the putrid water which carries all the excrement of Paris down to the sea.[21]

As a final form of making this dream-world real, Monet created a garden of great beauty which he made yet more beautiful in painting which also shuts out the hills, fences and railway lines that could be seen from the real garden. Monet painted these works with such sensuous plenitude, accompanying them with such reiterated public insistence that they were painted in front of the motif, that by the early 1880s they were accepted, even by critics who had been most hostile to them, as being truthful depictions of the real world.

It is easy to interpret the tensions between this relentless beauty and contemporary social realities in terms of bourgeois ideology, of 'false consciousness', but this does not lead one very far, and condemns one to read the paintings simply as lovely but deceitful objects. It does not allow one to ask whether such paintings can bring any forms of understanding specific to them, any knowledge one does not have already from non-pictorial sources.

Monet's search for an ideal state of being in his painting was so intense, so obsessive, so driven, that it suggests not only a desire to escape the fragmentation of modern life, but a more fundamental desire for what all have lost, the infant's integration with the undifferentiated body of the mother. His works increasingly fused earth, sky, solid matter, water in one shimmer of colour suggestive of the 'universal vibration of light', and of a mystic wholeness of being. And yet Monet continued to stand detached, condemned to be an observer. He remained, of course, an adult, one shaped by the modern world, and his search for a means of creating oneness in a sophisticated modern society was embodied in pictorial structures which fluctuate ceaselessly between wholeness and disintegration. His life's work was thus shaped by what his friend Geffroy called 'the anxious dream of happiness'.[22]

Monet's Impressionism is too often looked at with nostalgia for a past which never was, rather than as a form of painting whose very structure embodies the strain of its exclusions. It is only through penetrating to the painful gaps and emptiness at the heart of his paintings that one can more fully accede to what those paintings might promise – not just pictures of a nice home in the suburban countryside or pretty landscapes, but an alluring vision of a harmonious relationship between contemporary human beings and a transformed but unspoiled nature, and an expression of the ultimately impenetrable otherness of individual men and women, an otherness which confers its own dignity. His painting also asserts the meaningfulness of the struggle to make sense of a disordered world. . . . But these visions too flicker, and summon up for me Walter Benjamin's words, 'there is no document of civilization which is not also at the same time a document of barbarism'.[23]

The conditions of living which Monet required for the creation of his ideal world – a society which would allow him to gain considerable wealth but which demanded certain kinds of painting for wealthy patrons, painting which would foster speculation – were also those which threatened his ideal personal world from within. In a broader sense, the marketing of his painting makes literal the processes of a society in which all values are transformed into monetary ones, all objects into items of consumption – including those supposed to embody alternative values: those most saleable commodities, works of art.

In his last works, the great waterscapes in the Orangerie, Monet struggled as never before to find an alternative to the fragmentation of time which he had previously used as a means of excluding loss from painting. The immense stretches of painting were menaced not only by his blindness but by the threatened destruction of a civilization and its landscape in the Great War, and by the imminence of the old man's own death. The *Grandes Décorations* were reparative in the profoundest sense, in that they admitted disintegration, the ravages of time, into their constantly reshaped structures. It was these paintings which Monet ensured would never be sold: two huge, flawed, unfinishable cycles, terrible in their intensely personal impersonal beauty.

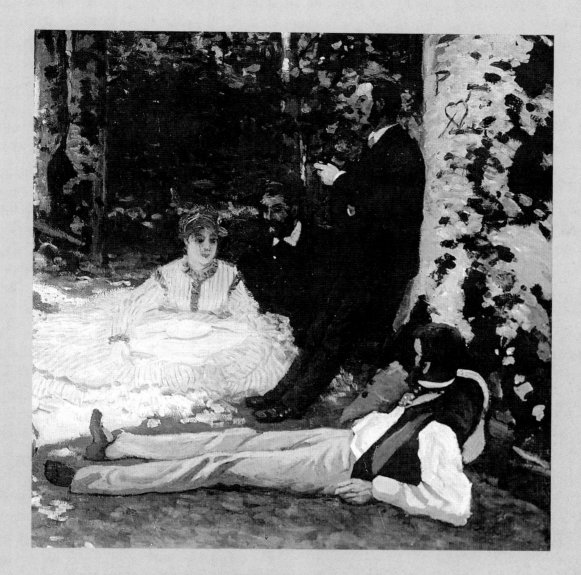

# PART ONE

Modern Times

1840-1878

# I

# A Young Artist of the Second Empire

*. . . don't you feel that one does best alone with nature? . . .*
*One is too concerned with what one sees and hears in Paris*
*. . . . what I will do here . . . will simply be the expression of*
*what I personally will have felt. . . .*
MONET, 1868

*Claude Monet . . . is happy to find human traces everywhere.*
*. . . Like a true Parisian he carries Paris into the country. . . .*
*He seems to lose interest in nature if it does not show the*
*imprint of our customs.*
ZOLA, 1868[1]

## I

A VISITOR TO CLAUDE MONET'S HOME WROTE IN 1853, 'IN THE DAYTIME, walks and sea-bathing; in the evenings, improvised concerts and dances . . . everything enlivened this house whose hosts were disposed to take life happily.'[2] This agreeable picture of a happy bourgeois family, prosperous enough to enjoy the recreations of its class in the open air and in the privacy of the home, was one which Monet sought to re-create both in his life and in his art, as can be seen in his painting *Terrace at Sainte-Adresse* of 1867, which shows Monet's father with other members of his family and friends on the terrace of his aunt's seaside villa. The apparently casual glimpse of up-to-the-moment life is observed from a private space, the enclosed family garden, and painted in such a way that every element – human, natural or man-made – is given equal emphasis: the ships bringing wealth to Le Havre – and to his family – are shown as a spectacle as agreeable, but no more significant, than the dazzling display of flowers; while the people are represented equally dispassionately as objects to whose inner life Monet has no access. Figures, flowers, boats fragment into particles of brilliant colour beneath his detached gaze.

Oscar Claude Monet was born in Paris in 1840; when he was five years old, his family moved to Le Havre where his father joined his brother-in-law's wholesale grocery business. During the 1840s, when the economic foundations of modern France were being laid, Le Havre was rapidly developing as one of its major ports; in 1889 a journalist wrote in an article on Monet that, in contrast to 'the poetic coast', Le Havre was 'a new town; a modern accident [made] of iron and heaped-up rough-cut stone, the American city without past, without traditions of art'.[3] Experienced without conscious thought from his earliest years, the new city would shape Monet's modernism, his vision of a world without

the associative meanings given by memory, existing only in the present, and precariously secured against disintegration only by his insistent creation of sensual wholeness.

Monet was eight when the Second Republic was declared; nine during the terrible civil strife of the 'June Days' in Paris; eleven when the Republic fell to Louis-Napoléon's *coup d'état* in 1851; and his adolescence was spent during the prosperous early years of Napoléon III's Second Empire, the *fête impériale*. The 'business milieu' – the term is Monet's[4] – in which he was brought up acquiesced in Napoléon's usurpation, relinquishing the political rights for which it had struggled in exchange for the 'order' under which it would be free to develop its economic power and consolidate its social dominance. Napoléon's pose as a benevolent conciliator, guiding a socially harmonious state to the prosperity which would ultimately bring social justice to all, was sustained by a massive manipulation of opinion, in which acquiescence was shaped not only by direct repression and censorship but by active propaganda, achieved most forcibly by the colossal deployment of architecture, town planning and public spectacles – above all, the international exhibitions of 1855 and 1867 – to make the Empire's achievements visible and omnipresent. It was indeed the first modern regime to organize appearances and construct a passive audience on a mass scale. Rapid economic expansion continued the transformation of France into a capitalist economy dependent on the development of the consumer mentality, while political repression and *laissez-faire* policies created a society in which the sphere of action was individual and private, rather than collective and public, and in which families like Monet's acquired the wealth to make themselves secure in private worlds devoted to the cultivation of individual well-being, a situation which they assumed to be the natural order of things.

An illegitimate government fully aware of the necessity of manipulating appearances employed all its powers to make the visual arts bear the message that these social forms were universal, natural, transcendental, and thus to neutralize any art forms which might suggest otherwise. This determination was expressed very soon after Louis-Napoléon's *coup d'état* by Persigny, his Minister of the Interior, at the awards ceremony of the Salon of 1852: 'If a government which has its origin and its very principle of being in the poetic sentiment of the masses, were to disdain the cult of the arts for the cult of material things, it would be unfaithful to the conditions of its existence. . . .'[5]

The pursuit and consumption of art became a major bourgeois pastime, and it was in this guise within his family that Monet first encountered it. His mother was an accomplished singer who encouraged him to draw and hired plaster casts for this purpose. He also studied drawing at school under the guidance of Jean-François Ochard, but such drawing was probably considered simply as a component of a well-rounded education, and Monet never mentioned it in his later accounts of this period: 'I was born undisciplined', he claimed in 1900; 'even in my

earliest years, no one was able to make me submit to rules . . . [school] seemed to me like a prison . . .', and the moment he was free, he would escape to the cliffs and the sea.[6] Monet always exaggerated his youthful rebelliousness, but his art was shaped by the nineteenth-century ideology of artistic freedom, and by the belief that bourgeois institutions threatened individual self-realization. He sought alternatives to institutional structures, and when he was obliged to enter a formal teaching studio, he insulated himself from it, fully accepting the teaching only of those outside the school who encouraged him to express his own experience of nature.

Monet constructed this account of his early years in terms of a dramatic opposition between two modes of representation: caricature and *plein-air* painting. He recalled that he filled his school exercise books with 'ultra-fantastic ornaments, and the faces or profiles of my teachers [represented] in the most irreverent manner', and he extended his gift for summing up a person's physical characteristics in a few swift lines by copying caricatures from contemporary illustrated journals. At a time when political caricature was severely restricted, these journals catered for city-dwellers' demand for images in which they could hope to recognize themselves and others resident in their transformed and swollen cities. The caricaturists – of whom the greatest, Daumier, was idolized by Monet – developed compositions and modes of notation to register the forms of consciousness engendered by urban experience in ways which would be of major significance for avant-garde painting in the 1860s and 1870s.[7] Monet's talent for caricature put him in touch with this important imagery and was influential in his paintings of modern life, as can be seen in his 1869 painting *La Grenouillère* in which, with a caricaturist's wit and economy of means, he represented two women in bathing-dresses almost like seals. Monet's early caricatures were rather glib notations, a youth's self-asserting demonstration of skill at the expense of his model, but the brushstrokes of the painting show how he sought out signs by which to show the physical being of the figures as participants in a social scene. Between the painting and the caricatures lay Monet's apprenticeship in the new modes of seeing developed by the younger generation of Realists in the early 1860s.

The first steps in this apprenticeship were made with the help of the landscape painter Eugène Boudin, whom he may have met as early as 1856. When their works were shown with some by Millet and Troyon in the window of a picture-framer's shop in Le Havre, Monet saw his caricatures before an admiring crowd and, he said, 'I split my skin with pride'; but, 'impregnated . . . with academic principles', he shared the public's disgust for Boudin's landscapes.[8] Yet it was Boudin who was to do most to change Monet's arrogant attitude to the external world by persuading the youth to go painting *en plein air* with him. Monet was to recall their expedition in terms used to evoke religious conversion, and in a vivid present tense:

Boudin sets up his easel and begins to work. I watch him with some apprehension, I watch him more attentively, and suddenly it was as if a veil had been torn away: I had understood, I had grasped what painting could be.

He also said that as he watched Boudin painting, 'I was overcome by a profound emotion. . . . More, I was enlightened.' The word '*illuminé*' – filled with light – was not a word Monet would use casually. Since he had already seen Boudin's work, his reaction was to seeing the *act* of painting, and it was this which aroused the most intense emotions of which he was capable. More than thirty years later he wrote to his old friend, 'I have not forgotten that it was you who first taught me to see

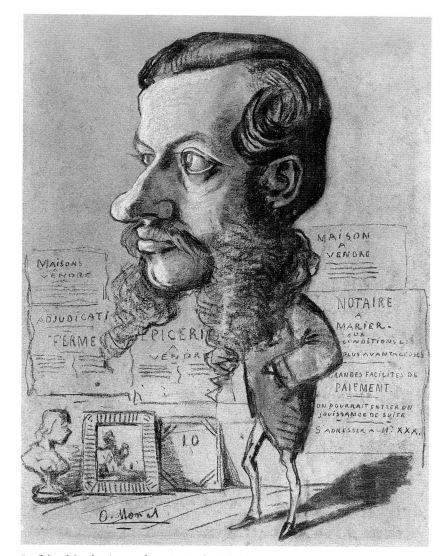

5   'Léon Manchon', an early caricature by Monet, *c.* 1860

and to understand.'[9] For Monet seeing was understanding, but it was made real only in the act of painting.

On that first expedition, Monet would have seen Boudin start to paint on an empty canvas, searching out equivalents for what he saw with small brushstrokes which broke larger forms into delicate nuances of tone, and which simultaneously created a new wholeness. It was crucial that Monet's first experience of the miracle of the creation of form should have occurred in his first encounter with *plein-air* painting. It was also crucial that his first lessons in painting were given by an artist who believed that works painted in the open air had a truth lacking in studio paintings, for *pleinairisme* had no rules beyond those of truth to individual experience and it confirmed Monet's antagonism to formal institutional teaching.

The critics' comments on the ever-increasing number of *plein-air* paintings in the Paris Salons reveal growing appreciation of such paintings as the expression of personal experience, but this appreciation had not yet superseded the belief that the real value of painting was found in formal work in the studio, where momentary personal experience could be generalized, and endowed with the traditional

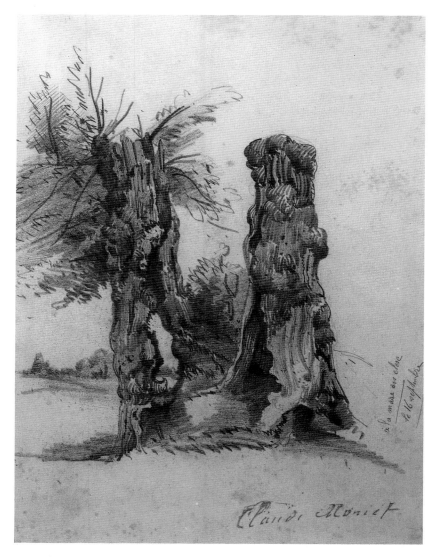

6   Eugène Boudin, *Pear-tree on the banks of the pond, c.* 1853–6, 44 × 70 (17 × 27¼)

associations valued by the educated audience. Underlying these practices was the belief that nature was significant to the extent to which it had been transformed by human mind and emotion. By the mid-nineteenth century, science had undermined this anthropocentric view of nature, which was increasingly seen to have a reality indifferent to human values and was conceived as a mechanistic structure of dynamic forces to which humans as physical beings were subject. Positivist ideology, which held that there was no reality beyond that verifiable by the senses, led logically to the conclusion that nothing was true unless individually experienced; interpretation of the physical world thus became a perpetually renewed *individual* act, which ceaselessly discounted the authority of the past in favour of the isolated experience of the present moment. The new attitude to nature was intimately connected with bourgeois individualism, and with the structuring of time in urban industrial society. For the painters of nature no reliance could be placed on previous experience – either that of other artists or their own – which could at best provide only a hypothesis, a provisional guide for what they were seeing. This ideology made *plein-air* painting inevitable, for it required direct confrontation with a specific segment of nature, while studio work meant reliance on inherited concepts of nature, on memory, on previously learnt equivalents between nature and paint.

Obviously Monet did not change overnight after his meeting with Boudin, and his surviving sketch-books show that he continued his caricatures alongside more self-effacing drawings of landscape motifs. There were characteristics of Monet's mature style even in these relatively conventional drawings, and the process of exploring a landscape through drawing remained with him all his life, and shaped the linear character of much of his work. He said, in his eighties, 'I have never liked isolating drawing from colour. It's my own way of seeing, it's not a theory.'[10] His *Study of Trees* shows how, instead of representing the continuous 'skin' of the tree trunks, he boldly contrasted dark and light in the stabbing, separate stripes which characterize the brushwork of many later works; the writhing lines form dramatic silhouettes against the bare landscape, just as rocks composed of coloured lines rear against the sea in pictures of Belle-Île painted nearly thirty years later. Even in a more conventional drawing executed in 1856, Monet flattened out the

architecture by emphasizing the horizontals and softening the diagonals, thus creating a tension between linear surface pattern, three-dimensional form, and space which animates his mature paintings, even when colour is at its most luxuriant. Monet was to seek the truth of a natural scene as if it were separate from himself, but he was to find it when he was able to find in the motif the formal structures to which, for unknown reasons, he was predisposed.

These structures can be seen in Monet's first known painting, the *Landscape at Rouelles* of 1858. Given that Monet had been painting for so short a space of time, it is an extremely accomplished work, revealing already a keen sense of light, although its precision of detail and degree of finish suggest that it was painted in the studio. Monet's handling of delicate gradations of tone within broad contrasts of light and dark suggests the influence not only of Boudin but of Boudin's friend, another pleinairist, Daubigny, who painted in the Le Havre area. The painting is, however, more conventional than theirs in its tonal structure and in the sharp-focused precision with which the detail of the foreground plants is realized. The confident simplicity of the colour scheme – blue, green, yellow – and the skill with which the multiple greens are enlivened by touches of yellow bespeak the colourist Monet was to become, and,

7   *Study of Trees, c.* 1857, pencil drawing, 29.8 × 22.8 (11½ × 9)

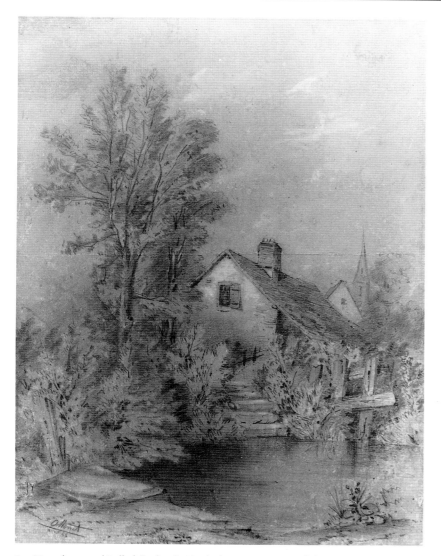

8 *House by a pond* (called *Banks of a river*), August 1856, pencil drawing, 39 × 29 (15¼ × 11¼)

indeed, the work is striking in demonstrating the continuity of Monet's work. Trees in tranquil, watered meadows were commonplace in nineteenth-century landscape painting, but the line of poplars quivering in the light, with their reflected trunks forming a grid in water at the base of the painting provided a theme that he was to explore all his life.

Monet's mother died in January 1857 when he was just over seventeen years old, perhaps a few months after Boudin's revelation to him. This juxtaposition of the discovery of painting with the death of the woman who had encouraged his artistic pursuits and with the disintegration of his first family may well have determined Monet's desire to re-create this family as both context and subject for his painting.

Mme Monet's role in encouraging Claude's artistic activities was taken over by his aunt, Marie-Jeanne Lecadre, who supported her nephew until the late 1860s, though she seems to have used the allowance she gave him to try to make him pursue a proper career and a respectable life. She herself painted, presumably in the manner permitted to ladies as an 'accomplishment', but her possession of a small Daubigny landscape (which she later gave her nephew) and her friendship with the

Realist painter Amand Gautier suggests that she had some knowledge of progressive painting. Gautier, a close friend of Courbet, a Republican and a participant in the Parisian *vie de bohème*, was to become the first of Monet's radical friends, and the strange figure he makes in the apparently conformist family suggests that it would be a mistake to view the attitudes of Monet's father and aunt too simply. Monet always stressed their opposition to his career as a painter, but they were, in fact, prepared to support his years of apprenticeship. They could have expected that if Monet — with his obvious talents — followed an approved course of instruction and the unwritten laws of artistic advancement, he could hope for a respectable career. Monet had, however, become committed to the more heroic history of the avant-garde which suggested that, while the artist who insisted on the expression of personal experience as opposed to traditional values would take time to earn public acceptance and a living from art, talent and dedication would ultimately be rewarded. In this sense the artist — as an individual with vision in advance of his time — could enact the ideals of freedom, self-realization and progress on which liberal bourgeois society depended.

Although unsuccessful in winning a municipal scholarship to study in Paris, Monet had amassed the considerable sum of 2,000 frs. from the sale of his caricatures; on this sum, well beyond what a working-class man could earn annually, he could hope to exist for some time. He left Le Havre in May 1859, so that he could see the Salon.

When Monet arrived in Paris, the Mecca of all aspiring artists and writers who felt 'suffocated' in provincial towns, the city was undergoing those transformations which were to give it its modern form. By the end of the 1840s, because of its dizzying increase of population, Paris was, in Maxime Du Camp's words, 'about to become uninhabitable'; Napoléon III had decided to remedy this situation, to glorify his regime and to ensure control of the capital, by appointing Baron Haussmann Préfet de la Seine, with extraordinary powers to restructure Paris as a great modern city.[11] Huge sections of it were demolished and rebuilt; boulevards were driven through the tangle of medieval streets with time-blackened façades hiding foetid courtyards, streets which were often so narrow that vehicles would crush pedestrians against clammy walls, splashing them with the horrific

9 *Landscape at Rouelles* (W.1), 1858, 46 × 65 (18 × 25¼)

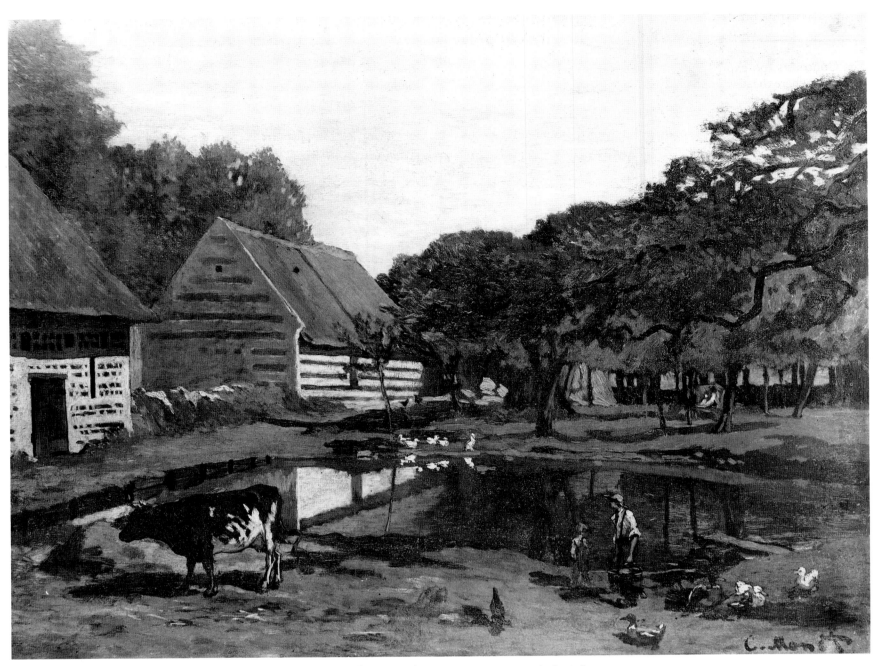

10 *Farmyard in Normandy* (W.16), c. 1863, 65 × 80 (25¼ × 31¼)

debris of open sewers and filthy gutters. One such street was described by a young writer, Emile Zola, who had arrived in Paris a year before Monet. *L'Oeuvre*, Zola's novel of artistic life, was written nearly twenty years later but based on the lives and characters of his friends of the 1860s, and its 'hero', the painter Claude Lantier, has some characteristics of Claude Monet. Zola contrasts Lantier's momentary romantic interest in the picturesque darkness of an old street with the young artists' triumphal walks across a Paris in which the new boulevards opened the city to light, and in which they saw themselves as the conquerors of the new Realism.[12]

Throughout the 1860s, when Monet lived much of the time in Paris, armies of navvies continued to hack down centuries-old streets, and build the apartment blocks and the new financial, commercial, judicial and administrative buildings necessary for the swelling population, as well as new hospitals, railway stations, markets, department stores, theatres and palaces of mass entertainment. There were profound ambiguities at the heart of these transformations, embedded in a complex discourse of the old and the new, dark and light, hidden and visible, and, cutting across them, the reality and the deceptions of appearances. The sense of dislocation produced by the destruction of the urban fabric – poignantly expressed in Daumier's 'Behold our nuptial chamber' in which the bourgeois complains that the demolition workers 'respect nothing. They don't have the cult of memory' – meant that tradition and a remembered community were no longer adequate guides to social relations in the city. Something of the new relationship to the city was expressed by a writer in 1861:

We are in modern Paris, rather like foreigners in a spa; we take deep breaths of the *air we are given*, we look with wonderment and satisfaction at the new streets and houses that they are building; *we enjoy it all without being attached to anything*, just as if this city were not our own.

The Goncourts too expressed their sense of being foreigners in their own city, where the new boulevards reminded them not of the world of their youth, Balzac's Paris, but of London or 'some Babylon of the future'. 'It is stupid', they wrote, 'thus to come here at a time of construction.'[13] Yet a young provincial like Monet would not have felt this nostalgia for a lost past, but more probably the exhilaration of being in a city which offered an endless feast for the eyes, which promised participation in the centre of the creative world, a new world in the making. For Monet and thousands of others it was sight rather than accumulated experience which offered access to this new social existence, a fact expressed in the insatiable demand for images of that society, and their spectacular proliferation in photography, illustrated journals and on the walls of the Salon.[14]

Nearly all Monet's paintings of Paris would contain crowds of undifferentiated figures and it is probable that for him, as for his contemporaries, a crucial aspect of the modern city was the crowd, Baudelaire's frightening but exhilarating 'immense reservoir of electricity'. Dependent on the masses, the new regime both feared and desired their presence, and sought new modes of controlling them through control of visibility. Increasingly compartmentalized along class lines, the new city exposed its inhabitants to view, for counting, for classification, while the new streets, geometrically articulated, regularly punctuated by lampposts and trees, were lined with standardized buildings, and numbered. These processes were recalled by Renoir, who in his seventies spoke of the clearance of his *quartier* as an act of despotism, and remembered how the motley population of a street market 'was dispersed, classified, catalogued in the organization of the new Halles', although when young he had approved of these changes because he was 'for progress'.[15] The consolidation of Napoléon III's regime was accomplished partially through the new levels of control necessary to improve health and hygiene, and which developed

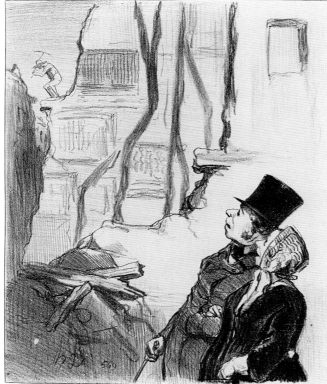

11 Honoré Daumier, 'Behold our nuptial chamber . . .', lithograph in *Charivari*, 13 December 1853

simultaneously with the new instrument of identification and classification: the camera, with its mechanical impersonal gaze.[16]

Although methods of construction making use of iron were used in many new buildings, they were – with the exception of the interiors of railway stations, department stores and exhibition buildings – rarely visible, being encased in stone and adorned with opulent but mechanically produced sculpture. The city was a dazzling setting for the display of the new rich – industrialists, speculators, financiers and businessmen – while the old working-class quarters were decimated, pushed to the periphery of Paris, concealed behind new façades, controlled by new streets whose straightness and width were intended to make street revolution impossible. Contemporaries described this process as 'strategic beautification', a phrase which vividly reveals the ideological significance of a manipulation of appearances in which the fundamental conflicts of modern urban life were transformed into spectacle. A striking prefiguration of this attitude is to be found in the Goncourts' comment on the *coup d'état*:

I am sure that *coups d'état* would go even more smoothly if there were seats, gallery boxes and orchestra seats which would allow one to see them really well and not miss anything. But this *coup d'état* nearly failed: it dared deprive Paris of one of her greatest pleasures: it did not please the spectators.[17]

It was from this period that Paris was presented as '*la ville lumière*', the city of light; a city of pleasure with its new parks and boulevards; a city of abundance with a continuous spectacle of new theatres, open-air concerts and parades, glittering shop windows and department stores full of dazzling displays of luxury goods (often produced, as suggested by Zola, in rooms in the darkest quarters of Paris);[18] a city of conspicuous consumption whose buildings overflowed with decorative cornucopias and wreaths, just as the new Halles overflowed with the produce so dazzlingly described in Zola's *Ventre de Paris* (1873). And these spectacles all climaxed in the great international exhibitions of 1855 and 1867 with their displays of thousands of items of goods (including works of art), their millions of visitors from around the world.

The feverish speculation engendered by the demolition of whole areas of the city was vividly evoked in Zola's *La Curée* (1871) in the image of Paris as a living prey ripped apart by speculators, and submerged in a rain of gold.[19] Zola's torrid imagery of the financial and sexual corruption of the Second Empire revealed that it was not wealth but the appearance of wealth which was essential in this glittering edifice: the speculator Saccard, for example, builds his extravagantly opulent private *hôtel* and spends millions adorning his wife to sustain the illusion that he has untold riches so that he can continue to create fictional wealth. To its opponents, the new Paris was 'an immense hypocrisy, a colossal Jesuitical lie', for it provided the conditions for a society which defined itself in terms of appearance – and, as its inhabitants realized, appearances could be fatally deceptive.[20] Appearances could be manipulated to create power, to control opinion, to confer a precarious status; but they could also provide a hidden space in an authoritarian society for the free play of the imagination. The tension between the 'real' and its disguises fascinated artists and writers: it was the central theme of many Realist novels, manifesting itself in Baudelaire's exaltation of the dandy and the courtesan, of the transforming power of fashion and cosmetics, or in Manet's paintings of figures in fancy dress which did not disguise, and which he used in a blatant – and, to his contemporaries, threatening – game with the central ideal of Realism, the naked truth.[21]

At the heart of this new society of spectacle, at the centre of the vulgar glitter of the imitation Imperial court, was Napoléon III – the 'enigma', the 'sphinx', as he was called by Zola – while a conspiratorial opposition clothed itself in the romantic guise of *la vie de bohème*, a shadowy milieu in marked contrast to the transparent illumination of the new Paris – but one to which Monet did penetrate. It may have been Amand Gautier, to whom he had an introduction from Boudin and perhaps from his aunt, who took him to the Brasserie des Martyrs, the headquarters of the Realists and of radical bohemia, described by Monet's friend and biographer Gustave Geffroy as a 'turbulent and mysterious thieves' lair . . . where art, philosophy, even politics found asylum'.[22]

Like any young man straight from the provinces, Monet explored the modern wonders of 'this astounding Paris', as he called it.[23] He also made straight for the prodigal feast of the Salon, then held at the Palais de l'Industrie in the Champs-Elysées.

By the late 1850s the Imperial government had succeeded in imposing its artistic ideology through its control of the juries which determined which works should be exhibited and rewarded in the Salons, as well as by manipulating the press. In accordance with its claim to derive authority from all sections of society, its artistic policies were eclectic, recognizing all styles as equally valid, judging works according to their internal formal qualities and in this way emptying the dominant art forms, Classicism, Romanticism and Realism, of ideological meaning by reducing them to simple aesthetic categories. A similar neutralization was effected by official support of the bland concept of the *juste milieu*, the mean between the real and the ideal, the material and the spiritual. Recognizing the value of the 'real' in promoting its image of itself, the government encouraged realistic modes, rewarding those who created images of contemporary life that confirmed its concept of a harmonious society in which every person visibly occupied a defined position. So persuasive was its progressivism that by the time of Monet's arrival the regime had strongly influenced the art of those who had created a radical Realism during the Second Republic – Millet, Breton, and even Courbet.[24]

Critics' comments indicate that Salon audiences preferred realistic images of contemporary society, but this was true only if those images confirmed dominant social values, and so long as they did not confront them with aspects of their society they did not want to see. Paintings of contemporary life were required to be faithful imitations of appearance, but any painting which revealed too clearly its processes of visualization, thus raising the issue of the relativity of appearances, could be as threatening as one which presented inadmissable reality. Manet's shadowy *Absinthe Drinker* (Ny Carlsberg Glyptotek, Copenhagen), excluded from the 1859 Salon but shown in the artist's studio, did both.

The contradictory discourse of light and dark, truth and falsehood, also operated in the Salon, where officially sanctioned art had appropriated Realism's language of truth. Paradoxically, while Realist theory invoked the metaphor of light for this truth – Théophile Thoré, for example, wrote that the Realists painted 'those classes of society which have never had the privilege of being studied or *brought to light* by painting'[25] – the works of the first generation of Realists were generally lower-toned and more sober in colour than the paintings of such highly regarded artists as Meissonier and Gérôme, in which light illuminates every detail, leaving nothing to the imagination of the spectator. Illumination was even more brilliant in the decorative Classicism of

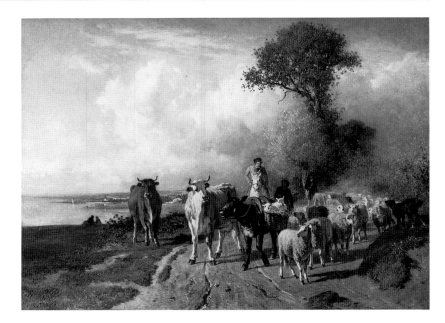

12    Constant Troyon, *The Return from the Market*, c. 1855, 97.5 × 131 (38 × 51)

Cabanel or Bouguereau which, like much of the most fashionable art of the Second Empire, was characterized by abundance and opulence and, despite its ideological justification in terms of 'the ideal', by a contrived sensuousness. The younger generation of Realists – the future Impressionists – were to paint brilliant light with something of the sensuous prodigality of the period, but at the same time they revealed the means by which their works were created with a frankness which proclaimed their antagonism to the deceptive surfaces of fashionable and officially patronized art.

The Salon, with nearly 4,000 paintings, sculptures, drawings, prints and architectural projects, could have seemed altogether confusing to Monet, who until then can have seen relatively few paintings; but his excited letters to Boudin show that, with remarkable confidence, he judged everything he saw according to the sincerity and skill with which nature was represented, rejecting anything which suggested conventional facility or 'chic'. He was interested only in the Realists and pleinairists: he admired the Realist genre pictures of Gautier and Adolphe Leleux and the 'warm light' of Théodore Frère's 'magnificent paintings from the Orient', but he was pleased to see that 'landscapists were in the majority', and excited by the luminous landscapes of the Barbizon school: Corot's landscapes were 'simple marvels', Daubigny's *Les Graves de Villerville* (Marseilles) 'sublime'; and he exulted in the 'wind in the clouds' in the 'marvellous' stormy skies of Troyon's *The Return from the Market* and the luminosity of the misty sunrise of his *Departure for the Market*.[26]

Daubigny and Troyon were the landscape artists most favoured by the Imperial administration, and Monet sought Troyon's advice about his career. Troyon insisted that he should study drawing intensively, for, although he had a gift for colour, 'like nearly all his generation' his draughtsmanship was weak; he should therefore enter a recognized studio, such as that of Couture, to learn to draw the figure – at that time regarded as the foundation of all serious art. Troyon also counselled Monet not to neglect painting, to execute copies in the Louvre, and to spend time in the country doing some developed studies

before returning to Paris in the winter to begin his studies in earnest. This was standard advice for a soundly based career; Monet's family approved, and Monet seemed prepared to accept it. But he chose instead to enter a 'free academy', the Académie Suisse, writing to Boudin nine months later that he was working hard, having 'great fun' drawing from the figure. There were, he said, 'only landscapists' in the studio: one was Pissarro, then following Corot's example with an enthusiasm which Monet shared.[27]

The Académie Suisse gave no formal instruction and simply provided facilities whereby beginners and established painters alike could draw from the nude. This freedom contrasted strongly with the more rigid curricula of the academic teaching studios, where progressive mastery of a sequence of skills – drawing from prints and casts, from the living model, and only then being allowed to use paint – was designed to instil in the student a respect for institutional authority and a reliance on precedent as the safest guide in the production of works which would be morally elevating, not only through the choice of significant subject-matter, in which idealized figures performed exemplary actions, but also through the association of style with eternal values. The arts administration and the majority of critics gave lip-service to these doctrines, but in fact adopted a more eclectic approach, while the bourgeois audiences preferred more appealing subjects and more descriptive styles; consequently academic teaching had relaxed many of its requirements, and had even integrated *plein-air* study into the curriculum.[28] Even the most liberal academic studio, however, could not accommodate a student who wanted to learn only the technical skills which would enable him to express his own experience. This was the fundamental reason for Monet's choice of a 'free' studio in which he could develop his own disciplines, and learn not from precedent but from his own observation, clarified by study of contemporary painting, by discussions with fellow students and advice from those painters he respected.

His rejection of an academic studio may have been precipitated by opinions he heard at the Brasserie des Martyrs. Monet later said with surprising vehemence that the Brasserie 'made me lose much time and did me much evil', but it probably helped him define himself as a Realist formed by the Second Empire, in contrast to those who had come to artistic maturity in the 1840s and under the Second Republic and who had been scarred by the *coup d'état*.[29] The Brasserie was intensely political: its most notable *habitués* were those who could not resign themselves to the Imperial autocracy, to the cruelties of a society based on a pitiless struggle for wealth, or to the social and artistic hypocrisy which disguised the stupidity, the suffering and the injustice inherent in the system. They both sought and were forced to seek an alternative to bourgeois modes of living in the so-called *vie de bohème*. Fresh from the provinces, the young Monet may have been attracted by the rose-tinted melancholic gaiety with which Mürger's *Scènes de la vie de bohème* (1851) had coloured this life; but with his secure bourgeois identity, he was probably equally repelled by its reality, represented with ferocious humour in Vallès's *Les Réfractaires* (1865), an unsparing account of the miseries and humiliations, as well as the courage, of those who chose or were condemned to this life.[30]

The struggles of participants in the *vie de bohème* to construct an alternative to the alienated, impersonal life which capitalism was imposing on the city-dweller did shape the new avant-garde even as it sought to embrace bourgeois life, partly because these struggles strongly influenced the bourgeois audience's concept of the artist. The

*vie de bohème* was comprised of small, shifting groups providing mutual defence from a hostile society, against whose philistinism their members were the more bitter because of their dependence on it. They accepted a hand-to-mouth existence, generally based on journalism or on coaching, which denied the fixed hours, the sharp separation between work and leisure, and between impersonal, regulated space and time and private space and time, which characterized industrial, commercial, administrative work in the modern city. 'That which they do cannot be called work', Flaubert wrote of the bourgeois view of artists in his *Dictionnaire des idées reçues* – a view gently satirized in Daumier's 'Landscapists at work'. They also mocked the hypocrisies of bourgeois marriage, the sanctities of the family, and tended to have informal sexual liaisons. Bohemian life thus had a symbolic function, in that it enacted forms of freedom inaccessible to most members of society. For sons of the bourgeoisie like Monet, the *vie de bohème* tended to be a *rite de passage*, a phase of student life traversed before settling into a career and marriage. For others, it was deadly serious: in *Les derniers Bohèmes* of 1874, Firmin Maillard gives a tragic list of artists who were to go mad or commit suicide, while others – like Vallès and Andrieu – after years of suffering and impotent hatred of authority found their moment of realization in the Commune.

The Brasserie des Martyrs attracted artists of all schools, above all the Realists, among whom the most notorious was Courbet, with his exhilarating confidence in the significance of painting the here and now, and his buoyant contempt for idealist art, for institutions and authority of any kind. There were also radical writers such as Gustave Matthieu, Pierre Dupont and Jules Vallès, and the champions of Realism Champfleury, Duranty and Castagnary. Then there was the enigmatic Baudelaire, then writing his 'Le Peintre de la vie moderne', which was to be the most significant theoretical contribution to the Realism of the 1860s, the Realism of Manet and Degas, of Monet, Bazille and Renoir.

Monet was not simply an onlooker; he was observed making a caricature of a journalist watched by Andrieu, an educational reformer whose son would become a Communard, and he made several friendships through which he would have become acquainted with contemporary debates on Realism – in particular with the writers Jules-Antoine Castagnary and Théodore Pelloquet, who defended the new painting in the opposition paper *Le Siècle*. Through Castagnary Monet may have become aware that Realism's earlier concern – or its perceived concern – with social injustice was giving way to a closer involvement with contemporary bourgeois life.[31]

Although Monet saw Courbet in the Brasserie, he did not make his acquaintance; he could have listened to him, however, and could have heard of Courbet's and Baudelaire's ideas during that first stay in Paris, through studio gossip and from mutual friends such as Amand Gautier and Boudin, who spent time with Courbet and Baudelaire that summer in Normandy. Courbet had had no formal artistic training, and was a determined advocate of self-education, asserting in late 1861, when he acceded to the petition of students of the Ecole des Beaux-Arts that he set up a teaching studio: 'I cannot teach my art, nor the art of any school at all, since . . . I assert that art is wholly individual and is for each artist only the talent which results from his own inspiration and his own studies of tradition.'[32]

These were views which Monet shared, even if his study of tradition was to be far more restricted than Courbet's: either now or in the early 1860s he copied Rembrandt's *Flayed Ox* and a detail from Rubens's Medici cycle, but otherwise made few copies as part of his

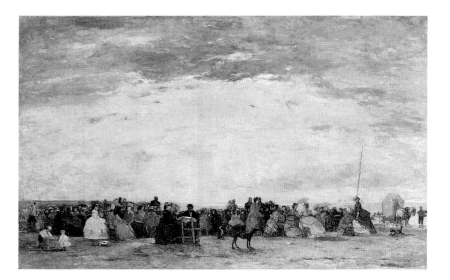

13   Charles Daubigny c.1865, *Banks of the Seine near Mantes, c.* 1856, 48 × 75 (18¾ × 29¼)

14   Eugène Boudin, *Beach Scene at Trouville,* 1860, 70 × 106 (27¼ × 41¼)

learning process.[33] Indeed as a student he looked seriously only at the work of artists who had come to maturity in the previous forty years – those categorized as the 'generation of 1830': Delacroix, Millet, Rousseau, Corot, Daubigny, Daumier and Courbet; at Troyon, Boudin and Jongkind; and, after his return to Paris in late 1862, at a new generation of Realists, most significantly Manet. For Monet, a true modern, tradition was encompassed by the life-span of his parents.

Monet discussed 'the generation of 1830' in a letter to Boudin in 1860 about a major exhibition of contemporary French painting which made him realize that 'we are not so decadent after all'. His judgments were as confident as in 1859: the Delacroixs were 'splendid'; Couture was 'finished'; Troyon no longer stood up to the other landscapists; and he now praised Courbet and Millet, as well as Corot. He told Boudin that there was not 'a single good painter of marines', so that Boudin would have 'a good place to take'. This ability to grasp the major directions of contemporary art, and to consider appropriate strategies for success, can also be discerned in Monet's comment that the exhibition showed landscape was becoming the dominant genre, as was confirmed by the Académie Suisse where he was 'surrounded by landscape painters'.[34]

The landscapes of the 'generation of 1830' offered a vision of permanence: those of Corot, Millet, Daubigny and Troyon were inhabited by peasants or other timeless figures at one with the slow rhythms of the countryside, while Courbet tended to paint uninhabited landscapes and the indifferent sea, and was more concerned with the natural forces which had shaped rock, plain or cliff than with landscapes shaped by man. There were as yet only signs of the more dynamic modern landscape imagery which Monet was to develop: in the late 1850s Daubigny painted a bourgeois lady on the banks of the Seine in place of his usual washerwomen, and in 1860, while continuing to create traditional landscapes with peasants and fisherfolk, Boudin painted the first of his rapidly executed representations of fashionable figures on the beach at Trouville, which suggest a landscape that was not eternal but up to the moment.[35]

The landscapes Monet painted in the spring of 1860 on the Marne, one of Daubigny's favourite painting areas, and an early painting of

factories (W.5) have been lost, and the major work to survive from this period is the *Corner of a Studio* (ill.17), in which a palette, old books, an unframed landscape and table are represented with a vigour for which there was no contemporary precedent, and which suggests the determination of the young man to assert himself as the Realist among Realists. The verve with which he applied the paint shows that Monet already had a strong sense of its abstract physical substance, and of its ability to suggest rather than describe form, which may have derived, paradoxically, from his continuing work as a caricaturist. This robust physicality contrasts strongly with the decorative rhythms of the tapestry and carpet, which are almost completely separate from the tonal structure of the painting. The coloured dynamism which evolved from such early experimentation would become the major structuring agent of Monet's mature painting.

The eighteen months in Paris in 1859–60 were of great importance for Monet: the experience of the Brasserie probably cured him of any lingering romantic bohemianism, and encouraged him to define himself, less as a rebel against the values of his class than as an individual seeking to develop his art in the context of those values. Monet never voluntarily lived the *vie de bohème*: he lived hand-to-mouth when this was forced on him, but as soon as he had the means (and often when he did not), he lived the life of a *bon bourgeois*, a life which his secure middle-class childhood had accustomed him to regard as normal. Nevertheless, in Paris he came into touch with the most progressive tendencies in contemporary art, which were to make the paintings he created for his society so threatening that he was for many years excluded from it.

In 1861 Monet drew a 'bad number' in the lottery for military service, and although his father and aunt could have afforded to pay a poorer man to do the seven-year service for him – common practice for those with sufficient means – they did not do so, because they felt that Monet was not seriously pursuing his career. He was indeed attracted by the idea of a life of adventure, and joined a cavalry regiment in Algeria in June, staying with it for over a year, until he was sent home in August 1862 to convalesce after an illness. His military duties were clearly not

arduous – he was able to paint, and he later said that his experience of the brilliant light of North Africa was to be important for his work. He decided during his convalescence that he would devote himself to the serious study of painting. Once again a meeting with a pleinairist was decisive, for while painting on the Normandy coast he met Johan Barthold Jongkind, who had, he said, almost as strong an influence on him as had Boudin. Monet's family agreed to 'buy him a man' for 3,000 frs., and asked the fashionable painter Auguste Toulmouche, a relative by marriage, to oversee his studies.

He had returned to Paris by the late autumn of 1862, when he entered the studio of Charles Gleyre, a painter of perfectly finished, luminous, dreamlike paintings on poetic subjects. Despite Monet's claims that he spent only 'fifteen days' or a few weeks with Gleyre, he probably remained in that studio for about eighteen months, until it closed in mid-1864 – although his attendance may have been token.[36] During this period he had a series of experiences which enabled him to move from a fairly simple *pleinairisme* to more complex styles and to modes of expression suitable for the representation of modern life and modern perception.

In Gleyre's studio he met students of his own age, Auguste Renoir, Frédéric Bazille and Alfred Sisley, who formed the nucleus of the group which was to sustain these painters in their years of discovery and marginalization. They came from different backgrounds – Bazille from the *haute bourgeoisie*, and Monet and Sisley from the new, moderately rich bourgeoisie, while Renoir, who came from the educated Parisian artisan class, had been earning his living as a porcelain painter and at other crafts since he was thirteen; they had different temperaments, perceptions, social connections, yet they were to share studios, go on landscape-painting expeditions together, meet after a day's work in Paris cafés or country inns to discuss what they had done, to argue out what they had seen and the means they had found to represent it. At this time, these and other painters, including Pissarro, met at an open-air café whose very name, the Closerie des Lilas, was appropriately different from the Brasserie des Martyrs; for instead of conceiving themselves as martyrs of Second Empire society, they accepted and delighted in what that society could offer.

Renoir recalled that students in Gleyre's atelier called Monet 'the dandy' because, although 'he did not have a penny', he wore shirts with lace cuffs, affected an aristocratic arrogance of manner, and had 'the best tailor in town' whose bills he never paid, dismissing demands with a lordly 'Sir, if you insist, I will withdraw my custom'.[37] These reminiscences – which ring true to what is known of Monet's attitude to his debts – suggest that he then modelled himself on the figure whom Baudelaire saw as quintessentially modern, the dandy, and that he was trying out the appearance he as an artist would need to present to the world. Such attitudes sit curiously with the image of the pleinairist, the sincere painter of nature's truth, but, as has been suggested, once the language of truth had been appropriated to express the official ideology of the Second Empire, its use became complex and problematic. On a simpler level, Monet may have been influenced by Bazille, his closest friend, whose letters to his family give a vivid picture of the enjoyable life of an art student who, despite a generous allowance, ran up debts, enjoyed fashionable clothes, the life of the boulevards, concerts, opera, theatre, private theatricals, regattas, and the Parisian intellectual and artistic salons. A close friend of another art student, Vicomte Lepic, son of the Emperor's aide-de-camp, Bazille enjoyed the spectacle of the Empress, the 'beautiful people' and 'beautiful coaches' in the Bois de Boulogne, and could note quite dispassionately the police intervention and censorship which followed minor demonstrations against the Emperor.[38] Monet's social and financial situation meant that he did not have Bazille's access to fashionable Second Empire society, but he shared his friend's assumption of the right to the good life, which he was to make the visible subject of his art.

In Gleyre Monet found perhaps the only recognized teacher whom he could tolerate. The so-called 'Neo-Greeks', of whom Gleyre was the leader, painted the daily life of the ancients as if they were Second Empire ladies and gentlemen, and some of his pupils had turned to the representation of similar scenes in contemporary life, producing small, rather precious, delicately painted images of upper bourgeois society which were popular with dealers, as with many critics and the general public. As Merson pointed out in his review of the Salon of 1861, the Neo-Greek style served as an antidote to radical Realism, preventing Toulmouche, for example, from being submerged in 'modern pressures'.[39] Although, as a Republican, he refused to exhibit during the Second Empire, Gleyre had a high reputation. He was liked by his students, for he generously charged no fees except for the model, and stressed individuality in those who studied with him, asserting in words that could have been Courbet's, 'Do not draw on any resources but your own', and encouraging them to paint *en plein air* in their holidays. At the same time, like any traditionalist, he insisted that mastery of drawing was the necessary foundation of painting. Bazille wrote to his parents after he had been with Gleyre for several months, drawing up to six hours a day, six days a week, 'I haven't touched colour yet, besides I don't expect to do so until I can draw very well'; Renoir later acknowledged that the discipline 'of having to copy the same

15   Charles Gleyre, *The Earthly Paradise, c.* 1870, 24 (9¼) diameter

model ten times over is excellent', and that it was with Gleyre that he learnt his 'trade as a painter'.[40]

Monet's situation was not so easy, since he had painted with a recognized painter for a considerable time, had real understanding of contemporary Realist practice and theory, had painted forceful Realist works, and was already dedicated to *pleinairisme*. He had been drawing for years, but the synthetic line of his caricatures and the exploratory line of his landscape drawings ran counter to the kind of mastery that Gleyre required. Monet later said that Gleyre had criticized one of his figure studies: 'When one executes a figure, one must always think of the antique. Nature is all right as an element of study, but it has no interest. Style, you see, there's nothing but that.' Although the anecdote was told forty years later, and was typical of many stories of the conflict between academic teacher and rebellious student, it does sum up the differences between Gleyre and Monet for whom drawing would already have been a mode of exploring the visible being of the model. Something of the shock of their encounter is reflected in Monet's words, 'Truth, life, nature, everything which aroused my emotions, everything which for me constituted . . . the unique *raison d'être* of art, did not exist for this man.' In order 'not to exasperate' his family, he continued to put in an appearance in the studio, to do 'a sketch after the model, to be present at the correction sessions' — and since Gleyre attended only twice a week, Monet had plenty of time to work in his own studio. His clearest rejection of academic teaching can be seen in his refusal ever to paint the nude, unless, in these early years, as an exercise in Gleyre's or in his and Bazille's studios.[41]

Despite Monet's antagonism to academic teaching, it is possible that Gleyre's emphasis on style forced him to consider the artifice of painting more directly than he had done before. He had returned to Paris at a crucial time, when a number of critics were beginning to affirm the demise of Realism as embodied in Courbet, but when a newer generation of painters, represented above all by Manet, was coming to maturity. These painters were particularly concerned with matters of style and with the stylistic means appropriate for the representation of contemporary life, while the older generation of Realists tended to assume a fairly straightforward equivalence between the structures of nature and of painting. Courbet suggested that his mode of creation was somehow like that of nature, but younger artists were more conscious of the artificiality of the means used to create an image of the external world.[42] In 'Le Peintre de la vie moderne' Baudelaire, now a close friend of Manet, was raising crucial questions about the role of pictorial abstraction in the imaging of the objective world, describing how the artist could use signs — a line or spot of colour — to activate the spectator's imagination in such a way that it could re-create the image of the object. Baudelaire's essay was published in 1863 in Carjat's *Le Boulevard*, but Monet — who was photographed by Carjat — could have learnt more of such ideas from Bazille, who called regularly at the home of his relatives, Commandant and Mme Lejosne, where Manet and Baudelaire, Whistler and Fantin-Latour, Nadar, Champfleury and Duranty were also received. As well, Bazille visited Manet at this time, when the older painter was working on the *Déjeuner sur l'herbe* and *Music in the Tuileries*.[43]

Realism was forced to define itself in relation to two forms of modern technology which enabled the mass production of images: photography and lithography. For Baudelaire the mechanical nature of photography was the antithesis of the artifice that is art, but he

16   Honoré Daumier, 'Nadar elevating photography to the level of art', lithograph in *Le Boulevard*, 25 May 1862

maintained that lithography's speed of execution, which demanded abstract, synthetic modes of evoking reality, made it ideally suited to the representation of modern life. Baudelaire's friend and Monet's hero, Daumier, had entered the debate with his 'Nadar elevating photography to the level of art', published (as were 'The New Paris' and 'Landscapists at work') in *Le Boulevard* in 1862. The print seems to celebrate the mass appeal of photography and the new view of reality given by its mechanical gaze, yet it was the lithographer who made the leap of the imagination which enabled him to grasp not only the dynamic instability of the balloon, but the dynamic movement of sight as it progressed through multiple planes of space. Like many of Daumier's images, it is concerned with the processes of seeing, expressed in the rapid, abstract notation evoked by Baudelaire. In the context of such ideas and images, Monet may have come to understand a mysterious phrase which he, the aspiring landscapist, could well have read in Baudelaire's 'Salon of 1859', in the section on landscape (where Boudin was praised): 'most of our landscapists are liars precisely because they have not lied'.[44]

When Monet returned to Paris in late 1862, he probably could no longer believe that *pleinairiste* landscape was in the vanguard of exploratory Realism, as he had done on his earlier visit, for this position was now occupied by the painters of contemporary urban life who in

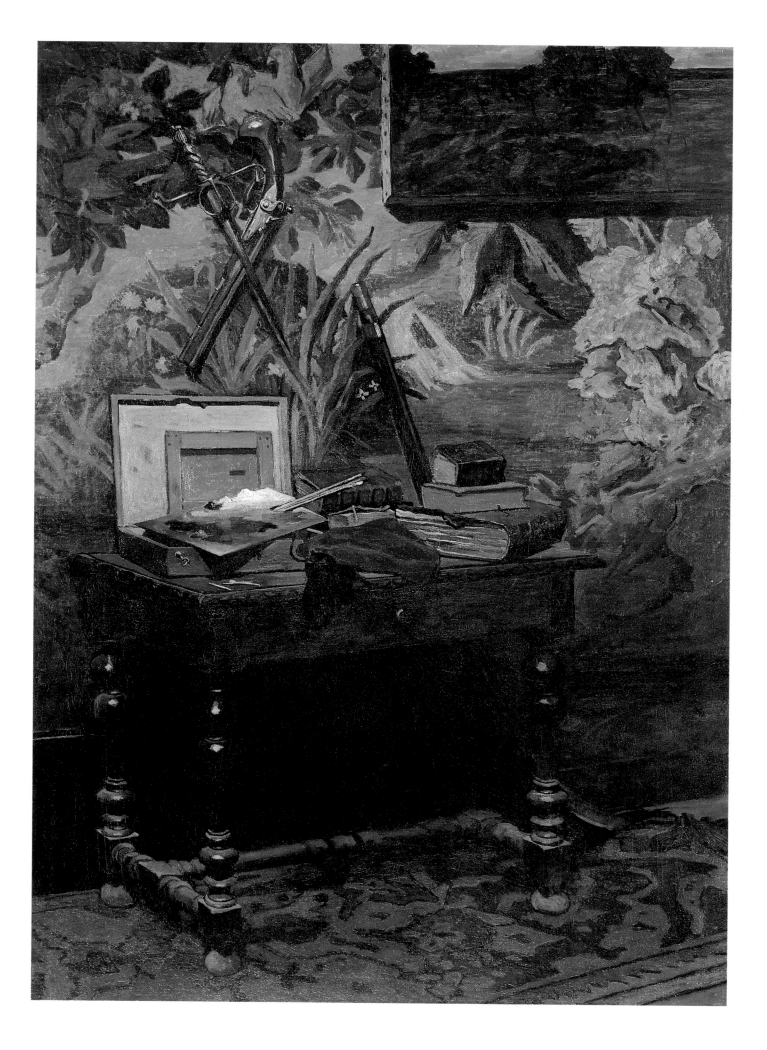

17　*Corner of a Studio*
(W.6), 1861, 182 × 127
(71 × 49½)

1859–60 had been graduating from their teaching studios, Manet, Fantin-Latour, Whistler and Tissot. Critics and the public attached these artists to the 'school of Courbet', and they did indeed take up those aspects of his painting concerned with contemporary bourgeois life. They formed part of a broadly based movement which Castagnary was to define in 1864:

Our artist will thus be of our time, he will live our life, with our customs and our ideas. The feeling which we, society and the spectacle of things will give him, he will render in images in which we will recognize ourselves and our surroundings. For it must not be forgotten that we are both the subject and object of art.[45]

Although Courbet was seduced by the high life of the Second Empire and by its emphasis on individualist self-gratification, he made occasional gestures of opposition to it – and, although sporadic and contradictory, the sincerity of these gestures would be confirmed by his adherence to the Commune in 1871.[46] In contrast, Manet's paintings of

18    Edouard Manet, *Le Déjeuner sur l'herbe*, 1863, 208 × 264 (81 × 103)

19    Edouard Manet, *Music in the Tuileries*, 1862, 76 × 118 (29½ × 46)

the domestic and social pleasures of the bourgeoisie were the paintings of one who knew that society from the inside. Coming from the established Parisian bourgeoisie, liberal, republican, maintaining a demeanour of sceptical detachment amidst the financial and sexual excesses of the *fête impériale*, he was a participant none the less, a *boulevardier* profoundly influenced by the transformation of bourgeois life in Napoléon's new Paris. Manet's first major paintings of modern urban life, both public and private, as well as the first major essay on modern urban art, Baudelaire's 'Le Peintre de la vie moderne', came into being in the early 1860s when the first phase of Haussmann's transformations had been completed. Both were responding to the realization that the structures and techniques of traditional painting were incapable of rendering the city-dweller's experience of the structureless crowd, of being submerged in numberless, unknowable lives encountered as random, momentary physical shocks; and they found that the pared-down, synthetic notation developed by illustrators of Parisian life suggested means by which painters could develop a language of pictorial signs which would enable the spectator to grasp the image with the unthinking speed appropriate to recognition in the city.[47]

Monet probably first saw Manet's paintings in the spring of 1863 at the Galerie Martinet on the fashionable boulevard des Italiens, and at the Salon des Refusés housed with the official Salon in the Palais de l'Industrie, for it is unthinkable that he would not have gone to see the works which caused such a scandal in the name of Realism, and which were a rallying point for younger artists. Promoted as a liberal gesture on the part of the Emperor, the Salon des Refusés provided an arena for an open rehearsal of the opposition between official notions of an acceptable Realism and a new Realism, provocative because it represented contemporary subjects without giving them easily readable 'meanings'. In his report on the Salon, Comte de Nieuwerkerke, Director-General of the Imperial museums, made thinly disguised threats against 'deviations of taste' and 'eccentricity', and qualified his recognition of the principle of 'the greatest liberty' in art, by warning that 'in exchange for this liberty of tendencies whose legitimacy we are pleased to recognize, we demand from you . . . obstinate, patient, committed work. Distrust the "good enough". . . '.[48]

It is probable that Manet's *Déjeuner sur l'herbe*, shown in the Salon des Refusés, and his *Music in the Tuileries*, shown in the Martinet gallery, were a shock to the young pleinairist, Claude Monet: both were elaborate discourses on social and artistic artifice totally unlike the 'naturalness' of the landscapes which Monet had most admired. But late in life, Monet repeated a comment he had made just before Manet's death in 1883, that his encounter with the older painter's work in 1863 was his own 'road to Damascus', a 'revelation'. Baudelaire, who accompanied Manet as he did studies of the crowd listening to the band in the fashionable Tuileries gardens near the Imperial palace, wrote of the processes of socialization in which the little girls imitate the social rituals of their elders.[49] Not only did Manet paint little girls learning the artifice by which Parisian dandies and ladies of fashion turned themselves into spectacle, into art, he also represented diverse creators of Second Empire culture, including Baudelaire, the composer Offenbach, the writer Théophile Gautier, a spokesman for the culture of the court – and himself. Manet transformed the social group, his friends and himself into objects whose only existence lies in the visible, for his style is as emphatically artificial as the subject: the scene is represented by a kaleidoscopic scatter of flat patches of colour made specific by

seemingly random graphic signs. These patches of colour rest on the surface, and there is no continuity of space within the picture in which the figures could move. Breaking with the conventional illusionistic relationship between the painting and the scene represented, the picture forces awareness of the means used to create the image.

Contemporary *pleinairisme* contained nothing as self-conscious as this, either in subject or in mode of representation, and few of the recognized pleinairists – except Jongkind – were excluded from the official Salon. In his 'Salon de 1859', Castagnary had based his rousing assertion of the significance of the naturalist school on the achievements of the painters of the 'life of the fields', and claimed that the 'life of the towns' was yet to be adequately represented. Castagnary reasserted the Realist doctrine that 'Every epoch knows itself through the facts which it creates: political facts, literary facts, scientific facts, industrial facts, artistic facts . . . which all bear the imprint of its particular character'.[50] Most landscapists, however, painted aspects of rural life which had not changed, ignoring the increasing industrialization of agriculture in many areas, as well as the changes wrought on the countryside by the expansion of cities, railways, factories and urban recreation.

Monet may have known of a few attempts to develop an iconography for representing the modern landscape – the album published in 1862 with Daubigny's etchings of a boat trip down the Seine, showing the river animated by steamboats and the landscape fractured by a railway train, or Boudin's paintings of the middle classes enjoying themselves at the Normandy beach resorts, opened up by the railways, developed by speculators, popular with the Parisian middle classes and recently made fashionable by the court. The elegant figures are shown in the clear light of the coast, sea-bathing, gossiping or promenading on the beach, the ladies in up-to-the-moment crinolines, with their parasols, bonnets, ribbons and shawls fluttering in the breeze, contrasting with the darker, stiffer clothes of the gentlemen. These scenes of artificial socialization were the coastal equivalent of Manet's *Music in the Tuileries*, and it is possible that Baudelaire saw early examples (like the *Celebration in the port of Honfleur* of 1858) when he stayed on the Normandy coast in 1859. Boudin's small paintings differed from Manet's in that their delicate tonal continuities and distanced subjects remained within *plein-air* convention, as if the fashionable figures were simply substituted for the fisherfolk. There was, however, a difference between Boudin's representation of the crowded, fast-moving groups of visitors to the coast and the slower rhythms which animated his paintings of country people.

No landscape painters approached the radical artificiality of Manet's works, for they preferred to create an equivalent for the continuous substance of nature. Even in *plein-air* paintings like Corot's *The Sèvres Road (view of Paris)*, landscapists tended to work from a unified, mid-toned substructure, using a multitude of small, soft strokes which fused in such a way that the substance of the painting suggested equivalence with the continuities of the natural scene. Such structures are in marked contrast to the fractured surface of *Music in the Tuileries*, with its small, flat, 'jumpy' planes of colour which outraged Manet's contemporaries. Most landscapes were represented as distant from the artist, with their space hollowed out by means of traditional perspective, so that one may imagine a continuity between the space of the painting and that in which the spectator stands. Manet crudely denied this illusion by bringing the scene right up to the surface of the painting. Corot distanced his landscapes, so that patches of paint detached from form can be experienced as indistinct because far from the spectator, and

20   Camille Corot, *The Sèvres Road (view of Paris)*, c. 1855–65, 34 × 49 (13¼ × 19)

do not draw attention to themselves as paint. By the early 1860s, the relatively loose techniques of the Barbizon painters, which had been so bitterly criticized in earlier decades, had come to be regarded as directly equivalent to the motifs, and as so natural that they scarcely required examination. Castagnary, for example, wrote that in Jongkind's painting (ill.22) 'everything lies in the impression', so that execution 'disappears', concerning the spectator as little as 'it had the painter'.[51] This was the context of Baudelaire's remark that 'most of our landscapists are liars precisely because they have not lied'. It was in the gap between the artifice of modern urban expression and the 'natural' in traditional *pleinairisme* that Monet developed a form of landscape painting related to the new modes of urban expression.

Monet spent the 1863 and 1864 holidays from Gleyre's studio painting in the forest of Fontainebleau or on the Normandy coast, explaining to those supervising his progress that he had not abandoned the studio, although he had found 'a thousand charming things which I could not resist' in the forest.[52] Many of his early landscapes have been lost, but those surviving suggest that he was already drawing lessons from Manet's 'lies': his *Farmyard in Normandy* (ill.10) is a conventional *pleinairiste* subject directly related to works by Boudin and Daubigny, but it has a curiously staccato structure which brings it closer to Manet's artificiality than to the continuities of Boudin's open-air painting.[53] The linear recession created by the stripes and shadows on the barns, and by the reflected eaves and edging of the pool, is blocked and brought back into shallow space by the emphatic reflection of the barn – which, since it lacks its stripes, reads as a flat patch so luminous that it scarcely stays in place; the verticals which run across it are echoed emphatically in the background trees which are locked to the surface by the reflections. The open, unshadowed foreground which the gaze has to traverse is characteristic of Monet's 1860s landscapes, whereas in most *pleinairiste* works the foreground tends to be shadowed and angled in such a way that the picture's inner space is contained and distanced. Some of these characteristics are seen in Monet's earliest drawings as well as in his *Landscape at Rouelles* (ill.9), but there the paint adheres to the forms to create delicate continuities; here the paint is thick and pastey and

sometimes detaches itself from the object, while the linking of forms across space collapses the perspective and creates a multi-focused space which makes more active demands on the spectator than do more conventional works painted in the open air.

Monet made his first bid for public attention as a landscapist by submitting two large marines, *The Mouth of the Seine at Honfleur* (W.51) and *The Pointe de la Hève at low tide*, to the Salon of 1865. He was clearly determined to make a decisive impact in the only setting in which an artist could make a reputation and a career, for the scale and boldness of his paintings ensured that they would be visible amidst thousands of others. They declared their relationship to recent tendencies, decried by traditionalists as attacking the fundamentals of art and seen by the young as heralding the future, but they did so with a certain moderation. Monet had probably decided to make his name as a painter of the Normandy coast in canvases which would firmly declare his allegiance

21    Study for *The Pointe de la Hève at low tide* (W.40), 1864, 51.5 × 73 (20 × 28½)

22    Johan Barthold Jongkind, *The Beach at Sainte-Adresse*, 1862, 33.5 × 46 (13 × 18⅛)

to the school of *pleinairisme* and to the painters who had preceded him on that coast, Courbet, Daubigny, Jongkind and Boudin, all of whom had found favour with the Imperial arts administration and/or collectors;[54] but he displayed his individuality in the sheer physical density and specificity of his Realism and in his pairing of a traditional coastal subject, the *Pointe de la Hève at low tide*, with a painting which mingled traditional and contemporary shipping, *The Mouth of the Seine at Honfleur*.

Following normal practice, Monet painted studies for his Salon works; after the final closure of Gleyre's school, he spent the summer and early autumn of 1864 at Honfleur on the Normandy coast, with Bazille (working from 5 a.m. to 8 p.m.), or with Boudin and Jongkind, in whose company, he wrote, 'there's much to be learned'.[55] Monet's letters to Bazille express an exuberant confidence combined with a more thoughtful, sometimes even anguished, concern as to how nature could be represented. In one letter which introduced themes that would be heard throughout his life, he made it clear that painting was not simply a matter of recording what he saw, but also required 'reflection':

> I discover ever more beautiful things every day. It's enough to drive one mad, I've got such a desire to do everything, my head explodes. . . .
> I'm happy enough with my stay here, although my studies are really far from what I would wish. It's decidedly *frightfully difficult to make a thing complete in all its relationships*. . . . Well, my friend, I want to struggle, scrape off, begin again, for one can do what one sees and what one understands, and *it seems to me, when I see nature, that I'm going to do everything*, write everything, *and then go and do it*. . . .
> All this proves that one must think only of this. It's through observation and reflection that one finds it. Let's work, then, work continuously. . . . It would be better to be quite alone, and yet, there are many things that one can't work out on one's own. Finally, all this is terrible, and it's a heavy task.[56]

Late in life Monet told his biographer, Alexandre, that he, Boudin and Jongkind used to discuss how far a landscape should be composed, a crucial issue for artists concerned with truth, particularly in the context of the contemporary Parisian debate on the necessity of the artificial.[57] In his *Beach at Sainte-Adresse* of 1862 (the same beach which Monet painted in *The Pointe de la Hève at low tide*), one can see how Jongkind applied his principle of composing from what could be seen in the motif, emphasizing the verticals of the houses so as to create an internal network of vertical accents which tauten an otherwise rather loose structure. Monet's early drawings show that he had an aptitude for seeing structurally significant forms in a landscape, but Jongkind's practice probably encouraged him to utilize this ability as a means of deepening his understanding of the landscape. In the study for the Salon painting, the structural elements were embedded in the landscape and only gradually reveal themselves, while in the finished painting Monet translated them into a series of rather obvious geometric configurations – seen, for example, in the way the breakwaters form a spatial triangle with the beached boat, roof-top, strip of sand, cliff top and horizon line. Such configurations would help the Salon audience to explore the space of the painting and appreciate the skill of the painter, but they do not reveal as much about Monet's experience of the motif as do the paintings in which the finding of structure was part of the process of seeing.

Monet took care in his first exhibited works not to do anything too radical – *The Pointe de la Hève at low tide*, in particular, was traditional in its presentation of a distanced view which recedes smoothly from the observer and in its use of a descriptive brushstroke which mimics natural effects: a flat sheen of paint echoes the thin sheet of water as it recedes

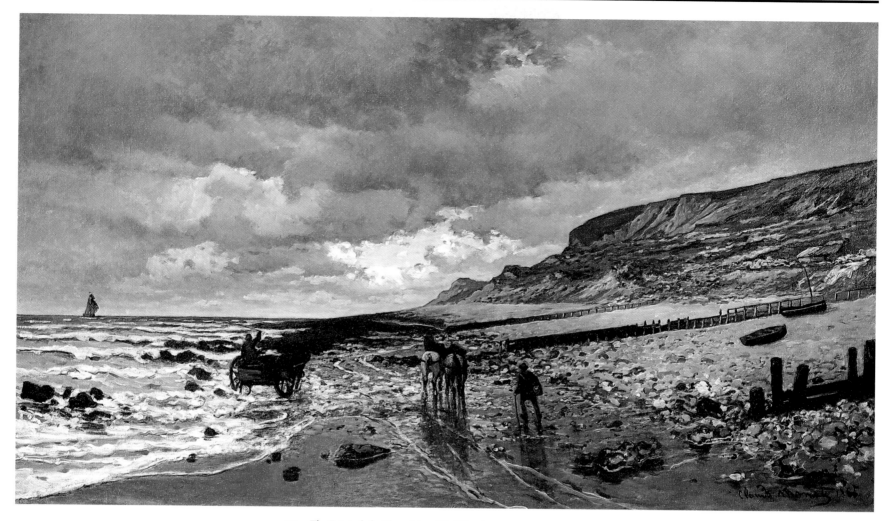

23    *The Pointe de la Hève at low tide* (W.52), 1865, 90 × 150 (35½ × 59)

from the sand, thick lines of white, green and grey paint enact ripples eddying over the receding water, and heavier textures represent the regular surge of waves coming in from the open sea.

*The Mouth of the Seine at Honfleur* and *The Pointe de la Hève at low tide* were accepted by the Salon jury and well received as evidence of a promising young talent with, as Mantz said in the prestigious *Gazette des Beaux-Arts*, 'a bold manner of seeing things and of imposing himself on the attention of the spectator', allied with 'a taste for harmonious colorations in the play of related tones, the sense of values'.[58] Monet's painting was immediately linked with that of Manet. The similarity of their names and the relationship of Monet's *Mouth of the Seine* to Manet's *The Battle of the 'Kearsarge' and the 'Alabama'* (ill.52), exhibited by the dealer Cadart in July 1864, perhaps created genuine confusion; but Manet was understandably angered, for his marine had been mocked, and his Salon entries, the *Olympia* and *Jesus insulted by the soldiers*, were being mercilessly attacked.[59] Monet's paintings were clearly more acceptable, in their fairly conventional representation of the substance of nature – quite different from the dizzy, tilted space, the abstract paint, and the abrupt simplifications of Manet's marine. In succeeding works, Monet disrupted the illusionist relationship between painting and motif in a manner which shows a still clearer debt to Manet.

The increasing materiality of Monet's paint – which was quite unlike Manet's repeatedly scraped, thin surfaces – may have owed something to his study of Courbet, whose 'name and works exercised a fascination on younger painters', as Monet later emphasized. Bazille may have met Courbet as early as autumn 1863, but Monet seems not to have done so before late 1865. Courbet's influence may be seen in the pastey surfaces of *The Pavé de Chailly* (ill.24), but Monet exaggerated the individual characteristics of his painting, as if to emphasize that he was learning 'without copying anyone'.[60] It was the first of a long series of works in which Monet – like Pissarro and Sisley – painted a slanting view along a road which simultaneously advances towards and retreats from the spectator, and which seems to express something of the indeterminacy of relationship between the visitor to the country and the natural scene. The work was painted with a tonal simplification so bold that the light and dark tones of the trees on the left almost detach themselves from them. Equally forceful is the foreground plane, which 'comes out' to where the artist or observer stands, while the ruts lie like ribbons of paint on the picture surface. There is no precedent for this disjunctive breadth of handling in Barbizon *pleinairisme*, or even in Courbet's landscapes, in which the continuity of space is suggested by the implied continuity of tone between the landscape and the spectator's

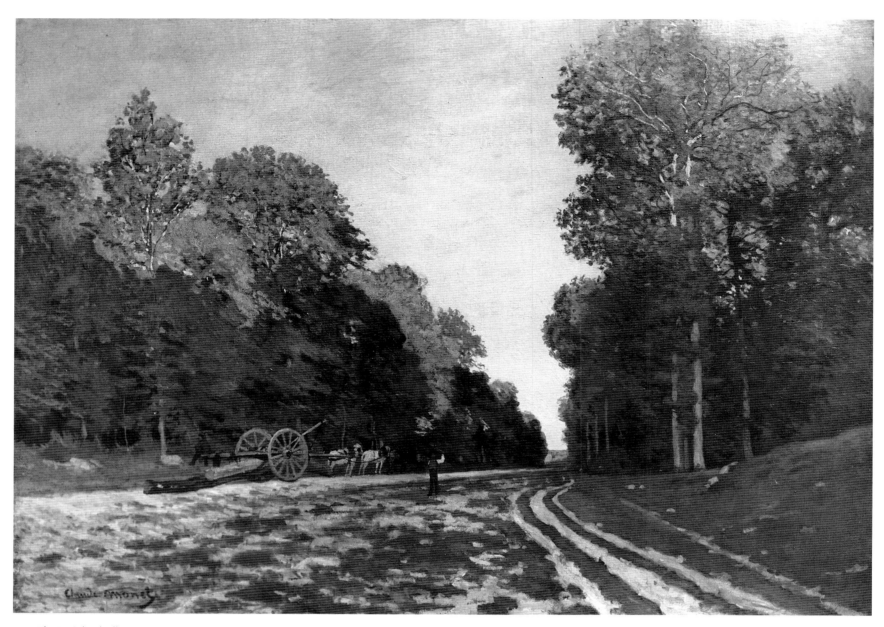

24   *The Pavé de Chailly* (W.19), *c.* 1865, 98 × 130 (38 × 50½)

25   Ryuryukyo Shinsai, *Susaki*, before 1830, woodblock print, 22.8 × 34.3 (21½ × 13)

position in relation to it; in Monet's painting, on the other hand, the foreground is so abruptly, so immediately before one that the paint cannot disappear in illusion. Even the strong tonal contrasts of Manet's *'Kearsarge' and 'Alabama'* were softened by distance and do not fracture space into a series of 'fixes' as Monet's did.

It is possible that Monet studied such effects in Japanese prints influenced by Western perspective. He claimed that he first found Japanese prints in a junk-shop in Le Havre in the 1850s, and, although so very early a date is unlikely, the great seaport was a likely place to have seen them on subsequent visits home.[61] He could also have seen the out-of-focus foreground which runs unchecked into spectator space in paintings by Jongkind, but the difference in scale between Jongkind's small works and Monet's five-footer makes the painterly substance of the latter's foreground more immediately apparent. Jongkind's use of this kind of space can be found in works which pre-date the arrival of Japanese prints in Europe, and this points to a general phenomenon of the 1850s and 1860s — an undermining of linear perspective and a fracturing of continuous space which is particularly characteristic of the radical close-ups of avant-garde art, but can also be found in much academic art. *Consciousness* of such changes was induced, not only by modern urban experience, but by non-traditional modes like Japanese

prints, and by the constant presence of photographic images which shattered the unitary construction of space (see Wildenstein, I, p. 17).

# II

Monet's careful location of himself as an artist with his relatively conservative entries to the Salon was a sensible move at the beginning of a career which would have to depend entirely on his own efforts. His ambitions were, however, immense, and in his next painting destined for the Salon of 1866, he turned himself from a promising painter of traditional themes to one tackling the central issue of the avant-garde: the representation of contemporary life in a style which would register contemporary modes of consciousness. Bazille and Monet had painted 'life-sized studies' in Monet's studio and perhaps 'models in the sunlight' in a city garden, and Monet had painted small portraits, but his Salon painting was to be a figure composition on a huge scale. Monet may have been inspired by calls from Baudelaire and Castagnary for a painter of modern social life, yet nothing could predict the scale of his response – a canvas 4.60 metres (15 feet) high and at least 6 metres (19 feet, 8 inches) long – a scale traditionally used to represent significant themes, not something as trivial as a picnic, frequently the subject of images in illustrated journals.[62] Monet was, alas, unable to complete the work in time for the Salon, and left it unfinished; some ten years later, it was so damaged after he had left it as pledge for a debt that he cut it up and destroyed the damaged parts. All that now remains are a few pencil sketches, a large charcoal study, two oil studies of a pair of figures and of the whole composition, and two large fragments of what was to have been the Salon picture.

The Picnic [Le Déjeuner sur l'herbe] (ills.26–9), unfinished, unexhibited, was a painting without an audience beyond Monet's small group of friends and the artists – including Courbet – who came to admire it while it was being painted.[63] In this sense, it was a painting without a history, without those meanings created in the interaction between a work and its audience. This remained true of Monet's paintings of the 1860s, for after 1865 only three of his works were accepted for the Salon: the fashionable modern portrait, Camille or The Woman in the green dress (ill.31), which was shown with the radically abstracted Pavé de Chailly in the Salon of 1866, and one of his modern seascapes, Ships leaving the jetties of Le Havre (lost; see pp. 50–1), in the Salon of 1868. Monet's ambition to make his name as a painter was thus frustrated by juries which were partly appointed by the government, partly elected by and from those who had received official honours. Some works were shown in dealers' windows, enabling him to establish a presence, but not an interaction with the wider audience provided by the Salon, and he acquired an 'invisible' reputation through comments by sympathetic critics, particularly when Zola devoted a long passage to his work in 1868.[64]

Paintings which Monet conceived as addressing a wide bourgeois audience were forced to remain private, their only audience a small group of painters, a few critics, a few collectors, and, once a year, those hostile juries which refused to let them be seen. The same was true of many works by his friends, Bazille, Renoir, Sisley and Pissarro, although none of them was excluded as ruthlessly as he. In the second half of the 1860s the public was then able to get only a patchy idea of what critics were defining as a new school of painting, concerned with contempor-

ary life, for although the juries could not exclude the new painting entirely, they did deprive it of any coherence as a movement.

The scale of Monet's Picnic would have located it in a sequence of great innovatory statements made by the heroes of modern painting at the outset of their careers – it would have been Monet's Oath of the Horatii (Salon 1784), his Raft of the Medusa (Salon 1819), his Burial at Ornans (Salon 1850–1). It would have declared Monet the leader of a third generation of Realists by launching a manifesto of a new kind of Realism which would confront Manet's Déjeuner sur l'herbe, and would attach itself, through its scale and its denial of any meaning beyond that of the existence of ordinary people, to Courbet's Burial at Ornans, seen as the manifesto of Realism when exhibited at the Salon sixteen years earlier.

The subject of Monet's painting was, of course, directly related to Manet's Déjeuner sur l'herbe, but Monet wanted to make a more straightforward declaration of modern Realism, so his painting would have been both a homage to and a declaration of independence from Manet: its scale would make Manet's work seem small; its boldness of execution would make Manet's seem tentative; its determined modernity would emphasize the ambivalent relationship of Manet's painting to the present; it would, above all, be 'natural', as opposed to the disquieting artificiality of Manet's world. The country which Monet represented was not the ambiguous stage set of Manet's Déjeuner sur l'herbe, but a scene in the forest at Fontainebleau; not artificial nature, nor indeed 'natural' nature, but recreational nature; not an elaborate play on the Renaissance theme of nude figures in a landscape, but a simple evocation of ordinary people enjoying themselves. What Manet meant to Monet's group is suggested by Bazille's comment that he was the Cimabue and the Giotto to their 'new Renaissance' – in other words, he was the 'primitive' who laid the foundations for a new conquest of reality which they saw as unambiguous, full of light and colour, informal, up-to-the-moment and, above all, enjoyable.[65] They seem not to have appreciated the social signification of Manet's artificiality, and to have been interested only in the way he drew attention to the artifice of paint in creating an equivalent of the external world.

In looking for a model for a more natural figure painting, Monet looked behind Manet to Courbet, who had none of Manet's fastidious Baudelairean detachment from 'natural' nature. By the late 1850s, Courbet's art seemed to express the most complete acceptance of Second Empire worldliness and sensuality, but he would still occasionally paint one of those works which exploded its hypocrisies – such as The Young Women of the banks of the Seine (Salon 1857), or the anticlerical Return from the conference, rejected even from the Salon des Refusés of 1863. Monet's Picnic was, however, to be a whole-hearted celebration of what the fête impériale could offer. It was not an expression of the ambivalence of bourgeois status which had so disturbed the Parisian viewers of the Burial at Ornans, nor of the ambiguities of sexual and individual identity in modern society that outraged Manet's audiences.[66] Monet simply represented members of his own class – people he knew – secure in the order of things, enjoying the good things of life, and he suggested no other meaning beyond the fact of their existence at that moment, with no past, no future, no history. Despite the self-conscious intent of this manifesto-painting, it is moving in its sheer exuberance. It is as if Monet had at last found his subject, and his previous rather sombre, vigorous realism is forgotten in this explosion of brilliant light which pours through the fluttering leaves to sparkle on the women in beautiful clothes and on the laden cloth.

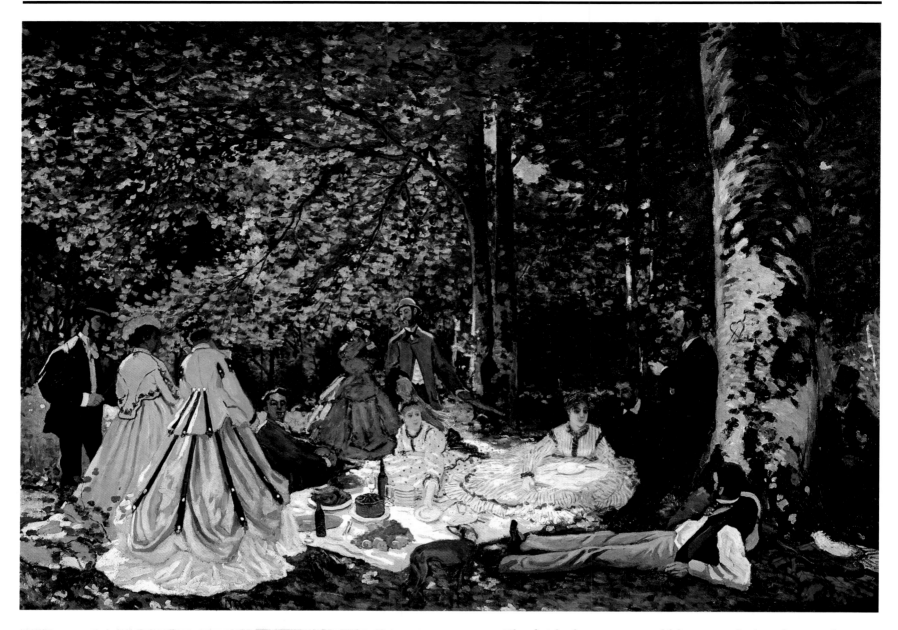

The finished painting would have invoked tradition only in its scale, which would not only have gone against contemporary bourgeois taste for small, intimate works, but demanded elaborate processes of preparation which countered Monet's own need for direct experience of the motif. Following the procedures he would have learnt in Gleyre's atelier, Monet may have derived his 'idea sketch' from a historical source: a painting in the Louvre, Carle van Loo's *Hunt Picnic* of 1737; and he developed his composition through drawings as well as through oil studies of figures and the group.[67] Monet proceeded, however, to undermine academic procedures by using an improvisatory technique for his painting — he did not square up his oil sketch for transfer to the big canvas, but drew straight on to the canvas, improvising in paint in a manner which was closer to the practice of lithographic drawing than to the elaborate paint structures of academic painting. He may have been conscious of Baudelaire's contention that 'for sketches of manners, for portrayals of bourgeois life and the fashion scene, the quickest and cheapest means will evidently be the best. . . . there is in the trivial things of life . . . a speed of movement that imposes on the artist an equal speed of execution'.[68]

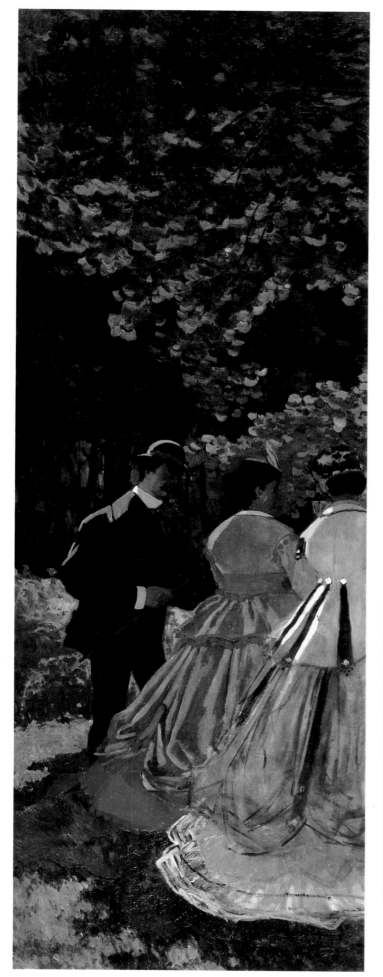

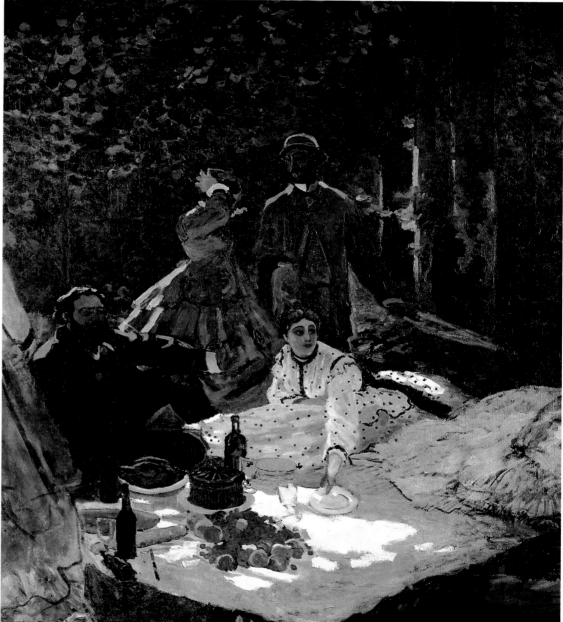

30    Gustave Courbet, *Young Women of the banks of the Seine*, 1856, 174 × 200 (68 × 78)

It was, however, to prove impossible to reconcile speed with the demands of a Salon 'machine'. Monet spent nearly a year working on his painting, going to Chailly in the forest of Fontainebleau before the Salon opened in 1865, and spending about three months doing studies of the forest setting in which one can see his growing appreciation of brilliant light filtering through foliage. He was probably joined by Camille Doncieux, who seems to have been the model for one of the figures, and who was to become his mistress and later his wife, and by Bazille, who posed for several figures. Monet thus used the elaborate processes of high art to create an image of an informal meeting of friends, gathered in relaxed poses in 'the *déshabille* of their consciousness', to use Proudhon's phrase – an image which contradicted the main purpose of formal figure painting, the exposition of significant content.[69]

Every aspect of the painting shows Monet's awareness of the current debate on modernity. The fragments of the work destined for the Salon and the composition study show that it was carefully structured to express the unstructured, which contemporaries felt an essential aspect of modern life. Baudelaire coupled his dictum, 'modernity is the fugitive, the casual and the accidental', with an insistence that it should be fused with that other essential element of art, the eternal; but Monet was prepared to ditch the eternal, and, as did Courbet in *Burial at Ornans*, represented the figures as if they were moving round a central void before settling into position. (That this void was a feast not a grave was symptomatic.) The grouping has no formal climax to govern its random movements; every figure, every casual gesture and shifting pose, is equally stressed. In his review of the Salon of 1863, Castagnary had written that the 'revolution' which was 'appearing everywhere' in painting

issues from the very depth of modern rationalism. It springs from our philosophy which, by again placing man within the society from which psychology had separated him, has made social life the principal object of our future researches. It springs from our

politics, which by taking the equality of individuals as a principle, and the equality of conditions as a desideratum, has banished false hierarchies and lying distinctions from the mind.[70]

To write of 'the equality of individuals' and of 'conditions' in Napoléon's free-enterprise Empire was, of course, a fiction, but a potent one for those who believed in progress, and for those who were undermining the traditional hierarchy of the arts, not only by painting egalitarian – for which one should read 'bourgeois' – subjects, but also by utilizing techniques drawn from the mass-produced imagery of journalistic illustration, photography and commercial posters. Moreover, paintings with unhierarchical structures, which accorded no special significance to any part of the field of vision, reflected what was felt to be characteristic of modern urban experience.

A woman raises her arms to take off her hat, a man indicates a place with his umbrella, a woman stretches to offer a plate, a man shifts his weight – each is suspended in a moment of time which, like that of the camera, is detached from continuity, but which is also endless, since it is impossible to know what phase of a movement is being represented. The interlinked chain of seated and standing figures may owe something to the continuity of movement of Watteau's *Embarkation for the island of Cythera* (which Monet later said was his favourite painting in the Louvre; ill.272),[71] but characteristically Monet fractured continuity by depriving it of any narrative content, so the figures exist only in the moment in which they are seen. This could be compared with the way narrativity was constructed in Courbet's *The Young Women of the banks of the Seine*, by the rowing boat with the top hat in it which raises questions – who rowed them here? when will he or they return? – questions which intersect with the drowsy continuity and suggest before and after. . . . In Monet's painting there is nothing that can redeem the moment. Thus although he knew some of his sitters intimately, he represented them as if they were seen in a glance by a casual passer-by: they must have their own lives, their own histories, but these are opaque to those who must rely only on sight.

The increasingly rigid working hours of modern commerce and industry were complemented by fixed units of leisure, and the 'day in the country' became the weekday dream of the city-dweller, a dream which many could realize when the railways began to provide quick, cheap transport into the suburban countryside. Zola gave a class structure to the day in the country in 'Aux champs' (1878), which opens: 'Parisians today have an immoderate taste for the country'. The 'walk to the fortifications' was, he said, 'the classic promenade of working people and the *petit bourgeois*'; once there, the military zone and factories lay in front and a stifling Paris behind; employees in modest circumstances and comfortably-off workers 'go further, to the first suburban woods, and even the real country', while railways, steamboats, omnibuses and trams opened up the country beyond to those better off. 'On certain sunny Sundays', wrote Zola, 'it has been estimated that a quarter of the population, 500,000 people, take vehicles and [railway] carriages by assault, and spread out over the countryside', with families picnicking, and 'happy groups, loving couples and solitary walkers'.[72] The casual visitors who came to enjoy themselves for a few brief hours before returning to work did not experience the Parisian countryside in terms of its historical or literary associations; it was not a place for meditation on the eternal values of nature – as in much Barbizon landscape painting – but rather, a place for immediate sensual gratification, for direct, unreflective pleasure in simple physical existence and in sunlight and fresh air.

In much contemporary literature, as well as in images in contemporary journals, the suburban countryside was represented as a place of escape from moral restraint, a locus for illicit sex. That overcrowded living conditions and the omnipresent gaze of co-habitants in the city almost necessitated such escape perhaps made it particularly reprehensible when exposed to the public gaze in the Salon. In the Salon of 1857, Courbet's *Young Women of the banks of the Seine* shattered the Golden Age idyll of the harmony between human sexuality and nature by implying that sexuality involved prostitution, a financial transaction, while Manet's *Déjeuner sur l'herbe* suggested the liberated sexuality of the *vie de bohème*.[73] Monet probably conceived his painting in terms of these two works but characteristically made no play on sexuality, and even if Watteau's island of love was in his mind, *The Picnic* expresses nothing more explicit than relaxed companionship.

Those indicators which were keenly scrutinized at a time when social identity was so unstable make that of Monet's picnickers quite specific. Perhaps pursuing Baudelaire's recommendation that the painter who wished to penetrate to the essence of modernity should study fashion prints, Monet even updated fashions which had changed during the long genesis of his painting. He did so without Baudelaire's philosophic passion for the artificial, but the study of fashion could have influenced the way he presented the body as an object. That his painting may have been intended as a pastoral complement to the artificial rituals of urban *haut bourgeois* recreation represented in Manet's *Music in the Tuileries* draws attention to the casual formality of his figures. Their attitudes relate to contemporary characterizations of what the Goncourts called the 'modern body', referring to Gavarni's presentation of it in terms of 'its melancholy, fatigue, alienation, informality, nonchalance, its looseness at rest and in movement'.[74] They were concerned with the alienated urban body, but, although at first sight Monet's figures suggest an alternative state of sensual plenitude and self-realization, their rather languorous movements, the seriousness of their enjoyment, their isolation even in companionship, demonstrate the aptness of the Goncourts' words.

No equivocal gesture, pose or expression links figure to figure or figure to spectator, as in Manet's *Déjeuner sur l'herbe* and Courbet's *Young Women of the banks of the Seine*; there is no hint of undress, let alone nudity, no suspect bohemian velvet jackets and berets, and yet there are some indications of freedom from restraint: Monet's picnickers are lolling on the grass in a popular pleasure area, and the young women are unchaperoned. They are not daughters of the bourgeoisie, but, as is clear in comparison with the overdressed underdressed *Young Women of the banks of the Seine*, their clothes are worn for pleasurable display, not provocation. Fashionable but not necessarily luxurious, such clothes were becoming available beyond the well-off middle classes through the sale of ready-made clothes in the new department stores, cheaper materials, fashion journals and paper patterns – and, as Renoir's father, a tailor, regretted, were erasing traditional marks of distinction.[75] In this, his first painting of modern life, Monet's models were – as they would always be – his friends and the woman with whom he was intimate. He was depicting something which was a reality for him and his friends: at ease in their casually elegant clothes, they were the sons of the bourgeoisie for whom a liaison with a girl from the working class was often an acceptable episode before settling into a profession and marriage with someone of one's own class. That Monet (like Sisley and Cézanne) was to marry his model/mistress was indicative of the way he used his life as material for painting. In this sense his painting is

autobiographical, but characteristically Monet did not look inward, and rather, turned his selfness into the object of sight.

'He is an "I" with an insatiable appetite for the "non-I", at every instant rendering it . . . in pictures more living than life itself which is always unstable and fugitive.' Baudelaire's characterization of Constantin Guys is more eloquent of Monet's painting: the pleasures of a day's outing in the country, of friendship, of casual liaisons, of good food, of sun dancing through leaves and scattering its light over pretty clothes, were true to Monet's experience, but were painted with a sensual concentration which made them transcend the casual moment. The figure of the servant unpacking the food on the right indicates that Monet was representing a standard of life that he knew, but did not then enjoy. In sketches he set the picnic by the side of a road in the forest, but he finally enclosed it in layers of sun-dappled foliage in such a way as to suggest that the casual moment is also a seamless, uncontradictory state of physical satiation. The tension between the moment – the single shock of sensation – and his desire to make it secure may have been one reason why Monet never finished the painting, for the attempt to capture the moment when a woman begins to take off her hat, or even to capture the fashions of the summer of 1865, was incompatible with the months of work necessary to create a huge figure painting. *The Picnic* was the image of something intensely desired; at the same time, it was an image of something which existed, even as an elusive, created moment, and it was something which Monet could always dream of re-creating. The tension between the desired and the real was to characterize all Monet's painting once he had accepted the challenge of the modern.

Nevertheless the large oil sketch and the surviving fragments show extraordinary mastery – particularly striking since the twenty-five-year-old Monet had not painted figure groups before, let alone ones of this size. His ambition may have been kindled by Delacroix's murals in the church of Saint-Sulpice, near the studio he shared with Bazille, and a place of pilgrimage for young painters since the murals were completed in 1861. The painting of Jacob struggling with the angel in chequered sunlight, under huge oak trees like those of the forest of Fontainebleau, would have been a particular challenge to Monet. Yet even on this scale, Delacroix's use of divided colour and the continuity of his gradations of light was subtle in comparison to Monet's violent contrasts of light and shade.[76] He may have studied the way Courbet represented sunlight shining through leaves on *The Young Women of the banks of the Seine*, by broad contrasts of yellow and yellow-green; yet Courbet's contrasts, like those of Delacroix, function within a continuous scale of greens from which the distinct leaves emerge, while Monet suppressed the scale and juxtaposed vividly contrasted strokes of bright blue, dark green and yellows only slightly tinged with green. Courbet used separate strokes of clear colour to represent the luminosity of fabrics which cohere in continuous surfaces which curve in space, while Monet – as can be seen most clearly in the yellow dress in the sketch or the grey one in the final painting – used contrasting tones of the same colour, isolated from one another on a pale ground. These contrasts are so sharp that those which represent the fall of sunlight on the figure almost detach themselves from it. Monet could have found a precedent in Manet's *Music in the Tuileries* (ill.19), with its jostling patches of colour – described by one hostile critic as a 'medley of red, blue, yellow and black'[77] – its frieze-like arrangement of figures, fragmented cut-outs in tapestry-like space, articulated by flattened tree trunks. Such radical simplifications may have owed something to Japanese prints, whose influence on Monet's depiction of landscape

31    *Camille (Woman in the green dress)*
(W.65), 1866, 231 × 151 (90 × 59)

space has already been suggested. The abbreviated graphic signs used by the Japanese were being adapted by a number of avant-garde painters of contemporary life as a means of embodying their dynamic perceptions of urban life, unencumbered by the laborious illusionism of academic painting. The earliest Japanese prints which arrived in France were those representing Europeans in Kyoto and Yokohama, and may also have been among the earliest collected by Monet.[78] He probably found their bemused observation of European fashion both amusing and instructive, for he could see how they were puzzling out ways to see the previously unseen, just as he was struggling to find means of representing contemporary life which, in the ideology of the perpetually new, could not have been seen before.

Neither Japanese prints nor Manet's painting employed contrasts of tone on the scale used by Monet, and he may have looked to another alternative to high art, commercial posters. Twenty years later in *L'Oeuvre*, Zola recalled the 'band' of young Realists marching across Paris, crossing the Pont des Arts 'to insult the Institut' and, in the rue de Seine, seeing 'a poster printed in three colours, the violently illuminated advertisement of a circus [which] made them shout with admiration'. He may have remembered the first large-scale coloured advertisements by the printer Rouchon, some of whose figures were life-size and represented by strong contrasts of tone.[79] Closely connected with the development of department stores and the diffusion of fashion to the *petite bourgeoisie*, such posters probably interested Monet more than the tight, descriptive fashion plates, in suggesting another mode of subverting the discourses of high art (seen also in his depiction of an undecorous heart and initials carved on a tree in *The Picnic*). Japanese prints and commercial posters could have strengthened Monet's awareness of the potential of the visual shorthand he had employed in his caricatures to evoke reality without creating a materially continuous, illusionist equivalent for the forms of the external world. The crucial structural change occurred in the adaptation of graphic signs to painting, and, as can be seen in the unfinished parts of *The Picnic*, Monet seems to have conceived his painting as a huge drawing on a light ground, a dynamic structure composed of more or less discontinuous signs. His painting was then making a radical break with the traditional construction of volumes emerging from a material continuum still operative in Courbet's *Young Women of the banks of the Seine*.

Monet probably experienced the full force of these contradictions between different modes of visualization when trying to complete *The Picnic*, for there must have been a reason why, having failed to finish his astonishing *tour de force* for the Salon of 1866, he did not do so for the next, particularly when his successes in 1866–7 made this financially possible. Was it sheer disappointment (had he not written to Bazille, 'if it doesn't work out I think I'll go crazy')? Did he find that the processes of academic art were incompatible with the representation of the 'moment'? Or did he decide that his 'signs' — the flat silhouette of Bazille's hand, the bright blue patch of sunlight on his shoulder, arm and hand, the patches of dark and light which 'read' head — could not be reconciled with the continuity of light-filled space that he was also creating?

According to Monet, Courbet advised him not to give the jury the pretext to exclude the unfinished *Picnic* from the Salon, but to complete it for 1867, and in the meantime to paint a more modest work 'quickly and well, in a single go'.[80] Monet's response was to paint *Camille* (soon called *The Woman in the green dress*). Influenced by the absolute necessity

32   Utagawa Sadahide, *Shop of foreign merchants at Yokohama*, 1861, woodblock print, 33.8 × 70.3 (13 × 27½)

33   Jean-Alexis Rouchon, poster for 'Au paradis des Dames', 1856, 145 × 103 (56½ × 40)

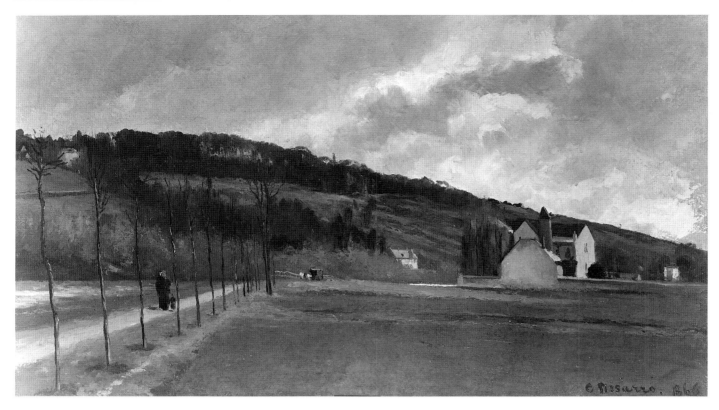

34 Camille Pissarro, *The Banks of the Marne in winter*, Salon 1866, 91.8 × 150 (36 × 58½)

of his obtaining a success in the Salon, Monet reverted to a form of illusionism and a subject which Mantz had called for in his 'Salon de 1865', in the *Gazette des Beaux-Arts*, when he praised Cabanel's portrait, *Mme la vicomtesse de Ganey*, as an example 'of the modern grace which still awaits its historian and its poet' – those who would concern themselves with 'the strange seduction' of contemporary fashion and with 'the costumes, coiffures, beauty' of contemporary Parisiennes. 'It is precisely because these pretty things pass so quickly', wrote Mantz, 'that it is necessary . . . to fix their fleeting souvenir on canvas', and he exhorted artists to ensure that 'in a century's time, it will be shown what those whom we have loved were like'.[81] Monet may also have been influenced by works popular with the general public like Toulmouche's *Forbidden Fruit* (Salon 1865), which shows girls giggling secretly over a book, although its saucy anecdotalism emphasizes the gravity that characterizes Monet's paintings of contemporary women.

*Camille* and *The Pavé de Chailly* were accepted by the Salon jury, although it was very severe this year, accepting only (!) 1,998 paintings. Its severity was rumoured to have caused the suicide of an artist who had been accepted in previous years, while other artists demonstrated and demanded a Salon des Refusés. Courbet's *Woman with a parrot* (Metropolitan Museum of Art) and the *Covert of Roe-deer* (Musée d'Orsay) were greeted with almost unanimous praise, while Monet's *Camille* could have given the impression that the younger generation of Realists would conform.[82] Yet the jury was strikingly arbitrary in its choice of Realist work: Manet's paintings were rejected, as was Bazille's *Girl at the piano*, but, on the other hand, Degas's *Steeplechase, fallen jockey* (National Gallery, Washington), a sketchy, daringly asymmetrical work, was accepted, perhaps because of the artist's social connections. Also accepted were Pissarro's *Banks of the Marne in winter* – which enjoyed Daubigny's support on the jury – and Sisley's *Village Street in Marlotte* (Albright-Knox Art Gallery, Buffalo). Both employed the radical

breadth of handling which could also be seen in Monet's *Pavé de Chailly*. The jury may have been swayed by the art policies of the Imperial administration, which emphasized the equality of styles as the creation of isolated individuals, denying their character as movements of differing ideological character. It was not vigilant enough: Thoré claimed that the Salon put Courbet in his rightful place as the most important artist of his period, that it advanced the 'young school' and increased sympathy for artists dedicated to nature; Zola whipped up controversy with his punchy attack on the jury and on those Realists he felt had sold out to official standards and popular taste – Courbet, Millet and Rousseau – and with his vigorous defence of the new generation of Realists represented by Manet, Monet and Pissarro; while the critic of the large-circulation weekly *L'Illustration* identified the group as a group in his comment that visitors to the Salon had been 'offended by the roughness, the coarseness, the savagery of execution, the inaccuracies of the vaunted improvisers'.[83]

Monet represented Camille as a fully realized, rounded form emerging from continuous shadowy space, and, instead of emphasizing the textures of the paint as in *The Picnic*, delighted critics with his virtuoso rendering of silk, fur and velvet. The painting was, according to Bazille, '*un succès fou*', and even received a tribute in verse, celebrating this image of the 'Parisienne, oh queen, oh woman triumphant'. Thoré gave a romantic account of its genesis:

I wish to reveal to the jury that this opulent painting was done in four days. One is young, one had picked lilac instead of staying shut up in the studio. The time of the Salon was approaching. Camille was there, coming back from picking violets. . . . Henceforth Camille is immortal and is called *The Woman in the green dress*.

In contrast to this evocation of youthful enjoyment of spring in the open air, Charles Blanc saw the woman as a woman of the boulevards, one of those 'already made up with layers of pearl white and carmine, [who]

pass by proudly, decked out in their vices and their elegance, imposing their fashions on virtue, their wit on journalists, and their slang on the vernacular'. This was a response typical of conservative critics who tended to read any avant-garde Realist work as immoral, and characteristic of nineteenth-century city-dwellers' scrutiny of the traces by which one may recognize unknown lives. Camille's face appears hard, and this, with her rich clothes flaunted in the shadows, could easily have aroused such associations in a society saturated with graphic illustrations of women of doubtful morals, particularly since the painting was catalogued under her given name, *Camille*, as would be done only for a woman of questionable status.[84] The representation of what was seen as an immoral woman did Monet no harm with the critics, probably because the woman he represented did not confront the spectator – male or female – with her opaque individual being as did Manet's image of *Olympia* (1865), whose gaze turns the spectator's gaze back on himself. Thus, despite its grand scale and its determined lack of coquetry, which differentiated it from the 'toulmoucheries' popular with the Salon public, *Camille* remained simply the object of an easily satisfied glance. Zola – whose *Confessions de Claude* had been investigated by the police for immorality when published in 1865 – wrote of Monet, 'there's a temperament, there's a man among this crowd of eunuchs'.[85] Sexuality was never far from the debate on Realism.

André Gill captioned a caricature of *Camille*, 'Manet or Monet? Monet – But it's to Manet that we owe this Monet; bravo Manet, thanks, Monet!',[86] but this time Manet was not provoked into refusing an introduction to the younger painter. Monet and his friends were welcomed into the group of avant-garde Realist artists and writers who met regularly at the Café Guerbois in the newly built quarter of Batignolles, a short walk from Pigalle where Monet lived for the first half of 1866. In this, the headquarters for the debate on modern life, Monet, Renoir, Bazille, Pissarro and Sisley joined Degas, Fantin-Latour, Bracquemond, and the writers Astruc, Duret, Duranty, Castagnary and Zola. With the exception of Pissarro and Zola, and unlike the first generation of Realists, all accepted as a matter of course the overwhelming normalcy of bourgeois society. Monet's financial difficulties and his long periods of work outside Paris may have distanced him from the cultured and sophisticated society in which Manet, Degas and Bazille were at ease, but he later acknowledged that

There was nothing more interesting than these conversations with their endless conflict of opinions . . . you were encouraged to do sincere and disinterested research; there you would gather stores of enthusiasm which would sustain you for weeks and weeks until the definite shaping of an idea. You always left in a better temper, with a firmer will, and with your thoughts sharper and clearer.[87]

It was in this progressive, liberal bourgeois group that the concept of painting as 'research', as open-ended experiment, evolved, and, as it did, the support of the group became crucial because the painters' exploration of their experience of nature could not be understood by the public, on the few occasions when the Salon jury let their works be seen, so it was only their fellows who could confirm whether their new modes of representation made sense, and, in the 1870s, could interpret them to the progressive bourgeoisie.

Monet also benefited materially from his Salon success: a replica of his painting was commissioned by the dealer Cadart, and his aunt, delighted to have been sent several copies of Zola's article praising Monet's work, restored his allowance which she had apparently cut off. Monet's immediate response to this temporary respite from financial worry was to return to what Zola said was 'the dream of every painter –

to put life-size figures in a landscape', attempting to repeat his success with another painting of contemporary beauty for the Salon of 1867, the *Women in the garden*.[88] Monet intended it to replace *The Picnic* as a manifesto of the new painting, a *pleinairiste* celebration of the pleasures of contemporary bourgeois life, of women in fashionable clothes picking flowers – which they so much resembled – in the dappled sunlight and luminous shade of a lovely garden. Since the picture was to be painted in the open air, Monet chose a simpler motif and a more manageable size than *The Picnic*, but it was still 2.56 by 2.08 metres (8 feet, 4 inches by 6 feet, 10 inches), so that he had to dig a trench into which he could lower it to paint its upper part. This eccentric procedure demonstrates the lasting impact of Boudin's belief that 'Everything painted directly on the spot, always has a strength, a power, a vividness of touch that one does not find again in the studio'. Until then, this belief had been tested only with small paintings, but Monet now sought to do so on the scale of a Salon 'machine'.[89]

Zola wrote in 1868 that Monet's sensibility was that of a city-dweller:

He loves the horizons of our towns . . . in our streets he loves the people in overcoats who rush busily here and there . . . he loves our women from their parasols, their gloves and their muslins to their false hair and rice powder, everything that makes them the daughters of our civilization.

In the country, Claude Monet prefers an English garden to a forest corner. He is pleased to find human traces everywhere. . . . Like a true Parisian he carries Paris into the country, he cannot paint a landscape without including gentlemen and ladies in elegant clothes. He seems to lose interest in nature if it does not show the imprint of our customs.[90]

Painted at Ville d'Avray, a village just outside Paris, the private garden of Monet's picture was the complement of the cliff-like apartment blocks and geometric streetscapes of Haussmann's transformed Paris, just as the elegant clothes depended on the development of the fashion industry during the Second Empire. Crucial in the economy of consumption, fashion depends on seeing the human as object and on ceaseless change in which each 'moment' of fashion constantly supersedes the one before; it was, then, intimately related to the new aesthetic based on pure visibility and on the capturing of a single unrepeatable moment.[91] The *Women in the garden* is a true image of the mode of looking demanded by fashion, for – unlike *The Picnic* in which, despite their seeming self-absorption, the figures are shown interacting as members of a group on a social occasion – there is no sense of communion between the figures. This is not only because Monet used a single model – Camille – for the three women on the left, but because she and the woman on the right are shown in the stiff poses fashion-plates used to display clothes, and are represented simply as lovely, up-to-date objects.

Monet may have hoped his interest in representing figures in the open air might be validated by a subject related to paintings of Second Empire beauties and leaders of fashion by established artists; it could be seen as an avant-garde, bourgeois equivalent of Winterhalter's huge *The Empress Eugénie surrounded by her maids of honour* (1855), then on display in the Palace of Fontainebleau. Winterhalter's self-conscious pattern of profile and frontal faces resembles Monet's variations on Camille's face, and in both paintings the huge skirts are spread out like the petals of flowers in a luxuriant artificial nature. Winterhalter's painting is hierarchic, and its setting evocative of an eighteenth-century aristocratic park rather than a bourgeois garden, and, although both paintings have the decorative opulence characteristic of Second Empire style, Monet's

looks almost naïve in comparison with the illusionist virtuosity of Winterhalter's work.

Manet, Degas, Bazille and Morisot also painted with a simplicity which pointedly rejects such flashy illusionism, but their work has a sobriety and reticence which differentiates it from the celebratory character of the *Women in the garden*, and which could have reflected the efforts of the old *haute bourgeoisie* to which they belonged to distinguish itself from the vulgar excesses of the new rich of the Second Empire (as emphasized by Zola in *La Curée*). Nevertheless, if Monet expressed straightforward pleasure in what the prosperity of the Second Empire had given the new bourgeoisie, the fact that he had developed his Realism through a *pleinairisme* brought up to date by the urban avant-garde meant that his expression was shaped by a notion of truth at variance with the Second Empire aesthetic of conspicuous appearances, and by an understanding of artifice at variance with that society's desire for illusion. It might be thought that the younger Realists' emphasis on truth to appearances could easily be appropriated by that society's manipulation of appearances as a means of securing or even of attaining bourgeois identity. Contemporaries did not, however, confuse the two, and were repelled and even threatened by the frankness with which Manet and his followers revealed their processes of representation.

Monet 'drew' his figures directly on to the lightly tinted canvas (as can be seen in what looks like a preliminary trial on a canvas re-used by Bazille),[92] creating a decorative surface pattern from the curves of dresses, path, lawn, sunlight and shadow, each of which is 'occupied' by a dominant colour. Within each colour area, Monet used delicate tonal modulations, so that he could suggest the continuity of forms in a light so brilliant that it even irradiates the shadows, and could avoid

35   Francis-Xavier Winterhalter, *The Empress Eugénie surrounded by her maids of honour*, 1855, 300 × 420 (117 × 164)

*Opposite:*

36   *Women in the garden* (W.67), 1866–7, 256 × 208 (100 × 81)

fragmenting the figures as he had done in *The Picnic*. For all the breadth of his handling, he showed the most subtle control of intensely observed effects, as can be seen in the way he used large strokes of pure white, pinks and mauves on the blue shadows of the muslin, or creamy white on the green and white striped dress, to suggest light falling through leaves on to white material, or broad flat strokes of pink to evoke the warm light filtering through the parasol on to a face, or the gleam of skin caught by light through a muslin sleeve. He gave a firm linear structure to these felicities, weaving together the large flat planes of colour by means of the green, ochre and black lines which scroll over the great swell of the skirts, enchain bouquet to bouquet to rose bush; ribbon to parasol to branch; skirt to the edge of a shadow to a more distant skirt; leaves illuminated in the shadows to those silhouetted against the sky.

Despite the lovely subject, the jury rejected this painting, as well as Monet's huge, almost crudely painted *Port of Honfleur* (ill.51); Bazille's painting of figures in the open air, *Terrace at Méric* (Musée du Petit-Palais, Geneva); Renoir's *Diana* (National Gallery, Washington), a classical nude painted as if in the open air; and works by Pissarro and Sisley. The jury – which was presided over by Rousseau, and included Meissonier, Breton, Gérôme, Couture, but was without Daubigny who often supported them – excluded the younger Realists more effectively from view than it had in 1866, probably because they rejected what the Realists favoured by the administration regarded as essential: a reverential attitude to nature and a visibly patient effort to represent the contemporary as harmonious and – paradoxically – timeless. Many years later Monet claimed that Jules Breton insisted on his being rejected, on the very grounds that his work was 'progressing', and that it was necessary to dissuade young artists from continuing 'in this detestable path'. Nieuwerkerke had explained this function of the jury: 'A refusal is a salutary warning which a young and intelligent artist should understand. . . .' Breton's own work – which attracted the highest Imperial honours – expressed in both subject *and* execution his faith that 'work is a prayer', and depicted hard rural labour as ordered, tranquil, and rewarding, endowed with significance through its continuity with the work of centuries. Monet's exclusion from the Salon shows that, despite the dominant ideology of progress, its manifestation in the high arts was suspect and had to be controlled.[93] This may have been the more urgent since this Salon was to coincide with a huge exhibition of nineteenth-century art organized for the Exposition Universelle, and the presentation of French art to the world must not be marred by any controversial presence which might undermine its prestige.

In *Women in the garden*, this absolutely contemporary painting, Monet depicted the bourgeois good life with none of the techniques which fashionable painters of similar subjects used to distance them. Moreover the immediacy of Monet's depiction of an intimate scene was combined with a visualization of the figures as objects untouched by sentiment, and the tensions engendered by these contradictions may well have disturbed the jury (compare Tissot's *Hide and Seek* [ill.127] and Moreau's *Promenade* [ill.129]).

When Baudelaire wrote that 'most of our landscapists are liars precisely because they have not lied', he was expressing his preference for the paintings of dioramas or theatre scenery, paintings whose 'brutal and enormous magic is able to impose a beneficial illusion on me', paintings whose technical means were blatantly obvious unless transformed by distance. 'These things', he wrote, 'are infinitely closer to truth because they are false.'[94] The same could have been said about coloured posters such as Rouchon's advertisement for shipping or for

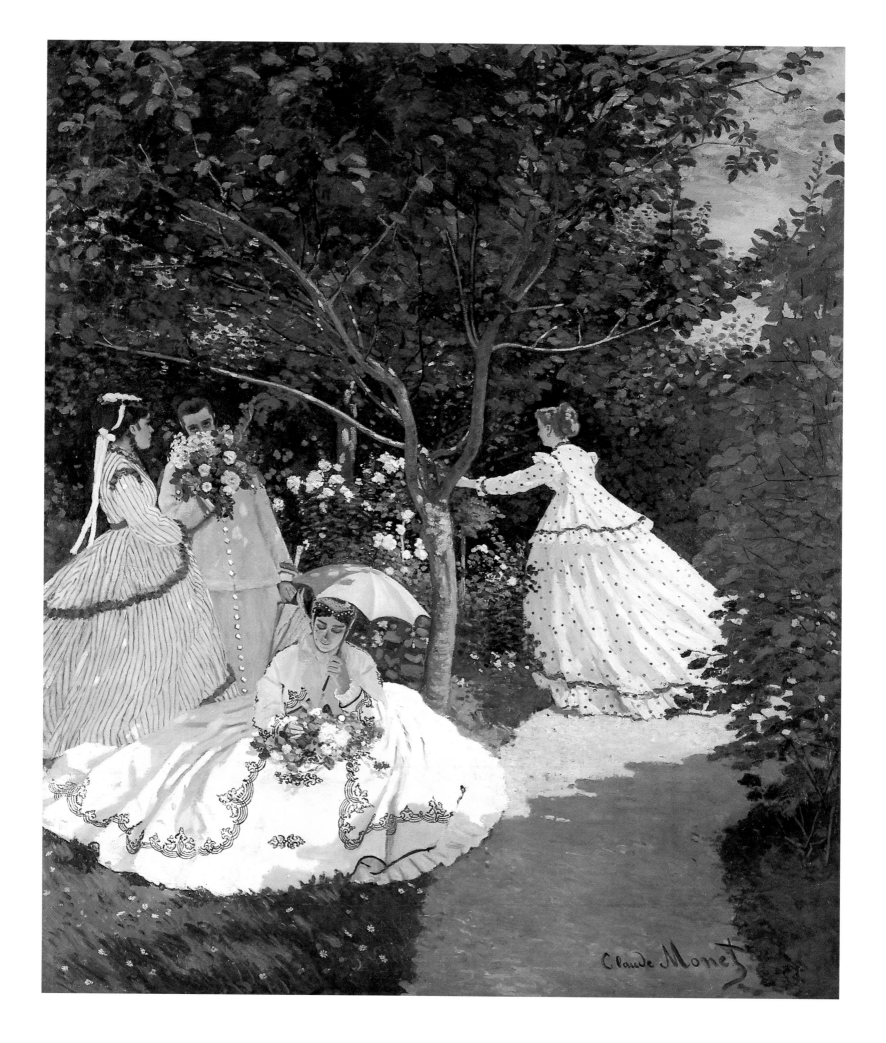

Claude Monet

the 'Paradis des Dames' in which there is no disguising the flat, opaque inks which create the image. There is something of this quality in *The Port of Honfleur*, which makes Manet's contemporary marines look elegant by comparison. But in the *Women in the garden* the broad techniques designed to create illusion at a distance are used to depict figures which are close to us, and made to seem even closer than those in *The Picnic* by the device of the path coming right into 'our' space as if we were standing on it. This foreground plane also reads as a flat shape on the surface of the painting, and such double readings, intensifications of those already observed in *The Pavé de Chailly*, make the spectator more aware of the abstraction of the paint which cannot disappear in the illusion of distance: the coloured plane becomes neither path nor paint, but a kind of fluctuation between them. These disjunctions fracture the painting into a number of spatial 'fixes', so that experience of its space is not of something continuous but of a coincidence of momentary recognitions. The nature of Monet's alternative to traditional spatial illusion can be appreciated in comparison with another 'close subject', Courbet's *Young Women of the banks of the Seine*, in which the space is unbroken, even though it is constructed as if the artist had stood on the foreground plane, looking down on the women and then across to the water, and in which the brushstrokes adhere to the different substances which they represent, so they can disappear in the illusion. Monet was probably made conscious of spatial disjunctions in Manet's paintings and in Japanese prints, but was the first to locate them in everyday bourgeois life, where – as the Salon jury's exclusions suggest – they seem to have had as great a capacity to disturb as Manet's scandalous subjects.

Monet's paintings challenged a complex discourse which constructed spectators as consumers of art. He used a technique which simultaneously distanced the spectator and invited intimacy: it accomplished the former by emphasizing the 'objectness' of the figures, even when they were physically close to the viewer, and it created intimacy by showing how the image was realized, in this way allowing the spectator to participate imaginatively in the process of creation. The qualities common to the huge variety of figure paintings favoured by dealers, collectors, the arts administration and the public which bought reproductions of paintings, show that they preferred immediate possession of the image to active, participatory experience. In Neo-Greek pictures of the domestic life of the ancients, the figures tended to be close to the spectator and immediately accessible through the meticulous, 'transparent' technique by which they were represented, but were distanced by the remoteness of the subject from contemporary experience; the fashionable painters of Second Empire bourgeois life, Stevens, Tissot and Toulmouche, employed similar techniques which cast the spectator in the role of a consumer, an admirer of impenetrable skills; their anecdotal subjects gave that spectator immediate access to a painting, but required no imaginative work once details of the painting had been scrutinized and the requisite emotion felt. Thus once the slightly *risqué* meaning of Toulmouche's *Forbidden Fruit* is defused, by easy recognition of the joke, the spectator has nothing to do except to examine the coyly suggestive details and to admire the skill with which they are represented (or see Moreau's *Promenade* [ill.129]).

Manet challenged such distancing by bringing his figures very close to the front plane, and by giving his figures a disturbing gaze which is directed at the spectator, and which challenges their being taken as simple objects of sight. In Monet's painting, on the other hand, the gaze is usually held within the scene depicted (in *Women in the garden*

Camille's outward gaze is deflected by the huge bouquet of flowers). The self-containment of Monet's paintings was closer to that of the fashionable paintings of contemporary life than to Manet's, but the jury still refused to let his works be shown. Monet's combination of techniques which imply distance, and those which invite participation, with a closer and closer scrutiny of his figures, in which the figures lose any being except that of being seen, suggests a desperate attempt to attain an intimate seeing which is all the more poignant since he nearly always painted friends and family. Such contradictions give even the prettiest of his paintings of contemporary women a seriousness which cannot be found in related subjects by Toulmouche or Tissot. Perhaps Monet's paintings came too close to alienated urban vision to be encouraged by those who controlled what the public were to see. That they were not mistaken is shown by the fact that Monet's desire to grasp the reality of the figure soon led to its atomization.

Rejection must have been a particularly heavy blow for Monet, because his work was a celebration of the values of those who had access to the high arts. Rather than teaching the young Realists to mend their ways, exclusion strengthened the group by forcing them to consider mounting a private exhibition (realized seven years later with the first Impressionist exhibition), which would have been more in accord with bourgeois ideology than was the Salon.[95] They could not, however, afford the exhibition. Monet's family again withdrew his allowance – not, as his father emphasized, because of the Salon failure, but in order to force him to abandon Camille Doncieux, who had become pregnant. Bazille came to his rescue by buying the *Women in the garden* for the large sum of 2,500 frs., although he could only pay in instalments of 50 frs. a month, and could not always manage that. In the late 1860s these 50 frs. were often Monet's major resource. Now began nearly twenty years of desperate letters to friends, dealers and collectors begging for financial help. Monet sold little in the 1860s, and that generally at low prices.[96] It would then be true to say that his dedication to certain modes of expression – when, as *Camille* shows, he was capable of attaining fashionable success – led to isolation, misery and frustration at the heart of the society he sought to celebrate.

In that fluid society, failure could mean, at best, loss of the joys that status and wealth could offer, at worst, appalling misery, and the new bourgeoisie made every effort to render the signs which distinguished it from the working class visible. Vallès wrote with ferocious irony of how his superior education condemned him not only to a respectable profession but to the appropriate 'uniform', the *redingote* (not the worker's *blouse* to which he had aspired in youthful innnocence), and recounted the desperate expedients necessary when he could not afford the *redingote*, the sign that he was repectable enough for the work which would feed him. The artist of the bourgeoisie required a secure income; without it, the necessity of living like a bourgeois so as to display the signs of success which would guarantee the quality of his work to potential buyers inevitably meant going into debt. Monet's income was erratic and he never knew what he would earn from one month to the next. A stable income meant one could buy more economically on account (one of Monet's recurrent crises was having his credit at his paint dealer's cut off), and could have secure accommodation (another recurrent crisis was being evicted, and losing earning power through interrupted work and seizure of paintings). When he did make money, Monet lived very well indeed, although much of what he earned had to go to meet the more pressing of his old debts. Indeed, if his standard of

living was bourgeois, his mode of living was closer to what the bourgeoisie considered characteristic of the working class, as expressed by Le Play: 'the worker, entirely lacking in foresight, . . . never saves, spends what he earns every day'.[97]

Monet probably shared the avant-garde's contempt for bourgeois philistinism, but he never denied his class. Throughout his life, a remarkable number of his closest friends were radicals, but he was not attracted by any general sentiment of social justice, and was content with a system founded on the ideology of individual self-advancement through hard work, initiative and will-power. However, although his large-scale paintings of the bourgeois good life could be seen as confirming this system of beliefs, the realities of his financial situation may have undermined it. The contradiction between the security posited by the figure paintings and their mode of production, between fashionable subject and techniques which disturbed those whose lives – or whose women – were being represented, meant that when he lost his allowance, he could no longer afford to paint large-scale pictures of contemporary life.[98] He continued, however, to dream of them, regretting, even in his eighties, that he had been forced to give them up, and to turn to small paintings more suitable for bourgeois apartments and more easily sold than the Salon 'machines' which brought fame.

Monet said in 1920 that he passed from figure painting 'to other exercises which took me further than I expected. I became fascinated with sunlight and reflections', and he may have found the problems of painting *en plein air* so complex that he could deal with them only on a small scale.[99] This realization would have become acute when he was finishing the huge, sun-filled *Women in the garden* while he was painting snow scenes on the motif near Honfleur. During 1867, Monet sometimes painted a motif, or closely related motifs, under different effects of light – a road under snow, a beach in bright hazy light, city streets in diffuse midday light – some of which were as much about the processes of sight, and about different modes of representing those processes, as about the pleasures of sitting on a beach or by a river. Far from embodying instinctive reactions to nature, these paintings were shaped by Monet's ambition to bring landscape up to date. He was keenly aware of theoretical debates in Paris, and his exploratory approach to nature was informed by an intensely self-conscious modernist concern with the processes of image-making.

The sheer novelty of the codes of representation of Japanese prints played a role in the Parisian avant-garde's debate on the necessary artifices of Realism.[100] Monet's use of such artifices may be seen in the *Cart, Road under snow, near Honfleur* (ill.38), even though his desire for immediacy of experience induced him to paint it on the spot, when it was 'cold enough to split pebbles', as a journalist wrote. 'We saw a little brazier, then an easel, then a gentleman wrapped in three overcoats, with gloved hands, his face half frozen . . . it was M. Monet studying a snow effect.'[101] Japanese print-makers evoked snow-covered ground and trees with a combination of delicately tinted planes and graphic signs, and their influence can be seen in the way Monet represented the unshadowed open foreground by unbroken areas of thick white paint subtly inflected with blue- and violet-tinted greys which hint at forms veiled by snow; hazes of near-white suggest snow on skeletal trees and the radiance of the sky behind them, and a few dark strokes act as a sign for a partially covered bush. Having been freed from the need to describe, Monet could concentrate on rendering the eye's grasp of the wholeness of the scene, and on finding equivalents for the impression of the brilliant light which reflects from snow even on an icy grey day.

37   Utagawa Hiroshige, 'Ochanomizu', from *Famous Places in Edo*, 1853, woodblock print, 21.8 × 34 (8½ × 13)

Monet also made use of practices derived from his study of Japanese prints in three paintings of Paris seen from the balcony of the Louvre in the spring of the same year, 1866–7. The contrast between the figures of Europeans and Japanese in the lively prints of street life in Yokohama and Kyoto, which Monet probably collected in the 1860s, were striking confirmation of the Realist belief that every epoch and society had its own appearance, manifested not only in different features and different clothes, but in different postures, different ways of walking, and even different ways of looking at what was around one. Monet's intensive study of such images of an unknown culture, which inevitably he saw from the outside, probably reinforced his tendency to view human life as something accessible only to sight, unknowable, opaque.

The climax of the *fête impériale*, the Exposition Universelle of 1867 – a 'festival for the enjoyment of the universe' – would have intensified such forms of consciousness. The Exposition attracted over 10 million visitors from all over the world, come to marvel not only at the miracles of modern construction and production, but at Paris itself, the transformed City of Light. The immense elliptical iron and glass exhibition building with its seven concentric galleries was dedicated to 'The History of Labour and its Fruits': the first galleries were devoted to the products and manufacturing processes of all countries, from ancient to modern times, while the culminating one contained the largest exhibition of contemporary art ever assembled. All human life – or as much of it as the authorities thought should be seen – was assimilated into a spectacle whose symbolism was blatant: the transformation of matter by means of man's labour through the ages as it reached its climax in Napoléon III's new Paris. In the huge park surrounding the exhibition building, what a visitor called 'the delirium of speculation' was given free rein to create a confusion of buildings in every conceivable historic or national style – the Japanese, for example, had a pavilion in a Japanese garden and gave demonstrations of their arts and crafts. It was, said this visitor, 'an endless spectacle' expressive of this

century of fever and prodigious activity when steam and electricity lend their wings to human industry, when a quarter of an hour on the Stock Exchange makes and unmakes millions, when in eight days Prussia changes the fate of Europe, and in ten years M. le préfet de la Seine [transforms] the face of a city laboriously shaped by seventy kings. . . .

38    *Cart, Road under snow, near Honfleur (W.50)*, 1865,
65 × 92 (25½ × 36)

39    *Saint-Germain-l'Auxerrois (W.84)*, 1866, 79 × 98 (31 × 38)

40 *The Garden of the Infanta*
(W.85), 1867, 91 × 62 (35½ × 24)

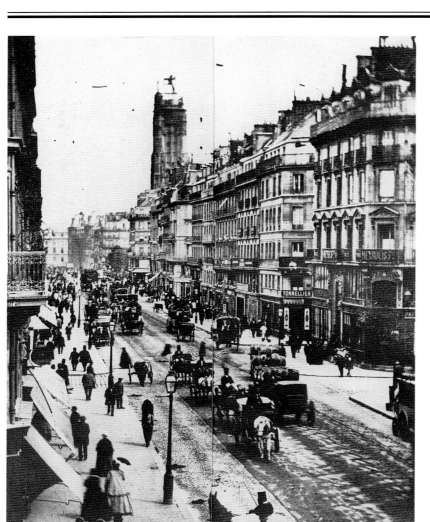

41   Utagawa Hiroshige II, *The English Delegation at Yokohama*, woodblock print,
33.6 × 71.5 (13 × 28)

*Left*:

42   The Rue de Rivoli photographed in the 1860s

*Opposite*:

43   *The Beach at Sainte-Adresse* (W.92), 1867, 75 × 101 (29 × 39½)

44   Edouard Manet, *L'Exposition universelle, Paris*, 1867, 108 × 195.5 (42 × 76)

The ideology of progress was thus made visible, and its products served and stimulated a never-sated visual consumption. The effect of this superabundance – experienced also in the new department stores and the Salon – according to the same visitor, 'dazzles the sight more than it speaks to the mind; it leaves the soul cold, and the senses deranged'.[102]

The arts were placed at the centre of this dizzy spectacle of all that created the good life, but the works of the youngest generation of Realists – in particular, Monet's *Women in the garden* – were excluded. Manet and Courbet built pavilions to show their work, but since neither had the Salon jury's stamp of authenticity, they too were little regarded.[103] Manet painted a view of the Exposition, with staccato juxtapositions of different types of spectators in a manner related to the Japanese prints of European visitors in their cities, and laconic in the face of the Exposition's hyperbole.

The works of Monet, Bazille, Renoir, Pissarro and Sisley were invisible in the triumphant illumination of the official celebrations of

Napoléon's bourgeois Empire, and it was probably no coincidence that both Monet and Renoir painted their first views of Paris in the spring when the Exposition opened. The more conventional of these paintings – like Monet's *Saint-Germain-l'Auxerrois* (ill.39) – relate to the well-established genre of topographical views of city streets from high viewpoints which allowed comprehensive but distanced views, and which were used by photographers to meet the inexhaustible demand for images of the vistas opened up by Haussmann's planning. The square in front of the church had recently been transformed by the demolition of houses to make space for a Renaissance-style town hall and a 'Gothic' bell tower, but Monet ignored the 'period' additions, and took from the new Paris the most significant thing it could offer him – light-filled space. He used small strokes of closely related colours to suggest the way light shines off the countless planes of the worn masonry of the church façade so that the space before it seems to be filled with the luminous shimmer of spring light. This is the white light of the Île de

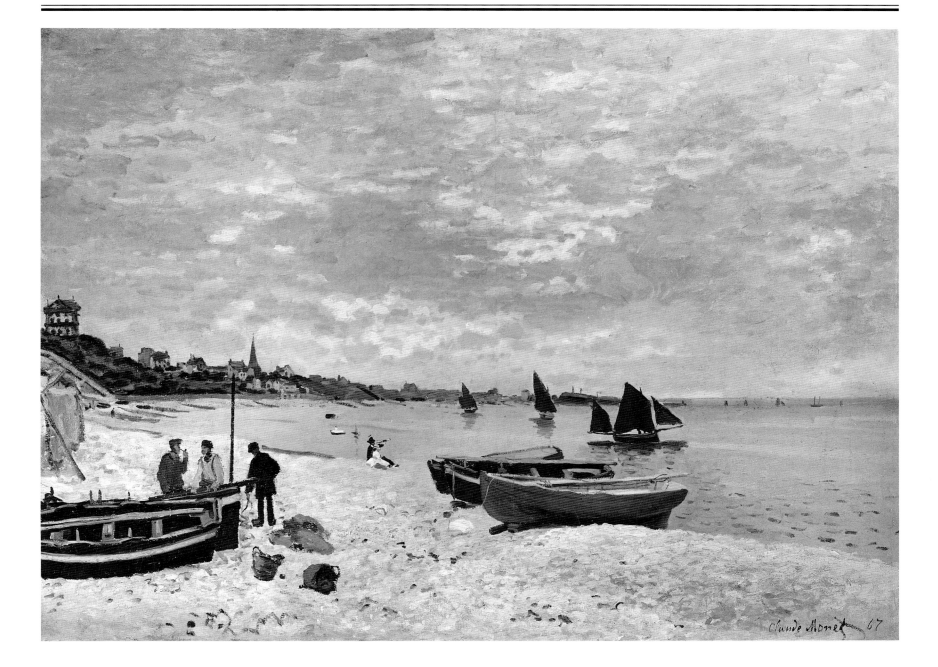

France which fractures into sparkling particles on the chestnut spikes, in the dappled shadows and the kaleidoscopic crowd. As in all Monet's paintings of the city, the scene was viewed from on high, treated as a pleasure for the eyes, but no more; it expressed no nostalgia for the lost city, but equally did not engage in the rhetoric of the new.

The dislocations of *The Garden of the Infanta* (ill.40) also suggest the influence of photography and of Monet's study of Japanese prints on the topographic tradition. As if conceiving the rectangle of canvas as the viewfinder of a camera, he focused on the central area represented in his *Quai du Louvre* (The Hague, Gemeentemuseum), and embodied the action of the eye as it moved in a series of 'fixes' across the lawn immediately below him to the garden, the animated street, the Île de la Cité and the distant Panthéon. The *Quai du Louvre* was bought by the dealer Latouche and shown in his shop window in January 1869 (where it was apparently criticized by Daumier), and *Saint-Germain-l'Auxerrois* was purchased by Astruc, probably before the summer of 1870.[104]

## III

Although Monet's father and aunt had cut off his allowance, he was offered food and shelter at his aunt's villa at Sainte-Adresse providing he would agree to abandon the pregnant Camille. He decided to appear to obey, while secretly providing Camille with money, generally obtained from Bazille.[105] This extraordinary situation intensifies one's sense of the muteness of his paintings of people – generally including members of his family – on the beach or seaside terrace at Sainte-Adresse.

The earlier pleinairists avoided scenes which suggested change in the countryside, but Monet and his friends tended to paint in areas which were rapidly changing. Even as a boy, Monet had experienced the rapid growth of Le Havre, and would have observed the building boom which linked it to near-by fishing villages like Sainte-Adresse, which

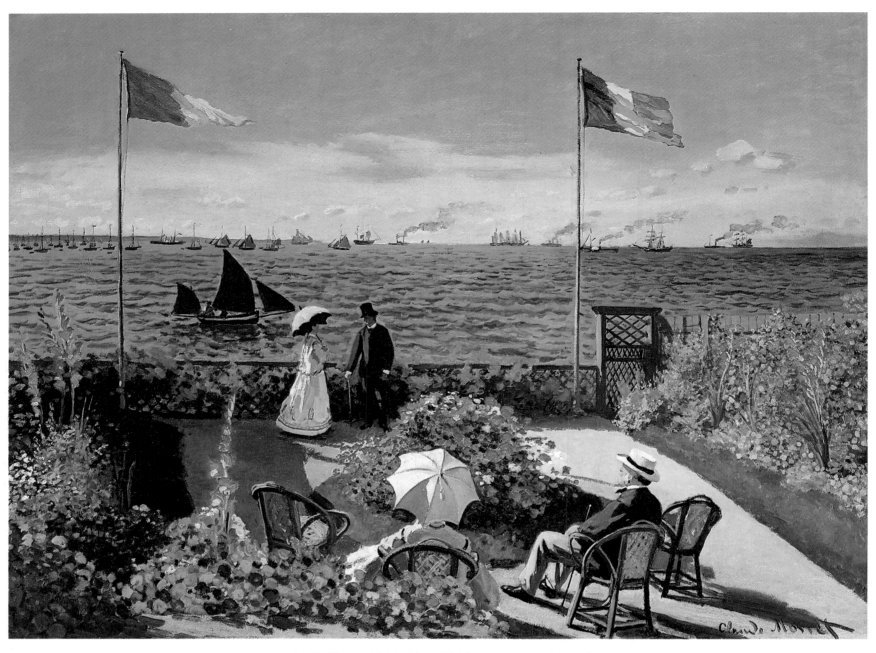

45  *The Terrace at Sainte-Adresse* (W.95), 1867, 98 × 130 (38 × 50½)

were dotted with the residences of wealthy Havrais – like that of his aunt – and with hotels and villas for summer visitors, and in which traditional fishing and shipping were mingled with leisure activities and the movements of pleasure craft. These things appear in Monet's paintings of the beach at Sainte-Adresse – the same beach he had painted in 1864–5 as a place untouched by the modern. His paintings of people enjoying themselves on the beach may have been suggested by images in the illustrated journals as well as by Boudin's successful paintings of fashionable Normandy seaside resorts, but while Boudin represented his figures as members of the world of fashion, gossiping and promenading together (ill.14), Monet depicted the summer visitors on a less fashionable beach as isolated couples, spectators rather than social beings: in *The Beach at Sainte-Adresse* (ill.43), the fishermen stand idly by their boats, while a distant couple watch yachts through a telescope. This is one of a number of paintings in which Monet showed the act of looking as a physical process, as did Degas, Renoir, Manet and

Cassatt in their paintings of people using opera-glasses or binoculars, which created a kind of spatial 'fracture' between the gaze of the spectator of the scene and the painted spectators' gaze. A related effect occurs in *Terrace at Sainte-Adresse*, where, however, the view of the spectator of the painting is more closely related to that of the spectators in it. Monet described the *Terrace at Sainte-Adresse* as his 'Chinese painting with flags' (the terms 'Chinese' and 'Japanese' were then used almost interchangeably), and, of all his early paintings, it shows the strongest influence of Japanese modes of representation and iconography.[106] In it he adapted one of the major themes of the *uki-oye* – the 'pleasurable life' – transforming a typical image of figures in a place built for the purpose of admiring the beauties of nature into a bourgeois garden constructed for the view. There he showed his relatives enjoying the kaleidoscopic spectacle of the pleasure yachts, fishing boats, the bright flowers and the steamships which brought wealth to Le Havre – and which was, at least temporarily, sustaining his painting.

The planes of flat almost raw colour were unprecedented in French painting. Duret stated in his 1878 booklet on Impressionism that before French painters saw Japanese wood-block prints, it was not possible to see a red roof, white walls, a green poplar, a yellow road or a blue river,[107] and it was clearly through his study of such prints, and perhaps of contemporary posters, that Monet evolved his use of simplified planes of colour as signs for a complex process of visual apprehension. He juxtaposed these large planes with small strokes of bright pigment in the leaves and flowers in such a way that their vibrations convey the glare of the summer sun with an almost painful intensity. The pulse of colour against colour destroys the tangible reality of objects and fractures the spatial continuum characteristic of earlier *pleinairisme*. This continuum is further dislocated by the tilting of the foreground area, its complete separation from the bright blue plane of the sea, and the flattening of the perspective of the red-brown fence. The scene is, then, represented by a series of slightly tilted planes on each of which the eye must stop, rather than follow unbroken movement into depth as in

46   Katsushika Hokusai, 'The Sazai pavilion of the temple of Five Hundred Rakan', from the *Thirty-six Views of Mount Fuji*, 1829–33, woodblock print, 23.9 × 34.3 (9½ × 13½)

traditional *pleinairisme*. These spatial fractures are only just held together by Monet's characteristic horizontal–vertical grid, and by the spiral movement set up by the chairs, flower-beds and parasols.

Monet used what he could learn from Japanese prints to help him embody *his* visual experience of the scene, and, despite the emphatic abstraction of the paint, it vividly conveys the concreteness of this experience – as may be seen in the contrast between the transparency of nasturtium leaves and the opacity of the geraniums; between the way light penetrates the thin film of the gladioli flowers, or refracts from the blinding blue sea.

Fractured space was a transposition of urban vision, displacing the slow experiencing of space by the telescoped succession of physical recognitions with which Monet had constructed his *Garden of the Infanta*. The *Terrace at Sainte-Adresse* is the antithesis of the natural scenes which absorbed the Barbizon painters: it represents the urban appropriation of nature, with the bourgeois garden imposing its

patterns on slopes shown untended in *The Pointe de la Hève*. Its sanded paths, geometric flower-beds, brilliant flowers, its promenaders in 'elegant *déshabille*' exemplify Zola's claim of Monet's exclusive love for 'nature which man has clothed in modern dress'. Framed by the flagpoles, the inner picture transforms the productive life of the seaport into a spectacle experienced from private space, the family garden.

Despite the loveliness of the painting, it has a certain emotional blankness which derives from the ambiguity of the relationship between our experience as spectators and that of the spectators in the painting. Monet's dedication to what he saw meant that he could not pose his figures in order to communicate meaning; they are, then, mute and ambiguous, and they demand a scrutiny quite different from the immediate, superficial recognition of meaning required of the spectator of anecdotal paintings of modern life. Nevertheless, the unexpected discrepancies, the over-controlled grid and lines of sight, and over-stressed connections, gaps and absences in this painting suggest something of the meanings which can be conveyed through sight. At least two of the figures – Monet's father in the foreground, and a woman cousin in the background – were members of his family, but the painting gives no sense of intimacy. The father's gaze, reinforced by his shadow and that of the flagpole, is directed towards the woman, but this emphasizes the distance separating them. As was characteristic of Monet's paintings on this theme, the family is enclosed by flowers which are here rigidly reinforced by the fences, so that the only relationship with the suggested freedom of the seascape is visual. The two empty chairs are given a peculiar prominence. They belong presumably to the distant couple, but there were others absent from this family party: Claude Monet himself, the observer and creator of this enclosed world – in other paintings he left an empty place for himself at the family table – and Camille Doncieux.

Monet wrote to Bazille from Sainte-Adresse saying that he was 'as happy and well as possible', in that he was working well and getting on with his family, who admired 'every brushstroke' he made; yet he was also worried about Camille alone in Paris, and sometimes 'without a sou'. Her pregnancy was a disaster, since Monet could not afford to marry: he had difficulty supporting himself, particularly when he could get no help from his family who probably hoped that he would make a respectable marriage to a woman who would bring a large enough dowry to help his uncertain career – as Camille Doncieux could not. He had nothing more positive to say about her than that she was '*gentille, très bon enfant*', but was uneasily aware that it would be 'really bad . . . to take a child from its mother', as seems to have been proposed.[108] Monet's only ambition was to paint, and to paint in ways which were proving unpopular; it may then have been the anguish of apparently having to choose between jeopardizing his career and abandoning Camille and their child, rather than the strain of painting outdoors, which led to a temporary loss of sight a fortnight before the baby was due.[109] Nevertheless, he borrowed money from Bazille and managed to get briefly to Paris in August for the birth of Jean, 'a large and beautiful boy', discovering that 'despite everything' he loved the child. Even then he returned to Sainte-Adresse to maintain the fiction of having separated from Camille, and he there continued his appeals to Bazille, lamenting that the mother of his child might not have the wherewithal to eat. By the end of the year, however, he was living with Camille and the baby in a room in Batignolles, and on New Year's Day 1868 we find him reproaching Bazille for not having sent his monthly payment for the *Women in the garden*: 'I'm without a sou, I've spent the whole day almost

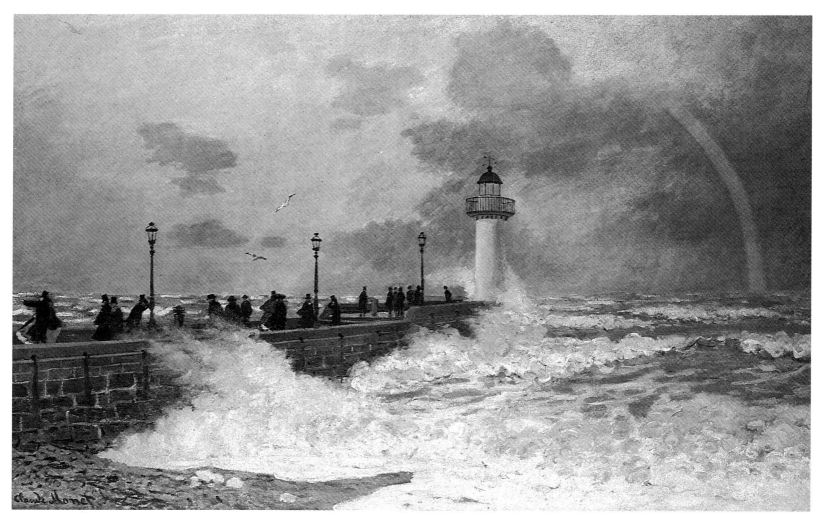

47    *The Jetty at Le Havre* (W.109), 1868, 147 × 226 (57½ × 88)

without a fire and the baby has a heavy cold; my position here is very difficult; I've got a lot to pay tomorrow and after. You must then find a way of giving me a sum of money.'[110]

While staying at Sainte-Adresse he worked on his Salon entries, *Ships leaving the jetties of Le Havre* and *The Jetty at Le Havre*, the latter another painting on the spectator theme also favoured by Boudin, who showed the same subject in the Salons of 1867 and 1868.[111] *Ships leaving the jetties of Le Havre* is known only through two caricatures, which suggest strong similarities with *The Port of Honfleur*, rejected from the Salon of 1867. *Ships leaving Le Havre* was accepted by the jury, after a fight by Daubigny, but *The Jetty at Le Havre* was rejected – even though Monet seems to have tried to produce a relatively safe picture, with some marvellously foaming waves – because Nieuwerkerke, now the Imperial Superintendent of Fine Arts, felt one was 'enough of this kind of painting'. Although the election of this jury reflected the liberalization of the regime – any artist who had exhibited in the Salon was eligible to vote for two-thirds of the jury, with one-third still being appointed by the administration – its composition was not substantially changed. Nevertheless the jury felt unable to exclude the whole of the new generation of Realists, and Castagnary could claim that this Salon saw

the triumph of young artists inspired by 'the life surrounding them', ascribing the dominance of 'liberated painting' to Daubigny, leader of those who expressed public concern about the tutelage of the goverment. The jury dealt with these large-scale paintings of contemporary life by hanging them, as Castagnary claimed, so they could not be properly seen: 'since [Renoir's] *Lise* has been successful, it's been shoved into the dump at the top of the wall, next to Bazille's *Family* . . . not far from Monet's big *Ships!*'[112] Although Monet's painting has been lost, it is worth considering the reactions to it, for these are the only published comments on his exhibited work in the 1860s, apart from brief remarks on his relatively conventional marines in 1865, and on *The Pavé de Chailly* and *Camille* in 1866.

In an extended discussion of Monet's painting, including works which had never been exhibited, and which he must have seen in Monet's studio, Zola wrote that he was impressed by 'the frankness, even the crudity of the brushwork' of the *Ships leaving the jetties of Le Havre*. Astruc disagreed: Monet's early works 'made us hope for a master. He has the love of water, the science of boats; when quite a child he played on beaches. . . . His mind became familiar with the phenomena of the sea. He is original and finds the appropriate accent for things'; but he now felt that Monet disconcerted 'those who followed him with a

friendly eye by sending us a hastily executed painting. . .'. This point was also made by a caricaturist who captioned his summary drawing: 'There was a . . . great big ship/Very well painted by M. Monnet [*sic*]/Which [or who] steams ahead and seems to say/*Go head! time is money!*' (the last line is in English).[113] Avant-garde critics claimed a causal relationship between 'speed of execution' and modern life, and also justified visible execution as a sign of an individual's sincerity and truth. But, while the Imperial arts administration, the jury, and critics close to the administration paid lip-service to the grand abstractions of the academic tradition, and lamented the dominant taste for execution which was, in Zola's words, 'wretchedly dextrous' and fit only for glove-box labels, they, like the majority of dealers, collectors, and those members of the public who bought photographs of Salon works, favoured painstaking execution in which brushwork would disappear in the creation of illusion. 'Finish' was also a question of what one was accustomed to see, and each generation had its conflict over it, but fundamentally the demand for finish was for painting as a form of magic which concealed the making of illusion, paradoxically combined with a demand for traditional skills as the visible proof of labour.[114]

Despite this, texts by both conservative and progressive critics reflect unease concerning the ambiguous status of works of art as 'products' or as creations embodying non-financial values: in 1859, a writer in *L'Illustration* criticized the location of the Salon in the Palais de

l'Industrie because its very name 'suggests too directly thoughts of *producers* and *consumers*', while Castagnary claimed that the Salon was a 'simple display case' for 'special merchandise', interesting not because of its monetary value, but for the 'fame and glory' it brought to its creators.[115] Such ambivalence was characteristic of more general bourgeois attitudes on the value of work: 'hard work' was assigned transcendent value, but, despite fascination with the mechanical processes of manufacture, there were strong motives for concealing the real processes of production which produced surplus wealth: as Marx pointed out, the bourgeoisie had 'very good reasons for imputing *supernatural creative power* to labour'.[116] In a form of transference, the signs that work had been expended in producing the 'transcendent' objects of art could be scrutinized, but visible evidence of the actual processes by which they were created could not be revealed. By using the English phrase 'time is money', the caricaturist associated Monet's work with shoddy manufacturing methods (and perhaps unconsciously transformed Monet's four-master into a workaday tug).

Monet's work processes were themselves ambiguous. The two paintings were so large — *The Jetty at Le Havre* is over 2 metres (6½ feet) long, and even Monet referred to the 'enormous steamship' in *Ships leaving the jetties of Le Havre* — that they were probably painted in the studio over a period of several months, with the help of pictures painted earlier on the spot, yet they were executed with seeming rapidity, as if

48 Bertall, 'Le navire de l'Estaminet hollandais (Palais Royal)', caricature of *Ships leaving the jetties of Le Havre* (W.89), 1867–8, in *Le Journal amusant*, 6 June 1868

49 'La sortie du port', caricature of *Ships leaving the jetties of Le Havre* (W.89), 1867–8, in *Tintamarre-Salon*, 1868

they were sketchy representations of distant views brought unbearably close.[117] (In a similar way, Manet would scrape down a painting again and again, so that when he had obtained the effect he wanted, he could finally paint the work with the freshness and directness of a large sketch). Much of the ambiguity concerning Monet's 'sketches' and 'finished works' derives from such practices for, even in those works which he regarded as sufficiently 'finished' to exhibit in the Salon, he tended to efface the traditional signs of difference between sketch and finished painting, preserving the scale but not the illusionistic techniques of a Salon 'machine'. Thus in the huge *Jetty at Le Havre* — in particular in the crude simplifications of the masonry — one is forced to be aware of the way brushstrokes construct the image. The response of most spectators was uneasy, and if the professional spectators, the jury, could not keep such works from being seen, they kept them at the distance implied by their technique by 'skying' them — an instinct shared even by the first apologists of Impressionism in the 1870s, who maintained that the brushstrokes made sense if one stood far enough away from the painting.

Another caricaturist, Bertall, expressed his sense of the crudity of Monet's painting:

Here at last is some truly naïve and sincere art. M. Monet was four and a half when he did this painting. . . . They say that the clock works marvellously on Sundays and holidays. . . . Purchased by the clock-maker in the passage Vivienne.

This association between *naïveté* and 'sincerity', child art and popular imagery, raised issues which had long been significant in avant-garde Realism, and Bertall's caricature with its schematic boats and waves and childlike representation of figures is but one in a line of similar caricatures of works by Courbet, Manet and other Realists.[118] Bertall's ironic claim that the painting was bought by an artisan, probably as a shop sign, reminds one that by the standards of high art, Monet's paintings were as crudely simplified as contemporary advertising; indeed, these ones of Le Havre suggest that he had studied coloured advertisements for shipping, with their straightforward concern with the up-to-date, their naïvely distorted foreshortening, their use of unaffected graphic signs to denote the curve of waves and the speed of a boat. The Realists' apparently childlike expression derived from a deliberate process of de-skilling in the illusionistic techniques of high art,

a process assisted by study of alternative systems of representation. They may also have felt — as was characteristic of Europeans' concept of the non-European — that there was something childlike in the Japanese prints representing Europeans as if seeing them for the first time. There are clear convergences in the way ships, rigging, rowing boats and waves are represented in Sadahide's *Trade at Yokohama: Europeans transporting goods*, and in shipping advertisements (ill.53), with Monet's use of simplified forms and flat patches of unmodulated colour.

These graphic conventions enabled Monet to dispense with an over-informative illusionism which might have encumbered the moment and embedded it in the continuity of time. This mode of representation depended on Monet's determination to see the external world as if he had not seen it before, for pre-knowledge was so dependent on established modes of representation that it would have prevented him from seeing the object as a system of signs. It also required the spectator's willing participation in interpretation — and in the perhaps bleak experience it embodied. In this Monet overestimated the public — and its intermediary, the Salon jury — which saw these works as crudely painted, childish simplifications. His exhibited work was ridiculed and a potential buyer refused the painting that was rejected.[119]

All that Monet gained from the Salon was the esteem of his fellows and of those who had already committed themselves to the modern, expressed most notably in the long passage the now notorious Zola devoted to him as in the front rank of the *'actualistes'*, those whose work was as up-to-date as the daily news. Since this was the result of a year's work, the future was bleak, so Monet took his mistress and child to Gloton, near Bennecourt on the Seine, where it was cheaper to live than in Paris. It was there that he painted *On the bank of the river, Bennecourt* (ill.64), another painting in which the presence of a spectator figure creates a break in the real spectator's experience of the scene, an experience made more complex by being integrated with a motif which was to become Monet's central obsession: reflections on calm water. This motif was ideal for a painter who was fascinated by nature but who as a modernist had lost the Barbizon painters' almost religious belief in its underlying stability of form, for the play of reflections undermined conventional perceptions of space and solid, and dislocated the conventional concept of a landscape painting as being a straightforward

50   Utagawa Sadahide, *Trade at Yokohama; Europeans transporting goods*, 1861, woodblock print, 34 × 119.7 (13½ × 46½)

51   *The Port of Honfleur* (W.77), 1866, 148 × 226 (57½ × 88)

reflection of nature. Already, in this first painting of the motif, the tension between the gaze of the real spectator and that of the painted spectator, together with the ambiguous relationship between the 'real' and the reflected world, creates a complex discourse on the representation of the visible.

Monet depicted Camille on a steep bank above the water as if she were an intermediary for the spectator, and it is only gradually that one realizes that she can see things invisible to the artist and which remain invisible to the spectator, for the sparkling foliage obscures the houses on the opposite bank and the large house can be seen only in reflection. The effect of this is to fracture the scene into divergent visual movements and isolated pauses of recognition which force one to look more intently at the means by which these visual experiences are created; how, for example, thick dabs suggest the almost palpable light falling through the leaves; how the varying textures and tones of blue dragged across flat grey-blue indicate the difference between ruffled and glassy water, water penetrated by light and water which reflects light; how the big patch of blue on the grey-blue below the bank registers the sky above the viewer. The painting is as broadly executed as a sketch,

but is visually so complex that it cannot be categorized as one. To do so would be to distort the dynamic, exploratory nature of Monet's painting.

If Monet could not 'see' forms more specifically than as sensations of colour, he simply put down touches of colour which stabilize only partially into images — a cow drinking, figures in a boat or on the bank. His refusal to shape undifferentiated sensations is the more remarkable in view of his personal relationship to both figure and landscape, for he and Camille were staying in the Auberge de Gloton, the house seen only in reflection. In *L'Oeuvre*, Zola made Bennecourt the location of the happy phase of the love affair of Claude Lantier and his mistress, Christine; although the figure of Lantier contained elements of Manet, Cézanne, Monet and Zola himself, and although Zola and Cézanne and their respective mistresses also stayed at Gloton in the 1860s, the idyll at Bennecourt seems partially based on that of Claude Monet and Camille Doncieux.[120] By the late 1860s the image of a woman in contemporary dress, a flowing river, a boat, had become the familiar stock-in-trade of pictorial, graphic or literary representations of amorous escapades in the country, but there is nothing of their suggestiveness in Monet's

painting, and this disregard of the centuries-old association between sexuality and inland waters – recently brought up to date by Courbet and Manet – throws light on his attempt to create a modern landscape painting. He was to be the only avant-garde painter of figures in a landscape never to represent the time-honoured theme of nudes in a landscape, and this shows how determinedly he detached painting from its past. The cultural memories associated with the nude were inappropriate to the modern countryside where the ideal of a golden age of harmony between the human and the natural suggests a continuity irretrievably flawed by such temporal factors as train timetables, office hours and fashion. To the Realist, nudity could only be nakedness, something almost unthinkable in the suburban countryside, and so – with the exception of such objects of scandal as Courbet's *Bathers* (Musée d'Orsay) and Manet's *Déjeuner sur l'herbe* – nudity in nature could be found only in the fictions of academic art (as in Gleyre's *Earthly Paradise*). Monet's paintings were peopled by his family and friends not simply because professional models were costly, but because the private world of family and friends was a primary location of contemporary experience – and here too, the representation of nudity and the direct expression of sexual desire were unthinkable.[121]

In *On the bank of the river, Bennecourt*, Monet represented Camille seated on the bank in town clothes. The boat which they have rowed across the river is simply that, and attracts none of that nagging attention demanded by the one in Courbet's *Young Women of the banks of the Seine*. Earlier pleinairists generally represented the people who lived in the landscape in some active relationship to it, but Monet depicted Camille as doing nothing but look at the landscape, which becomes simply a spectacle for the city visitor. She has no fictional relationship with the spectator, as have the women in Courbet's and, in different ways, Manet's paintings, let alone those of Toulmouche, and the severing of this relationship establishes something of the privacy of the figure.

If Zola's *L'Oeuvre* did evoke something of Claude Monet's and Camille Doncieux's stay at Bennecourt, it was very happy – but it did not last long. Monet wrote to Bazille that he had been evicted from the inn 'naked as a worm', and so desperate that 'I was idiotic enough to throw myself into the river', although he was too strong a swimmer for this to be serious. He obtained portrait commissions from a Havrais industrialist, Louis-Joachim Gaudibert, who lodged him in a château near Le Havre, but nothing, he wrote, could restore his 'old ardour . . .

52   Edouard Manet, *The Battle of the 'Kearsarge' and the 'Alabama'*, 1864, 138.8 × 129.9 (54⅝ × 51⅛)

53   Jean-Alexis Rouchon, poster for the Société industrielle des Moyabambines, 1859, 170 × 150 (66½ × 58½)

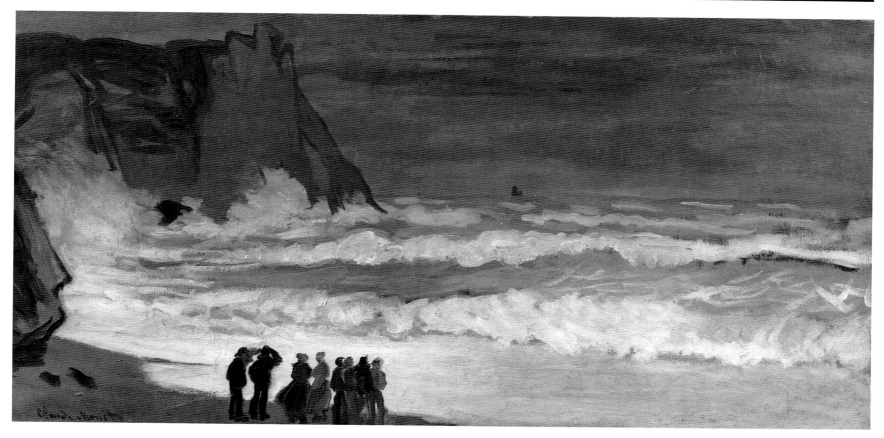

54   *Rough Sea at Etretat* (W.127), *c.* 1868–9, 66 × 131 (26 × 51½)

everything bores me as soon as I start to work; I see everything black'. But by late 1868 everything had changed: Monet was awarded a silver medal at the Exposition Maritime Internationale at Le Havre, and although the pictures he exhibited were seized for debt, *Camille* was bought for 800 frs. by Arsène Houssaye, the influential editor of *L'Artiste*, who assured Monet that he would 'launch' him. Houssaye had made a fortune in the transformation of Paris, and wrote novels on the erotic adventures of the boulevards; the attraction for him of what was seen as a painting of a woman of the streets was in character.[122]

Monet wrote Bazille a long letter from Etretat:

I'm very happy, quite enchanted . . . surrounded by all that I love. I pass my time in the open air . . . and naturally I work all the time, and I believe that this year I'm going to do some serious works. And then, in the evening, my dear friend, I find my little house, a good fire and a good little family. . . . My dear friend, it's marvellous to watch this little being [Jean] grow, and upon my word, I'm really happy to have him.

He spoke of painting Jean with two women in an interior for the Salon, and continued:

Thanks to this gentleman in Le Havre [Gaudibert] who has come to my aid, I enjoy the most perfect tranquillity, since I am free from all worries, so I'd like to remain always in this situation, in a corner of nature as tranquil as this. I assure you that I don't envy your being in Paris and scarcely miss the reunions [at the Café Guerbois], although I would however be pleased to see some of the *habitués*, but frankly I believe that what one can do in such a milieu is really bad; don't you feel that one does best alone with nature? I'm sure of this. Moreover I've always thought thus, and what I've finished in such conditions has always been best. One is too concerned with what one sees and hears in Paris, however strong one is, and what I will do here will at least have the merit of not

resembling anyone . . . because *it will simply be the expression of what I personally will have felt. The more I continue the more I regret the little I know. . . . The more I continue the more I see that one never dares to express frankly what one experiences.* It's strange.[123]

Although Monet insists on the necessity of being alone with nature, there is nothing of the Barbizon painters' reverential humility towards it. This is not to say that he sought to be purely objective, for the verbs he used for the experience he was trying to express suggest that his painting of what he saw was an active process which involved the mind in ways that were specific to it, and which had its own sources of emotion. Thus, if it was responsive to the raw shocks of modern experience, it also called on personal feeling, even if this was of a very particular, detached kind.

Monet had always emphasized the need for individual communion with nature, yet he also recognized that its representation depended on shared experience: 'It would be better to be all alone,' he had written to Bazille in 1864, 'and yet there are so many things which one cannot fathom by oneself.'[124] He had begun his painting career watching Boudin paint, and, nearly every year since, he had painted nature in the company of his friends, a practice which confronted them very directly with the subjectivity of perception and of the creative process, for even when they painted side by side, intending to represent what lay before their eyes, each had an individual mode of applying paint, a predilection for certain colours and tonalities, and for certain modes of structuring; each viewed the scene differently, focused on different elements, and had a different apprehension of space. For example, when Monet and Renoir painted together at La Grenouillère in

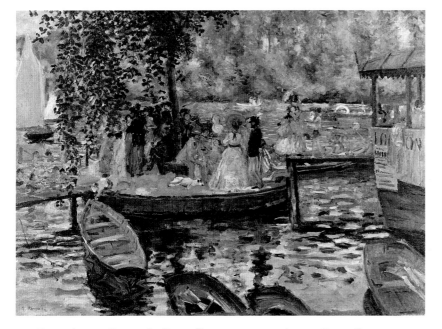

55   Pierre-Auguste Renoir, *La Grenouillère*, 1869, 66 × 86 (25 × 33½); see ill.63

1869, Monet's flat staccato strokes of opaque paint and his abrupt contrasts of tone formed the micro-structure of a composition which, with its rigid geometry and fractured viewpoints, was quite different from the more unified composition deriving from Renoir's small, curved, feathery strokes and closely related tones (ills.55 and 63).

The close-knit group of artists and writers probably became increasingly necessary to Monet when his attempt to create a painting modern in technique and iconography was deprived of any wider social meaning by the Salon jury's refusal to let it be seen. 'To exhibit', Manet wrote in 1867, 'is to find friends and allies in the struggle.' Deprived of this, Monet could rely only on the group to confirm what he was trying to achieve. It was a vicious circle, for the group created the conditions of its own further marginalization. Since it was itself the primary audience for the new language of painting, it could extend the limits of that language, thus intensifying public incomprehension and hostility. What such marginalization might mean was suggested by Monet himself when Bazille bought the rejected *Women in the garden*: 'It's painful if one is the only one to be satisfied with what one has done.'[125]

Earlier pleinairists had also been consistently excluded from the Salon and had formed similar self-protective groups, but as long as they maintained the traditional distinction between direct studies of a 'fragment' of nature and finished landscapes which embodied their inheritance of associative values and humanistic meanings, they were not, so to speak, completely alone with nature. Monet rejected this inheritance, and attempted to create a modern landscape painting which denied memory, destroyed associations, and which existed only in the moment of sensual apprehension; in this sense, he had nothing to rely upon but a precarious relationship with nature which he had perpetually to renew, and confirmation from the few who shared his ideas. In 'Les Réalistes du Salon' of 1866, Zola insisted on absolute 'liberty of human creation', and on the primacy of 'Truth . . . life, but, above all, different bodies and hearts interpreting nature differently'.[126] Without some collectivity, the logic of modern *pleinairisme* would imply a terrifying

prospect in which different interpretations of separate fragments of nature might have no meaning beyond themselves. Was it such a prospect which prompted Monet's comment, 'The more I continue the more I see that one never dares to express frankly what one experiences'?

Like the group, the family may have been a protection against consequences of this kind of vision, and although one had been forced on Monet in 1867, it almost immediately became necessary to his painting. The family was for Monet, as it was generally in the nineteenth century, an essential means of survival in an increasingly individualist society. Despite — and perhaps because of — his marginal status and precarious circumstances, he now began to struggle, both in life and in painting, to re-create his family as it had been before the death of his mother, and before he had embarked on his career as a painter. His own 'little family' was to be organized around his work; its members were his primary models, and were always represented as physically and financially secure.

The results of Monet's stay on the coast were limited: he was unable to complete the large painting of Jean and two women in his 'little house' (ill.61) for the Salon of 1869; his dream of financial security was soon ended; his paint merchant cut off his credit, and he was reduced to painting on top of earlier works; and he returned to Paris 'very hungry, with his tail between his legs'.[127] A further blow came when his *Fishing Boats at sea* (W.126) and his marvellously luminous snow piece, *The Magpie* (ill.62), were rejected by the Salon jury — although, as Boudin observed, a study of Sainte-Adresse shown by the dealer Latouche kept 'a crowd in front of the window the whole time of the [Salon], and the startling character of this violent painting has created a kind of fanaticism in the young'.[128] Bazille told his father that

The jury made carnage among the canvases of the four or five young painters whom we like. . . . Except for Manet whom they no longer dare reject, I am the least badly treated. Monet was entirely rejected. What pleases me is that there is real animosity to us. The fault lies entirely with M. Gérôme who treated us like a band of madmen, saying that he felt it his duty to keep our paintings from being shown.[129]

Bazille probably benefited from his social connections, for the jury accepted his broadly executed painting of a woman in bright sunlight, the *View of the village* (Musée Fabre, Montpellier), inspired by Monet's rejected *Women in the garden*, and he was supported not only by Alfred Stevens, painter of highly finished pictures of elegant society, but by Cabanel, one of the artists most favoured by the Imperial court and arts administration, whose lush painting of classical and literary subjects was the epitome of all the younger painters most detested.

Bazille was, however, able to participate fully in upper-class Parisian life in a way that was impossible for Monet, who was once again forced to retreat from Paris, this time to Bougival, a small town on the Seine a few kilometres from Paris, then being transformed into a pleasure resort for city-dwellers in search of fresh air and recreation. Houssaye advised Monet that he would benefit from his talents if he settled in Paris, but Monet replied that this was impossible, after the jury's rejection had 'taken the bread from my mouth and, despite my not very high prices, made merchants and collectors turn their backs on me. . . . The worst is that I cannot even work any more. . . . I would do anything to escape this situation, and be able to work for the next Salon.' The family's installation at Bougival was aided by Gaudibert, but they lived in misery, sometimes lacking food and fuel. Monet told Bazille that

Renoir brought them bread from his parents' home near by, 'so that we don't starve', and Renoir wrote laconically to their friend, 'I'm almost always with Monet. . . . We don't eat every day. All the same I'm happy because, as far as painting goes, Monet is good company.'[130]

They painted together at La Grenouillère, a bathing place on the Seine, popular with Parisians who could swim, hire boats, or eat, drink and dance at the floating restaurant. Such resorts were frequently represented in illustrated journals, and La Grenouillère – which was in every guide to Second Empire Paris – had recently received special attention because the Emperor and Empress had disembarked there when on a tour of the Seine a few weeks before the two friends began to paint its pleasures.[131] Monet told Bazille of the frustration of his hopes of executing a large painting of modern life for the Salon:

Here I've come to a stop, for lack of paints. . . . It's only I who will have done nothing this year. This makes me angry with everyone, I'm jealous, mean, I'm going mad; if I could work everything would go all right. . . . Now the winter is coming, a bad season for the unfortunate. Then the Salon will come. Alas! I won't figure there again, since I will have done nothing. I do indeed have a dream, a painting, the bathing place at La Grenouillère, for which I've done some bad sketches, but it remains a dream.[132]

Bazille was, however, able to complete a large painting of young men bathing in a river in Provence – the *Summer Scene* (Fogg Art Museum) – for the 1870 Salon.

Monet's wish to paint a Salon picture at La Grenouillère shows once again how he sought to locate his art within Second Empire society, this time choosing to paint a place that was 'in the news'. It was a place of dubious reputation, where the classes intermingled in ways which fascinated and excited: a journalist commented on the Imperial visit:

All true Parisians know this charming spot where we find . . . the elegancies of high society, bourgeois society, and above all, the demi-monde. . . . The aristocracy of Bougival and Croissy come there to bathe and to watch the antics of the men and women bathers. . . .[133]

Maupassant wrote of 'laughter, shouts, calls, insults [crossing] the river from bank to bank'; the procession from the station of 'bourgeois with their families', 'working girls with their lovers in shirt-sleeves, coats over their arms, top hats tipped back, with a tired, drunken air'; the mingling of drinkers, dancers, swimmers and boaters at La Grenouillère itself, and among them, he generalized happily, were 'tall girls with red hair, displaying . . . the double provocation of their breasts and their hips . . . three-quarters drunk with their mouths full of obscenities. . . '. Even Berthe Morisot's refined mother wrote about near-by Bougival where her son Tiburce had gone swimming, 'it's said that it's a little rendezvous – if one goes alone one comes back two or three – men have it easier.'[134] Morlon's rather later lithograph of La Grenouillère was made for a bourgeois audience with a seemingly insatiable desire for images of the sexual laxity of the lower orders. The squeezing of the figures into the foreground emphasizes the excitation of the water, the voluptuous bodies of the women in their revealing bathing-dresses, and the abandoned behaviour of the couples in their shoddy finery.

It was unusual for Monet to have chosen to paint at so equivocal a spot, and even more unusual that he seems to have responded to its sexual permissiveness in *The Embarkation* (W.138), the only one of his La Grenouillère paintings in which the figures are close to the spectator, and one of his few works which imply that the figures touch or may touch one another. The little sketch arouses memories of Courbet's *Young Women of the banks of the Seine* in the juxtaposition of the figures

and the prominent empty boat, and Manet's *Déjeuner sur l'herbe* in the interlinking of the seated man and woman, but it has an unease which relates it as much to Cézanne's strange representations of picnics. Monet's other paintings of La Grenouillère focus neither on a potentially erotic situation nor on the mixing of social classes; he simply depicts well-dressed figures in the middle distance where, with none of the rowdy behaviour described by Maupassant or pictured by Morlon, they chat calmly on the little island (mentioned in the article on the Imperial visit as 'the most frequented spot in the area'), teeter on the narrow gangplanks, or swim peacefully in the sparkling water.

Nevertheless it would have been exceptional to conceive a major Salon painting of an accessible place where both class separation and the

56  Antony Morlon, 'La Grenouillère', 19th-century lithograph

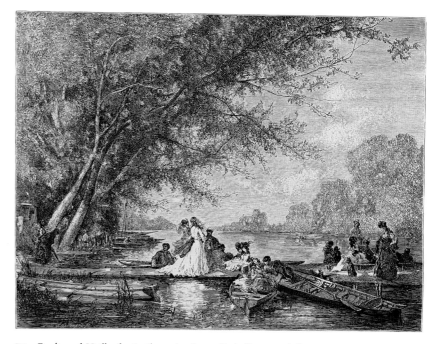

57  Ferdinand Heilbuth, *By the water*, from *Chefs-d'oeuvres de l'art contemporain. Le Salon de 1870*, 1870

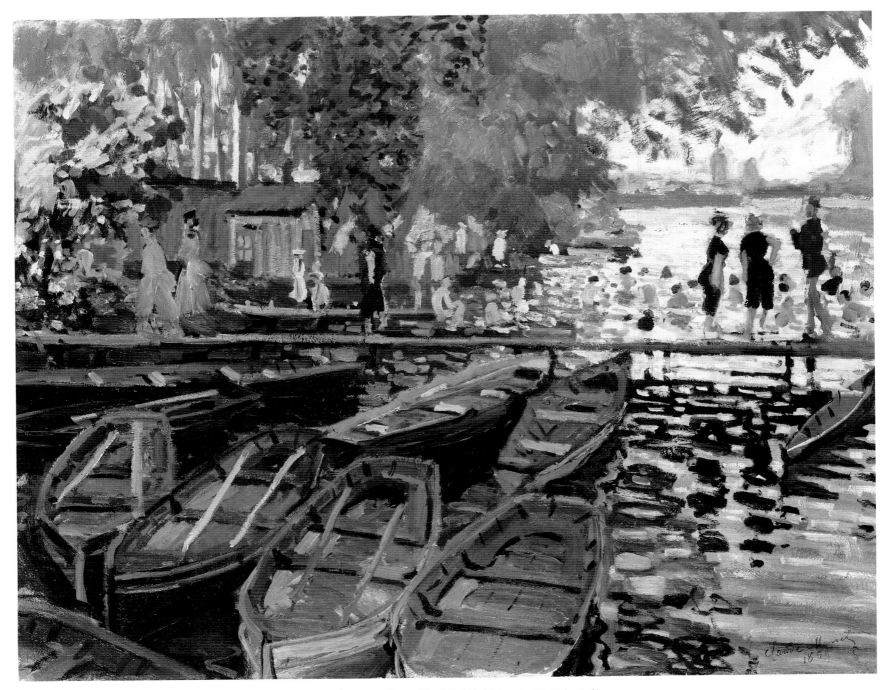

58 *Bathers at La Grenouillère* (W.135), 1869, 73 × 92 (28½ × 36¼)

rigid codes of erotic behaviour were known to be relaxed. Such scenes were allowable in the privacy enjoyed by the owner of lithographs or small paintings, but not in the Salon, which was known as an arena where (as Daumier's lithographs suggest) there was a strong sense that the classes were intermixed. On a large scale details such as the two women in bathing costumes talking to a gentleman, and represented by techniques which suggest freedom from control, would have been unthinkable in the Salon, where the unclothed or the underclothed had to be distanced by time, technique or the anecdotal belittlement of human experience. One of Monet's paintings (W.136; lost) may have been rejected for the Salon of 1870, while Heilbuth's *By the water*, which was accepted, and photographed by Goupil for sale to the public, shows how the theme could be made respectable. His was evidently a modern subject, but – as was apparently noted by Gambetta, who exclaimed, 'It's Cythera and Watteau at Bougival' – the formally dressed, decorous ladies and gentlemen seem to have been transposed into an eighteenth-century *fête galante*, so there was not only none of the rowdiness of the suburban pleasure spots, but also no risk of immediacy. Paradoxically, the witty traces of Watteau's *Embarkation for the island of Cythera* (ill.271) which colour Monet's paintings of La Grenouillère do nothing to weaken their uncompromising modernity.[135]

Monet was again hoping to create a Salon 'machine' with subject-matter which the mass-circulation journals had proved was popular with middle-class audiences, and by adapting techniques which those journals had made familiar. Monet saw his field of operation as the Salon, so his interest in informal graphic media with commercial associations was probably shaped by the ambition of the younger generation of Realists to revivify high art, rather than by any intention of evolving a populist alternative to it. Whatever the case, Monet's desire to create a large-scale Salon painting of contemporary recreation on the Seine was

to remain 'a dream', largely because of his financial situation. Since he had, however, struggled to complete large works in similar circumstances, it is possible that he did not now do so because of his unease at painting figures outside his familiar circle. This is suggested by his strangely gauche *Embarkation*, by his distancing of the figures in the other paintings, and indeed by the way he concentrated on representing his perceptions of the scene, rather than on its particularized human content, making his brushstrokes more emphatic and specific, not, as was usual, in the human figures, but in, for example, ripples in the foreground or even in the changing light on the distant water.

A year had passed since Monet had painted the reflective surface of water in the immediate foreground of *On the bank of the river, Bennecourt* (ill.64); meanwhile colourless snow had provided him with another medium through which to study effects of light. *Terrace at Sainte-Adresse, The Magpie* (ill.62) and *La Grenouillère* (ill.63) show that he had developed a structure which was no longer based on solid forms, but on the tension between a fluid atmospheric space created by colour vibration and a linear grid deployed in depth and on the surface. The conflict between the obtrusive surface grid, the space-creating diagonals and the colour structure of the *Terrace* was resolved in *The Magpie* by a kind of oscillation between the delicate atmospheric colour and the linear structuring of surface and depth. In earlier works, such as the *Farmyard in Normandy*, line defines the edges and the inner articulation of volumes which are also given strong local colours and specific textures; but in *The Magpie*, the blue- and mauve-tinted snow and delicate pinks and mauves of the house reduce the materiality of objects so that they fuse with the linear structure. There was, perhaps, overcalculation in the way gate, roof, trees and even clouds are drawn into a horizontal–vertical grid whose sudden shift into diagonals acts like a hinge which opens out into space, and it was not until he began his intensive study of water that Monet found a structure which was both firm and 'natural'. Reflections break solid forms into coloured particles, and enabled Monet to make dense, opaque pigment express the way in which the countless, ceaselessly moving planes of the water surface absorb, reflect and materialize light, absorb, reflect and dematerialize the solid world. In so doing, he made drawing and colour one.

Close examination of *La Grenouillère* reveals something of the inextricable processes by which Monet both saw and represented nature. He probably began with a drawing in paint which gave the picture a linear structure that was maintained throughout the painting process, and on the basis of which he evolved the colour structure in an improvisatory way which enabled him to find previously unseen relationships. Space was suggested by diminution of the figures, and by the sharp diagonals of the boats, restaurant and walkway; these are locked to the surface by an emphatic scaffolding formed by the verticals of the central tree and its reflection, the posts of walkways and restaurant, and those of the figures which echo one another almost to the point of invisibility (as in the two 'hairline' figures in the distant boat), and by the horizontals of the central walkway, the echoing ripples, the brilliant strip of sand, and gay stripes of blue and yellow-green water. The discontinuity between depth and surface codes fractures the spectator's exploration of the pictorial scene into a series of separate 'moments' of apprehension, in such a way that the unity of the painting is not a given, but is created from an accretion of such moments, each of which is, in a sense, lost as the eye moves from them. This form of discontinuous unity can be observed in earlier works, but Monet now realized it with an assurance that allowed complex interrelationships to

develop as he painted, as can be seen – in just one detail – in the way the thick curved strokes in the water below the central tree both strengthen its vertical and undermine it, by acting as a transition to the reflections on the horizontal plane of the water. Such contradictory, fluctuating relationships penetrate the entire painting and give it its paradoxical sense of completion.

*La Grenouillère* is so complex and so complete that it is unlikely that Monet conceived it only as a study for a finished painting. It suggests that he found the traditional separation between study and finished work increasingly unsatisfactory because it implied a separation of the process of seeing a landscape from that of creating a pictorial structure to represent it, and it is clear that he could not isolate one from the other.[136] He continued to paint or to complete pictures in the studio, but by far the greater number of his works were to be painted largely in the open air, with the phases of visualization embodied in a single canvas, and generally painted over several sessions, rather than explored in sketches and transferred to the final picture. Studio work tended to give a false continuity to those discontinuous moments of recognition characteristic of modern vision, but in front of the motif Monet could develop structures which embodied discontinuity, as in *La Grenouillère* where his improvisatory brushstrokes seem to register his cumulative awareness of the complex life of the water, with its steady central current smooth or glassy, ruffled or shimmering in the sun, breaking in an almost audible slap-slap of ripples near the bank.

The sun-filled paintings of La Grenouillère do not even hint at Monet's economic misery, but it may have been the threat of its continuing, and the apparent impossibility of creating a market for his more formal or his more experimental works, which dictated his return to more traditional *pleinairiste* compositional modes in paintings executed in the winter and spring of 1869–70. In *The Bridge at Bougival* (ill.65), Monet used the conventional shadowed foreground, with a diagonal roadway and receding figures, leading to a luminous distance, thus creating a continuous space filled with sparkling spring light. Even in this painting there were characteristic breaks in illusion which draw attention to its abstract materiality – for example, the paint which represents sunlight falling on the roadway seems to detach itself from the surface, or the lines describing ruts, gutter and shadows 'become' paint before one's eyes. In fact the problematic of representing what he saw may have been more intense for Monet in works which were closer to the traditional illusionist codes of oil painting than in paintings like the *Terrace at Sainte-Adresse*. Such paintings emphasize (once again) that, far from being an innocent recorder of 'what he saw', Monet was highly conscious of the coded nature of visual signs, insistently drawing attention to them by varying them from painting to painting, or (as in *The Bridge at Bougival*) by including different codes in one painting.

Monet sold the relatively conventional and finished *Bridge at Bougival* to the dealer 'Père' Martin for 50 frs., plus a small Cézanne. This was one of the pitifully few works sold by Monet in the 1860s, and its price can be compared with the 8,000 frs. the State paid for a larger painting, Chenu's *The Stragglers; snow effect*, shown in the Salon of 1870, a fairly broadly painted work with an unconventional composition, made acceptable for a State purchase of this importance by its use of anecdotal subject-matter.[137]

By the end of March 1870, Monet would have been shocked to hear of the rejection of his *Luncheon* (ill.61) and perhaps *La Grenouillère*. Boudin wrote to Martin: 'You know that they have pitilessly rejected

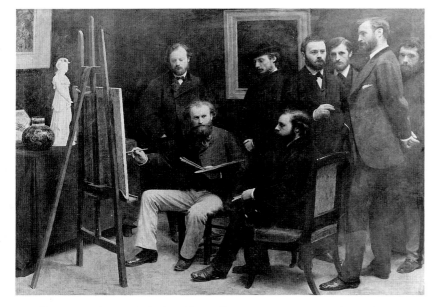

59   Henri Fantin-Latour, *A Studio at Batignolles*, 1870, 204 × 273.5 (79½ × 106¾)

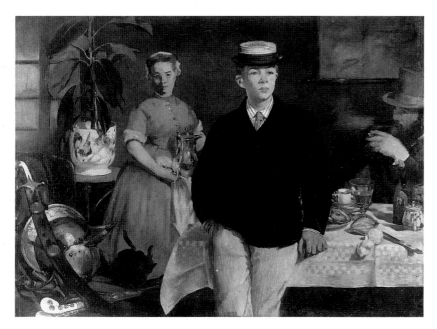

60   Edouard Manet, *Luncheon in the studio*, 1868, 118 × 153 (46 × 59½)

Monet, one wonders by what right. . . .' This rejection must have been more difficult to understand than any previous one, for the jury – from which Daubigny resigned in protest – was said to have accepted 'almost everything that could be accepted': almost 3,000 paintings, including landscapes by Pissarro, cityscapes by Sisley, and Bazille's *Summer Scene* and Renoir's *Bather* (Museu de Arte Moderna, São Paulo), significant examples of the modern nude in the landscape, probably made acceptable by their reference to tradition.[138] To the informed, Monet's work was conspicuous by its absence, but his position in the Realist

movement was affirmed by Fantin-Latour's *A Studio at Batignolles*, where he is shown as a rather shadowy figure in Manet's studio among writers and artists – including Astruc, Zola, Renoir and Bazille – who were recognized as Manet's followers and supporters. His name was kept before a public which could scarcely have known his work by Castagnary and Arsène Houssaye; the latter, in his influential conservative journal *L'Artiste*, declared that 'the two real masters of that school which, instead of proclaiming art for art's sake, proclaims nature for nature's sake, are MM. Monet and Renoir, two real masters like the Courbet of Ornans, by the brutal frankness of their brush'.[139]

In his *Luncheon*, Monet seems to have gone out of his way to paint an uncontroversial work in pointed contrast to the strange artificiality of Manet's *Luncheon in the studio*, shown in the Salon of 1869. Monet's painting is descriptive in style, relatively finished in technique, and insists on the bourgeois values of the sanctity and privacy of the family. Monet focused tenderly on the charming child, and emphasized the wholeness of the family by indicating his own, the father's, presence by his empty chair, his waiting egg and folded newspaper. Privacy is suggested by the shallow space in which the walls close in on the little family, and into which light only filters, and Monet made it complete by using Camille as the model for both mother and visitor, so that the two profiles echo each other as they look at the child. The *Luncheon* was one of the very few works in which Monet suggests a relationship between figures, but by contemporary standards it was very reticent. Its intimacy is curiously fractured by the figure of the servant, inserted between the two ladies, even though she is quite far behind them. This figure was essential as a sign of the bourgeois status of the family, but physically it disrupts the domestic circle.[140]

Monet experienced this domestic idyll in 1868, but in the months between the painting's conception and its exclusion from the Salon, it must have come to seem like the re-enactment of an illusory moment of security, while the comfortable bourgeois status suggested by the servant, the room, the furniture, the table setting, the books, the food, was a desperate fiction.

The threat to bourgeois security was not simply a personal one: the recent moves to liberalize the Imperial regime had stimulated rather than stilled opposition: the lifting of press censorship in 1869 unleashed a virulent oppositional press; a series of major strikes were severely repressed; the student and working-class quarters of Paris were alive with conspiratorial rumours, and in January 1870 the funeral of an opposition journalist shot by the Emperor's cousin turned into a gigantic demonstration against the Empire. Bazille could not go to the funeral 'because of the pouring rain' and because he was posing for Fantin-Latour, but he wrote:

There was not a single worker left in Paris. Without Rochefort, these 200,000 men (at least) would have been brutally shot. You will see that all this will end badly . . . there is a general unrest which will set off the guns at the slightest pretext, which will not fail to come.[141]

For a time, art and private life maintained their seeming primacy. With the exclusion of *Luncheon* from the Salon, what Monet had intended as a public expression of family happiness was realized only privately when he married Camille Doncieux on 28 June 1870. Courbet was a witness, but Monet's family ignored the occasion and the Doncieux family could give Camille only a very modest dowry, which was never fully paid.[142]

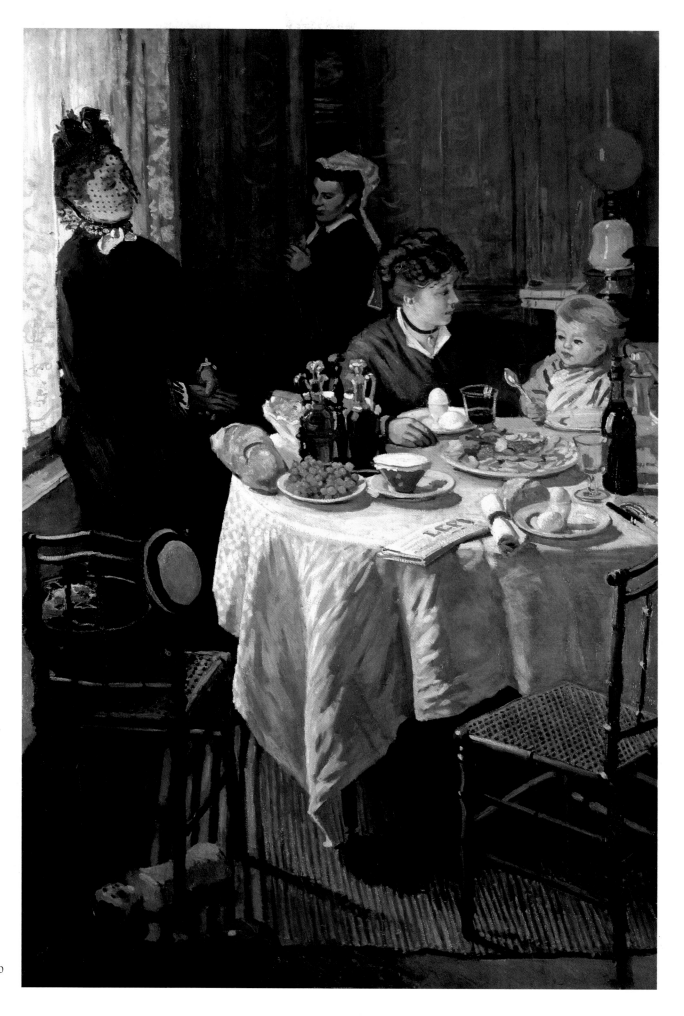

61   *Luncheon* (W.132), 1868–70, 230 × 150
(89¾ × 58½)

For the summer painting season Monet took his family to Trouville; he may have hoped to profit from the popularity of Boudin's paintings of the famous seaside resort, and was perhaps again planning a large-scale painting of contemporary recreation. Boudin generally set his figures in a broad band against the sea, but Monet showed the fashionable world in its new architectural setting, depicting the profusion of towers, pitched roofs, pavilions, balconies, chimneys, mouldings and sculpture of the luxury hotels recently built for the newly rich, whom he represented with almost satirical economy (needing only a few brushstrokes to depict the ritual of greeting on the terrace of the Hôtel des Roches Noires). The season at Trouville was in full swing when Napoléon III declared war on Prussia on 19 July, and it continued even after the first defeats, just as Monet continued to paint Parisians secure in their summer habitat. Unlike Bazille and Renoir, Monet had no intention of getting involved even after the Republic was declared on 4 September and the decision taken to continue the fight against Prussia. He stayed in Trouville until the autumn when, in accordance with his life-long principle that nothing should interfere with his painting, he left for London, presumably to avoid being called up. He was followed by Camille and Jean.[143]

It is understandable that Monet's six or seven months in London were not productive — he painted only six known works and all are small. In France, whatever his difficulties, his belief in himself as *the* painter of contemporary life had each year given him the resilience to surmount the humiliation of rejection and to re-embark on the struggle to paint another major modern-life subject. Even when excluded by the society which he was trying to represent, he could be confident — from the history of nineteenth-century painting — that he would eventually be accepted. Monet could have little faith in his future as a painter of modern life if he had to work in a society to which he had no access, and when the fate of the society of which he had been part was in doubt. The abrupt collapse of the Empire, the regime he had known throughout his years of consciousness, was succeeded with traumatic speed by the siege of Paris by the Prussians, the defiant establishment of the Commune in Paris and its two-month siege by the Provisional Government in Versailles, followed by the victory of the Versailles troops and their appalling revenge on the Communards. Presumably, like most of his friends, Monet welcomed the establishment of the Republic, but it is unlikely that he would have had any sympathy with the Commune's threat to bourgeois society, for he and his art were too deeply shaped by

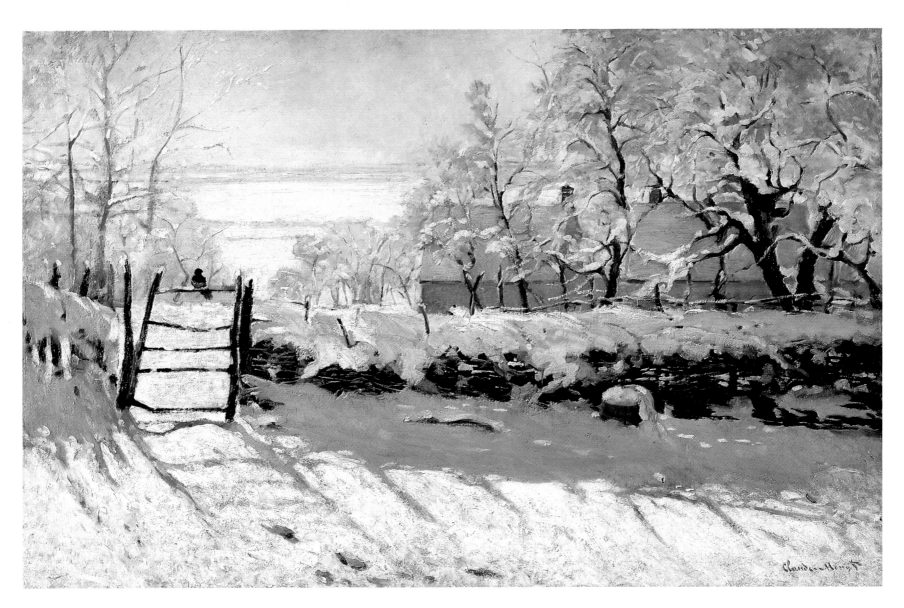

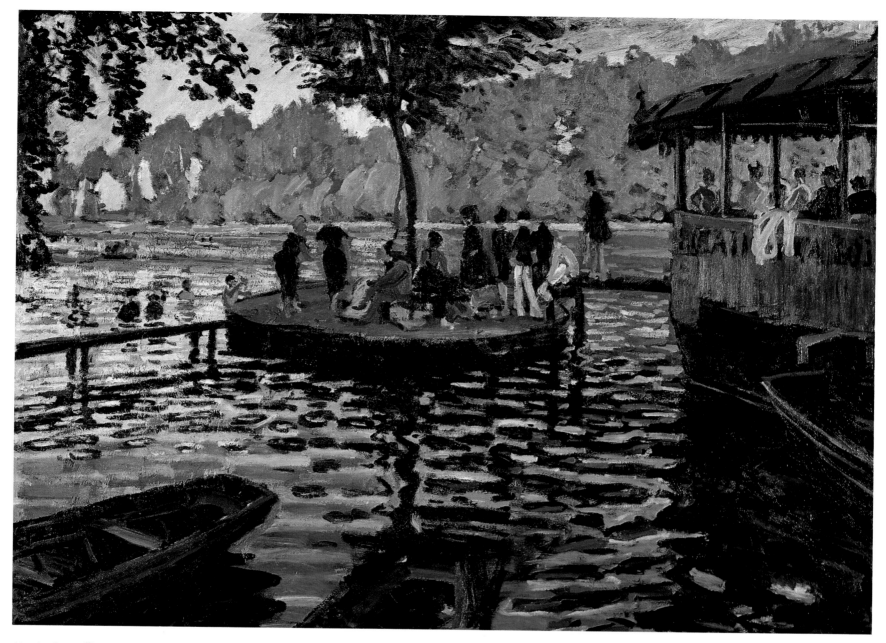

63   *La Grenouillère* (W.134), 1869, 75 × 100 (29 × 39)

*Opposite:*

62   *The Magpie* (W.133), *c.* 1869, 89 × 130 (34½ × 50)

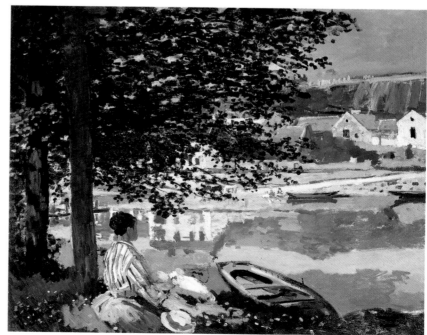

64   *On the bank of the river, Bennecourt* (W.110), 1868, 81.5 × 100.7 (32 × 39⅝)

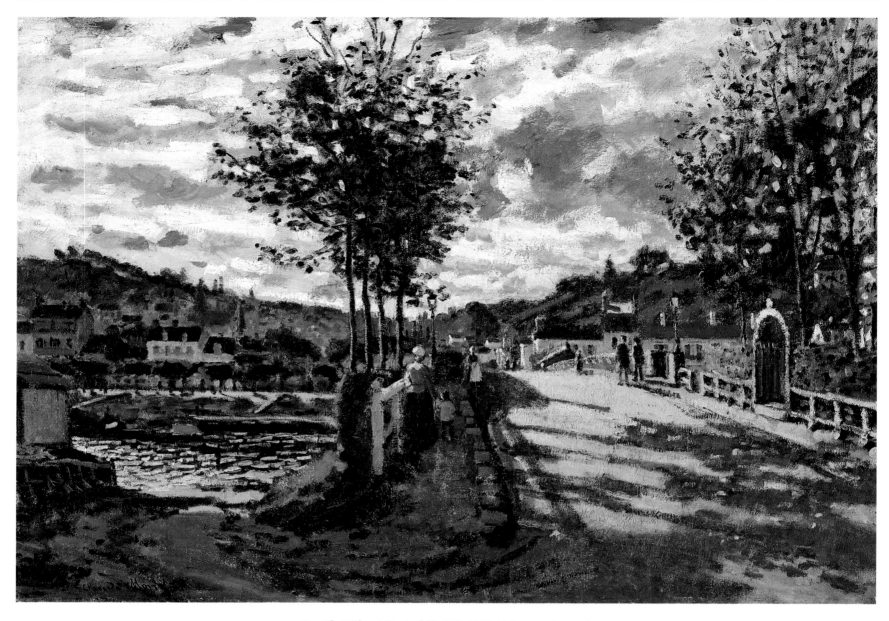

65    *The Bridge at Bougival* (W.152), 1869, 63.5 × 91.5 (25 × 36)

that society for him to conceive of any other; still, having heard a rumour that the Communard Courbet had been shot without trial, he wrote to Pissarro, 'How ignoble has been the conduct of Versailles, all this is frightful and makes one ill. I don't have the heart to do anything. All this is heart-rending.'[144]

In England Monet formed part of a small group of exiles which included Pissarro, perhaps Sisley, Daubigny and the art dealer Paul Durand-Ruel, who until his death in 1922 was Monet's most consistent financial support, thus playing a crucial role in the evolution of modernist landscape painting. 'Without him', Monet said in the 1920s, 'we would have died of hunger . . . we owe him everything . . .'.[145] Durand-Ruel's aid was immediate, for he purchased works by Monet during their exile. This was more than ever necessary because Monet could no longer hope for help from his family: his aunt had died a week after his marriage, and his father had married his mistress and

acknowledged a daughter, shortly before himself dying in January 1871. Monet may also have heard of the death of that other sustaining figure, his closest friend, Frédéric Bazille, killed uselessly in the French retreat.

Monet visited the London museums with Pissarro, and recalled at the end of his life that they had been 'vividly impressed by the Turners in the National Gallery'. Monet's biographer, Alexandre, stated that the London trip caused Monet 'to examine himself', and to seek things different from those which had previously concerned him, and Turner's painting may indeed have forced a crisis in his work at a time when his confidence was already undermined by the anguish of exile.[146] Turner's paintings of storms at sea — such as the *Calais Pier* of 1803 (National Gallery, London) — were so powerful and so truly observed that they may have made Monet doubt his own paintings on this theme, for he did not return to it until the early 1880s and then only in fragmentary views of modest scale. Even more impressive would have been Turner's

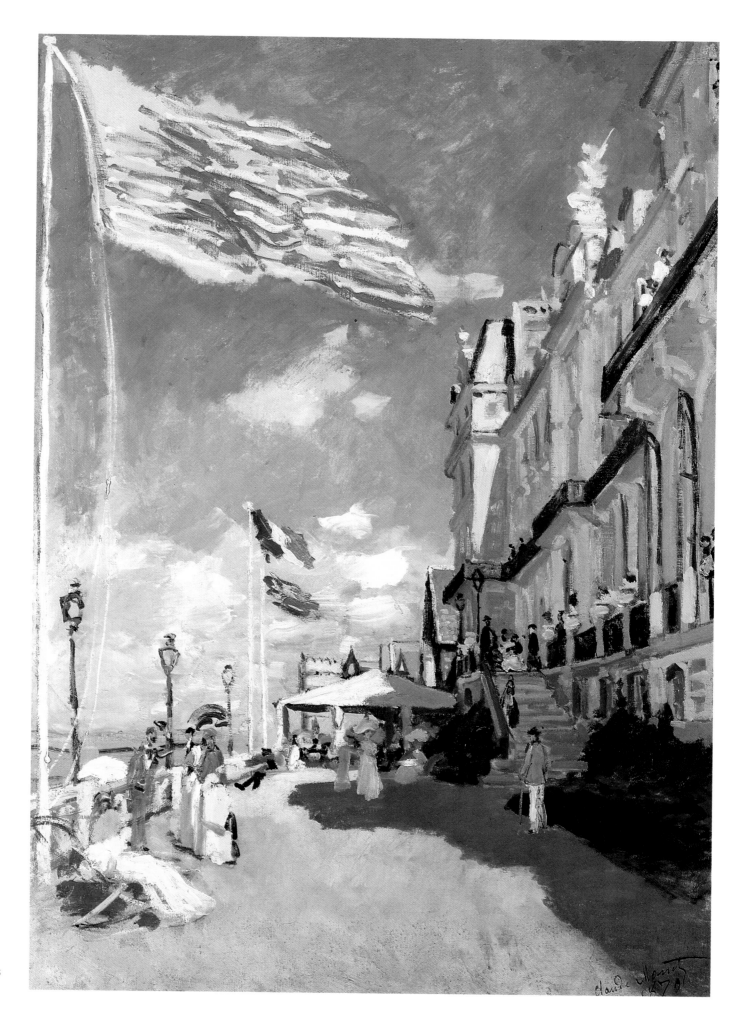

66    *The Hôtel des Roches noires,*
*Trouville* (W.155), 1870, 80 × 55
(31¼ × 21½)

astonishing dissolution of solid form into quivering veils of vibrating colour, suspended in mist or spray, reflecting in and off water, while his visionary paintings of modern steamboats or trains, transubstantiated as temporary accretions of radiant particles, must have made Monet re-think the *naïveté* of his own celebrations of modern steam power.[147] Yet their art was so different that, at this stage, Monet simply did not know how to use what Turner had discovered. Turner's aerial visions were of distant motifs, Monet had been concerned with close ones, and always needed to express his sense of gravitational reality, of the groundedness of the earth, the horizontal tension of water. More fundamentally, his detachment from the observed world was expressed in fragmented visual sensations and discontinuous structures which were utterly unlike Turner's works, in which light and matter fuse in space in a seamless continuum seemingly achieved through an intuitive, synthetic, empathetic grasp of the scene as a whole.

Turner's paintings must, however, have haunted Monet's mind, for they had an intermittent underground influence on his painting once he had returned to France and to a landscape which he knew intimately. In the 1870s, Turner's painting may have played a role in Monet's retreat from the 'close motif' and his more poetic treatment of some modern subjects: the relationship between Monet's *Autumn Effect, Argenteuil* and Turner's *Chichester Canal* (p. 86) suggests that Turner's example helped Monet to use reflections to structure deep space; the *Impression, sunrise* (ill.73) or *Sunset on the Seine, winter effect* (ill.155) indicate that the paintings of the English artist could have shown Monet how to suspend the light of the sun in mist.

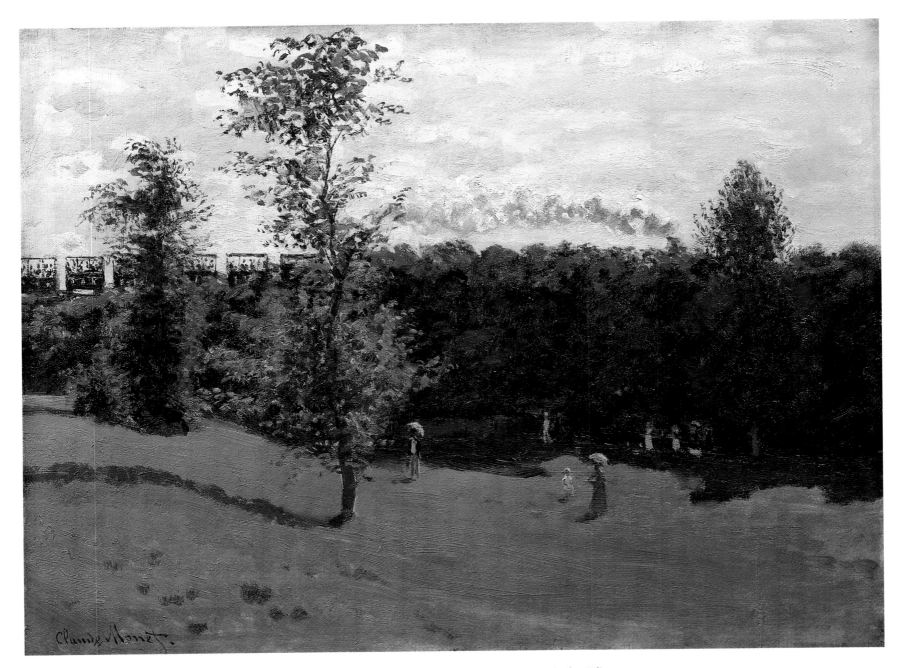

67   *Train in the countryside* (W.153), c. 1870, 50 × 65 (19½ × 25¼)

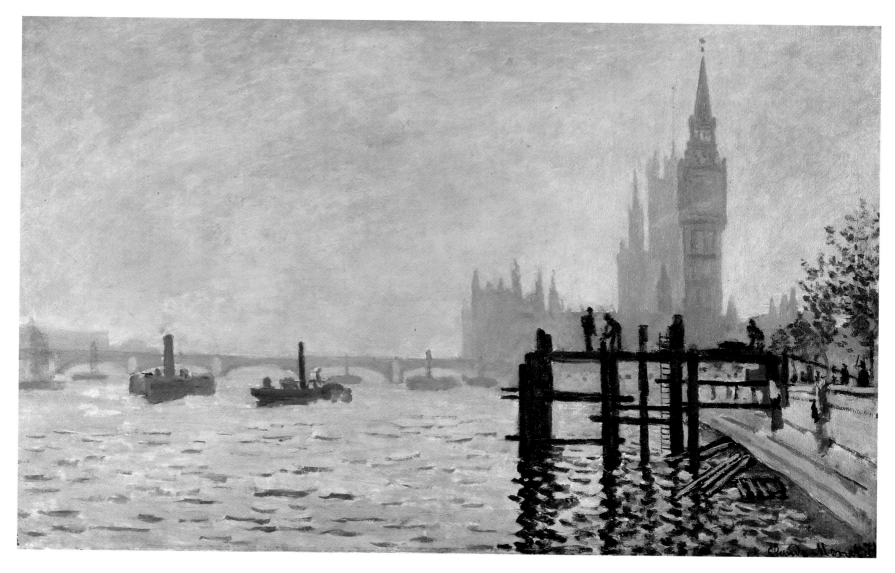

68  *The Thames and the Houses of Parliament* (W.166), 1871, 47 × 73 (18¼ × 28½)

69  Joseph Mallord William Turner, *Rain, Steam and Speed – The Great Western Railway*, 1844, 91 × 122 (35½ × 47½)

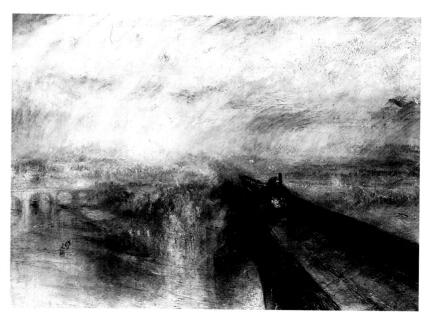

Whistler's art too may have influenced the increasing subtlety of colour/tone relationships in Monet's art after the 1860s. They had probably met at the Café Guerbois on one of Whistler's frequent visits to Paris, and Monet had probably studied the American's use of Japanese art and his refined, abstract colour in the works he had shown in the Salons (his own *Magpie* could have been an exercise in composing in scales of tinted whites, inspired by Whistler's 'Symphonies in white'). Whistler probably influenced Monet's little paintings of London parks, which have an almost melancholy detachment, unusual in his work but perhaps expressive of his own detachment from London; and the fastidious abstraction, closely related scales of tinted greys, and exact placing of tonal accents of Whistler's paintings of the Thames may have shaped the delicate composition of towers, arches and distant tugs in Monet's *The Thames and the Houses of Parliament*, a motif painted by Daubigny five years earlier. Yet Monet shattered these elegant 'harmonies in blue and grey' by abruptly inserting elements which were much closer to his own expression – the stark grid of the jetty, the rawly painted Embankment which juts into the spectator's space, and the curiously insistent floating wood. He simply juxtaposed two modes of structuring, the tonal and the linear, as if he were too impatient to integrate the two, and as if to draw attention to the artificial coded nature of such structuring.

The Monet family left England at the end of May 1871, presumably as soon as they learnt of the fall of the Commune. For some reason Monet

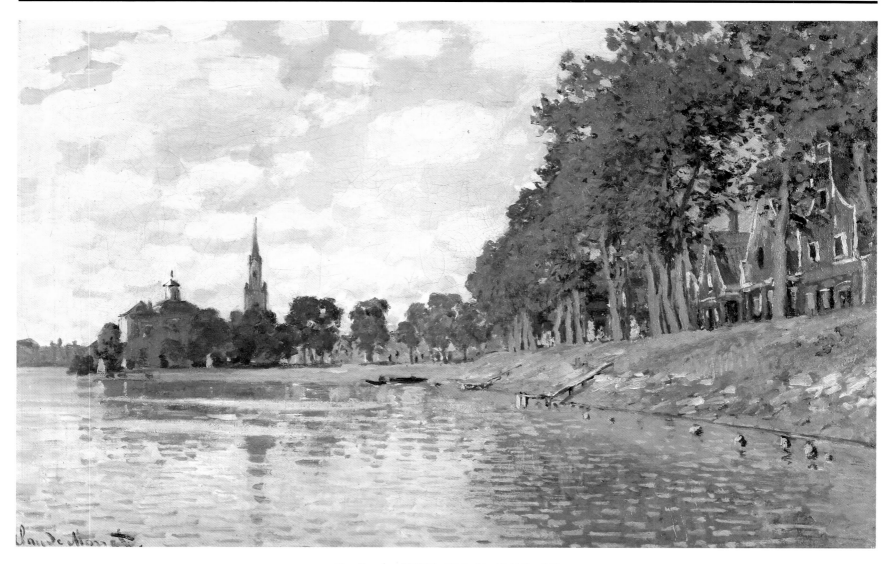

70    *Zaandam* (W.183), 1871, 47 × 73 ($18\frac{1}{4}$ × $28\frac{1}{2}$)

delayed his return to France for four months, staying at the little town of Zaandam, near Amsterdam. In contrast to London, this was a very productive period, for he painted 24 known works in four months.[148] Zaandam was surrounded by water, and criss-crossed by canals which provided exactly the kind of motifs Monet wanted – flat, reflective water surfaces and a man-made geometry of 'hundreds of windmills', posts, masts, bridges which formed arresting linear configurations to structure the luminous skies and still waters. He painted windmills stark against the sky, with a scaffolding of posts and masts reflected as starkly in the water; he painted reflections of trees and houses seen in the middle distance across a wide expanse of sheeny or ruffled water, or on narrower canals where reflections occupy most of the water and dissolve solid forms into countless fragments. These were Monet's first paintings of a densely populated area or crowded resort in which the human presence is merely incidental – there are little dabs and flecks of the brush which indicate figures in a boat, crossing a bridge, walking along a bank or fishing, but their presence does not pervade the scene as it did in the paintings of Paris, Sainte-Adresse, La Grenouillère and Trouville. Despite the evidence of human activity, his Dutch landscapes

feel deserted. Zaandam was a town in the course of full industrial expansion, but Monet ignored the modern and painted only those motifs which evoked stereotypical ideas of the Dutch landscape. He remarked to Pissarro that Zaandam had 'everything that one could find amusing'.[149] This was the attitude of the tourist, grasping samples of a foreign place, and it would characterize Monet's reaction to any place he did not know intimately – that is, to any landscape beyond the Seine valley and the Normandy coast.

In the first half of November 1871, Monet returned to a Paris which had undergone terrors unimaginable since he had left it less than eighteen months before. There was a determined emphasis on business – and pleasure – as usual, but memories of the suffering, humiliation and horror of those months could not be erased; the overall shape of the new City of Light remained, but it was scarred by the fire-blackened shells of many of its major buildings, and stained by memories of the blood which had been shed. Monet's great project of creating paintings of the pleasures of contemporary life on a grand, public scale may have come to seem as ephemeral as the regime under which it had been conceived.

# 2

# The Suburban River:
# Argenteuil and Paris 1871-1878

*Under the summer sun, skin and clothes take on a violet tint
from the reflections of green leaves. The Impressionists paint
figures under trees violet. Then the public explodes. The critics
shake their fists and call the painter a 'communard' and
a 'scoundrel'.*
DURET, 1878

*[Monet's] is a highly conscious art, based upon observation,
and on a completely new feeling; it is poetry through the
harmony of true colours, Monet adores real nature.*
PISSARRO, 1873

*Their paintings open [like] windows on to a joyous
countryside, on to a river laden with skimming boats, on to
a sky streaked with light mists, on to an enlivening and
charming outdoor life. Dream infuses them, and, completely
impregnated by them, it flees towards loved landscapes which
they recall all the more surely because the reality of their
appearance is there most striking.*
SILVESTRE, 1873[1]

ARGENTEUIL. IS THERE ANYWHERE IN NINETEENTH-CENTURY FRANCE THAT WE feel we know better than this stretch of river which Monet painted sparkling in the sun, alive with yachts, bordered by peaceful paths where strollers saunter in the light-scattered shade of poplars, and where even the distant factory chimneys are transformed by the vibrating light? Monet seems to have revealed so frankly the process of seeing that went into the creation of these paintings, and they accord so perfectly with our dreams of a day in the country, that we are seduced into thinking of them as exact representations of the 'reality' of Argenteuil. He was indeed determined to represent what he saw, but his choice of what to represent and his modes of representation were determined as much by personal needs, fears and desires as by the real, and these last led him to create an ideally beautiful world. And yet, when these works were first exhibited, critics used the language of political radicalism to discredit them. What was it in Impressionist painting, which seems so clearly to confirm the values of the bourgeois public, that aroused the suspicion that it offered a revolutionary threat to that society? Was it that, at a time when there were still fears for the political and social stability of France, there was seen to be a connection between the Impressionists' attack on the institutions of art and on refined pictorial techniques developed 'by the work of centuries', and the Commune's attack three years earlier on social institutions and a social fabric which the bourgeoisie felt to be the work of centuries?[2] Did the Impressionists' exclusive emphasis on the good life — a life that was relatively modest and attainable — seem transgressive when it was demanded that the arts be purified so as to help regenerate France? Or did the threat lie somehow in the very substance of painting itself?

For Monet, Argenteuil was a place where he could continue his creation of a modern landscape painting as if nothing had intervened between his new paintings and those he had executed at Sainte-Adresse or La Grenouillère. Yet his new works were to be subtly different, in that their subjects were more exclusively modern and more private. In the 1860s he had worked towards, or had tried to work towards, a major Salon painting of contemporary life every year, and his smaller works tended to be subsidiary to these larger projects; his paintings of the 1870s were less confrontational than the major works of the 1860s, which combined arresting close-ups with techniques which suggest distance, and he tended to paint relatively small works on closely related themes, with a more delicate attentiveness to particular effects of light. They represent a sustained exploration of a well-defined geographic area, characterized even more strongly than before by tension between a continuous meditation on the landscape and the momentary shock of apprehension which detaches the 'instant' of the painting from any continuity with the past but which is, in a sense, secured by an insistent, uncontradictory beauty. Monet's earlier efforts to create images which would render bearable the losses brought by modern urban experience may well have been intensified by the catastrophes of 1871, which profoundly threatened the society that had nourished his kind of art and which on a personal level coincided with the death of his father, and caused the death of his closest friend, Bazille.

The town of Argenteuil, as exhaustively documented in Tucker's *Monet at Argenteuil*, was in the messy process of being transformed into a suburban dependency of Paris, shaped by its service relationship to the metropolis: dormitory town, industrial expansion area, tourist site.[3] It was, then, particularly suited to Monet's representation of a nature vitalized by the modern, and the modern made pleasurable by nature. He transformed even unpromising aspects of this modernization: a commuter train in the snow becomes a fantastic spectacle; the houses of commuters sparkle in flowery fields; factory smoke imparts magical tints to the sky; the poisoned river glitters in countless nuances of colour; the stark lines of a boulevard quiver with delicate shades of silvery light. At Argenteuil, the family in the protective garden became a major theme for painting as a reparative experience; it imparted the character of the domestic garden to the suburban countryside, reinforcing the image of the good life without apparent threat or blemish.

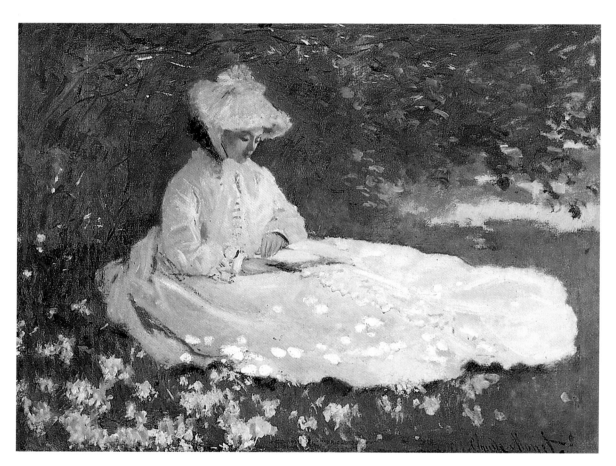

71 *Camille reading* (W.205), 1872, 50 × 65 (19½ × 25¼)

72 *Luncheon* (W.285), 1873, 162 × 203 (63 × 79)

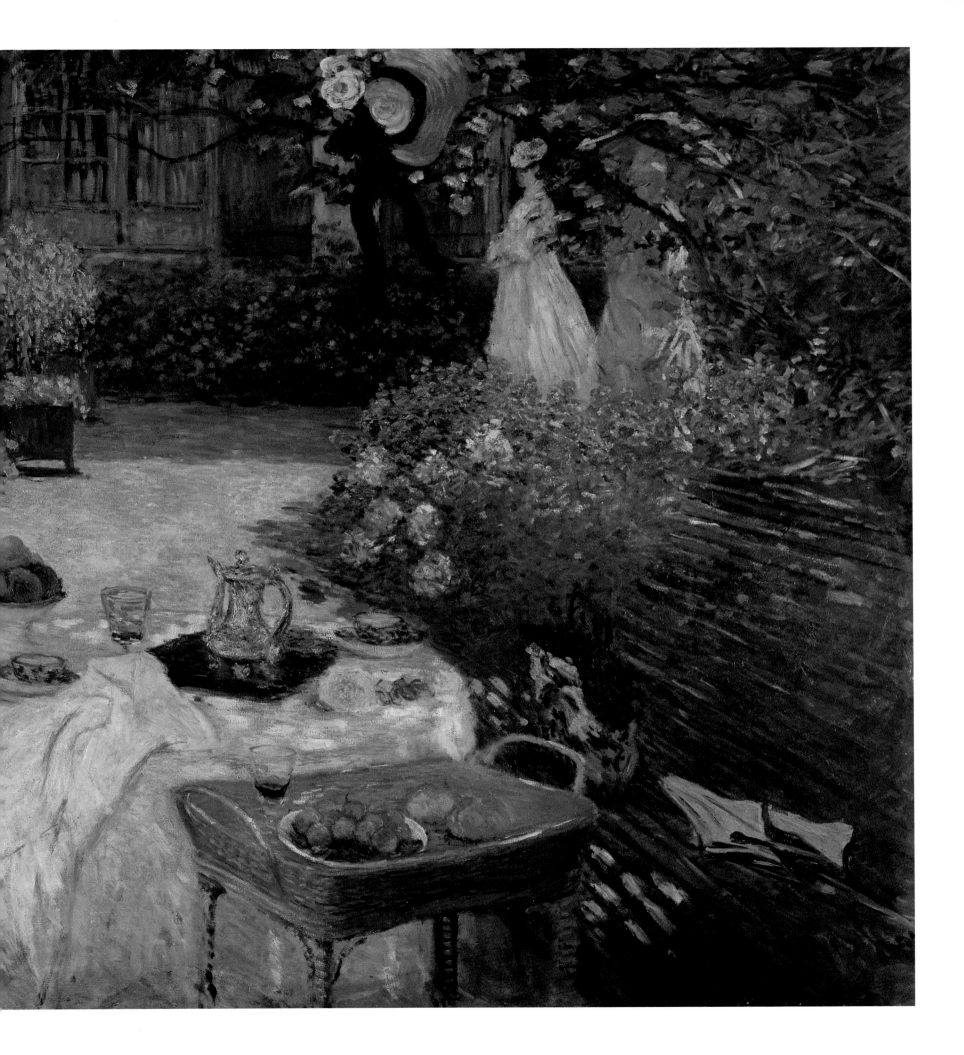

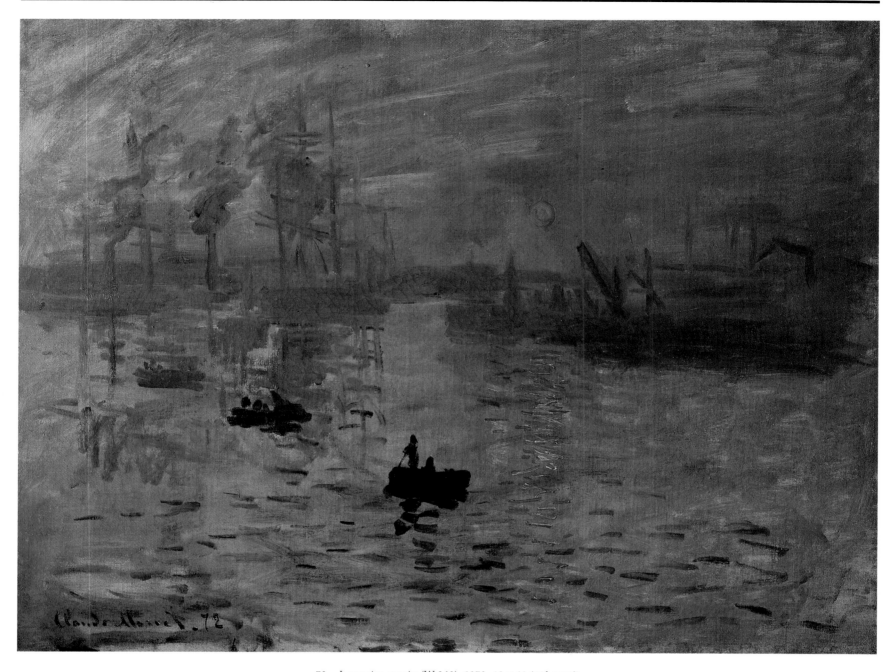

73   *Impression, sunrise* (W.263), 1873, 48 × 63 (18¾ × 24½)

To categorize Monet's attempt to maintain this vision as escapist idealism is to misunderstand the potential significance of the intensity of desire manifested through his paintings. The desire to heal life and, in particular, to recuperate those things lost in modern urban society by means of paintings which in both subject and technique suggest a realized vision of free, pleasurable work and of the unconstrained joys of the body in a nature liberated from servitude by modern technology, may be a profound one. If expressed in ways which invite participation in its meanings, it may be productive of social thought and action.

Zola's remark that 'Like a true Parisian [Monet] takes Paris to the country'[4] continued to be true in the 1870s, not simply in terms of Monet's subject-matter, but of structures and techniques which were responsive to aspects of contemporary urban experience, such as mechanized time and the fragmentation of perception, and which united

his representation of the urban, the suburban and the rural. After mid-1876, Monet tended to pull apart the constituents of contemporary experience in his subject-matter, either by depicting landscapes without people or modern features, or by painting his most emphatic pictures of modern constructions, the *Gare Saint-Lazare* series. Whatever his subject-matter, the technique and structure of his painting continued to be expressive of 'the modern'.

Monet and his colleagues painted aspects of contemporary life whose popularity was attested by the many works on such themes reproduced in illustrated journals and in photographs of selected works from the Salons; but the manner in which they were represented by the Impressionists was appreciated only by an élite, and this led them to create exhibitions which countered, in every way, the structure and the ideology of the Salon. Monet earned large sums in the 1870s and

attracted a dedicated group of collectors, but the exhibitions of his work did not substantially enlarge this group, and, in the economic recession of the 1870s, sales of his paintings did not provide him with sufficient funds to sustain the standard of living on which his art depended. In each successive exhibition, Monet clearly affirmed the self-conscious modernism of his painting by revealing the ways in which his consciousness engaged with the external world, and the means by which he realized his images – revelations which seem to have repelled potential audiences. In the 1870s Monet projected a Utopian vision in terms of scenes which were visible and so, to that extent, it appeared real; but the very circumstances in which his desired world was conceived made it impossible of attainment – except in paint.

The Impressionists' paintings attracted more rather than less hostility as the 1870s advanced, perhaps because of the incompatibility between their depiction of the bourgeois good life and the emphasis of reactionary post-Commune governments on a morally elevating art, and because terrifying civil war had so profoundly threatened bourgeois society that the painters' transgression of conventional modes aroused suspicions of political subversion.

The bourgeoisie – the subject of and the assumed audience for Monet's painting – had never been so profoundly threatened as during the ten weeks of the Commune in 1871. Only this can account for its acquiescence in the execution of between 20,000 and 35,000 Parisians, not only in the frenzy of killing in the *Semaine sanglante*, but in the military trials which succeeded it and which lasted until early 1875. Almost 400,000 denunciations testify that Parisians were not passive spectators of repression. A torrent of vituperation poured from the press and, later, from literary works in which the Communards were represented as sub-human, innately evil, crazed by alcohol and noxious fevers, and willing to destroy an entire city to satisfy their bestial instincts. In fact, an administrative report of October 1871 established that the 100,000 workers (excluding women) 'killed, imprisoned or in flight, missing today in Paris', comprised the élite of workers and artisans, including the art workers who had given Paris its image as a city of art and fashion.[5]

The arena in which Impressionism evolved was one of political and ideological crisis: the widespread desire for moral regeneration inspired by the humiliations, grief and terror of *'l'année terrible'* was manifested in the reassertion of traditional values rather than in social reformism. The desire often took form in acts of piety, prophecies, in pilgrimages encouraged by the Church and by legitimists working for the restoration of a Christian monarchy, and resulted in a climate of repressive moralism. Until mid-1873, there was a real possibility that the conservative Assemblée Nationale would vote to restore the Bourbon pretender, the ageing Comte de Chambord, until this was thwarted by his insistence on restoring the white flag of the *ancien régime*. After this anachronistic comedy, the struggle for power continued between the Orleanists and the Bonapartists on the centre-right and the Republicans, who themselves split into parties of the centre-right, of Gambetta's centre-left, and of the extreme left, the *'intransigeants'* – a name also given to the Impressionists. It was only in 1875 that the Assemblée Nationale decided – by one vote – that France would remain a republic; only in 1876 that it was judged safe to plan for the Exposition Universelle which opened in 1878; only in 1879 that the government returned from Versailles to Paris; only in 1880 that it felt secure enough to make Bastille Day a national holiday again, and to grant amnesty to

the Communards; only in 1881 that the strict censorship was lifted and laws passed ensuring the freedom of the press.

Despite the loss of tens of thousands of workers in the massacres and executions, and through imprisonment, deportation and exile, contemporary texts – both in the press and more formal literary works – reveal an obsessive fear of working-class insurrection. Few writers sought to understand the Commune, and most conceived it as a monstrous aberration which could be conjured away by sheer force of denial; some retreated even further into the world of art than during the Second Empire; others founded their hopes for a restoration of order on a Manichaean division between those who owned property, who worked and who had knowledge, and those who did not. Dumas fils asserted that it was the duty of the possessors to help the poor, and of 'those who work to make those who do not, work, or pitilessly to exterminate them if they refuse'. If the poor, the lazy and the ignorant could be made to disappear, nothing need disturb the ideal of progress which would bring the good life to those superior *individuals* who had the will, the consciousness and the capacity for hard work.[6]

Even Zola justified the savage repression, writing a few days after the *Semaine sanglante*: 'The bloodbath which [the population of Paris] has just undergone was perhaps a horrible necessity to calm some of its fevers. You will now see it grow in wisdom and in splendour.'[7] A month later he wrote to Cézanne:

Today I'm peacefully back at Batignolles, as if coming out of a bad dream. My little house is the same, my garden hasn't changed, not a stick of furniture or a plant has suffered, and I can believe that those two sieges were ugly farces, invented to frighten children.

What makes these bad memories more fleeting for me is that I haven't for an instant stopped working. . . . Never have I had more hope or a greater desire to work, for Paris is born again. As I have often said to you, our reign is coming.[8]

Both the Left and the Right believed that art should play a role in the moral regeneration essential to the task of national reconstruction. The art of the new France, purified and ennobled by suffering, would not only counteract the decadence of the Second Empire and the barbarism of Prussia, but would establish an absolute gulf between itself and the Commune. The Communards were presented as vandals essentially hostile to art, as in Théophile Gautier's comment in 1872, 'Isn't it the aristocracy of the masterpiece that shocks the most envious mediocrity? Of course, the ugly abhor beauty.'[9]

To those with such views, one of the ugliest was Courbet, who had narrowly escaped death, having been treated leniently when tried by the army for plotting against the State and for complicity in the destruction of the Colonne Vendôme (he had, in fact, protected the nation's art treasures, had opposed extremists and was not a member of the Commune when it had been decided to destroy the Colonne as 'a monument to barbarism'). Courbet was still serving a prison sentence, but only of six months, when Monet returned to France. Boudin, Monet and Amand Gautier were among the few artists to support him, writing him a warm letter and trying to visit him in hospital where he was on parole. Manet was more typical, saying with cruel finality that, since Courbet had shown cowardice at his trial, he was 'now not worthy of any interest'.[10]

The vile things written about Courbet register the outrage of *'honnêtes gens'* at an artist having transgressed the barriers between the sacred world of art and political action. In the conservative *Le Figaro*, Alexandre Dumas fils wrote in June 1871 – while proclaiming his own republicanism – that the Republic can

produce spontaneous generation . . . what fatty ooze could have generated, for example, this thing that is called M. Gustave Courbet? . . . by the aid of what manure, as a result of what mixture of wine, beer, corrosive mucus and flatulent dropsy can have grown this resounding gourd, this aesthetic belly, this imbecile and impotent Ego?

And Leconte de Lisle wrote in a private letter that the 'diseased dauber' Courbet 'deserves not only to be shot . . . but that the filthy paintings he once sold to the State should be destroyed'.[11]

Monet cannot have sympathized with the Commune's radical threat to bourgeois society, but he knew that not all its adherents were 'horrifying monsters': he had been a friend of Courbet and Amand Gautier, and he owed Courbet a great deal as painter; he had known Andrieu and Vallès, as well as many of the artists who, under Courbet's presidency, had served on the Commune's Fédération des Artistes which, during its brief life, had attempted to free art from institutional restraints on teaching and exhibition in ways of which Monet would have approved.[12]

Many avant-garde Realists shared Monet's ambivalence to the Commune, and many who had played anti-authoritarian, anti-bourgeois roles during the Empire now upheld the need for order and for bourgeois values.[13] Whatever their personal sympathies, whatever their degree of undstanding, the Commune had threatened their world, their kind of art, their audience, too profoundly for them to look very closely at it. Their response was to make their expression of a harmonious, uncontradictory social order more intense and exclusive than before, as if to demonstrate that the events of 1870–1 were, in Zola's words, 'a bad dream'. Paradoxically, however, critics were to see a direct connection between political radicalism and Impressionist painting, as if to justify Feydeau's contention that

Henceforth all advanced opinion in politics, in political economy, even in philosophy, will be suspect: behind it will always appear the spectre of demogoguery, horrible, repugnant, drunk with blood and wine, with stolen gold glittering between its filthy fingers.[14]

The works which Monet painted in the first months after his return to France show how quickly he evolved a form of painting which was reparative in style and subject. Only one work expressed something of the anguish of the period – with an indirectness which is itself revealing. This was the rain-washed, subdued, sketchy *Pont-Neuf*, painted in the heart of devastated Paris, probably before Monet went to Argenteuil.[15] Just outside the frame, on the Île de la Cité, was the burnt-out Palais de Justice, and the cloud of steam billowing from the under-side of the bridge may have reminded Monet of the smoke that came from smouldering buildings all along the Seine as the sun rose on 29 May 1871, and as the executions of anyone suspected of complicity with the Commune continued. Monet's earlier paintings of city life in Paris or Le Havre were lively depictions which suggest interaction among the figures, whereas in *The Pont-Neuf* each figure is isolated from the others, and the discontinuity between them, and between them and the spectator, is made more absolute by strange discrepancies in their scale. The painting contains something of the emotion of a poem written immediately after the *Semaine sanglante* by Clément, who had been associated with Courbet on the Commune's education committee and in the affair of the Colonne Vendôme:

> Sauf les mouchards et des gendarmes
> On ne voit plus par les chemins
> Que des vieillards tristes aux larmes
> Des veuves et des orphelins.[16]

74   Edouard Manet, *The Barricade*, 1871(?), 46.2 × 32.5 (18 × 12¾)

75   'Modes de 1871 – Saison d'hiver', in *L'Illustration de la mode*, 1871

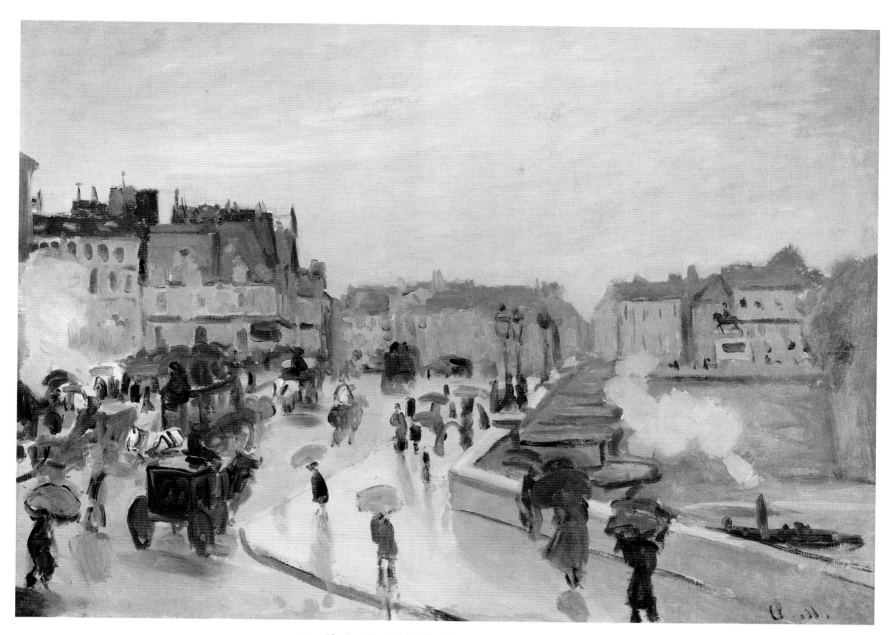

76    *The Pont-Neuf, Paris* (W.193), 1871, 53.5 × 73.5 (21 × 28¾)

Monet had heard of the horrors of the *Semaine sanglante* only at second hand, and in this little painting he may have been trying to experience something of what had happened in the city that had formed his art. Yet the very nature of that art prevented him from participating in the recreation of past experience.

Within a few weeks Monet had moved to Argenteuil, which too had been extensively damaged in the war and by the Commune, and there, soon after his arrival, he painted two more pictures of a bridge – one of the road bridge into the town, being reconstructed after its partial destruction. He may have been attracted to the motif because of the contrast between wooden scaffolding and the cloud of steam and their reflections in the glassy water. Steam, exalted by the rhetoric of progress as the miracle which would transform man's weary labour, break down frontiers, bring mankind together and distribute raw materials and manufacturers round the world to increase the prosperity of all peoples, is here represented simply as a fact of vision.[17] An anonymous lithograph shows similar imagery in the context of the post-war reconstruction whose key words were 'peace, work, order'.[18] Entitled

'The Splendours of the Republic', it depicts 'all the peoples of the earth', including those from Alsace, Paris and the provinces, joining Thiers – recently confirmed as President of the still provisional Republic – in subscribing to the loan of 1872. This was the second of two loans required to pay off the huge indemnity demanded by Prussia as a precondition for leaving France, and was massively over-subscribed.

Reconstruction was promoted not only as an economic necessity but as a patriotic duty, so the economic boom of the second half of 1871 (partly caused by a massive programme of rebuilding destroyed bridges, roads, railways and factories) was infused with moral fervour. There had been a change of regime, not of society: free-enterprise capitalism was back in business with a decimated working class controlled by repressive legislation. The lithograph presents an image of social harmony in which diverse peoples and classes are united in a common cause, inspired by the promises of progress: old and new are juxtaposed in vignettes showing traditional rural labour alongside smoking factories, or a train on a bridge crossing a river where a steam tug is contrasted with a more traditional vessel. This is Monet's kind of

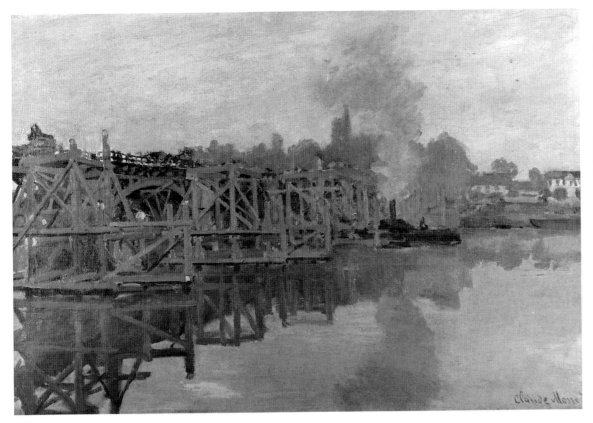

77   *The Bridge under repair, Argenteuil* (W.194), 1872,
60 × 80.5 (23½ × 31¼)

78   The railway bridge at Argenteuil in ruins, *c.* 1871

imagery, yet, although his *Bridge under repair* could be associated with the rhetoric of progress and of reconstruction in post-war France, the painting itself is entirely unrhetorical in its muted detachment, with the steam tug locked into position by the choked barrier of timber.

In May 1872, de Pontmartin, the critic of *L'Univers illustré*, proposed that Couture should paint a new version of his *Romans of the Decadence* (Musée d'Orsay) (1847), showing all members of society united in the shared task of reconstruction and revenge: poets would lament the fatherland, painters console its griefs; the peasant would contribute to the repayment of the Prussian indemnity; the workman would prepare the tools of the *revanche*; there would

no longer be women of pleasure, but women of piety and of duty, no longer courtesans crowned with flowers, but the nurses of our field hospitals, the generous inspirers of works of reparation and of salvation, the sublime beggar-women who extend their white hands asking us for the mite which must dry tears, feed the orphans, raise and fertilize the ruins . . .[19]

Monet's painting too was reparative, but in indirect, private ways. His paintings of Argenteuil were to express an optimistic vision, not in terms of moralizing social programmes but through the representation of domestic happiness and of the rebirth of nature, as shown in a small group of pictures of the river, orchards and gardens in the spring of 1872. These include the paintings of Camille and friends under the lilacs, and of Camille herself in a white dress tinted with rose and green and spangled with light (ill.71). It is spring in Argenteuil, a year since the Commune's *'temps des cerises'*; at Versailles, twenty-seven kilometres (17 miles) away, the military trials continue, and Monet is painting his wife secure in the sun-dappled foliage of a private garden.

Several weeks later, in his review of the Salon, Zola voiced his astonishment that the art which it contained was unchanged despite the terrible events since the last Salon, in 1870:

In the distance, effaced by the rain, I saw the gaping windows of the Tuileries, open to the dirty yellow of the sky.

Well! Two years! So many shocks, and still, in the same rooms, the same chaps made of gingerbread, the same worthy ladies of sugar candy![20]

Théophile Gautier wrote in *L'Artiste* that the public also believed that the Salon should have responded to the recent tragedies, although he was pleased that there was no hint of the immediate past, and that 'despite everything, the mind always returns to the eternal themes of life'. In the same journal, Paul de Saint-Victor claimed that art was all that France now had: 'she clings to the genius of Art as the only column still standing among her ruins. She feels that on this point of leverage the fatherland can reconstruct itself on a new plan.' De Pontmartin in *L'Univers illustré* welcomed 'all that proves the immortal vitality of dear and unhappy France, [and] any awakening of intelligence and of art; peaceful revenges which allow us to await others'. Referring to the enormous prices recently attained by painters of the modern French school, both writers criticized the frivolity of much recent art ('small and pretty, precious and over-finished') as 'no longer in accord with the bloodstained mourning of our frightful misfortunes'. De Saint-Victor admitted that immediate regeneration was not possible, but noted 'a certain elevation, if not of style at least of subject' in the Salon.[21]

Similar views were expressed by those who had been in the liberal opposition under the Empire, notably by Castagnary:

While the whole of France feels it necessary to renew itself, to elevate itself, to raise its soul and accustom itself to severe duties, will [painters] peacefully continue their landscapes, their interiors, their still lifes, their examination of the Middle Ages or antiquity? Will they not understand that they have a higher language with which to speak to their contemporaries than these mute or frivolous images? Since art is part of public education, will they not feel that any artist is culpable who remains below the role which society assigns him, either in personal dignity or in the elevation of his thought?[22]

Since Castagnary went on to defend Courbet's paintings, his words must have seemed suspect, particularly since he also attacked the authoritarianism of the new Salon regulations which reversed the liberalization of the late 1860s and restricted the election of the jury to artists who had won a medal or the Prix de Rome. The jury had reduced the total of works shown to about a third of the number shown in 1870, and made sure, as Castagnary asserted, that 'One walks through [the Salon] without knowing what country one is in or what date it is. . . . One would think oneself far from the Seine, far from Paris'. In language which was provocative for that place and that time, he called for liberty, reliance on 'public opinion' and 'the glorification of humanity'.

Cham published a caricature of a couple, their hair standing on end, reading the Salon *livret*, with the caption, 'Subjects on the Commune terrifying the unfortunate *bourgeois* visiting the exhibition'.[23] The fact that there was only a handful of such works (mainly etchings or watercolours of buildings burnt during the *Semaine sanglante*) suggests that any direct reference to the Commune in the visual arts was taboo. The same desire to excise the immediate past from sight motivated Meissonier's determination to have Courbet's paintings banned from the Salon forever. Courbet's works were, however, exhibited by Durand-Ruel, a devout Catholic and legitimist, while the Salon jury's decision to exclude him was criticized by writers in the left-wing Republican press who were to support the Impressionists — though Manet and Zola seemed to accept his invisibility.[24]

The Salon did contain representations of the war, the siege of Paris, the sufferings of Alsace, and a few paintings — such as Puvis de Chavannes's *Hope* (Musée du Louvre) and Feyen-Perrin's *The Spring of 1872* — alluded to the post-war situation. Zola, probably referring to the government's exclusion of two works on the Prussian invasion (which had been hung in places of honour), wrote that 'In stifling the cry of vengeance against Prussia, the government has left [us] only the stammerings of our grief'.[25] Clearly much was expected of art.

Zola's conviction that the Realists' time had come rested on his belief that:

> After every social catastrophe, there appears . . . a desire to return to the truth. . . . And I hope . . . that, when the Republic has pacified France, from all this blood and all this stupidity there is going to emerge a broad current. It will be yesterday's pariahs . . . the group of naturalists who will continue the scientific movement of the century.[26]

Nevertheless, possession of truth as embodied in the metaphor of light continued to be in dispute in the 1870s in ways which were related to, but disturbed by the Impressionists' use of light.

One function of the metaphor may be observed in a series of articles in *L'Illustration* in the summer and autumn of 1871 on 'Les Bas-fonds parisiens' — the 'lower depths' of Paris society — accompanied by full-page images in oppressive detail of such places as a rag-pickers' cabaret. In answer to 'everyone's question' as to what was 'at the bottom of these abysses of great cities', the author proposed a descent to

> the lower depths, where vice, ignorance, misery, laziness, drunkenness hold their *danse macabre*. By making light penetrate into these holes, we will learn to know them, and once the evil is known, the remedy no doubt will come.[27]

The illustrations ignored the main participants in the Commune, skilled industrial workers and artisans, and constructed an absolute gulf between the bourgeois reader in the world of light and a scarcely human proletariat in a murky underworld.

The light which controlled the image of the real was selective: occasionally it shone into those phantasmagoric depths, more often it

was allowed to cast a steady illumination on social situations in which everyone knew his or her place, as in the many paintings (some purchased by the State or sold as photographs) of bourgeois charity to the deserving poor, who were almost always women and children. After May 1871, the struggle of the bourgeoisie to affirm those signs which declared it different from the lower orders seems to have become yet more insistent in the visual arts. It is in this sense that one should understand Duranty's assertion that modern painters should depict the figure in his specific environment, surrounded by objects 'which express his wealth, his class, his profession'.[28]

While Salon reviewers were calling for an art of 'self-denial, of vigour, of virtue, necessary for a people threatened in its existence and in its honour',[29] Monet was painting the enchanting pictures of his wife and friends under lilac trees, where the sunlight seems not to come from the distant sky, but to be made material as the golden riches of the happy occupants of this sanctuary. The painting of *Camille reading* (ill.71) is more intimate than her earlier 'portrait', *Women in the garden* of 1866, not only because it is of much smaller scale, but because the artist stood above his wife, representing her in the sensuous fusion of swaying sunlight and 'green shade' in a completely enclosed world, whereas in the *Women in the garden*, the path leading out to the spectator suggests a world beyond the painting. Camille is shown absorbed in reading as if she had no thought for the observer, whereas her poses in the earlier painting are directed at the unknown spectator of the Salon. In the 1872 picture there is nothing to suggest that the figure has any other existence beyond that specific moment in that specific place. In one sense this establishes her identity as someone to whom the casual observer has no access; in another it emphasizes her private subjection to the artist in the world of his creation.

In the Salon, Feyen-Perrin exhibited a painting called *The Spring of 1872*, which showed a 'poor, pale girl, a peasant with torn clothes, crossing a field where fragments of shells are mingled with new grass'. The catalogue entry contained a verse by Armand Silvestre:

> All is being reborn.
> The scented shroud of flowers
> Has closed again over our dead, long without burial,
> And springtime returns, soft, charming, balmy:
> So lightly, o Nature, do our griefs [rest] on your soul![30]

79 'Les Prisonniers à Versailles — les Petrôleuses', in *L'Illustration*, 24 June 1871

Monet's and Feyen-Perrin's paintings should be seen in the context of the return to normalcy celebrated, for example, in *L'Illustration* which, in the second half of 1871, reported the races at Longchamp and the 'three ranks of carriages' in the Bois de Boulogne, and depicted resort life and winter fashions, shocking alongside detailed illustrations of the Communard prisoners at Versailles (ill.79). In December 1871, the journal reproduced two works by Emile Bayard, *1870* and *1871*, showing in the first a doting young middle-class couple with their son and daughter picking flowers in the fields near a river before the war, and in the second the widow in deep mourning walking with her children in the devastated Parisian countryside, 'on the slopes of Buzenval where, in January, so many fathers died'. Claretie wrote that only one word should be added to these images, 'Remember! [*Souviens-toi!*]'[31]

Monet too painted a family in the flowery Parisian countryside, but his paintings did not invoke memory, since they represented the specific moment in such a way that all previous moments were superseded, thus rendering the reparative character of his art fragile and ambiguous. Unlike the officially promoted or commercial images of reconstruction, Monet's art was unaffected by the values of *l'ordre moral*; it affirmed the joys of life with an exclusivity and an intensity which suggest that the Utopian promise of the good life was real.

80   Emile Bayard, *1870*, in *L'Illustration*, 16 December 1871

81   Emile Bayard, *1871*, in *L'Illustration*, 16 December 1871

# I

Argenteuil was an ideal place for Monet to continue his development of a landscape painting which was both modern in subject and modernist in expression. The town on the river was close enough to the city to participate in its dynamism, intensity and vitality, and close enough to the country to participate in its regenerative powers; it could thus promise the benefits of the modern without the alienation of the modern city. The scale of modern Paris meant that it could be represented only as a distanced vista or a fragment, while Argenteuil, where the modern permeated the landscape, was small enough to be represented with both richness of detail and a kind of wholeness. All this made it possible for Monet there to inject the artifice of modernism into the 'natural' landscape tradition.

It was at Argenteuil that Monet found the means to create those continuities which he, like so many of his compatriots, found necessary after the traumas of 1870–1, and which precariously alleviated the fragmentation inherent in his dedication to modern experience. Soon after he arrived there, he had found the ideal conditions about which he had written to Bazille – the material security to work all day, his 'little house' with his 'good little family'.[32] One means of creating continuity depended on the making – in actuality and in painting – of a garden as lovely as those he had painted at his aunt's house at Sainte-Adresse. Indeed, with the death of his father Monet became head of the family, and as he did so, Argenteuil replaced Sainte-Adresse, where he had painted the first of his small pictures of a landscape being transformed by city-dwellers' restless search for country pleasures. That the riverside town replaced the coastal resort, lost to him by the death of his father and aunt, is suggested by the melancholy of a small picture (W.266) of the beach at Sainte-Adresse which Monet painted in 1873, and in which the beach is deserted, the breakwater broken down.

Durand-Ruel's purchases during the post-war economic boom, when the demand for contemporary works of art brought startling

82 *Camille in the garden, with Jean and his nursemaid*
(W.280), 1873, 59 × 79.5 (23 × 31)

increases in prices, gave Monet the income of a rich man: he earned 12,100 frs. in 1872 and 24,800 in 1873, of which 9,800 and 19,100 respectively were from purchases by Durand-Ruel. Since a Parisian doctor and his family could live adequately on 7,000–9,000 frs. a year (even with professional expenses and the higher cost of living in the city), Monet was well able to create as comfortable a life-style in Argenteuil as that to which he had been accustomed as a child.[33] *Camille in the garden, with Jean and his nursemaid* was not fictional in showing that he could rent a pleasant house with a large garden, employ servants, and buy Camille the leisure and the elegant clothes which mark her status as a lady. The continuity of Monet's domestic life was asserted in the two large paintings of *Luncheon* of 1868–70 (ill.61) and of 1873 (ill.72), depicting his wife, Jean, and a woman friend, with the artist's place indicated at the table. The earlier picture is set in a cramped interior whose furnishings, accessories and clothes point to a comfortable bourgeois status which Monet had not then secured, but the later one, painted in the golden light of a summer's afternoon in his Argenteuil garden, is more prosperous, sensuous and expansive, and Monet dwells lovingly on the peaches and plums, the bread rolls, silver coffee pot and porcelain cups, the cut-glass goblets with their dregs of wine, the single cut rose and the snowy linen. The painting fulfilled Duranty's dictum, that painting should depict a person's setting, 'express his wealth, his class, his profession', but here that person – who was both present and absent – was the creator of the setting and could express his ideal image of wealth, class and profession as something absolutely secure.

Enclosed by the house and layers of flowers and leaves, the garden of Monet's *Luncheon* of 1873 seems more private than the interior of the earlier work, where the curtained window and the visitor in veil and gloves signal a world outside. The figures there are displayed to an imagined audience as a social grouping, but in the 1873 painting Monet depicted the time after the social event, when those present have separated, and showed them absorbed in their own lives, and thus reinforced the intimacy of the painting. Comparison with Firmin-Girard's *Garden of the Godmother* (Salon 1875) underlines the effect of the spatial gaps in Monet's painting: Firmin-Girard's is a more typical imaging of family unity and its religious basis, with the charming mother, daughter and godmother in the bourgeois garden, their idealized interrelationships shaped by the absent male creator. Monet hints at his own presence, but also refuses to construct such relationships (compare also Bayard's *1870*).

Monet's paintings suggest that nothing had occurred in the years between the two except that his family had become richer and more private, whereas '*l'année terrible*' had seemed to threaten the family structure of society, most obviously in the deaths of thousands of men in war and civil war. Dubois's *The Departure* (ill.83), exhibited in the Salon of 1873, depicting an elegant lady watching departing troops from the safety of her garden, shows how the domestic genre could promote the idea of sacrifice for the country and hint at the *revanche*. The bourgeoisie believed that the Commune threatened family life even more fundamentally than did death in war. Anti-Commune writers could not find words strong enough to express their repugnance for the women of the Commune who had stepped out of the role which society had assigned them; they were represented as obscene furies, frantic with lust, who tore corpses apart, sharing 'the many remains which they had smelt out like real wild beasts'. Du Camp shows how quickly 'description' turned into panic exaggeration:

From the height of the pulpits of churches turned into clubs, they unveiled themselves, with screeching voices . . . they demanded '*their place in the sun*, their civic rights, the equality refused them', and other obscure claims which perhaps hid the secret dream which they were readily putting into practice: plurality of men.[34]

83   Hippolyte Dubois, *The Departure*, Salon 1873

Sexual fears also pervaded the language of a parliamentary inquiry into 'the role of women during the struggle of the Commune', which pronounced that women were drawn into revolutionary activity by 'sloth, envy, thirst for unknown and passionately desired pleasures'. The Commune was believed to have replaced the family by free sex and collective child-rearing, and so to have 'outraged the most sacred sentiments of the family and of man'. On the day after its defeat, the editor of *La Cloche* declaimed:

Let us rebuild our homes which these wretches wished to infect with their false morals, before burning them with their petrol! Strengthen these holy and dear commonplaces of the family, the law, of civic duty.

One of the set-pieces of anti-Commune writing was the realization of the Communard that evil politics had led him to destroy his dream of

family happiness in 'a little house' with its 'little garden' in the suburban countryside.[35] In Monet's painting this dream was kept intact.

In the 1870s Paris and Le Havre were the two poles of the east–west axis of the Seine valley which – with few exceptions – marked the limits of Monet's painting. Paris, Argenteuil and Le Havre were linked by rail and river whose contrasting temporalities shaped that painting: he painted the train steaming past the smoking factories of the Déville valley, and the railway lines running west from the great iron and glass palace, the Gare Saint-Lazare in Paris, down the Seine valley to Le Havre, and to Argenteuil, where he painted the train crossing the Seine on the iron bridge or at the station. He hinted at the river in Paris in *The Pont-Neuf*, painted it as it flowed through Argenteuil and Rouen to the great port of Le Havre where it joined the sea, and where he depicted the untidy mixture of old and new, fishing boats, sailing ships, steam tugs, and the sun rising through mist and smoke, as he looked east towards Paris.

Monet's exploration of the Seine valley may well have been shaped by tourist guidebooks. A very large number of his subjects of the 1870s were discussed and illustrated in Jules Janin's *Voyage de Paris à la mer* (1847; with much of the material re-used in his *La Normandie*, third edition, 1862). In both books, wood engravings by Daubigny and Morel-Fatio depict the first Gare Saint-Lazare; trains with plumes of smoke on bridges over the Seine, with steamboats beneath them (ill.89); smoking factories in the countryside; sailing ships moored at Rouen and different views of the harbour at Le Havre. Janin's account of the journey from Paris through Rouen to Le Havre by rail and the voyage from Rouen to Le Havre by steamboat celebrates the marvels of its modern construction, and the illustrations, like Monet's paintings, emphasize the penetration of traditional landscapes by modern technology. The books also contain images of the mouth of the Seine and of Le Havre's harbour and jetty related to Monet's paintings of the 1860s, which confirm the early shaping of his vision by commercial tourist imagery. Two drawings by Daubigny containing a tiny figure of an artist sketching a train on a great viaduct could have been particularly suggestive for an ambitious young artist. It was not, however, until the 1870s that Monet's work acquired a sense of the continuity of the tour as it was expressed in Janin's books – a continuity which was constantly fractured by the characteristic discontinuities of modern vision.[36]

Almost the only images related to Monet's paintings of the Seine missing from Janin's books are those of Argenteuil itself (although there is one of the train to it passing over the bridge at Bezons). Argenteuil gradually came to absorb Monet's attention and, between spring 1874 and early summer 1876, he painted nowhere else. In the seven years between late 1871 and his departure in January 1878 Monet produced 181 known works at Argenteuil and 61 elsewhere. That a relatively large number were painted during shorter painting trips is explained by the fact that they tended to be less densely worked than the Argenteuil paintings; they have something of the quality of a tourist snapshot, a momentary view snatched from the wholeness of place.

The evolution of Monet's style in the 1870s depended on his long and intense scrutiny of a single place. This evolution was not unilinear – he continued to vary his style from work to work, sometimes returning to earlier modes and rehearsing new ones – but he gradually evolved a micro-structure based on small touches of colour which became characteristic after he had been at Argenteuil for about eighteen months, and which he made increasingly less descriptive in handling and colour. The small, regular, coloured brushstrokes in closely related tones gave

84 *The Goods Train* (W.213), 1872, 48 × 76 (18¾ × 29½)

85 *The Train in the snow* (W.356), 1875, 59 × 78 (23 × 30½)

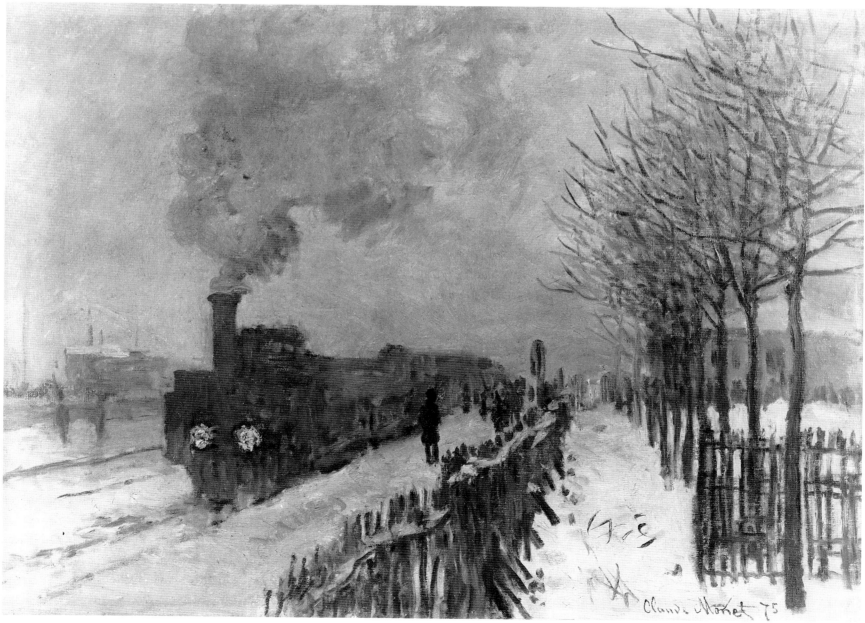

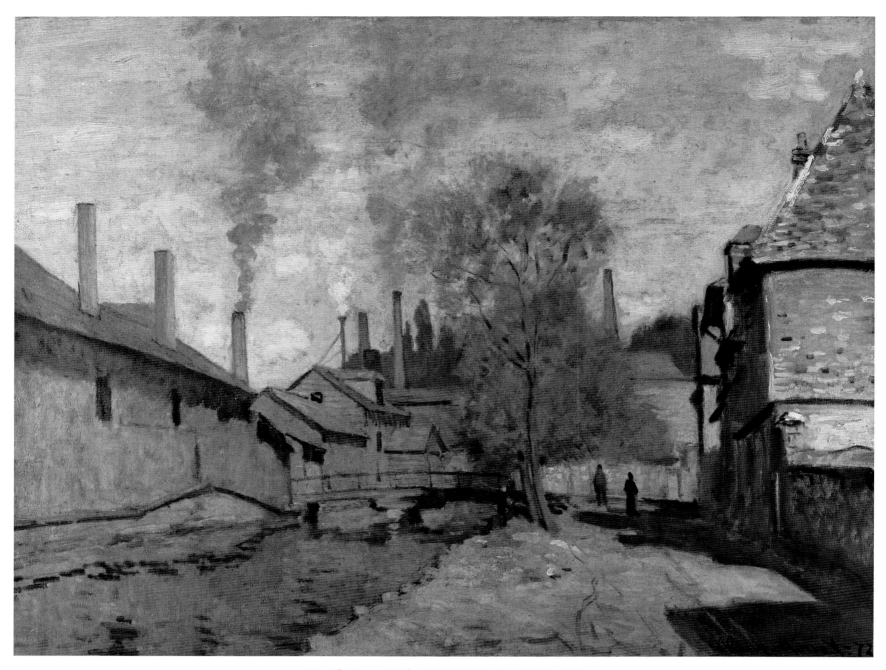

86    *The Stream at Robec* (W.206), 1872, 60 × 65 (23½ × 25¼)

the painting a continuous, subtly inflected surface which could suggest the continuity of space and of coloured forms in that space. The precision of this technique made possible the creation of firm linear structures without using lines which would isolate form, and of subtle volumes without using deep shadows which would create 'holes' in the coloured surface. The painting thus formed was a luminous, fluctuating substance which could suggest the vibrancy of natural light. Monet's intense concentration on the infinite variety of effects and motifs in a defined area also suggests that he was trying to represent his continuing experience of the wholeness of Argenteuil — an enterprise condemned by the increasing fragmentation of his mode of seeing.

In his move to Argenteuil, a mere fifteen minutes by rail from Paris, Monet was participating in a demographic movement that was the corollary of modern urbanization: the spread of the previously compact city over the surrounding countryside.[37] The development of rapid-transport systems, the establishment of fixed hours of work, the accumulation of wealth, made it possible for the middle classes to seek an alternative to a city apartment in a suburban residence. Argenteuil's history was being excised — its religious foundations surviving as tourist sites, its religious festivals becoming increasingly secularized and commercialized, its agriculture being replaced by major industries established even before the Second Empire. Once the iron bridge completed the railway link to Paris in 1863, old factories were expanded, new ones established; speculation in land intensified as Parisians purchased holiday retreats or commuter houses, and subdivisions encroached on fields and vineyards. The quiet of the old town was shattered by the clangour of machines, the hiss of steam, the rattle of trains, the hoot of steamboats; smoke, steam, even toxic and corrosive fumes from the factories discoloured the sky and were discharged into the river, and the river itself was heavily polluted. To attract new industries and new residents, the town council made improvements similar to those in the new Paris: new roads were 'pierced' through an

urban fabric randomly developed over the centuries; old roads were straightened and given macadamized footpaths, articulated with trees and gas lamps; entertainments, in particular the regattas, were organized. Despite its industrial transformation and its pollution, Argenteuil was seen as 'the country' in contrast to Paris, which every commentator agreed was stifling, noisy and intolerably crowded. Argenteuil was a favoured recreation spot for Parisians who could saunter along its shady promenades or through the surrounding fields, climb the hills, ramble in its old streets, visit its religious monuments, or go boating. Boating was the modern sport, accessible to all but the poor (whose excursions, as Zola claimed, were only as far as the city fortifications); it gave those chained during the week to desk or factory bench a sense of freedom borne on a current whose continuity was the antithesis of work hours. As if to preserve this dream, Monet never represented people working in Argenteuil – unless they were artists – and when he did approach the theme of work, it was outside Argenteuil.

In early 1872, a few months after his return to France, Monet visited Rouen, where he painted two pictures of factories in the industrial suburb of Déville where his brother lived. One (ill.84) shows a hill covered with smoking factories, the huge plume of smoke of a goods train, and a small group expressing their astonishment at this drama of modern industry. They are stock figures from guidebooks or illustrations in journals of the marvels of modern technology, and they reappear in *The Railway Bridge* of 1873 (ill.4), where two men observe a train crossing the recently restored bridge and, in a different context, in *The Boulevard des Capucines* (ill.94). The function of these observer figures – which Monet had used in works of the late 1860s such as *Terrace at Sainte-Adresse* and *On the bank of the river, Bennecourt* – is to emphasize the nature of the motif as a spectacle; it distances the real spectator from the motif, makes experience of it indirect, and simultaneously intensifies consciousness of the act of looking. Monet used the device rarely after 1873, and the function of calling attention to the process of seeing was taken over by the visible brushstrokes. In *The Goods Train*, Monet did not depict those who worked and who created this spectacle, any more than he did in *The Stream at Robec*, a painting of workshops just outside Rouen, which is enigmatic in that there is nothing in the motif to suggest why Monet painted it, and in its tonal realism and rigid linear grid a curious reversion to works of the early 1860s like the *Farmyard in Normandy*. The figures are reduced to linear accents which are simply echoes of other linear accents, and give no sense of human presence: here, as elsewhere, despite the rhetoric of the necessity of work for the regeneration of France, the workers, the ghosts at the feast of the country's renewed prosperity, are absent.[38] When Monet returned home, he began his first intensive investigation of Argenteuil, focusing on its river promenade and pleasure craft, and ignoring the industrialized landscapes he had painted in Rouen.

In his first year at Argenteuil Monet painted nearly all the motifs he would explore more deeply in subsequent years; rehearsing certain themes, discovering Argenteuil, re-establishing continuity with what he had done in the 1860s and, in effect, reviewing the possibilities of modern French landscape painting. Some of his works of this period related to his earlier landscapes and to Barbizon painting – as in depictions of older parts of the town or of the countryside which recall Corot or Millet – but generally he favoured landscapes which were being transformed by the modern: a new boulevard, the river with its mix of industrial and leisure use, its promenade, pleasure boats and regattas; his wife and their friends in their modern paradise garden.

Monet's *The Wooden Bridge* (ill.88) shows that his representation of Argenteuil was not a process of simple recording. Manet bought the painting in 1872, perhaps because he appreciated that Monet was playing with the artifices of representation as consciously as he himself did. It is an almost over-structured image of the modern river in which the old and the new are starkly juxtaposed, but it does not so much inform the spectator about that particular scene as demonstrate the artist's power to create a new reality, and since it is a résumé of many of the motifs which would occupy Monet for the next five years, it suggests that he was trying out these powers soon after his arrival in a new environment. The meaning of his struggle to represent a modern Utopia lies not only in his subject-matter but in his power 'to recreate nature touch by touch' (to use Mallarmé's words).[39] In this sense Monet was as much a modernist as Manet. His modernism took the form of a continuing process of assuming *artistic* control of a complex and frequently intractable environment. In order to realize such control, Monet's vision had to be very selective, but he struggled to make it appear true to his perceptions of the world.

Monet twisted the silhouette of the wooden bridge so that it reads as an absolutely flat pattern, making its reflection only slightly less sharply defined than the bridge itself, and it is sometimes hard to distinguish between the 'real' and the 'reflected' image. The bridge and its reflection frame an inner picture of the river, the villa with the tower, factory chimneys, yachts and steam tug, the floating boat-hire office, and their reflections. The marks on the canvas create fluctuating readings: for example, one's reading of the central void falters between interpreting

87   James Abbott MacNeill Whistler, *Nocturne: Blue and Gold – Old Battersea Bridge*, 1872–5, 66.6 × 50.2 (26 × 19½)

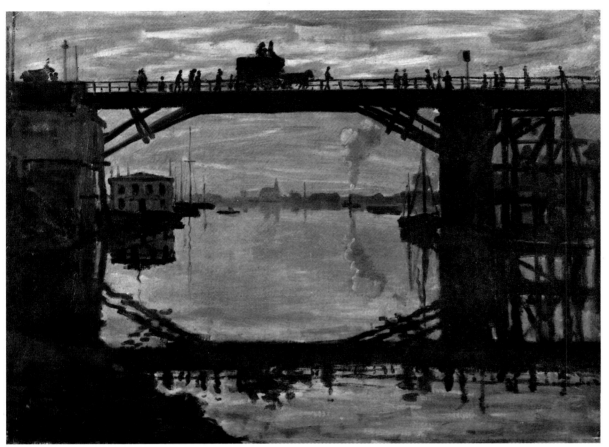

88  *The Wooden Bridge, Argenteuil* (W.195), 1872, 54 × 73 (21 × 28½)

*Below:*

89  Morel-Fatio, 'Oissel', wood engraving in Jules Janin, *Voyage de Paris à la mer*, 1847

90  Johan Barthold Jongkind, *The Bridge of l'Estacade*, c.1853, 43 × 72 (16¾ × 28)

the reflections as shapes on a horizontal plane of water, and as part of a pattern on the picture surface. It is as if Monet were testing the relationship between descriptive marks and structural ones by *forcing* a disjunction between them, and forcing attention on the ways in which abstract matter can signify external reality. The painting may also have been a means of defining his mode of expression through confrontation with very different representations of similar motifs — for example, as Tucker suggests, with one of Hokusai's *Thirty-six Views of Mount Fuji*; contemporary guidebook illustrations, with their descriptive realism; and Whistler's *Nocturne: Blue and Gold — Old Battersea Bridge* of 1872–5.[40] Whistler's bridge is like an insubstantial dream image, but Monet, like Jongkind in his *Bridge of l'Estacade*, emphasized the specific nature of his intractable raw materials — the stumpy, coarse shapes of bridge and boathouse, the awkwardly placed scaffolding — and so emphasized the processes which enabled him to transform the external world into his own. This was, as Pissarro claimed, 'a highly conscious art'.[41]

The works Monet painted in the spring and summer of 1873 were more confidently modern than were these reticent paintings, but their progressivism was more at variance with an increasingly repressive regime. The relative calm of 1872 had seemed to confirm the stability of Thiers's conservative government, but in April 1873 the election of a radical as deputy for the Seine, as well as intensified demands for an amnesty, gave the Duc de Broglie a pretext to denounce the radicals as the 'new barbarians' returning to Paris 'to the acclamations of the amnestied Communards', and to replace Thiers as President of the Republic by the reactionary Maréchal MacMahon. The new President promptly proclaimed '*l'ordre moral*', and sought to bring about a return to a hierarchical society governed by the 'notables', the traditional

91   *Houses at Argenteuil* (W.277), 1873, 54 × 73
(21 × 28½)

ruling élite, and to restore 'traditional' moral values by tightening already repressive social legislation and censorship.[42] An immediate consequence was the vote of the Assemblée Nationale to make Courbet entirely responsible for the huge cost of restoration of the Colonne Vendôme, even though he had been acquitted of any responsibility for its destruction; he was forced to flee to Switzerland, where he died four years later. The Catholic Right also succeeded in having a law passed that allowed land on Montmartre to be appropriated for the erection of Sacré-Cœur, as a symbol of repentance for the sins which had led to defeat and civil war. The summer, meanwhile, was filled with rumours of the imminent restoration of the Comte de Chambord as 'Henri V'.

Monet was not responsive to the increasing conservatism — indeed, he painted fewer of the more traditional aspects of Argenteuil, fewer cautious Barbizon-related landscapes, and turned more decisively to the modern: the iron railway bridge replacing one destroyed in the war, the new houses invading the fields; three paintings of women and children walking through fields of poppies, and seven paintings of Camille, Jean and friends in the garden of his house. These works are more radical in structure and technique than those of his first year at Argenteuil, and they were painted more densely, suggesting longer, more searching sessions before the motif. Monet exhibited *Impression, sunrise, Poppies at Argenteuil, Autumn effect, Argenteuil,* and *The Boulevard des Capucines,* with the *Luncheon* of 1868–70 in the first Impressionist exhibition of 1874, and they show his evolution from a tonal structure to one built up from minute touches of colour.

Some of the early paintings of the most up-to-date aspects of Argenteuil were executed with a rawness which suggests Monet's need to experience the reality of that which he would turn into his own world.

In 1873, for example, he painted *The Railway Bridge at Argenteuil* (ill.4), crudely slicing the industrialized forms into the barren banks which in 1874 he softened with trees, reflections, and long grasses. After these works the modern was represented as a pleasurable and exciting spectacle in which progress spreads its abundant benefits without any ill effects. The world of work appears only as a distant spectacle or, most often, through its miraculously produced effects: factories are indicated by chimneys as slender as the masts of yachts, piercing the horizon as church spires had done in Barbizon landscapes, and the plumes of smoke which absorb light and delicately stain the sky; work is implicit in the regular arrival and departure of the train crossing the great iron bridge which had been manufactured in Argenteuil. Implicit too in the paintings is leisure, dependent on the artificial divisions of time of the capitalist world and on the accumulation of wealth; it underlies the paintings of the new commuter villas, the creation of private gardens. Thus, as Duret wrote in 1878, Monet painted not 'rustic nature' but 'embellished nature'.[43] In the 1860s his paintings of modernizing places were interspersed with paintings of a more or less undisturbed rural nature, but after his first year at Argenteuil he concentrated almost exclusively on a landscape penetrated by the modern in a manner determined by modern experience. The man-made Dutch landscape (although formed over the centuries) probably helped him to explore the interaction between the forces of nature and human constructs. He gave shape to wind, water and light through their interaction with the shaped environment: the flowing river was articulated by regularly planted lines of poplars, by bridges and their reflections, by factory chimneys, by queues of moored yachts waiting for the intervals in the city's work; intensity of sun and cloud was registered by these repetitive

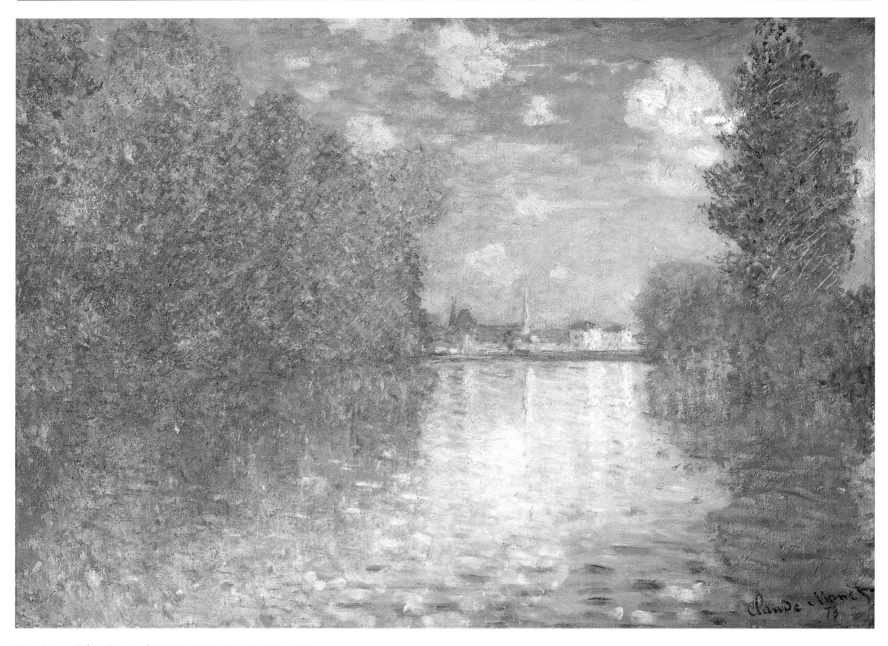

92    *Autumn Effect, Argenteuil* (W.290), 1873, 56 × 75 (21¾ × 29¼)

93    Joseph Mallord William Turner, *Chichester Canal, c.* 1828, 65.4 × 135 (25½ × 52½)

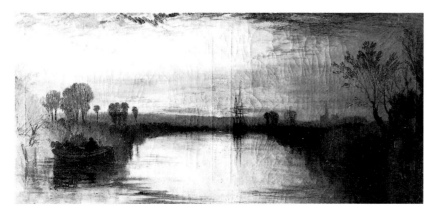

markers, wind in the way it fills the sails of a yacht or directs the smoke of factories or steam tugs; the modern boulevard provides a series of accents which enable us to 'see' the frosted misty light that fills it.

Despite a subject which refers not at all to the modern, *Autumn effect, Argenteuil,* painted about eighteen months after *The Wooden Bridge,* is a clearer expression of modern consciousness than the earlier picture, for it severs the 'shock' of the moment from the past more completely than did *The Wooden Bridge* with its suggestion of progress from past into the present.

For all his spontaneity of handling, Monet put considerable thought into the linear and colour structure of his pictures before beginning to paint. The few drawings which survive from the 1870s — which, like most of his drawings, were not so much studies for particular works as investigations of the possibilities of certain kinds of motif — show that Monet 'saw' the motif in terms of contours: the internal drawing is sparse, shadows are rare and are indicated by a slight

thickening or multiplication of line. This mode of registration favoured motifs with a linear geometry which could be used to tauten the fluidities of water, snow, or mist, and which Monet also found in Japanese prints. He was now using a dominant colour-scale for each different motif, and while the practice probably derived from Whistler, Monet's scales of pure colour were determined more directly from observation of the motif. They enabled him to assimilate his linear structure to a dynamic colour structure, as he had been unable to do in paintings of the 1860s, such as the *Terrace at Sainte-Adresse.*

Whatever the planning that went into a work, once Monet began to paint, intuition took over, and the painting evolved according to a deepening awareness of the motif. Close analysis of *Autumn effect* suggests that each brushstroke makes sense in terms of Monet's experience of the motif, and that each contributes to the construction of pictorial unity. As in the London and Zaandam paintings, the view across a sheet of water to trees and buildings in the middle ground and background distances itself from the spectator; Monet used this view frequently after the 1860s, probably because it was particularly suited to the representation of light-filled space, as he would have seen in paintings by Turner such as *Chichester Canal.* Unlike the Barbizon landscapists in their use of the long view, Monet kept the foreground open and either unshadowed or with transparent shadows, so that his paintings announce themselves as open and accessible. This very

accessibility emphasizes the disjunction between the natural and the pictorial worlds. Moreover, while Turner's paint disappears in veils of colour, Monet's forms a densely encrusted surface, and this too emphasizes that the painting is creating an equivalent to, rather than an illusion of, nature's light. In an article written in 1873 Silvestre discussed the influence of Japanese prints on the paintings of Monet, Sisley and Pissarro; and, indeed, the *Autumn effect* has an obvious relationship with the drastically simplified compositions and flat planes of colour of many Japanese prints in Monet's collection.[44]

Using colours analogous to those of the prism, with generous admixtures of white, applied in small touches on a lightly tinted ground, Monet was able to suggest the continuous luminosity of a waterscape in which light filtered through trees into shadowed water, and where the water surface refracted, absorbed and reflected light into the shadowed parts of the trees. He created equivalents for the brilliance of that surface by constructing the *Autumn effect* from interwoven scales of warm yellows and cool blues, animating them by smaller touches of related and contrasting colours (for example, the shadowed parts of the red-gold trees on the right are made to vibrate by small touches of blue and violet). The veil of golden leaves is so pervaded by light that it cannot be described as in shadow, but as having an almost imperceptible lessening of luminosity. As in Turner's *Chichester Canal,* the trees and their reflections are represented as one luminous shape in which solid and

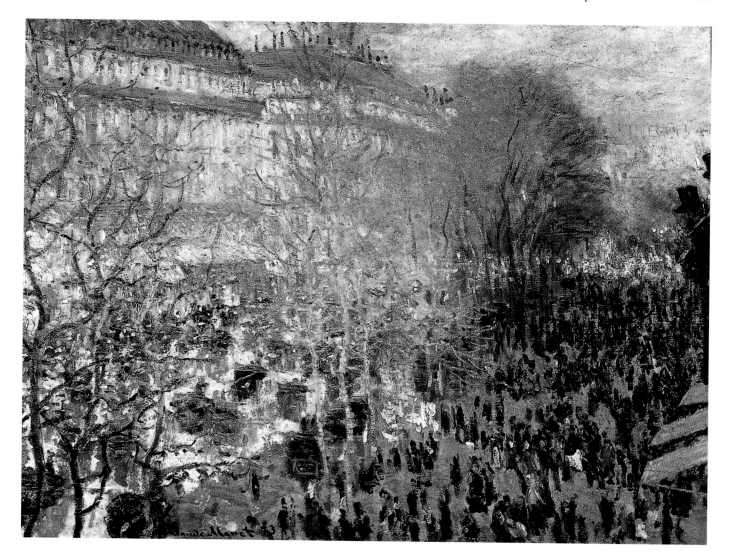

94   *Boulevard des Capucines*
(W.292), 1873, 61 × 80
(23¾ × 31¼)

95   Utagawa Hiroshige, 'Picnic to admire the red maples at the Kaian temple at Shinagawa', from *Famous Places in Edo*, 1853, woodblock print, 14.3 × 20.5 (5½ × 8)

96   Katsushika Hokusai, 'The Island of Tsukuda in the Musashi province (Edo)', from the *Thirty-six Views of Mount Fuji*, 1829–33, woodblock print, 24.9 × 37.2 (9¾ × 14½)

fluid are scarcely differentiated, and the water at the bank is almost invisibly shadowed, for it reflects the brilliance of the sky. Thus what looks at first sight like a confused mass of red-gold reveals itself as a subtle record of complex perceptual experience.

This micro-structure made it possible for Monet to represent the scene in terms of sensations of colour, rather than of known objects – as he had attempted to do in earlier works like *On the bank of the river, Bennecourt*; for example, in the area of colour below the bank, where he saw no change of colour, he would not now differentiate between the tree and its reflection even if he knew they were different 'things'.

None of this was a passive response to the scene, for Monet was intent on finding and making his particular kind of wholeness, and his pictorial choices were both pictorial and representational, both subjective and objective. What kind of thinking determined the heavy scratches which aerate the trees on the right? or the line of dark bright blue in front of the shimmering town, added at the end of the painting process, at the same time as the long strokes of blue and white which indicate ripples on the water? The line of blue locks the distant view into the whole by linking it with the almost imperceptible darkening which separates the trees from their reflections (which is, indeed, imperceptible without this link), and with this last decisive touch creates a unity which is dependent on the physical world, but also declares its otherness as Monet's own world.

Monet used this micro-structure to shape his image of the modern city in two views of the boulevard des Capucines, painted from high above the street – like nearly all his Paris views – from the studios of the photographer Nadar, where the first Impressionist exhibition was held a few months later. With the significant exception of *The Pont-Neuf*, and *The Rue Saint-Denis* and *The Rue Montorgueil* (ill.143) of 1878, Monet's paintings of Paris in the 1870s are of the new Paris and, except for the shabby, melancholic *Pont-Neuf*, painted soon after the Commune, they all show it as a dynamic and exciting spectacle.

The individual figures in Monet's 1867 paintings of Paris suggest that the groups are composed of individuals who have only temporarily lost their separate being. In *The Pont-Neuf* each figure is isolated and is clearly differentiated from the surrounding space, but in *The Boulevard des Capucines*, the tiny flecks of colour fuse the figures and the

standardized components of the street into an indivisible continuum. The winter light is as much an active presence as the crowd, as it glows in the shadow, gleams coldly in the canyon of the street, catches fitfully at the bare branches and an advertisement column, shines icily on a distant crowd, touches softly on distant buildings. The fragmentation of the human into pure object with which one can have no empathetic relationship is emphasized by the insertion of two men in top hats on a balcony on the right. They are looking at the same spectacle as the spectator, yet they are part of the spectator's spectacle; they are more individualized than the kaleidoscopic crowd, yet, because they are fragmented, their individual being is denied; but, even their partial identity attracts the attention and establishes a curious visual deflection which dislocates and distances the whole scene. Degas and Caillebotte depicted the individual alienated in the city, but in Monet's paintings it is the real spectator who is alienated at the heart of a pleasurable spectacle.

The sharp cutting of the scene is like a mimicry of a photographic snapshot and gives the impression of a view snatched out of time. Unlike Monet's earlier Paris paintings, everything here – the wide boulevard with its rigid geometry of pavements, recently planted trees, gas lamps and standardized apartment blocks – is brand new, and, although its complex micro-structure would have taken a long time to paint, and although it takes a long time for its subtleties of observation to emerge, like the photograph it has no past, no continuity other than the spatial continuity of that constructed moment.

To Walter Benjamin the nineteenth-century city street was an extension of the bourgeois interior, a public space which one experiences as private.[45] Similarly, Monet's suburban countryside was an extension of the private garden, as one can appreciate in the continuity between the women promenading in the closed garden in the *Luncheon*, those walking in a forest of flowers in the same garden, which now incorporates the neighbouring suburban houses, and those wandering through fields of poppies or along the river. The time of the suburban landscapes is different from that of the cityscapes: unlike the figures in *The Boulevard des Capucines*, undifferentiated fragments of the city's dynamism, those in *The Pool at Argenteuil* (ill.100), though cursorily represented, have an individual presence which somehow

escapes annihilation by the moment and possesses a certain continuity. This ambiguous continuity is stronger in those paintings in which Camille and Jean wander through the landscape, playing a role in Monet's creation of wholeness which is of quite a different kind from that which could be constructed from the fragmented sensations of the city street. In the *Poppies at Argenteuil* (ill.99), the second mother and child are like echoes of the first, and suggest that the landscape reveals itself as the figures move through it. Their movement is, however, captured in a moment which seems to be continuous but which is none the less frozen.

The distinction is clearer in a contrast between Monet's unequivocally modern *Railway Bridge at Argenteuil* (ill.4) and Corot's *Bridge at Mantes* (ill.110), painted three to five years earlier. Monet depicted a momentary conjunction of movements – the train cutting across the starkly functional bridge and the slow glide of the pleasure yachts – intersecting with the gaze of the men pausing on their walk and of the real spectator. A second later these interconnections will have been severed, and the scene will have ceased to exist. Unlike Monet's stark juxtapositions, Corot's closely related tones of green and grey establish a continuity among all the elements in the composition, which contains no hint of the present day (no reference, for example, to the railway bridge behind the stone one). Monet's imagery was that of the up-to-the-moment modern tourist guide, whereas Corot's painting suggests an unbroken continuity with the past; a timeless landscape in which the fisherman has always been and ever will be a tranquil participant, rather than an individual who at the time may well have decided to abandon rural servitude for the lures of the modern city.

## II

The continuity of Monet's exploration of Argenteuil was inflected by the struggle he and his friends had to find an audience for their work in small group exhibitions. By April 1873, they were planning such an exhibition.[46] During 1872–3 Durand-Ruel's prodigal buying of Monet's work was accompanied by steady purchases by other collectors, but none of them could match Durand, either in the number of purchases or the prices paid for the work of painters little known to the public. Since it was now clear that there was small point in his submitting works to the Salon, Monet was directly dependent on the dealer for the continuity of his ideal life, and even he may have felt this was a precarious foundation for that life, particularly since Durand-Ruel was selling very little from his large stock of Impressionist works. Moreover the dealer restricted his purchases to Monet's prettiest pictures of his garden or trees in bloom, or to those which most resembled the Barbizon paintings from which he had made the profits which enabled him to speculate in Impressionist paintings. The most 'modern' picture Durand bought was *The Goods Train*, which was summarily painted and small enough to be presented as a study, and he purchased only two small paintings of Argenteuil as a modern resort, the *Pleasure Boats* (W.229) and *Argenteuil, end of the afternoon* (W.224), one of four studies of the promenade along the Seine which could have been seen as modern versions of Daubigny's river scenes. Monet may then have felt that his most important patron did not appreciate his more radical works; but this became almost irrelevant when the economic depression so severely affected Durand-Ruel, who had over-extended himself and lost the confidence of many of

his clients because of his massive investment in the new art, that he was forced to give up buying it by the end of 1873.

The Salon of 1873 confirmed the conservatism of the new arts administration and of the jury. Monet, Pissarro and Sisley did not submit; Morisot was accepted; Renoir was rejected, and could show his large painting of fashionable life, *A Morning Ride in the Bois de Boulogne* (Kunsthalle, Hamburg), only in a new Salon des Refusés, while Manet's huge success with his Old-Masterish *Le Bon Bock* (Philadelphia Museum of Art) must have suggested to his friends that the only way to succeed in the Salon was to compromise.

Reproductions of works publishers judged to be popular suggest that the public liked paintings of heroic deeds in the last war, of past heroes who had sacrificed all for their country, and of women participating in patriotic acts, such as a mother making a vow for a soldier son, or an elegant lady watching departing soldiers (ill.83). The public also liked paintings of picturesque beggars, fashionable ladies or coy young couples astray in the fields.[47] Monet and Renoir too painted pretty women in gardens and meadows, but with none of the detail and the polish which attracted high prices.

As the Salon opened Paul Alexis published in *L'Avenir national*, a journal of the radical left, an article on the organization of labour in contemporary art, in which he used the language of politics as it had been used in the debates on art during the Commune. The new Salon regulations, he asserted, made 'Republican artists accuse the government of discrediting the Republic. Are not others . . . going to regret the Empire and M. de Nieuwerkerke?' He advised artists to form an association 'to free its adherents from the exploitation of dealers and the guardianship of the State'. Artists, Alexis wrote, were 'workers' or 'producers', and since workers had organized themselves against capitalist forces in the 'great working-class movement of trade unions', it was appropriate for artists to do the same, in order to prevent their only 'capital' – fame – from being exploited: inflammatory words so soon after the Commune and at a time when unions were suppressed.

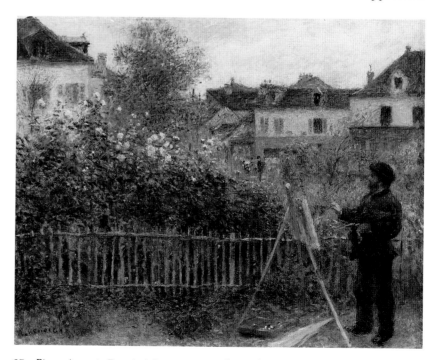

97   Pierre-Auguste Renoir, *Monet painting in his garden at Argenteuil*, 1873, 46 × 60 (18 × 23½)

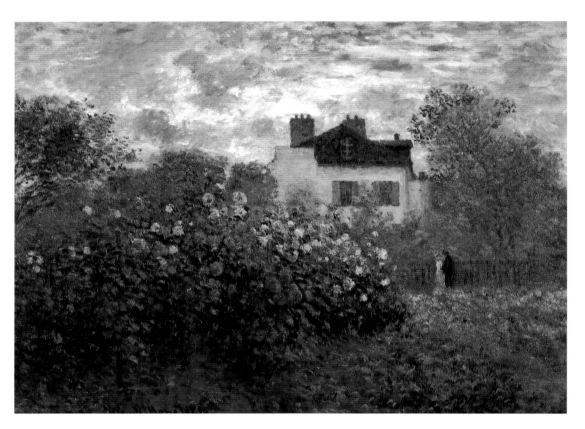

98   *Monet's garden at Argenteuil (The Dahlias)* (W.286), 1873, 61 × 82.5 (23¾ × 32)

99   *Poppies at Argenteuil* (W.274), 1873, 50 × 65 (19½ × 25¼)

Alexis claimed to have heard many artists talk about association, and his invitation to them to discuss these issues in *L'Avenir national* was immediately taken up by Monet, who announced that a group of artists was forming a society like the co-operatives proposed by Alexis. The journalist promised support for their 'legitimate ambition of rendering nature and life in their grand reality', and their aim of 'governing themselves' as a real example of 'democracy in art'. The establishment a fortnight later of the government of '*l'ordre moral*' would have made this language suspect.[48]

The notion of an alternative to the Salon was probably encouraged by signs of success: paintings by Monet, Pissarro and Sisley fetched high prices at an auction of the collection of Ernest Hoschedé, the wealthy, spendthrift owner of a Parisian department store, and their works were illustrated in a three-volume catalogue of Durand-Ruel's collection, along with those of artists like Corot, Delacroix, Millet and Courbet, in such a way as to suggest that they were heirs to the French tradition. Armand Silvestre's preface to this catalogue was not only the first, but also one of the most perceptive accounts of early Impressionist landscape painting. He noted that the 'caressing' harmony of Monet's, Pissarro's and Sisley's work was realized through the 'very fine and exact observation of the interrelationships between colours', and was related to 'the diapason', a musical harmony composed of distinguishable parts. He also perceived the relationship between Monet's subjects and his particular formal structures:

On gently stirring water, he loves to juxtapose the many-coloured reflections of the setting sun, of motley boats, of changing skies. Colours made metallic by glossy waves rippling across small, smooth surfaces glitter on his canvases. There the reflection of the bank trembles, there houses are cut up like in the children's game where objects are reconstructed from fragments. This effect, of an absolute veracity . . . may have been [borrowed] from Japanese images.

He claimed that the paintings would soon be successful because of their sheer happiness:

A blond light illuminates them, and all is gaiety, clarity, a springtime holiday, evenings of gold, or apple trees in flower — another inspiration from Japan. . . . Their paintings open [like] windows on to a joyous countryside, on to a river laden with skimming boats, on to a sky streaked with light mists, on to an enlivening and charming outdoor life. Dream infuses them, and, completely impregnated by them, it flees towards loved landscapes which they recall all the more surely because the reality of their appearance is there most striking.

Silvestre was unusually perceptive in realizing that although Impressionism was 'a kind of analytic work', it was not a mechanical recording of sensory stimuli, and that it expressed the dream of a fulfilling life in modern nature, and desire for 'loved landscapes'.[49]

The belief that the exhibition of the 'Société anonyme des artistes peintres, sculpteurs, graveurs, etc.' which opened on 15 April 1874, in studios just vacated by Nadar on the boulevard des Capucines, was greeted by overwhelming hostility is one of the myths of modern art, for most of the critics were well disposed, particularly to the notion of an alternative to the Salon, and they praised many of the works, even if with reservations and some outbursts of anger. Nevertheless, if myth is a symbolic mode of conveying felt truth, it is necessary to enquire why the exhibition left a sense of its having been a shock. Reactions would, of course, have been spoken as well as written, and they may have given the level-headed Pissarro the notion that the critics were antagonistic: 'Our exhibition goes well', he wrote to Duret. 'It's a success. The critics are devouring us and accusing us of not studying.'[50] It is easy to judge harshly the writers who criticized Impressionist paintings and the public

who laughed at them, yet if one regards as simply ignorant and perverse their accusations of political radicalism, madness or charlatanism, one loses sight of the seriousness of the Impressionists' attack on accepted modes of representation and of exhibiting and selling works of art. To understand the critics' reactions, one must consider the total effect created by the Impressionists' defiance of the authority of the Salon; their crude colours; their relatively 'sketchy' techniques; their fragmentation of the figure; their rejection of traditional narrative, didactic or moralistic modes of representing contemporary life; and their demand that the spectator participate in their processes of creation.

These factors had specific implications in early 1874, when the horrors of the recent past and fears of the immediate future were constantly in mind. Victor Hugo's *L'Année terrible* was published four days before the exhibition opened, and had sold 80,000 copies in that week; an exhibition of works from private collections was held to aid refugees from the 'lost' provinces; the excavations for Sacré-Cœur were begun in early May. While the Assemblée Nationale was debating new constitutional laws, the Comte de Chambord came secretly to Versailles in the hope that MacMahon and the Assemblée would recognize him as king; rumours of his presence were reported in the same journals as carried reviews of the Société Anonyme. On 7 May an editorial in the conservative *Paris-Journal* claimed that the royalists' white flag 'acted on the ignorant masses like a red flag on a bull', allowing radicals to disguise themselves as guardians of the public peace, and said that if there were not agreement on a government and a flag, the French might as well shoot one another, 'and the fatherland would die'; in the same issue Chesneau asserted that the Impressionists had been named the 'Intransigeants' — dangerous radicals of the very kind feared by the editor.[51]

In his review of the Salon, de Pontmartin said that thanks to 'the happy diversion' created by artists, he would not have to think of the current situation; but his own writings show that this was not possible: commenting on the crowds which gathered around Munkaczy's *Arrest of the night vagrants* (Budapest, National Gallery), he speculated on 'the treasures of hatred' built up by the disinherited, and on the 'protest of the proletarian, or even outlaw, against regular life, social servitude and the privileged'. He kept returning to the painting with 'an undefinable unease', anguished that Realists could not paint so as to give 'an idea of reconciliation'.[52] Like many other writers on contemporary culture, Pontmartin asserted the necessity of an art that would elevate, console, heal — and remind. Convinced Republicans expected more from the vitality of art than from any specific moral message it might contain: Castagnary saw it as a patriotic duty to enquire into the state of 'that gushing spring which since the Revolution has come forth from the entrails of the people', while Emile Blémont stated the intention of the *Renaissance littéraire et artistique* to become 'the mouthpiece of a generation whose ambition it is to raise the mind and the heart of France and to give the fatherland the best of consolations possible after so many disasters' — literature and art.[53]

Most of the articles on the Société Anonyme attempted to be fair, and to steer a precarious course between the Scylla of authoritarianism and the Charybdis of anarchy, towards the open sea of free enterprise. Embedded in their rationalizing discourse were other, less balanced views which emerged particularly strongly in anecdotes about the adverse effects of the exhibition on visitors. Some journalists reported public reactions, and these may also be inferred from the content and tone of critical articles written for specific audiences. There were

significant differences between articles in the conservative and progressive press, between the Bonapartist, Republican centre-left and radical-left newspapers, and between mass-circulation and specialist journals.[54] Naturally these differences were not absolute, particularly since many critics had written only under the Second Empire and had to adjust themselves to an unknown regime. Moreover, given the exigencies of free-lance journalism, one cannot assume a simple correlation between the politics of a particular publication and those of a journalist, any more than one can assume a correlation between avant-garde painting and progressive politics — as was recognized by the young Georges Rivière in an essay of 1877, 'Aux femmes', in his short-lived journal, L'Impressionniste:

Your husband, who is perhaps a Republican, becomes furious at a revolutionary who sows discord in the artistic camp. . . . He complains about political and administrative routine . . . but he sees painting through old paintings.[55]

The major supporters of the Impressionists were to come from those sections of the bourgeoisie — professionals, industrialists, financiers — who upheld the moderate, modernizing Republic. The most conspicuous exception was Durand-Ruel, whom Renoir described as 'a well-ordered bourgeois, a good husband, a good father, a loyal monarchist, practising Christian [and] a gambler . . .', that is, a speculator in the value of paintings. The article which this monarchist had commissioned Silvestre to write was partly recycled in Silvestre's review of the 1874 Société Anonyme exhibition for the centre-left journal L'Opinion nationale, where he repeated his appreciation of the Impressionists' expression of modest bourgeois pleasures in 'the joyous countryside' and in 'relaxed and charming' outdoor life.[56]

Apart from Leroy's facetious article in the mass-circulation Republican satirical journal, Le Charivari, it was the right-wing or centre-right journals which emphasized the public's lack of comprehension of the exhibition. In his article, 'L'Exposition des Révoltés', in La Presse, Cardon asserted that it was 'a mystification shocking to the public or the result of a mental derangement'; a writer in the septennalist La Patrie made the same connection: 'the exhibition of Intransigeants . . . one could say, of madmen'; while in the Paris-Journal, Chesneau suggested that the exhibition should have been more exclusive, because the only works worth studying — the Impressionist paintings — were also the ones 'whose curious meaning escapes the great majority of visitors'. Chesneau had been closely identified with the Imperial arts administration and his élitist stance was characteristic of such critics.[57]

All the journalists commended the exhibition as a private initiative providing an alternative to government protectionism: in Gambetta's République française, Philippe Burty praised the idea of a direct appeal to the public in surroundings which enabled that public to make its own judgements; in Hugo's radical Le Rappel, d'Hervilly characterized the exhibition as 'the free manifestation of the tendencies and personal talents of a certain number of independent characters who completely reject the jury and administrative tutelage'.[58] The radicals' emphasis on freedom and on the right of the public to judge for itself was subtly different from comments by critics of the centre-left, such as Silvestre, who drew attention to the brutality of the Salon exclusions, which could destroy in minutes the work of a year, as the reason why painters 'increasingly enter the ways opened by private initiative'.[59]

Cardon believed that the creation of a number of art societies, 'each with its own public', would benefit art through 'the development of intellectual liberty', and that they would be welcomed by the administration which proposed handing over the direction of the Salon to artists by 1875. He added that 'many people' did, however, view the prospect of artists organizing themselves with 'terror'. The proposal by the Directeur des Beaux-Arts, de Chennevières, was liberal only at first sight, for those taking charge would be members of the Institut and artists who had been awarded medals or decorations. Indeed de Chennevières later wrote, 'Democracy has always filled me with horror. . . . I meant to found an artistic guild founded on an élite . . . on the election of the best by the best.' Notions of freedom in the arts were particularly complex for post-Commune bourgeois society, when artists were given the role of enacting freedom, and writers formed by the Empire commended free enterprise in the exhibition and sale of art, but focused on the art-for-art's-sake characteristics of Impressionism, and denied its participatory aspects.[60]

The suspicion that Impressionism was somehow associated with political radicalism was never voiced directly by hostile or conservative critics, but was filtered through the comments of those who knew them or were sympathetic to them, generally in ironic asides or disclaimers by left-of-centre or radical Republicans. It was a suspicion that gradually became more strongly expressed during the course of the exhibition, as if the journalists were picking up on a subject being discussed at the time. In La République française, Burty merely wrote of a 'group of militant and committed comrades'; a fortnight later, in the conservative La Presse, Cardon titled his review, 'the exhibition of the Rebels', while in the liberal Republican Le Siècle, Castagnary wrote sarcastically, 'Let's then have a little look at what these terrible revolutionaries bring us that is so monstrous, so subversive of the social order', and he concluded that it was not a revolution or even a school, but 'a manner'. In L'Artiste, an élite journal dominated by writers who had been closely associated with the Imperial arts establishment, Marc de Montifaud implied that the exhibition was a publicity stunt, and that once the public recognized that it was in the presence of 'a clan of rebels', it 'left its prejudices in the cloakroom' and went peacefully through the exhibition. Finally in the septennalist Paris-Journal, Chesneau commented that this 'école du plein air' 'had been baptised in a funny enough way with the name, the Group of Intransigeants'.[61] The term was used to designate the Republicans of the far left who were suspected of identifying with the Commune — although they rarely sympathized with its revolutionary aims — and who criticized the savagery with which it had been repressed, and demanded an amnesty. In 1876, Mallarmé claimed that when Impressionism first appeared 'the public with rare prescience dubbed [it] . . . Intransigeant, which in political language means radical and democratic'. In 1874 Castagnary's scepticism about Impressionism's subversiveness may have meant less than his continuing defence of Courbet, and that he carried it on in Le Siècle, the major voice of the liberal opposition under the Empire and now of the moderate left; the journal had been stigmatized two years earlier by Feydeau, in his protest against giving

the same political rights to the most intelligent and most educated men of a nation, and to brutes who are good only to make themselves drunk with the adulterated wine of the cabarets and at the same time with the doctrines of Le Siècle.[62]

The Impressionists were generally seen as the immediate followers of Courbet and Manet, who were now linked as dangerous radicals despite the popular success of Manet's Bon Bock in 1873; and there was some surprise that Manet did not exhibit with the Société Anonyme. Courbet had been in exile in Switzerland for ten months, and his trial on

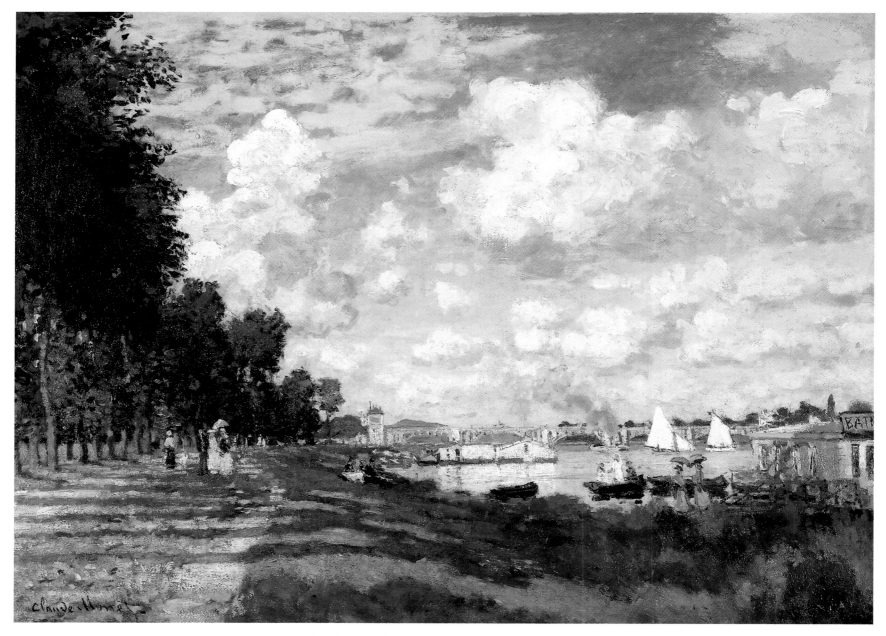

100    *The Pool at Argenteuil* (W.225), 1872, 60 × 80.5 (23½ × 31¼)

charges relating to the destruction of the Colonne Vendôme was imminent in 1874 when de Pontmartin called Manet 'this Marat of a pictorial revolution of which Courbet was the Danton'. At the same time Aubert, infuriated by Manet's *Gare Saint-Lazare* in the Salon, admonished the painter to 'think of the moral disorder [to] which aesthetic disorder has led . . . the frenzied Courbet'. Many may have remembered Courbet's highly publicized rejection of the Légion d'honneur in 1870, and his explanation in *Le Siècle*:

The state is incompetent in matters of art. When it undertakes to bestow awards, it usurps the function of popular taste. . . . I've always lived a free man; let me end my life free; when I'm dead, let this be said of me: he belonged to no school, no church, no institution, no academy, least of all to any regime but the regime of liberty.

A few minutes' walk from the Société Anonyme exhibition, the scaffolding around the Colonne Vendôme which was being reconstructed ostensibly at Courbet's expense would have been a tragic reminder for his friends, and would have helped to confirm his enemies' suspicion of the dangers of a free, unhierarchical art.[63]

One of the central issues of the Société Anonyme exhibition was that of participation: it was implicit in the way it was administered and presented, and in the Impressionists' subjects and techniques, and had been made explicit in Alexis's welcome of the project as 'democracy in art'. Participation was, however, offered to a restricted audience, for the members of the Société cannot have expected mass public attendance as at the Salon: they probably conceived of their audience in terms of the educated and prosperous élite who had begun to buy their works, while hoping for the informed critical response and the wider public approval that would stimulate demand. In fact publicity attracted 3,500 visitors, a very large number for a small exhibition, even compared to the 40,000 who went to the Salon. The contradictions inherent in the avant-garde's choice of subjects and techniques which implied the notion of democratic participation can also be seen in Mallarmé's two articles on Manet and the Impressionists, which were written with his customary opacity and published in specialist journals. While the critics accepted an alternative to the Salon, few responded to the invitation to exert

independent interpretation and judgement, and most probably sympathized with de Pontmartin's determination never to 'preach disdain for the hierarchies; to suppress them in society is to create chaos; in art, it is to discourage elevated aspirations . . .'.[64]

The hierarchical structure of the arts had been challenged by the Commune's Fédération des Artistes which, under Courbet's presidency, defined its aims as the 'government of the world of art by artists' and the 'free development of art disengaged from all government tutelage and all privileges'; the equality and independence of all artists would be guarded by a committee elected 'by the universal suffrage of artists'; exhibitions would be organized by artists themselves; instruction in the arts would be free. The Fédération would encourage 'the free and original expression of thought', and the public would be invited to give its views on 'all initiatives towards progress'.[65] These proposals were reversed by Thiers's government, whose regulations were even more restrictive than those of the last years of the Empire. Many of the Fédération's aims were related to those of the Société Anonyme, but there were fundamental differences: the former sought to unite artists with craft workers in order to undermine the hierarchy of the arts, but the Société was concerned exclusively with the high arts, and its invitation to participate was restricted to the élite which visited private galleries. Nevertheless, although the Société Anonyme was a limited-

liabilty company, a typical private-enterprise structure, it may have been thought that its co-operative aspects had been influenced by the institutional models of the Commune. Suspicion may also have been aroused by Alexis's advocacy of artistic associations based on the then illegal trade unions, in a journal which published Monet's letter on the group's projected exhibition, and such suspicions may have been confirmed by comments of Duranty — well known as a supporter of avant-garde Realism — on the speeches at the prize-giving at the Salon of 1872. 'Frankly', he wrote, 'I preferred the artistic Commune, it had more ideas and bite than all these who are steeped in old formulae . . .'.[66]

The exhibition of the Société Anonyme ran counter to the ideology of the Salon in almost every aspect: where the administrative structure of the Salon was authoritarian, that of the Société was participatory, with collective decisions, no jury, and shared dues and profits (if any); where the Salon presented the public with an art whose quality was guaranteed by the jury system, the Impressionists presented themselves as a group of private individuals, asking the public to judge their work on its merits; where the Salon awarded medals and prizes, the Société had no marks of distinction, again asking the public and the critics to make their own judgements; where the Salon hanging favoured certain artists at the expense of others, the Société arranged works alphabetically within groups of the same size, and hung them on only

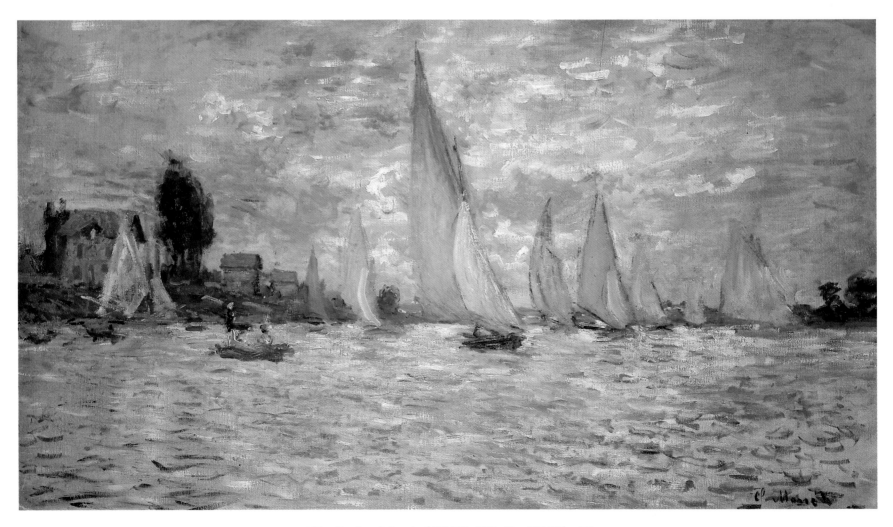

101   *Regattas at Argenteuil* (W.339), 1874, 60 × 100 (23½ × 39)

two levels. The Salon displayed thousands of works; the Société consisted of 29 artists, exhibiting 165 works, in a sympathetic environment lit 'almost as if in an apartment', and allowing that close and intimate observation which Impressionist works required.

The Société Anonyme exhibition was, of course, also designed to sell paintings. In 1880 Monet described the Salon as an 'official bazaar',[67] and it was indeed a vast display of varied goods; but it differed from bazaars or department stores in that most of its goods probably remained unsold, and this suggests that the Salon had other ideological functions. One – which was particularly strong after 1870–1 – was to preserve the notion of art as proof of the civilization of the nation, and as the bearer of eternal values unsullied by monetary considerations. The vast majority of works in the Salon did not accord with these elevated notions, and the thousands of trivial subjects, undistinguished in form or technique, created such a cacophony of visual sensations that it was impossible to make sense of them. Burty agreed with the exhibitors of the Société Anonyme

that modern official exhibitions are, because of the number and enforced placing of the works, the negation of judgement and of pleasure; [and] that it is impossible to leave with a clear idea of an artist, a work or a tendency which departs from well-tried and accepted ways.[68]

The *raison d'être* of the Salon was, then, to be found in a stupefying superabundance, akin to the 'phantasmagoria' of commodities of the Expositions Universelles and the fantastic spectacle of the department stores evoked in all their splendour in Zola's *Bonheur des dames* (1884).[69] The unwritten criteria of the Salon jury favoured works which distanced the spectator through style or subject-matter; high finish; condescending, tongue-in-cheek attitudes; and sentimental narratives calculated to elicit an immediate response, without depth of involvement. The spectator, one among the 40,000 visitors to the Salon, was in these ways maintained in the role of spectator: the stupefied observer of an endless procession of works; the consumer of ready-made meanings, rather than a participant in their creation.

The Société Anonyme was probably also developed as an alternative to the dealer system which was now challenging the Salon. A number of articles in the early 1870s suggest increased awareness of what Pontmartin called 'the prodigious growth of art dealers in recent years', with so many in the quarter of the rue Lafitte that one could not avoid 'paintings, more paintings, yet more paintings'. Clearly the same superabundance was being produced through the dealer system as through the Salon. De Pontmartin's suspicions, that dealers harmed art by assigning a monetary value to every aspect of painting, and by imposing 'the wishes of His Majesty the public' on the artist, were widely shared. He warned the artist against becoming dominated by monetary values which could divert him from 'the cult of the ideal, the pursuit of beauty, moral elevation', and advised him to welcome 'the austere lessons of adversity'. Monet and his friends did not need to be taught this hypocritical lesson, and would have been more mindful of the warnings given in the anonymous pamphlet, *Aux artistes-peintres*, about the way a dealer could control the artist's access to the public, acquire power by giving advances on work as yet undelivered, and impose the taste 'of his clientèle'.[70]

By exhibiting relatively few works in an almost domestic setting, by showing images of contemporary life with no explanatory narrative content, and by employing techniques which showed how the image was created, the Impressionists were developing a new relationship between painting and spectator. Their exhibitions of the 1870s and early 1880s should be seen as an attempt to prevent this relationship being mediated by the State or by the dealer, and to seek an alternative to these two forms of commodification – aspirations which were defeated by the growing strength of the free-enterprise dealer system.

The impression given by this first exhibition was probably confused, for in order to dispel the notion that it was a kind of Salon des Refusés, Degas insisted on including as many artists of reputation as possible. Thus, besides Monet, Renoir, Pissarro, Morisot, Sisley, Degas, Cézanne and Guillaumin, there were twenty-one other artists, most of whom were Realists, but who had little in common with those who were coming to be called 'Impressionists'. Most of the journalists, however, fixed unerringly on works by Impressionists for detailed discussion, while Chesneau criticized their 'major error of logic and tactics' in including not only talented artists who differed from them (Cals, de Nittis, Boudin and Bracquemond), but painters 'who trail at the far end of the last banalities of the official Salon'.[71] Moreover, each Impressionist showed works which differed markedly one from another: Monet's submission included the large Realist *Luncheon*, excluded from the 1870 Salon, some sketches and four Impressionist works: the *Fishing Boats leaving the port of Le Havre* (W.296) of 1874 may have acted as a reminder of his last work seen by the general public, the *Ships leaving the jetties at Le Havre* shown in the Salon of 1868, while his other paintings, *Impression, sunrise*, *Poppies at Argenteuil* and *The Boulevard des Capucines*, were provocatively new.

The group of paintings represented the full range of his themes – the family; the world of work in a modern industrialized port transformed into spectacle; the world of leisure in a landscape like a domestic garden; the modern city with the great shopping street as a glittering phantasmagoria. Yet since Monet's work had long been invisible to all but a few friends and collectors, these few paintings could not have conveyed the consistency of his exploration of the modern. Moreover all the evidence suggests that it was the obtrusiveness of his technique which confused and antagonized his audience. He may have chosen to exhibit works which were very different in style in order to encourage spectators to examine them closely, but there were such contrasts between the descriptiveness of *Luncheon* and the suggestiveness of *Impression, sunrise*, and between the sketchiness of *Impression, sunrise* and the complex paint structures of *Poppies at Argenteuil* and *The Boulevard des Capucines*, that a number of critics, and presumably the uninformed visitor, were forced to focus on the paint, and could see no more than spots and smears on the canvas. Thus de Montifaud, who admired the *Luncheon*, was disgusted with the landscapes, and stated that the *Impression, sunrise* was like a painting by a child 'who for the first time spreads colours on any old surface'. Indeed the contrast between *Luncheon* and the other works justified the critics' assumption that the Impressionist paintings were 'sketches'.[72]

Although the Impressionists continued to distinguish between sketches, studies and finished paintings, these distinctions were becoming blurred, because they tended to make their preliminary 'study' of the motif on the canvas, and then to develop the finished painting from it. With the hindsight given by a century of exposure to direct painting, it is easy to see the difference between Monet's finished painting, *Poppies at Argenteuil*, and Corot's oil sketch, *Marcoussis. An orchard, morning*. Corot's painting, though subtle and suggestive, is fairly generalized, and it is difficult to imagine that he could have added to it in any way that would have made it more specific. The longer one

102  Camille Corot, *Marcoussis. An orchard, morning*, c. 1865, 24.5 × 34.3 (9½ × 13¼)

103  Charles Daubigny, *Fields of poppies*, Salon 1874, 127 × 220 (49½ × 85¾)

looks at it, the more one becomes aware of the delicacies of the paint, but one does not 'see' more of the motif, while the more one looks at the Monet, the more one sees the complexity of what he saw. He was not simply representing what Corot called 'the effect', but embodying what were for him two inseparable processes: that of 'seeing' the motif and of creating a pictorial whole. This can be observed by comparison of his pictures with the pre-prepared structure of Daubigny's 2-metres-long painting of *Fields of poppies*, shown in the 1874 Salon. In Monet's *Poppies at Argenteuil*, one can see the warm grey ground on which he painted the major elements of the scene in broad contrasts of tone and with thick strokes of paint which echo their shape. This was the preliminary study, which did not disappear in the painting process, but was woven continuously into the completed paint structure as he made the broad impression more precise: he overlaid the broadly painted pinky-mauves and greyish greens of the grassy slopes with thin patches or thick dabs of related colours which suggest unseen rises and hollows, paths invisible in the waving grasses. Monet's deepening awareness of the specificity of the motif can be seen in the way he suggested that some poppies are in the grass, while others seem to float above it, by painting dabs of red while the green was wet, so that they partially merge, and applying others when the green was dry so that the reds preserve their brilliance and radiate almost dizzyingly. Finally Monet strengthened the internal coherence of the painting by adding small accents of clearer colour – blue to the parasol, red to the ribbon, cream to the hat – and echoing these colours in the distant house, so as to broaden the space through which the figures endlessly move. The paint structure shows that Monet had a general idea of his painting when he started it, and that he found its internal relationships as he painted.

Since Monet and his friends made visible the processes by which they created their images, and exhibited them under conditions in which they could be closely examined, clearly they intended that these processes should be *seen*. Mallarmé's criticism of the kind of painting which hides 'the origin of this art made of unguents and colours', confirms the modernist concern with truth to the materiality specific to each art. He continues, 'As for the public, arrested, itself, in front of the immediate reproduction of its multiple personalities, is it never going to turn its eyes away from this perverted mirror . . .?'[73] In 1874 very few wished to do so, and to accept the invitation to see posed by Impressionist paintings.

Burty commented that at first sight 'everyone . . . sincere and courageous' was impressed by 'the clarity of colour, the frankness of the massing, the quality of the impressions', but that a second view 'does not fail to come into conflict with received ideas as to finish, chiaroscuro, the pleasantness of sites'. Many of the critics shared his view, but his reservations about sketchy technique were expressed most forcefully in conservative journals like *La Presse*, where Cardon wrote, 'Soil three-quarters of a canvas with black and white, rub the rest with yellow, distribute red and blue spots haphazardly, and you'll obtain an impression of spring in front of which adepts will fall into ecstasy'.[74]

Today one has little difficulty in 'reading' the thick smears and dabs of blue-lilac and rose-tinted greys and orange in *Impression, sunrise*, but this should not lead one to underestimate the inability or unwillingness of Monet's critics to interpret the pictorial signs. Since 'impressions' had been accepted for many years in the Salons and appreciated as the rapid registration of ephemeral effects, Monet might have expected that his use of the word 'impression' in his title would induce critics to see his work in terms of an established mode. But only Castagnary did so:

If one insists on characterizing [these painters] with a word which explains them, it will be necessary to create the new term of *impressionists*. They are *impressionists* in that they represent not the landscape, but the sensation produced by the landscape. The word itself has passed into their language: Monet's *Sunrise* is not called 'landscape' in the catalogue, but 'impression'.

It was not, Castagnary said, their espousal of *le non-fini* which was new – that was characteristic of the work of Corot, Daubigny and Courbet – but the fact that they 'exalted it and erected it into a system', so that it became 'a mannerism'. And in this sense, he complained, 'they leave reality and enter full idealism'.[75] Castagnary too refused to examine the works closely and was unable to see the implications of his own realization that the systematic incorporation of *le non-fini* into the process of embodying 'the sensation produced by a landscape', signified a relationship with the motif which developed in time. Deeply involved

104   E.G. Grandjean, *Le Boulevard des Italiens*, Salon 1876

in the defence of Courbet, Castagnary may have felt these qualities superficial in comparison with the grave and dense *stasis* of his exiled friend's painting.

Some critics dealt with the problem of visible paint-handling by recommending that the spectator retreat to a distance or screw up his eyes so that the painting would make sense – Castagnary wrote that he needed 'to cross the street' to look properly at *The Boulevard des Capucines*. It was this painting, a modern subject which could be seen from the gallery windows, which aroused the widest differences of opinion. In *Le Rappel*, d'Hervilly praised Monet's representation of 'the excitement and kaleidoscopic nature of Parisian life', while Chesneau rhapsodized:

Never has the prodigious animation of the public street, the swarming of the crowd on the asphalt and of the vehicles on the road; never has the ungraspable, the fugitive, the instantaneous qualities of movement been seized and fixed in all its prodigious fluidity as it is in this extraordinary, this marvellous sketch. . . . At a distance, in this stream of life, this quivering of huge lights and shadows spangled with brighter lights and heavier shadows, one salutes a masterpiece. One comes nearer, and everything melts away; there remains a chaos of indecipherable palette scrapings.[76]

Conservative critics were most disturbed when the broken brushstroke was used for the human figure: the imaginary painter of Leroy's review exclaimed at the sight of the 'innumerable black paint-lickings', 'Do I look like that when I walk down the boulevard des Capucines?', and Cardon, who was sarcastic but calm when writing about landscapes, exploded:

When it's a question of the human figure, it's quite another thing . . . it's enough to render the *impression* without resolved line, without colour, without shadow or light; to realize such an extravagant theory, one falls into an insane, mad, grotesque mess. The scribblings of a child have a *naïveté*, a sincerity which makes one smile, the excesses of this school sicken and disgust one.[77]

Accepting the impersonal mode of seeing imposed by the modern city, Monet used the same clearly visible brushstrokes to suggest human figures as he used for trees, buildings and pavements, so that the paint signifies that human beings are no more important than the other elements of the objective world, and that they are equally subject to the dynamism of urban nature. The painting exemplifies the dehumanization and relativity of vision which characterized many aspects of

contemporary culture: science had displaced human beings from the centre of the universe; subjected them to purely physical forces; reduced them to a collection of atoms like any other temporary concretion of matter. Avant-garde Realist novels recorded lives subjected to impersonal forces which destroy any notion of free will: the most striking example, Zola's great cycle of works on a single family, not only expresses his horrific vision of the ways in which individual lives are doomed by the 'laws' of heredity and by inexorable social forces, but also presents individuals differently as the point of view shifts from novel to novel.

Both academic art and *juste-milieu* Realism rested on inherited conventions which set humans firmly at the centre of a world conceived as a stable structure composed of finite objects which were differentiated from space and whose wholeness was confirmed rather than disintegrated by light (as in the rigid geometry and clear definition of Grandjean's *The Boulevard des Italiens*, Salon 1876). Humans were not the unchallenged centre of the Impressionists' world, which was not only constantly changing itself, but was changed by the viewpoint and the individual perceptions of the viewer. Their mode of painting, unlike the academic, implied a world about which no final statement could be made.

Thus, although the Impressionists exhibited images of what the bourgeoisie valued – a pleasurable life amidst the delights of the country, the amenities of the new suburbs and the spectacles of the modern city – the images were rendered in a relativist style which many found disturbing. Relativity of vision may have seemed a threat, at a time when most of the middle class wanted absolutes, finding straightforward explanations for defeat and civil war in the decadence of the Empire and the bestiality of the working classes; seeking reparation in hard work and the discipline of *l'ordre moral*, and subscribing in their thousands to the building of the neo-Byzantine Sacré-Cœur as a symbol of national repentance. These *bon bourgeois* would have appreciated the sentiments of the critic of *L'Univers illustré*, who wrote, soon after the Société Anonyme exhibition had closed, that Mercié's *Gloria victis!* on exhibit in the Salon, could 'repair and console', could reconcile the warring factions and parties which divided the nation, and that

Amidst all our griefs it is a consolation to dream of those works of art which will . . . maintain the flame of patriotism and protest against proscription and forgetfulness. No, it is not thus that a fallen and frivolous people acts, determined to finish with all that reminds it of the humiliation it has undergone . . . the possible revenge, the necessary rehabilitation, the implacable hatred.[78]

The Impressionists aligned themselves with those who wished to forget, and to find reparation without brooding obsessively on '*l'année terrible*', on decadence and revenge. It was probably this which made their exhibition welcome to writers whose allegiance was to progressive or radical Republicanism, and who believed in modernization, in the future rather than the past.

The members of the Société Anonyme could have been satisfied with their exhibition: the critics had recognized it as an alternative to the Salon, and there had been praise as well as criticism of their paintings. The Impressionists had acquired a public identity. Nevertheless, the critics tended to regard Impressionism as a passing phase, sharing Castagnary's view that the young painters should grow up and realize their talents by painting finished works. Chesneau ended his article with a warning:

But the 'Société Anonyme' – since there is a limited-liability and even a co-operative company – should think of this. Its present organization opens the door to all the

incompetents, all the laggards of the official exhibitions, as shareholders. It's the kiss of death.

    If the society does not reform its regulations, if it does not affirm a common principle, it will not survive as an art society. Its survival as a commercial company does not interest me in the least.

Unfortunately, although Burty claimed that the Impressionists had 'already conquered . . . those who love painting for itself', not many of their works were sold. None of Monet's major paintings were purchased at the exhibition, although Ernest Hoschedé bought *Impression, sunrise* for 800 frs. immediately afterward. Since the Société Anonyme had only just covered its costs, it was dissolved in December 1874 without holding a second exhibition which had been announced for the autumn of that year.[79]

## III

With one significant exception, Monet painted only at Argenteuil for the two years between the first and the second Impressionist exhibitions. Following Daubigny's example, he had a rowing boat converted into a studio so that he could paint on the river itself. Manet depicted him in this studio-boat as a confident, energetic figure, painting that part of the river where the pleasure boats congregated, with, in the distance, the smoking chimneys and the spire of a villa which Monet often depicted. Manet showed his friend in the act of creating his chosen world from the chaotic life around him — and doing so in an almost familial situation, with Camille accompanying him in the private space of their boat.

    It would never occur to today's spectator that the luminous water depicted in these paintings was heavily polluted by thousands of litres of human waste pumped daily into the Seine a short way upstream from Argenteuil. Tucker quotes from the official reports and newspaper articles which complain of the sludge, the stench, and the 'accumulation of filth, dogs and cats in putrefaction'; in 1874, the *annus mirabilis* of these lovely paintings, the mayor of Argenteuil wrote, 'Before long, maybe in several days with the heat, the water level is going to drop again and expose a considerable area of chokingly smelly slime', and by 1878, a few months after the Monets left the town, the mayor had announced that 'the pollution of the river is complete'.[80] Maupassant's experience of the Seine as 'that lovely, calm, varied, stinking river, full of mirages and filth' would have been shared by the first admirers of Monet's paintings, but naturally they preferred the flawless dream image, the mirage of the perfect summer days of memory. Nineteenth-century photographs of the pool at Argenteuil show how completely Monet transformed the messy incompleteness of the modernizing river into sensuous plenitude and closure. His focus on each tiny incident of light as revealed in each ripple, each change of colour, enabled him to construct a world which was his own, which was 'real', but which excluded any reference to realities which might threaten it.

    The studio-boat allowed Monet to glide from motif to motif and to retain his privacy amidst the busy summer pleasures, and it facilitated his more intensive investigation of single motifs seen from a variety of viewpoints. His views of the road bridge suggest his movement around the bridge as he viewed it from a distance or from close to; frontally or from sharp or oblique angles; in greyish light, or more often in the brilliant light of a summer's day. These experiences were embodied in

different colour structures, and in different techniques ranging from the broad and sketchy to delicate tissues of colour. In the 1860s Monet's painting campaigns were subordinated to the production of major works for the Salon, but in the 1870s his *oeuvre* came to represent a continuous engagement with a complex external world which was itself changing. As early as 1864, he had begun painting pairs of works under slightly different conditions of light (W.29–30), and he had recently painted two pictures of the poppies at Argenteuil (W.274–275), and four of the promenade (W.221–224; ills.114 and 124), but it was only when he settled down to paint Argenteuil, rarely venturing beyond the river as it crossed the town or further than two kilometres (1¼ miles) away from it, that continuities between different groups of works began to develop. The significance of this continuity was originally private, for Monet did not exhibit interconnected works until the second Impressionist exhibition of 1876, so they were seen only by his painter friends, his dealer, and perhaps by critics and collectors who visited him

105    Edouard Manet, *Claude and Camille Monet in the studio-boat*, 1874, 80 × 98 (31½ × 38½)

106    The pool at Argenteuil, *c.* 1875

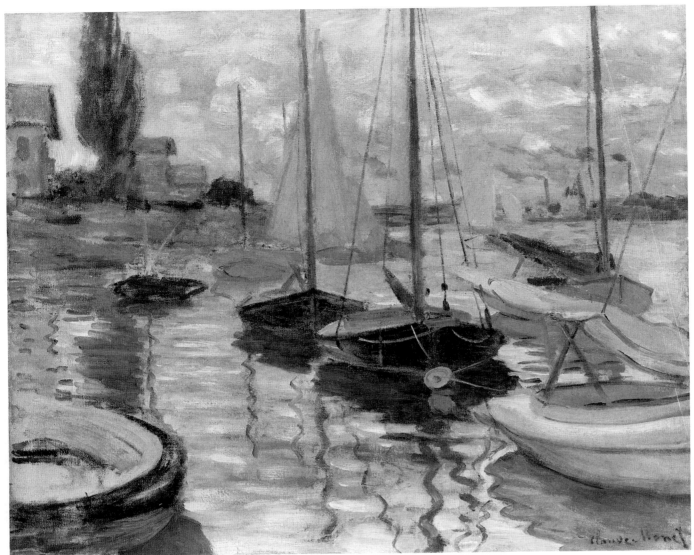

107    *Yachts moored at Petit-Gennevilliers* (W.227), *c.* 1874, 54 × 65 (21 × 25¼)

*Opposite:*

108    *The Road Bridge, Argenteuil* (W.312), 1874, 60 × 80 (23½ × 31¼)

109    *The Road Bridge, Argenteuil* (W.315), 1874, 54 × 73 (21 × 28½)

at Argenteuil, none of whom purchased related works until the later 1870s.[81] Monet himself seems only gradually to have realized that this mode of working might have an appeal for potential patrons.

Seen in interconnected groups, the paintings reveal themselves as part of a continuous process of creating an internally meaningful world from the raw material of modern life, and they suggest, once again, that the fragmentation of Monet's mode of visualization made necessary a compensating search for continuities which were themselves undermined by his dedication to the truth of experience. These contradictions were made more intense by the fact that, although *'la vie moderne'* impelled Monet towards painting what could be glimpsed in the moment, what existed in that moment was so complex that it took a long time to paint. Even quite small details, such as the under-side of the first arch of *The Road Bridge, Argenteuil*, reveal infinitely subtle interchanges between direct light (from the unseen side of the arch), diffuse light, and light reflected from the water which itself reflects the illuminated shadows of the arch. With such complexity Monet could not have 'known' what he had seen in the moment of apprehension. A less finished work, depicting a single pier of the bridge, should be seen less as a study, a preliminary, than an alternative mode of grasping the moment. Monet's desire to construct continuity within the modernity

to which he was committed was one which he shared with his class — perhaps with particular intensity after the traumas of 1870–1. This continuity was built from the moments of the modern present, and was thus fragmented from within.

Monet's work also had to be sold. The relatively small paintings recording his intensive investigation of Argenteuil were purchased by a small group of collectors which included — besides fellow artists and writers, the opera singer Jean-Baptiste Faure, and the Romanian doctor Georges de Bellio — representatives of the modern financial–industrial complex, some of whom had occupied influential positions in the Second Empire. These included the bankers Albert (or Henri) Hecht and Ernest May, the stockbroker Clapisson, the department-store owner Ernest Hoschedé, the businessman Fromenthal, the industrialists Jean Dollfuss and Henri Rouart (the latter also a painter, who exhibited in some Impressionist exhibitions), the entrepreneur and newspaper-owner François-Henri Débrousse, the publisher Georges Charpentier, and possibly V.E. Dalloz, a journalist, Second Empire deputy and administrator. Bankers, industrialists, entrepreneurs, together with what Gambetta called *'la bourgeoisie plus moyenne'* — professional men, journalists, shopkeepers, owners of small enterprises — animated by faith in progress, were to be the major support of the new Republic. In 1877,

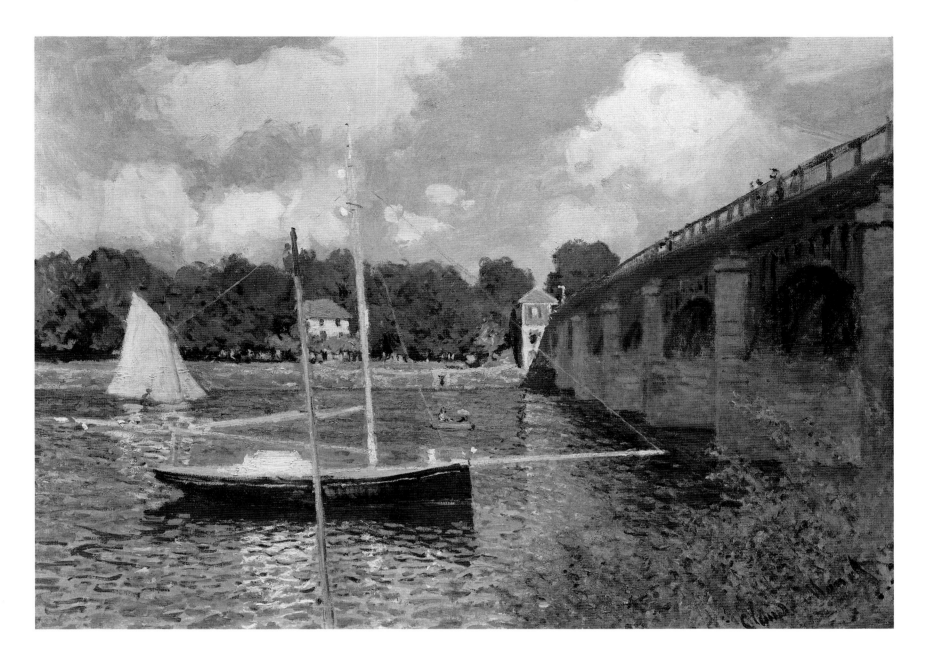

Gambetta would celebrate their adhesion to it as a sign 'to France and to Europe, that there is no longer division in our country', and that there was a 'fusion between bourgeoisie and workers, between the capital and labour which fertilize one another'.[82] These businessmen appreciated Monet's paintings of modern life, although their purchases show that they were interested, not in the continuity of his investigation of Argenteuil but in paintings as a record of unique moments of individual sensibility. Moreover, after the early 1870s, Durand-Ruel was in financial difficulties and could not continue buying with the prodigality he had shown between 1871 and 1873. Monet's income for 1874 fell drastically to 10,555 frs. (which included 4,200 frs. from Faure and the 4,800 frs. which Hoschedé paid for five paintings), less than half what he had earned through Durand-Ruel's purchases in 1873. This was still a substantial income for the period, but nevertheless one finds him writing to Manet asking for a loan to tide him over the next rent day. Without the purchases of Hoschedé and Faure (and, to a lesser extent, de Bellio) between 1874 and 1878, Monet would have been in even worse straits, since most collectors of his paintings tended to choose small, sketchy works or to buy cheaply at auctions.[83]

At Argenteuil the contradiction at the heart of Monet's work between the momentary and the continuous, between modern

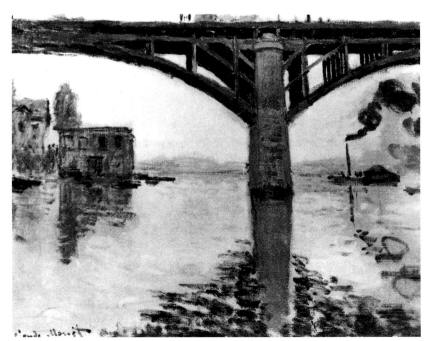

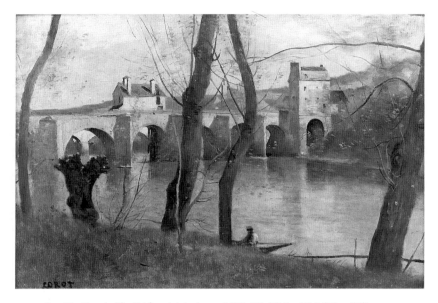

110   Camille Corot, *The Bridge at Mantes, c.* 1868–70, 38.5 × 55.5 (15 × 21½)

technological time and natural time, was embodied in two of his most important subjects of the 1870s: the train and the river. These were not only his subjects, but the means by which Monet had explored the Seine valley since he first visited Paris in 1859. The time of the river is unbroken; each phase flows ceaselessly into the next; it changes constantly, yet remains the same. The time of the railway is fragmented into standardized measures by timetables dictated by the world of work, and enforced by the inexorable command of the signal. The two subjects intersect in a group of paintings of 1873–4 which depict the continuous time of the river punctuated by the regular arrival and departure of the Paris train over the iron bridge. Two of these paintings were painted from the same viewpoint in different effects of light which alter their entire structure. In the motif depicted in grey light (ill.121) there are only short reflections, and the river flows past the great piers, its surface puckered against the current by the same wind which blows the engine's smoke before it. In the sunlit work (ill.112), the emphatic reflections of the piers carry right across the water, as if arresting the river, so that only the implied movement of the wind-driven yacht gliding towards the stark bridge suggests the intersection of natural and machine time. In *By the bridge at Argenteuil* (ill.113), the bridge slices across the landscape and severs the church spire, in a graphic expression of the superseding of the past by the present, and it is only the wandering Camille and Jean who give some continuity to the landscape.

Monet carefully structured these contrasting modes of time, and may well have utilized what he had experienced in the rapid movement of train travel to express the 'shock' of the moment, just as he had utilized the structures revealed by the mechanical click of the camera shutter or of modern graphic techniques. Earlier landscapists had moved slowly through a landscape which revealed itself as a continuity in which each phase flowed into the next, while from a train – as is suggested by Daumier's *A Third-class Carriage* – a landscape is grasped in rapidly superseded fragments, snatched glimpses and staccato juxtapositions. In the pair of paintings of the railway bridge, Monet depicted the machine-age sleekness of the bridge emerging suddenly from feathery bushes, while at its far end a break (a shadow in the sunlit painting, a patch of light in the cloudy one) isolates the bridge as a

strange, top-heavy fragment in the soft landscape. This stark juxtaposition of the rural and the technological shows the railway bridge in symbolic relationship to the countryside rather than in its functional relationship to the industrializing town with its factories and port facilities (as Jongkind depicted it in his stark *Bridge of l'Estacade, c.* 1853; ill.90). More exact realist documentation would have detracted from the coherence of Monet's construction of the modern as pleasurable spectacle.[84] In contemporary journalistic illustrations of this kind of subject the notion of progress is generally spelt out with some literalness by showing aspects of the past being superseded in the present. In Monet's paintings it is embodied in such a way that the apprehension of the present moment cancels out the losses of the past, as if to maintain the present as pure enjoyment.

All that summer of 1874 Monet painted the happy life on the river to which the train gave many city-dwellers easy access, depicting the yachts in regattas with wind-filled sails racing across the water, gliding past leafy banks, or moored waiting for the weekend visitors, their bare masts creating delicate geometries. The many images give an impression of shifting, fleeting moments as inconstant as the water itself. Although the river is busy, few figures are shown, and it was generally only in drawings of people watching a regatta or on a racing yacht that Monet showed any interest in those participating in these activities such as he had shown in the 1860s in his plans for large-scale pictures of modern recreation.[85] The paintings of boating suggest a world of ideal freedom, of hours of physical enjoyment snatched from the inexorable timetables of the modern city. Maupassant described his love for the river, for ten years his 'only absorbing passion . . . I loved it all with an instinctive passion of the eyes which spread through my whole body with a profound and natural joy'. In Monet's paintings of the river, too, visual experience becomes total and exclusive, and does not require the human figure with which to identify.[86]

Within this group of paintings there re-emerges a minor motif – the villa with steep roofs and a spire in Louis XIII style at the end of the

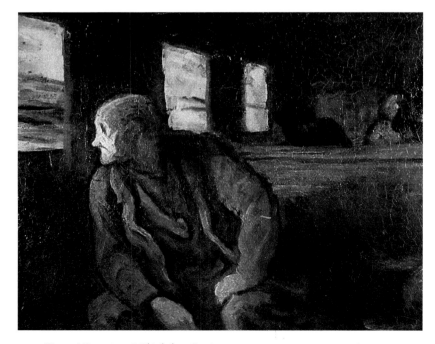

111   Honoré Daumier, *A Third-class Carriage, c.* 1865, 23.5 × 32.6 (9 × 12¾)

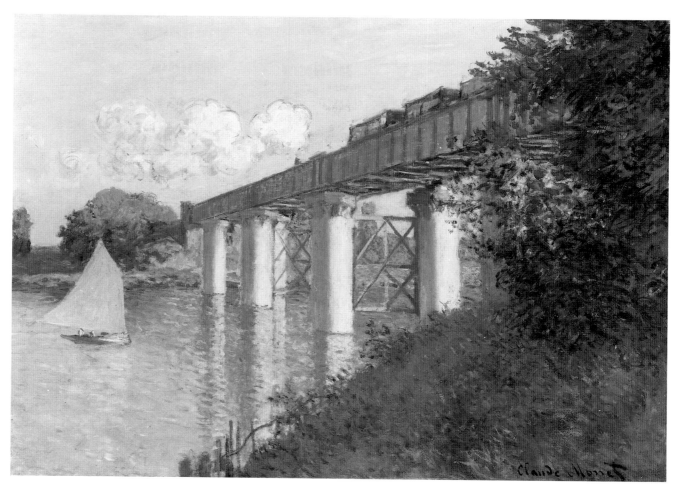

112  *The Railway Bridge, Argenteuil*
(W.318), 1874, 54.5 × 73.5 (21¼ × 28¾)

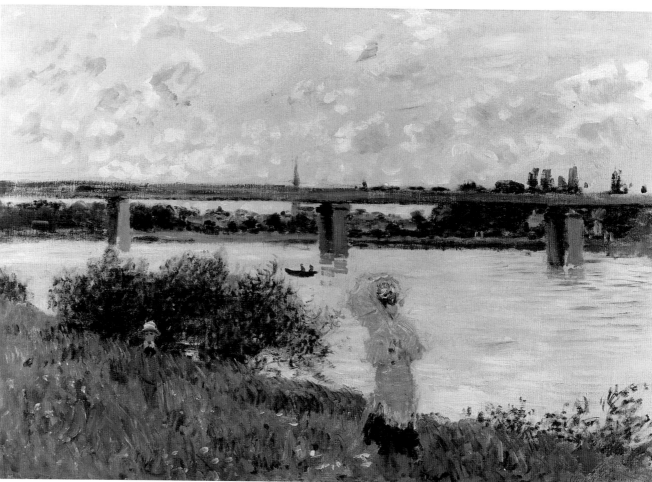

113  *By the bridge at Argenteuil*
(W.321), 1874, 54.3 × 72.4 (21⅝ × 28½)

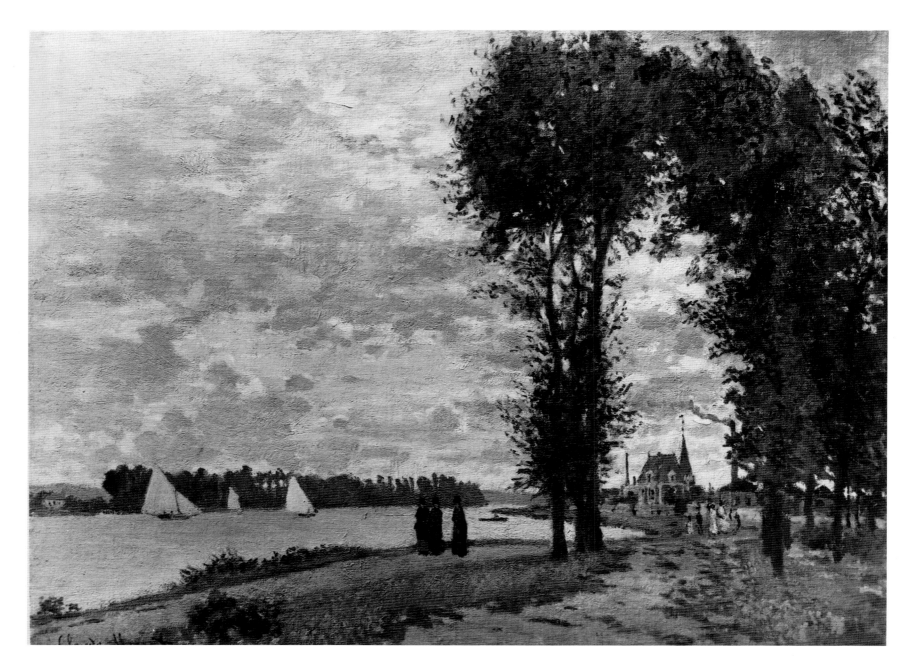

promenade which Monet included in at least thirty works. His use of this motif may have been influenced by the recurrent image of Fujiyama in Japanese prints — he owned nine prints from Hokusai's *Thirty-six Views of Mount Fuji*, two from Hiroshige's set, and five other works by Hiroshige in which the steep triangle of the mountain is shown from many different viewpoints, appearing unexpectedly behind other motifs, sometimes the clear 'subject' of the image, sometimes almost invisible (ills.46 and 96).[87] It is unlikely that Monet conceived any of these works as a series (the paintings were sold separately and he did nothing to indicate their interconnectedness), but the constant presence of this motif, from the time of his first paintings at Argenteuil in early 1872 to his last in 1877, reveals his seeking to grasp the reality of the Seine at Argenteuil by continuous but fragmented movement around it. Many of the Japanese sets of prints were conceived as journeys — journeys significantly different from those recorded in railway guides. This was true of Hiroshige's *Fifty-three Stages of the Tokaido*, from which Monet owned three prints — and something of the restless continuity of the journey characterizes Monet's relationship to Argenteuil, and can be compared with Corot's calmer assimilation of the Seine a few kilometres away at Ville d'Avray.

In the first painting in which the villa appears, it is placed half-way between the sides of an inner frame created by the road bridge, like the pivot of a balance between the yacht on the left, and the steamboat on the right; in his last paintings at Argenteuil it appears like a dream château beyond a foreground blazing with flowers. In the years between, Monet represented it at every season, in sunlight, flood and snow, from early morning through the noon light to sunset, and from many different viewpoints — along the promenade; from the rural peace of the Petit Bras; from the river basin with its tangle of boats, through the road bridge, tucked behind the boat-rental office, hidden behind masts and sails; from across the river with an untidy straggle of suburban development or, almost dream-like, behind reeds painted with an Oriental delicacy. As Monet's relationship to it changed, so did his relationship to other motifs — bridge, banks, promenades, trees, chimneys, boat house — which act as markers for his changes of viewpoint, and which also register the interpenetration of time dependent on the city with the continuous time of the river. Reviewed together, these images have an obsessive inconstancy which shakes conventional assumptions about the stability of reality and confirms the aptness of Mallarmé's comment that 'the represented subject, which

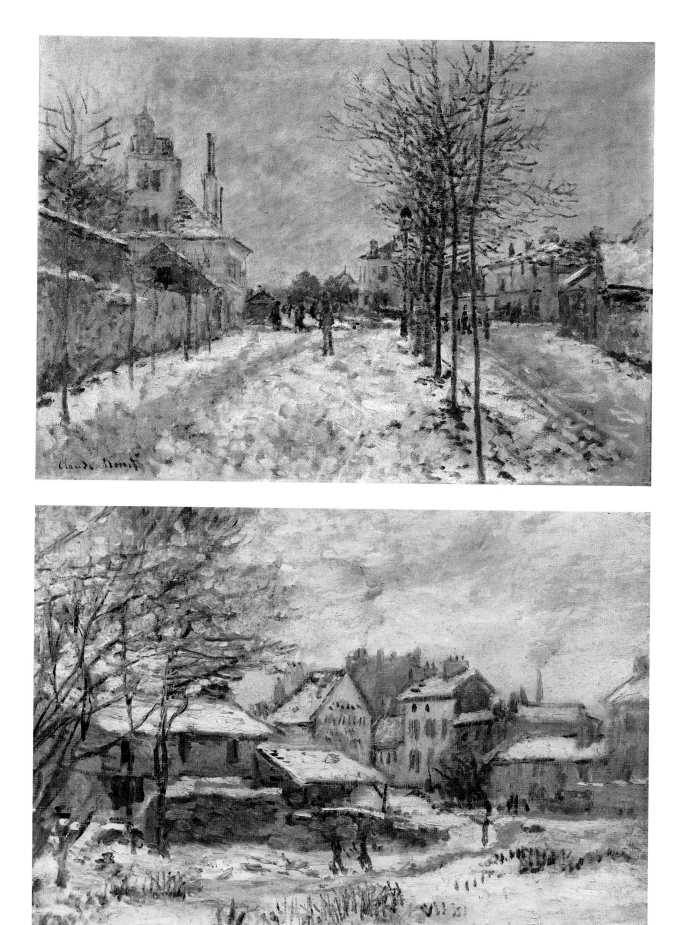

Opposite:

114 *The Banks of the Seine at Argenteuil* (W.221), 1872, 53 × 71 (20¾ × 27¾)

115 *The Boulevard de Pontoise at Argenteuil, snow* (W.359), 1875, 60.5 × 81.5 (23½ × 31¾)

116 *Snow effect, sunset* (W.362), 1875, 53 × 64 (20¾ × 25)

being composed of a harmony of reflected and ever-changing lights, cannot be supposed always to look the same, but palpitates with movement, light, and life'.[88]

Rendered in almost as many ways as there were paintings, the motif of the villa registers Monet's exploration of the ways in which marks of colour could embody his perceptions of the river. Mallarmé wrote with real insight that Impressionist painting did not imitate 'the material portion' of nature, but gave the artist a sense of 'the delight of having recreated nature touch by touch'. This can be seen particularly clearly in the four paintings of the villa at the end of the promenade, painted in the summer of 1872 (W.221–224), in each of which there is a different structure of brushstrokes and scale of colours (ill.114). In *The Promenade at Argenteuil* (ill.124), which represents the river in the warm light of a summer's evening, the colour structure and brushwork are more dense and subtle than the vigorous painting of the same scene with an overcast sky and racing clouds. In the former Monet painted the water in a saturated blue and, once it was dry, dragged wet strokes of brighter blue, blue-green and pale mauve over it in a way which suggests that the water is so calm that the reflections on its surface are almost undisturbed. He interwove a scale of greens with a warmer scale of pinkish tones, and with another of violet-blues which range from near-white in the sky and the brightest water to deep mauve in the roof of the villa, vivifying them with sharper, clearer 'notes' of colour – a bright pink roof, violet hills, white dresses and sails, a distant patch of bright green grass. The painting is unified by a web of subtle correspondences between line and colour, some of which (as in the shadowed trees on the island and the tiny finials on the house) are so delicate as to be almost imperceptible. The piers of the bridge are represented by dots of light which 'read' as verticals, and which link with the hair-line horizontal of the bridge to form a micro-structure that allows one to gauge the diagonals which act as guides into depth, and which are such delicate deflections from the horizontal that they do not fracture the tranquil surface. The exquisite subtlety of these relationships is equalled by that of the colours: for example, those representing the evening light coming through the screen of trees – thick strokes of yellow-green on the grass, orange-yellow on the mauve, blue and violet path – are found in pastel shades in the buildings and – again almost invisible – behind the bridge.

Monet returned to this view of the motif in the winter of 1874–5 when he also did a number of paintings of Argenteuil under snow which allowed him to show as beautiful some of the aspects of a traditional town being transformed by modernization.[89] He did not describe the major manifestations of change – factories, new streets, housing developments – but suggested change by showing its traces in the smoke-filled sky or in the transforming cover of snow. This can be seen in *Snow effect, sunset* (ill.116), in the uneven humpiness of the snow which suggests an urban waste, unshaped by the straight pavements and gutters of a modern boulevard such as Monet depicted, in steely light, in *The Boulevard de Pontoise at Argenteuil, snow* (ill.115). As a group, these paintings convey the untidy, random change which occurs in a conurbation once modern development shatters its old fabric, and they suggest that Monet conceived the modern in terms of interacting forces which could be caught in the moment, rather than through the enumerative description of the components of change.

When Monet painted the modern, he depicted only its pleasurable qualities, merely hinting at any disagreeable aspects in shadowy silhouettes or in smudgy traces which could be viewed aesthetically. In *Snow effect, sunset*, the heavy smoke and the grey mass in the dirty yellow sky indicate the presence of the huge Joly ironworks which employed hundreds of workers and supplied bridges and girders throughout France and Europe. This was as close as Monet got to depicting the factories which were springing up in the town, to the consternation of its inhabitants, who were disturbed by the clangour and stench, the noxious even corrosive wastes. Although he was concerned with the visible effects of change, nowhere did Monet depict what produced such change: industrial labour, commercial activity and financial speculation.

A number of modern commentators seem almost to share Zola's disillusion with the Impressionists brought on by their refusal to emulate the discursive form of the novel which, Zola believed, should treat every aspect of contemporary life no matter how complex. These commentators have failed to see that the paintings of Monet, Degas and Manet could render the bourgeois world-view as keenly as could Zola's epics of commerce and finance, precisely because they were restricted to what could be seen in the moment.[90]

Monet's only painting of labour, *Men unloading coal*, shows labourers reduced to impersonal parts of a machine, locked inexorably into its endlessly repeated, fragmented movements.[91] The painting does not invite the spectator to consider the human meaning of this labour, probably because the figures are treated almost decoratively, like musical notes on a stave, without individual life. Monet painted this work at Asnières, an industrial suburb of Paris, away from his semi-urban Utopia at Argenteuil, and the fact that the work was not part of a painting campaign in that industrial area suggests that the scene caught Monet's attention as an interesting motif as he was passing. In this it has something of the truth of a class relationship found in Courbet's painting of stone-breakers, seen as he passed by them in a carriage, and posed in his studio in such a way that they preserve the anonymity of working people observed from such a position. By the arrangement of their limbs and tools across the surface of his painting, Courbet assimilated these figures into an endless mechanical process, yet the intensity of his observation allows something of the individual life of the old man and the boy to reach expression, if only in terms of an obdurate physicality which the painter could see, but not know. By contrast, Monet's attention may have been drawn to the motif by its similarity to a print by Hiroshige in his collection. 'The Coast of Kujukuri in the province of Kazusa', and this would suggest that Monet's attitude to the figures was mediated by the pictorial, in particular by an exotic, pre-industrial image.[92] The labourers were, then, distanced by a bourgeois class-view which was more securely internalized than in Courbet's case.

Mallarmé described the Impressionist as 'the energetic modern worker'.[93] In Monet's world the only people who work are painters: in the summer of 1874, he depicted Manet at work (W.342); Renoir represented him painting in his garden (ill.97), and Manet pictured him in his studio-boat on the sunlit river, creating the world he wanted to see (ill.105). Unconstrained by the pitiless demands of machine-time which ruled the men unloading coal, the painter's work is represented as free and pleasurable. Monet's painting of labourers was consistent with a class view which, far from desiring to know the truth of such conditions of labour, was determined that they should not be seen. The Commune's attempt to ensure that workers were properly rewarded for their labour had profoundly threatened the free-enterprise system which had brought prosperity to the French bourgeoisie; Durand-Ruel's support of Monet's work between 1870 and 1873 would have made it clear that his

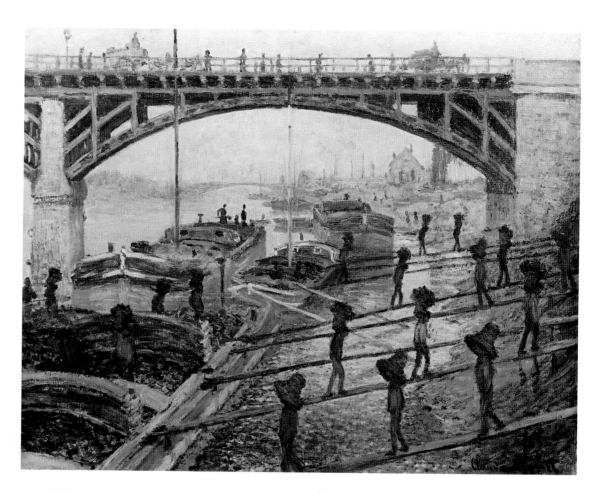

117 Utagawa Hiroshige, 'The Coast of Kujukuri in the province of Kazusa', from *Famous Views of various provinces*, 1853–6, woodblock print, 33.6 × 22.4 (13 × 8¾)

118 *Men unloading coal* (W.364), 1875, 55 × 66 (21½ × 25¾)

existence as a painter of modern life, and the maintenance of a bourgeois life-style on which that existence depended, were themselves dependent on speculation on his work. His painting was, then, an aspect of the miracle of reconstruction in post-Commune France; but rather than depicting the processes of reconstruction, it displaced them into the processes of art.

The *Men unloading coal* was purchased by one of the two bankers, Albert and Henri Hecht, at an auction of works by Monet, Morisot, Renoir and Sisley held at the Hôtel Drouot in April 1875. The 74 paintings would have made a much more homogeneous exhibition than that of the Société Anonyme, and it was probably this that provoked a clearer division between the supporters and opponents of the Impressionists. The conservative and radical press tended to take antagonistic positions. A journalist who approved of the exhibition wrote in *L'Echo universel*, 'even in the best days of the great struggles of Romanticism against the academic never were there heard more maledictions or more expressions of enthusiasm'; the sale-room columnist in the conservative *L'Art* said that the room at the Hôtel Drouot was 'literally crammed, and the bids were disturbed by regrettable asides of doubtful taste', while 'serious critics' supported the artists' right to submit their work 'to the reasoned judgement of the public'. He went on,

. . . one could not see without smiling several worthy chaps well up in matters concerning colonial goods, calico and flannel, decked in borrowed plumes as connoisseurs, in front of the most formless scribbles; we heard one of them speak of the genius of M. Claude Monet and pronounce the great name of Turner in the same breath as the ignorant aberrations of this painter . . . .

And, abandoning his supercilious detachment, the writer claimed that 'these pseudo-collectors' were 'nothing but vulgar speculators'. Albert Wolff in *Le Figaro* raised the same issue: 'perhaps those who speculate on art of the future could make good business', he said, from paintings

which could be produced 'by a monkey who had got hold of a box of paints'. Burty – who had written the preface to the auction catalogue – claimed in *La République française* that: 'Peevish connoisseurs and idlers who had taken their orders from well-known studios tried to interrupt the bidding which was very gallantly sustained by a group of serious collectors'. The journalist in the radical *Le Rappel* – probably d'Hervilly – echoed Burty's praise of the paintings as 'little fragments of the mirror of universal life', and a day after the sale wrote defiantly, 'I must not hide from the enemies of the impressionists – since there are impressionists – that I have bought one of these canvases and my collaborator Emile Blémont has bought two.'[94]

The establishment of the Republic only two months before the auction had not led to a diminution of political tension, for MacMahon was determined to maintain repressive conservative government. Moderate Republicans supported the constitutional laws, but many of the '*intransigeants*' opposed them, since they believed that such laws preserved the power of the traditional ruling classes. The principles of *l'ordre moral* were applied with increasing rigour. Demands for a morally elevating art found a response in Baader's huge allegory, *Remorse* (Museé d'Orsay), shown in the Salon a few weeks after the Impressionists' auction; but Ernest Pichio's *Triumph of order*, or *Le Mur des fédérés* (lost) – the place where the last resisting Communards had been executed – was banned from the Salon by the Directeur des Beaux-Arts, de Chennevières, on the grounds that 'Such sorrowful memories should not be evoked at a national gathering; they are . . . of a kind to arouse the political passions to which art must remain foreign'.[95]

The author of the 'Chronique de l'Hôtel Drouot' in *L'Art*, which contained an account of the Impressionists' auction, commented that March 1875 was the first time sales of paintings had felt 'the disastrous influence of political uncertainties', and it was probably this, together with suspicions of political radicalism, which resulted in the very low

prices the Impressionists obtained for their works. Monet received only 2,825 frs. for his 20 works, including what he himself paid (with Durand-Ruel's help) to buy back certain works, the prices of which he felt were too low (the *Meadow at Bezons* [ill.122], at 190 frs., the *Men unloading coal*, at 225 frs., and the interior of his house, with Camille and Jean [ill.127], at 324 frs., were the highest prices paid for his work).

The auction was used as a public occasion at which to rehearse political allegiances. The supporters of the Impressionists could demonstrate the modernity of their outlook: in purchasing *Men unloading coal*, the banker Hecht could, at little cost, display his independence of the economically conservative forces of the early Republic, by acquiring a painting which was stylistically advanced, but which transformed urban work into an aesthetic spectacle. Conservatives, on the other hand, used the occasion to criticize the relationship between the new painting and 'vulgar speculators' by mocking the ignorance and misreading the status of those in the modernizing financial–industrial complex who purchased the works.

Although Monet's work attracted a few new buyers in 1875, the auction marked the beginning of an eight-year period of chronic financial difficulties, in which his dream of creating landscape painting modern in both technique and subject eventually foundered. In the summer he returned to paintings of the river; as is seen in a picture looking across the water to the distant villa, Monet still used small strokes which dissolve forms into vibrating tissues of colour, but he made these strokes larger so that the colours become more intense, and the structuring of the paintings more assertive than in earlier, more tightly painted pictures of this motif.

At about this time Monet wrote to Manet: 'Since the day before yesterday I haven't a sou or any credit either at the butcher or at the baker's. Although I have faith in the future, you can see that the present is really painful'; ten days later he wrote that he was 'in the clutches of a bailiff'. It may also have been at this time that he told Manet that, if he could not escape his situation, 'my box of colours will be closed for a long time. . . . As I said to you, it's finished'.[96] And yet he was painting some of the loveliest pictures of his career — those of Camille, Jean and friends in fields of poppies and in the garden of a new house to which the family had moved in autumn 1874.

Monet's wife and son appear in so many of the Argenteuil landscapes that one has a poignant sense of their role in his transformation of Argenteuil into his own world. The sense the two figures give of progression through the landscape may have been influenced by the Japanese prints representing journeys, and by those which show people visiting the country to enjoy the beauties of nature. One of the prints owned by Monet, Hiroshige's 'Picnic to admire the red maples at the Kaian temple at Shinagawa' (ill.95), depicts two pairs, each of a woman and child, passing through a visitor's landscape as they do in the *Poppies at Argenteuil*.

As Tucker has shown, the four pictures (W.377–380) of Camille and Jean in fields on the plain of Gennevilliers, across the river from Argenteuil, were painted in an area which had been irrigated and fertilized by untreated waste from the Paris sewage system. In 1875, it was proposed to increase the area so treated, and in 1876 an opponent of the scheme wrote:

the roads and paths are bordered by a conduit open to the sky in which flows black and infectious filth. . . . During the real heat of summer . . . a foetid stench rises from these fields. Should our countryside whose general appearance is so radiant be a victim to this transformation, so little to its advantage?[97]

As in the paintings of the polluted river, Monet conjures up a counter-vision of that radiant countryside as a modern Utopia where the joys of leisure could be experienced in their plenitude, and where the characteristics of the domestic garden are transposed to the countryside to exorcise the negative effects of modernization.

The private garden in the suburb, the dream of many city-dwellers, and the promenaders in their city clothes and with their possession of leisure were different forms of the modern city's colonization of the rural, and were summarized in Zola's comment that 'like a true Parisian', Monet 'takes Paris to the country. He cannot paint a landscape without placing fashionably dressed ladies and gentlemen in it'. Prouvaire made a similar point about Morisot's paintings in the 1874 exhibition: 'She confronts the charming artifice of the Parisienne with the charm of nature. It's one of the tendencies of the new school to intermingle what Worth and the good Lord have made. . . .'[98] The leisurely promenade of the women in the closed world of the *Luncheon*, and in the more open garden of *The Dahlias* (ill.98), is also found in *Poppies at Argenteuil*; while the figure of Camille seated in all her city elegance in the *Meadow at Bezons* (ill.122) suggests that she is as secure as if she were in the enclosed family garden.

Monet was all his life a gardener, and his gardening formed part of his picture-making. In his first house at Argenteuil, he provided the Oriental pots filled with flowers (which accompanied the family on all its moves), and may have been responsible for the massing of flowers in closely related harmonies. In most of his paintings of this first garden, Monet chose his viewpoints so as to exclude the surrounding houses, and when those houses do appear, he emphasized the formality of his own garden and its barriers against the surroundings. He placed a corresponding stress on the propriety of Camille's pose as a bourgeois lady of leisure, which is underlined in *Camille in the garden, with Jean and his nursemaid* by a clearly expressed social hierarchy. In other paintings of this garden, like the *Luncheon*, the masses of flowers overwhelm the formal boundaries to create a world turned in on its inhabitants. It was in this private space that Monet painted Camille, for once not passively waiting but rising abruptly from the bushes and arranging her hair, while Jean lies in happy abandon amidst the sun and flowers.[99] The house in which the Monets lived after 1874 — the 'pink pavilion with green shutters', as Monet described it when inviting Victor Chocquet and Cézanne to lunch in 1876 — was one of those built to house Parisians wishing to move to the suburbs.[100] Monet added a part-time gardener to the servants he already employed, and created a garden with his characteristic mixture of formal and informal planting, with large masses of colour.

Monet's gardens concentrated the beauties of nature so that he could paint them with scrupulous attention to what he could see, and thus express an ideal protective harmony as real. Even so the paintings were not without tension: for example, in *The Garden Bench*, Camille's expression is gloomy and her relationship to the gentleman awkward. The isolation of the figures both from one another and from the artist has been interpreted as a sign of Monet's estrangement from his wife, but this is to miss the point of his determined anti-narrativity.[101] Before the early 1880s Claude Monet's personal life is closed to us, but his paintings show that Camille Monet was constantly with him when he worked, not only as a model but, as can be seen in Manet's painting of the two of them together in the studio-boat, as a companion. The evidence of their intimacy reveals something of major significance in his painting.

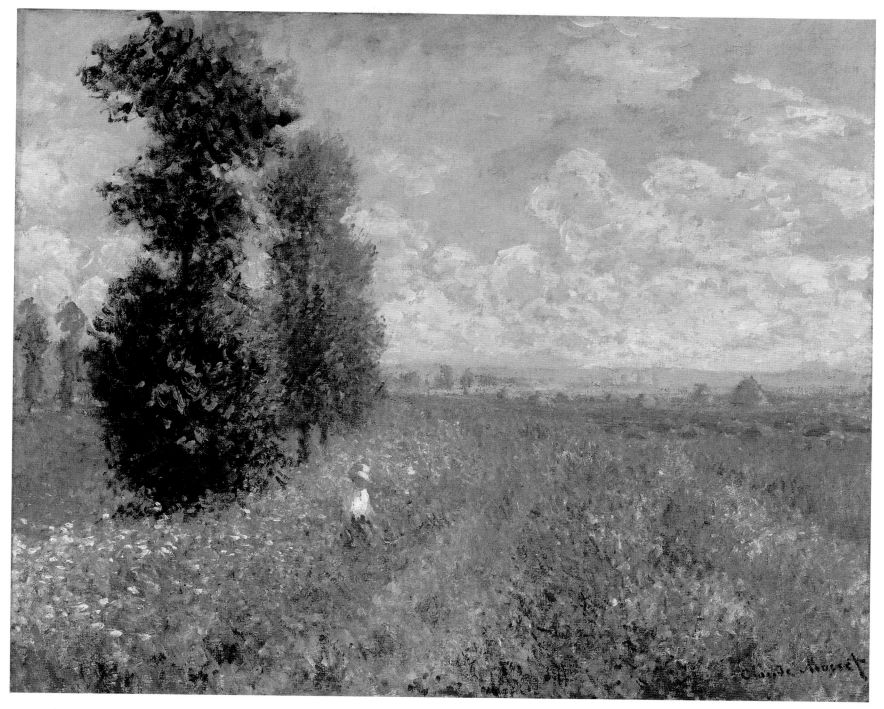

119  *Poplars, near Argenteuil* (W.378), 1875, 54.5 × 65.5 (21¼ × 25½)

120  *The Garden Bench* (W.281), 1873, 60 × 80 (23½ × 31¼)

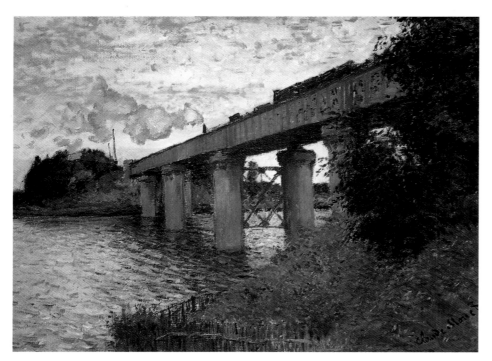

121 *The Railway Bridge, Argenteuil* (W.319), 1874, 55 × 72 (21½ × 28)

122 *Meadow at Bezons* (W.341), 1874, 57 × 80 (22¼ × 31¾)

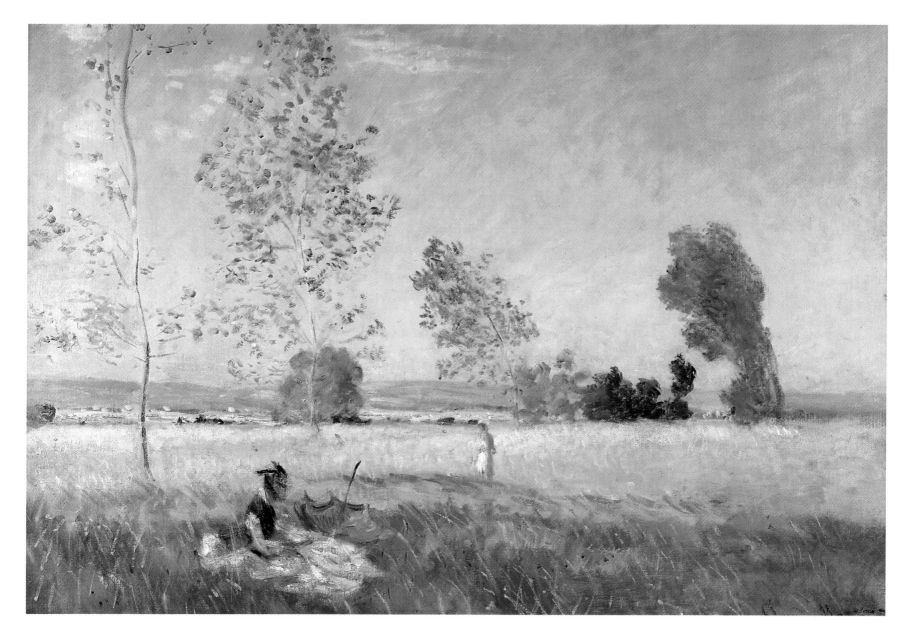

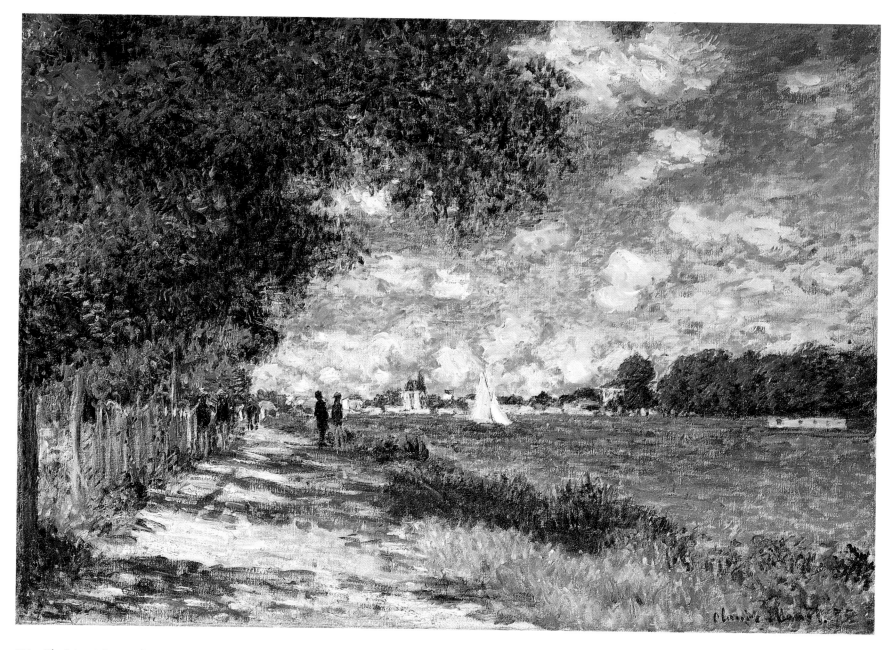

123 *The Seine at Argenteuil* (W.373), 1875, 59.7 × 81.3 (23¼ × 31¾)

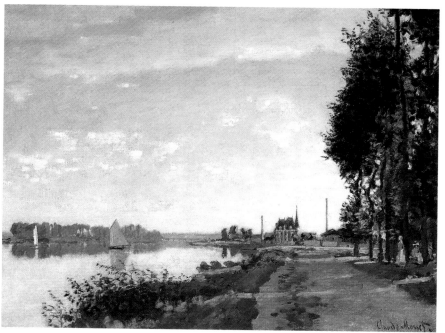

124 *The Promenade at Argenteuil* (W.223), 1872, 50.5 × 65
(19¾ × 25¼)

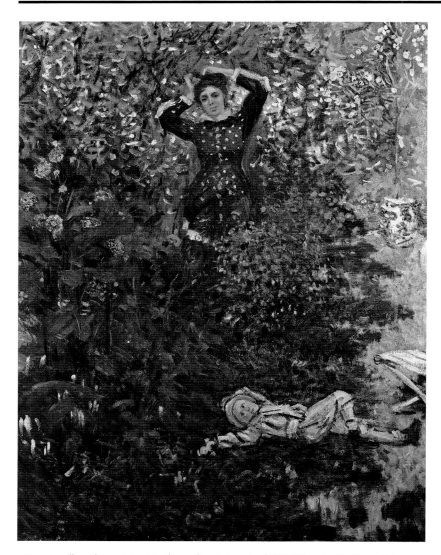

125   *Camille and Jean Monet in the garden at Argenteuil* (W.282), *c.* 1873, 131 × 97 (51 × 37¾)

Paintings of figures seemingly alienated from one another or, more exactly, not shown to be linked by affective relationships, were characteristic of avant-garde Realism's reification of the external world, including the human figure. Manet, Monet and Degas, in particular, represented figures as objects, refusing to invent interconnections between them if these could not be seen, and their vision was so uncompromising that it could shatter figures into particles of paint, and even, in Degas's case, disconnect limbs from a body. Monet's paintings were unusual in that he located this kind of objectification in the heart of the family, where it is generally assumed that intimacy will be visible – and where Morisot, no less dedicated to perceptual truth, was able to *see* affective relationships. An inherited vocabulary of pose and gesture enabled the Salon painter to construct images in which the relations between figures were spelt out in a visible net of discursive meanings; but the artist shaped by avant-garde Realism could not use narrative constructions to cover up the incompleteness of the observed moment. (Here one could compare Tissot's *Hide and Seek* with the painting of Camille and Jean in an interior.) Nevertheless, as is seen in *The Garden Bench*, the Realist approach could give the figure an irreducible material being which allowed it individual life even if – or rather, because – its

inner life was not penetrable by sight. Camille's movement in *Camille and Jean Monet in the garden at Argenteuil* is unexplained, but is haunting precisely because it cannot be explained in narrative terms.

Something similar occurs in *The Promenade* of 1875, in which Monet represented Camille and Jean as if in the instant his wife had turned to look at him, and the breeze caught at her veil and dress, at the fluttering grasses and summer clouds. The only relationship is that conveyed by the separate gaze of the woman and of the child, which intersect with that of the artist as they look down on him with the gravity and inwardness inherent in the human figure, and which this kind of painting could embody. It could thus suggest intimacy, an intimacy prolonged in that casual moment, but made ambivalent by the intensity of Monet's dispassionate gaze.

Adrien Moreau's *La Promenade*, exhibited in the 1874 Salon at the same time as Monet was showing his *Poppies at Argenteuil* in the first Impressionist exhibition, is an example of popularly acceptable narrativity, selected for one of the albums of photographs of Salon works. Prouvaire, writing for the radical *Le Rappel*, said that Monet's painting 'happily mingles the flowered hats of the ladies with the red poppies of the wheat fields'.[102] Both paintings represent elegantly dressed women in the suburban countryside, but Moreau displays a condescension towards the women which was typical of Salon art, implying that all they were interested in was the distant rowers, of the disreputable kind whom Monet painted only once.[103] By innuendo Moreau's painting attaches itself to the long tradition associating sexuality with the water of rivers and streams; Salon art often gave a risqué flavouring to that association, but here the women are protected from a mythical sexualized nature by their over-elaborate restricting clothes, by fences and walls. The women in Monet's painting are obviously ladies (as Prouvaire recognized), but he displays no amused condescension and provides no cute anecdote to explain away their insistent passage through the fields. The picture suggests a kind of idealized freedom, but one which was made secure, not by fences and barriers, but through painting.

Moreau gives an exact account of the material of the dresses, of grass, fence and wall, and completely disguises the material with which he makes his account. Monet's visible brushstrokes call attention to the material with which he represents what he sees, and thus raise the possibility of choosing to see and to represent reality in ways which differ from those chosen by others. Nevertheless, the freedom which Monet's paintings seem to promise is held in ambiguous suspension by his need to construct a world which contains no apparent contradictions. The obverse of that freedom is suggested in the claustrophobic layering of material forms in Monet's painting of Jean and Camille in their house, which he has turned outside in, bringing the garden inside in the potted plants and floral curtains. Nevertheless, as shown by comparison with James Tissot's *Hide and Seek* of *c.* 1877, Monet's very refusal to provide narrative connections suggests that the two figures may have an existence beyond that created by the painter.

While he was painting these idyllic paintings, Monet must also have been thinking of the next Impressionist exhibition – to be held early in 1876 – and of his desperate need to find buyers. His paintings of women and children in the garden and flowery countryside did sell fairly well (Faure, for example, may have purchased *Camille in the garden, with Jean and his nursemaid* in 1874, *In the garden. The artist's family* [W.386] in 1875 and *Poppies at Argenteuil* between 1874 and 1877), but not at sufficiently high prices, and there may have been a connection between

126  James Tissot, *Hide and Seek, c.* 1877, 73.4 × 53.9 (28½ × 21)

*Right:*

127  *Camille and Jean Monet in the house at Argenteuil* (called *Corner of an apartment*) (W.365), 1875, 80 × 60 (31¼ × 23½)

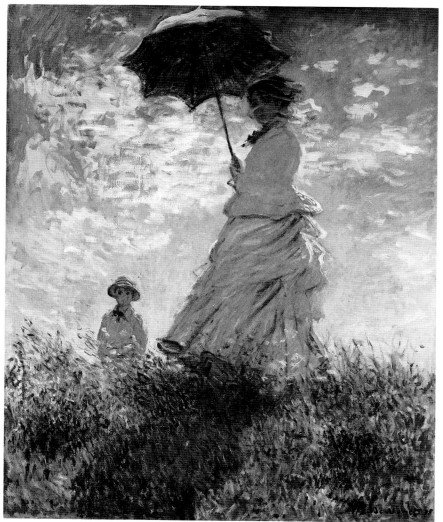

*Left:*

128  *The Promenade* (*Woman with a parasol*) (W.381), 1875, 100 × 81 (39 × 31½)

129  Adrien Moreau, *La Promenade*, Salon 1874

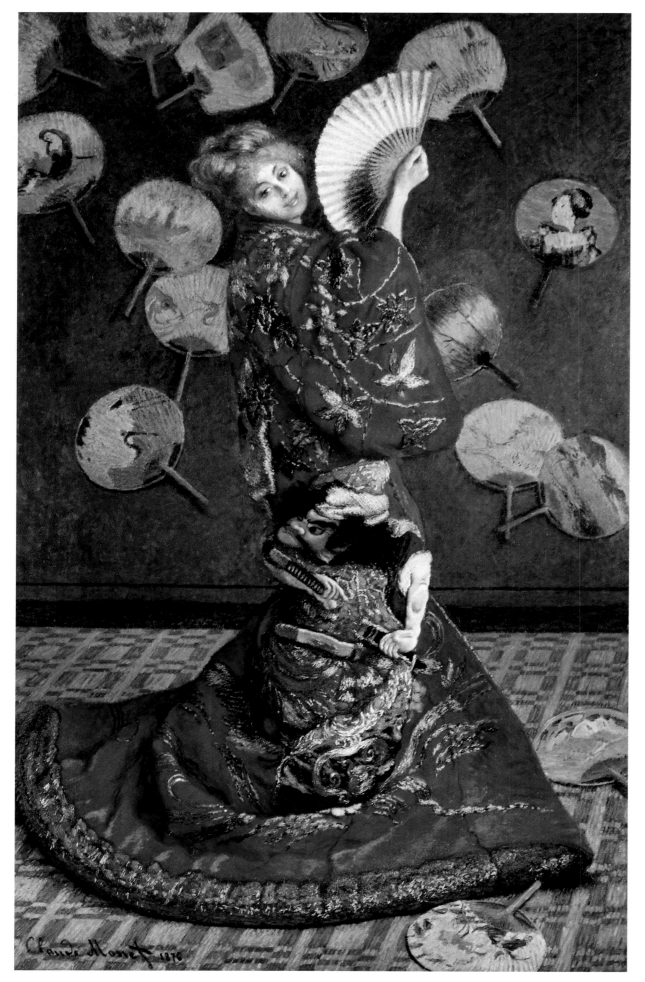

130    *La Japonaise* (W.387), 1875–6, 231.5 × 142
(90¼ × 55½)

the increasing sensuousness of such paintings and the growing financial threat to Monet's possession of the Utopian world symbolized by the garden.[104] *In the garden* — with his wife and son enclosed by vivid flowers, sun-striped foliage and a fence-like line of trees — was painted when his earnings had dropped so drastically that he felt he might have to give up painting. If such works were a means of establishing continuity within the modern, by securing the image of the family in its environment, that ideal continuity was undermined by the failure of the works, considered as money-gaining objects, to preserve it.

The second Impressionist exhibition (not yet so called) opened with 252 works by 20 artists in Durand-Ruel's premises in the rue Le Peletier in April 1876. The works of each artist were grouped together, so that each had something approaching a solo exhibition within the larger one. Monet selected 18 works which represented the varied aspects of his modern landscape painting: 8 works were identified in the catalogue as being painted at Argenteuil or its environs, while 5 others represent Camille and Jean in the family garden or in the fields: *Camille reading*, the *Meadow at Bezons*, *The Promenade*, *The Dahlias* and the *Luncheon* of 1873. Argenteuil was shown as it changed through the four seasons, in paintings focusing on the multiple life of the river: 4 to 8 of these contained the villa motif. The exhibition would have demonstrated the continuity of Monet's exploration of a small, well-known place between 1872 and 1875, thus emphasizing both the instability of appearances and the many ways in which a motif could be depicted. Argenteuil was presented as a place of pure pleasure, with the spectacle of modern life juxtaposed with the joys of the river, and the beauties of the family garden equalled by those of the domestic meadows. Monet also included two paintings of the pleasures of beach and river done in the 1860s, *The Beach at Sainte-Adresse* and the *Bathers at La Grenouillère* (W.136; lost), which demonstrate the continuity of this theme in his *œuvre*. He also brought his family up to date by including the *Luncheon* of 1873 (called *Decorative Panel* in the catalogue), just as he had shown the *Luncheon* of 1868–70 in the first exhibition.

Wholly surprising in this context was a painting called *La Japonaise*, his only work in the exhibition on the scale of the *Luncheon*, and perhaps having a submerged relationship with it, in that it depicts Camille. The picture shows her wearing a Japanese actor's robe and in a pose influenced by Japanese prints of courtesans or actors, some of which were in his collection; it is unique among Monet's paintings of Camille in showing her flirting with the spectator, in a manner more common in the Salon than in avant-garde painting, and quite different from the inwardness given her in *The Promenade*. Monet may have been playing on the European idea of the Japanese geisha as a prostitute; but he stressed the element of masquerade by painting Camille in a blond wig which emphasizes her Europeanness.[105] The coy play of sexual innuendo was characteristic of some Salon art, and it is possible that, in desperation about his financial affairs, Monet sought to repeat the success he had had in the Salon of 1866 with *Camille*; at least one critic noticed the relationship. That earlier painting was believed to represent a prostitute, but few critics made this association with *La Japonaise*, perhaps because the sexual symbolism of the sword-thrust was too blatant to be spoken of. The critic of the legitimist *Gazette de France* was the only one to suggest inadmissible content: '*La Chinoise* [sic] has two heads: one of a *demi-mondaine* on her shoulders, another [of a] monster placed — we dare not say where . . .'. In later life, Monet himself called the painting 'an obscenity', but his comment could have had as much to do

with having introduced sexuality into his familial world as with the ostensible subject.[106] Monet was excited by the challenge of painting the robe and, as critics pointed out, he made his image of the embroidered warrior seem more alive than that of the real woman.[107] Despite this, the model's coquettish glance ensured that the painting would be recognized by conservative critics as conforming to their expectations of how a contemporary woman should be represented.

The 1876 exhibition attracted more sustained critical attention than did that of 1874, but hostility to it was more clearly marked. Several conservative critics emphasized that they had reserved judgement on the first exhibition to see what would eventuate, but it was becoming clear that that had been, not a single publicity-seeking protest against the Salon but a credible alternative, and that the Impressionists, far from reforming in response to criticism, were determined to carry on as they had begun. There were fewer painters exhibiting than had done with the Société Anonyme, so the 1876 exhibition was stylistically more unified than the earlier one, and thus made a clearer statement of opposition to official art. Even the critics of specialist art journals devoted serious attention to the exhibition. In the *Chronique des arts et de la décoration*, de Lostalot wrote that the works shown no longer attracted laughter or indignation, that some of the exhibitors showed real talent, and were now more willing 'to reinforce with intellectual effort the sensory impression they were seeking' — perhaps he felt this because Caillebotte, Monet and Degas all exhibited major figure paintings. Nevertheless, the critic maintained that 'this school . . . declares a profound contempt for those methods which can be taught', and that 'it aims absolutely to subordinate material practice to effect'. Dax was equally inconsistent in *L'Artiste*: he claimed that 'the *intransigeants*' would make a revolution 'more violent and general than that of 1830'; that they displayed 'a profound individuality which one cannot find in the Salon', but that they had 'an absolutely false point of departure'. In *L'Art*, Mancino spattered quantities of ink in asserting that he had no intention of 'making common cause with those comrades who forget themselves in burning sophisticated incense in honour of people who do not have even the merit of sincere madness . . .'. This 'band of crazed egoists', he wrote, 'speculate daringly on human stupidity'.[108] Most of the paintings of Monet, Renoir and Sisley were on loan (9 of Monet's 18 works were owned by Faure), so that Mancino's expression of shock, that those who should know better were joining in praise of the suspect group, indicates that conservatives now felt it necessary to combat a movement which was gaining adherents. Conservatives did, however, join moderate and radical critics in suggesting that the Impressionists could have a reforming effect on French art: Bigot allowed that their 'vigour, frankness and brutality' could benefit 'the affected daintiness of the contemporary French school', while Castagnary held that they should not be excluded from the 1876 Salon — the first under the Republic — because they had played a role in the movement away from artifice, falsity and 'chic' and towards 'light and truth'.[109]

The division between the conservative and the liberal and radical Republican press was more pronounced than in 1874: Berthe Morisot wrote to an aunt that the group found no favour with *Le Figaro*, 'so much loved by the good public. . . . On the other hand we are praised in the radical papers. . . . In short, we're being taken notice of, and we have so much self-esteem that we are all very happy'.[110] The language of the critics was that used by editorial writers in their comments on the continuing political crisis. It was strangely compounded with charges of madness, insinuations of disease, and suspicions of political radicalism of

the worst kind. This language could, however, slide into or emerge from calm and even perceptive aesthetic judgements.

The article referred to by Morisot was by Albert Wolff, who wrote:

Five or six lunatics, including one woman, a group of unfortunates stricken with a mania of ambition . . . These self-named artists are called *intransigeants*, impressionists; they take canvases, paint and brushes, throw on a few colours haphazardly and sign the result. In the same way the crazed minds at the Ville-Evrard pick up pebbles . . . and believe that they have found diamonds.[111]

Others wrote of 'insanity', of 'brutalities of the brush, dementias of execution and insanities of conception which are absolutely revolting'; reviewers compared the painters to patients in Dr Blanche's asylum, or claimed that it was 'unhealthy' to look at their paintings of red or yellow trees, 'indigo' houses, 'carmine or poppy-red' water, and their figures which 'resembled corpses'; fear of madness or uncontrolled behaviour lay below their jokes about the paintings causing a man to have an epileptic fit or to bite passers-by in the street.[112] In the conservative *Le Soir*, Bertall made an easy transition from his assertion of lunacy to the political, 'it is, they say . . . the art of the future. For a new people, a new art'. In the Bonapartist journal *Le Pays*, Blavet stated that the Impressionists were 'the discontented, the radicals of painting who, not having been able to find a place in the ranks of regular painters, have formed themselves into a society, have raised some revolutionary banner . . .'. In the *Revue politique et littéraire* Bigot contrasted the Impressionists' exhibition with one containing highly finished pictures of modern life by de Nittis, Firmin-Girard, Berne-Bellecourt, and similar artists. He claimed that collectors paid very high prices for their works, but that despite 'some rare fanatics' like Faure, the public had no desire to buy Impressionist paintings. Bigot called the former 'the official school' and the Impressionists 'the revolutionary school' — and, he went on, 'it seems to me that France, which is accused quite wrongly of loving revolutionaries, loves them in art, as in politics, less today than ever before.'[113]

The fears of the right had been exacerbated by the large number of left-of-centre candidates elected that March to the Chambre des Députés, in the first elections under the new constitutional laws. The ultra-conservative Veuillot called the elections 'the continuation of the Commune's massacre of the hostages', and the right exerted increasingly strong pressure on MacMahon to withstand any liberalization. On the left there were renewed demands for an amnesty for the Communards, and the exiled Courbet sent an open letter to the newly elected deputies appealing against the 300,000 frs. fine recently imposed on him for the destruction of the Colonne Vendôme. His letter received no response, but may have lingered in the minds of the Impressionists' critics.[114]

Two days after Bigot's article appeared, Louis Enault made the most revealing identification of the new painting with radical politics. Radicalism, he wrote in *Le Constitutionnel*, was 'affirming itself everywhere', and 'painting today has its *intransigeants* as does politics', although it should 'inhabit the heights of the ideal'. Political *intransigeants*, he claimed, saw 'no justification in trying to repair the social edifice, they must have one which is quite new. . . . The ground on which they intend to raise their monument must offer then a *tabula rasa*.' Then – in an extraordinary transition – he warned of the risk of going into Durand-Ruel's gallery, for there one would be confronted by 'lines drawn by chance or by the blind, and colour which is nothing but the

debauch of all the colours of the rainbow . . .'. This 'daring little group', he wrote, 'plants its banner in mid-Paris', and its doctrines were 'singularly dangerous'.[115] The editorial in the same issue of *Le Constitutionnel* stated that Gambetta was reforming his party so as to obtain progress 'no longer by conflict, but by study and work'. The leader writer maintained that the *intransigeants*, rather than the conservative majority, were now the enemy, since they opposed Gambetta, sought an amnesty, and 'wished to make the Republic an instrument of destruction instead of an instrument of progress and civilization'. Only a fortnight earlier *Le Rappel* had published a speech by Victor Hugo in the Senate, in which he called for a complete amnesty, as 'the reparation owed to the people of Paris'.[116]

The relationship was clear: on the one hand, the symbolic order defined by the idea of 'study and work', 'moderate progress and prudent civilization', and in art, correctitude and purity of line, harmony of colour and respect for tradition; on the other, the instinctive and the unworked; random lines and orgiastic colour; the destruction of the past to clear the ground on which to build a new order. Bigot asserted that the painters called themselves 'the *intransigeants*, that is, something in art like Naquet's radicalism in politics', and that 'the new school suppresses . . . all that was slowly conquered through the work of centuries'.[117]

In fact, none of the political writers in the radical journals advocated a *tabula rasa* in politics, and none of the critics in those journals ever suggested that the Impressionists sought revolutionary destruction. In *Le Rappel*, Blémont (who had bought two Impressionist works in 1875) expressed the hope that 'mature fruits' would derive from the 'new liberty' of the Impressionists:

They have no laws other than the necessary relationships between things. . . . And as there are perhaps not two men on earth who perceive exactly the same relationships in the one object, they do not see the need to modify their direct, personal sensation according to any convention.[118]

This view contrasted with the basic premiss of conservative aesthetics: that there was one way of perceiving the external world and a correct way of representing it. Blémont did go on to say that while in theory he agreed with their principles, in practice he found that the Impressionists 'do not always fluently read the great book of nature', thus indicating his own underlying belief in a unitary vision. Nevertheless, his proviso was probably less apparent to hostile critics than his first assertion of the relativity of vision, and meant less than the fact that his article appeared in *Le Rappel* on the same day as a report of the commission on an amnesty. In an issue attacking the Impressionists' 'unhealthy lucubrations', the editor of the Orleanist journal *Le Soleil* had expressed the fear that the radical press would 'sow the spirit of agitation and of revolution in all France'; while two days after Blémont's article, a writer for another Orleanist newspaper, *Le Moniteur universel*, intoned:

Let us profit from this situation to inform the 'impressionists' that they have found an obliging judge in *Le Rappel*. It is quite natural that the *intransigeants* of art should give a hand to the *intransigeants* of politics.

The phrase suggests not simply that they held the same views, but that the artists somehow helped the political radicals.[119]

The specific complaint that the Impressionists disdained the work necessary to transform the *ébauche* into a *tableau* had meaning when work, invoked as a precondition of 'progress and civilization', was used by moderates to distance themselves from the radical left. Their claim that the Impressionists rejected all that tradition could teach, in order to

create a *tabula rasa*, should be understood in terms of the rhetoric which invoked the Communards' destruction of Paris. Mancino's term describing the Impressionists as 'vandals' was precisely that used against the Communards. And it was at just this moment that those seeking amnesty raised the spectre of the thousands of Communards massing on the borders or awaiting their release from prison and return to Paris.[120]

Hostility was also directed at the Impressionists' eccentricities of colour. In *Le Soleil* Porcheron described *The Railway Bridge at Argenteuil* – owned by Faure – as 'the last word in Impressionism: blue boat, green, violet, pink and yellow trees', while an unidentified critic cited by Geffroy commented,

Monet exhibits a collection of landscapes lit up by fireworks. There are some which are all blue, some which are all yellow, some all pink, many pinks. . . . When he wants to, however, M. Monet knows quite well how to make himself understood by the public. It is enough for him to stop speaking Japanese or Bengali, and to express himself in good French as he has in painting the *Railway Bridge at Argenteuil*, the *Meadow* and the *Beach at Sainte-Adresse*. These three pieces would look good in the official Salon. . . .

Acknowledging that Monet had 'the eye of a real landscapist', Bigot too praised the *Meadow at Bezons*, but criticized Monet's 'unfortunate taste for blues and pinks', and those landscapes which were 'discordant and gaudy'.[121]

Critics were also repelled by the highly visible brushstrokes of broken colour which resulted, in Bigot's words, in 'a shimmering chaos of brutal brushwork'. Blémont commented that Monet 'pushed too far the decomposition of sunlight, the flickering of colours, the iridescence of light'. This was, however, a criticism based on knowledge, and it is noteworthy that he, like other critics who addressed their readers as if they shared the specialist language with which it was possible to discuss Impressionism, wrote for the centre-left or radical Republican press. In *L'Opinion nationale* Silvestre stated that the school

proceeds from a truly new principle of simplification. . . . Concerned solely with accuracy, it uses elementary harmonies: with little care for form, it is exclusively decorative and colourist. Its aim is . . . totally incomplete, but its works will undoubtedly have a place in the legend of contemporary art. . . .

It has realized the *plein air* to a degree so far unknown. It has made fashionable a singularly clear and charming scale of colours; it has sought new relationships. For a vision of things so refined that it bewilders and spoils by the over-use of conventions, it has substituted a sort of analytic impression very summary and very clear. . . .

Those who wrote for journals which – in a spectrum ranging from liberal Bonapartism to centre-left and radical Republicanism – defined themselves as progressive, stressed the scientific, exploratory nature of Impressionism, and sometimes its application of free-enterprise principles. Silvestre referred to the Impressionists' 'pictorial researches'; Blavet explained in the Bonapartist *Gaulois* that the Impressionists' separation from the Ecole des Beaux-Arts was motivated not by 'disdain' but by their 'need for great liberty of experiment', as if in their 'own laboratory'. On the other hand, Blémont's comment on Monet's 'decomposition of sunlight' was criticized by Enault, who wrote in the conservative *Constitutionnel* that the Impressionists' '*tabula rasa*' was 'nothing but the debauch of all the colours of the rainbow fractured as they emerge from the prism'.[122]

Notions of relativity of vision and the scientific analysis of colour were discussed more systematically by Duranty in *La Nouvelle Peinture*, the first sustained account of the movement, which appeared at the time of the exhibition. Duranty wrote:

From intuition to intuition, they have succeeded . . . in splitting sunlight into its beams, its elements, and in recomposing its unity by means of the general harmony of the

colours of the spectrum which they spread on their canvases. . . . The most erudite physicist could not quarrel with their analysis of light.[123]

This scientific explanation was to dominate interpretation of Impressionism until quite recently, although the painters – who would have been well aware of the difference between prismatic and material colour – probably used such concepts in a metaphoric rather than a literal way.

In the exhibition, the grouping of works according to artist not only emphasized the unity of each group as the creation of a single individual, but also drew attention to the different means used by different artists to construct their images of 'the real'. Nearly all the critics commented on these differences: some implied that the more extreme works were deliberately provocative, but only Blémont sought an explanation in terms of relativity of vision. Bigot inadvertently touched on a crucial factor when he commented that Impressionism

operates only by means of flat colours juxtaposed one against the other. It intends that one should be able to count the marks made by the brush or, rather, by the palette knife, for the brush is itself an instrument too delicate to represent brutal reality. To express objects as they appear at a distance, to express only their essential note . . . such is the programme of our new realists.

He thus observed the ambivalent combination of techniques which signal distance and those which imply closeness which had characterized Monet's work since the 1860s.[124]

The hanging of the exhibition, the abstracted colour scales and highly visible technique were invitations to critics and public to participate in the paintings' construction of reality, but once again there seems to have been little response to the invitation. The puzzling fusion of techniques noted by Bigot probably played a role in alienating spectators from pleasant bourgeois subject-matter, while the continuing suspicion of political radicalism could have made the invitation to participate in a non-authoritarian situation seem subversive.

In his essay, 'The Impressionists and Edouard Manet', Mallarmé claimed that the painters' relativity of vision was related to the contemporary situation in which 'the multitude demands to see with its own eyes'.[125] If it did make such a demand, it was certainly not granted: press censorship was still severe; repressive legislation prevented any significant working-class organization; a parliamentary regime had been established, but the people were not sovereign, and the conservative 'République des ducs' sought to maintain the power of the traditional élites. Mallarmé sensed that the new art was profoundly related to the values of the advanced liberal bourgeoisie, and he wrote in the spirit of Gambetta's ideology of reconciliation between the classes as the necessary foundation of the moderate Republic. Impressionism, he said, was 'the representative art of a period which cannot isolate itself from the equally characteristic politics and industry'. It could also be a means of social reconciliation by educating 'the public eye':

the public will then consent to see the true beauties of the people, healthy and solid as they are, the graces which exist in the bourgeoisie will then be recognized and taken as worthy models in art, and then will come a time of peace.

Mallarmé's optimism – which was shared by most supporters of Impressionism – was in harmony with that of progressive Republicans like Gambetta who opposed his vision of a *joyful* regenerated France to the conservatives' gloomy emphasis on the lost past and a fearful future, just as the happiness of Impressionist painting contrasted with the sombre art demanded by *l'ordre moral*. Renoir knew Gambetta through his patron Charpentier (to whom Monet was trying to sell *The Train in*

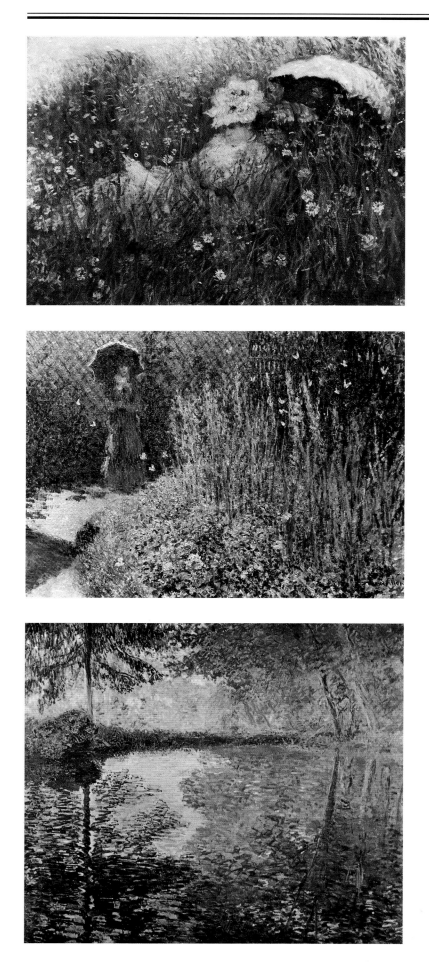

*the snow*), and had obtained the support of his journal, *La République française*, for their exhibitions.[126]

Monet sold no works from the 1876 exhibition, but *La Japonaise* was purchased for 2,010 frs. at auction that April, and the *Luncheon* was bought by the wealthy Gustave Caillebotte who, as painter, boat-builder and gardener, was congenial to Monet and was to be one of the most important supporters of the group. Other collectors appeared in 1876: Victor Chocquet, whose modest salary as a public servant was not enough to meet Monet's needs, and the wealthy Romanian doctor, Georges de Bellio, who had acquired about thirty Monet paintings by the early 1880s and who helped him with advances, loans and gifts when things got really desperate. Hoschedé continued to be a major patron despite his own financial problems. But Monet's works were bringing lower prices, while his expenses, taxes and accumulated debts were increasing, so that, although he earned the considerable sum of 12,313 frs. in 1876, his situation actually became worse, and the expedients to which he resorted only put off the day of reckoning. The members of the group introduced prospective patrons to their friends, and the better-off ones helped the poorer when they could, but the situation was grave even for those who had independent means: Eugène Manet wrote to his wife, Berthe Morisot, 'The whole clan of painters is in trouble. The dealers are overstocked. . . . Let's hope that buyers will return.'[127]

This situation probably influenced a major change in Monet's modern landscape painting, which began to manifest itself about the time of the 1876 exhibition in a gradual separation between his paintings of modern life and his paintings of nature. He did no more pictures of modern life in the suburban countryside, and transferred such themes to Paris, where they culminated in his most unequivocally modern works, the twelve paintings of the Gare Saint-Lazare. At Argenteuil he turned to a more contemplative exploration of time in nature, undisturbed by the manifestations of urban time, the trains and holiday yachts. His only paintings of modern life in the open air were those of the public space of city parks or the private space of the garden.

In the spring of 1876 Monet painted four views of the Tuileries gardens (W.401–404) from Chocquet's apartment in the rue de Rivoli which mark the end of his two years' exclusive concentration on Argenteuil. They were painted from the same high viewpoint which he had used in his earlier city paintings and which signal his detachment from the motif. A group of three paintings of the fashionable Parc Monceau (W.398–400) are the only cityscapes in which he kept the ground-level viewpoint he used to depict the Argenteuil domesticized landscape, but the paintings of the park lack the intensity of observation given by Monet's emotional commitment to that landscape. The Tuileries paintings suggest fragments snatched from a larger continuity. In the most finished painting of the group, the Pavillon de Flore and the pond are sliced by the edges of the canvas as if by the lens of a camera. Photographic too is the refusal to construct significance: the Palace of the Tuileries was one of the most spectacular of the burnt-out ruins left after the Commune, but Monet depicted only a fragment of the bare north face of the Pavillon, the only trace of its past.[128]

The change that was occurring in Monet's paintings of the suburban landscape can be seen in a group of four paintings of his studio-boat on its peaceful odyssey among the silvery-green willows enclosing the Petit Bras (W.390–393). Manet's picture of Monet in the studio-boat in 1874 showed him at the heart of the busy river shaping

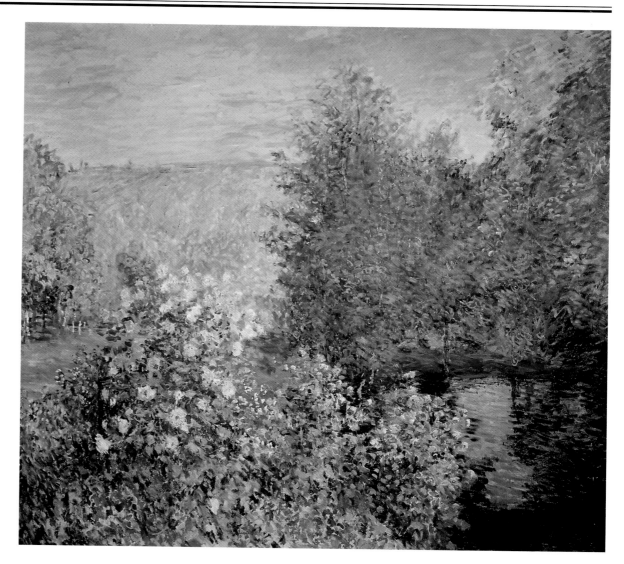

the modern, but the only hint that the 1876 pictures were painted on that same river appears in one showing Argenteuil glimmering in the distance like a mirage rather than an actual place (W.392). In the other paintings the boat is lost in luxuriant vegetation as if in some temperate jungle. The four paintings suggest the continuous passage of the boat through the river landscape, since each shows it at a different distance, as if it were moving away from the spectator. This kinetic continuity is similar to that suggested by the passage of Camille and Jean through the countryside, and the presence of Camille in the painting of the moored boat confirms her role in Monet's privatization of the Argenteuil landscape. This river world turns in on itself even more completely than does the garden, for the glassy water reflects the willows, the ungainly craft and its absorbed occupant in such a way as to suggest that it is itself a reflection on the world of reflections.

The wildflowers which enclose Camille in *In the Meadow*, the most lyrical of the works in which Monet transformed the Argenteuil fields into a protective garden, are transposed into elaborately artificial ones in *The Gladioli*. The garden is irradiated with light; the warmly tinted canvas glows through the vibrating colour particles, while tiny strokes of white paint float off the picture surface and reveal themselves as a cloud of butterflies. In this group of ten paintings (W.406–415), Monet registered his movement around the garden in relation to the 'pink house with green shutters' or the lattice fence, whereas in 1875 he

enfolded the garden in layers of light-filled leaves and flowers. Temporal continuity is also given by the six images of Camille, walking incessantly along the paths at varying distances from the spectator. In some of the paintings, her figure gives an impression of strain and lassitude which suggests that the first signs of the illness from which she was to die in 1879 may have communicated themselves to the painter who seems to have watched her so dispassionately.[129]

Monet's insistence on the protective garden may have been influenced by another threat about which he wrote to Dr de Bellio:

I just can't manage . . . the creditors are unyielding, and unless there's a sudden appearance of rich collectors, we will be thrown out of this nice little house where I was able to live modestly and where I could work so well. I don't know what will become of us. . . . I was, however, so full of ardour and I had so many projects. . . .[130]

Ernest Hoschedé probably answered his dream of a 'rich collector' when he invited Monet to the Château de Rottenbourg at Montgeron, on the other side of Paris, to paint four large decorative panels for its dining room. Monet spent several months working on the panels and other works, presumably painting studies for the decorations which, since each was nearly 2 metres ($6\frac{1}{2}$ feet) high or wide, were probably painted in the studio at Montgeron and then at home. Despite this, each painting was executed very freely, as if painted *en plein air*. The compositions reveal Monet's inventiveness when he could work on a

large scale. In the *Corner of a garden at Montgeron*, he brought together his favourite subjects — flowers and water — for the first time, but *The Pool at Montgeron* was a more daring reversal of conventional space: the pool occupies more than two-thirds of the painting and bears the reversed images of trees and the unseen sky. The eye moves freely, as if into the depths of the pool or across its surface to the radiant trees, only gradually becoming aware of the reflection of a woman in a fashionable hat, both there and not there, fishing on the other side of the pool, beside a faintly indicated figure. There is also an image of a woman in the *Corner of a garden at Montgeron*; one becomes conscious of her presence only through the broken colours which hint at her reflection. The woman in both paintings may have been Alice Hoschedé, the cultivated wife of his patron, who was to become Monet's companion and later his wife. It is not possible to know if their intimacy began during Monet's visit to the château, but within four years their lives would be linked by the death of his wife, and her desertion by her husband.[131]

Perhaps Monet's stay at Montgeron with this modern Maecenas rekindled his ambitions as a painter of modern life, for when he returned to Argenteuil late in the year, he began preparations for his most programmatic works of this kind, the twelve views of the Gare Saint-Lazare painted between mid-January and early April 1877. The train was the nineteenth-century symbol for the progress which would bring prosperity and social justice to all, and the great stations were invoked as the temples or cathedrals of the new civilization. Something of this exaltation is expressed in Monet's emphasis on the power of the engines, the stark force of the iron station and railway bridge, the westward thrust of the rails through the great canyon of new apartment blocks, the dynamism of huge clouds of steam. His practice of representing the alterations made in a scene by changes of light or viewpoint became more explicit in the *Gare Saint-Lazare* series. The rigid geometry of the great glass vault with its regular linear articulations provided a perfect medium for registering such changes, because the

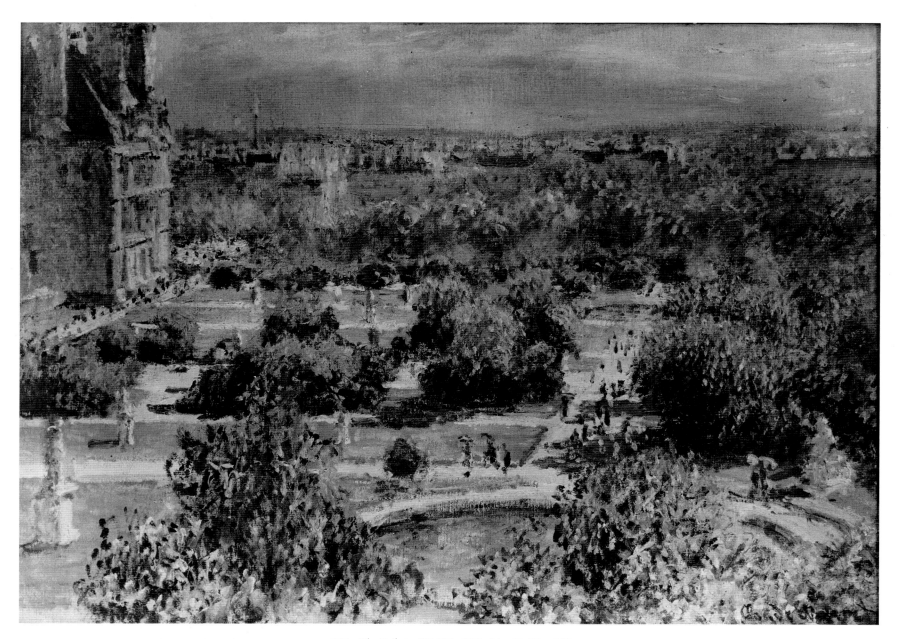

135   *The Tuileries* (W.401), 1876, 54 × 73 (21 × 28½)

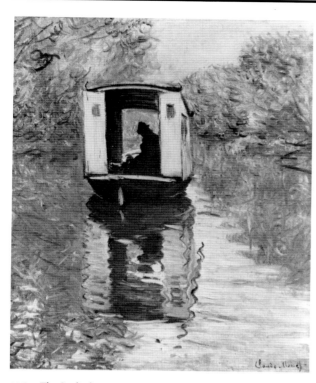

136 *The Studio-boat* (W.390), 1876, 72 × 60 (28 × 23½)

137 *The Studio-boat* (W.391), 1876, 80 × 100 (31¼ × 39)

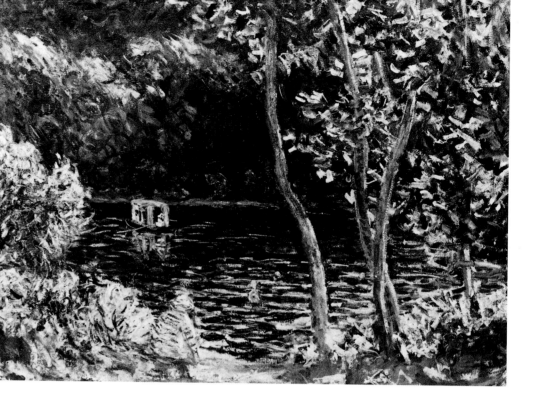

structure itself seemed to change according to the colour and density of the atmosphere within it – as can be seen in the difference between the painting with bright midday sun overhead filtering through the glass and another, with a colder light, painted earlier in the day when the interior of the station is shadowed. Everything in these paintings was modern; little of the setting would have existed when Monet first arrived from Le Havre in 1859, for the station was reconstructed in the early 1860s when the surrounding *quartier* was also built. Thus the scene scarcely had a past, and Monet painted it as a series of moments fragmented by timetable and signal.[132]

He obtained permission to work in the station, and since he would have had to plan his positioning carefully, he explored its different aspects in a number of drawings. Caillebotte helped him rent a small apartment near by, where he probably also worked intensively on the paintings. He represented the engines of the *'grandes lignes'* to Normandy as well as those of the suburban lines which led to most of the places where he had painted, while outside the station he showed the tangle of tracks and the iron Pont de l'Europe. Manet depicted the area outside the station in his 1874 Salon painting, *Pont de l'Europe* (Washington, National Gallery of Art), as a modern-life background to his figures, while Caillebotte also focused on figures when he painted the same railway landscape in 1876. But Monet was not interested in the human aspects of the scene, and depicted the engines, not the carriages, a few smudgy figures, not the crowds of passengers or the railwaymen, so no human presence distracts from the huge vault and the glimmering cliffs of apartments. In *The Gare Saint-Lazare, the arrival of a train*, there is a figure in the close foreground, but it is depicted so hazily that the eye passes straight over it to the bulk of the engine. The confrontation here is not with the human gaze – as in Manet's painting – but with inanimate

modern constructions. Monet's displacement of human centrality is seen most starkly in *The Gare Saint-Lazare, the signal*, where in the immediate foreground, in the space traditionally occupied by the figure, Monet painted a blank sign. This was noted by the critic of *L'Artiste*, who wrote with revealing exaggeration, 'a grim and menacing disk dominates the front plane'.[133]

## IV

Requesting a loan of his *Cabin at Sainte-Adresse* (W.94) for the third Impressionist exhibition in 1877, Monet told Duret that it would be advantageous 'to show myself under different aspects'.[134] He exhibited only two paintings of the pleasures of the suburban river, and only two which sustained the image of happy plenitude in the home and in the fields: *Camille and Jean Monet in the house at Argenteuil* (called *A Corner of an Apartment*), showing the luxuriant interior of the Monets' second house at Argenteuil (a picture lent by Caillebotte), and *In the Meadow* (lent by Duret). Over half the 30 works Monet showed were of modern urban subjects, ranging from the *Grand Quai of Le Havre* of 1874 (W.285) to recent paintings of the urban pleasure spots, the *Parc Monceau* (W.398) and *The Tuileries*, and, most significantly, 8 paintings of the Gare Saint-Lazare, Monet's largest display of a group of works on a single subject and hence his clearest public expression of the relativity of vision.

If the Impressionists hoped that opposition to their work would lessen with familarity, they were to be disappointed by a hardening of critical attitudes to the third exhibition, which opened, again in the rue

Le Peletier, on 5 April 1877. It did attract more attention from serious journals, but hostile reviews outnumbered the favourable ones. Nevertheless Zola claimed that 'even as it laughs, the public throngs to the exhibition. More than 500 visitors a day have been counted'. Georges Rivière asserted in his little journal, *L'Impressionniste*, which appeared during the exhibition, that the opposition was orchestrated by the press; but the public, he said, was examining the paintings more closely than in the first exhibition because it had been convinced by the Impressionists' 'insistence . . . on pursuing their researches'. A writer in the radical *L'Homme libre* also suggested that the public expressed horror partly because the press implied that it should. Commenting that all 'the curious and lazy' of Paris had poured into the exhibition of 1876, Bigot claimed that the Impressionists wanted crowds in order 'to hear the philistines howl', but that it did not matter what the public thought, for its artistic education was still mediocre. Those who knew about art had not at first been scandalized, he asserted, because they believed in 'liberty for all', and had had 'sympathetic curiosity' about the future of the movement; but their sympathy had cooled when confronted with

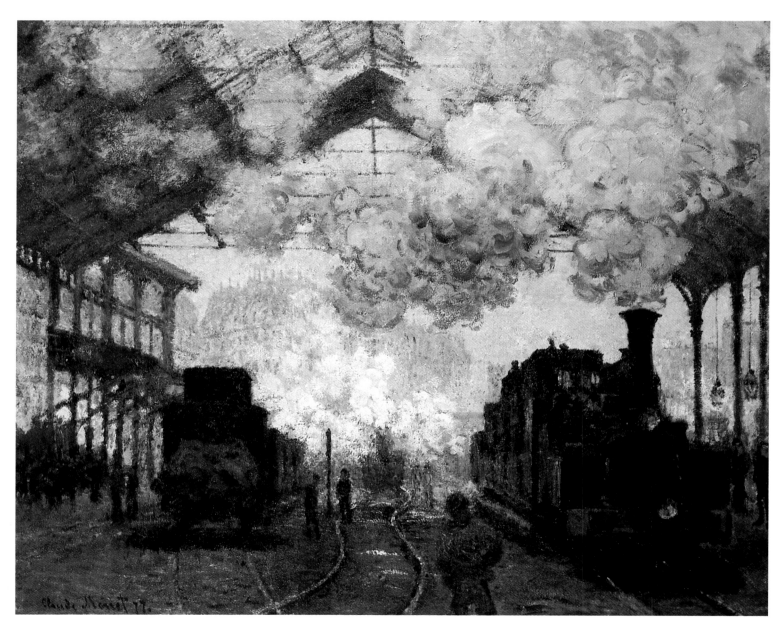

*Opposite*:

138  *The Gare Saint-Lazare*, drawing (sketchbook MM.5128, 23 verso), 1877

139  *The Gare Saint-Lazare, the arrival of a train* (W.439), 1877, 82 × 101 (32 × 39¼)

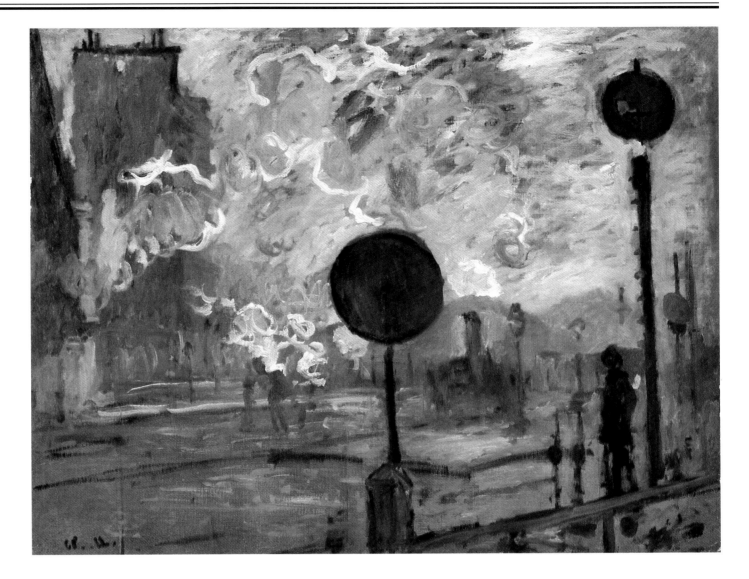

140  *The Gare Saint-Lazare, the signal* (W.448), 1877, 65 × 81.5 (25¼ × 31¼)

141  *The Pont de l'Europe, the Gare Saint-Lazare* (W.442), 1877, 64 × 81 (25 × 31½)

the 1876 exhibition, and they had become more severe in 1877, since the Impressionists had not made progress – indeed, he said, had intensified their faults, and they were still showing crude *ébauches*.[135]

The sense that Impressionism had become worse than in earlier years may have been caused by the more assertive modernity of Monet's 'exhibition within an exhibition', and by Cézanne's works, which were always seen as outrageously provocative. The Impressionists also created unprecedented publicity, which traditionalists believed was inimical to art, by means of the journal *L'Impressionniste*, and posters around the city in which they defiantly adopted the name that had been given them in derision. Even worse, they had admirers and even partisans.[136] The exhibition opened during a political crisis which was to climax, shortly after it closed, with the semi-constitutional *coup d'état* of *le seize mai*, when MacMahon replaced a new centre-left ministry with a reactionary one, guided by the ideology of *l'ordre moral*. That the crisis cast its shadow over the exhibition may be sensed in Bigot's comment that 'recent political incidents' had caused the painters to adopt the name 'Impressionists' in place of that of 'Intransigeants' as 'the public had baptized them'.

Opposition to the group became almost official with a hostile article by Roger Ballu, 'inspecteur des Beaux-Arts', in the conservative *La Chronique des arts et de la curiosité*. Ballu found the works of Monet and

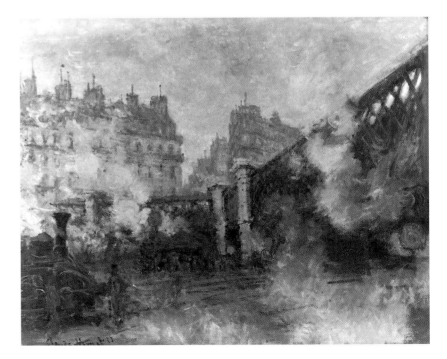

Cézanne particularly shocking; 'children playing with paper and colours', he said, 'do better'. Other conservative journals echoed the now familiar refrain: it was only 'unhealthy curiosity', *Le Figaro* stated, which could draw people to 'this museum of horrors'. In *Le Pays*, the critic fulminated at this 'dementia, a deliberate choice of the horrible and the execrable', while *Charivari* published a caricature of a policeman advising a pregnant woman not to enter the exhibition.[137]

Nevertheless, even hostile critics found it necessary to seek explanations for the work. In *L'Artiste*, Frédéric Chevalier denounced Impressionism as

an effervescence of colour, a phantasmagoria of effects, a bacchanal of lines, a fury of brushstrokes, an orgy of impastos, an explosion of light, of audacities of composition, of unprecedented dissonances and insolent harmonies . . . A savage, irreverent, disordered, heretical art . . .

He tried, however, to establish a correlation between 'our contemporary customs and the revolution attempted by the new apostles':

Their brutal handling, the ordinariness of the subjects they prefer, the appearance of spontaneity . . . the wilful incoherence, boldness of colour, mistrust of form, the puerile *naïvetés* which they carelessly mix with exquisite harmonies, this disturbing combination of qualities and faults is not without analogy with the chaos of antagonistic forces which trouble our era.

The Intransigeants, he concluded, need not be condemned, but could be evaluated, even if the audience's education was not sufficiently advanced to allow this.[138]

Bigot too sought an explanation in contemporary life: it was

not true nature which they . . . try to represent, [but] it's above all, the nature that one glimpses in views in the great city or its environs, where the discordant notes of the houses with white, red or yellow walls and violet shutters, intermingle and form violent contrast with the vegetation of trees.

Bigot concluded with a lamentation for the poetry and the 'truth of nature' of Corot, Rousseau, Daubigny and the Dutch landscapists. Paul Mantz made similar points in a long article in the conservative Republican newspaper *Le Temps*. He disputed the Impressionists' claim to that title on the grounds that the real Impressionist could represent a quickly moving cloud, and 'three or four brushstrokes should suffice to fix the fleeting image'. There had been Dutch and English Impressionists, but there was, above all, 'the charming revolt! the blessed insurrection!' of 1830. Corot was 'the first impressionist of the world', and his grasp of the motif and the effect of light were so exact that 'it is easy for the spectator to reconstitute or to dream the absent detail'; but with today's Impressionists, Mantz said, one 'had to make long efforts, one had to be terribly subtle to understand their *naïveté*'. Bigot took the notion of *naïveté* further, claiming that the Impressionists' wish to 'return to the infancy of art, simply exposes them to the risk of returning to childish art'.[139]

Conservative critics sought to discount Impressionism by proving the superiority of the earlier tradition which was not only comprehensible and based on 'conscientious observation of nature', but had poetry or 'soul'. Even the previously sympathetic Burty commented in *La République française* that Impressionism was only an 'eccentric development' of what Corot sought; he was particularly critical of the landscapists. Marc de Montifaud quoted Mantz's comments on Corot to criticize the lack of finish in Impressionism, and claimed that these 'aggressors of the palette' were attacking the bourgeoisie, and that the vocabulary of the Impressionists bore 'a passable resemblance' to that of *L'Assommoir*. Zola was then under intense attack by conservatives,

radicals, *and* moderates for his novel of 'the working world . . . of the decadence of the Parisian worker through the deplorable influence of the environment of the *barrières* and cabarets', but de Montifaud was concerned particularly with the novelist's notorious use of popular speech (which was one of the factors that gave *L'Assommoir* a force that prevented its being categorized as a moralizing narrative on the dangers of drink). The Impressionists' perceived crudity of technique might then invest paintings of modern urban life with something of the threat of Zola's novel.[140]

Most of the critical comments on Monet centred on his coarse technique, crude and unlikely colours, and neglect of form, Mantz asserted that he 'cares so little about being understood that he does not deign to turn his stammerings into speech', while Bigot claimed that Monet was 'indisputably a decorator', but that 'as soon as one is a few paces away . . . one can no longer see anything but a formless sketch and a series of coarse blotches, unpleasant blues, pinks, ochres'. It was possible to admit of a degree of sketchiness in decorative works which would be seen at a distance; but no critic, it seemed, could see the visible brushstroke as a record of the process of creating an image, or could look beyond his own difficulties of interpretation and his sense of the unnaturalness of the colours – criticisms made of the Barbizon painters in their time – to consider, as Mallarmé had suggested, the conventionality of the means at the painter's disposal. Even sympathetic critics separated the decorative and the representational functions of Impressionist colour. Duranty's scientific argument for the accuracy of their colours was becoming influential, but other critics now began to emphasize that they were abstracting in an aestheticist way: Rivière did this with his phrase, 'an inexpressible, almost musical gaiety', and his claim that the Impressionists treated 'a subject for its colours and not for the subject itself'. Perhaps it was only Mallarmé who appreciated their use of colour as a medium of exploration, simultaneously seeking out their own perceptions of the object, embodying the experience of these as a process, and creating a decorative whole.[141]

Monet seems to have tried to draw attention to this aspect of his work by exhibiting paintings of very different degrees of 'finish', which could have made it clear that he sometimes distinguished between finished work and sketch (*esquisse*). Even if the finished paintings of the Gare Saint-Lazare were more broadly painted than critics found proper, comparison with sketchier works could have revealed that considerable work had gone into them, but there is no evidence that such comparisons were made. They were constructed to appear like rapidly captured momentary effects, yet the density of their paint suggests otherwise. Monet did a number of drawings exploring different motifs – he drew the main elements of *The Gare Saint-Lazare, the signal* with pure unshadowed lines, which he translated into thin, fluid pigment in the painting, rendering the clouds of smoke with a bold calligraphy. *The Gare Saint-Lazare, the arrival of a train* is, on the other hand, densely worked with layers of granular paint, thin scribbles and glazes (seen vividly in the apartment blocks appearing through the thinning smoke), while the calligraphy which captures the dynamism of the smoke clouds is absorbed in multiple veils of delicate colour. Monet is unlikely to have developed such a complex structure in the hurly-burly of the station, and he would have worked on it in the apartment he rented near by, returning to the station to verify the effect, whereas *The Signal* could have been painted on the spot in one session.

The painted substructure of *The Gare Saint-Lazare, the arrival of a train* remained visible through its complex layers of pigment. In this, it

was related to the modern architectural structures admired by the avant-garde, as is suggested by Renoir's comment in *L'Impressionniste* that the Halles, structurally very similar to the new stations, were 'the only buildings' in Paris 'having a truly original style and an appearance appropriate to their function'.[142] Rather than paint a building like the recently completed Opéra, whose modern structure was heavily disguised by masonry and abundant decoration, Monet chose one whose structure was made completely visible by the light which it articulates but does not obstruct. In academic painting the sub-structure is disguised, while Monet's painting, composed of discrete brushstrokes, reveals how the image was constructed 'touch by touch'. This could be appreciated by avant-garde writers and by a self-consciously progressive group of connoisseurs, but it disturbed the traditional. For example, de Banville (writing as 'Baron Schop') doubted that the external world was 'only an accumulation of many-coloured spots', rather than 'an ensemble of forms and contours, as we have imagined it for centuries'.[143]

Monet's paintings of the Gare Saint-Lazare attracted more attention than his other works in the exhibition, and whether hostile or not, critics recognized something of their meaning. Only Zola found it necessary to comment on the modernity of their subject-matter, and indeed such subjects seem to have been taken for granted in the exhibition as a whole, just as a large number of works in the 1877 Salon — many photographed for commercial distribution — were accepted as straightforward representations of modern life. What was at issue was the way modern subjects were painted.[144]

The hostile critic of *Le Figaro* wrote that Monet 'shows us the Gare de l'Ouest in all its aspects . . . he has tried . . . to give us the disagreeable impression which results when several engines whistle at the same time'. Other critics commented on the sensations of sound produced by these works: Rivière evoked 'the shouts of the workers . . . the shrill whistles . . . the incessant clangour of iron and the formidable panting of steam'; the journalist of *L'Homme libre* wrote, 'it's unbelievable, and yet this station is full of noise, screeches, whistles. . . . It's a pictorial symphony'. Zola claimed that

One can hear the roar of trains . . . see the flood of smoke coiling under the huge sheds. There, in these modern frames of beautiful amplitude, is the painting of today. Our artists must find the poetry of stations, just as their fathers found that of forests and flowers.

Despite 'the monotony and aridity of the subject', Rivière felt that the variety of the paintings demonstrated Monet's mastery of 'the science of arrangement on canvas'. He also drew attention to the relativity of appearances revealed in two versions of one scene:

the train has just arrived, and the engine is about to leave again . . . it shakes its mane of smoke which jostles the glass roof. . . . Near this painting, another of the same dimensions, represents the arrival of a train . . . smoke billows into the distance and escapes upwards and the sunlight shining through the glass panels, gilds the sand of the tracks and the machines. . . .[145]

As Rivière pointed out, the paintings of yachts shown in the 1876 exhibition conveyed the impression of a fragile continuity from a series of isolated moments, but the intervention of the machines in the Gare Saint-Lazare paintings fractures any continuity into isolated shocks of recognition. Chevalier's analogy between Impressionist painting and 'the chaos of antagonistic forces which trouble our era' is particularly relevant to these paintings of urban technology, which enact the stark conflict between continuous time and mechanically fractured time. Baignières had made an even more revealing analogy between Impressionist techniques and contemporary technology:

Here then the art of painting is reduced to a sort of telegraphic mechanism of which the first appliance is the eye, the second the hand and the third the canvas upon which impressions are fixed as are the characters of a telegram on blue paper.

Although based on the common misconception that Impressionism was a mindless recording of visual data, the critic's use of this mechanical analogy suggests something of that modern consciousness which fractures the external world into a series of moments. Bigot sensed this consciousness purely in terms of loss:

There is no intimate sentiment, no delicacy of impression, no personal vision, no choice of motifs which show you something of the man and something of the artist. One seeks in vain for a thought and for a soul behind this eye and this hand.[146]

The *Gare Saint-Lazare* series sold well to Monet's usual patrons, who for the first time were purchasing related works on a single theme: despite his imminent bankruptcy, Hoschedé bought three, as did de Bellio, and Caillebotte acquired three in 1878. By then the subject was topical, for the new left-of-centre government was embarking on a major programme to extend and modernize the railways as an essential component of the progressive, positivist Republic.[147]

After completing the *Gare Saint-Lazare* series, Monet spent only eight or nine months more at Argenteuil, before leaving it forever in January 1878. During that time he seems to have painted only four works, in which he returned to the scene he had painted four times in 1872, looking down the river to the villa and the factory chimneys beyond. Since he was probably thinking of leaving Argenteuil, these works can be seen as a last reflection on the place which had meant so much to his art. Two of the paintings are like inventories of his favourite motifs — the bath-house, a recently planted garden, yachts, rowing boats, the promenade with its elms, the distant villa. The other two works are more sensuous and more poetic. In *Argenteuil, the bank in flower* (ill.142), Monet juxtaposed the private, sensuously close space of the garden and the distanced public space of the promenade. More clearly than ever before, the dematerialization of the external motif and the intense materiality of the painted world demonstrate that in Monet's countryside private space and public space were one. They were his creation, his world, his dream.

Monet went closer to the villa than in 1872, but represented it as if more distant, a rose-grey silhouette glimmering in a space vibrating with the coloured light of the setting sun. Factory chimneys and flowers, steam tug and rowing boat are transfigured by the golden-rose light into an enchanted world. *The Flowering Bank, Argenteuil* (W.450) is more tranquil; the water is still, the blazing flowers distanced; there is neither steam tug nor factory smoke. The painting is like a nineteenth-century response to Watteau's *Embarkation for the island of Cythera* (ill.272). The composition, with the two figures on the bank watching the two figures in the nearer boat and the second boat in the distance, suggests something of the continuity of movement of Watteau's figures, from symbolic resistance to final departure for the island of love. Promenading and fishing take, however, the place of ideal love in the modernizing landscape.[148] Moreover, in characteristic modernist fashion, the painting has no narrative continuity: the figures are isolated, one from another and couple from couple; none the less the painting draws the eye from the figures on the bank to those further down the river, and past them to the west, past a fairy-tale château, away from suburban Argenteuil, away from the modern city to the light-filled distance.

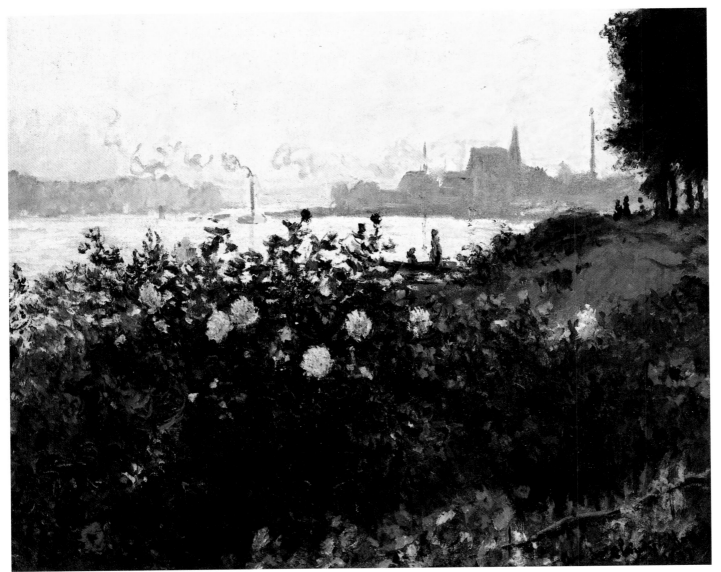

142  *Argenteuil, the bank in flower* (W.453), 1877, 54 × 65 (21 × 25¼)

Monet's troubles were not so easily escaped and, as he wrote a few months later, 'daily necessities call me back to reality'.[149] The fact that he was painting so little, despite desperately needing money, indicates some sort of crisis, probably caused by the continuing threat to all that was essential for his art: his family, a secure and prosperous home and a beautiful environment. Camille was pregnant and so gravely ill that doctors advised an operation, and the family was being threatened with eviction. Monet told de Bellio that his belongings were about to be sold up and that 'once out on the street', he would have to take any work that was offered; his last chance was that de Bellio might buy 25 works for 500 frs. altogether. In June 1877 the doctor bought 10 works for 100 frs. each, and advanced Monet the 500 frs. But Monet also begged Manet for help, and wrote to Zola of his desperation at the prospect of having to tell his 'poor wife the reality', and asking for 200 frs. to save them from being evicted. Monet earned 15,197 frs. in 1877, more than he had made since 1873, but his earnings were immediately swallowed up by his accumulated debts (for example, in May 1877 he met a 1,350 frs. debt to his paint merchant with 16 paintings and was left with 50 frs.). Moreover well over half of his earnings came from Hoschedé, who was declared bankrupt in August, so that even Monet could have hoped for little more help from that quarter.[150]

The repressive policies of the reinstated government of *l'ordre moral*, the fears of a right-wing coup against the Republic already weakened by the economic crisis, may have made Monet's Utopian dream of a life in which the beauties of nature were harmoniously fused with the pleasures of modern life impossible to sustain. He had been able to construct an ideal social world from the raw materials of an industrializing Argenteuil and its heavily polluted river, but he could do so only so long as his ideality had some basis in private reality; the threat to his family, home and way of life had made that reality very precarious. This is the context of *Argenteuil, the bank in flower*, in which the vision of an ideally beautiful modernity is cut off from the artist by the fence which runs across the foreground, assimilating the garden to the distant vision rather than enclosing him within its protective layers.

Monet and his family left their home of seven years in January 1878 in an atmosphere of crisis, having had to beg to avoid having their possessions seized and to pay their removal costs. Their move to the more expensive capital did not, of course, relieve the situation, especially since Camille's continuing illness and the birth of their son, Michel, in March, added to their expenses. Monet had to spend an increasing amount of time trying to sell his works, which went for lower

and lower amounts (the Hoschedé bankruptcy sale in June confirmed this downward trend).[151] The economic crisis exacerbated the divisions in the Impressionist group and contributed to the failure of plans to hold an exhibition in 1878. Renoir and Sisley exhibited in the Salon and thus, by a recent decision, were precluded from taking part in an Impressionist exhibition. Pissarro feared the complete breakdown of the group, telling Caillebotte that Monet was 'afraid of exhibition . . . [and] believes that [our artistic union] prevents us from selling — but I hear all the artists complaining, so that's not the cause'.[152]

Monet, Sisley, Morisot, Pissarro and Renoir might have been heartened by the seriousness with which Duret discussed them as *the* Impressionists in his brochure, *Les Peintres impressionnistes*, published in May 1878. Claiming that, despite continuing criticism, they had attracted the attention of '*le grand publique*' in 1877, and had the support of a significant group of collectors and writers, Duret established their genealogy, showing that they developed their 'personal sensations' from the painting of their 'fathers', Corot, Courbet and Manet, from *pleinairisme* and Japanese art. He declared Monet the Impressionist *par excellence*, and in a long passage set the terms for Monet criticism for decades to come:

Claude Monet has succeeded in fixing the fugitive images which his predecessors had neglected or considered impossible to render with the brush. The thousand nuances which inflect the water of the sea or of rivers, the play of light in clouds, the vibrant colours of flowers and the spangled reflections of leaves in the rays of a fiery sun, have been seized by him in all their truth. No longer painting the landscape in terms only of the immobile and the permanent, but in the fugitive aspects given it by changes of atmosphere, Monet transmits a singularly lively and striking sensation to the perceived scene.

In his review of the brochure, Ephrussi was ironic about Duret's enthusiasm, but defended the movement as responsive to its time:

Should not art be transformed in accordance with the usages and customs of each epoch, follow movements of thought . . . disengage from every thing the psychological impression however fugitive it is? Must one be severe towards these searchers after new ways, these neo-realists of contemporary art?[153]

Perhaps encouraged by such considerations and by the sales of his Gare Saint-Lazare and Tuileries paintings, nearly all the works which Monet produced during his short stay in Paris were of modern-life subjects: the city parks, the untidy mix of factories and foliage at the Île de la Grande Jatte on the outskirts of Paris, and two streets ablaze with the flags with which the Parisians celebrated the *Fête du 30 juin*, the opening of the Exposition Universelle and the first national holiday observed since 1869.

The Exposition Universelle was intended to celebrate and to promote the regeneration of France and, above all, Paris after the disasters of 1870–1. It would demonstrate the confidence of the new Republic which in late 1877 had emerged strengthened from its first constitutional crisis and was generally accepted as the appropriate form of government for a modern France. On the eve of the celebrations, *Le Figaro* wrote ominously, 'Enjoy the present moment, *bourgeois* of Paris, God alone knows what tomorrows he has for you', but concluded that those in the old working-class districts 'will come down into the streets, this time without pikes and Carmagnoles; all will be joy and hope'. Immediately after the celebration, it wrote euphorically of 'the unanimity with which all citizens — without distinction of class, wealth or opinion — decorated and beflagged their dwellings'; these were 'peaceful conquests', and except for the ruins of the Tuileries and the statue of Strasbourg draped in mourning, one could believe that France

was 'intact and united'. It was, then, appropriate that in *The Rue Saint-Denis* (W.470) Monet painted a huge flag bearing the words 'VIVE LA FRANCE', imparting its rhythms to the tricolour flags of the Republic. He had never before painted in these ancient streets from which working-class insurrection had repeatedly come, which Napoléon III and Haussmann had attempted to isolate and control, which had been at the centre of the Commune's resistance, and in which, as the press noted, the display of flags on 30 June was particularly striking.[154]

Shortly before the Exposition opened — and while he was writing his history of the Commune — Duret commented in *Les Peintres impressionnistes*:

Under the summer sun, skin and clothes take on a violet tint from the reflections of green leaves. The Impressionists paint figures under trees violet. Then the public

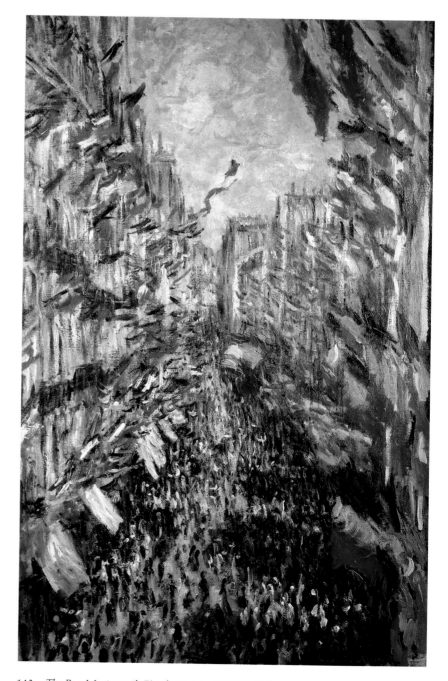

143 *The Rue Montorgueil. Fête du 30 juin 1878* (W.469), 1878, 80 × 48.5 (31½ × 19⅛)

explodes. The critics shake their fists and call the painter a 'communard' and a 'scoundrel'.[155]

Since the issue of the amnesty had not been resolved, the Commune could not be consigned to the past, but the fears which it had aroused seem to have been swamped by the general euphoria occasioned by the Exposition, and Duret's comment remains naggingly elusive: What was the connection between violet flesh tints and the communard? Had 'communard' become a generalized term of abuse or did it retain some potency as indicative of almost unspeakable fears of social disruption?

There had been considerable doubt about holding the Exposition Universelle because of the fear of mass gatherings. An official report published in 1878 commented that many had questioned whether, 'after the cruel events of 1870–1' and 'the inevitable rigour of the measures of repression taken against the insurgents', it was time 'to raise this veil [of mourning and grief]', to invite other peoples to public celebrations, giving them 'the spectacle of our monuments still in ruins'. *Le Rappel*, however, supported the Exposition as 'a revenge, a pacific battle', and drew attention to the numbers of workers lost in 1871, and the need for an amnesty.[156] The Exposition would make visible what 'the democracy of shareholders' had achieved through mastery of modern science, technology and industry, and would be a demonstration of faith in a free-enterprise system in which hard work and individual initiative would bring justice and happiness to all. Yet, as Halévy suggests, the spectacular success of the Exposition changed its atmosphere: 'the apotheosis of Work was forgotten, and, as in 1867, Paris became the theatre . . . of "a permanent *mardi gras*"'.[157]

Monet's dazzling paintings of Paris on 30 June 1878 should be compared with the little painting of the Pont-Neuf of late 1871, with its sombre mood and isolated, hunched figures, as further examples of the desire for reparation which had shaped his work since that time, and which, because of Impressionism's insistence on the moment, had to be constructed in terms of a forgetfulness, a displacement of the past. The new works were painted seven years after the destruction of much of Paris by bombardment and burning, after the horrors of the siege and the repression of the Commune, but, were it not for the ruins of the Tuileries and other buildings, still standing in central Paris, if not in Monet's painting, those events might have seemed even more like 'a bad dream' than they had to Zola in 1872. 'It is not the Seine which flows through Paris', wrote one contemporary, 'it is Lethe', the river of forgetfulness.[158]

In Monet's *Rue Montorgeuil* the depersonalization of figures in an urban context is taken even further than in earlier works such as *The Boulevard des Capucines*: the confetti touches evoking the crowd fuse together in larger patches of light and shade in the depths of the street, and the figures are completely subordinated to the dynamism set up by the flags, which twist and turn down the narrow chasm in ceaseless, fragmentary movement, activated above all by the reds, which almost leap off the surface of the painting. The physical experience of the breaking down of individual consciousness into a collective dynamism is pictured with a force equalled only forty years later by the Futurists.

Monet and his friends were in a significant sense excluded from the celebrations, for their work was nowhere exhibited, and their financial difficulties may have made them feel that the Exposition's promise of progress was not for them. The jury for the art section of the Exposition was so severe that it excluded even significant members of 'the generation of 1830', Delacroix, Millet, Rousseau and Troyon, and

Durand-Ruel organized a loan exhibition of their paintings in August. The Impressionists decided that to hold another exhibition in his gallery in these circumstances would, in Pissarro's words, be 'a fiasco'.[159]

In a volume edited by Louis Gonse, Paul Mantz commented that the official exhibition of modern French art revealed something not so apparent in the annual Salons, something marked by 'a certain sadness':

it lacks gaiety, ardent and extravagant youth. Good Lord, how reasonable we have become! and how dark we paint! [French artists] obstinately seek to appear serious and convinced and underline every least word. Considered as a whole, the modern school gives the impression of believing that the spectator has not a ready intelligence and will not understand unless everything is spelt out. . . .[160]

The image of modernity projected by the Exposition as a whole was, then, contradicted by the regressive character of the official art exhibitions, while Impressionist painting, which in many ways shared the values which shaped the Exposition and was deeply responsive to the modern, was completely excluded from view. It had the 'gaiety, ardent and extravagant youth' whose absence in official art Mantz bemoaned, and whose semblance Paris took on in 'the permanent *mardi gras*' of 1878. In 1877 Rivière had commented on Renoir's *The Swing*:

One senses there the absence of all passion; these young people are enjoying life, the superb weather, the morning sun filtering through the foliage; what does the rest of humanity matter to them! They are happy. . . .[161]

His words could also have applied to the figure painting of Monet and Morisot. Yet, if the comment expressed the mood in Paris in the first secure year of the young Republic, it must have seemed to the Impressionists that, after over a decade of unremitting work, only a handful of writers, collectors and fellow artists were capable of finding positive values in their art.

Writing about the public's 'complete indifference' to Durand-Ruel's exhibition of a previous avant-garde, 'the generation of 1830', Pissarro claimed ironically that the public had

had enough of this . . . dull painting which requires attention, thought. All that is too serious. *As a result of progress, we are supposed to see and feel without effort, and above all to enjoy ourselves.* Besides, is art necessary? Is it edible? No. Well then![162]

Most of the officially sanctioned works in the Exposition were, as Mantz emphasized, readily appreciated because their meanings were clearly 'spelt out' through subject, composition, precision of handling and literalness of detail, but this instant gratification was not, in Pissarro's view, supplied by the works shown by Durand-Ruel, which required serious study of the language of painting. In their own exhibitions, Monet and his friends had offered access to the intimacies of this language through their use of contemporary subjects which their middle-class public enjoyed in life, in illustrations and in officially sanctioned art; but they did so in ways which did require effort 'to see and feel' and which challenged contemporary codes of representation.

The Impressionists' failure to be accepted by the class whose values they represented, together with the sufferings engendered by the slump in the economy, evidently shook Monet's confidence in the representation of modern life and in its presentation in group exhibitions. Although they were rooted in perceptual experience, the paintings of Monet's first twenty years as a painter were Utopian, their endless beauties generated by a longing for some ideal, sensuous plenitude. Henceforth he was, however, to locate his 'loved landscapes' – as Silvestre called them[163] – at a distance from those shaped by the modern city.

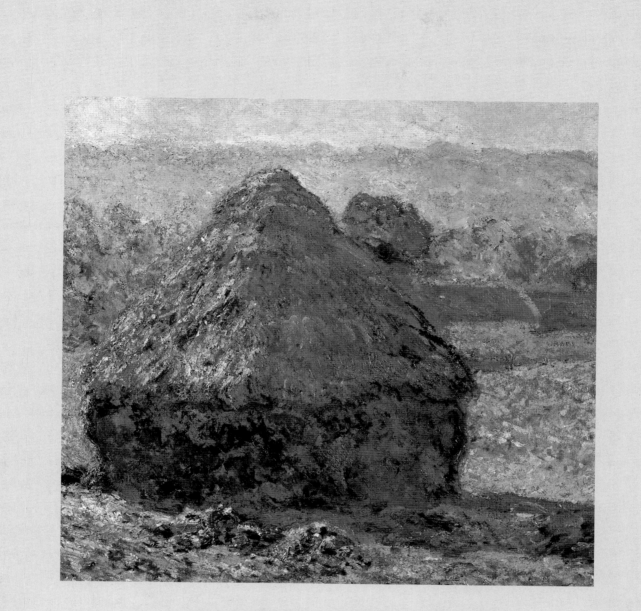

# PART TWO

Challenging Time

Vétheuil and Giverny 1878-1904

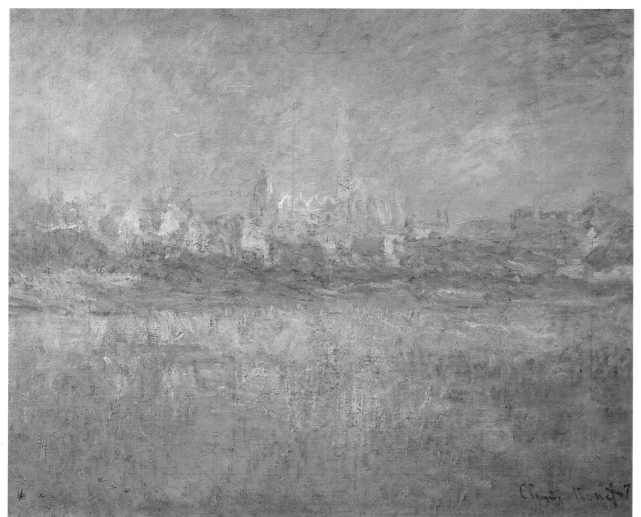

144   *Vétheuil in the mist* (W.518), 1879, 60 × 71
(23¼ × 27¾)

145   *Vétheuil, winter* (W.507), 1879, 69 × 90
(27 × 35)

146   *The Church at Vétheuil, winter* (W.505), 1879,
65 × 50 (25¼ × 19½)

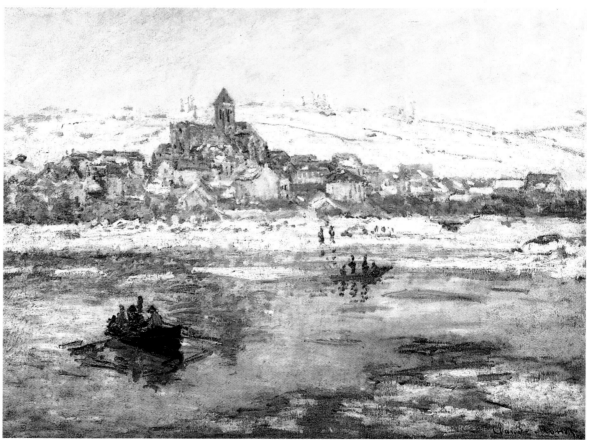

147    *The Frost* (W.555), 1880, 61 × 100 (23¾ × 39)

148    *Vétheuil seen from Lavacourt* (W.528), 1879,
60 × 81 (27 × 31½)

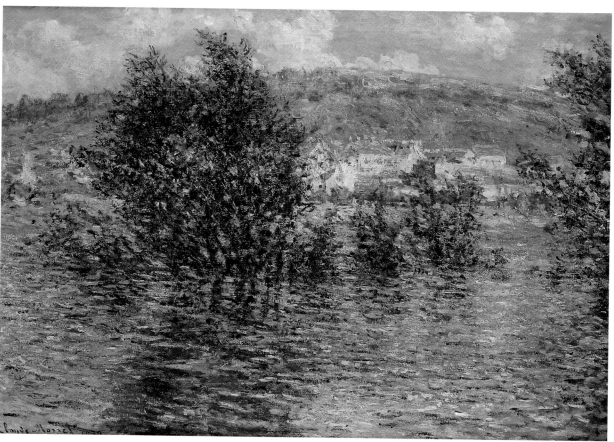

# 3

# *Vétheuil and the Normandy Coast 1878-1883*

*You no doubt have news of Paris from others. . . . more and more a peasant, I scarcely know anything new.*
MONET to DURET, 1880

*I myself think very little of the opinion of journals, but one must recognize that, in our own period, one can do nothing without the press.*
MONET to DURAND-RUEL, 1883

*I know my value, and am more demanding for myself than anyone else can be. But one must see things from a commercial point of view.*
MONET to DURAND-RUEL, 1883[1]

THE FOUR YEARS BETWEEN MONET'S MOVE DOWN THE SEINE TO THE LITTLE town of Vétheuil and his final move to Giverny, still further down the Seine, were crucial in determining the form his art would take in the second half of his life. In particular they confirmed his specialization as a landscapist. At Vétheuil, undistracted by any intrusion of the modern, he could concentrate with unprecedented intensity on his perceptions of a tiny area of nature. Duret had recently commented that Monet painted 'embellished nature', rather than 'natural nature'; now Monet not only turned away from modern socialized landscape, but represented the populated, densely cultivated Vétheuil countryside as if it were 'natural nature'. Henceforth, except for painting his family in the garden or fields at Vétheuil and Giverny, and on the beach and cliffs at Pourville in the 1880s, Monet no longer represented modern life. His paintings of the *fête nationale* in 1878 were the last in which he depicted human life in the city, for when he painted in Rouen, London and Venice in the 1890s and 1900s, he represented their huge monuments as if they were natural features. Nevertheless Monet's landscapes of the rural heartland of France were shaped by the modes of vision he had evolved during his most conscious engagement with the modern: the continuity of rural time was shattered into ever more precise units; the associational values which had fused the French landscape with the Arcadian were displaced, shepherds, nymphs and peasants departed, and the agricultural landscape shaped over the centuries was gradually transformed into one of pure, re-creative vision. For example, by contrast with *Argenteuil, the bank in flower*, a picture of the suburban river shaped by the modern, *The Bank of the River, Lavacourt* was more closely related to the traditions of French rural painting: Monet depicted the human landscape as if it were

'natural', but so dazzling is the display of abstraction by the figuring brushstroke that the painting reveals itself as a modern intervention in that landscape, an act of self-conscious pictorial language.

In 1880, in a speech supporting amnesty for the Communards, Gambetta told the Chambre des Députés, 'You must close the book of these ten years . . . and you must say to everyone . . . that there is only one France and one Republic'.[2] The return of the Republican government from Versailles to Paris, the partial amnesty of 1879, the re-establishment of 14 July as a national holiday and the declaration of a full amnesty in 1880, were the last steps towards securing the Republican regime, even though its confidence was simultaneously undermined by economic depression. Monet's two paintings of a flag-bedecked Paris were very much in the spirit of the intense desire to forget the past in the delights of the present, but he never again painted such straightforward images of the confidence of the progressive Republic; indeed, his Vétheuil paintings sometimes suggest the anti-modern values of the Barbizon landscapists. His withdrawal from the urban environment and his retreat into nature coincided with the economic depression, and with the widespread disillusion with the conservative reformist Republic, seen as a cynical 'Republic of opportunists'.

Monet went to Vétheuil for a summer's painting season; he was held there for personal and financial reasons and he became so deeply absorbed in painting the area that he resented leaving it even on short trips to Paris, where he kept a *pied-à-terre* to assist his 'hunt for purchasers'.[3] At the same time, while he wrote with a certain satisfaction about how 'countrified' he had become, he was well aware of what was happening in Paris, and adopted new strategies to create an audience for his painting.

This period has been characterized in terms of the 'crisis of Impressionism', when the Impressionists began to question their commitment not only to modern-life subjects, but to informal open-air painting and to group exhibitions.[4] The economic depression made Monet abjectly poor in these years, and probably sapped his confidence in creating a modern iconography which would appeal to a large enough section of the public to support him. His struggle to continue painting when confronted with repeated financial crises eroded his relations with his fellow Impressionists, and although he was rescued by Durand-Ruel's re-entry into his life in 1881, his Impressionism was never again to be shaped by a collective endeavour. The undermining of his relations with his Impressionist colleagues coincided with the death of Camille, and the threatened disintegration of his family. With the exception of an 1879 painting of Michel Monet (probably) and another child with a nursemaid in an orchard (W.521), Monet did not depict his own family in the landscape between summer 1878 and spring 1880, and after Argenteuil, Camille Monet appeared in her husband's painting only on her deathbed.[5] He thus abandoned one vital means of finding his relationship to the landscape.

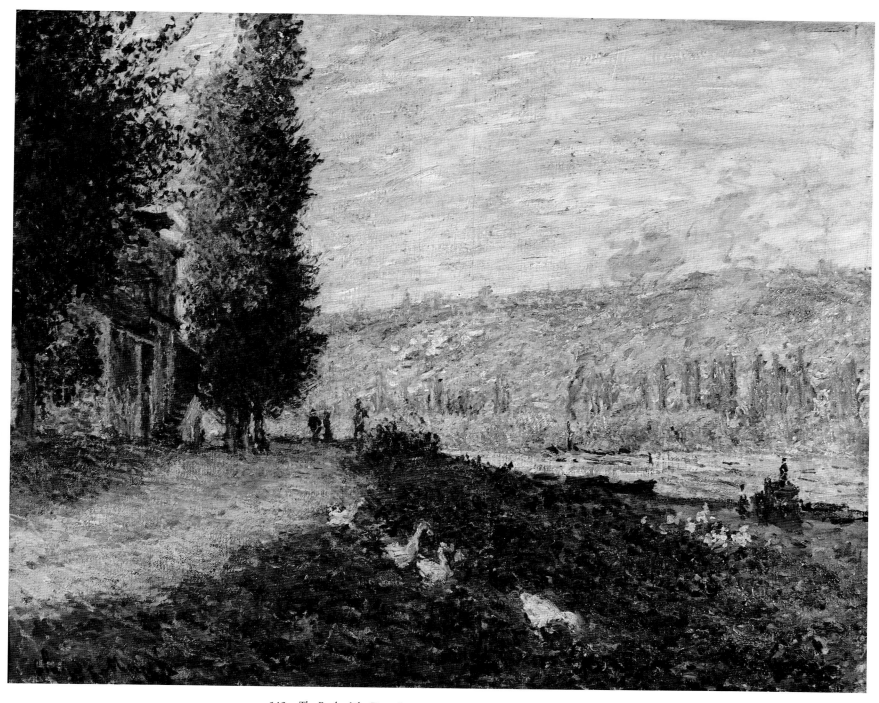

149  *The Bank of the River, Lavacourt* (W.495), 1878, 65 × 80 (25¼ × 31¼)

When Monet 'pitched his tent in a ravishing spot on the banks of the Seine',[6] he was joined by the family of the recently bankrupt Ernest Hoschedé, and it was decided that, partly for reasons of economy, the two families would set up house together. Their small dwelling sheltered the four Monets (including a baby) and eight Hoschedés (also including a baby), not to mention the Hoschedés' cook, nurse and governess. (Since they were not paid, the nurse and governess did not stay long.) The tensions of such a situation were exacerbated by increasing poverty and by Camille Monet's agonizing illness. Her husband may already have been attracted by the cultivated Alice Hoschedé: it is not known when the relationship of these two very emotional people began, but the increasingly extended absences of Ernest Hoschedé would have thrown them into one another's company,

and within a year of Camille's death in 1879, they must have been considering how they might spend their lives together. Monet was deeply affected by his wife's death, and although he found consolation in the gradual creation, with Alice, of a new family out of the children of both their marriages, it was surely a time of anguish and perhaps guilt, and this may have been one reason why his exploration of the Vétheuil landscape was a solitary one.[7] It was also extraordinarily concentrated: in his first two years there Monet painted scarcely any motif beyond a half-circle with a radius of two kilometres (1¼ miles) centring on his house; at least 178 paintings were executed in this area, before he broke out of its narrow confines in a visit to the Normandy coast in late 1880.

Vétheuil is perched above the Seine, but turns in on itself, with only narrow, stone-walled lanes and steps running down to a strip of

uncultivated land bordering the river. High slopes with woods and orchards close in behind the little town, but across the Seine lies a flat plain edged by the straggling hamlet of Lavacourt. Seen from Lavacourt, Vétheuil forms a shallow triangle with its apex in the church tower. The house rented by the two families was located just outside the left-hand angle of this triangle, on the road leading out of the town; across the road was their garden and orchard which led down to the river where the families moored their boats, including Monet's studio-boat. He was to absorb himself in this little world, exploring the contrasting views given by the enclosed village and the open plain, the broad river, its islands and narrower, tree-closed channels.

Twelve kilometres from the nearest railway station, at Mantes, Vétheuil was a small agricultural town unaffected by modern urbanism and industrialism; instead of a railway, its link with the outside world was by horse-drawn vehicle and by a ferry which took agricultural workers to the fields across the river. Monet usually depicted the town in the distance, scarcely differentiating it from the surrounding landscape, so that it seems to have grown naturally out of that landscape, rather than to have been a human creation. His paintings of Argenteuil registered the impact of modernism in the straightening of roads, the building of pavements, the erection of lamp-posts, but he almost always depicted Vétheuil's one modern structure, a fancy bourgeois villa with an ostentatious tower, as if it were part of the continuous fabric of nature.

Few of Monet's paintings at Vétheuil suggest that the river had a human, functional life – some show the ferry, and a mere seven pictures hint at what would have been its fairly constant commercial use by tugs and barges. The boats were used to animate the river's surface rather than to depict its human use. Even in the few paintings of his family boating, Monet represented the figures as unindividualized smudges or dots of paint (as in the *View of Vétheuil* [W.609], Nationalgalerie, Berlin), and generally Vétheuil and its surroundings were empty, as if abandoned to nature.

Monet's representations of an unmodernized landscape look back to the work of his immediate predecessors, Corot and Daubigny; but their paintings suggest a continuity between the landscape and the human beings who had shaped and occupied it over the centuries. Corot and Daubigny had acquired their means of expression in pre-industrial

France, and, as has been suggested, there was an accord between their subjects and the slow rhythms, continuous space, closely related tones, and sober, low-keyed coloration of their paintings. Moreover, their acceptance of the primary value of studio painting implied that their work attached itself to inherited forms, rather than seeking to exist purely in the present moment, and their landscapes had come to be accepted as embodying the essence of the French tradition. Monet's renewed interest in unpeopled landscapes suggests that he was being influenced by the conservative ideologies which maintained that essential truth is found through solitary communion with nature rather than in social experience, but Monet's experience of the modern in the 1860s and 1870s undermined the notion of the essential from within.

Vétheuil enabled Monet to absorb himself in nature's time, in the continual change of light through the day, in the passage of the seasons and the unceasing movement of the great river; yet, precisely because he was not distracted by yachts, trains or promenaders, he was confronted more starkly than before by the relativity of what he saw. He developed a practice of working with a few readily identifiable motifs – most often the towers of the church and of the modern villa, which appear again and again from different viewpoints – as markers to indicate the continuity of his exploration of the landscape. At the same time, however, the focus on such motifs had the effect of disrupting the image of the landscape, which fractures, stutters, breaks down into isolated acts of apprehension. Monet spent hours in front of the motif and years exploring the Vétheuil area, yet his 'Vétheuil' was still shaped by the modern urban mode of seeing which consumes what it sees in the moment, and fragments the visible world into instants of recognition, which are theoretically infinite in number, and no one of which has more value than another in penetrating to the reality of that world.

The effects of this fragmentation were intensified by the economic situation: falling prices forced Monet to produce more works, and to do so more quickly than ever before. Perhaps in reaction to this pressure, he developed ways of working which partially allayed the 'shock' of fragmented time: he devoted himself to subjects, such as the river or the sea, whose continuity he could actively experience; he recreated the ideal wholeness of the family within the protective garden or domesticated landscape; he began to evolve a mode of working in series, in which the motif was endowed with an ambiguous stability through being positioned in a sequence of moments of light; and, increasingly, he worked in the studio, a practice which tended to prolong the moment. As he began to emerge from his domestic and financial crises, Monet's works tended to become more densely painted, each canvas recording a complex accretion of observations, more durable in form than the earlier, sketchier works. Nevertheless his fundamental commitment to the encounter with nature and its constantly changing effects always instated discontinuity at the heart of any desired continuity. Monet's isolation at Vétheuil intensified the individualism inherent in his relationship to nature, in ways which would accord with the refined individualism cultivated by the Parisian avant-garde in the 1880s.

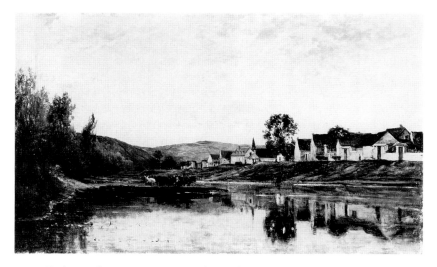

150   Charles Daubigny, *A River Scene: The Ferryboat at Bonnières*, 1861, 57.2 × 93.3 (22½ × 36¾)

# I

Monet spent his first months at Vétheuil as he had spent them at Argenteuil, exploring the area, and painting most of the motifs he would paint in the next three years. This exploration was partially conducted

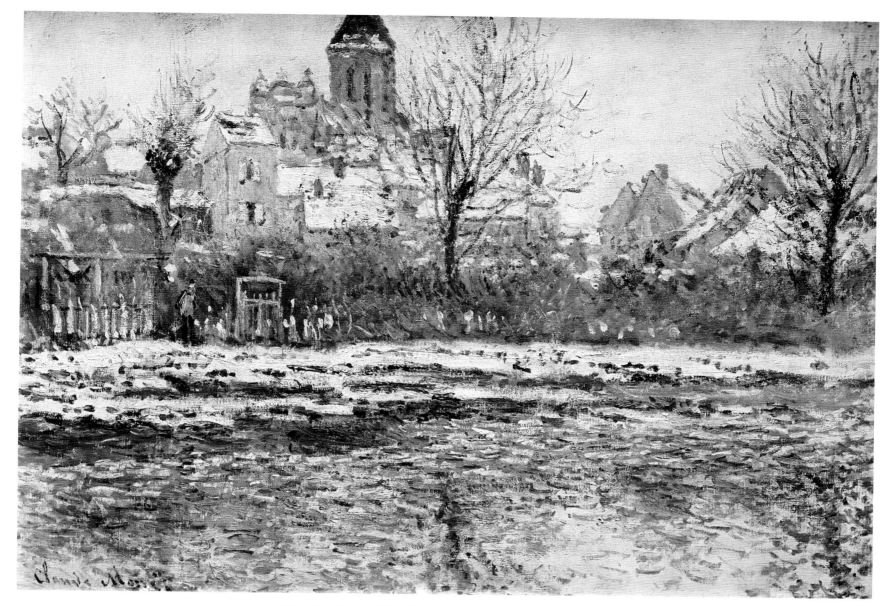

151    *The Church at Vétheuil, snow* (W.506), 1879, 53 × 71 (20¾ × 27¾)

through drawing, and his surviving sketch-books contain several Vétheuil motifs in which he used long or staccato scratchy lines, darkening or multiplying them to suggest shadow, but never creating blocks of shading to isolate solid forms. Sometimes in these sketches, Monet repeated contours or interior lines so often that they are difficult to read, but suggest that he was trying to embody the relationship between forms as much as the forms themselves.[8]

Only two paintings – those of the centuries-old church – were of motifs located within Vétheuil itself; otherwise Monet observed the town from a distance, choosing motifs which embodied the timeless aspect of the countryside, for example the cottages of Lavacourt on the towpath (W.495–501). In one painting of this motif, he stressed the rusticity of the cottages and unpaved path, and included geese, poultry and their keepers, the stock-in-trade of Barbizon landscape painting. In only two of these pictures is there a tug, a single example of those which regularly passed Lavacourt. In his paintings of the rivers of the Île de France, Daubigny favoured compositions like this, with a broad expanse of sloping bank which distances the cottages, and leads the eye gently into the depths of the picture, in a slowly unfolding appreciation of the calm balance of houses, trees, river and distant slopes. Monet goes much

closer to the motif, so that the eye is forced into abrupt spatial movement as it tries to adjust to the diagonals which advance towards the spectator as strongly as they converge on the distant figures. Daubigny distinguishes the textures of different components of the landscape, while Monet uses the same staccato strokes throughout the composition. The loosening of the brushstrokes from form enables Monet to create a structure whose unity is revealed to the spectator only as a process in time – experienced, for example, in the gradual discovery of the constructive role of the repeated vertical accents.

Monet painted this same motif four times, with minor variations. His procedure was similar to that he had used at Argenteuil – in, for example, the different versions of the flowering bank of 1877 – but the effect is different. There, the delicate variations are a response to significant differences in light and form, while here the repetitiveness is so insistent that it suggests a worrying after a different relationship to the motif – a desire, perhaps, to penetrate its inflexible otherness. This desire may have influenced Monet's attempted return to the continuities of the traditional humanized motif, but his mode of visualization inevitably destroyed those continuities. Similar imperatives underlay other groups of works, such as the three views of the village and church

seen from across the river, each painted with almost coarse, linear brushstrokes which draw attention to the ways in which they construct the image. The largest, a panoramic view of *Vétheuil, winter* (ill.145), is so broad in its handling that, in certain areas – as in the immediate foreground, or the dots on the far bank – colour does not resolve into recognizable form. Thus the village, visibly constructed from the same material as the hills and river, seems, despite the presence of the figures in the boats, like a natural growth within a deserted landscape without any human continuity.

In *The Church at Vétheuil, snow* (ill.151), Monet came closer to the bank, and used short, vigorous linear strokes to establish a network of horizontal and vertical accents which give a sense of completeness to the painting. He came yet closer in *The Church at Vétheuil, winter* (ill.146), and accentuated the differences between the tones which register delicate changes of light and texture in the buildings, trees and fences, and the large patches of tinted white which represent the snow without 'settling into' explicit description. As can be seen in the 'hinge' between the whites in the horizontal plane of water and those on the vertical plane of the bank, Monet seems to have been playing a game of recognition between these contrasting modes of representation.

The repetition of motif in these paintings emphasizes, even more strikingly than in Monet's earlier works, the different processes by which coloured marks create the image, and undermines the sense that the external world has a fixed reality independent of the way it is perceived by the individual. In this sense, *Vétheuil in the mist* (ill.144) is not only an extraordinary embodiment of light made material in early morning mist, but suggests that the town has no reality except that revealed by the image.

Monet decided to stay at Vétheuil, despite Camille's illness, because he could still sell paintings of that area and because it was cheap to live there; nevertheless his earnings fluctuated drastically (he earned 1,070 frs. in January 1879, and 200 frs. in February and March). He was nearing forty, and felt that he had been struggling all his life to no effect:

I'm absolutely disheartened and demoralized by this existence which I've been leading for so long. When one is in [this state] at my age, there is nothing more to hope for. Unhappy we are, unhappy we will remain. Every day brings new anguish and every day there arise new difficulties which we will never escape. . . . I no longer have the strength to work in such conditions. I hear that my friends are organizing a new exhibition this year, I must give up taking part, having done nothing which is worth the trouble of showing.[9]

His feeling was shared by other Impressionists. Pissarro, whose situation was even worse, wrote:

What I have suffered is beyond words . . . what I suffer at the actual moment is terrible, much more so than when I was young, full of enthusiasm and ardour. Now I am convinced that I am lost for the future. Nevertheless, it seems to me that I would not hesitate, if I had to start again, to follow the same path.

He, however, kept his faith in collective action, while Renoir and Sisley had decided to exhibit at the Salon. Pissarro told Caillebotte that Monet had come to believe that the group exhibitions 'prevents us from selling', and in fact Monet agreed to show in the 1879 Impressionist exhibition only because his colleagues might think him 'a coward' if he did not. The wealthy Caillebotte, who was coming to take Bazille's place as Monet's moral and financial support, and who paid the rent on his *pied-à-terre* in Paris, was determined that the exhibition would be held and that Monet would exhibit. 'I will take care of everything', he wrote. 'Send me a catalogue immediately . . . Put down as many canvases as you can. I'm sure that you will have a superb exhibition. You get discouraged in a frightening way.' Caillebotte advanced him 2,500 frs., and arranged the loan of 29 of his works from different collections – 17 from the 1860s and 1870s, and 12 Vétheuil paintings – thus giving Monet a small retrospective. It is a measure of Monet's alienation from his friends in Paris that he took no part in planning the exhibition, and did not even visit it.[10]

The 1879 exhibition aroused less passion than in previous years, and although there were no important theoretical reviews, hostile notices were more or less balanced by sympathetic ones. The rather muted reaction was probably because the absence of Morisot, Renoir and Sisley, and the presence of Degas's protégés detracted from the polemical character of the exhibition as a manifestation of *'intransigeants'*. Lafenestre, in the arch-conservative *Revue des deux mondes*, predicted that 'the little band of independents . . . the last remnants of the group of impressionists' would not last long, since it was losing 'all those who could barter independence for . . . the humblest place in the official Salon'. Only Degas and Cassatt, he said, were worthy of consideration.[11]

Bertall, previously their virulent critic, asserted that the artists exhibited only 'a gentle madness'. Silvestre claimed that the public had become accustomed to 'this summary translation of external things'. Duranty, in a reassuring article in the conservative *Chronique des arts et de la curiosité*, said that those who had not seen artists paint, had not been associated with those seeking a new way in art, and who wanted only immediate gratification in their gallery visits, would tend to mock 'laborious essays which resemble the experiments of the chemist or the physicist' in their 'decomposition' of light. In *L'Art*, Tardieu drew attention to the effects of the consumption of culture: 'never', he wrote, 'has there been such interest in the arts, never has there been less passion for them'; Manet was recognized in the Salon, where Renoir's work was well hung, while the *'artistes indépendants'* earned 700 frs. a day (in entrance fees) 'without discussion, without polemic, without publicity':

To the passion . . . of earlier years has succeeded a general curiosity which neglects nothing, which disdains nothing, which is interested in everything, but whose imperturbably calm and vaguely well-meaning scepticism nothing can disturb.[12]

Probably referring to Caillebotte's and Monet's painting, Lafenestre noted that earlier landscapists, such as Rousseau, Troyon and Millet,

preached . . . horror of infected cities and love of the healthy countryside . . . If [the Impressionists] go to the fields, it's on Sunday, with the crush of city-dwellers, pushing as far as Asnières or Bougival . . . only to find that which is the least rural in the world, crudely painted taverns, men canoeists in pretentious undress and women canoeists in shoddy furbelows.

Monet's paintings of Vétheuil were located in 'the healthy countryside', but to Lafenestre they seemed to have been irremediably corrupted by the modern.

On the other hand, the critics of the moderate Republican press sang so unanimous a chorus of praise for Monet's two paintings of the flag-bedecked streets of 1878 as to suggest relief that this *'intransigeant'* was participating in the 'movement of reconciliation'. Ernest d'Hervilly exulted in 'the immense and joyful palpitation of the tricolour flags repeating themselves endlessly, the surge and agitation of a celebrating populace'; Burty and Silvestre transformed the urban spectacle into a phenomenon of nature: the former evoked 'the tricoloured foliage of flags', the latter claimed that Monet

has recovered all his verve and audacity in two canvases of the festival of flags. What a teaming crowd under the banners, and how the wind tosses them in the light. It looks like a storm and the waves beating on a ship with tricolour sails.[13]

Apart from these two paintings, critics generally preferred Monet's works of the 1860s, probably because they had become accustomed to their language; Sébillot, for example, liked the early marines, but had 'trouble understanding a number of his newer canvases where all the colours of the rainbow have been juxtaposed'. Most focused on what they saw as the painter's hasty execution: claiming that Monet was exhibiting 'thirty works which one would say were done in an afternoon', Wolff said that he had once thought 'that the author of these casual sketches, of this superficial but felt impression of nature, might become someone, and here he is, still in a mire from which he will never escape'. Hostile criticism was to be expected from Wolff, but he had a powerful influence on opinion and his sweeping dismissal of 'the little sect . . . lacking any study, any science, any truth, and common sense' could not be ignored.[14]

Indeed, despite fairly favourable critiques and the attendance at the exhibition of more than 15,000 visitors, Monet had reason to be disturbed by the continuing critical emphasis on the incompleteness of his painting. He may already have heard of Zola's remark, in an article published in Russian in St Petersburg (and partly reprinted in French in Paris in July 1879), that Monet 'seems exhausted by hasty production; he is satisfied with the "good enough"; he does not study nature with the passion of a real creator'. This perennial criticism could have been more worrying, since Duranty and Duret had both given explanations for the apparent sketchiness of his paintings. Duranty's ideas on the Impressionists' 'decomposition of light' related closely to Duret's observations on Monet's rendering of 'fugitive impressions which his predecessors had neglected or considered impossible to paint': 'the thousand nuances of the water of seas and rivers, the play of light in clouds, the vibrant colours of flowers, and the variegated reflections of foliage in the light of a blazing sun'. The interpretations of the two critics soon came to dominate theoretical interpretations of Monet's art, but did not go uncontested. In his review of Duret's pamphlet, Ephrussi had written, 'It seems to me that to render these instantaneous impressions properly . . . one needs less summary processes, a surer hand, more conscious execution, more conscientious work'. It was some time before there was general understanding that there was a necessary relationship between summary brushstrokes and the representation of rapidly changing effects of light. Such criticism clearly affected Monet, who wrote to Hoschedé in May, 'I alone can know my anxieties and the difficulties which I create for myself in order to finish canvases which do not satisfy me and which please so few people'.[15]

Monet's financial difficulties did force him to sell works which he did not consider complete – he even had to offer works in 'job lots' at a single price[16] – yet he was also moving towards a new kind of structure in which brushstrokes, increasingly detached from form, created what might be called a dynamic completeness, one which develops in time. One such work, *Vétheuil seen from Lavacourt* (ill.148), was lent by Duret to the 1879 exhibition. Like most of the works executed at Vétheuil and on the Normandy coast in this period, it was painted with a wide variety of brushstrokes, which form a thick, dry, almost chalky paint substance calling attention to itself even more emphatically than did the Argenteuil paintings. Those earlier works were more responsive to the forms of the landscape, whereas in the later works Monet used these pastey strokes to express the linear forces *within* those forms. The

mobile brushstrokes integrate the linear surface divisions, characteristic of the earlier works, into the continuity of coloured light in space. In the view of Vétheuil, the painting is simply divided by the horizontal of the bank and the central vertical of the darkest trees and their reflections; but the horizontals are subtly inflected into convex curves by means of brushstrokes representing the ripples which flow outward from the bushes. In earlier works in which Monet represented water stretching away from him – as in *Autumn effect, Argenteuil* – he used horizontal strokes to articulate the plane of water, but in *Vétheuil seen from Lavacourt* he seems to have been trying to register complex effects of focused and peripheral vision. Thus visual incidents seen peripherally – depicted at the base and sides of the painting – appear to be blurred and to curve away from the spectator.

Not only do the curved brushstrokes embody the dynamics of sight, they also allow the spectator to participate imaginatively in the creation of pictorial form, for their very obtrusiveness as brushstrokes, which so disturbed Monet's contemporaries, shows how he used them to create wholeness – as, for example, in the way they complete the curves of the hill in the lines representing ripples of water, while the long brushstrokes depicting trees and their reflections are also absorbed into this linear dynamism. The painting thus creates a form of stability which derives from changing relationships and fluctuating brushstrokes. It is a stability so evanescent that it can embody the gleam of rain-washed light as it breaks into myriad slivers of colour on the mobile surface of the water.

In his May letter to Hoschedé, Monet said that it was impossible for him to meet his share of expenses for the joint household, and that it would be better if he and his family departed. Nothing came of his suggestion, perhaps because he was depending on Alice Hoschedé to nurse his wife. Also in May, Ernest wrote that 'Camille Monet's long agony is truly sad', and that she had only a few days to live; but in mid-August Monet was appealing to Dr de Bellio for advice, for his wife was 'too weak to stand up or take a step . . . or support the least bit of food. It is necessary to be continuously at her bedside, watching for her slightest wish'.[17] In the same letter he begged de Bellio to purchase a number of paintings 'at any price you like . . . 200 or 300 frs.', so that he could buy materials to work. Perhaps because he had received so many appeals, de Bellio was dismissive about Camille Monet's condition, and brutal about her husband's painting:

I must say – with all the frankness you know me to possess – that it is truly impossible for you to dream of making money from canvases which are so incomplete. You are, my dear friend, trapped in a terrible circle from which I do not see how you can escape. To make money one must have paintings and to make paintings one must have money. . . .[18]

Camille Monet died on 5 September 1879 after having, in her husband's words, 'horribly suffered'. Forty years later, he still remembered sitting by the bedside of what was left of the woman who had been central to his life as a painter and who, as he said, 'had been and still was very dear to me'; and he still recalled the shock of discovering that he was 'so much a painter' that he found himself observing 'the changing colours which death had imprinted on her face'.[19] He did paint her, an astonishing image of dissolution in which insubstantial, drifting, thread-like strokes of mauve, blue, rose and white suggest something of the mystery of a body from which life had departed (ill.306). The painting is something other than a *souvenir*, a record of a dead woman. Monet had cut off the normal emotional responses so that he was

observing the loved face as an object, seeking to penetrate the moment of change itself. His mode of painting, which so inextricably fused seeing and feeling, and feeling and forming, resulted not in a description of a past moment but in a re-creation, the giving of life to something dead, so that the moment is endowed with continuity.

Monet's letter to de Bellio, with its immediate transition from Camille's agony to his need for paints, reveals how inseparable were his fears of the disintegration of his family from those for his survival as a painter. De Bellio's cruel truism, that one needed finished works to make money, and money in order to make finished works, emphasized the contradictions inherent in the situation, for Monet's new, more dynamic paintings suggest that he was increasingly aware of the mobility of the moment, just as he was coming under increasing pressure to immobilize it in 'moments' complete enough to sell.

That Monet felt an intimate connection between the presence of Camille and his painting of landscape is suggested by the fact that he painted no landscapes for over three months after her death, concentrating instead on representing fruit, flowers and game. Still-life paintings may also have been necessary, since those sold better than his landscapes, and since creditors were threatening to evict the two families and to seize their goods. Alice Hoschedé, who had once been given a dowry of 100,000 frs., had inherited a mansion and been dressed by Worth, wrote to her husband of 'killing myself with tiredness, doing work beyond my strength, even going so far as to saw wood', and soon complained that Monet was having to help support their family.[20] Yet, even if Monet was forced to paint still lifes, they hint at intimate meanings: the *Pheasants and plovers* suggests an association between the strangely juxtaposed pairs of large and small birds, in their inert, unequivocal deadness, and the destruction of Monet's family as a living unity of two adults and two children. It suggests too an association between this destruction and Monet's enforced painting of still life for which the French term is *nature morte*, dead nature.[21]

Monet returned to landscape to paint the seemingly dead river during the winter of 1879–80, the worst ever recorded on the Seine, which froze in December, thawed dramatically in early January, and half-froze again until mid-February. Monet painted the grip of ice on his beloved river, the ice-floes choking the river or drifting downstream, and finally the icy winter sun setting over the freely flowing river (ill.154).[22] It has been suggested that the paintings of the frozen river were an expression of Monet's guilt and despair at the death of his wife and at some (never proven) transgression with Mme Hoschedé: but, although it is tempting to relate the paintings of the arrested life and rebirth of the river to the human drama of death and renewed life of Camille, Claude and Alice, Monet never used nature to mirror his feelings in any straightforward way. In these paintings any literal parallel between a natural effect, a human situation and the emotional content of the painting simply does not operate. It was when the river was fully frozen, at a time of their most extreme financial distress and when Alice Hoschedé was writing almost daily to her husband reproaching him for his absence, that Monet painted some of his most ravishing pictures of the beauties of winter sunlight, with the delicate scales of white tinged with rose, blue and mauve. And in some of the paintings of what he called the 'terrible thaw' (when he had been heartened by sales to the dealer, Georges Petit, whose advice that he should hold out for higher prices he triumphantly relayed to de Bellio with the warning that the doctor should now expect to pay more substantial prices for his paintings), Monet represented the ice-floes

as sombre and almost menacing, using livid colours – sharp blues, cold pinks and mauves, icy red-purples – and locking the potential movement of the river into a rigid horizontal/vertical grid.[23]

Monet's account of the way he observed his dead wife simply in terms of colour sensations shows that he could shut off the affective relationships between himself and what he observed, so that what he painted retained its 'otherness'. The reparative character of his art did not, then, consist of projecting his emotions into what he saw, but of creating a kind of wholeness from his processes of observation. Yet, precisely because he could cut off his immediate emotional ties with an object, other associations could arise. In four of the paintings of the frozen river (W.553–556), the luminosity of the snow is gashed by the stark tones of a boat immobilized by the ice (ill.147) in almost the same position as that occupied by another boat in the painting of Camille, *On the bank of the river, Bennecourt*. Although he never used it explicitly, Monet was, as we have seen, well acquainted with the insistent association of the sexuality of women with flowing rivers and empty boats, and such an association could subconsciously have caused him to focus now on the boat which, caught in the deathly grip of the ice, had obvious resonance in his current situation. Although he was deeply averse to using landscape for symbolic purposes, and, although his paintings and his words suggest that he found the indifference of nature to human concerns of primary significance, his very detachment could have allowed the play of subconscious associations between the death of a loved woman and the freezing of the great river, both of which had been central to his life as a painter.

Unlike the works executed in the winter of 1878–9, with their small, rather scratchy strokes of dry paint, those of the winter of 1879–80 were constructed from longer, more fluid strokes of clear colour in closely related tones. Thus, in the luminous *Lavacourt, sun and snow* (ill.156), the contrasting areas of colour representing the cold shadowed foreground and the hills warmed by the cool early morning light are formed by long strokes of blue and violet, of pink and saturated orange.[24] The stillness of the snow-bound slopes is intensified rather than disturbed by the twisting lines of eaves, roofs and pollard willows, and the staccato strokes on the green cottages have an energy, which Van Gogh was to recognize. The influence of Japanese art is apparent not only in the daring asymmetrical balance of the composition and the use of the transparent tints of wood-block prints, but in Monet's more developed use of a swift calligraphic brushwork which probably owed something to Japanese ink paintings, which he could have seen in the collections of friends and acquaintances like Gonse, Bing, Duret and Burty. Japanese artists had given demonstrations of painting at the Exposition Universelle of 1878 and in the homes of Charpentier and Burty, and Edmond de Goncourt gives a vivid description of the processes by which Watanabe painted 'a real *kakemono*'.[25]

Japanese painting emphasized the beauties and austere pleasures of a nature more solitary than that generally represented in Japanese prints, and this corresponded to the change that was occurring in Monet's work of the early 1880s. There was to be an increasing affinity between his paintings and the subjects of Japanese literati paintings – delicately toned snowscapes, flowing waters, cabins hidden in steep mountains, nestling at the base of a rearing precipice or suspended over a void. Their bold calligraphy indicating the latent forces within rocks, cliffs and water probably interested Monet, but his own calligraphy was coloured so that, instead of the monochrome line and wash of Japanese painting, he would use, for example, violet-blue lines accompanied by

152  *Still Life, pheasants and plovers* (W.550), c. 1879, 67.9 × 90.2 (26½ × 35)

blues and violets so heavily saturated they appear almost white. Goncourt's description of Watanabe painting emphasized that he used lines as a final articulation of an otherwise complete painting, and Monet too painted line over realized forms, to give dynamism to the composition.

Japanese paintings may also have helped Monet to develop more abbreviated signs, as may be seen in *Lavacourt, sun and snow* in the quick squiggles of pale orange on the distant bank. These are completely detached from known forms, and are completely undescriptive, but act convincingly as signs for distant trees still unformed in the early morning light. The darker violet lines on the lower left act similarly as signs for sloping ground, shadows, a path, or a runnel of frozen water; signs for processes and relationships in the landscape, rather than literal descriptions which would immobilize form. That contemporary critics were aware of the mode of expression by graphic signs is indicated by Silvestre's comment on Degas's work in the 1879 exhibition as being

the most eloquent of protests against the confusion of tones and complication of effects from which contemporary painting is dying. It is a simple, correct and clear alphabet cast into the workshop of calligraphers whose arabesques have made reading unbearable.[26]

A desire to create works that were more complete, as well as to emulate Renoir's success in the Salon of 1879, may have influenced Monet's decision not merely to abstain from exhibiting with his friends and to submit paintings to the Salon, for the first time in a decade, but to paint landscapes on a large scale in the studio from *plein-air* studies. In March 1880 he wrote to Duret:

I'm working hard on three big canvases of which only two are for the Salon, since one of the three is too much to my own taste to send, and it would be refused, and I must make something more sober, more bourgeois. It's a big gamble to take – not to speak of my suddenly being treated as a coward by the whole group, but I think it's in my interest to take this course, being almost certain to be able to do business, notably with Petit, once I've forced the doors of the Salon; but I don't do this because I want to, and it's really

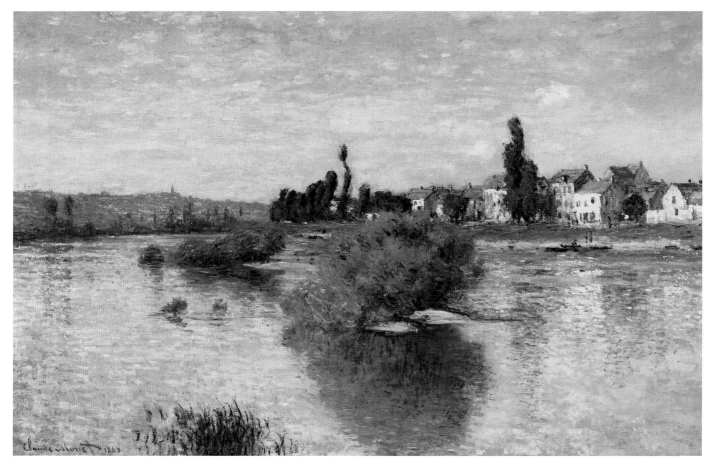

153  *Lavacourt* (W.578), 1880,
100 × 150 (39 × 58½)

unfortunate that the press and the public haven't taken more seriously our little exhibitions which are so much preferable to the official bazaar. Anyway, since it's necessary to do it, let's get on with it.

The three paintings were *The Ice-floes*, *Lavacourt* and *Sunset on the Seine, winter effect* (ill.155). The jury refused the first and accepted the second; the third was the one which Monet did not submit.[27] *The Ice-floes* may have been rejected not only because of its forcefully unconventional composition, but because this bleak, unempathetic image of the otherness of nature was alien to the dominant taste for more humanized or more obviously wild landscapes. Monet seems to have tried to reconstitute his visual experience of the scene, incorporating the effects of peripheral vision in such a way that the ice-floes, held in place only by the vertical reflections and the foreground bank, seem to advance towards the spectator as if about to flow out of the front of the painting.

*Lavacourt*, the painting accepted by the jury, represented a major compromise in that Monet used works painted as much as eighteen months earlier (W.538–541) to produce a generalized image of a particular landscape. The composition was daring by Salon standards (it was perhaps based on Japanese paintings in which the motif advances towards the spectator in the centre of the composition and recedes at the sides), but the rather mechanical brushwork does not convey a sense of its having evolved from a visual experiencing of the motif.[28] The scene is thus instantly apprehended and makes no demands on the spectator's interpretive faculties. Since Monet was deliberately attempting to produce a work that would accord with bourgeois taste, it would seem from *Lavacourt* that he believed the bourgeoisie could appreciate only the known, the ready-made and the finite. Even so, the painting was

'skied' at the Salon, so that it could not be properly seen. As one might expect of an ex-Minister for Fine Arts, de Chennevières claimed that the painting probably would not have benefited from 'being seen closer', but admitted that its 'luminous and clear atmosphere makes all the neighbouring landscapes appear black'.[29]

Zola – who might have recalled that the last time Monet had shown in the Salon, in 1868, then too he had been skied – asserted that if Monet had continued his struggle there, he would by now have gained his rightful place in French art; but in *La République française* Burty maintained that Monet had been foolish to abandon the independent exhibitions when success was on the way. Zola again attacked Monet's hasty production, adding innuendoes on his private life:

Many rough sketches [*ébauches*] have come out of his studio in difficult times. . . . When one is too easily satisfied, when one delivers a sketch [*esquisse*] which is scarcely dry, one loses the taste for pieces which are deeply studied; it is study which makes solid works. Today, because of his need to sell, Monet's work bears the signs of haste.

Maintaining 'silence on considerations of a personal nature', Zola advised Monet to devote himself 'to important works, studied over the seasons, without thinking of exhibiting . . .'.[30]

Monet never repeated this experiment with the Salon, and was instead to develop a strategy of solo or restricted group exhibitions. In April 1880 he had been invited to follow Renoir in holding a one-man exhibition in the gallery of the modish journal, *La Vie moderne*. Renoir's patron, the publisher Charpentier, was the administrative editor of the journal, and the Charpentiers' salon was frequented by writers (including Duret and Zola, both of whom he published), politicians, bankers, financiers, industrialists, and journalists, many of whom were

154  *The Ice-floes* (W.568),
1880, 97 × 150.5 (37¾ × 58¾)

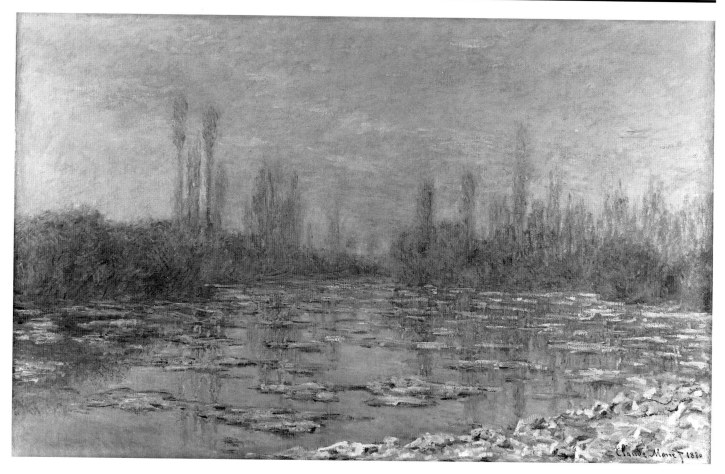

associated with Gambetta. Cultivated, liberal professional men with access to power – through political and social connections, financial strength, or the ability to mould opinion through publishing and writing – these people upheld the concept of a modern, secular Republic, and were typical of those who were to patronize Monet's paintings of 'natural nature'. They were supporters of the regime's major act of reconciliation, the final amnesty for the events of 1870–1, which took effect on the eve of the restored national holiday of 14 July, shortly after Monet's exhibition closed, and which showed that the anxiety caused by the prospect of the return to France of such notorious persons as Jules Vallès or Louise Michel, a well as thousands of others, was a mere temporary ripple on the continuing stream of Republican politics, a politics based increasingly on what contemporaries saw as pragmatism rather than principle.[31]

Duret helped Monet organize his exhibition, which opened on 7 June, coinciding with the Salon where his *Lavacourt* could be seen. The 18 paintings he showed represented the different aspects and phases of Monet's art: a marine and a domestic interior of the 1860s, 3 modern-life paintings from the 1870s, and 15 works painted at Vétheuil, including 2 recent still lifes, *The Ice-floes* refused by the Salon jury, 2 *plein-air* paintings of the frozen river, painted in sunlight and in grey light, and probably *Sunset on the Seine, winter effect*, another of the large works Monet painted in the studio.[32]

Monet's bid for success in the Salon and his solo exhibition – accompanied by a catalogue, an interview by Taboureux, one of the journalists of *La Vie moderne*, and by an enthusiastic review in the same journal – were denounced by Degas as 'outrageous publicity-seeking'. Certainly the interview was curiously modern, in the opportunity it

gave Monet to construct his own history and his own image as an artist, and in the way Taboureux pictured him in the setting of his own house and garden.[33] Monet was using every means he could not only to break out of a financial situation which made it difficult for him to develop his paintings as he wished, but also to control how his work would be interpreted.

Since Monet exhibited a family interior of 1868, a still life with dead birds of 1879, and one of the first paintings of his recently reconstituted family, shown in a meadow near Vétheuil in 1880, the exhibition of 1880 may also have had a private symbolic meaning in embodying his struggle to create the familial context which he found essential for his painting. His domestic situation was, as Zola hinted, becoming public in a less than desirable way through gossip.

In his preface to the catalogue, Duret commented on the painter's daring, in going as far as the Japanese in developing 'an absolutely new system of colouring' in which nature appeared 'coloured and full of clarity', he claimed that Monet completed the revolution begun by Corot and Courbet – who had lessened the distance between *plein-air* study and finished studio work – by making what had been successive operations *simultaneous*, in works painted entirely in the open air. He described how Monet painted:

he begins suddenly to cover [a white canvas] with patches of colour which correspond to the sensations of coloured patches conveyed by the observed scene. Often in the first sitting, he obtains only a rough sketch [*ébauche*]. Having returned to the spot the next day, he adds to the first sketch, and the details become clearer, the contours more precise. He continues in this way until the painting satisfies him.

The implication was that only by painting *en plein air* could Monet

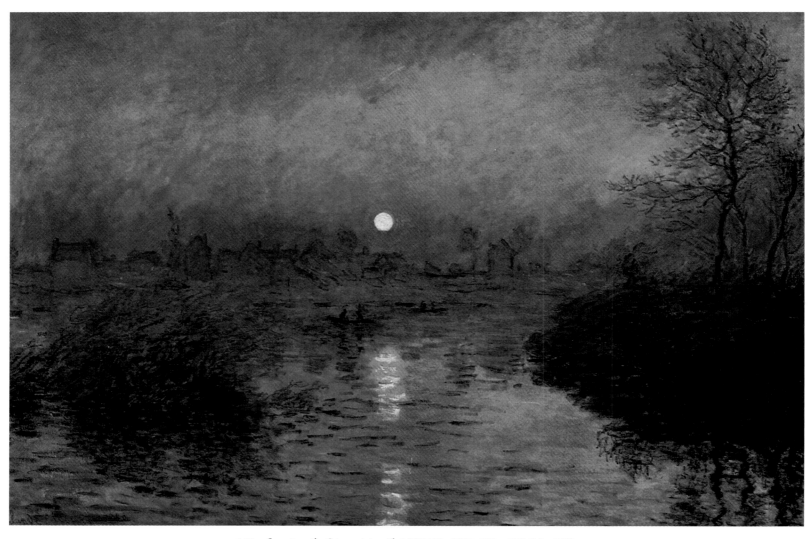

155    *Sunset on the Seine, winter effect* (W.576), 1880, 100 × 152 (39 × 59¼)

capture 'the most ephemeral effects of light, changing reflections, skies, weather'. Duret undoubtedly wrote the article after discussion with Monet and observation of him at work, yet he did not mention that the artist also painted in the studio, although Monet's letter about his Salon paintings would have made this clear. Monet's comments to Taboureux were even more emphatic: 'I have never had a studio,' he claimed, 'and I don't understand how one could shut oneself up in a room. To draw, yes; to paint, no.' Then, with a gesture which encompassed the Vétheuil landscape, he exclaimed, 'That's my studio!'[34]

In published interviews Monet continued until the early 1900s to foster – or not to deny – the notion that all his works were painted in the open air, but in private communications from the early 1880s onwards, he made it clear that he was taking 'notes' to develop at home, and that he spent a great deal of time finishing works in the studio. Monet did not, however, have a proper studio in the late 1870s and through much of the 1880s: in the Vétheuil house, he painted in his attic bedroom or in a sheltered courtyard, and for several years at Giverny he painted in a room like a living-room at one end of the house, as if he wanted his painting to be related to the life of the family.[35] Several of his *plein-air* paintings of the 1880s suggest that he often liked to work in the

company of members of his family, as he had in the 1870s, so his antagonism to 'a studio' at this time may have had something to do with his desire to locate his art within the intimacy of familial space, as well as his wish to emphasize the purity of pleinairist experience.

In 1880 anyone who had any understanding of recent painting would have been aware that carefully constructed works like *Sunset on the Seine, winter effect* and *The Ice-floes* must have been painted in the studio. Why then did Monet actively promote the fiction of pure *pleinairisme*? Traditionally studio work was used as a means of generalizing the individual experience of the motif in accordance with inherited notions of the beautiful, but Monet's imperative was towards ever more particular fragments of time embodying absolutely specific moments of apprehension. By far the largest number of his works were painted almost entirely from the motif, for it was his direct experience of nature that gave the essential generative power to the work. Thus, when Monet finished his paintings indoors, it was not to generalize them, but to add those touches which would clarify them as the expression of the individual's experience of the unique moment. Nevertheless the fact that he found a studio painting – the *Sunset on the Seine, winter effect* – to his 'own taste' suggests that his tentative move towards studio painting

was inspired not only by his need to be acceptable to the public but by a desire to find a way of painting which would relieve him of total dependence on the 'shock' of the moment. Perhaps the complex emotions aroused by the death of Camille, and by the way he found himself painting her body, strengthened his need for a form of stability within the relentless passage of moments.

The *Sunset on the Seine, winter effect* is one of those hallucinatory paintings in which the rising or setting of the sun in the mists of dawn or twilight inspired the painter to extraordinary acts of visualization. The intensity of these pictures probably derived from Monet's emotion at the moment when light begins to reveal form emerging from inchoate matter, or when, with fading light, form is about to dissolve back into the formless. This is the moment when light performed those functions that he was performing as a painter. The central section of *Sunset on the Seine, winter effect* — with the far bank, the figures in boats and the orange disc with its broken reflections — is so closely related to *Impression, sunrise* as to suggest that Monet conceived it almost as a manifesto of a new phase in his art, in which he had rejected modern iconography and was seeking alternatives to the singular pleinairist moment.

Unlike the small *plein-air* paintings of the motif which were built up from vigorous brushstrokes, the studio painting was constructed from large areas of thin, beautifully modulated clear colours (an almost brilliant green in the sky above the blue-green houses and their reflections, an orange-pink in the water echoing the duskier pinks in the sky), over which Monet painted long coloured brushstrokes representing not only fugitive ripples and reflections, but the solid islets which are thus suffused with vibrating light. Perhaps because the work was painted in the studio, memory could become active, and draw recollections of other paintings into the creative process, Monet might, perhaps unconsciously, have drawn upon Turner's paintings of the sun rising or setting beyond the brilliantly coloured transparent waters of a river whose surrounding banks are also suffused with light, or on the Japanese ink paintings in which rocks or islands floating in mist or water create space around themselves without the use of rigid linear perspective. Studio painting could give Monet access to other forms of mental experience than those invoked in painting in the open air, thus enriching the ways in which he could respond to the motif.

Despite the publicity, a large number of visitors and Duret's informed preface to the catalogue, the 1880 exhibition attracted no serious critical attention. Most writers claimed that Monet had not realized his early promise, and that his work was underdeveloped and incomplete — even Burty described the works he liked best as 'fragments of undeniable power'. Neither the painting intended for the Salon, the tightly composed *Ice-floes*, nor Duret's eloquent insistence that *pleinairisme* did not imply that a painting had been completed in a single, hasty sitting, nor the exhibiting of works with obviously different degrees of finish was capable of dislodging this stubborn view. Monet may indeed have reinforced the prejudices of those for whom Impressionism *meant* incompleteness, with his proud assertion in the interview: 'I am and I wish always to be an Impressionist'. His solo exhibition was intended as an assertion of the purest principles of Impressionism, in protest, he said, against the way 'the little chapel' had become 'a banal school opening its door to the first dauber who arrives'.[36] The exhibitions of the 1870s may have convinced Monet that relatively few people could understand the abstraction necessary to represent his sensations, and that all he could do was insist on the purity of his pleinairist experience of nature in the simplified terms which might appeal to some members of the public and to progressive journalists and critics.

The exhibition seems to have stimulated demand for his work, and resulted in one major sale — Mme Charpentier's purchase of *The Ice-floes* for her husband. She obtained it at a reduced price (1,500 instead of 2,000 frs.), but this was more than Monet had received for a long time, and the work would be hung where it could be seen by leaders of opinion in the Republic. Perhaps it was for these reasons that, in early July, Monet was able to write cheerfully that he was in a 'good state of mind for working'.[37]

The pictures of orchards full of blossom, of fields of wheat and poppies, and of the flowery banks of the Seine which Monet painted in the spring and summer of 1880 were more sensuous than any works since Argenteuil, and in some of them he began painting his family again — now joined by Mme Hoschedé and her children — in meadow and garden. He returned to the theme in early summer in two paintings representing the younger children and two women on one of the islands, with Vétheuil glimpsed through the trees (ill.163).[38] The image is formed from interwoven veils composed of tiny strokes of colour in delicate scales of green, yellow-green, blue-green, blue and pink. Different tones of pink are to be found as dark patches which reveal themselves to be roofs, as paler patches and lines on the distant hill which resolve themselves into fields and a road; they reappear, almost invisible, on the church tower, and, more strongly, in the faces of the children, only to fade in faint glazes in the grasses at the base of the painting. Similar scales structure and penetrate the entire composition, and enable the spectator to experience space and to create wholeness by tracing echo after echo of a colour that may also be a tree trunk, a part of a clock tower, an edge of a wall, a veil of leaves, a tint on a parasol, a pinafore or a hat, a shadow in the grasses, or even vibrant slivers of light in the space beneath the trees. As the eye traces these relationships, the multiple layers of hazy grasses become visible and weave an image of the countryside as soft, protective, enclosing.

The painting is related to the pictures in which the figures of Camille and Jean make the Argenteuil countryside intimate, and it demands an attention different from that of earlier Vétheuil paintings, in which casually suggested figures do not counteract the impression that the place is almost deserted. Camille Monet had accompanied the two families on their first long walks around Vétheuil, until she had become too ill to go out, but she never occupied the pictorial landscape as she had at Argenteuil.[39] In this role at least, Alice Hoschedé never took her place, and in the few paintings in which she is or may have been represented, her figure generally lacks the distinctive physical presence of Camille Monet, so that her identity often can only be inferred. This is so in a group of 1880 paintings which return to earlier themes of the pleasures of summer, and in which Mme Hoschedé may be seen in the distance, boating or sitting by the river (W.607–609). Even in a close-up painting of her sitting under willows (ill.164), she is represented by long, curved strokes of blue, green and white of the same substance as those used for the grasses, suggesting an almost immaterial presence, a shimmer of white in the transparent shade rather than an individual woman. A pious woman, Alice was determined to do her duty, not only by her own six children but by Monet's two sons, but she ran a great social risk in continuing to live in the same house as the widower Monet, in the absence of her husband. She could not then be cast in the bohemian role of mistress/model which Camille had occupied before her marriage, and was not visually available in the same way.[40]

## II

After two years of painting within two kilometres (1¼ miles) of his home, Monet broke out of Vétheuil's gentle enclosure for a short visit to the Normandy coast in September 1880, returning there for a longer period in March 1881 and again briefly later that same year. His trips were probably occasioned by the improvement in his affairs – he earned nearly 14,000 frs. in 1880 and over 20,000 in 1881. Yet, although he did plan a trip to London to paint 'a few views of the Thames', he seems to have had no wish to return to the painting of modern life. He represented himself as 'more and more a peasant' – while he had, in fact, a sophisticated knowledge of artistic life in the capital.[41]

Monet's coastal scenes of this period, like his early Vétheuil landscapes, tended to be uninhabited even when he returned to the resorts of Sainte-Adresse and Trouville, where he had once painted modern seaside life. Only one painting, *The Cliffs at Petites-Dalles* of late 1881 (ill.158), contains figures; they are akin to the spectator figures of the 1860s, but Monet now locates them on a lonely boat ramp watching the turbulent sea and racing clouds, rather than the spectacles of modern life. In other paintings he depicts views as if they were as deserted as those Millet had painted on the most remote part of the Normandy coast a decade before (ills.161 and 162). Monet may have felt a continuity between Vétheuil and the Channel coast, familiar to him from his childhood, since the chalk plain, through which the Seine flows to the sea, breaks in great cliffs on the coast like the bones of the softer countryside of the interior. At Vétheuil, among the gentle transitions of hill to plain, he could continue to use relatively conventional nineteenth-century landscape schema, but on the coast with its stark contrasts of scale, where very slight changes of viewpoint could completely transform a scene, he evolved compositions of daring formal inventiveness. He may have studied Millet's use of Japanese images for his representation of the vast space between cliff-top and sea by sharp juxtaposition of simplified forms very distant from one another – as in Hiroshige's 'Distant bank of the river Oi', which he may already have owned (ill.160).

If Millet's paintings influenced the compositions viewed from the cliffs, Courbet's paintings of Etretat of the late 1860s may have influenced those along the beach. In contrast, however, to the dense substantiality of Courbet's paintings, Monet used long linear strokes which express not only the surge of sea and wind, but the ways in which they have eroded the cliffs. These paintings, like the inland paintings of thaw and flood, testify to Monet's new interest in the ways in which landscapes are shaped by natural forces, rather than by the human agencies whose effects he had depicted at the coastal resorts in the 1860s and at Argenteuil. Here too he could have been influenced by Japanese prints or ink paintings of waves beating on rocks whose writhing shapes seem no more permanent than those of the sea. The most striking examples of this new dynamism are the pair of paintings, *The Sea at Fécamp* (W.659–660), painted on Monet's third visit to the coast, in which the lower part of the worn cliffs is represented from so close up that the cliffs are almost out of focus, and seem about to collapse before the force of the waves which burst into spray and pound the rocks (ill.168). The image may have been influenced by Japanese ink paintings depicting a wedge of cliff severed from the rest of the painting, with force lines or geological strata rendered in a bold calligraphy echoed by lighter washes, or by paintings in which the dynamism of waves, waterfalls or wind is suggested by rapid linear notations. In

Monet's painting, however, cliffs and water are represented by writhing lines of thick, tacky paint which adhere together to form a continuous pastey surface which has a materiality alien to the Japanese paintings, where the ink is absorbed by the paper and unpainted areas play a role in the composition. Despite the profound differences between the two forms of painting, the Japanese may have helped Monet develop abstract notations for the substances and forces of nature – notations which made increasing demands on the spectator's preparedness to interpret them.

Monet's concentrated campaign of painting at Fécamp was made possible by Durand-Ruel, who re-entered his life in February 1881, when he bought 15 paintings for 4,500 frs. in one visit to Monet's Parisian *pied-à-terre*. This meant that Monet did not need to exhibit with the Impressionists, and could concentrate more intensively on his painting. Although much of Durand-Ruel's purchasing was financed by loans from the Union Générale bank, which crashed less than a year later, in January 1882, he was to remain Monet's most considerable patron until about 1884. The pattern of their financial relationship seems to have been set at the time of Monet's trip to Fécamp, when he wrote to the dealer asking for a large advance so he could stay longer on the coast in order 'to develop certain studies'. Since Durand was advancing funds against future purchases, Monet could hope for some financial stability; in exchange the dealer had first choice of new works, and after Monet's return Durand-Ruel purchased 22 works, including 16 painted at Fécamp, for 300 frs. each. Monet was then able to tell other purchasers that he could not sell for less than he sold to his dealer.[42] Thus Monet's new dealings with Durand-Ruel marked the beginning of the assimilation of his works into the cycle of speculation.

The summer paintings of 1881, like those of 1880, were densely worked, sensuous in handling and sparkling with colour. Instead of painting members of his family in the meadows, Monet now painted them in his garden. This was the first time he had painted the Vétheuil garden, although Taboureux who visited him in 1880 found it sufficiently remarkable to comment on his use of masses of 'natural flowers'. Facetious about 'those wild beasts of art called Impressionists', the journalist noted that Monet inhabited 'a charming house, absolutely modern, where you and I, my dear chief editor, would live without a shudder, like the good *bourgeois* we are'. It was possibly no coincidence that Monet began to paint the family garden at the time he was planning to leave Vétheuil, because any move would raise the prospect of the breakup of the shared household.[43] In the summer Monet painted two pictures of a lady (W.680–681), who is probably Alice, reading at a table in the garden (ill.165). In paintings of the garden at Vétheuil, he insisted upon the presence of the fence, whose emphatic rail and palings sharply mark off the world of the domestic garden from that which lies beyond, whereas in most earlier paintings of this subject, the woman was enclosed by foliage, and Monet rarely showed the prosaic boundaries of the garden. The *Terrace at Sainte-Adresse* was an exception, in that in this work Monet fenced in the figures, creating a secure space from which they survey their world, whereas Alice Hoschedé is shown as completely absorbed within the garden. Later in the summer of 1881 he painted four pictures (W.682–685; ill.166) of the garden, ablaze with golden sunflowers, hollyhocks and nasturtiums, and in two of them he painted Michel Monet, Jean-Pierre Hoschedé and a woman – who may have been Alice – coming down the garden steps on to a path lined with the Japanese pots that Monet had owned at Argenteuil (e.g. W.264).

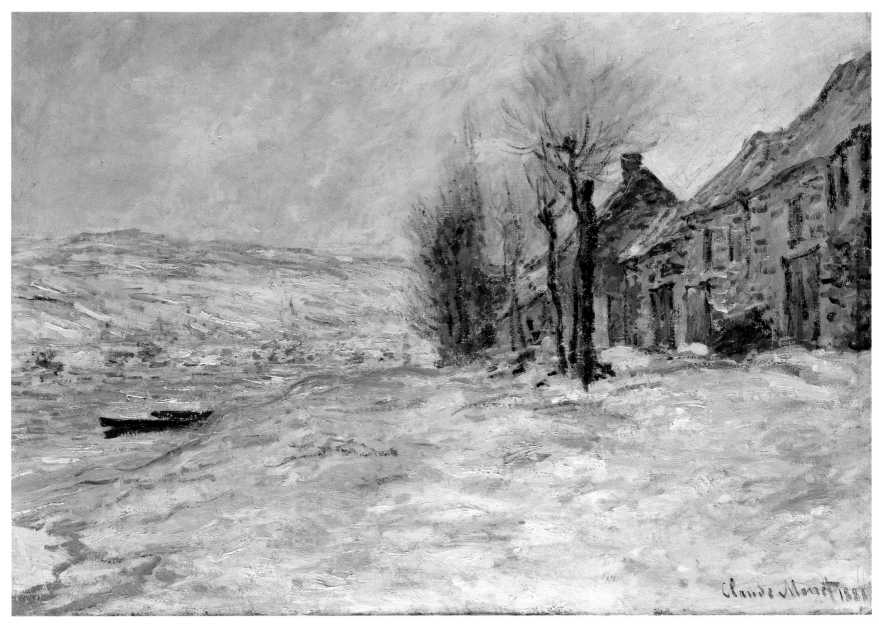

156  *Lavacourt, sun and snow* (W.511), 1880, 59.5 × 81
($23\frac{1}{4} \times 31\frac{1}{2}$)

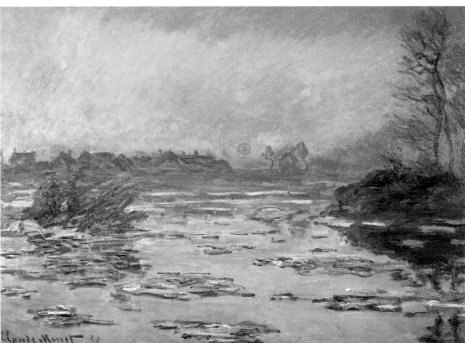

157  *Sunset on the Seine at Lavacourt* (W.574), 1880,
60 × 80 ($23\frac{1}{4} \times 31\frac{1}{4}$)

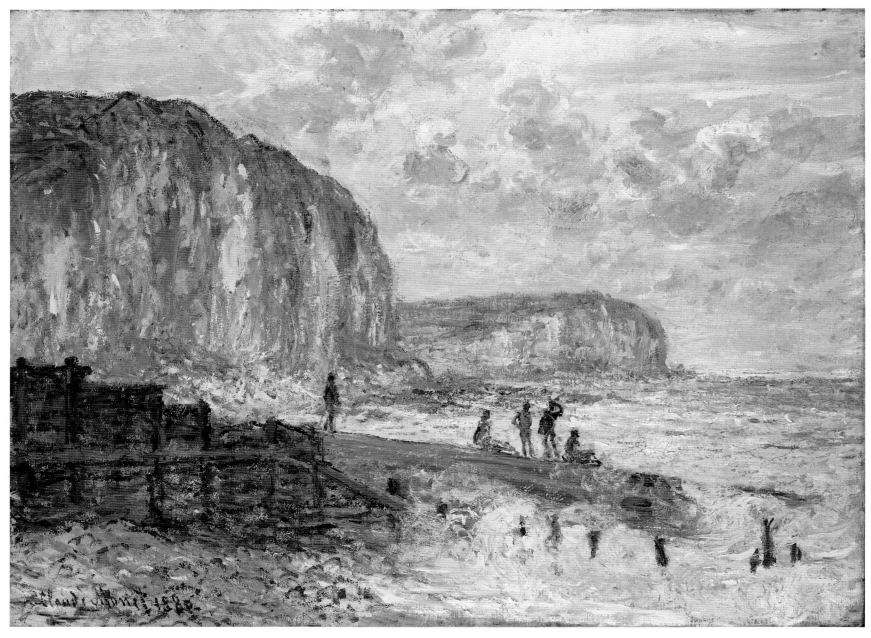

158    *The Cliffs at Petites-Dalles* (W.621), 1881, 59 × 75 (23 × 29¼)

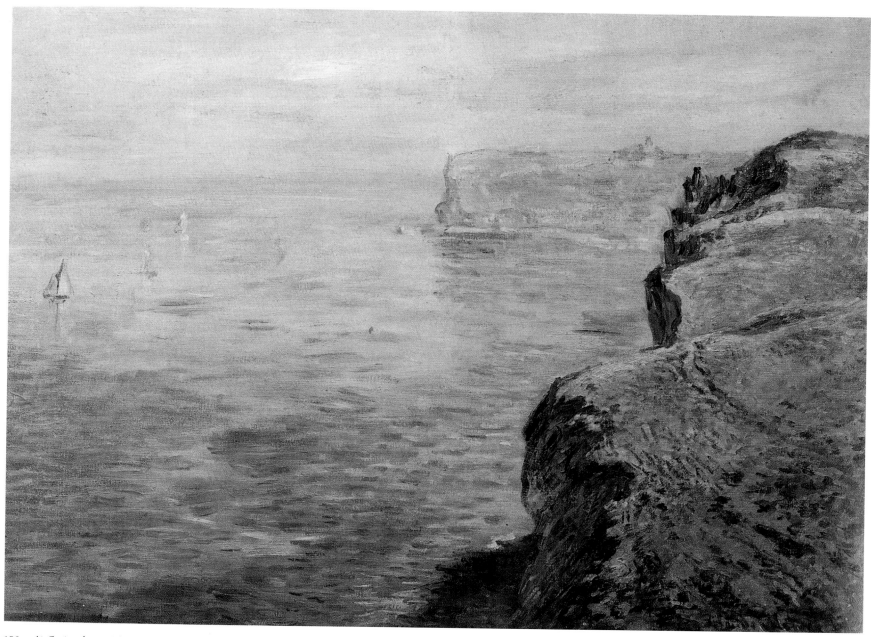

159   *At Grainval, near Fécamp* (W.653), 1881, 61 × 80 (23¾ × 31¼)

*Opposite, below left and right:*

160   Utagawa Hiroshige, 'The Pass from Satta to Yui', from the *Fifty-three Stages of the Tokaido*, 1833–4, woodblock print, 22.6 × 35.3 (8⅞ × 13⅞)

161   Jean-François Millet, *Le Castel Vendon (the sea near Gruchy)*, 1871, 60 × 74 (23¼ × 29)

162   *Calm weather, Fécamp* (W.650), 1881, 60 × 73.5 (23¼ × 28¾)

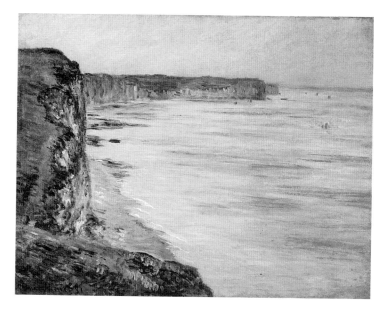

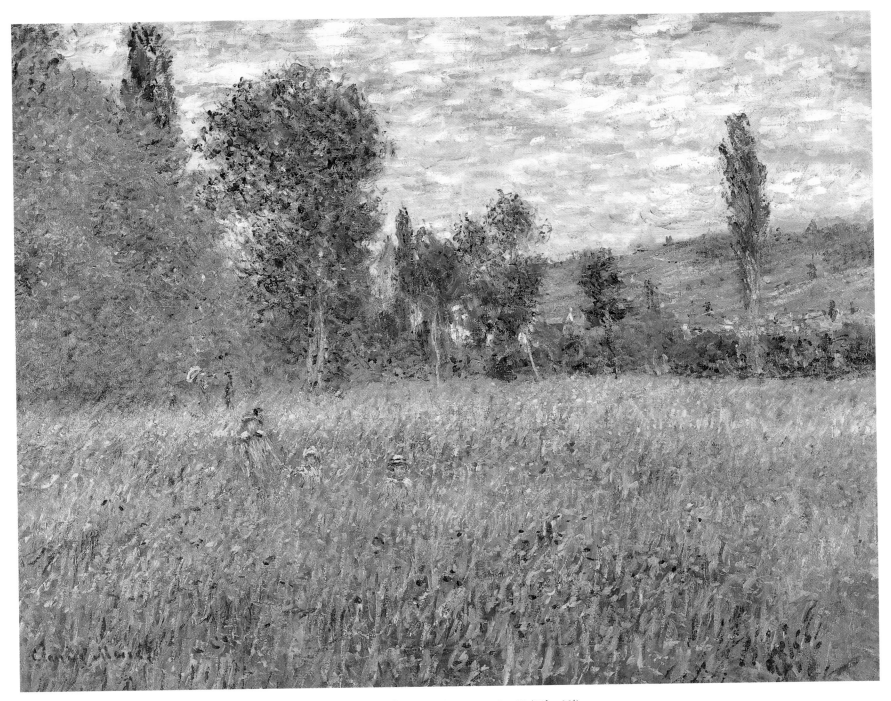

163    *The Meadow* (W.535), *c.* 1880, 79 × 98 (30¾ × 38¼)

There is not a hint of the world beyond the garden; no indication that the family house is separated from the garden by the main road into Vétheuil, and despite the sensuous profusion of the flowers, every form is locked into place by the vertical axes of the house, the steps and the path which leads to the space in which the painter must have stood. The construction suggests that the painter's gaze returns that of the children, thus creating a world turning forever in on itself, with coruscating flowers making a funnel of the steps, and almost overwhelming the evanescent figure in shimmering white. Once again Monet used the visible setting to create an image of a world which he passionately desired. The two paintings could have been executed at much the same time as he painted a picture of the Seine behind a cloud of nasturtiums in his garden.[44] Monet had marked his departure from Argenteuil in a similar way, bringing together the world of the river and the world of the garden, securing both when his future was shrouded in anxiety.

In December 1881 Monet and his two sons and Mme Hoschedé and her six children left Vétheuil for Poissy, a town on the Seine twenty kilometres from Paris. This move was decisive, since the relationship between Monet and Alice Hoschedé could no longer be seen as a continuation of a *status quo* established partly by her husband. Thanks largely to Durand-Ruel, Monet had earned 20,400 frs. in 1881 and now, somewhat farcically, Ernest Hoschedé was in debt to him for seven-tenths of the costs of the shared ménage. Hoschedé may then have acquiesced in the new situation, but he could at any time claim his conjugal rights, while his wife, worried about the effects of her liaison on her daughters, occasionally threatened to end it.[45]

Monet spent most of 1882 working at Pourville on the Normandy coast. His intention of painting 'many canvases' there on a short visit from mid-February to mid-April set a pattern,[46] but his work was

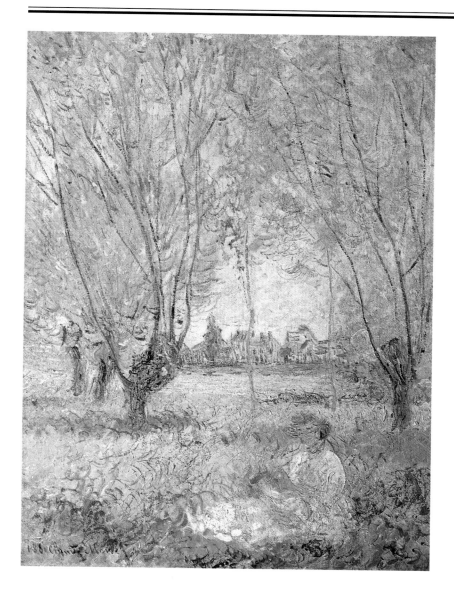

interrupted by the sometimes acrimonious preparations for the seventh Impressionist exhibition, and by his brief visit to its opening. Monet felt threatened by the possibility of having to exhibit with Degas's minor Realist followers, Raffaelli, Forain and Zandomeneghi, and with Pissarro's protégés, Gauguin, Guillaumin and Vignon. He wrote to Durand-Ruel:

At the point where we are now, it is essential that an exhibition be really well done or not done at all, and it is absolutely necessary that we should be among ourselves, and that not a single stain should be allowed to compromise our success.[47]

Because of the involvement of 'certain persons', he initially refused to take part. Durand-Ruel was, however, in deep financial trouble after the collapse in January of the Union Générale bank, and desperately needed a successful exhibition to sell some of his considerable collection of Impressionist paintings. Since he had advanced large sums to Monet, the painter was obliged to comply with Durand's wishes, particularly since the dealer now owned so many of his paintings that he could himself have put together an exhibition. Degas and his friends withdrew, however, leaving only nine painters, Monet, Morisot, Sisley, Pissarro, Caillebotte, Renoir, and Gauguin, Guillaumin and Vignon, to present what the critics acknowledged to be the most coherent exhibition of Impressionist paintings yet seen. Some felt, however, that it was weakened by the absence of the Realists and by the preponderance of landscape over representations of contemporary life. Eugène Manet wrote to his wife, Berthe Morisot, that an 'idiot

164  *Woman seated under willows* (W.613), 1880, 81 × 60 (31½ × 23¼)

165  *Woman seated in a garden* (W.680), 1881, 81 × 65 (31½ × 25¼)

*Far right:*

166  *The Artist's Garden at Vétheuil* (W.685), 1881, 150 × 120 (58½ × 46¾)

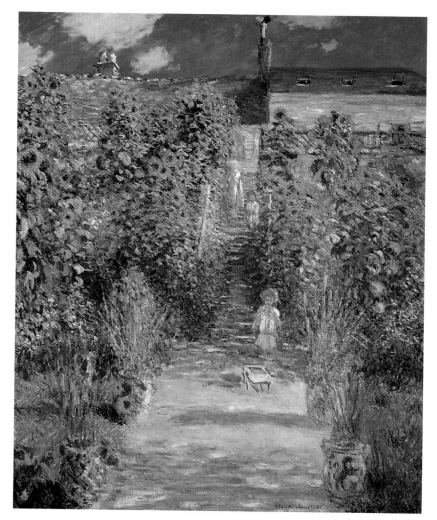

Gambettist newspaper' said that the exhibition was 'decapitated' by the withdrawal of Degas and Cassatt.[48]

The 'Septième Exposition des Artistes Indépendants' opened on 1 March 1882 in a building housing a panorama of what Burty called 'one of the most bitter days of our defeat in 1870', the battle of Reichshoffen. The incongruity — commented upon by Burty and Claretie — was perhaps more apparent than real, since the exhibition included Renoir's *Luncheon at Bougival*, Pissarro's tranquil paintings of peasants, Monet's *The Artist's Garden at Vétheuil* (ill.166), Sisley's pictures of the Île de France, and Morisot's *In the country*, which were perfect expressions of the bourgeois Utopia which the Republic sought to bring into being a decade after *'l'année terrible'*.[49] That other associations lay uneasily below the surface of consciousness can be seen in Renoir's outburst, in a draft of a letter to Durand-Ruel:

To exhibit with Pissarro, Gauguin and Guillaumin is like exhibiting with some socialist cell. A bit more and Pissarro will invite the Russian Lavrof or some other revolutionary. The public does not like what smells of politics.... Get rid of these people and give me artists like Monet, Sisley, Morisot, etc., and I'll be with you, because it's no longer a question of politics, it's pure art.[50]

Renoir was probably anxious about what his patrons, leaders of moderate Republican opinion, would think of his association with apparent extremists, and Monet too may have wished to avoid any such contamination in the minds of prospective patrons.

In any case, the paintings shown in the exhibition — particularly in the absence of Raffaelli's descriptive images of the socially dispossessed on the ugly periphery of Paris — exemplified Renoir's emphasis on 'pure art'. This may explain the more considered reactions of critics, who seem to have accepted that Impressionism was an artistic movement which had come to stay and which could be appraised more or less on its own terms. Their comprehension was probably facilitated by the fact that the painters who had been exhibiting together since 1874 — Monet, Morisot, Pissarro, Renoir and Sisley — had achieved mature styles of marked individuality, based on shared techniques and modes of seeing. In addition, since over three-quarters of the 203 works shown were landscapes, it was easier for critics to discriminate between the different artists and among the multiple aspects of the works of each artist. The critics recognized the homogeneity of the group: the exhibition, Bigot said, was 'more truly that of a school', while Wolff commented less positively, 'When one has seen one painting by an independent, one has seen them all; these works are signed with different names, but they seem to come out of the same factory'.[51]

When Monet suddenly capitulated to Durand-Ruel's insistence on the exhibition, he made it clear that his representation was to be as 'complete as possible', and that it should focus on works done in the last two years at Vétheuil and Fécamp, 'ice effects, the poppies, some fields of wheat, some still lifes.... Above all, don't put in the big *Lavacourt* which was in the Salon, but rather the big *Winter Landscape, setting sun* [*Sunset on the Seine, winter effect*]'. He asked Durand to borrow *The Ice-floes* from Mme Charpentier: 'it's one of my good things, and as you have nothing that is rather big, it should do well'.[52] Thus, alongside small, often informal works with daring asymmetrical compositions, emphatic brushstrokes, and colour dominants, Monet showed *The Ice-floes*, with its carefully calculated tension between the inward drag of perspective and the forward curving flow of the water, and its marvellously interwoven scales of pink, gold and violet.

The critics' response to Monet's work was generally favourable. Although Silvestre continued to emphasize the inadequacy of the new painting as art, while acknowledging its potential to reform 'enfeebled methods', he was enthusiastic about Monet's work:

For me M. Monet is not only the most exquisite of the Impressionists, he is also one of the true contemporary poets of the things of nature; he does not simply paint it, he sings it; a lyre seems to be hidden beneath his palette. Look especially at that delicious landscape, the Willows ... which seems to be a décor prepared for some idyll to come. How the foliage flutters! What a caress in the sky ready to envelop a lover in search of spring....[53]

Silvestre's kind of poeticism was to be central to the interpretation of Monet's work once he moved away from modern subject-matter. Often inflected with a 'scientific' interpretation of Monet's 'decomposition' of light, such criticism would enable his audience to assimilate his paintings into the French landscape tradition and to slur over the radical break he was making with it.

Critics admired Monet's most formal painting, *The Ice-floes*, but his marines attracted most attention. Huysmans exclaimed, 'his studies of the sea with waves breaking on the cliffs are the truest marines I know', Silvestre admired 'this sea at *Grainval* ... with its big violet shadows that fall from the cliff and flutter like the material of a dress', and Chesneau wrote:

For the first time one saw alive on canvas the palpitations, the smells and long sighs of the sea ... the streams of receding waves on the beach, the dark green coloration of deep waters, and the violet tints of waters shallow over their bed of sand, all those ephemeral feasts of colour, those enchantments of moving light.

The exhibition was hung in three registers, one above the other, and since one critic complained about a painting with pink cliffs hung immediately above a green sea, it is possible that Monet's paintings were grouped thematically, so as to draw attention to the extraordinarily inventive compositions, colour schemes, brushwork, and to their 'absolutely remarkable effects of perspective'.[54]

Huysmans's change from disdain to whole-hearted admiration was symptomatic of a more general critical change, marked by acceptance of the specificities of Impressionist language, and sometimes by real efforts to comprehend it. In 1880 Huysmans had claimed that Monet suffered from 'indigomania' and was too easily satisfied with 'sketchy and hasty painting' based on 'uncertain abbreviations'; but in 1882 he wrote that Monet 'seems to have decided not to scrawl off piles of paintings in any old way'. The painter who suffered from 'diseased retinas', as he said in 1880, had become 'a great landscapist whose eye, now cured, seizes with surprising fidelity all the phenomena of light'. The critics' growing appreciation should be set against the fact that Monet's recent paintings were formally more radical than any previous ones. The seascapes, fragments severed from the continuity of landscape, were painted with more clearly marked colour-dominants, more emphatic calligraphic brushstrokes, and more abbreviated graphic signs than were earlier landscapes; the petals and leaves of the *Sunflowers* writhe with the same linear dynamism that animates *The Sea at Fécamp* (ill.168), and in the *Sunset on the Seine, winter effect* Monet accentuated those qualities which critics associated with sketches — roughness, breadth of execution, abruptness of composition, simplification of colour-dominants. The reading of his work as more complete could then have justified Monet in thinking that it was the eyes of the critics, rather than his own, which had been 'cured'. Wolff was still complaining about 'hasty production', but several critics were thinking hard about the relationship between the Impressionists' sketchy technique and the effects they sought: Chesneau explained that although 'their formula —

raw, summary, necessarily rapid – seems incomplete, it is . . . not so at all, since their aim is attained once the sensation of movement is conveyed to the spectator', while Hepp commented, 'under the appearance of broad improvisation, they hide their care for detail and contour'.[55]

Indeed, the apparently rapid calligraphy in *Sunset on the Seine, winter effect* suggests the rapid notation of a momentary effect – when the wintry sun, diffused in the misty air, is about to disappear in a final blaze of light – yet, as we know, the work was a sophisticated composition, painted in the studio from *plein-air* studies. One critic saw the sun's disc as 'a slice of tomato stuck on to the sky', but Huysmans felt he could see 'how . . . the cold little breath of the water rises in the foliage to the tips of the grass'. Some critics were, then, able to read patchy or linear brushstrokes as equivalents of rapid visualization, indeed as proof of capacity 'to seize' changing effects of light 'in the rapid moments of their duration'.[56]

Hennequin explained the Impressionists' use of colour in terms of the dominant hues which exist in every natural scene, transposed into pictorial colour-dominants to unite the different tones of a painting. Less sympathetic critics saw dominant colorations as quite arbitrary – the writer for *Le Réveil* wrote that 'Monet . . . has painted some cliffs made out of raspberry and currant ice-cream. . . . Underneath, there is another canvas in green ice-cream that turns out to be a raging ocean'.[57]

Chesneau's long article on the exhibition did some justice to the complexities of the Impressionist endeavour, and was, Monet wrote to Durand-Ruel, 'exactly what I like'. Chesneau claimed that

The French impressionists . . . no longer translate the abstract reality of nature, nature as it is, as it could be conceived by the intelligence of a scholar, but translate nature as it appears to us, the nature which the phenomena of atmosphere and light make for our eyes – if we know how to see.

Realist aesthetics always contained a tension between the notion of an art which aspired to the objectivity of the scientist, and a belief that knowledge of the external world could be attained only through individual perception. Chesneau seems to have been prepared to dissolve this dualism and to discard the notion of the objective in his emphasis on the relationship between the transiency of subjective experience and the inconstancy of phenomena:

They do not exist in themselves as does abstract reality; they pass, leaving only an impression on our mind and in our memory, only a souvenir, that of an enchantment of movement and of colour. That is what the painters, well-named 'Impressionists', aspire to and succeed in rendering for us; it is this souvenir which they desire, and which they know how to capture.[58]

Thirteen years earlier Monet had expressed his understanding that the painting of nature was a subjective process, when he declared that his painting would 'simply be the expression of what I personally will have felt'.[59] Chesneau's words suggest an unusual awareness of the intensity of desire inherent in the Impressionists' determination to represent that which passes, and of the role memory plays in such representation. Monet's desire to create and to secure an ideal physical existence, more concentrated than that which can be grasped in the flux of life, perhaps lay in those memories which transform the world of childhood into one of intense happiness; but his painting of Camille on her deathbed indicates that he was also trying to grasp that which exists in the very moment it was becoming a 'souvenir'. Monet was, however, wary of the generalizing effects of memory, and his obsession with capturing a momentary effect before it ceased to exist meant that he was always seeking to paint what he had not seen before; nevertheless the

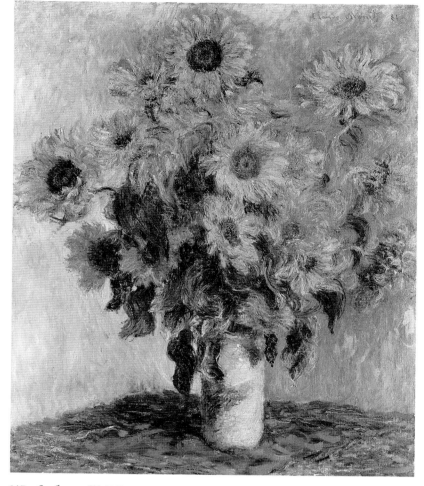

167   *Sunflowers* (W.628), 1880, 101 × 81.5 (39¼ × 31¾)

process of finding equivalents for what he saw was dependent on memories of what had been. Such memories – of the ways in which repeated, yet always new gestures make the infinitely varied marks which create intelligible form – were internalized, and could be relied upon to operate without conscious thought. Memory was, then, central to Impressionist processes of creation, and, since its conscious operations were denied, it was all the more powerful in its ambiguity and elusiveness.

Once Impressionism began to be accepted by more than a small group of sympathizers in the later 1870s, it was generally interpreted as an extreme form of naturalism in which apparent eccentricities of colour and technique could be explained in terms of the scientific analysis of light and the speed of execution necessary to 'capture' it. On the other hand, Impressionism's harmonies of colours, flattened space and visible brushstrokes were also explained in terms of a search for decorative effect. The notion of Impressionism as decorative occurred in incidental phrases by sympathetic critics as early as 1874, but did not become a developed argument before the early 1880s. As is suggested by Silvestre's comment that *The Ice-floes* was 'a canvas of a marvellous precision of impression and an immense decorative effect', the decorative was not seen as an alternative to truth to nature, but as a fuller realization of it, and it was in this sense that Monet strengthened the decorative aspects of his art in the 1880s.[60]

Monet had reason to be pleased with the results of a more homogeneous exhibition: his own works amounted to an extensive solo exhibition, and the large, unified group of paintings done at Fécamp, although pictorially challenging, had been generally well received. Huysmans paired him with Pissarro as having 'at last emerged victorious from the terrible struggle', and, although attendance and receipts were less than expected, Monet would have been heartened by Hepp's comment that Durand-Ruel, who had previously been criticized for his emphasis on Impressionist painting, 'now rides in triumph'.[61] It was, however, the last Impressionist exhibition in which Monet participated.

Monet received Chesneau's article when he returned to Pourville after attending the opening, and it may have encouraged him to continue the formal innovations of the Fécamp paintings. Eugène Manet told Morisot that 'Everyone is rather broke as a result of recent financial events and painting is feeling the effect', but the collapse of the Union Générale did not immediately affect Durand-Ruel's purchases, and he pressed Monet to deliver more of the saleable paintings of the coast. Monet replied that he had finished some works, but that he preferred to show him 'the whole series of my studies at the same time, since I wish to see them all together at my home'.[62] This is the first evidence that Monet found it necessary to review studies of a particular place as a group, and that he conceived such a group as a 'series', even though the

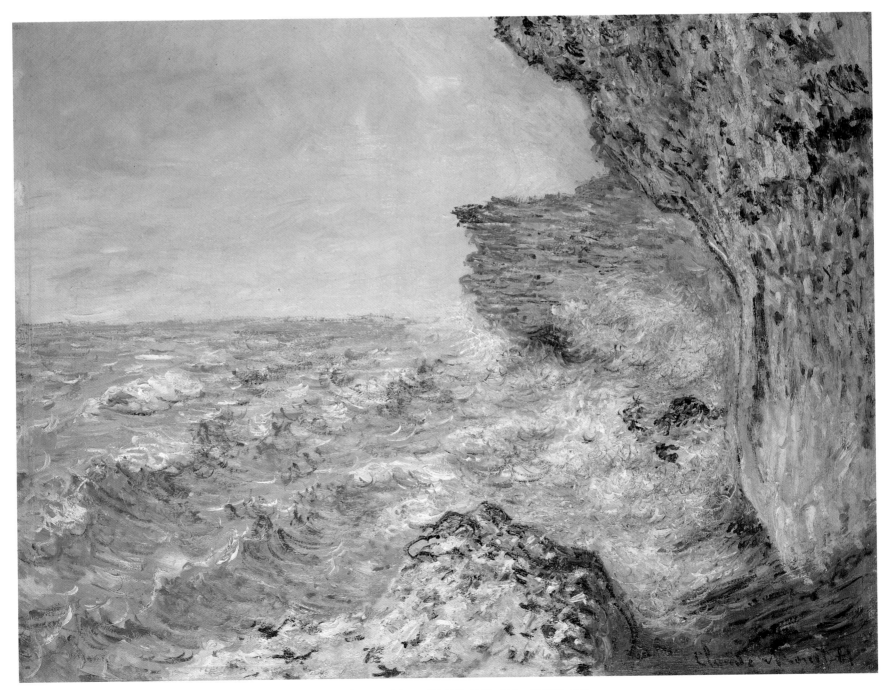

168    *The Sea at Fécamp* (W.660), 1881, 65.5 × 82 (25½ × 32)

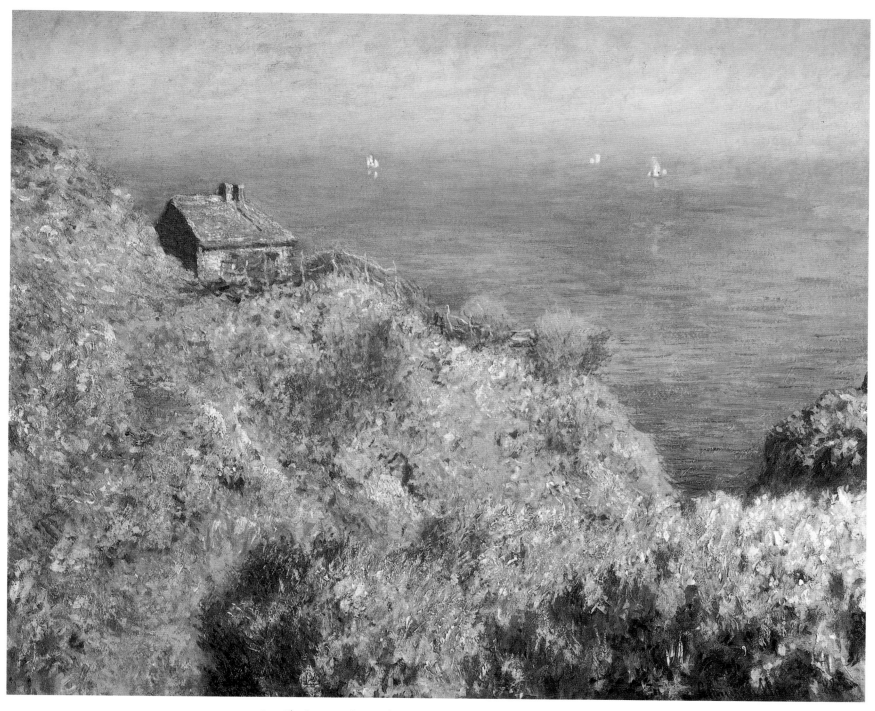

169   *The Customs-officers' Cabin, Varengeville* (W.732), 1882, 60 × 78 (23¼ × 30¾)

practice had been inherent in some works painted at Argenteuil and in the Gare Saint-Lazare paintings. Monet created several such groups at Pourville, representing a motif at different times of day and in different effects of weather and states of the tide. The largest group consists of 14 paintings of the Customs-officers' cabin, depicted in calm or stormy weather, bright or clouded sun, from early morning to late afternoon (W.730–743). There are 5 paintings of the cabin snuggled in the curve of the grassy cliffs high above the sea; 9 seen from above, with the cliff-top and cabin silhouetted against the sea far below, or absorbed into the looming bulk of the cliffs. The cabin plays a role like that of the villa at Argenteuil or the church tower at Vétheuil in registering the artist's movement within the landscape. At Argenteuil and Vétheuil, however, the motif was developed over a long period and was not detached from

its surroundings, so that the various views of it are not sharply differentiated one from another, and they thus suggest the continuity of Monet's exploration of the landscape. Since he was visiting the coast for only a short period, time shaped the paintings Monet did there in quite a different way: each view was sharply isolated from its surroundings and this emphasizes its character as a moment severed from time. Such views also make one more aware than in earlier paintings of the artfulness of the painter's choice of motif.

The influence of Millet can still be seen in the daring asymmetries and abrupt juxtapositions of widely separated forms that Monet had developed in the Fécamp paintings, but the colour structures were more densely worked. In *The Sea at Fécamp*, Monet represented a single effect, that of waves dashing against a cliff, but in *Rising Tide at Pourville* he used

multiple curving strokes, brushed so rapidly that they do not entirely cover the canvas, to create complex rhythms vividly expressive of the forces which animate the scene – the wind tearing at the grasses and scrubby bushes, and the flattened, foaming breakers racing towards the shore, while unseen clouds are registered by the patches of green on the violet-grey sea. By contrast, in *The Customs-officers' Cabin* (Philadelphia Museum of Art), Monet represented the more enduring forces of the landscape, using the drastic spatial simplifications of Japanese art to express the great upward thrust of the cliff, whose height is emphasized by the compacted gravitational pull exerted by the cottage at the base of the painting and by the luminous horizontal plane of the sea.

At Pourville Monet wrote almost daily to Alice Hoschedé, as he was to do for the next twenty years when away on his painting trips. His letters are like a diary of the joy and anguish of learning a new landscape. Those from Pourville voice his desperation at the impossibility of obtaining the effects he wanted, at the constant changes in weather, at the necessity of working against time to produce works which would satisfy him and allow him to return to his family. He now worked on so many canvases of a particular motif under different effects of light that he needed someone to help carry them (losing a day's work when the man was drunk), and he told Alice that on one day he worked on eight studies, for about an hour on each, concentrating so intensely that when he finished he could not 'see clear'. Anxious to calm her reproaches at his long absence, he still repeatedly put off his return, because he would need 'two days of sun and two or three of grey weather', and when he had a few days' good weather, he 'trembled' when it became cloudy, for he had much to do and spring was approaching: 'I've worked so long on certain canvases that I no longer know what to think of them, and I become more and more difficult with myself . . . and then nature is changing terribly at this moment.' The impossibility of what he was trying to do is suggested by his assertion that 'most of my studies have ten or twelve seances, and several twenty': if he spent twenty sessions trying to represent a passing effect, he would have to wait for the return of a similar effect of light nineteen times – and the effect could be lost in a moment. . . .[63]

The dense paint structure of *The Fisherman's House, Varengeville* shows that it was one on which Monet worked over many sessions. Layers of small brushstrokes, thick scumbles, and delicate transparent patches in greens, pinks and ochres with touches of mauve are built up over a substructure composed of larger, more generalized brushstrokes, so as to create a relief structure which almost mimics that of the cliffs.

Monet explored the linear structure of this and other motifs in drawings in which a thin, nervous, continuous line, without a hint of shading, is used to express the bulk and the inner structure of the cliffs.[64] The paintings, too, are unified by linear brushstrokes which are, however, absorbed into soft clouds of colour in ways which reveal that the process of 'seeing' the landscape was inseparable from the process of structuring it. These processes can be traced in the way the almost non-referential bright green brushstrokes in front of the cabin transpose the delicate curves of the fence into those of the landscape; these reappear almost invisibly as a path descending the slope on the left; in a small patch of eroded ground and then, more strongly, in the bushes on the slopes in the foreground. Monet reinforced these echoes and linkages by adding touches of darker green, blue, and orange-red towards the end of the painting process, probably after he had returned home and could review his works together. This review enabled him to strengthen the unity of each work, and to add the articulating brushstrokes which

would characterize each painting in the different groups of motifs more clearly. Despite its dense, pastey surface, the painting evokes a fragile moment of brilliant early morning light, in which there is still a sense of the misty vibration of dew as the sun warms air which appears still to be cool in the shadows. Far beyond, the tiny white sails somehow intensify the suggestion that the light which fills the huge space between cliff and smudged horizon is diffused in an almost transparent mist which thins as it nears the cliff.

Having sold more than 20 works to Durand-Ruel for 8,800 frs. (a sum partly swallowed up by earlier debts),[65] Monet returned to Pourville in June, accompanied by Alice and the eight children who were to spend the summer holidays there. They were to mediate his return to the modern-life themes of people enjoying themselves at a seaside resort, paddling in the water, walking on the cliffs, admiring the sea or the setting sun. Yet this return to earlier themes marks a further phase in Monet's work, as it tends away from paintings which suggest human interaction with the landscape to ones in which nature is expressed as something more elemental, for, unlike the individualized figures which appear in the 1860s and early 1870s paintings of the Channel resorts, those in Monet's new works were represented by small flecks of colour. Some were related to the spectator figures found in paintings of the 1860s and 1870s, but their gaze is not clearly defined and plays no role in the visual exploration of the scene; moreover, with the exception of *The Cliff-walk, Pourville* (ill.177), the structure of the new paintings suggests that the figures are extraneous to the landscape, and could even be eliminated from it.[66] This was not because these figures are visitors to the coast – in Monet's paintings they had always been that – but because they are added to the scene in ways which divert attention from what the *painting* indicates was the artist's real concern – the perceptual exploration of the drama of light. A seascape (W.772) consisting simply of sea and sky suggests that Monet wished to exclude all but the pure natural geometry of the elements, so as to study the infinite interactions between luminous sky and reflective sea.

When he did paint a modern-life motif, a large villa on the cliff, the villa appears less a commonplace sign of the ecological transformation of the coast, as in *The Beach at Sainte-Adresse*, than as something vulgarly out of place. In the *Church at Varengeville* (ill.182), Monet used the same

*Opposite:*

170 Drawing for *The Customs-officers'
Cabin,* 1882 (sketchbook MM.5131,
12 recto)

171 *The Customs-officers' Cabin* (W.743),
1882, 60 × 81 (23½ × 31½)

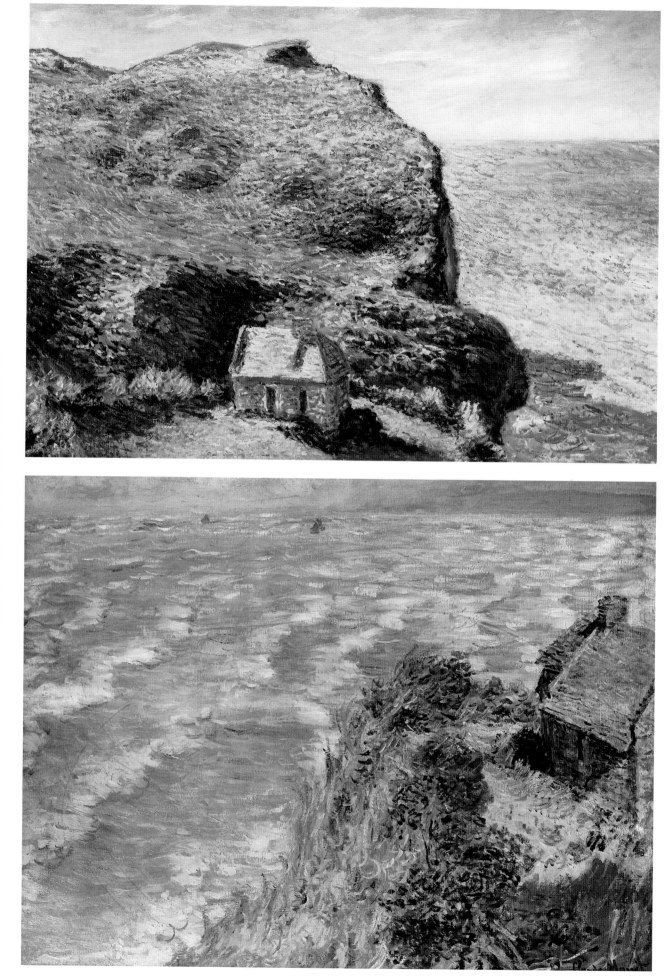

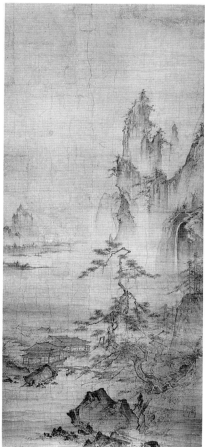

172 Shūbun, *Landscape,* ink on paper, first
half 15th century, 88.9 × 33 (35 × 13)

173 *Rising Tide at Pourville* (W.740),
1882, 65 × 81 (25¼ × 31½)

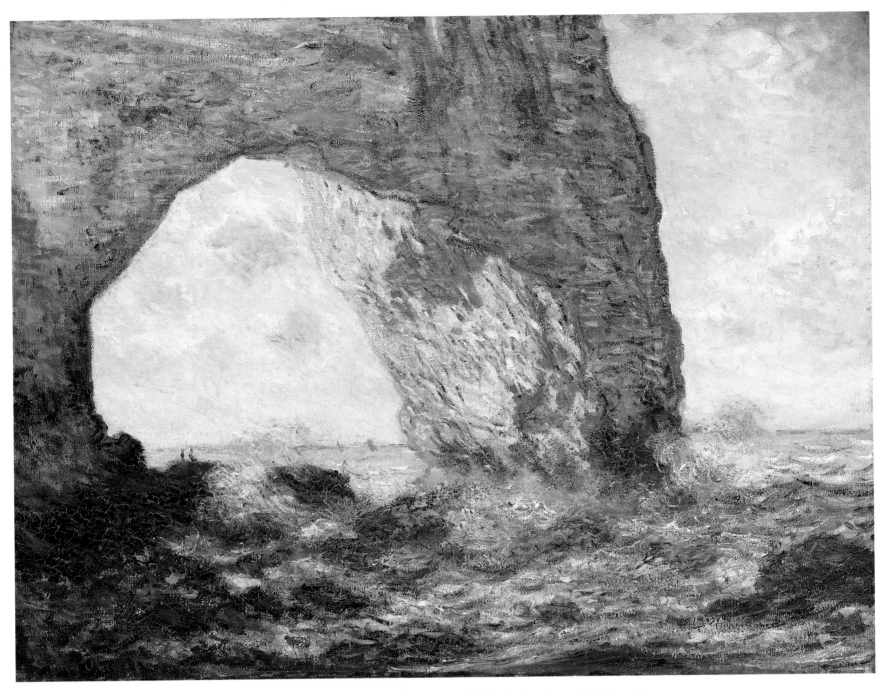

174   *The Rock Arch at Etretat (The Manneporte)* (W.832), 1883, 65.4 × 81.3 (25¾ × 32)

brushstroke for the church as for the cliff, while in *The Cliff near Dieppe* (ill.179), his use of small staccato strokes to suggest the bulk and detail of the villa contrasts with the large calligraphic strokes he used to indicate the cliff face. Squat and foreign, the villa is not integrated in the landscape, but the centuries-old church is like the climax, the summation, of the enormous geological and gravitational forces which shaped the cliff, and which Monet represents in writhing lines of brilliant colour. The minute figures almost invisible at the base of the cliff (like those in *The Rue Montorgueil*) exist only as particles of this immense dynamism. Even in *The Cliff-walk, Pourville* the frocks, shawls and parasols of the elegant ladies, venturing to the edge of the cliff, flutter in the same wind that whips up the grass, breaks the surface of the sea into racing waves, and fills the white sails. The figures have a double role: as bourgeois ladies, the obvious creations of culture, they detach themselves from nature; but they are also subject to its dynamism, and are part of nature, not simply spectators of it.

Despite his delight at being able to work at Pourville again, by the end of September Monet was completely discouraged by the 'crazy number' of works he had begun, and which bad weather prevented him from completing.[67] He continued to work on them in his studio, and he sold 25 paintings to Durand-Ruel before the end of the year. His practice of painting a number of closely related motifs which made sense of one another as a group may have confirmed Monet's determination to have his work exhibited by itself or with the work of another artist which complemented his own (he proposed Renoir as a figure painter). Durand-Ruel agreed to give Monet his own exhibition as the first in a

series of shows of his Impressionist painters. Monet had sold him works to the tune of 24,700 frs. in 1882 and, although the dealer had been able to sell some of these paintings, there were rumours that, as Gauguin wrote to Pissarro, Durand would 'soon have 400 paintings which he will not be able to sell'.[68] The exhibition was then not only an artistic event, but a financial speculation on a near-monopoly.

In late January 1883 Monet returned to the Normandy coast, to Etretat, a fishing village being transformed into a resort, where he had lived with Camille and Jean in 1868. Etretat had already sheltered a number of painters, among them Delacroix, Jongkind, Courbet, who were attracted by the beauty of its light and its famous chalk cliffs which the sea had worn away to form three arches and a solitary 'needle'. This was perhaps the first time Monet had painted a tourist place known primarily to his audience through illustrations in journals, picture postcards and guidebooks — settings he favoured on other painting tours in the 1880s and 1890s.[69] He was, however, to transform the postcard view into something strange and elemental, in tension with more conventional touristic expectations. He also found suggestions for motifs in Courbet's paintings and in Japanese art, making them his own by exploring their possibilities in drawings of the cliffs. Perhaps because his studio paintings of 1880 had sold well (the stockbroker Clapisson had bought *Sunset on the Seine, winter effect* in mid-1882), he planned two big paintings for his exhibition, to rival the great paintings which Courbet executed at Etretat in 1869, *The Cliff at Etretat after a storm* and *The Wave* (Musée du Louvre). Monet would have seen both in Courbet's retrospective exhibition at the Ecole des Beaux-Arts in 1882, an exhibition which marked his rehabilitation after the Commune.[70]

Monet thought his project 'terribly daring' because Courbet had painted the cliff so 'admirably', but he did not complete any big pictures because, in this three weeks at Etretat, the weather was bad, and he had to spend time seeking loans for his exhibition which was to open in late February. He was moreover tormented by a visit which Ernest Hoschedé was making to his wife with the threat of taking her and his children away. Monet wrote to Alice from Etretat:

... must I accustom myself to the idea of living without you. ... I know well that I cannot and must not say anything against what you decided yesterday; I must submit myself, having no rights. ... It's all the same to me whether my canvases are good or bad. The exhibition is the least of my worries. ...

I wished to make the pretence of going to work, to try to work even, but my things remained next to me on the shingle without my even thinking of opening my paint-box; I stayed there stupidly watching the waves, wishing the cliff would crush me.[71]

Given the unusual physical energy of his language, it is possible that on this occasion Monet did invest nature with his own emotions, perhaps projecting them into the turbulent instability of *The Cliff and Porte d'Aval in stormy weather* (W.820), in which the cliffs seem to disintegrate before the pounding seas.

Hoschedé's threat was not carried out, and Monet returned to Poissy within two days of this letter, taking with him 'masses of documents' with which to do 'big things' at home. He worked on the group until November, so, although he was also painting decorative panels for Durand-Ruel and was to be interrupted by the move to Giverny, it is clear that studio work could now take months; as he told Durand-Ruel, 'these retouches which seem to do nothing are much more difficult than one thinks'.[72] One work completed at home would have been *Turbulent Sea, Etretat*, perhaps the one in which Monet was most conscious of rivalling Courbet, for it contains descriptive details — the

fishing boats and cave entrance — unusual in his work, but found in Courbet's painting of the Porte d'Aval. If Monet intended to pay homage to his old friend, and thereby to assert his own place as leader of a new generation of landscapists, he took care to do so in a markedly different manner. Courbet's painting was considerably larger than Monet's, and massively calm, with that gravitational weight which distinguishes his landscapes. The closest cliff is rooted heavily to the ground; the sea clings to the horizontal plane, and thus emphasizes the vertical force of the cliff. Monet depicted the cliffs in long, linear

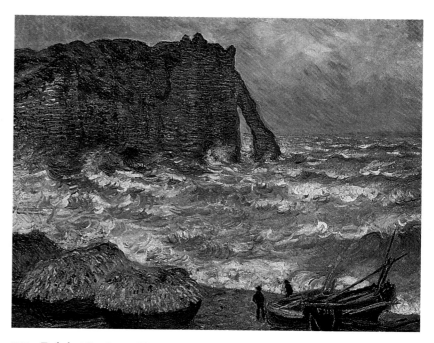

175    *Turbulent Sea, Etretat* (W.821), 1883, 81 × 100 (31½ × 39)

176    Gustave Courbet, *The Cliff at Etretat after a storm*, 1869, 133 × 162 (52 × 63)

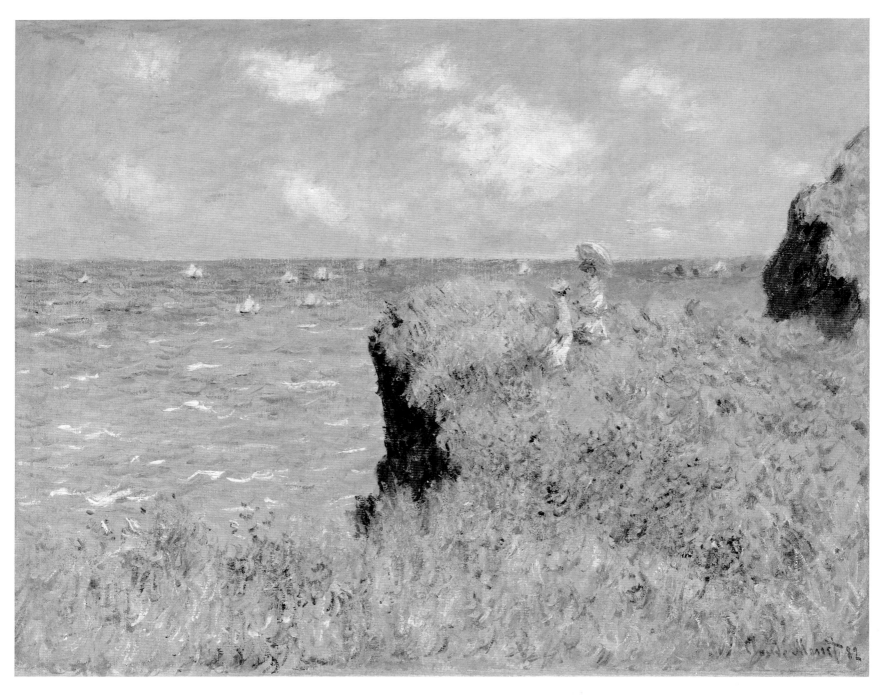

brushstrokes, with parallel stripes suggesting their thrust, their stratifications, bulges and declivities. The linear energies of the cliff are no different, but simply more concentrated, than those embodied by the curved strokes which suggest the beat, suck and leap of the waves. The mobile lines never reach stasis, never allow the eye to rest, and thus suggest a single, unrepeatable conjunction of complex forces. In his *The Wave*, Courbet represented the moment when a huge wave is about to break, while others beat towards the shore or suck back from it; but the glaucous weight of the seas and their heavy horizontality suggest that the moment will last forever, while Monet depicted a moment in which there never is and never can be any cessation of movement.

The most original works which Monet executed at Etretat were two paintings of the huge rock arch, the Manneporte. One was left as a vigorous study (W.833), while the other has a dense paint structure which must have been executed over several sessions and finished in the studio, before it was bought by Durand-Ruel in July (ill.174). Monet had written to Alice soon after his arrival at Etretat:

You can't imagine the beauty of the sea for the last two days, but what talent is necessary to render it, it's enough to drive one mad. As for the cliffs, they're like nowhere else. Today, I descended to a spot where I've never dared venture before, and I saw there some admirable things, thus I returned really quickly to find my canvases, at last I'm happy.... I'll have to work like the devil ... to get ready for my exhibition.[73]

Monet depicted the arch looming above him, sharply cropping nearly a third of its height, and severing it from the rest of the cliff, and from the continuities of the humanized landscape (the two tiny, almost invisible figures merely serve to indicate the huge scale of the arch). Monet may have remembered a print possibly by then in his collection, Hiroshige's 'The entrance to the caves at Enoshima in Sagami province' (ill.180), with its dramatic rock formations, tiny figures, and contrast between calm, distant sea and surging waves which suggests that the forces which animate the sea have shaped the arch. Monet's painting also has a strong affinity with the daring simplifications of Japanese painting: Japanese painters would deploy a few rapid brushstrokes around the base of a rock as signs for the complex forces of the sea; Monet made use of similar abbreviations to embody the dynamic interaction between water, light and rock.

Light changes far more quickly on the Normandy coast than it does in the sheltered inland valley of the Seine, and the huge expanse of water constantly changes as light changes. *The Manneporte* embodies the moment at which waves are flung up as spray and begin to fall back into the churning water, the moment at which a transient gleam of light from the unseen sun behind the arch intensifies the shadows on the foreground water. This moment exists within the continuous surge of water, and the continuous flux of light, and the painting, by being so evidently a painting, succeeds in prolonging the moment in all its instantaneity – something which would be impossible if it imitated the substances of nature.

Monet was unable to complete any of the Etretat paintings in time for his exhibition, which seems to have been conceived as a retrospective with at least 56 works, mainly from Durand-Ruel's collection, with loans from Duret, de Bellio, May and Baudry.[74] There were 11 still lifes and flower pieces, and nearly 40 landscapes and marines, ranging from an 1864 picture of the Normandy coast (W.39) to others painted there in the early 1880s. Modern-life subjects – the domestic garden (W.284), the railway station (W.442), country recreation, the boulevard and city park – painted in the 1870s would have contrasted dramatically with the two dozen works painted at Pourville and Varengeville in 1882, and which suggest a nature indifferent to the small human presences or traces that mark its surface. These last included four views of the Customs-officers' cabin (W.730, 733–734, 736) and three paintings of the cliffs casting multi-coloured shadows on to the sea (W.792, 806, 808). Even if these groups were not hung together, they would have emphasized, even more forcibly than in 1882, the dramatic constructive changes demanded by changes in light, and the extraordinary inventiveness by which Monet transformed the motif by using different colour-dominants and different brushstrokes.

The exhibition opened on 28 February 1883 in Durand-Ruel's new galleries on the fashionable boulevard de la Madeleine. Although

*Opposite*:

177   *The Cliff-walk, Pourville* (W.758), 1882, 65 × 81 (25¼ × 31½)

178   *Edge of the cliff at Pourville* (W.757), 1882, 60 × 73 (23⅝ × 28)

179   *The Cliff near Dieppe* (W.759), 1882, 65 × 81 (25¼ × 31½)

Pissarro described it as 'a great artistic success, very well organized', it attracted few visitors and, at first, little critical attention. Monet called it a 'catastrophe', and blamed Durand-Ruel for not publicizing it sufficiently. 'I myself', he wrote, 'think very little of the opinion of journals, but one must recognize that, in our period, one can do nothing without the press', adding a day later that criticism and even insults were preferable to silence. 'No, from the artistic point of view [press opinions] change nothing, I know my own value, and am more demanding of myself than anyone else can be. But one must see things from a commercial point of view.' From the same 'point of view', he sometimes made gifts of paintings to sympathetic critics, and wrote thanking others for favourable notices. He needed money, but was afraid to ask Durand-Ruel for an advance: 'I'm terrified by the number of canvases you have of mine; if you don't sell them, is it possible for you to encumber yourself further?' And he threatened that he would have to sell to others.[75]

Despite Monet's fears, the exhibition inspired a number of articles which were longer and more considered than most of those the Impressionists had previously received. Few were hostile;[76] most of the critics started from the general premiss that while Monet's paintings might seem strange, one did become accustomed to them, and they sought reasons for the strangeness and for the way it gradually insinuated itself as meaningful and even revelatory. The first significant article was by Gustave Geffroy, a journalist on Clemenceau's radical *La Justice*. Using *The Customs-officers' Cabin* as an example, he maintained that the 'summary design' of Monet's paintings, with their simplified planes and economical line, was the 'necessary vehicle' for the painter's representation of 'the brilliant, ever-changing colours of nature'. More profound was the writer's observation that Monet's pursuit of sensation could lead to the disintegration of known form – when his 'reality' could take on 'the allures of a nightmare'. Geffroy may have been thinking of the floating colours and string-like brushstrokes of *Effect of mist near Dieppe* (W.724), or the startling streaks of brilliant colour on the cliff face in the *Church at Varengeville, morning effect*. It is significant that the threat of disintegration of form, which had been a commonplace of hostile criticism in the 1870s, could now be accommodated almost without comment in a sympathetic article, as if the 'nightmare' were a given.[77]

In *La Vie moderne*, Silvestre wrote that Monet's painting was 'a great return . . . to the reality of impressions', and that, despite its variety, his work had an 'artistic unity' in which one sensed 'a powerful synthesis, an action meditated in the mind, something willed and durable'. In these words – perhaps inspired by the almost wilful inventiveness of the nine pictures of cliffs shown in the exhibition – Silvestre made clear his view that Monet's paintings were consciously developed formal structures capable of transcending the moment represented.[78]

In a major study in *La République française*, Burty claimed Impressionism for the Republic of opportunists. He referred to the tumult aroused by the early exhibitions, and noted that 'refined connoisseurs' now supported the Impressionists, 'and opened to them even the *Gazette des Beaux-Arts*, the academic journal *par excellence*'. In 1874, however:

Only *La République française* was favourable to [Monet], the great citizen who was its director [the recently dead Gambetta] understood from the beginning that politics was foreign to the situation, and that new formulae . . . are, in art as in science, the gauge of real progress and the prerogative of French genius.

Monet was no longer, Burty wrote, 'the slave of hasty production provoked by the need to sell on the very day. In selling more dearly, he

180   Utagawa Hiroshige, 'The entrance to the caves at Enoshima in Sagami province', from *Famous Views of various provinces*, 1853–6, woodblock print, 34 × 22.8 (13¼ × 9)

*Opposite:*

181   Nagasawa Rosetsu, *Rocky coast*, late 1790s, painted screen, ink and gold leaf on paper, 171 × 372.7 (67⅜ × 146¼)

can work longer on a canvas, can shape his intention more precisely'. He described Monet's execution as 'completely modern', but asserted that since the work was painted at arm's length, it could be judged only 'at a distance'. Seen at a distance, the painting was deprived of the ability to disturb habitual perceptions, but also of its intimacy and its capacity to involve the spectator in its own process of becoming. Burty also implied the existence of an audience, educated, motivated and sure of its individualistic values. 'For painting which is so personal', he wrote, 'there must be spectators who know clearly how to pursue what they feel, to stop at what they love'.[79]

One of the most striking examples of the status which Monet's art had achieved was the article which appeared in the prestigious *Gazette des Beaux-Arts*. The writer, Alfred de Lostalot, commented that the appearance of 'the name of this painter in a review which claims to be ranged among conservative art journals . . . amounts to saying that we refuse to see in him an anarchist of painting'. With this almost indifferent phrase, de Lostalot dismissed the assumption, which had been persistent since the 1870s and perhaps even earlier, that there was some connection between Monet's painting and destructive political radicalism. The article on Monet appeared with ones on Raphael, Rubens and Velasquez, and was the only one in the whole issue on a nineteenth-century painter. This suggested that Monet's position within the great tradition of art was assured; but, more basically, because there was no relationship between these different forms of art, the placement cut Monet's painting off from its own time, making it one form of art commodity among others. De Lostalot's article was apposite at a time when Monet was considering ways of exhibiting his paintings that would appeal to an élite audience which he hoped could appreciate his increasingly experimental pictorial language.[80] The critic disregarded any paintings of modern life in the exhibition – *The Boulevard des Capucines*, the *Impression, sunrise*, *The Pont de l'Europe*, *Gare Saint-Lazare*

(W.442), evoking a timeless realm of refined sensation. He also ignored any question of spontaneity, either in execution or in response to the work, indicating that appreciation was a matter of specialist knowledge. He thus further transposed Monet's art into the discourse of privilege.

De Lostalot's central theme was that Monet's 'mode of seeing is not that of all the world'. With a curious sceptical phrase – 'if the rumour that he paints always *en plein air* is believed' – he scorned those who felt that Monet's *pleinairisme* gave 'precious guarantees of exactitude of which no other trademark would assure them in the same degree'. He maintained that Monet did little that was new, for the 'laws of nature' – in particular those concerned with the perception of colour – were employed by Rubens and Veronese, while Monet's 'audacities' already existed in Millet's pastels. De Lostalot claimed that the public was indifferent or hostile to Monet's art because he 'painted in a foreign language . . . of which he alone, and a few initiates, possesses the secret'. The critic clearly believed himself such an initiate, and he gave a pseudo-scientific explanation: Monet painted in sunlight dominated by yellow tones, so his vision of nature was tinged with yellow's complementary, violet; 'he and his friends see violet; the crowd sees otherwise', but those in the know could appreciate 'an exquisite symphony in violet'.

Although de Lostalot emphasized that painting is a language which can be learned, he did not suggest that it was one in which anything was said. When confronted with Monet's work, he found 'the first impressions . . . strange and unlikely', but once 'the eye becomes accustomed and the eye awakens', Monet's paintings could stimulate 'nervous fibres which, in my case, are early mute before nature'. The strangeness of Monet's painting could then be assimilated into a conservative discourse which assumed that its primary aim was to animate the spectator's 'nervous fibres'.[81]

Monet's 1883 exhibition marked the beginning of his acceptance as the foremost landscape painter of his day, an acceptance which was expanding beyond a small circle of fellow artists, progressive critics and collectors, to the fashionable élite. His exhibition could still have been prefaced by his claim, 'I am – and wish always to be – an Impressionist', yet it demonstrated how profoundly his Impressionism had changed since 1878. With a few exceptions, such as *The Cliff-walk*, the recent landscapes were unquickened by modern life – houses seem to be abandoned, churches outgrowths of nature, and even the sails of yachts refuse to signify a human presence[82] – whereas his 11 modern-life paintings of Paris and Argenteuil were social landscapes, lively with human activity. The critics passed them over in silence, and it seems that Monet's judgment accorded with theirs, for he never again painted the suburban modern, and the modern figures in the landscapes which he painted in the second half of the 1880s suggest that the bourgeois occupation of the countryside had become elemental. The commentators on Monet's art divested that art of any social content; henceforth it was to operate within the territory of a heightened individualism to which the Symbolists too were dedicated.

Monet's exhibition inspired Burty to eulogize those painters who pictured a 'soft, poetic' France with its misty atmosphere and subtle colours, and to conclude, 'While we are constructing the edifice of the Republic stone by stone, let us consider that art is destined to give it its final adornment'. The critic ignored the torrid streaks of colour, the stark compositions and sheer dynamism of works like the *Church at Varengeville, morning effect*, and disregarded the 'nightmare' disintegration of form that was recognized by Geffroy. Burty narrowed the potential meaning of Monet's painting by defining it in terms of the modish slogans, 'science', 'progress', 'poetry', which characterized the discourse of nationalistic, moderate Republicanism, and like other critics, he made it clear that, for this society, the essential art would be landscape painting – which, even when pictorially radical, was seen as presenting an image of France that had endured for centuries.[83]

182    *The Church at Varengeville, morning effect* (W.794), 1882, 60 × 73 (23½ × 28½)

# 4

## Domestic Landscapes and Tourist Painting Trips 1883–1889

*And it is life . . . which fills these canvases . . . the life of air,
the life of water, of scents and light, the ungraspable, invisible
life of meteors synthesized with admirable boldness and
eloquent audacity which, in reality, are only delicacies of
perception, and which signify a superior understanding of the
great harmonies of nature.*

MIRBEAU, 1889

*. . . my ambition is to give you only things with which I am
completely satisfied, with the freedom to ask you for a little
more money . . . otherwise I will become absolutely
a machine for painting.*

MONET to DURAND-RUEL, 1884[1]

THE ARRIVAL OF THE MONET–HOSCHEDÉ FAMILY IN GIVERNY IN LATE APRIL 1883 was saddened by the news of Manet's death. Monet acted as a pallbearer, with Zola, Duret, Burty, Fantin-Latour, Alfred Stevens and Antonin Proust (once Gambetta's Minister for the Arts), as the only representative of the younger generation of painters who had been so deeply influenced by Manet. Monet's inclusion symbolized the pre-eminent position he was to attain in French art in the 1880s.

Monet now had within his grasp the three conditions for his life as a painter which he had evoked for Bazille some fifteen years earlier – the financial security 'to work all day', his family and a home. The home, an old farmhouse, was in a small agricultural village in Normandy, just over the border from the Île de France, at the heart of the area which Monet had painted all his life: the Seine valley between Paris and the sea. Monet asked Durand-Ruel for 4,500 frs. for the move and the rent, assuring him that he hoped 'to paint masterpieces', since the Giverny landscape delighted him, and he would have in the 'fixed place' which had so long eluded him 'the tranquillity which is the first necessity if one is to work well'.[2] Monet did not, of course, then know that he would remain at Giverny for forty-three years, the second half of his life.

Although there were occasions in the next two years when Alice Hoschedé felt that she might have to leave Monet, the move to Giverny established their relationship as lasting, acknowledged – and crucial to Monet's art. Her income provided the base for Monet's increasing prosperity; the running of the home and the bringing up of the eight children was her province, and this strong-minded woman created a refined and pleasurable home environment which centred on Monet's art, and to which, as his recognized companion, she welcomed his

friends. She herself was well read and, with Mirbeau, may have encouraged Monet's reading of contemporary literature; and she took care that her daughters acquired the usual feminine accomplishments which added to the comforts of the home. Mme Hoschedé probably influenced the increasing refinement and exclusiveness of Monet's painting. The sons of the two families do appear in some of Monet's paintings, but his favoured human subjects were Alice's daughters – boating, walking, reading, painting in the lovely countryside. The double family was undoubtedly full of complex tensions, intensified by the tyranny of Monet's painting, but the girls enabled Monet to create an image of a feminized landscape of idyllic happiness.[3]

Monet's long stay at Vétheuil had prepared him for the search for isolation which characterized much of the culture of the 1880s and '90s. Although Giverny was close enough to Paris to enable him to keep in touch with the cultural life of the city, it was distant enough to give him the peace he required for his exploration of perception. Monet may have shared the sentiments of his friend Mirbeau, who wrote on his retreat from Paris:

How good I will find it there, in this little lost corner, embalmed in the scents of the burgeoning earth! No more struggles with men, no more hate . . . nothing but love, that great love which falls from the peaceful skies. . . .[4]

As the 1880s progressed, Monet's paintings expressed an increasingly refined individual sensibility, registering extraordinarily acute perceptions with pictorial means which declared their artificiality even more strongly than before. His individualism was reinforced by his search for a more prestigious public for his work, and shaped by the general cultural tendency towards the private.

Although his work had been selling well, the severe economic depression which lasted from the early 1880s to the mid-'90s meant that Monet's financial troubles were not yet over; and indeed, even when he was becoming wealthy in the late 1880s, he never lost the fear of finding himself 'without a sou'. His earlier periods of financial ease had been so quickly succeeded by crises of poverty that he had a lasting terror that 'misery awaits us'. Durand-Ruel's losses in the crash of the Union Générale, coming so soon after his prodigal purchases of Monet's work in 1881–2, must have seemed like a re-run of the situation a decade earlier.[5]

Monet was now resolved to shape an audience which could sustain his art more strongly than could his purchasers in the 1870s; it would have to be an audience capable of taking risks – of speculating – as Hoschedé and Durand-Ruel had done, but also wealthy enough not to bankrupt itself in the process. It was not cheap to maintain his family in the unostentatious affluence crucial to his art (that family having quadrupled since he left Argenteuil), and by the early 1880s Monet was coldly determined to achieve material success, using means which repelled – and fascinated – his old comrades: he arranged for his

paintings to be shown in luxurious surroundings where they could be contemplated as unique and precious objects, alongside works by fashionable artists like Helleu and Gervex, indicating that he had no objection to his pictures being seen next to shallow and facile work by others so long as these smelt of success. He fought to keep his prices high, learnt to play one dealer off against another and encouraged speculation in his paintings. Monet's new imagery may have suggested an alternative to the urban industrial world, but the conditions of production and exhibition – of these series of closely related but unique works, produced for an unknown luxury market, almost as if designed for speculation – were in profound accord with France's evolving finance capitalism.

It did not take long, after the less than heroic establishment of the Third Republic, for many to become disillusioned with the mediocrity of the 'government of opportunists'. Dissatisfaction was intensified by a series of scandals, of which one – the crash of the Union Générale bank – inspired Zola's novel *L'Argent* (1890), with its extraordinary vision of a society both corrupted and energized by financial speculation, which promised the transformation of the earth and of mankind, but could cause untold misery for its victims. For over a decade the corruption associated with the Panama Canal project tainted more and more parliamentarians, newspapermen and financiers, including some of Monet's patrons. Secure in the belief that French society was composed (in Gambetta's words) of 'individuals in the process of rising', a sequence of rapidly changing governments made it clear that there would be no fundamental transformation of that society, despite the sharpened awareness of the inequalities brought about by the economic depression.[6] The promise of progress leading to general prosperity and social justice through liberal parliamentarism and the free-enterprise system thus seemed increasingly hollow. Alternatives were sought in socialism, in anarchism and in a romantic nationalism which almost swept General Boulanger to power in 1889.

The intellectual avant-garde's contempt for the rhetoric of liberal democracy was clearly articulated in Mirbeau's 'Prélude', published on 14 July 1889 at the beginning of an electoral campaign:

Well! my worthy voter . . . if you have a glimmer of reason in your head . . . the day the electoral beggars, cripples and monsters cross your usual path . . . on that day, you will go peacefully to fish or to sleep beneath the willows or to find girls behind the haystacks or to play bowls. . . . On that day, . . . you would be able to boast of having achieved the only political act . . . of your life.[7]

With Gustave Geffroy, Mirbeau was Monet's most fully committed supporter in the 1880s and '90s; both men were his close friends and both advocated revolutionary change. Geffroy – the *'juste de la Justice'* – was a socialist, and by the late '80s Mirbeau was one of the most influential of the many intellectuals, writers and artists who were actively committed to or sympathetic to anarchism, because of its insistence on the need to destroy stultifying institutions so that each individual could have the fullest possible freedom for self-realization.[8]

Like most artists and writers who, at this time, denounced bourgeois culture, bourgeois materialism and bourgeois institutions, Mirbeau's and Geffroy's notions of art rested on a frank acceptance of the bourgeois ideology of individualism; both saw the artist as the ideal role-player of that ideology, and defended Monet's refined, precious and exclusive art as the epitome of individual liberty. The liberal Republic favoured the artistic pluralism of an avant-garde composed of multiple warring factions as an expression of the vitality of free-enterprise society. There were in fact the closest connections between these factions, for each believed its enactment of individual freedom, despite being marginalized, marked a crucial difference from a debased society. Antagonism to that society was more significant than the differences between the factions. It was for such reasons that Mirbeau could be the 'polemicist of every fashion and of every struggle of ideas of the late nineteenth and early twentieth centuries, from naturalism to symbolism and from Impressionism to anarchy',[9] and thus that his erotic, if not obscene, novels could be justified. His eroticism is as difficult to reconcile with Monet's domesticity as his extremism, his provocativeness and his violence – but they did share a passion for gardening and for nature, and Mirbeau proved to be another of the strong friends Monet seemed to need.

Through frequent trips to Paris and frequent visits from his friends, Monet kept in touch not only with his old comrades, but with those animating new cultural tendencies: Mallarmé, Mirbeau and the 'decadent' Huysmans. Morisot, Rodin and Whistler became significant friends, and Monet not only exhibited but also fraternized with artists such as Helleu, painter of modish Parisiennes, who had acquired their reputations by applying a judicious mixture of impressionistic colour and handling to elegant, picturesque or poetic subjects which appealed to *haut bourgeois* taste.

The conventional opposition between Impressionism and Symbolism rests on a simplistic polarity between the Impressionists' dedication to truth to nature and the Symbolists' concern with subjective experience and abstract modes of expression. Yet, as has been seen, Monet had always been conscious of the subjectivity of his 'sensation of nature', was fully aware that the processes of representation were as much mental as physical, and repeatedly drew attention to the artificiality of his paintings. These aspects of his art were, however, more strongly articulated in the 1880s, and were recognized by Symbolist writers, as they had been earlier by Mallarmé.

Monet was repelled by those Symbolists who rejected the truths of the external world, and who sought to use paint as a means of expressing mystic experience. Many Symbolists were, however, concerned with mental experience as it was conditioned by the modern, and believed that modern science could reveal truths of mental being more profoundly than could any sentimental mysticism. For example, one of the most important of the Symbolist critics, Félix Fénéon, was deeply interested in the Neo-Impressionists' scientific analysis of the way light could be represented by 'divided' colour, and Monet seems to have made his painting more rigorous in response to Fénéon's criticism of it as technically brilliant, but incoherent, unscientific, and facile.[10]

While some members of the avant-garde were committed to seeking reform or even the destruction of the social system, for most, disillusion with what they saw as a shabby, materialistic, corrupt present was translated into dreams of escape – escape into the exotic distance, into the past or the hereafter, into the world of dream or into the depths of the mind; escape into an ideal, sensuous, totally harmonious aesthetic environment. There was a yearning for spiritual values, believed to be lost in over-sophisticated urban cultures but to survive in 'primitive' societies or wild, unhumanized nature. At Vétheuil Monet had already returned to the Barbizon vision of an essentially rural nature, and had excluded those who worked and lived in the place, while in Normandy he had transformed the holiday coast into a wilderness of huge cliffs, deserted beaches and empty tracks. Figures disappeared entirely from the works which Monet then painted on a series of trips to different

parts of France and northern Italy; in 1884 he showed the Mediterranean coast as strangely empty of people, its olive groves and gardens like exotic jungles, its villages like organic growths, its modern villas uninhabited, overwhelmed by strange plants; in 1888 he painted its tree-lined beaches like some desert island, or the Fort d'Antibes like a dream castle; he also chose to paint at Belle-Île because it was known as wild and savage, and thus capable of producing a 'different note' from his usual sun-suffused landscapes.

Monet's 'series' – groups of paintings on a single motif, multiplied according to changes in light – were evolved on painting trips to these tourist areas, far from the domestic landscape of Giverny; he then spent months finishing them at home, heightening the expression of specific effects and strengthening the decorative relationships between individual works and the ensemble.

Monet's painting trips were to places sanctioned by guidebooks, and known through commercial images. His landscapes of the late 1860s and '70s express something of the city visitor's experience of the countryside, but his 1880s pictures of the Mediterranean and of Brittany suggest something of the experience of the tourist seeking to acquire an image of a place from which he or she is inevitably detached. This detachment – quite different from Monet's particular kind of detachment from the intimacies of the Giverny landscape – was a necessary condition for the fragmentation inherent in his series, and for the expression of a modern relationship to landscape in terms of pure perception. It was the tourist paintings which conquered a *haut bourgeois* audience for Monet.

That his increasingly obsessive desire to grasp a moment of light could result in a form of alienation from the landscape is suggested by his fear that he might become 'a machine for painting' unless he could spend sufficient time working in his studio on a large group of paintings begun in the open air on his painting tour of 1884. In 1909, as if searching for a way to express his sense of some emotional lack in Monet's painting, the critic Louis Gillet came to ask 'if this great landscapist really loves nature', and to describe how Monet sought to represent 'the collection of nervous shocks of which the visual image is constituted' (Laforgue also referred to 'shocks' of colour).[11] The fragmentation of the passage of light into a sequence of moments, like the pulverization of the image into 'nervous shocks', represents an intensification of the appropriation of nature by mechanical time.

The tiny village of Giverny scarcely exists in Monet's painting, and nowhere more than at Giverny did Monet give the landscape the characteristics of an enclosed garden, a garden which absorbs his models, the members of his extended family who appear casually as small figures in the landscapes of 1885, and become the subject of major works between 1886 and 1888. The landscape Monet created at Giverny was inhabited by those he knew intimately, and although he tried to represent them 'as if they were landscape',[12] they endow it with a form of continuity precisely because the human figure demands a different kind of attentiveness from that generally required by a landscape painting. But this quality of intimacy gradually came to pervade the paintings of the Giverny countryside. Thus, although they were records of experience that was becoming past, they were not '*souvenirs*' like the paintings of Antibes or Belle-Île, for they embody something of the continuity and intensity of Monet's long exploration of that tiny part of the Seine valley.

For Monet, rising prices and the growing demand for his work simply provided the conditions for achieving his private aims in

painting: the pursuit of his personal experience of nature; the testing to the limit of the mysterious connections between vision and paint; the creation of some sort of wholeness from the chaos of fugitive sensations. There were, however, strains in this situation: Monet's courting of a fashionable Parisian audience threatened to undercut his desire to pursue individual perception to the point where known form disintegrates; the increasing preciousness of his work co-existed uneasily with his cultivated interest in a wild, untouched nature; subjecting his work to financial speculation undermined the non-material values attributed to artistic creation; and, finally, his expression of the fragmentation of time was in irreconcilable conflict with his desire to use painting to heal the losses brought by time.

# I

Monet did not paint at Giverny until the summer of 1884, for he was working on the Etretat pictures and 36 panels representing flowers and fruit for 6 pairs of doors in Durand-Ruel's salon (ill.183). He did several views of the church in the nearest town, Vernon, and of the Seine, but this was all; in December 1883 he told Durand-Ruel that it was 'a century since I have worked on nature in the open air.'[13] Giverny was to become the centre of Monet's being as a painter: its topography and light provided the basis for creating works which were markedly different from the tourist 'other', and since the tourist series were finished at Giverny, his new visual experiences and pictorial strategies were fed back into the Seine valley paintings. On his painting trips, conscious that his time was limited, Monet would immediately seek out characteristic motifs as a means of working his way into an area's particular light and topography; but, although he could be amazed by the sensations aroused by that area, *what he saw* was to a certain extent shaped by his preconceived ideas of the place, which he had deliberately chosen to contrast with and to extend his normal modes of visualization. He said that he did not immediately begin to paint at Giverny because one 'must always take a certain time to familiarize oneself with a new landscape', and his exploration – or rather, assimilation – of that landscape took years rather than weeks.[14]

In December 1883, Monet and Renoir visited the Mediterranean coast together, but Monet returned within a month, explaining to Durand-Ruel, 'I've always worked better in solitude and following my own impressions'.[15] He was almost always alone on these painting trips, and the works he produced were subtly different from the relaxed, social paintings done in the company of his friends in the 1860s and '70s. His daily letters to Alice Hoschedé reveal the complex ways in which time threatened his representation of landscapes foreign to him. On his arrival, he would be exhilarated by the new landscape, and would expect to be able to bring 'good things' home in a few weeks; soon he would be complaining about his difficulty in capturing effects different from those to which he was accustomed; after a time he would review the works he had painted shortly after his arrival, and although he generally found them bad, they helped him realize what he had been learning about the landscape. However, the discrepancy between those paintings and what he could now see made him realize with increasing desperation that he would need longer to work on them. And all the time he was tormented by the fickleness of the weather, the speed with which light and season changed and the slowness with which he worked.

183    One of six doors painted for Durand-Ruel's salon (Porte B), 1882–5

Monet's December 1883 visit to the Mediterranean would have made him aware that its brilliant light and hot colours contrasted strongly with the characteristic 'white' light of the chalky Seine valley and the Normandy coast which he had represented in paintings exhibited earlier that year. His letters show that he was fearful of boring his public, and he was determined to exploit a landscape whose every aspect, he said, represented 'a country quite different from our own', hoping to get an exhibition out of it with about three weeks' work on the spot. He stayed for two and a half months. At first he could not isolate acceptable motifs, for he confessed himself to be 'a man of isolated trees and wide spaces', and found the vegetation too dense, confused and full of detail.[16] He was delighted that the same light returned day after day, but found it more and more difficult to render the particular brilliance of that light, and after painting for nearly a fortnight he felt he was only beginning to understand it. His canvases multiplied – 45 have survived – and he was spending a dozen sessions on some of them, changing them more times than he could tell. It was, he said, 'the labour of a madman'.[17]

Monet painted *Cap Martin, near Menton* (ill.196) with a bravura characteristic of his approach to scenes unfamiliar to him. Long, curving brushstrokes express the internal rhythms of the landscape, and its different parts: those shaping the road are echoed in the mountains beyond; the brushstrokes are modulated into stronger curves as they shift from the shadowed road into the trees, and reappear in the clouds and the cloud shadows on the mountains. By dissolving form into lines of colour – with the hot orange pinks of the road and the hard blues of the sea echoed in a muted key on the distant mountain slopes – Monet made the whole composition vibrate with those pinks and blues which he saw as characteristic of Mediterranean light.

The Mediterranean works were also influenced by Japanese art, but, as was often the case with Monet's paintings of places he did not know, the influence operated in terms of stylistic clichés, as can be seen in the oblique viewpoint and the geometrically defined area of bright colours of *Cap Martin, near Menton*. The non-European mode of representation did not in this case help Monet to develop his own way of representing the landscape, and merely overlaid a naturalistic structure – one has only to compare this painting with Cézanne's searching, tentative, almost awkward ones of the same area, to realize how conventional it is. This conventionality may also have been shaped by Monet's use of guidebooks for information on possible motifs.[18] Images derived from such sources afforded tourists a mode of verification, assuring them that they were seeing the 'real thing' and providing a record of the fact that they had done so. They were signs that the place depicted was being transformed into a commodity, and something of this character informs Monet's paintings of Bordighera and Menton, which suggest equivalents to the notion of 'the Riviera' – heat, brilliant light, luxuriant vegetation. The *Cap Martin* is a dazzling response to a particular site, yet it does not suggest that Monet's acuity of perception enabled him to *know* the landscape. He remained the outsider, the tourist with an intense, but inescapably exterior vision.

The painting of tourist sites was, of course, far from new, and the walls of the Salons were covered with works of this kind. It could, however, be said that Monet was the first avant-garde painter of tourist areas in an age when middle-class tourism was becoming a major phenomenon of modern life, and his paintings can be distinguished from earlier eighteenth- and nineteenth-century ones by their resolutely anti-associational character. They do not evoke the past (even when imaging

184  Paul Cézanne, *The Gulf of Marseilles seen from L'Estaque*, 1878–80, 59.5 × 73 (23¼ × 28½)

a ruined bridge), and do not refer to the inhabitants of the landscape, or its uses. They are, indeed, mute records of places visited, icons of exotic sites, and their character as commodities is underlined not only by Monet's repetition of motifs, but by the exteriority of their style. Tourist vision was an extreme form of Monet's object vision, but the latter could operate in the context of the intimately known — the landscapes of the Seine valley or Normandy coast — while tourist vision functioned in landscapes known first through other texts, graphic, pictorial, verbal. Gillet later expressed something of the difference between the search for motifs of the Barbizon painters and that of Monet:

The life of a landscapist has become easy. These bourgeois tours and holidays are far from the arduous campaigns of the men of 1830. There is no longer that passionate exploration of the earth . . . that hunt in pursuit of virgin sites and wild beauties. . . . Monet did not know that anguish of the motif. Nothing is more banal than Etretat, Fécamp, the Côte d'Azur . . . .[19]

Monet was 'feverish and anxious' not only about the problems posed by the new landscape, but about how his new works would be received in Paris. He told Durand-Ruel that he would have to see all the works at home so that he could review them calmly and decide which were too undeveloped to sell, and which could be offered for sale if 'retouched with care'.[20] Since it took Monet over two months at Giverny to complete the 21 works which Durand had selected, 'retouching' had clearly developed into something more ambitious. The paint structure of some of the works indicates that Monet reinforced the long, curved brushstrokes, strengthening the linear and colour links across surface and into depth, and, at the same time, heightening the decorative unity of each work. He may also have considered the decorative relationships between the works and, in reviewing the whole group in the studio, he would have compared them one with another, rather than with the absent motif. Monet's experience of landscape was, in this way, to be shaped increasingly by his own paintings.

Monet wrote to Alice Hoschedé about the colours in these paintings:

Obviously people will exclaim at their untruthfulness, at madness, but too bad — they say that when I paint our own climate. All that I do has the shimmering colours of a brandy flame or of a pigeon's breast, yet even now I do it only timidly. I begin to get it.[21]

His belief that his perceptions had become so acute that the public could not share them was related to the Symbolists' notion that an artist's consciousness is so intense that its expression can be appreciated only by a small group of equally refined spirits. In his essay on Impressionism, written a few months before Monet's trip, Laforgue claimed that

The common eye of the public and of the critic who is not an artist — trained to see reality in the harmonies established and fixed by a host of painters whose vision is mediocre — this eye cannot compete with the keen eye of artists. They, more sensitive to variations of light, will naturally record on canvas relationships between rare, unexpected and unknown nuances of light which will make the blind protest against wilful eccentricity. . . .

Monet's metaphors, 'colours of a brandy flame or of a pigeon's breast', and his claim that he would need a palette of 'gold and jewels' to represent the brilliance of Mediterranean light, make it clear that he was aware that he needed abstract equivalents to express his perceptions of nature. Laforgue expressed a similar understanding when he wrote that 'the language of the palette with respect to reality' was a 'conventional tongue', that is, a system of accepted signs for reality.[22] The Naturalists' assumption of a straightforward correlation between nature and its image on canvas implied that the image could be read even by the uneducated spectator, but an emphasis on pictorial artifice was almost invariably associated with an audience which was socially or intellectually exclusive.

Monet's work at Bordighera was disturbed once again by financial worries — business was bad, he wrote to Alice, and 'the recrudescence of hatred of our painting will be harmful to Durand-Ruel'. The latter's business was in danger of collapse: having bought 21 of Monet's works at prices ranging from 600 to 1,200 frs., so that Monet had earned 18,200 frs. — at least on paper — before the middle of the year, the dealer was finding it difficult to pay the artist what he owed him, and could advance him only small sums of money. Monet besieged him with letters begging for more, claiming that he was 'tormented at knowing that you are tormented to such an extent, and at taking money from you which costs you so much to gain'. He was 'terrified . . . at the thought of going backwards and beginning the hunt for buyers again', and anxious to get the dealer to agree that he might sell to others. In October he told Durand-Ruel that he could not meet 'the most essential needs. My mounting debts will inevitably lead to a catastrophe for me'.[23]

By the end of November Monet was telling Pissarro that the worst was over — largely because of Durand's tenacity and faith — but his demands for money were to continue for many months, and to be particularly intense in the summer of 1885. After his bankruptcy, the dealer was allowed ten years to pay off his creditors, but he could not support Monet in any sustained way until the early 1890s. This situation exacerbated the contradictions Monet faced in painting: 'the longer I continue', he wrote in October 1884, 'the more difficult I find it to bring a study to a satisfactory conclusion, and at this time the weather changes so quickly . . .'. Durand-Ruel suggested that the lack of 'finish' in his pictures was a major reason for his lack of success, but Monet indignantly rejected the dealer's proposal that he should produce more 'finished' works, telling him that he was working hard on his paintings, and that they would be as finished as he found it necessary to make them. And yet the pressure to sell and to sell fast was severe.[24]

185    *Haystacks, evening effect* (W.900), 1884, 65 × 81 (25¼ × 31½)

Although Monet spent much of 1884 working on Durand-Ruel's panels, that summer he began to paint the Giverny countryside. Some of these landscapes show the influence of the Mediterranean works, in their choked composition and almost garish colour (W.909–917), but in three paintings of haystacks (W.900–902), Monet found what was to be his favourite type of composition at Giverny – the horizontals of an open field or river bank set against the verticals of a copse or line of trees which form delicate but insistent traceries, enabling him to represent the direction and density of light in space. The topography of Giverny makes one very conscious of the particular qualities of its light: the village nestles on gentle slopes above the miniature river Epte; flat meadows, articulated by screens of poplars or pollard willows, stretch a kilometre or so to the Seine, behind which rises a steep escarpment. The enclosure of the valley makes its misty vibrating light almost materially visible, while its east–west alignment emphasizes the passage of the sun as it rises to the east of the village and sets behind the escarpment beyond Vernon. Soon after his arrival in Giverny, Monet reinforced the protective character of this landscape by beginning to develop a garden in the orchard attached to the house, gradually extending its domain and making it an ever more complete sanctuary.[25]

Monet's first sustained exploration of Giverny, from the autumn of 1884 to the summer of 1885, began with a survey of the area, accomplished by drawing as well as painting. Moving around the valley, he tried out a range of motifs, examining possibilities in the village, its surrounding fields and hillsides, on the Seine, in neighbouring villages and on roads leading to and from Giverny. Monet's concentration was interrupted by the necessity of organizing works for a group show at the Georges Petit gallery in May 1885. After the exhibition, he created his first paintings of summer light in the fields around Giverny.

As early as December 1882, when he visited Petit's 'Exposition Internationale' with Pissarro, Monet had been tempted by the idea of exhibiting in this prestigious gallery; he wrote to Durand-Ruel,

While acknowledging the banality and low worth of most of the paintings exhibited at M. Petit's, one can't deny that the public is subjugated and dares not make the least criticism; so well hung are the paintings, so luxurious the room (which is, indeed, very beautiful), that they impose themselves on the crowd.

Monet's participation in the 1885 exhibition was seen as disloyal to his Impressionist colleagues and to Durand-Ruel. He maintained, however, that, as long as Durand-Ruel had so many Impressionist works in stock, he could only benefit from any improvement in the saleability of Monet's works – so the exhibition, Monet believed, 'could have happy results for the future of all of us'.[26]

Monet was anxious to maintain contacts with his old comrades: in November 1884 he wrote to Pissarro and Renoir to arrange a monthly dinner, as an occasion for 'getting together again and talking, for it's stupid to isolate oneself. I myself am becoming an oyster.' The dinners were to continue throughout the 1880s, attended by the Impressionists and writers closely associated with them – Mallarmé, Mirbeau, Geffroy, Duret, Zola, Huysmans – sometimes joined by Durand-Ruel, collectors, 'society' artists and writers.[27] This eclecticism – different, for example, from the more ideological gatherings at the Café Guerbois in the 1860s – was typical of the '80s. Monet kept in touch with Parisian intellectual life in other ways, writing to Pissarro for a copy of Huysmans's book – *L'Art moderne* (1883) or *A rebours* (1884) – and to Zola for tickets to a revival of the Goncourts' *Henriette Maréchal* for himself and Caillebotte, and to congratulate the novelist on *Germinal* which he had read as it was serialized. His letters express no sense of contradiction in having read that unsparing account of men and women, in Mirbeau's words 'disinherited from earthly joys, condemned to darkness, who toil, struggle for breath, perish in these sepulchral nights, and who never see the sun setting on distant horizons . . .', while painting in the luminous Giverny countryside, working in the studio on pictures requiring 'a palette of gold and jewels', and preparing to exhibit in one of the most sumptuous galleries in Paris.[28]

In late November 1884 Monet had received a copy of an enthusiastic article on his work which Octave Mirbeau had published in *La France*, a substantial journal of the left, after Durand-Ruel had arranged a meeting between them. Pissarro felt that the intemperance of Mirbeau's defence, in an earlier article, of the Impressionists and their dealer might strengthen their 'adversaries'; Monet agreed that 'moderation' might have been better, but he could scarcely have hoped for more enthusiastic support from a writer who was so much in view that de Bellio congratulated Monet on having reached a turning-point in his career, and when Monet gave Pissarro reasons for optimism after their worst crisis, he singled out Mirbeau's articles in their defence.[29]

Mirbeau's article was tinged by his belief in contemporary decadence, and implied that only the chosen few could appreciate the beautiful, the natural and the true:

What will it be thought of us later when it will be said that all those who were great artists, and who will carry into posterity the glory of this century, were insulted, vilified – worse still, joked about . . . .

Nation of scoffers . . . we must see everything in terms of the five acts of a vaudeville or a melodrama . . . and must force nature and life to yield to all the deformations of the spirit.

He recalled that an influential critic had even accused Monet of being a Communard, but that the painter had made no concession to 'the cowardice and mediocrity of his time'. Mirbeau found Monet the most 'complete painter among modern landscapists':

He has captured [nature] at every hour, at every minute . . . he has expressed it in all its changing aspects, all its fugitive [effects of] light. . . . he renders the impalpable, the ungraspable in nature . . . its soul, the thoughts of its mind and the beating of its heart.

Mirbeau seemed to suggest that Monet could simply transform nature into painting with 'no arrangement, no décor, no preoccupation with effect, no research into staging. He derives his effect simply from exactitude to things, put in their light and in the ambient air . . .'. He concluded by claiming that posterity would link Corot and Monet in 'the same definitive glory'.[30]

Mirbeau introduced two of his own personal beliefs into the criticism of Monet's work: his pantheistic view of nature as composed of invisible energies which penetrate its every aspect, and as endowed with its own 'thoughts', moods or 'reveries' to which the artist has access. Indeed, being part of the pantheistic unity, the artist was a sentient part of nature's 'reveries'. Thus, despite his naturalistic account of Monet's painting, Mirbeau's interpretation clearly went beyond Naturalism. Monet often acknowledged favourable critical articles, but this time he reacted with unusual warmth, even sending Mirbeau one of his recent paintings of the Customs-officers' cabin.[31]

At this time Mirbeau was notorious as a reactionary. He had only recently ceased editing Les Grimaces, a rabid but short-lived journal in which he viciously attacked what he saw as Jewish control of French financial life, and the decadence and materialism of contemporary society (he himself had been a stockbroker until 1882). But if Monet believed that the support of a highly visible conservative would reassure a conservative public, his belief was ironic, for Mirbeau was undergoing a breakneck conversion from the extreme right to the anarchist left. This trajectory was characteristically extreme, but many other members of the avant-garde, disillusioned with contemporary society, also embraced anarchism. A year after writing his first article on Monet, enraged by the government ban on the stage version of Germinal for 'its socialist tendencies', Mirbeau was attacking the government's 'eternally inhuman policies which think only of protecting the powerful, sheltering the rich, smiling on the happy . . .'.[32] Meanwhile, Monet had succeeded in addressing the same constituency through the 'Exposition Internationale' which opened in Petit's gallery in May 1885, attended by 'le tout Paris'.

With its meaningless assortment of styles and subjects, the exhibition of over 100 works by 39 artists of different nationalities must have resembled a miniature Salon: the Academician Bonnat's Job (Bayonne), Arab sheiks and Italian peasants shared space with Gervex's paintings of haut bourgeois life, Aux Ambassadeurs and First Communion at La Trinité, and his notorious paintings of modern sexuality, Rolla (Marseilles) and Nana (Bordeaux), could have been seen to mock Raffaelli's Return of the Ragpickers. Monet had refused to exhibit with Raffaelli in 1881, and presumably now felt secure enough to show with him without fearing that his own work would be contaminated in the eyes of a fashionable audience. Raffaelli was popular enough, as the undisturbing liberal conscience of the 1880s, to receive an honourable mention at the Salon that year, and any social implications his works might contain could be defused by condescending irony – as in de Lostalot's description: 'witty investigations in the suburbs of Paris . . . noting with incisive line the flora and fauna, men and beasts, of that desolate milieu'. Nearly all the French exhibitors were Salon medallists and holders of the Légion d'honneur. In the Gazette des Beaux-Arts, de Lostalot commented that 'not the least of the curiosities of this exhibition is to see men like M. Bonnat and M. Monet fraternizing':

In this reunion of distinguished artists, one finds all temperaments and all tastes . . . [a] chaos of ideas and contradictory acts. . . . Let's then enjoy the pleasure of examining the works one by one without second thoughts . . . the more different they are, the more varied will be our pleasures.[33]

The eclecticism of this private exhibition, like that of the Salons, assimilated the paintings into an undifferentiated wholeness in which potential meanings were reduced to a simple frisson of interest, and the only remaining response an aesthetic one.

Monet showed ten landscapes – two paintings of the Riviera, three of the Giverny area and five of the Normandy coast. Only two works – paintings of the Customs-officers' cabin – were of the same motif, and all, except for a dramatic image of the Manneporte owned by Petit, were paintings of proven popularity or of relatively safe, pretty, sensuous or dramatic motifs. The critics were virtually all favourable, de Lostalot almost entirely so; he still stressed that Monet had 'a manner of seeing that is personal to him', and that his technique was 'brutal' (a judgement that Monet accepted), but now claimed that his works were 'not sketches: neither he nor anyone else could add anything to them'.

Monet's works sold well, so his paintings of a seemingly untouched, deserted nature and of exotic tourist areas seem to have

186  Henri Gervex, First Communion at the church of La Trinité, 1877, 402 × 291 (156¾ × 113½)

187    *Meadow with haystacks at Giverny* (W.995), 1885, 73.6 × 93.4 (28¾ × 36½)

been in accord with *haut bourgeois* taste. He had chosen to exhibit them to the fashionable world in circumstances of luxury and exclusiveness, and they were seen unproblematically in those terms.

Spring had brought Monet to the banks of the Epte for his first paintings of the little river (W.980–984), and the works painted that summer of 1885, after the exhibition – such as the *Meadow with haystacks at Giverny* – show the effects of his concentrated study of this tiny area in their complex embodiment of the processes of visualizing the landscape.[34] The *Meadow with haystacks* is densely painted, with a substructure of bold, somewhat pastey strokes beneath highly elaborated layers of small brushstrokes which reveal something of the way in which Monet's perceptions of the motif deepened as he painted. In the screen of trees at the back of the meadow, flecks of violet, brilliant pink, yellow-green and dark bright blue are painted on top of the darker greens of the trees,

suggesting that the colours of the sky, meadow and escarpment beyond the trees were only gradually perceived and added as colour sensations, not as known forms, after the trees had been realized. The subtle distinction between the golden light of the late afternoon sun slanting through the trees on the right – revealed by touches of yellow, red and violet on the shadowed side of the trees – and the light behind the further line of trees, which fills the distant valley with a roseate luminosity, and turns the distant hills violet, has the force of something which is immediately familiar, even if one has never 'seen' anything like it before. Even more extraordinary as an act of visualization are the diagonal flecks of pure red which – unseen at first – emerge in the corner between the two screens of trees, and suggest the vibration of sunset light in shadowed space.

This mode of seeing was brilliantly evoked in Laforgue's article, 'L'Impressionnisme' – not published in French until 1903 – in which he

characterized 'the Impressionist eye' in Darwinian terms, as the most advanced eye in human evolution: 'The Impressionist sees and renders nature as it is . . . solely as colour vibrations. Neither as drawing, nor light, nor modelling, nor perspective, nor chiaroscuro, those infantile classifications . . .'. In a Monet or a Pissarro, 'all is obtained by a thousand tiny touches, dancing in every direction like motes of colour.' Laforgue gives a detailed analysis of the physiological complexity of painting an effect 'in fifteen minutes', as an Impressionist would do:

the work will never be the equivalent of fugitive reality, but the record of a certain unique optical sensibility at a moment which will never be reproduced in an identical way in this individual, under the excitation of a landscape at a moment of its luminous existence which will never again be identical with this moment.[35]

With the exception of two little stick-figures in a snow scene of 1885, it was in these summer pictures that Monet first painted figures at Giverny – Alice Hoschedé and Michel sit in the shade of a haystack, Alice and the three youngest children walk through a meadow in the evening shadows, while one of the Hoschedé daughters is pictured in a field of flowers (W.994, 993, 996). They appear almost incidentally on the edge of the paintings or almost lost in vibrating shadows or flowers, but their presence can be felt as an essential component of Monet's Giverny.

In mid-September, Monet accompanied his family to Etretat, remaining there after they went home, until mid-December. He returned to the motifs he had rehearsed in 1883, exploring them in drawings in which the strange shapes of the cliffs and their main lines of stress are indicated by continuous, fluid lines.[36] His major motifs were the cliffs seen from across the water, with fishing boats grounded on the shingle or dotting the sea, as well as more daring compositions – the close-up view of the Manneporte, the bony cliffs seen from high above, or from a small beach below where he could paint only at low tide for no more than four hours at a time. On one occasion Monet – who later said he wished to be buried at sea – just escaped being a martyr to his art, as he told Alice:

I was in the throes of work under the cliff, well sheltered from the wind . . . convinced that the tide was going out, I wasn't alarmed by the waves which were dying out a few steps from me. . . . In short, completely absorbed, I don't see a huge wave which throws me against the cliff and I go head over heels in the foam, with all my material! I immediately felt myself lost, for the water held me, but finally I was able to get out on all-fours, but in what a state, good God! with my boots, thick socks and coat soaked . . . and my beard covered with blue, with yellow, etc.[37]

Guy de Maupassant, who used to stay at Etretat, described the painter going to work, followed by children carrying 'five or six canvases representing the same subject at different times of the day and with different effects. He took them up and put them aside by turns according to changes in the sky and shadows.' Published in September 1886, his article gave the first account of Monet's evolving serial practice.[38] Maupassant could have seen the four views of *L'Aiguille and the Porte d'Aval* with the arch standing out from the cliff, like a scrawny leg in the sea (W.1032–1034, 1043), or the four versions of the huge arch of the Manneporte seen from very close (W.1035–1036, 1052–1053), which show how Monet varied his technique according to effects of light. In one, he built up dense layers of small strokes over a broader substructure for an effect which shows the sea calm in the still steady light of midday (ill.209), while in two other paintings representing a more turbulent sea and a more fugitive effect of late afternoon light, he used rapid, calligraphic strokes which do not form a continuous surface

as the brushstrokes do in the more considered painting. The sketchier impressions suggest that the substructure of the more finished paintings was painted with very broad, loose strokes which establish two contrasting areas of tone, indicating the major areas of light and shadow. Monet elaborated the surfaces of the 'impressions' with freely drawn lines suggestive of the inner forces of the cliff, but in the more finished paintings he worked up the surfaces with a dense web of smaller strokes which mimic the bulk of the cliff, indicate the distribution of light over its different planes, and the striations and discolorations of the chalk. At the end of the painting process, probably in the studio at Giverny, Monet re-asserted the calligraphy and thus heightened the visual tension of the image in which the huge, dense arch is made luminous by the vibration of the light-filled air and the reflections from the radiant mirror of the sea. The arch assumes an almost hallucinatory power as it seems to loom and expand, while the eye tries to bypass it to lose itself in the luminous space beyond.

In 1883, Monet had been less successful in capturing the luminous vibration of white light – which Maupassant describes as 'dazzling without being garish . . . clear without being brutal' – so his attempts to embody the transparent 'rose and blue' light of the Mediterranean and the soft but brilliant white light of Giverny probably helped him realize the light characteristic of chalk coasts. Maupassant wrote that he had

188   *The Manneporte* (W.1053), 1886, 92 × 73 (36 × 28½)

seen Monet 'seize a sparkling fall of light on a white cliff, and fix it with a couple of yellow tones which strangely represent the astonishing fugitive effect of this ungraspable and dazzling brightness'. His article did not, however, convey the density of work which might succeed a rapid impression.

In one of his tirades against the weather Monet wrote, 'I haven't been able to resume any of my motifs of the Manneporte; when the tide was just what I needed, the weather was not there.' That particular conjunction of tide and weather might last only a few minutes, but Monet still had to search out its complexities with his slow accretion of brushstrokes which was incompatible with that never to be repeated moment when the plume of spray flung up by the mysterious workings of the sea coincided with the momentary gleam of late-afternoon sunlight. Maupassant may have seen no more of Monet's practice than the procession of children carrying different canvases, and a brilliant demonstration of a single effect, or – as Monet suggested to Alice – he may simply not have understood painting; in either case, his article presented the public with a simplified view of Monet's evolving practice of serialization.[39]

Monet worked on a large group of at least 44 works for some months after his return to Giverny, going back to Etretat for three weeks in February 1886, ostensibly to work on his paintings, but also absenting himself from Giverny to give Alice Hoschedé time to decide about their future.[40] As late as September 1886 he told Durand-Ruel, 'I could not do what you asked me for the great arch at Etretat. It's not retouchable, but the moment that any of these canvases don't satisfy you, I prefer to keep them'.[41] He was not shocked at the suggestion that he change a work at his dealer's request, and simply indicated that he considered the painting was complete. 'Retouching' in the studio was obviously at variance with Maupassant's account, published a fortnight later, of the mythic Impressionist painter, capturing an effect in an instant.

While he was finishing the Etretat paintings, Monet was continuing his exploration of the Seine valley at and around Giverny, with paintings of snow-covered villages, and then of willows with their spring foliage and orchards in bloom – luxuriant paintings which contrast strongly with the bare, bony shapes and empty space of the Etretat pictures. In *Springtime* (ill.214) – one of a pair of paintings of his orchard (W.1065–1066) – Monet painted Suzanne, his favourite model of the four Hoschedé daughters, with his own elder son, Jean, in shallow space filled with layers of variegated greens, pinks and blues which seem to filter a pinkish light into drowsy air. Curve echoes curve, embracing the figures within the lines of the trees, and Monet enfolded them in this palpitating space even more closely by covering a line of blue behind the trees – which would have suggested some space beyond the orchard – with green brushstrokes as bright as the grass on which the figures sit. This is not description, but a re-creation of the sensation of being submerged in blossom and new leaves, in the scent and warmth of a spring day in which everything is vibrantly alive.

In late spring 1885 Monet had told Durand-Ruel that he was gardening 'in order to prepare some beautiful motifs of flowers for myself for the summer',[42] but he painted his garden only a few times before the mid-1890s, and instead used his painting to transform the Giverny water meadows and fields of wheat, oats and poppies into an extended garden. It was probably no coincidence that Monet should have painted these two canvases of Jean and Suzanne under the flowering trees after the resolution of the final crisis in his relationship

with Alice Hoschedé secured the double family. In February 1886, when it seemed she might leave him, he had written to her from Etretat: 'the painter in me is dead . . . and it should not be thought that in agreeing to live separately, I will regain courage. . . .' Two days later, he commented on a letter in which she wrote of her joy in the 'happiness and success' of her daughters:

. . . as you say, I have no right to share in your joys. . . . I knew this very well at the beginning of our love, I had nothing, nothing to say to that, but after the years we have lived side by side, it's painful, and as it will get worse, I know what I will have to endure.[43]

Legally, as he well knew, Monet's family was a fiction; but once again he made it a reality in painting. Pictured in a garden-orchard in the heartland of France, this family was both ideal and real: it was presented as harmonious and secure, without any hint of pain or loss, but was painted in that 'real' light, under those 'real' trees in that homely, yet ecstatic spring orchard.[44]

Monet exhibited in the 'V$^e$ Exposition Internationale de Peinture et de Sculpture', which opened on 15 June 1886 in the Galerie Georges Petit. Despite his success in the 1885 exhibition, his financial situation remained insecure. There was a threat to his rising prices when some dealers, including Petit, plotted 'to kill [Durand-Ruel] stone-dead as an expert and dealer', as Pissarro wrote to Monet in October:

this is making a real mess which will again fall on the poor naïve painter who slaves over nature, and uses his temperament to do his work. . . . I'm astonished that you haven't said anything to me about these events full of disastrous consequences for us. You who read *Gil Blas* must know what's going on. . . . God save us from these gentlemen, so polite and so ferocious!

Monet was disturbed by Durand-Ruel's determination to extend his market by holding a major exhibition of Impressionist painting in New York. In July 1885 he had told the dealer that he did not like the idea of his pictures disappearing 'to the land of the Yankees. I would prefer to reserve a choice for Paris, because it is above all there, and only there, that a little taste still exists', and this unease may have strengthened his determination to seek a solution with Petit. In November, Monet told Pissarro – who was trying to organize another exhibition of the group, despite having dedicated himself to Neo-Impressionism – that Petit was refusing to let him show with his friends or exhibit works owned by Durand-Ruel. He also told Pissarro that he had taken the decision because 'at our age, one has to make the best of the business, and it will help our cause and Durand-Ruel's', explaining to the latter that it would be better if the public saw that their works were not entirely in his hands. He had never, Monet insisted, thought of abandoning 'either you or my friends, our interests are the same'.[45] A few months later, in April, when the dealer was in New York with his huge exhibition, 'The Impressionists of Paris', Monet criticized Durand-Ruel for preventing him from selling, lamenting that he had felt so near success, but now feared 'coming down again', and accusing the dealer of being 'imprudent to leave us without means of living'.[46]

These strategies, rumours and grievances were symptomatic of a jockeying for power in which Monet, Durand-Ruel, Petit and other dealers sought control over the sale of works which were just beginning a rapid increase in value. At the same time the avant-garde was splitting into rival but overlapping groups, each competing to assert itself as leader of the modern movement, and accelerating the dynamic of change characteristic of modernism. This process both contributed to

and was dependent upon the rapid growth of the modern dealer system, which was beginning to come into its own in the 1880s. Monet wanted to ensure that no one dealer would monopolize his work and thus control prices, but at this stage only Durand-Ruel had real faith in that work, and despite his financial problems, only he was prepared to risk advancing the painter money. The dealer had amassed a huge collection of paintings which could not be released on the French market without causing prices to fall catastrophically. This situation was saved by the success of Durand-Ruel's American experiment: he sold at least half the 48 Monets shown in the 1886 exhibition (most of these were landscapes), held another exhibition the following year and established a permanent branch in New York in 1888.[47]

Like the major collectors of Monet's works in France in the 1870s, the American buyers were mostly financiers and self-made industrialists, with some middle-class professionals, but able to speculate on a grander scale, sometimes buying a large number of works and re-selling them at high profits. Despite Durand-Ruel's success, Monet's expenses were high and, judging by his complaints, remittances slow to come in, so that, at first, there was little to offset Monet's dislike of the disappearance of his works to this unknown audience. By the end of the 1880s, however, the advanced finance capitalism of the United States was providing the means by which Monet could sustain an increasingly individualistic modernist art, allowing him to spend as much time as he wished on a work or group of works. What these self-made American millionaires and others got from Monet's painting was probably not so much the profits of speculation (maximizing of resources was part of their ideology, but the profits from art would have been minimal by comparison with their other assets) as status, as purchasers of cultural property, as well as the economic credibility conferred by conspicuous consumption. But his landscapes promised more, as was suggested by an American critic: 'The complex problems of human life . . . have no part in the landscapes. . . . They are full of a heavenly calm. Claude Monet . . . comes before us like a messenger of peace.'[48]

At their monthly dinner in March 1886, the Impressionists and their guests included Monet, Pissarro, Mallarmé, Huysmans and Duret, and discussion centred on Zola's recently published novel, L'Oeuvre. Shortly afterwards, Monet wrote to thank Zola for sending him a copy of the novel, saying that although he had read the book with real pleasure – finding memories on every page – he was nervous that Zola's characters would be identified with Manet, himself and his friends, that the public and press would see them as failures, and that, 'at the moment when we are succeeding, our enemies might use your book to defeat us'.[49] Monet acknowledged that the novel 'raised questions of art for which we have long been fighting', but he may have been disturbed by the way in which Zola, in a manner characteristic of the cultural eclecticism of the 1880s, intercut Realist debates of the '60s with his own interpretation of Impressionism, with hints of a more scientific Neo-Impressionism fused with a kind of academic Symbolism. The novel suggests that the painting of figures and landscapes in the open air was behind the times, and its most vivid pages narrate the obsession of the doomed artist hero, Claude Lantier, with an allegorical painting of Paris, the modern city, in the guise of a figure of a woman who gradually assumes the nightmare characteristics of a femme fatale. Monet's concern was shared by his colleagues, and was justified by the fact that L'Oeuvre, in serial and later in book form, was to have a far wider audience than that addressed by art critics, and that this audience would be exposed to Zola's ideas at length and in language of great persuasive power.

189   Georges Seurat, Le Bec du Hoc, Grand-Camp, 1885, 66 × 82.5 (26 × 32½)

Monet's nervousness was probably intensified by his hope for decisive success in the 'V^e Exposition Internationale de Peinture et de Sculpture'. His fellow exhibitors included, besides Rodin and Renoir, Boldini, Liebermann, Cazin, Raffaelli, Blanche, Gervex and Besnard, most of whom enlivened their works with impressionistic colouring and loose handling. Monet exhibited 13 works from the years 1884–6, including several readily recognizable tourist motifs from the Riviera and Etretat, and from a recent trip to Holland where he had been invited by a connoisseur who wished him to paint the fields of tulips. He also exhibited charming scenes from the Giverny area, including one of Alice and Michel in the shade of a haystack, painted in 1885 and owned by Petit, and the recent picture of Suzanne in the orchard (W.994, 1065). The only radical work was one of the close-up views of the Manneporte (W.1053), a painting which Monet particularly liked, but the only one which did not sell.[50] His works were well received; the critic of the respected XIX^e Siècle proclaimed Monet's triumph over the other highly fashionable exhibitors, and although the redoubtable Albert Wolff of the arch-conservative Le Figaro made his ritual complaint about the incomprehensibility of Monet's art, he did give faint praise:

The Sea at Etretat does not, however, belong to the naturalist genre. It is a fairytale lake. . . . It is then a fantasy sea with fantasist coloration, but very distinguished, with fantasy rocks . . . 'and really charming'.[51]

Yet if Monet had won over most conservative critics, he was now the target of the new avant-gardists, the Symbolists and the Neo-Impressionists whose most eloquent spokesman was the young Félix Fénéon. The eighth Impressionist exhibition – dominated by Gauguin, Degas and the Neo-Impressionists, among whom was Monet's old comrade Pissarro – closed just as the 'Exposition Internationale' opened, and to anyone visiting the latter after studying the intense discipline of Seurat's and Pissarro's landscapes, Monet's may well have seemed disordered, instinctual, fantasist.[52] Seurat's Le Bec du Hoc, Grand-Camp, with its superbly calculated thrust of cliff against horizon, might have seemed a particularly clear critique of Monet's The Rock Arch at Etretat

*(The Manneporte)*. These differences would have been emphasized by the proximity of Monet's paintings to Boldini's flashy portraits or Cazin's dreamy, melancholic landscapes. Fénéon's article on the eighth Impressionist exhibition positioned the Neo-Impressionists at the head of the avant-garde by placing the 'heroic period' of Impressionism firmly in the past. It was then, he wrote, that the older painters who had painted 'modern life and landscape' in the open air discovered the laws of divided colour — which they had, however, applied in an arbitrary way, while Seurat, Camille and Lucien Pissarro, Signac and others 'divided colour in a manner conscious and scientific'. Fénéon gave a detailed analysis of Seurat's division of colour in *A Sunday on the Island of La Grande-Jatte*, and praised his uniform, monotonous brushstrokes and absence of all bravura.[53]

The relationship between Impressionism and Neo-Impressionism should be seen in terms of the avant-gardist construction of history as an endless sequence of moments, each of which is rendered obsolete by the next. This notion was based on a concept of time to which Monet had adhered, but which he both still accepted and was beginning to resist, painting fragments of time with even greater rigour, but also seeking alternative modes of continuity in his figure paintings.

The suggestion that Monet may have risen to the unwelcome challenge of the Neo-Impressionists, with their insistence on scientific rigour and on mechanistic notation, may be confirmed by the evolution of his tourist series, in which there is an increasingly gritty obduracy. The Belle-Île, Antibes and La Creuse series were pictures of landscapes to which Monet was visually attracted, but of which he had no intimate knowledge, and they were executed in circumstances which he disliked intensely — staying in hotels, away from his family and loved landscape, and painted against the clock, but it was in them that Monet sought his form of the scientific. He retained the improvisatory techniques of which the Neo-Impressionists so much disapproved, but struggled to make them ever more responsive to the components of the moment of light.

Monet was satisfied by the 'Exposition Internationale'; he sold 12 works (including 3 to Petit, 5 to Faure) for 15,100 frs. and wrote in response to Berthe Morisot's congratulations that the exhibition was a

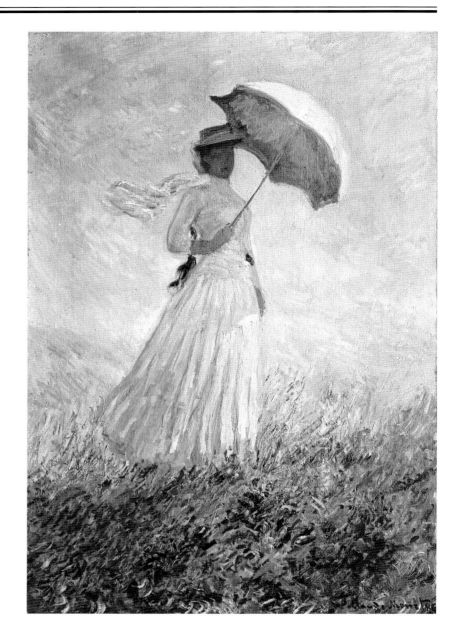

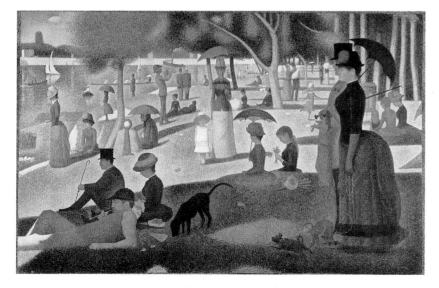

190    Georges Seurat, *A Sunday on the island of La Grande-Jatte*, 1884–6, 205.7 × 305.7 (80¼ × 119¼)

success: 'if one considers it from the point of view of sales, all that was exhibited has been sold, and to the right kind of person'. Presumably in reply to a comment of hers, he added:

As for having any pretensions to educating the public, it's a long time since I stopped believing that, it would be too greedy to want to sell only to true connoisseurs, and one would risk dying of hunger if one played that game.

He said much the same to Duret:

Yes, I'm very happy [about the exhibition] . . . and I owe Petit a magnificent candle. I'm neither more nor less strong but, finally, I'm with Petit, and the collectors have more confidence though, alas, without understanding anything more, but to wish to sell only to those who have knowledge would be too much to ask.[54]

The modern subject-matter of the 1860s and 1870s and the organization of the Impressionist exhibitions suggest that Monet once believed that the public could be educated to appreciate the new painting; one does not know if he ever considered whether the works which appealed to Petit's wealthy but ignorant clientèle might not be risking those qualities which appealed to 'true connoisseurs', and which demanded understanding and knowledge.

*Opposite*:

191   *Essai de figure en plein air (vers la droite)* (W.1076), 1886, 131 × 88 (51 × 34¼); see ill.213

192   *Luncheon under the awning* (W.846), c. 1886, 116 × 136 (45¼ × 53)

During that summer at Giverny – when, as he acknowledged to Morisot, except for the 'terrible disunion' among the Impressionists, he was 'very happy' – he painted two pictures of Suzanne Hoschedé (ills.191 and 213) on a bank on the Île des Orties where the family moored their boats. According to Jean-Pierre Hoschedé, Monet caught sight of Suzanne silhouetted against the sky and exclaimed, 'But it's like Camille at Argenteuil! Well, tomorrow we'll come back, and you'll pose here.'[55] The work he was remembering was *The Promenade* (ill.128), depicting his wife and son Jean in 1875, and the memory inspired him to paint his recreated family in the sketch, *The Promenade* (W.1075), which shows Blanche and Germaine Hoschedé, with their mother and Michel Monet summarily indicated behind them. No less significant is another unfinished work, the third of the large pictures of a meal – Camille and Jean at Etretat and at Argenteuil, and now Alice Hoschedé and Michel Monet seated at a table under an awning in the Giverny garden.[56] In all three paintings Monet embodies the ideal wholeness of the family, with an empty place-setting (which is insisted upon even in the unfinished painting) marking his own presence at the table from which he is absent because he is also the creator of that wholeness, the painter–observer

standing outside the domestic circle. The Giverny painting seems to have been an attempt to create a moment similar to that in the Argenteuil painting – when the meal in the garden is over, and the family has dispersed. One can only speculate on why Monet did not finish either this work or *The Promenade*, but it may have had something to do with the uncertainty of the status of his family in the mid-1880s. Nevertheless *The Promenade* once again indicated the family's role in transforming the rural into a private domain.

Something rather different occurred in the paintings of Suzanne which Monet exhibited in 1891, with his *Stacks of wheat* series, under the title *Essais de figures en plein air* (*Essays with figures in the open air*); he was then quoted as saying:

It's the same young woman, but painted in two different atmospheric effects; I could have done fifteen portraits of her, just like the stack of wheat. For me it's only the surroundings which give the real value to subjects.[57]

He was speaking with hindsight after painting thirty images of the stacks of wheat in a field transfused with light, yet, in one sense, he did paint the girl almost as a pure form of light. In the 1875 painting Camille

193   Berthe Morisot, *Eugène Manet and their daughter at Bougival*, 1883, 60 × 73 (23⅝ × 28¾)

is shown as an individual, seemingly glimpsed as she turns to look at her husband. The picture is quite specific about the weather: the patches of light and shadow respond to the small, rapidly moving silvery clouds which seem to be animated by the same breeze that pulls the dress around the woman's body and tugs at her veil. The later paintings are somehow more general: unlike Camille's direct gaze, Suzanne's is veiled, unseen, only to be guessed at, and she seems less an individual than some modern nymph, a personification of the forces of nature, of light and wind – an impression strengthened by the repetition of motif, with one painting suggesting cool morning light, the other the warm light of late afternoon. Nevertheless, precisely because what is represented is a human being, it is impossible to *see* it simply as an interpretation of a moment of light; instead it has a strange, almost hallucinatory effect, in which the reality of the person seems to wax and wane. In the afternoon effect, sunlight filters through the parasol and falls in a white radiance on the dress, and even its shadowed side is illuminated by the roseate ambient light. The breeze flutters the dress, the long scarf and the veil, making the figure scarcely more substantial than the waving grasses and floating clouds, less a solid, finite form than a concentration of light, a concentration which fluctuates and dissolves, particularly when viewed side by side with the figure in the other painting. The effect is related to the intense but ambiguous sensuousness of Mallarmé's *L'Après-midi d'un faune* of 1876, which conjures up a dreamlike state, heavy with the warmth of the sun-filled afternoon in which the distinctions between real and unreal falter, and the faun is both intensely present and endlessly absent.[58]

The poetic generalization of the figures in the two paintings can be interpreted in terms of the contemporary notion of '*rêverie*' as a mental state which resolved the Realist dichotomy between subject and object. Here, Monet's figure paintings may have been influenced by those of Morisot, a painter he much admired. Unlike him, she expressed a belief in the inner life, writing in 1881, 'the dream is life . . . the dream is more real than reality; there one is oneself, truly oneself. If one has a soul, it is

there'.[59] As much driven as was Monet by an obsessive desire to use paint to capture fugitive aspects of life, Morisot seems to have been more concerned than he with the mind's tenuous grasp of such experience, and – unlike Monet – she was capable of expressing the scarcely visible emotional ties between the members of a family. The first evidence of the growing friendship between the two is found in 1884, in correspondence over her commissioning of a large decorative panel of Bordighera for her new home (W.857). Morisot visited Monet in Giverny in the summer of 1885, and in the second half of the 1880s they were in frequent contact. Through her, Monet may have become better acquainted with her close friend Mallarmé, who was a regular visitor at her 'Thursdays' and at the dinners which she gave her artist friends.[60]

Renoir too could have had some influence on Monet's return to figure painting. He spent the summer of 1886 with his family at La Roche-Guyon, a few kilometres from Giverny, working on his *Bathers*, a painting which Monet thought superb.[61] *The Bathers* should not be seen as simply an artistic exercise designed to reform Impressionism or to create a modern classicism, but as an attempt to re-humanize a landscape from which the Impressionists had expelled the traditional inhabitants, the rural labourers. Monet's thoughts on the subject could have been sharpened by the extraordinary tensions in Zola's *L'Oeuvre*, in which Lantier turns from the struggle to paint a woman's flesh in the sunlight to an allegorical work which Zola endowed with such complexities of non-pictorial meaning that it destroys its would-be creator. Renoir's painting also expresses the dilemma of the theme of the nude in the landscape, at a time when the suspension of disbelief required by such a theme had become fragile in the context of modes of representation shaped by Realism.[62] *The Bathers* should be located, instead, in the context of the innumerable paintings of nymphs – often painted with impressionistic loose brushstrokes and clear colours – which still peopled the Salons and dealers' galleries in the 1880s and '90s. Such works were not so very different in their undemanding conventionality from the many pictures of bourgeois ladies in the countryside, some of which were painted by Monet's friends, Sargent and Helleu.[63] They too used the superficial techniques of Impressionism, but their loose

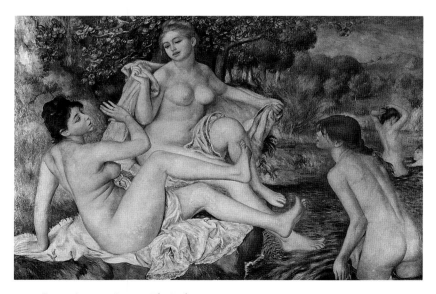

194   Pierre-Auguste Renoir, *The Bathers*, 1887, 116 × 118 (45½ × 66)

brushstrokes act like conventional signs for freedom of handling, their colours are pretty rather than structural, and, as was typical of academic Impressionism, they are not concerned with the dialectic between the real and its representation. Nevertheless, Monet is said to have thought well of Helleu's work, which was characteristic of the pictorial environment to which his bid for wealthy bourgeois patronage exposed him, and which he and other Impressionists had denied in the 1870s. Monet's *Essais de figures en plein air* make sense in this context, but it also defines their singularity.

The *Essais* embody the ideological tensions confronting avant-garde painters who sought to represent the bourgeois occupation of the landscape in the 1880s. This occupation was generally depicted in terms of female figures, with the significant exceptions of Seurat's paintings of the suburban river resorts, *Bathing at Asnières* (National Gallery, London), and *A Sunday on the Island of La Grande-Jatte*, Caillebotte's paintings of swimming and boating, and a few pictures in which Monet painted his sons, and perhaps Sargent, with the Hoschedé girls. The structure of the *Essais* is suggestive of a single atmospheric 'moment', but the repetition of the motif prolongs that moment into a timeless presentness, and thus embodies something of Monet's experience of the bourgeois countryside, expressed in terms of his own processes of making a landscape, and using the figures of the daughters of the family to do so. The paintings open up the reified moment in such a way that it can be penetrated by other associations, and the nymph of past ages can be present as a modern lady, encumbered by heavy skirts, hat, veil, gloves and parasol, who in one painting endlessly enacts a bourgeois promenade, and in the other endlessly views the scenery. The figures in the two paintings may be compared to the bourgeois couples parading through Seurat's painting of La Grande-Jatte, the most striking work in the eighth Impressionist exhibition; the impersonal artifice of its frozen figures may have inspired Monet to seek an alternative mode of embodying continuity through repetition, and to paint bodies which seem to experience the physical pleasures of the countryside in pointed contrast to Seurat's alienated bodies in the spaces of unease, of wary scrutiny of the signs of class, on the outskirts of Paris.[64]

Yet Monet was depicting female beings whose presence in that countryside was real, but who were not part of it, and whose existence was realized only as the object of sight, only through being *seen* in moments of intense perceptual awareness – for, despite the more enduring temporal nature of the images, they still retain an element of camera vision which has arrested the lady on her walk, intercepted and frozen her gaze. In terms of the desire for a humanized nature, Monet's figures escape the lovely absurdity of Renoir's *Bathers* or the tragic grotesqueness of Cézanne's, yet their very fragility as images is symptomatic of a countryside which Monet was depriving of its traditional functions and of its historical continuities, and making into a space of pure recreation.

## II

For some time Monet had spoken of his desire to visit Brittany, and he went there in mid-September 1886, where he found his way to one of the most dramatic parts of the province, the bleak, wind-swept island of Belle-Île, whose dark granite shores had been worn into jagged cliffs, twisted rocks and caves. Once again, he chose an area to paint in order to challenge his habitual modes of perception and representation, and to create readily saleable works to maintain the momentum set by his successes in Petit's gallery.[65] Since his marines generally sold well, he may have sought to produce a group of works which would contrast with his paintings of Etretat, and he would have known that the coasts of Brittany were rugged and sombre, its seas brilliant green – quite unlike Etretat, where the chalk cliffs impart their luminosity to the sea. His knowledge would have come from the innumerable Breton subjects shown in the Salon and in dealers' galleries, perhaps from guidebooks or the many literary accounts of touring in Brittany, and from Mirbeau who had a house there and had invited him to stay.[66] Monet went to Brittany with a tourist's preconceptions about the place, intending to produce a number of paintings in a short time to sell as a record of having been there, and with the tourist's hope of having his senses regenerated by new experiences. This approach came almost immediately into conflict with other attitudes to nature, and particularly to the sea; his short stay became a very long one, and he returned home with a large number of over-worked but unfinished paintings.

Since the 1860s Brittany had been a favourite painting area, both for avant-garde artists and for naturalists of all nations who believed that the survival of Breton customs and rural piety betokened a truer, more spiritual life than could be found in a materialist modern metropolis, and that its life and landscape could provide subjects which would attract attention and sales in that very metropolis, hungry for eternal verities. Gauguin was attracted by what he called the 'rustic and *superstitious* simplicity' of Breton peasants, and claimed, in words like Monet's, that he found 'the savage, the primitive' there.[67] Monet had no qualms about bourgeois materialism and was not in the least interested in the notion that true spiritual values were to be found in primitive life or in rustic simplicity; and he ignored picturesque peasants and fishermen, as well as landscapes that spoke of human occupation (just as he had painted the agricultural heartland of France for twenty years without painting those who worked it). He was attracted to Belle-Île not for its spiritual otherness, but as a source of new sensations, describing it to Caillebotte:

a landscape superb in its savagery, an accumulation of terrible rocks and a sea incredible in its colours . . . I am used to painting the Channel and I necessarily had my routine, but the Ocean is another thing entirely.

He told Durand-Ruel, 'It's all very well being a man of the sun, as you say, but one must not specialize in a single note', and was enthusiastic about 'this sinister land . . . because it takes me out of what I'm in the habit of doing', and he wrote to Alice, 'I – who am more drawn to soft, tender tints – must make great efforts to paint sombre, to render this sinister, tragic aspect'.[68]

Monet's stay in Brittany followed a now-familiar pattern: he expected to stay only two weeks, but the challenge of the new landscape made him extend that to two months. Within one month he had begun 38 paintings on a smaller range of motifs and a wider range of effects than he had ever before tried. He wrote, 'I know that to paint the sea truly, one must see it every day, at every hour, and at the same spot, to understand its life at that spot, thus I repeat the same motif four or even six times'. His nine groups of paintings included five versions of a storm, with waves battering at the rocks (W.1115–1119; ill.211), and six versions of *The 'Pyramides' at Port-Coton* (W.1084–1089; ills.195 and 208). All are depicted from a cliff looking down on to the sea and the weather-twisted rocks jutting from its flat surface, and represented in

grey weather, in bright cold sunlight, in a calm sea, in an ominous dark light with churning waters, and in a storm.[69] At Pourville and Etretat Monet had also painted a number of works with a view from cliffs, but the sea was shown either as distant or at an angle, while in the Belle-Île series, the sea is always depicted frontally and relatively close. Monet represented the water as a continuous substance, but galvanized it with long, curved and short, stabbing brushstrokes of boldly contrasting tones which express the dynamic interaction between the surging sea and the twisted rocks.

Monet's more rigorous repetition of different motifs may have been influenced by Fénéon's criticism of his recent work as arbitrary in handling and unscientific in its use of divided colour. In comparison with the elegant precision and scientific rigour manifested in the works of Seurat and Pissarro, Monet's paintings, Fénéon implied, were slipshod in their spontaneity and facile in their seductiveness. The article was published in *L'Art moderne* in September, a week after Monet had arrived in Belle-Île, and if it was sent to him, Monet could have realized that, for the first time since the second half of the 1860s, he was no longer the acknowledged leader of the avant-garde. Fénéon claimed that, despite the example of Pissarro, Monet would not 're-initiate his struggle with the public, dealers and collectors', and Monet may have sought to challenge this view by emphasizing the systematic character of his painting of series in changing light, and by asserting the primary importance of empirical work 'in the field' as against theoretical work in the studio. Fénéon was particularly critical of the Impressionists' painterly 'tricks of the trade' — 'sliding [brushstrokes] and the traces of bristles in the paint . . . used for water, circular strokes to make the clouds bulge', but, as if in deliberate challenge, Monet gave a dazzling display of virtuoso brushwork.[70]

All the Belle-Île paintings are characterized by colour-dominants composed of dark or bright blues, deep purple-violets, brilliant blue-greens, light grey-blues heightened by touches of orange and white: brusque and inharmonious colour combinations appropriate for Monet's apprehension of the island as 'sinister' and 'tragic'. These colours are not those of nature, but are derived both from an idea of place and an emotional reaction to it. Once the notion that an object had an inherent colour had been displaced by an awareness that colour is determined by light, it was gradually accepted that the artist could create *equivalents* for his or her perception of nature in whatever scale of colours was found appropriate. When the appropriate forms, colours and brushwork for a particular series had been 'found', Monet could, as it were, forget them — as he could forget what he was seeing, and forget his consciousness as an observer, in the agonizing struggle to 'find' equivalents in paint for every particle of shifting colour that constituted the scene. However, as soon as he began to paint, the picture acquired a certain fixity, giving a shape to moments of perception which had inexorably passed, never to return in exactly the same form. Monet's letters now reveal a fanatical determination to create an exact correlation between the painting and the motif in the atmospheric conditions in which it had originally been conceived. For example, he complained that when the sun was 'right' for a certain painting, it did not have the same relation to the tide as when he had begun to paint, and that every day the sun was shortening its course and lighting motifs from a different angle. He despaired; he scraped off a painting on which he had spent twenty sessions; he ruined others.[71]

Monet always spoke about the sea — his 'first love' — with more feeling than he did about the countryside, but his comments about Belle-

Île were couched in even more emotional terms, which seem to contradict his ostensibly objective desire to immobilize it at a moment when the sun *had been* at a certain angle. He told Durand-Ruel that he felt 'passioniate about this coast', and wrote to Alice, 'it was a joy for me to see that sea in fury; it was like a nervous excitation, and I was so carried away that yesterday I was desolate to see the weather so quickly become calm.'[72]

Gustave Geffroy — who had published a favourable article on Monet's art in Clemenceau's radical *La Justice* in 1883 — met Monet at Belle-Île, where he was doing research on the revolutionary Blanqui, and he soon became a close friend and a passionate supporter of the painter. He described seeing Monet with his easel tied to a cliff in a storm, lashed by wind, rain and spray, and he recalled the heroic Joseph Vernet who, like Turner, was said to have had himself tied to a ship's mast so he could observe and experience a storm at sea.[73] Monet embodied this experience in five paintings of *Storm at Belle-Île* (W.1115–1119) in which he used thick, wet brushstrokes of light blue, green, mauve and white dragged across one another in long curving streaks to mimic the turbulence of the sea as it surged, pounded and sucked at the rocks, which are no more substantial than the waves, and are shaped by the same rhythms (ill.211). The brushstrokes do not disguise themselves to give a semblance of water or rocks, but persuade one of their truth by the directness with which they identify with the rhythms of nature, and with which they express the dynamic of sight as it looks down on to the surface of the water, sweeps with the surging waves, leaps with the spray. This empathetic expression contrasts with the more conscious effects of the other Belle-Île works, and with the fanatical way in which Monet fractured the continuity of the sea into a sequence of separate 'fixes', souvenirs of the 'otherness' of Brittany which he evoked in a torrent of fashionable adjectives — 'savage' but 'delicious', 'tragic' and 'sinister' but 'superb'.

Anguished by the results of his stay, Monet wrote to Alice,

It's a rather beautiful day today . . . but on every good day I see changes in my motifs, and I must recognize that it's no longer possible to find my effects again, and I would have done better to leave three weeks ago, for since that time, I realize too late, I've only destroyed what I had done well, and since I'm resigned to bringing back incomplete things, it would have been better to have them *in their purity* of accent . . . In the end, I'm still going to try to save some canvases, the weather really seems to be turning fine. . . .[74]

About this time, Mirbeau wrote to Rodin in a letter which underlines the self-conscious nature of Monet's project at Belle-Île, 'It will be a new aspect of his talent, a Monet who is terrible, formidable, whom one doesn't yet know. But his works will please the *bourgeois* less than ever . . .'.[75] Monet visited Mirbeau briefly on his way home from Belle-Île. The writer was preparing his first novel, *Le Calvaire*, for publication (it was serialized while Monet was at Belle-Île). Largely autobiographical, it is a passionate denunciation of the ways in which authority warps the good inherent in every individual, and created a scandal over what was seen as an unpatriotic attack on the slaughter of the Franco-Prussian war. Mirbeau clearly intended to shock the bourgeoisie, but Monet — as Fénéon had predicted — 'either could not or dared not re-initiate his struggle with the public', and his 'terribilità' remained a matter of style which stimulated rather than shocked bourgeois sensibilities.

Mirbeau told Rodin in the same letter that Monet would 'bring back three or four completed works and thirty others at the stage of intentions'. Monet certainly worked on the Belle-Île series for many months at Giverny, and rather than tightening up his handling, in

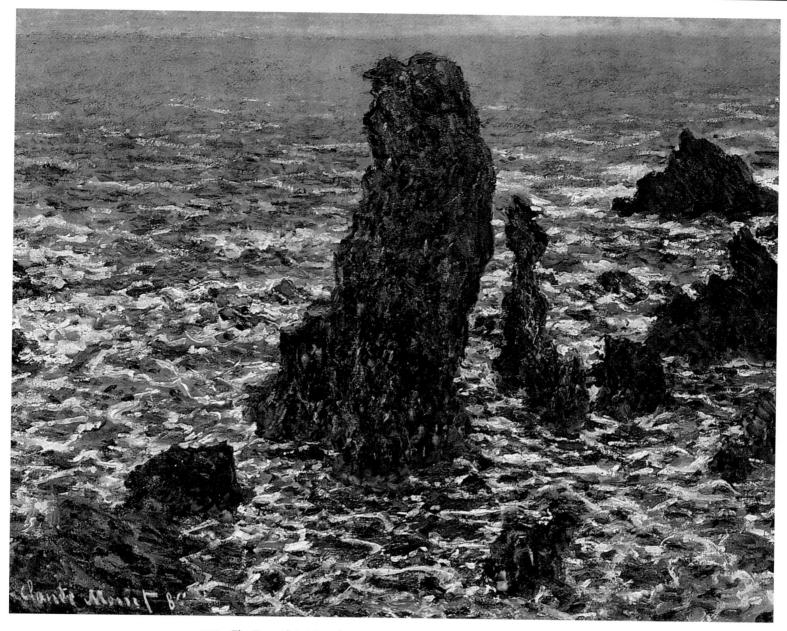

195    *The 'Pyramides' at Port-Coton* (W.1086), 1886, 60 × 73 (23½ × 28½); see ill.208

response to Neo-Impressionist critiques, he strengthened those aspects which enacted an immediate, instinctive response to dramatic effects. He emphasized the specific character of the paintings as a series by strengthening the interrelationships between the works and accentuating their variations on the livid colour scales and the writhing and stabbing brushstrokes characteristic of the Belle-Île pictures. For example, in the *'Pyramides' at Port-Coton* group (ills.195 and 208), he reinforced the twisting lines of or within the contours of the rocks, and intensified the colour-dominants by adding clearer 'notes' of the dominant or of its complementary. The reinforcing of the linear brushstrokes not only emphasizes the erosion of the rocks and draws attention to the way in which the rocks change from painting to painting, according to the changing effects of light, but also strengthens the rhythmic structure of each painting and its decorative relationship to other works in the group.

While working on the Belle-Île series, Monet continued to play a role in the Parisian cultural world: dining at Morisot's home with Mallarmé and Renoir; attending the monthly dinner at the Café Riche with his old friends, and another regular dinner at Les Bons Cosaques with Mirbeau, Rodin and Renoir as well as the fashionable artists Cazin, Gervex, Duez, Béraud and Helleu; possibly going to hear Wagner's *Lohengrin*; continuing to harass Durand-Ruel, and to play off one dealer against another. In 1887, Theo van Gogh, who exhibited avant-garde works at a branch of Boussod & Valadon's gallery, the successors to Goupil's, intensified the competition with Durand-Ruel, and became the major purchaser of Monet's works until 1890. Monet also devoted much energy to the organization of the 'Exposition Internationale de la Peinture', which opened on 8 May 1887 at the Petit gallery.[76] He and Renoir succeeded in getting Morisot, Pissarro and Sisley to exhibit with them; they squeezed out a number of artists whose work they felt

incompatible with theirs, and showed with others with whose work they felt reasonably congenial: Besnard, Cazin, Liebermann, Raffaelli, Whistler, Sargent, and Rodin, the most celebrated sculptor of his generation.[77] Although Degas could not be persuaded to join them, the old group was almost entirely reconstituted, but in a gallery and with artists acceptable to the *haute bourgeoisie*, whereas the Neo-Impressionists (except for Pissarro) and Symbolists now tended to exhibit in the new Salon des Indépendants.

Monet showed a luxuriant bourgeois interior painted at Argenteuil, *Vétheuil in the mist*, three of the lushest Bordighera paintings, and ten paintings of Belle-Île — the first time he had shown so many works from a single painting campaign. The critics — whether conservative or radical, traditionalist or avant-garde, whether they emphasized the naturalistic truth or the decorative or expressive qualities of Monet's painting — were all laudatory. Geffroy stressed the role of Petit's *salle mondaine* in winning them over, declaring that Monet had not 'toned down' his art — as some claimed — but that 'eyes have become used to this frank and seductive painting'. No critic equalled Mirbeau's rhetoric. 'Never', he trumpeted, 'has nature found so eloquent, so prestigious an interpreter . . . he has virtually invented the sea.'[78]

The ten paintings of Belle-Île consisted of single works, each from a different group of motifs, rather than a number of versions of the same motif. Even so, Maupassant's article on the Etretat paintings, which had been published the year before in *Gil Blas*, had told Monet's public about his practice of working simultaneously on as many as six canvases of a single motif, to represent changes of light; while Geffroy now discussed the Belle-Île paintings as a group, using the word 'series', and contrasting them with the groups of paintings from Bordighera and Holland. He also indicated the kind of calculation which determined Monet's painting campaigns: '*By means of* Belle-Île, Monet succeeded in revealing himself as capable of painting all the configurations of the earth, all states of the atmosphere . . .'. Paragraph after paragraph of word-pictures, inspired partly by the paintings and partly by his own observation of the motifs, suggest that Geffroy believed he could read directly from one to the other. Nevertheless, his account of Monet's mode of painting, which he had watched at Belle-Île, also shows that he realized that painting has its own pictorial momentum which is not entirely dependent on the motif:

He quickly covers his canvas with dominant values; he studies their modulations, and contrasts and harmonizes them. This procedure gives the paintings their unity. The colour of the rock and of the sea, the tint of the evening and the disposition of the clouds convey the shape of the coast, the movement of the sea, and, simultaneously, the time of the day.

Geffroy evoked the passage of time in a rhetorical form which was to become standard for the series:

Observe these thin bands of sky, these gleams of light, these clouds, these weak suns, these copper-coloured horizons, these violet, green, blue seas, all these very different states of the same nature, and you will see before you the dawn of morning light, the brightening of midday, the fall of night.[79]

In the *Gazette des Beaux-Arts*, de Lostalot celebrated the exhibition as a patriotic event proving the vitality of French art. He praised Whistler, whom Monet had worked hard to have exhibited, perhaps hoping that Whistler's work might be compared with his own, and thus draw attention to his use of abstract colour scales to give expression to his perceptions of nature. Whistler, de Lostalot claimed, used abstract means to affect consciousness in ways similar to music:

The subject is of quite secondary importance. The subtle artist makes use of it because he can scarcely do otherwise — how much more happy is the musician whose less restricted means permit him to compose romances without words!

De Lostalot noted that Morisot — another painter with whom Monet was anxious to exhibit — shared Whistler's 'tendency towards an art of impression [concerned with] the subjective sensations afforded by the contemplation of nature', and he found similar qualities in Monet's work:

Willingly or not, one must admire these fevered canvases where, despite the intensity of colour and the brutality of handling, the discipline is so perfect that the sentiment of nature freely emerges in an impression full of grandeur.[80]

Huysmans contributed a spectacular example of that Symbolist genre which sought to recreate pictorial effects in words:

From Monet a series of tumultuous landscapes, of abrupt and violent seas with ferocious colours, snarling blues, raw violets, harsh greens, of rocklike waves with solid crests under enraged skies. . . . The savagery of this painting seen by the eye of a cannibal is at first disconcerting, then, before the force which it emanates, before the faith which animates it, before the powerful inspiration of the man who brushes it, one submits to the grim charms of this unpolished art.[81]

Pissarro, on the other wing of the avant-garde, was deeply disturbed by Monet's new painting. On seeing one of them earlier in 1887, his phrases, 'an incomprehensible fantasy', 'absolutely incoherent', spluttered like those of the critics of the 1870s, but his main concern was that 'the disorder which issues from this romantic fantasy . . . is not in accord with our epoch'. When he saw Monet's works in the exhibition, he responded more thoughtfully: 'the aspect, evidently, is decorative, but also subtlety is lacking and roughness accentuated; I don't know if this relates to our vision which evolves towards harmony and which demands an art which is less [that of a] decorator, while being decorative.'[82] Pissarro here articulated a distinction important for Impressionist theory. By 'decorative', he understood an art which was harmonious because it accorded with the harmonies inherent in nature, and thus transcended mere beauty. By this standard, he felt that Monet's art was lacking, being decorative only in the sense of providing a pleasurable background for living, and he was clearly not convinced that Monet had met the challenge of Neo-Impressionism by his elaboration of 'scientific' serial processes. Paradoxically, the serial approach signalled not only the artist's subjection to the inexorable laws of nature, but also drew attention to the subjectivity of individual interpretation of these laws; for once the idea of nature's *essential* form had been destroyed, all that remained were partial, fragmentary, individual perceptions which the Neo-Impressionists rejected in favour of a grander, more stable, impersonal art.

For all the fevered sincerity of Monet's paintings of Belle-Île, Huysmans's refined *frisson* of horror seems the appropriate response, for Monet, the avant-garde tourist on Belle-Île, also delighted in the cultivated paradox of 'delicious' terrors. Evidently collectors did too, for he sold most of his works, telling Durand-Ruel that 'the buying public has given us a decidedly better welcome', and exulting that 'la maison Boussod' now held his work. Indeed, between the spring and autumn of 1887, Theo van Gogh had bought some 14 paintings for more than 20,000 frs., 7 of which he sold for high prices in the same period. Petit bought 3 and Durand-Ruel 4 works. Theo Van Gogh engaged in a practice which was to become increasingly evident in subsequent exhibitions — the rapid sale, re-purchase and re-sale of works (three or four of his Belle-Île purchases passed through his hands twice in the first year). Pissarro — whose loyalties were now with the 'scientific

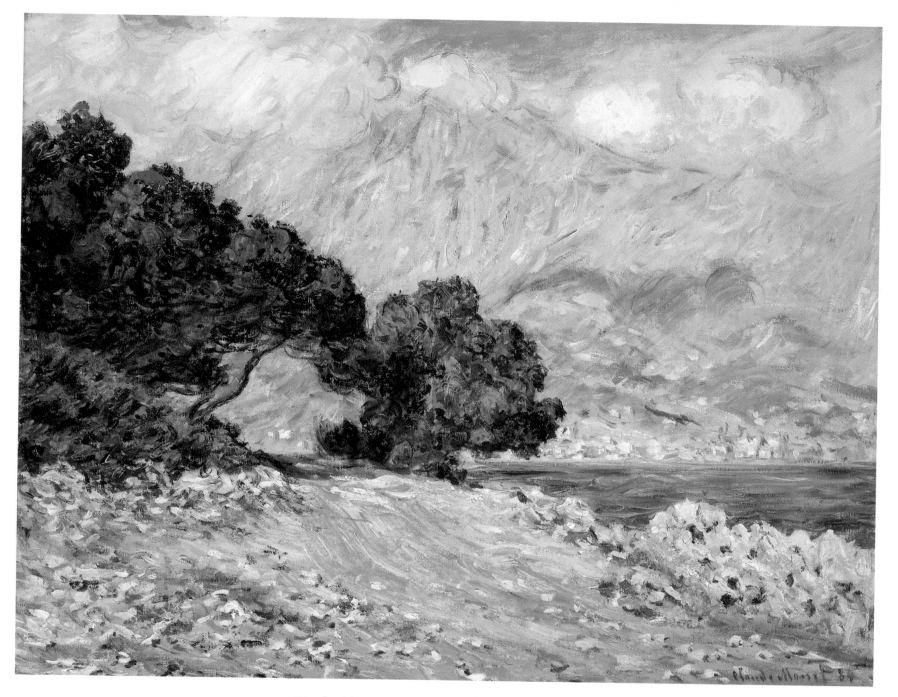

196    *Cap Martin, near Menton* (W.897), 1884, 68 × 84 (26½ × 32¾)

Impressionists' rather than the 'romantic Impressionists', but whose desperate finances forced him to exhibit – suspected that Petit was promoting Monet and Sisley at his expense (for example, their works were hung together, while the impact of his paintings was weakened by their being dispersed). Outraged, he wrote, 'this damned exhibition stinks of the bourgeois'. He was deeply worried that he could not survive if he had to rely on 'capitalists of average fortune', whereas Monet was attracting those with higher incomes, such as the stockbroker Paul Aubry, who had bought two or three Belle-Île paintings by 1889, and the industrialist Dupuis who bought three from Theo Van Gogh for 2,400 to 2,500 frs. each.[83]

Pissarro's sales had been particularly affected by the slump occasioned by fears of war with Germany, caused partly by General Boulanger's bellicose response to a border incident.[84] Boulanger emerged from the 'crisis' with his popularity enhanced, winning a Paris by-election shortly before Petit's exhibition opened, and from now until he fled France in early 1889 his popularity soared to extraordinary heights, putting him in a position where he could have staged a successful *coup d'état*. The phenomenon of *boulangisme*, with its heady mixture of fear and exhilaration and its romantic adventurism, was a symptom of a widespread and deeply-rooted disillusion with the conservative Republic, its ceaseless changes of government, its scandals and stench of corruption. Boulanger variously promised popular sovereignty, a restoration of the monarchy, the destruction of parliamentary democracy, national pride, *revanche*, order, radical reform. He was supported by all shades of opinion, from the extreme left to the extreme right, but was opposed by those who feared his 'caesarism', and by those who feared that, if he stood for *revanche*, it was 'revenge at home, revenge against the Versaillais, against the bourgeois, against the opportunists'.[85]

There is a connection between the way incompatible ideologies were held together by the figure of a heroic individual, and the contradictions within the world of high art, with its emphasis on the individual, its restless search for new sensations, exotic experience and heightened emotionalism. An anarchist like Fénéon, for example, celebrated both individualism and the mechanistic scientism of Neo-Impressionist theory in the mysterious incantations of Symbolist language, while Pissarro, anarcho-socialist and modest painter of peasant life, was invited to show with painters like Helleu – and Monet.

Apart from a brief visit to London – to which he planned to return in order to paint 'some effects of fog on the Thames' – Monet spent the rest of the year working at Giverny. Of the thirty-odd pictures painted in the Giverny countryside in 1887, more than a third contained figures, thus forming his most important group of figure paintings for over a decade. In August 1887, he wrote to Duret:

I'm working as never before, and on new ventures, figures in the open air as I understand them, made as if they were landscapes. It's an old dream which still plagues me, and which I would like once to realize, but it's so difficult . . . it absorbs me so much that I am made almost ill by it.[86]

In 1889 Mirbeau evoked the idyllic character of Monet's life, working far from Paris 'with its fevers, its struggles, its intrigues', living 'in a select landscape, in the constant company of his models'.[87] These models were, once again, the members of his family, shown enjoying all that the countryside could offer, and making it intimate by their presence: walking in meadows almost submerged in shimmering grasses

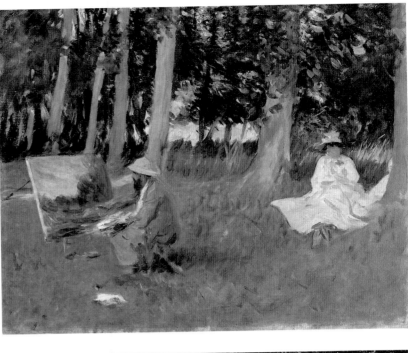

and flowers, fishing by the mirroring waters of the Epte, reading, painting, boating. Sargent's picture of Monet painting a landscape at the edge of a double screen of poplars, with one of the Hoschedé daughters seated behind him, seems to confirm Mirbeau's comment that Monet was 'in the constant company of his models' while he painted the Giverny countryside, just as he was at Argenteuil. In one of these works, Monet represented Blanche painting and another artist – who could be Sargent – working in the background, with the elegant Suzanne looking over his shoulder at his canvas. Blanche is positioned right at the front of the painting as if she were standing in Monet's space, painting him as directly as he was painting her. Her gaze entwines with his, thus undermining her role as the passive object of his painting and allowing her the status of an observing painter; in the background, however, her sister acts out the traditional role as spectator of the creative act.[88] It is a teasing example of the way in which Monet constructed the familial landscape as a closed system for painting, one which includes himself as

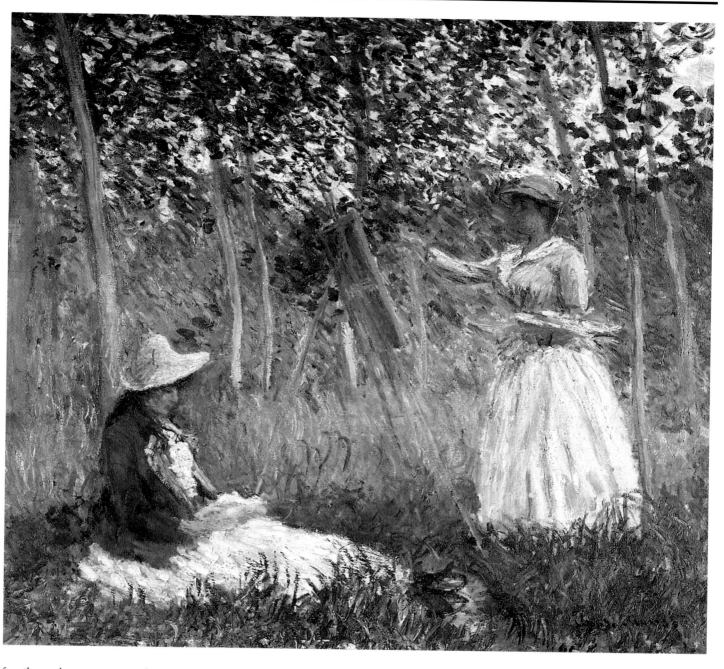

the absent member of the family and as its creator, but excludes him as the invisible observer.

The continuity of themes in Monet's figure painting intensified the sense of his art as an enclosed world in which a limited number of subjects echo and re-echo in different contexts; it is as if these subjects were latent in the painter's mind until summoned up by the sight of a similar subject – as occurred here in the real fields of Giverny, which were becoming the fields he knew through his painting. *Under the poplars, sunlight effect* (ill.200) is, for example, an echo of the *Meadow at Bezons* of 1874 (ill.122), but now the earlier painting has become an almost ecstatic vision of light, in which the subject – a bourgeois girl enjoying a summer walk – becomes curiously elusive. Monet represented the figure and its surroundings in minute strokes of colour which bind girl, flowers, grasses, leaves, and even the distant hills into a coruscating surface. In the *Meadow at Bezons*, one can imagine the moment passing, the woman closing her book and leaving the scene –

but, in the later painting, light transforms everything into its wholeness, and so makes the moment seem endless. Memory can thus enter it, so that it seems less a specific incident than an adult's dream of the perfect summers of childhood.

On a more ambitious scale, which looks back to the 1860s, Monet also painted at least six canvases showing the Hoschedé girls boating in the summer and autumn of 1887 or 1888; and he may have returned to these in 1890.[89] The group includes an oil sketch of Mme Hoschedé and her eldest daughter, Marthe, in a *norvégienne*, a round-stemmed rowing boat (W.1150); a large painting, *Girls in a boat*, showing Suzanne and Blanche in a similar boat, their shadows dark in the water beneath them; *In the 'norvégienne'*, which depicts Germaine, Suzanne and Blanche in the moored boat with their dreaming reflections luminous in the shaded water; and two pictures of Suzanne and Blanche in a skiff, *Boating on the Epte* (ill.207) and the *Pink Boat* (W.1249). Drawings suggest that Monet planned another painting of one of the girls reclining in a *norvégienne*,

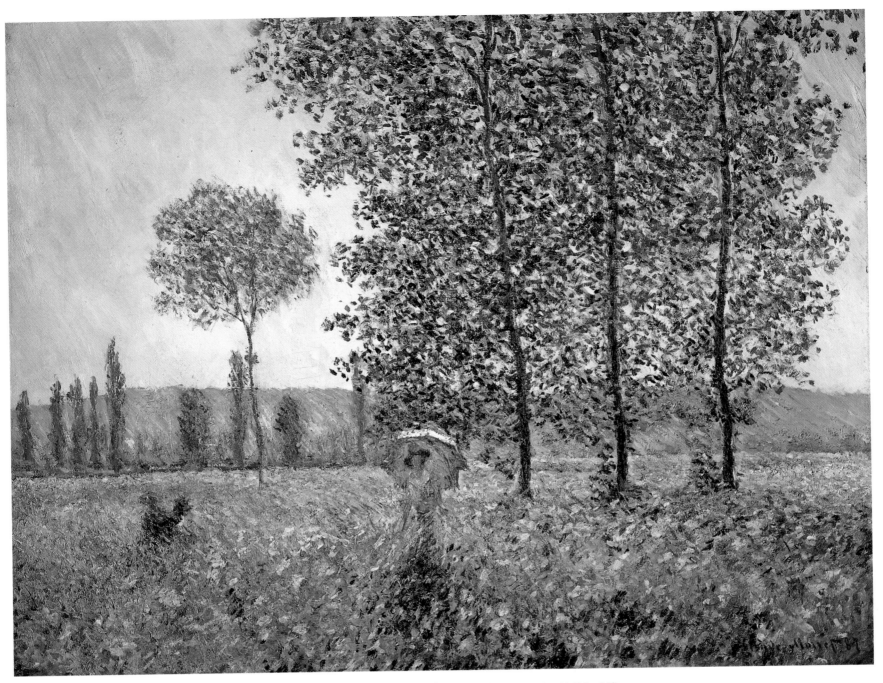

200   *Under the poplars, sunlight effect* (W.1135), 1887, 74.3 × 93 (29 × 36¼)

closely related to *The Empty Boat* (ill.221). One of the drawings shows two girls rowing on a river with its banks lined by poplars reflected in the water, but in most the view is restricted to the surface of the water.

Mirbeau wrote to Monet in early 1888 – shortly after he had finished his novel *L'Abbé Jules* – reporting that Geffroy had told him that Monet had slashed his 'superb' paintings of figures. 'Can't you then repair them?' Mirbeau asked. 'It's real murder. Be on your guard against the insanity of [being] always perfect'.⁹⁰ Monet left at least three of the works unfinished, and seems to have exhibited only two (or perhaps three), *In the 'norvégienne'* and *Boating on the Epte*.

People boating had, of course, been a central theme at Argenteuil, but Monet had then represented the figures in the distance with a few summary strokes of paint. One of the few exceptions is the painting of Camille Monet in the floating studio, but even she is shown as a shadowy silhouette rather than an individual person, and it was only in

the 1880s that Monet followed Manet, Caillebotte and Morisot, and painted boating as a close subject. In his daring painting of *Sculls on the Yerres* of 1877 (ill.205), Caillebotte painted the rower seen from directly above, looking down into the boat and on to the surface of a river shadowed by unseen trees and reflecting the unseen sky. In her *Summer's Day* (ill.206), Morisot depicted two well-dressed young ladies in a boat in the immediate foreground silhouetted against the water, like the figures in Manet's *Argenteuil* (Tournai) and Monet's *Girls in a boat*. Manet's, Caillebotte's and Morisot's paintings were social paintings: Caillebotte and Manet represent the shared pleasures of summer, while Morisot, with the lightest possible touch, somehow suggests the companionship of the two women, even though they are not shown directly interacting; she also depicts one woman looking out, as if sharing a fragile moment of communion with the artist/spectator. The women are painted in the fashions of that season, while the white

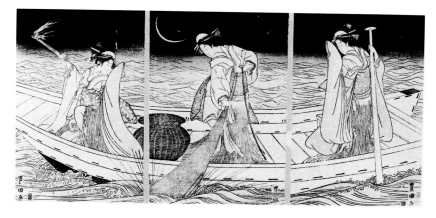

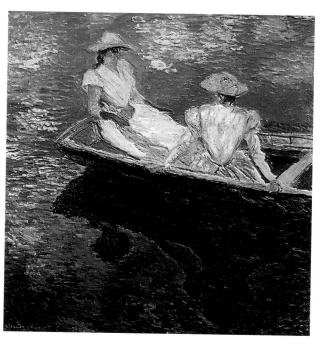

201 Utagawa Toyokuni, *Three Women in a boat fishing by moonlight*, woodblock print, 36.3 × 76 (14¼ × 29¾)

202 *Girls in a boat* (W.1152), 1887, 145 × 132 (56½ × 51½)

203 *In the 'norvégienne'* (W.1151), 1887, 98 × 131 (38¼ × 51)

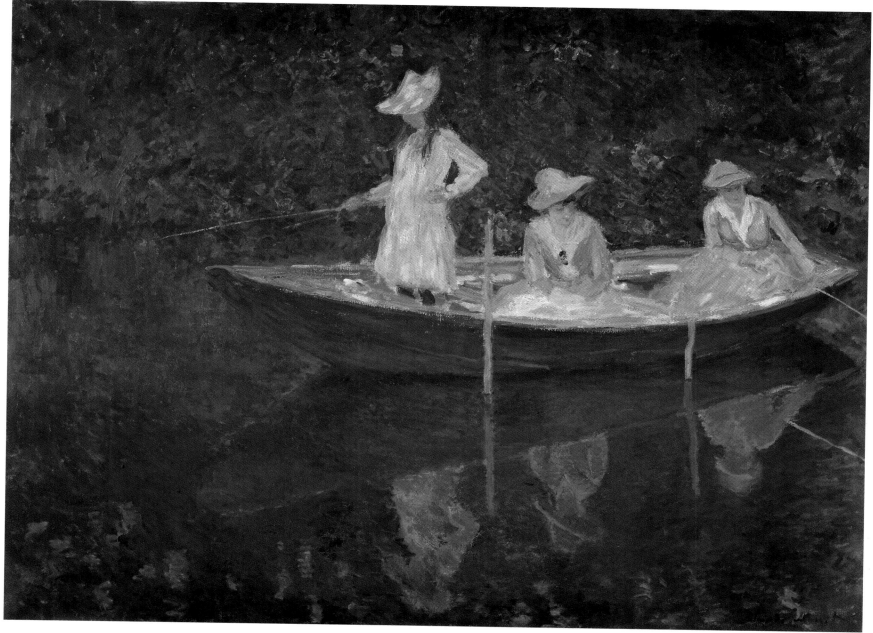

204   *Girl in a boat, c.* 1887, drawing (sketchbook MM.5129, 7 recto)

dresses of Monet's models in the *Girls in a boat* are somehow both true to the mid-late 1880s and also suggestive of something more general. His figures are far more abstract than Morisot's: looming white shapes, they are pulled away from any eye-contact with the spectator, and their faces are not only without expression, but without features. Given the huge difference of scale, the two figures are related to the Manneporte at Etretat, a looming white shape set against a luminous sea: they are shapes to absorb and to reflect light, shapes to cast shadows and to be reflected, and this is what Monet sought: 'figures in the open air as I understand them, made as if they were landscapes'.

Unlike Morisot, Monet looked steeply down on the motif, so that the surface of the water fills the entire painting and excludes any social referent beyond. The daring composition, with the boat in the upper part of the painting set against the empty plane of water below, enabled Monet to focus on the shadowed reflections of the girls whose semblance in the water is as 'real' as their painted selves in the light-filled air. In the drawings of girls boating, the rapid scribbles suggesting the reflections are as strong as those which register the figures and boat. The water surface is not indicated at all, and its semblance probably evolved only in the process of painting, during which Monet came to see reflection, shadow and sunlight sinking into the depths of the water, and to find ways of reconciling this kind of seeing into depth with the kind of seeing which slips across the reflective surface of the water. This complex visual experience could be compared with the painting of *The Pool at Montgeron* (ill.133), where Monet embodied the experience of the eye only as it scanned the surface.

*In the 'norvégienne'* is a less daring composition. The motif may have derived from Japanese art – similar scenes are represented on a fan in *La Japonaise* and in Toyokuni's *Three Women in a boat, fishing by moonlight* (perhaps already in Monet's collection). The painting is, however, unusually romantic for Monet and, in this, it is closer to certain Salon works – such as Charnay's *Last fine days* (Salon 1877) – than to French avant-garde or to Japanese painting. Even so, comparison with the almost anecdotal specificity of Charnay's contemporary figures is revealing both of the impersonality with which Monet painted the three

sisters and of the curious timelessness of the scene. The painting represents the mysterious play of reflections in a part of the river where the leaves meet overhead, creating a 'green shade' into which light filters, or falls in isolated splashes, and where the water has that glassy reflectiveness that comes with the fall of the breeze at evening. The picture plays on the pleasures of discovering relationships between the 'real' world and the world of paint – the pleasure, for example, of becoming aware of the way the dappled evening light tints Germaine's white dress with rose and mauve, and spatters her shapeless hat, or, as one's gaze is drawn into the foreground below the boat, the pleasure of apprehending the 'moment' where the poles – used prosaically to moor the boat and to tauten the composition – 'become' reflections. This 'hinge', where vertical becomes horizontal, marks that instant of consciousness which almost captures the transition between the 'real' painted world and its painted semblance, a dichotomy which had fascinated Monet ever since he painted *On the bank of the river,*

205   Gustave Caillebotte, *Sculls on the Yerres,* 1877, 89 × 115.5 (39¾ × 45)

206   Berthe Morisot, *Summer's Day,* 1879, 45.7 × 75.2 (18 × 29¼)

*Bennecourt* twenty years earlier. In the 1887 work, the reflected figures are suffused with a shadowy light, and the strange glow from the reflections of the luminous patches on Germaine's dress and on Suzanne's hat is seemingly more intense than the light which falls on the 'real' figures. Unlike the colours of *In the 'norvégienne'*, those in *On the bank of the river, Bennecourt* are local colours, inherent in the objects being represented. The later painting is composed in scales of closely related colours — blues, blue-greens, blue-violets, saturated pinks, mauves and violets, accented with small strokes of red and yellow. Although these colours convey the subjective impression of the fragile moment, they are so abstracted that they no longer indicate imminent change. The intensely still painting suggests a prolonged moment which will never end.

This dreamlike, suspended time has some relation to the time embodied in Whistler's paintings, which were also painted in carefully calculated scales of colour, and which Monet could have studied in the Petit exhibition or when he visited the painter in London in the early summer of 1887 (calling him on his return 'a great artist'). Whistler had written about the musicality of colour in his 'Ten O'clock Lecture' of 1885, one of the clearest expressions of Aestheticist doctrine. Duret, who was writing an article on Whistler, had heard the lecture in 1885, and Whistler himself persuaded Mallarmé to translate it — perhaps at a meeting which Monet arranged at the smart Café de la Paix in January 1888 — and Mallarmé sent Monet a copy of his translation in June of that year.[91] Whistler's insistence on the absolute separation between art and nature undoubtedly would not have appealed to Monet — his colleagues Morisot and Pissarro expressed reservations about it — but it may have encouraged his tendency towards more abstract colour structures. Unlike Whistler, however, Monet tested his colour modulations against his own experience of nature at every stage in his creation of a painting, whether before the motif or in the studio where that experience was being encoded in related works. Moreover, whatever the abstraction of his paintings, they are robust in comparison with Whistler's.

207 *Boating on the Epte* (W.1250), between 1887 and 1889, 133 × 145 (52 × 56½)

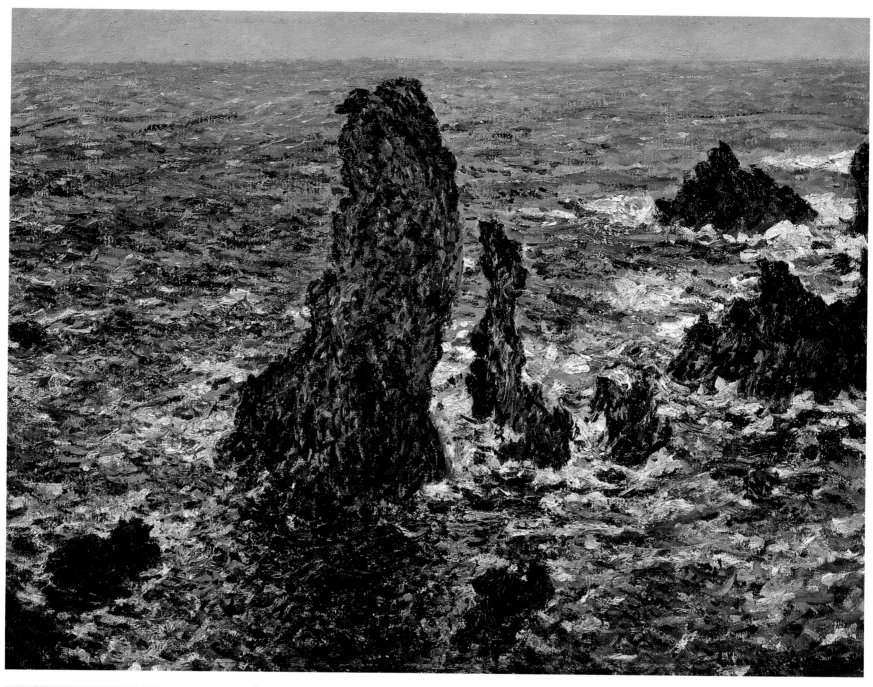

208 *The 'Pyramides' at Port-Coton* (W.1084), 1886,
65 × 81 (25¼ × 31½)

*Opposite:*

209 *The Manneporte near Etretat* (W.1052), 1886,
81.3 × 65.4 (31¾ × 25½)

*Left:*

210 Utagawa Hiroshige, 'Twin sword rocks, Bō no ura,
Satsuma province', from *Famous Views of various provinces*,
1853–6, woodblock print, 22.8 × 22 (9 × 8⅝)

211 *Storm at Belle-Île* (W.1116), 1886, 65 × 81 (25¼ × 31½)

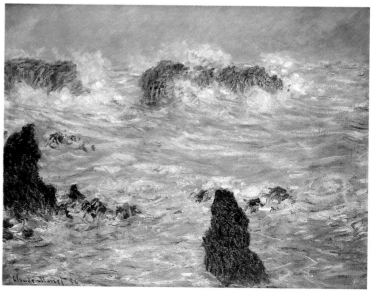

212   Berthe Morisot, *The Lake of the Bois de Boulogne*, 1888, drypoint etching,
15.5 × 11.5 (6 × 5)

*Boating on the Epte* shares the dreamy, reflective mood of *In the 'norvégienne'* and the *Girls in a boat*. Here too the plane of water occupies the field of vision; coloured by layers of visible and invisible foliage and by reflections of the unseen sky and clouds, it completely encloses the figures and boat. Its colours are warmer than those of *In the 'norvégienne'*, suggesting that it is afternoon rather than evening light which filters through the foliage, catches on a veil of leaves and sinks into the shallow depths of the water where it gleams in invisible currents. In *Boating on the Epte*, like *The Empty Boat*, Monet concentrated, not on the lure of reflections on still water, but on moving water in the depths of which float half-seen grasses, catching intermittently at the light gleaming from above. By cutting the boat at the frame, he created a subtle geometry in which the diagonal glide of the boat on the soft current is held in momentary suspension by the poised oars. The balance between movement and stillness is as elusive as the water weeds, both active and unseen, in water which always moves and is ever the same. Here neither boat nor oar disturbs the water, and the figures are still, their gaze scarcely focusing on the beauties around them.

In 1887 Mallarmé had asked Morisot, Monet, Renoir and Degas each to do an illustration for a volume of his prose poems, to be called *Le*

*Tiroir de lacque*. Only Morisot and Renoir did so, and in October 1889, Monet wrote to Mallarmé confessing that he could not do the proposed illustration for 'La Gloire'. His imagination is more likely to have been stirred by Mallarmé's 'Le Nénuphar blanc', which Morisot had illustrated with a drawing in coloured crayon, by which Monet had, in Mallarmé's words, been 'charmed'.[92]

Mallarmé wrote of rowing idly between the

sleeping vegetations of an ever-narrow and absent-minded stream . . . With no ribbon of grass detaining me before one landscape more than the next driven along with its reflection in the waves by the same impartial oarstroke, I ran aground in some clump of reeds . . . in the middle of the river: where all at once widening into a watery grove, it displays a pond's unconcern wrinkled with the hesitations to leave which a spring has.

He is going to visit an unknown woman to whom he has an introduction, but the movement of the water has lulled his mind into obliviousness of all except that drowsy momentum:

So much stillness lazed that, brushed by a sluggish sound into which the skiff half-glided, only the steady sparkle of initials on the bared oars confirmed that I had stopped, which recalled me to my identity in the world.

While he dreams in his grounded boat, he hears footsteps, but no one appears, so thinking he may remain closer to the imagined woman if he never sees her, the poet rows away, picking one of the water lilies which enclose 'in their hollow whiteness a nothing, made of intact dreams, of a happiness which will not take place.'[93]

Mallarmé's reverie seems to resonate in some of Morisot's paintings, drawings and etchings of the Bois de Boulogne.[94] One represents a man rowing a boat on the lake, whose surface is articulated by the slender verticals of reflected poplars, by reeds and a water-lily pad. The fragile lines accent the large areas of white paper, indicating the existence of forms in space with a tenuous allusiveness which suggests that they are almost on the point of non-being, and that Morisot was trying to embody her experience of place in terms of her belief that 'the dream is more real than reality'.

Alongside Morisot's works, Monet's paintings of girls boating appear intensely physical, but when Mallarmé's poem was first published in 1885 in *L'Art et la Mode*, it was illustrated with a conventional image of a girl in a boat, which could have suggested a link between the poet's absent woman and Monet's very real models.[95] Even so, the introspective, dreaming consciousness of the figures was new in his work, and could have been influenced by contemplation of Morisot's paintings and drawings, just as the drowsy sensuousness of the boating pictures could have been induced by meditation on Mallarmé's 'Nénuphar blanc'. The poet's evocation of the drugging of his conscious mind as the boat glides down the 'ever-narrow and absent-minded stream' finds an echo in the unfocused gaze of the two girls in *Boating on the Epte*, one of whom seems to be just becoming conscious of the suspended oar. Monet's tranquil stream, like Mallarmé's, has 'no ribbon of grass' to separate the 'sleeping vegetations' from their reflection. In the poem image after image reinforces the sense of enclosure, of a space where water and foliage have become one substance: the *'fluvial bosquet'* ('watery grove') marvellously evokes the absorption of the reflected trees in the water; the unseen park whose presence is known only in its reflection is *'humidement impénétrable'*, and the river itself is transformed into an enclosed pool where only hesitant ripples suggest its course. As if to complete this sense of enclosure, where every image is transposed into its aerial or watery double, the unseen lady makes the crystal of the river *'son miroir intérieur'*, 'her inner mirror'.

While the profound ambiguity of Mallarmé's language holds the mind in suspense between the imagined and the real, so that one can never know whether the poet has heard or simply imagined the footsteps, or whether the unseen woman ever existed, Monet's paintings insist on the physical presence of the daughters of his household. Nevertheless, Mallarmé's reverie, in which the mind fluctuates endlessly between 'dream' and 'reality', may well have intensified Monet's self-consciousness about what it meant to paint the 'real' — a question which seems to have become particularly acute when he painted figures. Unlike the tourist landscapes, the paintings of the girls boating embody continuities whose relationship to the 'moment' is both evident and elusive. As can also be seen in *On the bank of the river, Bennecourt* — painted only five kilometres away from Giverny, twenty years earlier — the representation of reflections on water seen very close raised questions of the relationship between the fragmentary moment of apprehension and the continuity of nature; these questions were less insistent when Monet used more traditional, distanced landscape schema in the 1870s, but in subsequent decades became crucial in paintings of rivers and pools seen from close to.

In the 'norvégienne' and *On the bank of the river, Bennecourt* show that figures whose gaze becomes the subject of the painting bring into play dimensions of time and of consciousness more complex than would a 'pure' landscape. Thus, even though Monet intended to represent figures in the way he depicted landscapes, their nature as human beings endowed with consciousness inevitably arouses speculation as to that consciousness, and this endows the painting with continuity. This may be demonstrated in a comparison between *In the 'norvégienne'* and the *Bend of the Epte* (ill.218), painted on the same river a year later. In both paintings an impenetrable screen of foliage doubled by its reflection creates a world turned in on itself, where nothing intrudes on the act whereby the painter transforms the real and its image into a new reality, the painting. Without the human presence, however, the *Bend of the Epte* remains simply a representation of a motif under a specific effect of light which will soon change, whereas *In the 'norvégienne'* suggests a moment which is lasting, a moment suggested by Mallarmé's words, 'ce suspens sur l'eau . . .', 'this suspense on the water . . .'.

In the 'norvégienne' may be another picture whose moment is prolonged by memories of past paintings, for the figure of Suzanne gazing dreamily at her own reflection — making 'of this crystal, her inner mirror' — fills the role played by Camille on the river bank at Bennecourt by embodying Monet's own consciousness as an observer, absorbed by the mysterious relationship between the real and its image. The earlier work was painted in the ambience of Realism which still shaped Monet's approach to his subject in the 1880s, and the involvement of Germaine and Blanche in the prosaic activity of fishing undercuts the reading by which the later painting becomes simply a metaphor for the making of art, like many avant-garde images of the period (above all, Seurat's *Models* of 1886). The girls' absorption suggests that they have their own being, which is inaccessible to the detached observer and which escapes total assimilation into art.

None of the close-up paintings of the Hoschedé girls painting, boating, reading or walking in the fields was exhibited before 1889; four then appeared in Monet's retrospective, and others in a small solo exhibition which preceded it; while the two *Essais de figures en plein air* were shown in his 1891 exhibition. Only three of the pictures were sold in this period; the others remained as private paintings kept in the family.[96]

## III

At the end of 1887 Monet wrote to Duret with exceptional cheerfulness: 'In Paris things could not be going better for me, even beyond my hopes, and I could not be happier, if I could be equally satisfied with my pictures.'[97] It was in this year that the redoubtable Mrs Potter Palmer, the immensely rich Chicago socialite and speculator in land, purchased seven of his paintings; for several years she would buy his works by the dozen, live with them to discover which she preferred and sell off the others — at a profit — to other American collectors.[98] It is unlikely, at this stage in his career, that Monet had much to learn from this magnificent exponent of free-market capitalism, but he was able to make use of her American prodigality to intensify the demand for his works in France, even while regretting that he was painting increasingly for a predominantly foreign, unknown audience.

In January 1888, just after his meeting with Whistler and Mallarmé, Monet made another trip to the south of France, this time to Antibes, where he stayed until late April, painting a series of at least 35 works. Following what was now his established practice, his visit was determined by contrast with his last series: 'After terrible Belle-Île', he wrote, 'this is going to be tender, here there's nothing but blue, rose and gold.' His words recall not only Whistler's 'harmonies', but the refrain of Baudelaire's 'L'Invitation au voyage', 'Là, tout n'est qu'ordre et beauté/ Luxe, calme et volupté'.[99] This is indeed the mood of these paintings, for, in the more constant Mediterranean weather, Monet could afford to concentrate for longer than he could on northern coasts on identifying the pigments with which to create the impression of intensely still coloured light.

He adapted the highly saturated colours he had developed, since his last visit to the South, to represent the chalky light of Etretat and the luminous white light of the Seine valley to the heat and intensity of Mediterranean light. He painted four versions of *Antibes seen from La Salis* (ill.216) as a rose, blue and gold dream town shimmering across a brilliant blue and green bay, framed by olive trees with shadows of an almost iridescent violet-blue; the hot dappled light is rendered in hot reds ranging from violet-red to pinkish ones, as if bringing the colours to the highest pitch still consonant with the harmony of the whole. Monet came to find the Mediterranean colour agonizing: he told Alice that he would bring back 'softness itself, white, rose, blue'; told Geffroy that 'one swims in blue air, it's terrifying'; described to Alice, air 'so limpid, so pure a rose and blue that the smallest inexact touch sullies it'. With Helleu he returned to his refrain, 'the longer I continue, the more I seek the impossible, and the more impotent I feel'. By mid-April he was working 'as never before', getting up at five, falling asleep at night 'without even having a minute to see my canvases', but at last reaching a point where, as a result of all his efforts, 'every brushstroke counts'.[100]

Monet wrote many letters from Antibes trying to organize an exhibition at Petit's gallery with the artists of his choice — Morisot, Whistler, Renoir, Rodin and now Helleu, painter of flashy pictures of fashionable women — and, when that fell through, making sure that his works would not be shown with 'the gang and its followers' in Durand-Ruel's gallery. He had come to distrust the dealer and his son, and regretted what he saw as his 'obsession' with the American market. He told Alice that he was worried 'to hear that politics are going really badly; that's all we need . . .', but the shadow of Boulanger was very pale in the magical light of the Mediterranean, annoying only in so far as it might affect his painting.[101]

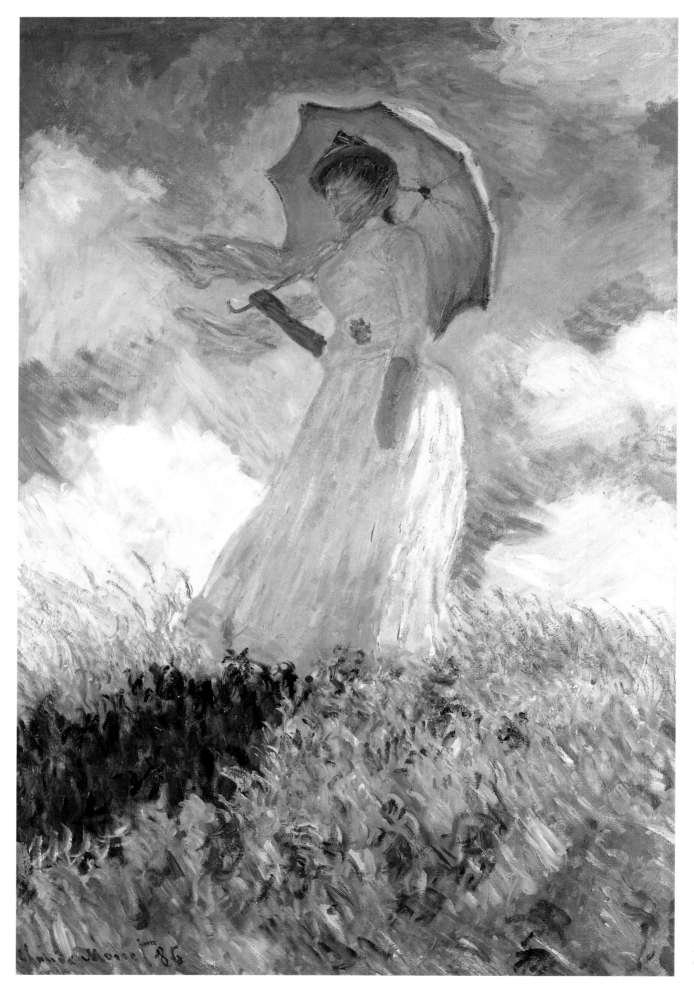

*Opposite:*

214  *Springtime* (W.1066), 1886,
65 × 81 (25¼ × 31½)

213  *Essai de figure en plein air
(vers la gauche)* (W.1077), 1886,
131 × 88 (51 × 34¼)

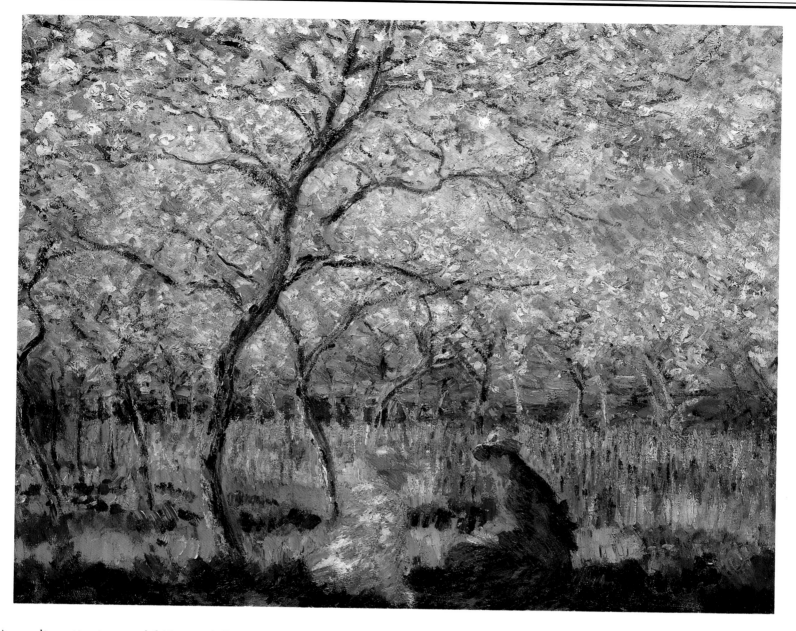

As an alternative to an exhibition with Petit, Monet showed 'Ten Marines from Antibes' in a show organized by Theo van Gogh for Boussod & Valadon, who were competing fiercely with Durand-Ruel for his work. This was the first time he had held an exhibition devoted to a single area, and it was greeted with great enthusiasm, perhaps because its sheer seductiveness was, as Geffroy suggested, a welcome distraction from contemporary events – presumably, the Schnaebele affair, a reminder of the threat from Germany from which Boulanger was able to profit. In his customary laudatory notice, Geffroy emphasized the unity of effect of the ten works:

Changing colours of the sea, green, blue, grey, almost white – vastness of the rainbow-coloured mountains – with colours, clouded, snow-covered – pale silver foliage of the olive trees, black greenery of the pines, blinding red of the earth – silhouette of the dewy, golden town, permeated by light . . .

He described the group as a 'compendium of these very different aspects of a landscape, recounted in terms of its atmosphere, its changing luminosity, its vibrations of light', but stressed that Monet was representing not only the specific aspects of a landscape but its more general principles, using 'the precision of his line' and 'his secret alchemy as a colourist' to give 'the idea of the light surrounding objects and the idea of space'.[102]

Writing for the Symbolist journal, *La Cravache parisienne*, Georges Jeanniot claimed that the paintings 'spoke not only to the eyes, but to the most sensitive nerves and imagination'; they suggested 'the psychological character of things', and seemed like 'distant evocations of spectacles seen before, spectacles which had struck the memory, leaving an indelible mark on it'. But Fénéon, the most rigorous of the new generation of critics, was not impressed:

[Monet] is instantly aroused by a spectacle, but there is nothing of the contemplative or the analyst in him. His fame grows, aided by excessive bravura of execution, an improviser's fecundity, and a brilliant vulgarity.[103]

Yet such refined judges as Morisot and Mallarmé felt otherwise: Morisot told Monet that she and her husband stood 'in ecstasy' for an hour before 'the one with little red trees in the front plane', and that the exhibition was full of admiring people; while Mallarmé wrote, 'I leave dazzled by your work of this winter; I have long put that which you do

above everything else, but I now believe you are in your finest hour'. Pissarro, on the other hand, was damning:

Monet's paintings don't seem to me to have progressed; the opinion of painters is almost unanimous on this point – Degas has been one of the most severe; he considers it only as sale-room art . . . he has always believed that Monet can make only beautiful decorations. But, as Fénéon says, it's more vulgar than ever. Renoir too thinks that it is behind the times.[104]

Jeanniot visited Monet at Giverny and reported that he 'never worked beyond the chosen effect (even if it lasts only ten minutes), and always in nature', emphasizing, 'Never any retouching in the studio':

The painter does not have what one would call a studio. . . . He uses a kind of barn, opened up with a large bay window, to store his canvases. . . . In these quarters with their earth floor, he is content to smoke his pipe, looking at the studies he has begun, seeking the cause of any defect, or talking about what he intends doing the next day if the weather is kind to him.

Geffroy's account of Monet's studio indicates once again how significant the familial environment was for his painting: 'This *salon-atelier* was full of life and youth in the days in 1886 when I went there for the first time, girls, youths, adolescents, the children and stepchildren of Monet, all united around him and Mme Monet [*sic*].'[105]

Jeanniot's insistence that Monet painted only on the motif was of course at variance with the fact that he brought back from painting trips a large number of works to be finished as a group in the studio (with some painted entirely from studies). The writer had, however, accompanied Monet when he went out painting, and noted that he painted directly, 'with astounding . . . agility', changing the canvas he was painting as soon as the effect changed. Jeanniot claimed that a picture could be regarded as complete 'after only one session which lasts as long as the effect . . . barely an hour and often much less . . .', and only implied that it would generally require further sessions. He thus invited the public to look at Monet's works as brilliant improvisations, the product of an almost miraculous encounter with an 'effect'. The work and the thought which went into the paintings were disguised in a manner which accorded with contemporary belief in the equally miraculous creation of value. Monet thought well enough of the article to write thanking Jeanniot for it.[106]

Vulgar or not, the works sold. Upper-middle-class domestic interiors of the 1880s – in which these works were destined to be placed – show that the conspicuous display of abundance was as much to contemporary upper bourgeois taste as it had been in the Second Empire, and Monet's paintings were to become increasingly attractive to such buyers. His multiplication of views of a tourist area may have been a means of creating wholeness in a situation where no wholeness could be found, but these brilliant and heartless paintings remained souvenirs, pleasing to the new purchasers of Monet's work who were also the consumers of these new tourist areas, so clearly differentiated from the *petit-bourgeois* occupants of the pleasure spots around Paris. The title of the 1888 exhibition, 'Ten Marines from Antibes', announced that only a limited number of works were there to be acquired, and competition to do so became intense. All the works exhibited had been purchased, for 11,900 frs., by Theo Van Gogh, but Durand-Ruel and Petit were the largest buyers of the remaining Antibes works which were not exhibited; they were resold quickly, mainly to other dealers and to private collectors in the United States. French buyers included Louis Gonse, connoisseur of Japanese art, Paul Aubry, and the Comte de la Rochefoucauld. Speculation had an immediate effect – the price of one

work rose from 1,300 to 3,000 frs. in eight days – and this was to intensify the felt need to buy 'a Monet' quickly. Contemporary art was beginning to be absorbed into the feverish growth of fictive values which was to be the subject of Zola's novel *L'Argent*, of 1890 – values which, in the midst of the speculation and corruption of the Panama Canal scheme, were poisoning French public life. More than one of Monet's buyers – past or present – was involved in the latter affair.[107]

Monet had been able to invest money in shares, and his contract with Theo van Gogh allowed him 50 per cent of any resales, so he benefited directly from the speculation in his works. Gauguin believed that the fact that 'Claude Monets become expensive' would improve his own prices: 'it will always be another example to the speculator who compares previous prices with those of today'; but Pissarro, earlier in the year, had expressed his sense of the possible dangers of such marketing strategies when he wrote that he did not 'wish to do anything without really possessing my subject', and that this was incompatible 'with speculation'. In this context, the words of the caricaturist of 1868 – 'Go head! Time is money' – have a lasting, if appropriately changed, resonance.[108]

Monet continued to explore the perceptions of coloured light which he had embodied in his Antibes paintings, in works he did at Giverny in the summer of 1888, applying the paint in small strokes of pure colour to which he added quantities of white which made the painting surface vibrate. In a group of four paintings of poplars in morning mist (W.1194–1197; ill.217), he represented the trees gradually coming to form as the sun warms the mist in which light is materalized, rose and gold. The nuances of colour are sometimes so delicate as to be imperceptible at first sight, but they convey an intimacy of observation quite different from the showy *tours de force* of *Antibes seen from La Salis*. In the *Bend of the Epte* (ill.218) a vibrating light seems to fill the space between the trees and the water. Short, pastey gold, green and violet brushstrokes ripple over the surface of the painting, resolving themselves into poplar leaves; these colours are repeated below in longer, flatter brushstrokes which suggest the silky, reflective water. The swooning sensuousness of the painting seems almost abstract, until one comes to see such details as the warm shadowed trunks on the bank in the foreground, which show that this abstraction is a vehicle of the most acute observation.

Monet used a similar micro-structure of vibrating touches of colour in paintings of his family. He probably continued to think about figure painting while at Antibes, for he wrote to Alice in a letter that unfortunately is fragmentary: '. . . it's perhaps that which will save me from this terrible specialization as a landscapist, and from this state of stupidity to which I am condemned.' At one stage he felt he might have to give up painting figures 'because of these damned Americans' – a colony of American painters at Giverny, some of whom interrupted his work. Monet was angered because he wished 'so much to prove' that he could 'do something else'. It was at this time, too, that he wrote to Mallarmé, hoping he would visit and requesting a copy of *L'Après-midi d'un faune*.[109]

Geffroy wrote that it was 'on his familiar path across the meadows bordering the Seine' that Monet found his new subjects: 'meadows . . . where poplars tremble in the light, where a narrow lilac path runs through yellow-green grass, where space is perceived through branches . . . whose every leaf is modelled by light' (W.1205). It was there that he painted stacks of wheat in the sunset (W.1213) which

215    *Stacks of wheat, effect of white frost* (W.1215), 1889, 65 × 92 (25¼ × 36)

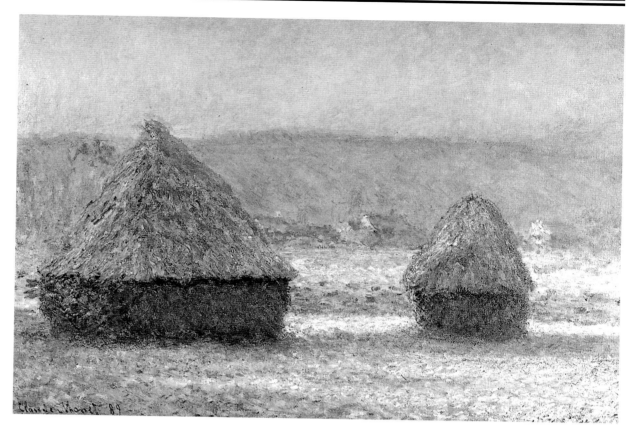

absorb and reflect the last gleam of light in phosphorescent flares of copper and flame, their bases circled by the blue of night, all alone in evening solitude in front of pale and transparent hills, the shadows of trees and incandescent skies.

The same meadows were used as settings for new paintings of the Monet/Hoschedé children: Suzanne and Jean are shown together in a landscape full of the roseate gold of a summer twilight (W.1205), and in the *Promenade, grey light* (W.1203) and *Landscape with figures, Giverny* (ill.219), 'in the same meadow, at different moments, girls and children emerge from and pass through the vibrant yet soft harmonies of the country, the season and the hour'.

The second painting depicts Jean Monet and Suzanne Hoschedé in the background, and Michel Monet and Germaine and Jean-Pierre Hoschedé in the immediate foreground so that their bodies are cut by the frame, and they seem to enter the artist's space and to look directly at him. Even though their bodies block the slanting rays of the sun and are thus in shadow, Monet irradiates them, using tiny, coruscating strokes of saturated colour to create an extraordinary impression of warm light in a space in which the figures – like the vibrating trees and light-misted escarpment – seem as much temporary accretions of energy as permanent forms. Geffroy evoked 'a mist of powdered gold' enveloping the entire landscape:

The declining flames of the sun redden the autumn atmosphere. . . . The nuances of the dresses in pink and blue material become lighter, reflect one another, are transformed, in this glow of light. The flesh-tints of the hands and faces become suddenly inflamed with the passage of brusque gleams of light, the long shadows of the bodies are blue with the blue of flames. . . .

The girls' hair is illuminated, and the eyes of the small boys darken, 'making holes in the incandescent vapour which descends from the skies, and which in its turn rises from the earth'.[110]

Mirbeau's and Geffroy's acceptance of Monet's statement that he sought to paint 'figures . . . as if they were landscapes' would seem to confirm a widely accepted belief that he was indifferent to the human presence in his painting, as would comments reported by an American painter, Lilla Cabot Perry.[111] Monet apparently told her that he wished he had been born blind and had then acquired sight so that he could paint without knowing what he saw; in other words, instead of 'seeing' in terms of known objects, he would concentrate on finding equivalents in paint for the sensations of colour given by the motif, adding touch to touch, until recognizable forms emerged as the image of his experiencing of the motif. Perry also reported his having said he would 'like to see' her place eyes under the nose, to displace the nose; but although the features of Monet's models were sometimes blurred, because of distance or intensity of light, he never displaced them. Probably he intended to emphasize that if the artist followed the truth of his or her sensations of colour, truth of form would inevitably result. By striving to represent figures 'as if they were landscapes', Monet was not denying their particular reality, but was struggling to see them as if for the first time, undistorted by conventional formulations or second-hand associations. In almost every one of his paintings where the figures are more than small dots in a distanced landscape, there is evidence – in the fact that the brushwork changes, and is more heavily built up in the figures than in the landscape – that they have received a different, more concentrated attention than have trees, grass, hills and sky.

No one was more aware than Monet of the subjectivity of the processes of seeing, no one would have experienced more consciously the way the eye inevitably focuses on the human figure, and he seems deliberately to have challenged this habitual reaction by placing figures so that their gaze intersects with his own, so close that the dissolution of the bodies into shreds of colour is inescapable, and the intensity of his

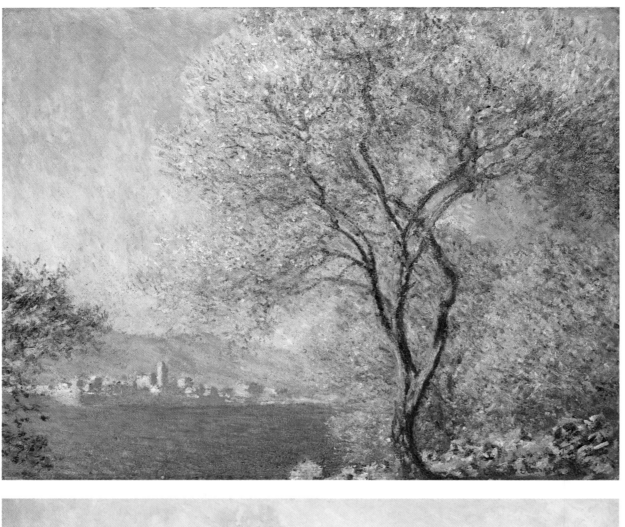

216  *Antibes seen from La Salis* (W.1168), 1888, 73 × 92 (28½ × 36)

217  *Morning Mist* (W.1196), 1888, 73 × 92 (28½ × 36)

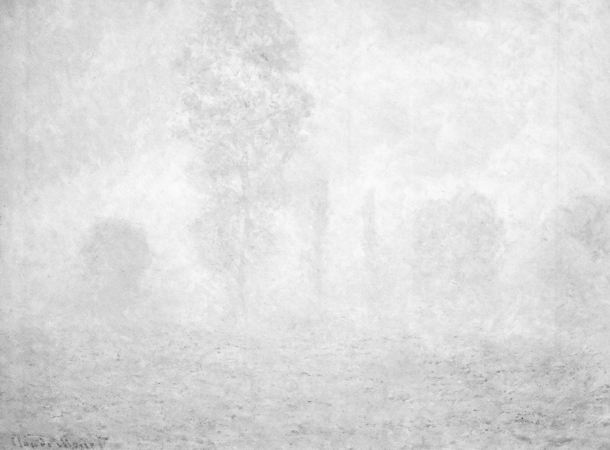

*Opposite:*

218  *Bend of the Epte* (W.1209), 1888, 73 × 92 (28½ × 36)

219  *Landscape with figures, Giverny* (W.1204), 1888, 80 × 80 (31¼ × 31¼)

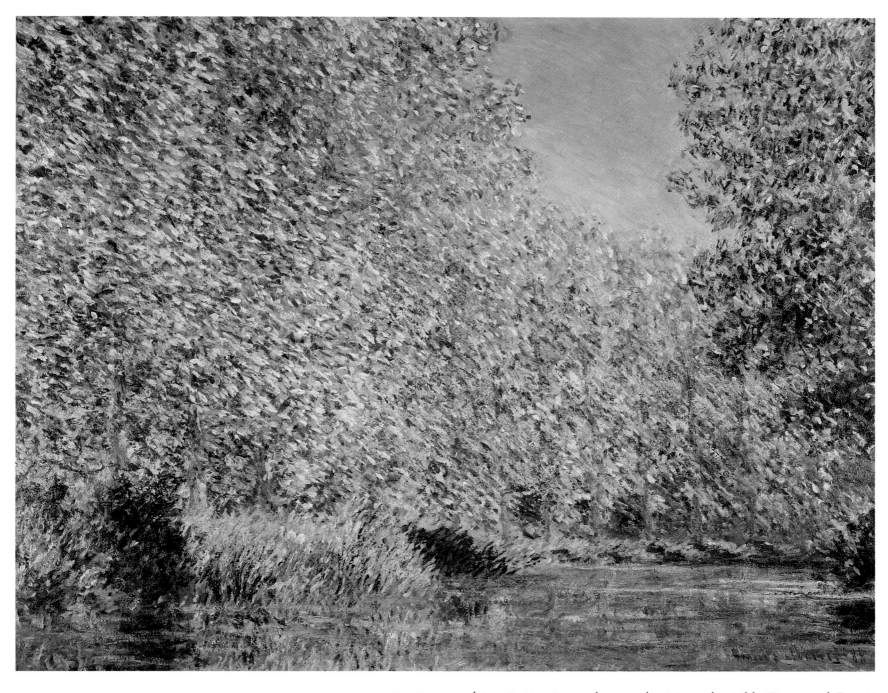

determination to see them *as objects* is made visible. Degas and Cassatt shared this objectifying vision, expressed acutely in Degas's images of the intimacies of women bathing, while Cassatt conveyed a stronger sense of the individual being of her subjects. One could contrast their mode of seeing with Renoir's representations of his family, where the figures exist as emanations of his desire, whereas the painters who depicted known figures as objects somehow allowed them the continuity of their own consciousness, however inaccessible to the artist — and to the spectator. Nevertheless, the fact that Monet located this mode of seeing within intensely pleasurable visual experience tends to obscure its impersonality, so that it was not recognized, for example, by the Neo-Impressionist theorists.

At first Monet's *Landscape with figures* suggests a casual moment with the children 'caught' in the characteristic straggle of a family walk, yet the insistence of the structure — the figures endlessly advancing into the artist's space, with every gaze fixed on him — emphasizes the fact that it was Monet who organized *this* moment in *this* landscape to embody his processes of representation as clearly as he had done in the

more literal depiction of artistic creation in *Blanche Hoschedé painting* (ill.198). His refusal to empathize with the figures gives them that opacity which he had confronted in the 1860s and early '70s, but in no other work is there such tension between closeness and distance, and nowhere else is his determination to maintain his object-vision in the face, literally, of intimacy expressed more clearly.

That same autumn of 1888 and the following winter Monet painted four or five pictures of stacks of wheat (W.1213–1217). In three of these he employed an almost identical, drastically simplified composition to register the passage of light.[112] With the four pictures of poplars emerging from early morning mists, these stacks of wheat mark the introduction into the domestic landscape of a systematic study of changes of light on a more or less unvarying motif. This had become Monet's dominant practice on his painting campaigns, and was to be realized at Giverny when he returned to the motif of stacks of wheat some eighteen months later.

In the meantime he continued to explore the representation of solid forms in coloured light on his next painting trip, when, as if once again to meet the challenge of the unfamiliar and the alien, he spent from March to May 1889 painting at least 23 pictures of the rocky gorges of the Creuse River in the centre of France, in a landscape which he felt recalled Belle-Île in its 'terrible savagery'. This painting campaign reveals more clearly than any earlier one how Monet's insistence on the exact 'match' between painting and the natural effect had become an obsession: it resulted in nine or ten repetitions of different motifs, painted while he was being plagued by continuous rain and with his hands painfully cracked by the icy cold.[113] The impossibility of what he sought can be seen in his decision not to alter his paintings in response to rain, because he would have to restore them to the original effect when the rain ceased; but by the time it had done so, that original effect had been changed by the coming of spring, which turned the landscape greener 'before one's very eyes'. The climax came when Monet paid a landowner to have the new leaves picked from an oak which had been bare when he started painting – an extraordinary, almost blasphemous action for someone so dedicated to nature.[114]

Monet represented the huge blocky forms of the Creuse by means of the most astonishing iridescent colours, generally applied in long calligraphic brushstrokes which embody the force lines of the obdurate hills. Like most works painted in this area, *La Petite Creuse* (one of three paintings [W.1230–1232] of the confluence of this river with the Creuse itself; ill.220) is painted against the light: the slopes are represented by huge scrawled linear strokes, but the light shining from behind them is broken into smaller strokes of incandescent colour which seem almost to lift off the surface of the hills and not only to sparkle on the water, but to vibrate in the huge gorge.

The group as a whole is remarkably unified: most of the works are painted from one of two viewpoints, and all in a distinctive palette composed of dominant scales of bright crude green, cold blue-violet, greeny-yellow and purple, with touches of sharp pinks and reds, particularly marked on the contours of the hills which block orange sunsets. For all their abstraction, the colours give a convincing sense of the place and its characteristic light, but the livid contrasts between them are so forceful that they almost set one's teeth on edge. Monet achieved an extraordinary *tour de force* in visualizing a terrain so alien to him – a terrain visibly shaped by vast, elemental forces. From this point of view, the stripping of leaves from the tree – which allows its linear energies to be drawn into those of river and rocks – is suggestive of the

unresolvable contradictions at the heart of Monet's struggle to penetrate to the reality of the landscape.

In the year 1889 Monet's successes of the second half of the 1880s assumed definitive form. Apart from having three paintings in the exhibition of a hundred years of French art, organized for the Exposition Universelle celebrating the centenary of the Revolution, Monet had two exhibitions of his own: in February-March, a small exhibition at Theo van Gogh's branch of Boussod & Valadon's gallery, and a retrospective of over 150 paintings, shown with 34 sculptures by Rodin, at Georges Petit's gallery in June.

The earlier exhibition included two recent figure paintings, *Promenade, grey weather* (W.1203) and *Landscape with figures, Giverny*, the landscapes, *Bend of the Epte, Stacks of wheat at Giverny, sunset* (W.1213), and a work of 1879, *Vétheuil in the mist*. It was accompanied by a major interview and inspired a number of enthusiastic articles, of which the most important were Geffroy's poetic evocations of the paintings, in *La Justice*, and Mirbeau's panegyric spread over two columns of the front page of the arch-conservative *Le Figaro*; the latter, according to Theo van Gogh, attracted many visitors to the exhibition.[115] The article in *Le Figaro* and the interview with Hugues Le Roux in *Gil Blas* gave the myth of Monet as a self-taught painter – who, in Mirbeau's words, needed 'no other master' than nature – its definitive form (while, in a letter for private consumption, Monet acknowledged his gratitude to Boudin for the 'advice which has made me what I am'). Geffroy's article contained what was to become the standard formulation of Monet's series:

If he were forced to remain in the same place, in front of the same landscape, before the same figure for the rest of his life, he would not pause a second in his work, he would find a different expression to fix every day, he would find one every hour, every minute.

He demonstrated this point in his evocation of the two paintings of the Monet and Hoschedé children in the meadows – one with 'light softly veiled by the oncoming dusk, the sweet and languorous ensemble of a dying harmony all in mauves, the other in the mingled red-golds and purples of the declining sun'.[116]

Mirbeau exalted Monet as the greatest artist of his age – indeed of all ages – in his 'supreme intelligence for the great harmonies of nature'. As if to answer Neo-Impressionist criticism, Mirbeau emphasized the rationality of Monet's development:

He organized his work with a methodical, rational plan of inflexible – in a sense, mathematical – rigour. In a few years, he succeeded in getting rid of conventions, reminiscences, in having only one commitment, that of sincerity, one passion, that of nature.[117]

Le Roux accepted the naturalistic interpretation of Monet's painting, but developed the notion of its scientific basis in 'the most recent theories of perception', according to which 'everything is reducible to movement. Vision is a movement of the ether', and colour sensations are relative, changing according to light and surroundings. Paintings like those of poplars in the mist probably inspired the interviewer's comment that for Monet, 'Impressionism is, above all, the painting of the *enveloppe*, of the movement of the ether, of this vibrating light which palpitates around objects'. Le Roux's article suggests that Monet now wanted to educate his audience as to the seriousness of what he was doing, for he told the interviewer about his experience of painting Vétheuil emerging from thick morning mist, an experience which seems to have been so crucial for him that *Vétheuil in the mist* became a talisman which he exhibited four times in the 1880s and always refused to sell. The way the village

and church take form in the mist could have seemed a convincing analogy for his own role as a painter, and it drew attention to the instability of subjective impressions. 'Did they really exist', asked Le Roux, 'or was it some phantasmagoria of the sun at play in the clouds? The apparition vanished. . . . But the painter had time to fix it on the canvas.' And he noted that Monet decided to show the painting in this exhibition and in his planned retrospective at Petit's gallery, because he 'thought it would be informative about his mode of working, that it would say much about its author and his dream'.[118]

Before these articles appeared Monet had been disappointed by reactions to the exhibition, telling Morisot that he went 'less and less often to Paris, where moreover, everyone is absorbed only in politics', and that he had a 'quite modest' exhibition, in which the public was not very interested because of the political situation. He was writing in the midst of the long-awaited climax of the Boulanger affair, when Paris was alive with fears or hopes of his seizure of power (ten days earlier Mirbeau wrote in *Le Figaro* that in 1886 he had recognized Boulanger as 'the man who would make the *coup d'état*').[119] A few weeks later Boulanger fled the country, and the crisis was submerged in the excitement of the opening of the Exposition Universelle. Away in Giverny Monet made no pictorial response to current events, except perhaps in deciding to show in his June retrospective one of his paintings of flag-bedecked streets which had celebrated the earlier Exposition of 1878.

Monet had a huge audience for his paintings in the official Exposition Centennale de l'Art Français, but all three were relatively naturalistic, almost traditional works; his overwhelming concern was obviously his huge retrospective, which in a sense offered a challenge to the state exhibitions. Petit held the exhibition during the Exposition Universelle in order to attract some of the thousands of visitors to Paris – and, in showing the work of Monet and Rodin who were being acknowledged (if not by academic die-hards or by the new avant-garde) as, respectively, the most significant painter and sculptor of their generation, he made a shrewd choice of an art which looked to the future, to the next hundred years, rather than to the past.[120]

The exhibition was the climax of Monet's attempts, since the exhibitions-within-exhibitions of the 1870s, to present his work as that of a single individual, still an unusual practice for a living artist. Although intended to represent what he called 'a part of the best I've done in the last twenty years' – with paintings for every year since 1864 except 1865 – over half the 150 works were painted in the 1880s, with the strongest emphasis on his most recent tourist campaigns (9 works from Belle-Île, 17 from Antibes, 13 from La Creuse). Paintings of Giverny were strongly represented, and would have exemplified the continuity of Monet's exploration of that countryside. Although most of the paintings in the exhibition were landscapes, the *Meadow at Bezons* of 1875, *The Meadow* at Vétheuil of 1880 and *Evening in the meadow* of 1888 could have revealed the role of his family in the domestication of landscape, while a group of paintings entitled *Essais de figures en plein air* – *Under the poplars, grey weather* (?W.1136), *Woman walking* (W.1133), *In the 'norvégienne'*, and *Under the poplars, sunlight effect* – would have displayed Monet's renewed interest in painting contemporary women, as foreshadowed by paintings of Camille at Bennecourt in 1867 and in the garden at Argenteuil in 1872, and of Alice in the garden at Vétheuil.

The almost didactic character of the exhibition can be seen in the fact that Monet again showed *Vétheuil in the mist*. In the context of a number of recent paintings of coloured light in suspension in the

moisture-laden atmosphere of Giverny (*Evening in the meadow* and possibly *Morning Mist*), the earlier picture could have shown how much richer and more subtle his handling of such effects had become, and could have been even more instructive than in the February-March exhibition about 'the author and his dream'.[121]

The exhibition opened on 21 June, and attracted a large press coverage, most of which was favourable, although there were comments – like those once made about the Impressionist exhibitions – that the paintings 'hurt the eyes' or were the result of 'a fatal malady of the visual apparatus'.[122] The exhibition marked a decisive point in Monet's career: there was a spectacular increase in the sales of his works (with a number of paintings exhibited as private loans being sold immediately, and a number of works changing hands three or four times in the next three years).[123] It gave critics, collectors and the art public their first opportunity to appreciate the continuity and the diversity of Monet's *oeuvre*, and to see large groups of his works from different painting tours, together with paintings of Giverny, thus ensuring that criticism in subsequent years would be more responsive to the complex issues raised by his work. The exhibition also allowed Monet to view his career, and this may well have influenced the greater self-consciousness and single-mindedness which characterized his subsequent painting.

There was a substantial catalogue, with major essays on Rodin by Geffroy and on Monet by Mirbeau (Monet said the catalogue was directed to 'the foreign public', presumably that visiting Paris for the Exposition).[124] Mirbeau's high-flown essay is more precise than his March article in *Le Figaro* – most of which he re-used – and suggests that intensive discussions with Monet had given him a deeper understanding of the ways in which painting called equally upon the perceptual, the mental and the emotional. His essay was so carefully constructed and so fervently written that it influenced a generation of critics, even though most emphasized one side or the other of the balance he finely drew between the complex aspects of Monet's painting. Like the *Figaro* article, it opened with a ringing assertion of Monet's individualism. In keeping with Mirbeau's hatred of all educational and cultural institutions, Monet, the ideal artist, had to have been self-taught, and had to reject the past in accordance with the principle that

the law of the world is movement, that art, like literature, philosophy, science, is perpetually on the move towards new researches and new conquests, that the discoveries of yesterday are superseded by the discoveries of tomorrow. . . .

Mirbeau claimed that the exhibition was a record of 'the law' of movement; it was biographical in that it summarized twenty-five years of Monet's work as an artist, and it made the spectator 'pass through the different stages which mark . . . the chronology of his progress'. Mirbeau's evolutionism also required that Monet should be male and healthy – a probable dig at the effete Symbolists. To attain visual and technical mastery, the artist-hero required 'moral isolation . . . concentration within himself, abstraction of his faculties before nature alone . . . forgetfulness of theory and aesthetics'.[125]

In a crucial passage by which he dissociated both himself and his hero from the mystical side of Symbolism, Mirbeau wrote:

The art which does not concern itself – even in dream-conceptions – with natural phenomena, and which closes its eyes to what science has taught us about the functioning of an organism, is not an art.

Truth, he asserted, is 'the unique source of the dream'.[126]

Mirbeau then gave a detailed account of Monet's practice, explaining that he did so in order to answer recently renewed criticism

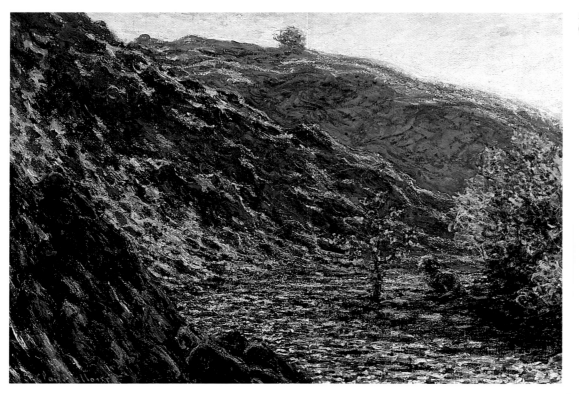

220   *La Petite Creuse* (W.1231), 1888–9, 65.7 × 92.7
(25⅞ × 36½)

that Monet was content with the '*à peu près*', the approximate. He claimed that since Monet had come to realize that on a calm day 'an effect lasts scarcely thirty minutes' (this was also true of figures, which were 'only a union of shadows, lights, reflections, mobile and changing things'), the painter made it a rule to cover his canvas in the half-hour before the effect changed; he would return every day at the same time and, if the effect were right, would paint the regulation half-hour. He would sometimes spend sixty seances on one motif, as he searched to find its internal tonal relationships, but would stop himself pitilessly if the light changed, and would 'run . . . to another motif'. Mirbeau's analysis came at a crucial point in the evolution of Monet's serial practice, when, as in the nine paintings of the ravine at La Creuse, painted close to one another in time, in afternoon and sunset light, Monet was not painting contrasting effects, but trying to discriminate ever more precise fragments of time. Mirbeau did not hint that Monet worked on his paintings in the studio – although he was well aware of the fact – and went as far as to say, '*le plein air est son unique atelier*'.[127]

Having established these technical matters to his own satisfaction, Mirbeau changed tone, and broke into a lyrical evocation of how Monet's paintings express the harmonious and rational laws of nature:

the life of air, the life of water, of scents and light, the ungraspable, invisible life of meteors synthesized with admirable boldness and eloquent audacity which, in reality, are only delicacies of perception, and which signify a superior understanding of the great harmonies of nature.

After this Mirbeau really let himself go for two pages of poetic prose on the paintings, in which he discerned not only the visible, but the invisible, 'the air, all the fluidities of light and the infinite reflections with which it envelops objects and beings'. Monet's pictures confronted him with 'living nature': and in its 'cosmic mechanisms, and in this life subject to the laws of planetary movement, the dream with its warm breath of love, its spasm of joy, takes wing, sings and enchants.'[128] This kind of language would increasingly be used to express the sense that Monet's

painting transcended naturalism, while being intensely true to nature, and Mirbeau's pantheism was to be characteristic of avant-garde criticism in the 1890s.

Yet Mirbeau evoked his experience of Monet's paintings with a vividness that suggests some paragraphs were written after the canvases arrived at the gallery.[129] The writer claimed that from the earliest figure paintings 'to the dazzling figures of Giverny; from the sunny gaiety of Argenteuil to the tragic landscapes of La Creuse . . .; from fields of vines dead under leaden skies to the stacks of wheat covered in snow . . .', Monet was guided by 'one thought': that of grasping 'the instant of the motif'. Through rigorous analysis Monet attained a synthesis of 'pictorial and intellectual expression' so intense that 'a fragment of sky or sea' 'grips you with the whole of your physical and mental being'. The critic sometimes found this experience so overwhelming that he forgot that the 'fierce seas of Belle-Île or the smiling ones of Bordighera' were 'made with a paste on a piece of canvas', but he constantly returned to the physical facts of Monet's painting – to 'paste' or to his use of 'long, fine and flexible' brushes.[130]

Mirbeau thus succeeded in evoking the complexity of paintings in which the spectator must draw on his or her own experience of nature to make sense of the experience embodied in them. He was one of the few writers to perceive an essential relationship between the demands of pictorial harmony and the notion of truth, both to the detail and to the broad principles of nature, and to see that this relationship fused sensation, thought and feeling. Convinced that contemporary society separated the physical, the mental and the emotional, as it severed the individual from nature and from the social, Mirbeau believed that Monet's painting could be a means of reintegration. Thus his insistence that Monet's art expressed 'the warm breath of love and spasms of joy' was more than a figure of speech, and so it was that he and Geffroy, passionate defenders of those 'disinherited from earthly joys', yet privileged bourgeois in their mode of life, could invest such hope in Monet's increasingly refined and precious art.[131]

# 5

## Concentration and Fragmentation: The Series 1890-1904

*One must know how to seize the moment of the landscape on the very instant, for that moment will never return. . . .*
MONET, 1891

*I'm still struggling as well as I can with the admirable landscape motif, which I've had to do in every weather in order to make just one which would be of no weather, of no season. . . .*
MONET, 1891[1]

AFTER 1890 MONET NO LONGER PAINTED HIS FAMILY IN THE MEADOWS OR on the river near Giverny, but the familial environment still provided the stable background for his extraordinary thirty-five-year-long visual exploration of this tiny area. The stability of that environment was ensured by the purchase of the family home in 1890, by changes in the family – most notably Monet's marriage to Alice Hoschedé in 1892 – and by his continuing creation of a luxuriant, all-embracing garden.

It was only after several years of painting the Giverny countryside that Monet began to apply the fragmentation of time, developed in other parts of France, to his practice of painting a number of versions of one motif under different effects of light. It was probably no coincidence that this fragmentation first became extreme at Giverny, whose intimately known fields and rivers provided a secure context for the exercise of what a critic called '*l'oeil moderne exaspéré*', by which well-known forms were atomized to a point where they gave way to 'unknown realities'.[2]

It was when figures disappeared from the intimate landscape that Monet began to represent stacks of wheat as temporary concentrations of light-filled matter rather than as structures that had a function in one of the most intensely cultivated agricultural areas of Europe; shortly after, he painted Rouen cathedral stripped of its historical and religious connotations, as much like a huge cliff as a man-made structure, and, at the end of the century, he used the centre of a great city as a huge architectural set against which to visualize the dramas of natural light diffused in polluted atmosphere.

For Monet this period was one of unbroken success and hugely expanding wealth. No matter what preliminary knowledge one has, nothing can prepare one for the overwhelming impact of seeing a large number of paintings of a single motif at the one time, and, in the 1890s, each exhibition of a series was greeted with ever more hyperbolic praise, and by the time of the Exposition Universelle of 1900, Monet was seen as one of the greatest painters of the French tradition. In the same period, his income from painting rose from over 100,000 frs. in 1891 to about 270,000 frs. in 1904 (the actual difference was greater, since Monet also had income from investments). All this enabled him to lead a secure, comfortable, indeed luxurious, life: journalists delighted in describing the house, the garden and even the meals of the painter, whom one compared to 'a gentleman farmer', while another noted that the family was served by 'a perfectly attired valet'. Monet's periods of intensive painting at Giverny were punctuated by long painting campaigns in Rouen, on the Normandy coast, and in London; by family crises, marriages, births, deaths. He paid frequent visits to Paris to discuss business with his dealers and to attend artistic events and entertainments (among these, a dinner of the Impressionists following a visit to the Utamaro exhibition, pleasantly described by Pissarro; Mirbeau's plays; a banquet for Puvis de Chavannes; Loie Fuller's '*danse serpentine*' and '*danse du feu*'; the Javanese dancers; and even wrestling matches). He was visited at Giverny by his friends, by artist colleagues, by writers, dealers and collectors.[3]

Secure as Monet was in the peaceful countryside, neither anarchist bombs, nor social unrest and its repression, nor the anguish and bitterness of the Dreyfus affair left any visible traces in his work, and he continued to paint his radiant visions while his closest friend Mirbeau struggled against the tyranny of institutions and capitalist exploitation of the dispossessed, writing for the anarchist press even when the government repression following the bombings made this dangerous. Monet's painting was increasingly appreciated by the establishment, which, under pressure from right-wing nationalists and from activists of the extreme left, was becoming progressively more conservative. His art was, however, no less attractive to sections of the anti-nationalistic left. Monet was confirmation of Mirbeau's and Geffroy's belief in the artist as 'a man free above all others', able to penetrate to the essence of nature, the only true source of art and of social life. While Monet directed his art at an increasingly exclusive, wealthy audience which Mirbeau and Geffroy helped to attract through their writings, they maintained their belief that his art would act for the social good by embodying those joys and beauties which they believed should and could be the possession of all. 'The people', Mirbeau pronounced, 'have a right to beauty, as they have a right to bread'.[4]

Partly because the flag-waving rhetoric of the Exposition Universelle was rendered hollow by continuing political scandals, by economic decline and by the lasting obsession with the power and menace of Germany, the 1890s were characterized by anxious questioning of the nature of French society and culture. As in the two previous decades, art was conceived as having a major role in national regeneration, but many believed that this could be achieved only through an intensively cultivated individualism. In the social ferment of the *fin de siècle*, bourgeois culture – both establishment and avant-garde – tended to turn in on itself, cultivating refined sensations sometimes to the point of morbidity, and concentrating on inner states of mind even

more intensely than in the 1880s. Reaction against what was seen as the excessive materialism of contemporary society was expressed in terms of spiritual yearning, in the exultant secular pantheism of the leftists, or in the Catholic revival which attracted many who had earlier been free-thinkers. Monet's ever more acute 'researches' into his own perception of light were appropriated by Symbolist writers concerned with inner life or mystical experience, while his leftist defenders sought to preserve the 'scientific' nature of his painting from contamination by the *fin de siècle* spiritual revival, even though their language had much in common with that of the Symbolists. The highly coloured, obscure, visionary tone of the new criticism was noted by Fénéon, who contrasted the 'grey' prose with which Duret had 'catechized the crowd' with 'the coloured, tumultuous and magniloquent' style of Huysmans's address 'to a more restricted public'.[5]

Landscape continued to be the privileged genre of this élite audience. Since it tended to be judged less in terms of specific moral truth or humanistic values, than of the pure pleasures of sight, paintings of a fertile but empty countryside came increasingly to be preferred to ones inhabited by peasants or urban visitors. Such landscapes lent themselves to interpretation as an expression of the traditional essence of France, and this sort of interpretation became even more marked than in preceding decades. At a time of doubt and conflict, Monet's paintings of the heartland of France with its rich fields, tranquil rivers and Gothic churches, offered a reassuring vision of 'la belle France'. While critics of the various branches of the avant-garde rarely used nationalistic criteria to evaluate his art, writers close to the establishment praised Monet's painting in terms of the essential Frenchness of its subject-matter, and – as it became more refined and decorative – asserted it as a supreme realization of the French tradition – a tradition they defined primarily in terms of the rococo and of Corot. His art seemed so much in accord with such nationalistic criteria that, in 1900, a critic exalted it as an expression of 'the spirit of an ardent and temperate people . . . to disparage it in France is to disparage oneself'.[6]

In the 1890s Monet's practice of serialization exacerbated tensions inherent in his art: his faith lay in nature as an independent reality, yet his obsession with the passing moment caused him to develop an extraordinarily rigorous mode of painting even after he had recognized the possibility of his being turned into 'a machine for painting'. It also led him to try to make nature conform to what he had already imaged in paint. At the same time the success of the series as 'limited editions' was contributing to the transformation of the continuous processes of consciousness into fragmented commodities.

Perhaps in response to these tensions – and to the interest in mental processes which was being manifested in many cultural forms – Monet began to develop modes of painting which gave continuity to consciousness as it engaged with the passage of time: he invoked memory by returning to earlier painting sites and, in areas where he had painted for half a century, he created images from hazy, mother-of-pearl colours, creating a fragile, dreaming mood which endlessly prolongs the moment of light. These works too were to the taste of wealthy collectors, and they sold quickly at increasingly high prices. Thus paintings conceived as a means of countering the fragmentation of modern life could not escape it, and, by the end of the century, were being deposited as fragmented moments of perception in collections across Europe and the United States.

# I

Monet did little painting between his return from La Creuse in the spring of 1889 and the spring of 1890, for he was finishing the Creuse landscapes, preparing his retrospective exhibition, and organizing a campaign to buy Manet's *Olympia* from his widow so that it could be presented to the State and take what Monet believed was its rightful place in the Louvre. Some persons – in particular Zola – interpreted Monet's initiative as self-promotion; the establishment was lukewarm about the proposal; and others believed that if Manet's work were to be represented in the national collection, *Olympia* was not the appropriate example. The radicals, however, strongly supported Monet's proposal – notably in an article which Geffroy wrote for *La Justice*, whose chief editor, the radical deputy Camille Pelletan, put strong pressure on the government to accept the gift. The affair generated such passion that another deputy, the opportunist Antonin Proust (who had been a close friend of Manet), challenged Monet to a duel, seemingly because he believed the artist had instigated an insulting article in which Mirbeau attacked him for obstructing *Olympia's* entry into the Louvre. Monet's seconds, Geffroy and Duret, managed, however, to resolve the matter. The affair casts an unusual light on Monet, who, whatever his volatility in private life, took care that the press should present him to the public in the best possible light, serenely comfortable in the domestic tranquillity of Giverny.

The letter to the Minister of Public Instruction, in which Monet made the formal offer of the *Olympia* to the State, makes it clear that he was locating himself in the tradition of the artists he named – Delacroix, Corot, Courbet and Millet – artists who had been neglected, but who were now 'the glory of France'. In asserting that Manet's work should now be officially recognized as part of that tradition – and rescued from American collectors – he was also positioning himself as its heir. The success of his campaign probably did much to confirm this strategy.[7]

The *Olympia* affair was unlikely to have been the fundamental reason for Monet's scarcely painting for almost a year, for he never let external matters seriously interfere with his work. He was now wealthy enough not to have to paint continuously, and he may well have needed this pause to think deeply about his painting: he was in his fiftieth year and his recent exhibition had laid the whole of his painting career open before him. Geffroy once noted Monet's preoccupation 'with what the press had to say about him', and at this stage in his life, Mirbeau's long essay may have encouraged self-reflection – as may an article Fénéon published in September 1889 which mocked the exalted tone of Mirbeau's account of Monet's methods:

Nowhere is the essence of a landscape recreated in an unexpected or fervent way . . . everywhere the joy of 'a beautiful painter' in the presence of colours with which to translate nature on to canvas; the exaltation of vulgar virtues; all the prestige of a marvellous execution irradiated by a banal lyricism.

Monet's aim, Fénéon said, was 'to immobilize the instantaneity of a series of changing views', but despite 'juggling with his stretchers and being upset by southerlies', the results were – simply – monotonous.[8]

Geffroy's comments on contemporary landscapists, in his review of the Salon of 1890, could have made Monet examine his tourist painting campaigns, for his friend criticized the Naturalist painters' 'uncaring search for the picturesque', which led them to unknown landscapes where they remained 'foreigners' and 'uncomprehending intruders'. Monet, Geffroy claimed, could paint everywhere and

anywhere, since he wished 'to fix the light between himself and objects', and could spend 'all his life painting the same objects, of which he would ceaselessly make different pictures'. Geffroy asserted the truth of the aphorism *'l'artiste doit être d'un pays'*; an artist, he maintained, should paint the country 'where he was born, or where he was brought up . . . If he has left it, let him return, let him there seek out his memories and gently evoke them . . .'.[9] Monet's memories of his *pays* – the Seine valley and the Normandy coast – could have been brought vividly to life by his exhibition, and they may have led him to question the value of painting landscapes foreign to him; and the memory of the insult to nature at La Creuse, when the painting of an inadequately known landscape led to the defoliation of a tree, may have further convinced him to concentrate on the landscape he knew intimately. Whatever the reasons, despite a promise to return to La Creuse, he settled down to paint his *pays* for the next three years, returning to subjects which he had long been making his own.

In June Monet wrote to Geffroy: 'I have again taken up things impossible to do: water with grasses waving in the depths . . . it's marvellous to see, but it's enough to drive one mad to want to do it.'[10] This motif was closely associated with paintings like *Boating on the Epte*, but Monet was probably referring to *The Empty Boat* (ill.221). This painting must have been conceived in 1887, when Monet probably did the drawings for the pictures of the Hoschedé girls boating. His sketch-book contains a sequence of three drawings of the boat viewed from this unusual angle: the first two drawings are horizontal in format: in the first, the ripples are nearly as strongly defined as the figure, of a half-reclining girl; in the second, the ripples become stronger and the figure seems to shrink. In the third – whose format is vertical, like that of *The Empty Boat* – the figure is so faint that it can scarcely be discerned, the ripples have become more marked, and the boat assumes the looming presence it has in the painting. House suggests that Monet probably painted the work in 1890, but was interrupted by the illness of his 'pretty models', and so he left the boat sketchily indicated, intending to give it the same density of handling he gave to the water when the girls had recovered; but that he did not do so because the water weeds had been raked, and he became absorbed in other paintings.[11] This seems unlikely, for Monet began a painting by positioning its major elements, and reserving areas of canvas for things which were to be painted later; but he did not do so here. Rather, as the sequence of drawings indicates, the motif of the water grasses gradually absorbed all Monet's attention until he recognized – and perhaps persuaded Mirbeau – that 'the drama' was not in the figures, but in 'an entire watery plant life' of grasses 'agitating, twisting, becoming dishevelled, scattering, reassembling, and then undulating, meandering, coiling and lengthening . . .'[12]

In Mallarmé's 'Le Nénuphar blanc' the existence of the unseen lady is kept intact by her absence. Monet's *Empty Boat* resonates with the memory of the absent girls, while its insistent emptiness is given an almost hallucinatory presence, bringing to mind all the empty boats of Monet's experience that we can know: the boat in Courbet's *Young Women of the banks of the Seine*, in Manet's *Déjeuner sur l'herbe*, and in Renoir's *Bather* (Salon 1870; São Paolo); the boat in his own painting of Camille at Bennecourt (shown in his 1889 exhibition), or in paintings of the frozen river at Vétheuil.

Since the late 1860s Monet had been fascinated by phenomena which register the effects of unseen realities or which evoke 'presence by a shadow'[13]: houses seen only in reflection; a ripple which momentarily catches at the unseen sky; shadows cast on the sea by invisible cliffs. The

relevance of this aesthetic can be seen especially vividly in *The Empty Boat* in the way Monet represented the *effects* of the grasses in the water rather than the grasses themselves, for had he focused on their known forms he would have lost the essence of what fascinated him, the almost unseeable interaction between gleams of light and undulating grasses in the ceaselessly moving depths of transparent water. The aesthetic of absence thus helped Monet in his struggle to see unseen realities (to see figures as concentrations of light, for example), while always remaining within the realm of sensation.

Mallarmé's ideas probably reinforced those of Mirbeau and Geffroy during Monet's long break from work in 1889–90 when, as I have suggested, he thought deeply about the direction of his art, helping him to realize an alternative to the externality of the tourist series. Monet must still have been thinking of Mallarmé's prose poems when, in October 1889, he confessed he could not do the illustration for 'La Gloire', as the poet had proposed. In 'La Gloire', as in the poems 'Eventails', through intensely sensuous associations of sound and image, Mallarmé transmutes everyday events or humble objects into new forms which depend on one's familiarity with them to give the sense that they have never been seen before.[14] *The Empty Boat* marked the beginning of Monet's three-year-long concentration on the Giverny countryside within two kilometres of his home, in paintings in which, as with Mallarmé's poems, one is made deeply aware of the artist's power magically to transform his materials – coloured paste and familiar objects – into his own unique world.

In 1891 Geffroy wrote that 'for a year the voyager gave up his voyages', and, while dreaming of landscapes he had painted or still wished to paint, Monet also knew

that an artist can pass his life in one place and look around himself without exhausting the ever-renewed spectacle. And there he is, two steps from his tranquil garden where fiery flowers blaze; there he is, stopping on the road one evening at the end of summer, and looking at the field where the stacks were constructed. . . .[15]

Monet worked on at least 24 paintings of the stacks of wheat for about seven months, from the summer of 1890 through the winter, including perhaps three months of work in the studio, before exhibiting 15 of them in Durand-Ruel's gallery in May 1891. Thus, in a period of concentration as intense as any he had known on his travels, Monet explored his experience of the utterly familiar, seeking what he had never seen at the heart of what he had been observing for years, and attaining a kind of primordial seeing within the domestic landscape.

The place was familiar, and so were the agonies of painting it. Monet hoped that a visit from Morisot, her husband and Mallarmé 'would raise my morale a little, for I am in a state of total discouragement. This cursed painting tortures me . . .'. But a week after their visit, as he told Geffroy, things were no better:

I am really [feeling] black and am profoundly disgusted with painting. It really is continuous torture! Don't expect anything new, the little that I was able to do is destroyed, scraped off or slashed. You can't imagine how appalling the weather has been for two months. It's enough to drive one totally crazy, when one seeks to render the weather, the atmosphere, the ambience.[16]

Yet even with two months of bad weather, Monet produced a large number of paintings, including at least one of 'water with grasses weaving in its depths', and ten of fields of poppies, the sensuous colours and soft brushstrokes of which evoke the very essence of summer. Clemenceau – temporarily out of political life because of having been

221   *The Empty Boat* (W.1154), between 1887 and 1890, 146 × 133 (57 × 52)

implicated in the Panama scandal – described seeing Monet in front of such a field with canvases on four easels, 'to each of which in turn, he gave rapid brushstrokes according to the changes in light caused by the passage of the sun'.[17] There were five pictures of the poppies in the water meadows (W.1251–1255), and five views, looking north-east from the slopes above Giverny, of oat fields vibrating with the red flowers (W.1256–1260). Two of the latter are identical motifs, differentiated only by light. In one, the distant trees are smudged with saturated blue, violet and green; the pink and orange tinted fields, delicately articulated by transparent green and violet shadows, and seemingly trembling in the misty light, drift in clouds of soft colour into the distance. In a painting of late afternoon light, Monet intensified the contrasts between the red-gold blaze of the flowers, the dark green, blue and violet shadows and the yellow fall of light in the trees. He was probably referring to these paintings when he apologized to de Bellio for not having written; in the evenings, he said, he was 'tired out and absorbed by what I'm doing', implying that he spent time reflecting on his paintings once his daily work on the motif had ended.[18]

In all the time he had been painting the Giverny landscape Monet had rarely painted a single version of a motif; as early as 1884, he had painted three versions of haystacks set against a line of trees and hills. Until the late 1880s, however, these were accompanied by a range of other motifs in two, three or even more variants, which convey a sense of restless movement around the valley rather than the concentrated attention to moments of light that is seen in four pictures of a group of poplars in mist and three pictures of identical stacks of wheat painted in 1888–9 (W.1194–1199, 1213–1217). Monet had always painted different versions of certain motifs – he had done pairs of works in the early 1860s (e.g. W.26–27, 29–34), four paintings of the promenade at Argenteuil (W.221–224), and several paintings of a train under the glass roof of the Gare Saint-Lazare (W.438–441). The repetition of motifs had gradually become his dominant practice on his painting trips, from Pourville to Belle-Île and Antibes, where he painted up to six versions of a single motif. It was within six or seven months of his return from Antibes that he began to paint the first group of stacks of wheat.

Monet had often painted stacks of hay: as early as 1865, in the *Haystacks at Chailly, sunrise* (ill.225), one finds both a specific effect of light, and the tension between a dense shape and the pull into deep space which characterizes the later works. The small haystacks in an extended landscape had been a favourite Giverny subject, but it was only in 1888 that Monet made the stacks the primary subject of a painting, and that he began to paint stacks of wheat rather than unevenly heaped haystacks. These stacks, constructed from sheaves of wheat, stood in the fields from harvest time in late July until late winter, when the sheaves were collected for threshing.[19] Almost geometric in form, their dense physicality within a field of coloured light provided an enormous challenge to Monet's processes of visualization; but, by the time he began painting them in 1890, he had nothing more to learn about the objects he was painting or about the procedures he would use. It was precisely this familiarity which enabled Monet to penetrate beyond the world of finite objects to see light materialized in space.

The composition of each of the *Stacks of wheat* is of the greatest simplicity: one or two shapes set against three horizontal zones, the field, the hills (which absorb trees and cottages), and the sky. These simple configurations enabled Monet to register the changing nuances of the vibrant atmosphere, and, in the strong directional light of the valley (with the sun rising to the east of Giverny, and setting behind the

Seine escarpment to the west), the stacks of wheat with their cast shadows could have acted for Monet like giant sundials with which to measure the passage of the sun through the day, and its changing angle through the seasons.

Other co-ordinates occur in the relationships between the two stacks, and between the stacks and the line of poplars, the grove of elms sheltering some cottages, the group of more exposed cottages, the straight escarpment directly across the Seine, and the break in the escarpment cut by the Grand Val. Thus not only did the angles of the shadows change as the sun moved in its course, but every relationship changed as the artist altered his own position slightly from the left to the right of the stacks (he never looked away from the SE to SW angle of the compass, so that his line of vision intersected the east-to-west movement of the sun). Again, the exploration of changing spatial co-ordinates was deeply embedded in Monet's art (as can be seen in his use of the motif of the villa at Argenteuil, the church tower at Vétheuil or the customs-officers' cabin at Pourville), but it was not a feature of his tourist campaigns, nor had it been, until very recently, of the intensely known Giverny terrain. Monet now stripped the scene of all descriptive detail – which was still present in the *Stacks of wheat* of 1888–9 – so that nothing disturbs the spectator's contemplation of these unfolding relationships.[20]

In the third week of September 1890 Monet wrote that good weather might cause him to postpone a visit to Morisot, 'because I have several landscapes I wish to save'. The good weather did return, for in October he wrote to Geffroy:

I'm working terribly hard, I'm struggling stubbornly with a series of different effects (stacks), but at this time of year the sun sinks so fast that I can't keep up with it. I'm beginning to work so slowly that I despair, but the longer I go on, the more I see that it is necessary to work a great deal in order to succeed in rendering what I seek – 'instantaneity', above all the *enveloppe*, the same light spreading everywhere – and more than ever I'm disgusted with things that come easily in one go. I am more and more obsessed by the need to render what I experience. . . .

The passage reveals the extraordinary dilemmas with which he was now confronted: he was working against time, but was no longer satisfied with a sketchy impression of a momentary effect; he saw with ever-increasing acuity the speed with which light changes, but needed more time to represent its complexity; he *experienced* the tension between a strong sense of the objectivity of what he observed – the inexorable passage of light which moved on regardless of any human presence – and the subjectivity of his perceptions, of his mode of representation. In his comment, 'I am more and more obsessed by the need to render what I experience', he used the verb '*éprouver*', which implies an experiencing of the external world in which feeling and even suffering are involved.[21]

The '*enveloppe*' was 'studio slang' for the atmosphere, and Geffroy had indicated its potential significance earlier in 1890 when he wrote that Monet 'does not wish to represent the reality of things, he wishes to fix the light which is between him and objects'.[22] Monet generally used delicate motifs which scarcely interrupt light to represent light-filled space, but here he placed massive forms in the centre of the painting so that they block the light. He had also done so in his paintings of the Manneporte, but there attention is focused on its great bulk set against a relatively passive background; in the *Stacks of wheat* of 1890–1, the eye, struggling with its habitual desire to focus on objects, is pulled into the space beyond those objects, where it becomes aware of 'the same light spreading everywhere'. The stacks in the paintings of 1888–9 are still experienced as *known* objects rather than as strange, vibrating shapes,

partly because they do not block light which filters in from the left and describes their forms in a relatively literal way. Monet may have become interested in the effects of blocked light through the immensely difficult representation of light in the huge rocky gorge of the Creuse, where he used small strokes of colour to animate the heavily shadowed rocks in the foreground, while their contours, illuminated by the sunset light beyond them, twist and vibrate with long strokes of bright pink pigment, and their solid bulk vibrates as if about to explode the constraints of matter.

The notion of his capturing what Chesneau had called 'the instantaneousness of a moment' had dominated most interpretations of Monet's work since the first Impressionist exhibitions, and had always been associated with summary execution, with the instantaneity of a snapshot, and with purely manual, even mechanical techniques; no critic before Mirbeau had allowed this operation any intellectual content. Fénéon wrote in 1886, 'these are impressions of nature fixed in their instantaneity by a painter whose eye dizzily appreciates the elements in a spectacle, and spontaneously decomposes the colours'; later he emphasized that 'instantaneity' was simply a form of mechanistic representation which allowed Monet 'to immobilize the instantaneity of a series of changing views'.[23] Mirbeau — and probably Monet — felt that 'instantaneity' had a deeper signification. All Monet's paintings, wrote the critic in 1889, were governed by 'one thought':

the characterization of a piece of ground, a bit of the sea, a rock, a tree, a flower, a figure in the light particular to it, in its instantaneity, that is, in the very minute when [his] sight settled on it and embraced it, harmonically.

To Mirbeau, this grasp of the motif as a harmonic whole was the essence of the '*rêve*', the moment of illumination in which subject and object penetrated one another, each infusing the other with its own 'state of consciousness'. Even though this experience was instantaneous, its realization in paint was not, so the artist had to proceed from an almost mystical experience of oneness to a 'minute analysis of the innumerable details which compose his paintings', and which were also answerable to the laws of nature:

Each object is *visibly* bathed by the air which endows it with mystery, envelops it with all the colorations which it has borne before arriving at it. . . . The drama is created scientifically, the harmony of forms accords with the laws of the atmosphere, with the precise and regular progression of terrestrial and celestial phenomena; everything moves or is stilled . . . is coloured or loses colour according to the hour rendered by the painter and to the sun's slow rise and descent. . . . Study closely any painting by M. Claude Monet, and you will see how each one of the multifarious details of which it is composed is logically and symphonically interlinked according to the direction of the luminous rays; how the smallest blade of grass, the most tenuous shadow of a branch is influenced by the horizontality or obliquity [of these rays].[24]

Analysis of Monet's practice can only begin to suggest the complexity of the representation of 'instantaneity'. Two drawings —

223   *Field of oats
with poppies*
(W.1258), 1890,
65 × 92 (25¼ × 36)

probably for the more pointed stacks painted in 1888–9 — show that Monet thought out the linear structure of the motif before beginning to paint, representing the stacks, their shadows, the cottages, trees, field and hills by pure line, and visualizing the stack *and* its shadow as one undifferentiated shape with its contours flowing without a break into those of the trees behind it. In the other drawing, he multiplied the contours of the stack, so that it swells in size, as if asserting itself against the landscape, and thus acquiring that strange looming presence characteristic of the paintings. Mirbeau said that Monet's practice of changing his canvas whenever the light changed led him to work on up to ten studies ('*études*') at once, 'almost as many as there are hours in a day'. In the summer-to-autumn season of work in 1890, Monet seems to have painted no more than eight pictures, but — as if fulfilling Mirbeau's claim that every detail was determined by 'the direction of the luminous rays' and every modulation of colour by 'the sun's slow rise and descent' — those paintings indicate the phases of the sun's movement and the direction which the artist faced more clearly than any previous group of works.[25]

Perhaps because Monet found that dusky light needed less work to achieve, the *Two stacks of wheat, end of the day, autumn* (ill.224), is less heavily worked than *Stacks of wheat, summer afternoon*, and reveals more of the early phases of the painting, when Monet laid in the major elements of the composition with broad parallel or criss-cross strokes

and long, loopy lines; according to Mirbeau, he covered the canvas in a first session of no more than half an hour. In subsequent sessions, Monet smudged on softly nuanced tones and strengthened the calligraphic lines which flow through the composition, linking the stack to the trees and hills behind. The work painted in brilliant noon sunlight looking south-west is far more complex, and Monet must have returned to it again and again, using an extraordinary range of brushstrokes — thick and fat or fine, almost linear ones, scumbles, tiny dabs and even flecks of paint — to build up a surface so dense that some of the original contours are like sunken channels. The density of the paint does not obscure substantial pentimenti which show that Monet had painted the smaller stack closer to the centre of the painting, but shifted it to the far left. The paint structure is so thick, striated and grainy that it receives and refracts light at multiple angles, and thus is itself a source of light. Like the other Impressionists, Monet sought to retain this effect by avoiding varnishes which give paintings a more even, reflective sheen which diminishes colour.

Monet translated his sense of the harmonic unity of 'the moment of the motif' into scales of warm and cool colours, interweaving nuances of the red-orange-yellow scales with the violet-blue-green ones, and mixing more white with those used to represent the background to create chalky mauves and greens which suggest the effects of moisture in the atmosphere. The warm colours are stronger in the foreground: the

broadly painted orange-red and orange-yellow body colours of the stack glow through the violet and vermilion of its shadowed base, and the muted orange-reds and mauves of its cone, while the light which fills the space on the other side of the stack was suggested right at the end of the painting process by the long, curving line of bright pinkish-ochre which rings its silhouette.

Mirbeau made it clear that 'instantaneity' was an act of vision in which discovery of the objective being of the motif was concomitant with perception of its harmony. Thus when Monet returned to the motif after having obtained his first impression, he would 'search out the interrelated harmonies of colours [accords de tons], the relationships of values scattered here and there in the motif, and [would], so to speak, fix them simultaneously. . . .'[26] One can observe the simultaneous expression of relationships discovered in time in the way certain scales of colour reappear in different parts of the painting: for example, yellow-greens, sharp bright blues and darker blue-greens create links between the small stack, the roofs, the shadows in the foliage, and cast by the trees and the large stack. The touches of mauve in the latter re-emerge in the trees and gradually reveal themselves as roofs, while simultaneously becoming part of the complex linkage of colour; the small brushstrokes of yellow-green added to the chains of blue, green and violet suggest the way the strongly directional late afternoon light begins to turn shadows dusky, while the upper foliage begins to lose detail in the blaze of the declining sun which catches at projecting foliage while shadows become darker in contrast. The warmth of afternoon light is evoked by the touches of pinky-ochres, brushed in late in the painting process, and which seem to float off the greens of the foliage and of the field; they are made more intense in the curving strokes on a pile of straw, in the shadow and contour of the large stack, and are finally locked into place

by the sharp red accent of the signature. The whole painting then is composed of the interpenetrating, contrasting scales of colour which suggest not only that Monet perceived the motif as an indissoluble whole, but that this wholeness can be experienced only in time. Yet the signature – which can, as it were, cause the painting to unravel into skeins of colour – makes it clear how much this experiencing of nature is also a matter of creating artifice.

This analysis can only begin to indicate the complexity of Monet's visualization of 'the same light spreading everywhere' at the time of year when, as he lamented, 'the sun sinks so fast that I can't keep up with it'. We cannot know how long it took him to decide what colour scales were appropriate for a particular 'moment', to choose the nuance of colour which might represent a fugitive detail of light, or to visualize the colour chords 'scattered here and there in the motif'; but the fact that he tended to wait for a paint layer to dry before continuing more often than he painted 'wet on wet', demonstrates the truth of Mirbeau's observation that every brushstroke was meditated, 'the product of mature thought, of comparison, of analysis'. The eight pictures of stacks painted in summer and autumn were probably worked on in the open air for something like two months, and Monet must have had to watch for long periods before the appropriate effect returned – and when it did, he might sometimes paint only a few strokes before it changed again.[27] Such problems had long been part of his experience, but his focus on a simple motif in a well-known landscape would have made him more conscious of the unresolvable contradictions of his enterprise: he was determined to stop painting when the light changed, yet since his first painted impression of a motif could be only a general one, he was forced to rely on memory in order to recognize whether an effect of light had returned; then, as the painting developed and became increasingly

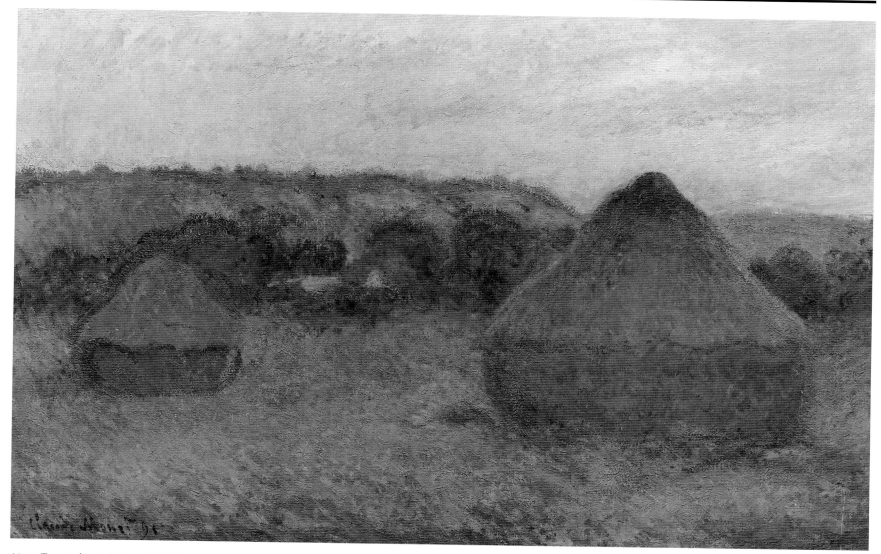

224 *Two stacks of wheat, end of the day, autumn* (W.1270), 1890, 65 × 100 (25¼ × 39)

*Opposite:*

225 *Haystacks at Chailly, sunrise,* 1865, 30 × 60 (11¾ × 23¼)

226 *Stacks of wheat, c.* 1888–9, drawing (sketchbook MM. 5134, 22 recto)

precise as a representation of the effect, Monet had to wait for an effect of light which resembled his painting. Moreover his long periods of watching for the return of an effect would have made him aware that, although the 'moment of the landscape' was shaped by an unrepeatable conjunction between hour, weather and season, each such moment melted imperceptibly into the next without a break in the continuity which he was seeking to violate. He himself hinted at what is fundamentally a terrifying vision of disintegration, in a deceptively simple phrase quoted by the Dutch writer, Byvanck: 'One must know how to seize the moment of the landscape at the appropriate instant, for that moment will never return . . .'.[28]

It was probably no coincidence that this period of intense concentration on a motif in a neighbouring field occurred when he was buying the house he and his family had occupied since 1883. Having emerged from his financial difficulties, Durand-Ruel was taking over from Boussod & Valadon as Monet's main, although by no means exclusive, dealer, and it was to him that Monet wrote in October, two weeks after his letter to Geffroy about the stacks:

. . . I will have to ask you for a lot of money, being on the point either of buying the house in which I live or having to leave Giverny, which would cause me great concern, as I am unlikely ever to find similar accommodation, nor so beautiful a landscape.[29]

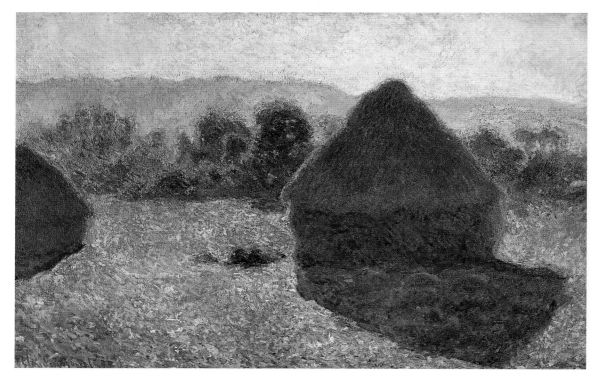

227   *Stacks of wheat, summer afternoon* (W.1271), 1890, 65.6 × 100.6 (25⅞ × 39⅝)

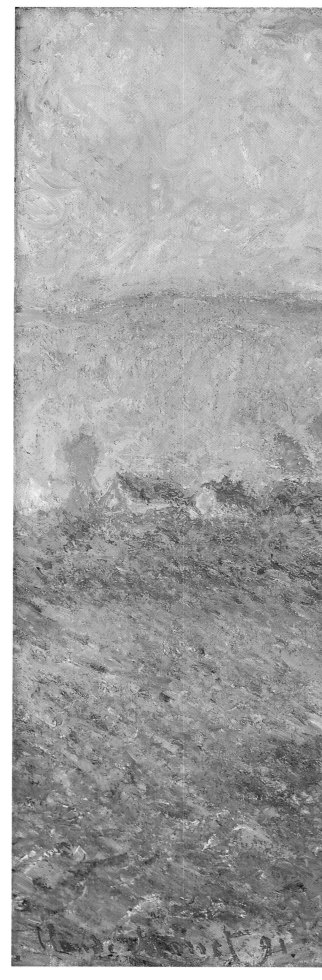

228   *Stack of wheat, sunset* (W.1289), 1891, 73 × 92 (28½ × 36)

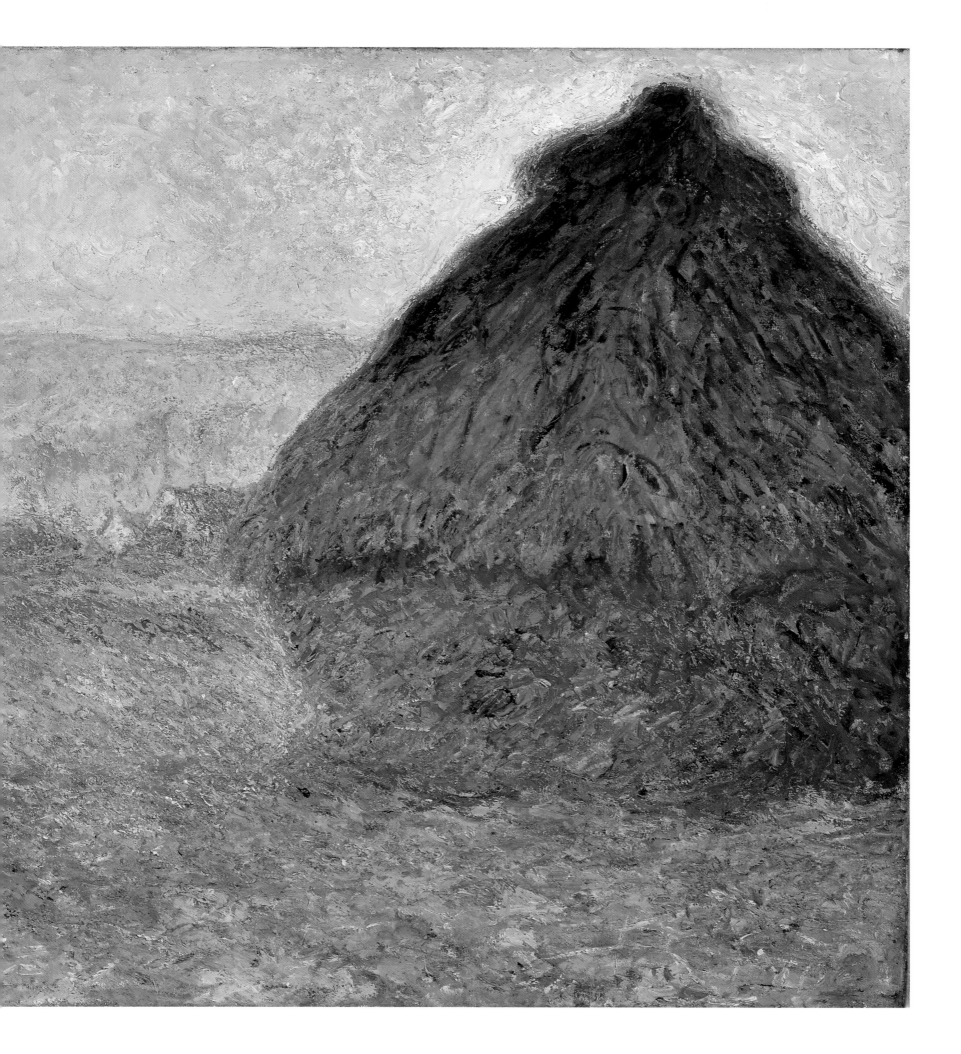

229    *Portrait of Suzanne with sunflowers* (W.1261), c. 1890, 162 × 107 (63 × 41¾)

Monet signed the contract for the purchase of his house in November, a fortnight before another significant milestone, his fiftieth birthday. It was also significant – in the symbolic and actual securing of Monet's family – that Ernest Hoschedé was known to be mortally ill; he died, after being attended by Alice 'for six days and six nights', in March 1891.[30]

It may have been during Hoschedé's illness that Monet painted what Mirbeau called the 'infinitely sad' figure of Suzanne, flanked by three strange sunflowers:

She is as strange as the shadow which envelops all and which is, like her, troubling. . . . But still more strange are these three huge flowers of the sun which . . . turn above and in front of her forehead, like three stars without rays, of an unexpected green with metallic reflections. . . . Involuntarily, one thinks . . . of one of those figures of women, spectres of the soul, that are evoked in certain poems of Stéphane Mallarmé.

This was probably Monet's last figure painting, and one which came close to Symbolism. Since the sunflower turns to follow the sun, it was traditionally used as a symbol of the sun's life-giving force (indeed one of its names in French is *soleil*). Van Gogh's plan of welcoming Gauguin to Arles in 1888 with twelve paintings of sunflowers – 'a symphony in blue and yellow' – may have been inspired by Monet's intensely alive *Sunflowers* of the early 1880s, and by such symbolism. The drooping head of the dead sunflower became an equally appropriate symbol for death, and this association could have been in Monet's mind after he learnt of Vincent's suicide in July 1890, followed in October by Theo van Gogh's breakdown. Theo's death in January 1891 was 'a really great loss to us all', wrote Pissarro for whom the dealer had been, as for Monet, the most consistent and appreciative buyer in the late 1880s.[31] Sunflowers, like water-lilies and other plants painted by Monet, were used by some Symbolists to convey literal meanings derived from literary or artistic sources; yet such symbolism originates in the natural characteristics of flower or plant, which are not necessarily codified into fixed meanings. Monet's painting probably operates in the latter way: the meaning of the portrait, with its melancholic mauves and greens, countered by the radiant sunflowers, is thus suggestive but elusive.

Mirbeau continued to stress the relationship between Monet's idyllic surroundings and his life as a painter in an article written for Durand-Ruel's journal, *L'Art dans les deux mondes* in March 1891. This opened with a lyrical evocation of the valley of the Epte and of Monet's garden – 'the milieu', wrote Mirbeau, 'one imagines for this prodigious painter . . . who enchants our dream with the whole of the dream mysteriously enclosed within nature . . .'.[32]

Monet told Mallarmé in mid-1891, 'I must confess that I have difficulty in leaving Giverny, above all now, when I'm arranging the house and garden to my taste'.[33] His acquisition of the house and his growing wealth mark a decisive stage in his creation of an ideal environment which provided the essential complement to the fragmentation of time and the atomization of form in the serial paintings. The process of transformation of the farmhouse garden and orchard, which had begun when Monet arrived in Giverny, accompanied the increasing aestheticization of the Giverny landscape in his painting: the 1885 picture of Suzanne and Jean in the orchard was succeeded in 1888 by paintings of the children in a landscape transformed into a place of enchantment by light, and of the girls in the flower garden itself – Germaine on a path lined with nasturtiums, carrying a huge bunch of flowers, and Suzanne wandering along another path, once again assuming her role as an echo of Camille as she walked the path between gladioli at Argenteuil (W.1207, 1420).[34] The Giverny countryside was shaped by agriculture, but the paintings of the fields of poppies of 1890 present it as an all-embracing garden in which Monet had now secured a permanent place.

It was in these circumstances that Monet began the next, most radical phase of his series – what Mirbeau rightly called 'the astonishing series of stacks of wheat in winter' – 17 works painted in a snow-covered landscape between early December 1890 and the thaw, which probably came in late January 1891, when the farmer collected his wheat for threshing. Throughout this period Monet was unusually cheerful about his work: in December he told Durand-Ruel that the snow had come 'with superb weather' and that he had 'masses of things in progress'; he was 'working hard outdoors from morning to night', and, although a family affair interrupted him for at least a fortnight, in late January he was still 'in a frenzy of work'.[35]

The fall of light on the stacks and the shadows they cast show that the summer–autumn paintings of the stacks represented relatively discrete periods of light – morning, broad daylight and evening – but the phases of light in the winter series are not so easily separated; it seems that Monet's increasingly acute sense of the tension between the 'moment' and the continuity of time led him to fragment that moment even further, multiplying the paintings as if seeking to run all the separate moments into a continuity. He also less frequently moved around the motif, shifting only slightly from left to right of the two stacks, so that the straight line of the escarpment remains a constant, and some kind of temporal continuity is suggested even as it is being shattered. His most extreme movement was sometimes to draw away from the motif, so that the single stack seems to hover in iridescent mist as if about to levitate, or to move so close that the stack seems to swell, as if about to occupy the whole field of vision.

Snow, having no inherent colour, was a perfect vehicle for the study of coloured light, and from *The Magpie* of *c.* 1868, with its numberless tinted whites, to the 1888–9 paintings of stacks of wheat 'covered with snow . . . in transparent mists', Monet had always been inventive in representing it.[36] Never had he been more so than in this last series, where the passage of coloured light over strong, changeless forms challenged him to create extraordinary combinations of iridescent, burning or icy colours. Despite the vivid colour contrasts among the different paintings, the series was very homogeneous, being composed of astonishing combinations of violet and blue, vermilion, orange and a few yellows, often mixed with copious amounts of white; greens appear more rarely, sometimes as strange after-image effects. Monet painted all the stacks with a warm base colour, generally a fairly dark red-orange or lighter yellowed orange, over which the pyrotechnics were deployed.

In the *Stacks of wheat, winter effect* (ill.232) the visible substructure is painted in yellowed orange overlaid with long strokes of a violet-blue, with pinks tinged with blue, and finally, a few lightly brushed touches of brilliant pinky-orange. The snow-covered field is rendered in thick, cakey tones of violet-tinted whites which become intense in the blue-violet veil of poplars, soften to pink in the sky, and are at their most dense in the shadows beneath the stacks. Touches of rich yellow, the complementary of violet, are scattered around the shadow and drawn in the irregular contour of the smaller stack. The same range of colours is used in the *Stacks of wheat, effect of snow, setting sun* (ill.231), in which Monet moved slightly to the south and looked more directly to the sunset in the west, but the colours are intensified so that they register the change they have undergone in the passage from sunless daylight to sunset – hard blues, sharper purple-violets, vermilions, mauve-tinted pinks, harsh orange suggest the menacing light created by snow clouds moving across the inflamed sky.

The use of an almost unvarying motif would have helped Monet to see 'the same light spreading everywhere', that is, to look at the scene without looking at specific forms. This was an extraordinary challenge when these firmly defined solids were so prominent, but the effect of this kind of unfocused looking can be seen in the way the stacks seem to swell and to darken as one looks 'past' them. The experience is most strikingly embodied in the *Stack of wheat, sunset* (ill.228), in which the atmosphere appears to be aflame in the last rays of the sun; its vibrating light tints the hills with violet and gold, casts a brilliant orange-gold across the field, where a haze of an indescribable livid pink suggests the thin, cold mist of a winter evening. Writhing red lines around the silhouette of the stack convey the effect of looking at a solid form which blocks brilliant light, as well as looking past its solid mass into light-filled space, when its contours seem to fluctuate and to multiply as the light eats into its substance. Monet seems to have tried to paint other after-image effects (as Seurat had done, and as Cézanne was doing) by introducing not only vermilion streaks, but touches of the darkest blue-green – the complementary of orange-red – into the shadowed side of the stack so that it too starts to vibrate, while in the *Stack of wheat, sun in the mist* (ill.230) the glowing stack blocks the sun and casts a greenish shadow which *floats* between it and the ground.

In other paintings the strangely assertive cast shadows depend on complex interactions between focused and peripheral vision: in looking into deep space beyond the stack, Monet would still have been aware that at the periphery of vision – at the 'edges' of what he could see – there was an undefined, shifting area of darkness whose presence he attempted to fix, and which he made more assertive as he moved his gaze to the shadows. Consciousness of such optical phenomena may explain the changes in position and scale of the stacks revealed by pentimenti in *Stacks of wheat, summer afternoon*; the shifting of the small stack to the left gives it room to expand and vibrate on the periphery of a gaze directed either at the large stack or into depth. The drawings showing stacks and trees ringed by multiple contours or dotted lines suggest that Monet allowed for the optical expansion and contraction of forms in light, and such phenomena may explain the fact that a number of the stacks in the paintings – notably the large one in this picture – were enlarged as Monet worked on them.[37]

The colours registering optical phenomena tended to be added towards the end of the painting process, which would have occurred in the studio in the three months between the thaw and the exhibition in May 1891. Thus the effects which suggest the most extraordinary acts of perception must have been painted from clues embedded in the paintings – and from memory. It was when one painting could be compared with another in the studio, that, by reinforcing a contour here, a haze of colour there, Monet could strengthen both the uniqueness of each 'moment of landscape' and the unity of the series as a whole.

The stacks, hills and trees of the works painted in 1888–9 and 1890 still convey a sense of their finite physical reality; but this was no longer true of the works painted in the snow, for they disintegrate under a gaze which fixed on every nuance of colour, striving to *see* space. Thus, in the *Stack of wheat, sun in the mist*, the ground itself seems to shift, the stack to waver, and the landscape to fray into floating skeins of paint of iridescent blues and orange. The strengthening of the contours and the shadow in the studio may have been a means of securing the ambiguous physical density of the stack, and of weighting it to the unstable earth.

An unusual amount of publicity had preceded the opening of Monet's exhibition on 4 May 1891, partly orchestrated by Mirbeau's article in Durand-Ruel's *L'Art dans les deux mondes*. As Pissarro's letters show, the art world was full of rumours: having heard that Monet was going to exhibit 'nothing but stacks', his old comrade commented, 'I don't know how it doesn't embarrass Monet to confine himself to such repetitions – these are the terrible effects of success!' Although Pissarro realized that Monet's ability to attract high prices for his paintings would ultimately be of benefit to himself, his immediate prospects were undermined by the demand for these paintings: 'For the moment,' Pissarro complained, 'only Monets are wanted, it seems he can't do enough. The most terrible thing is that everyone wants to have *Stacks of wheat at sunset*!!! . . .

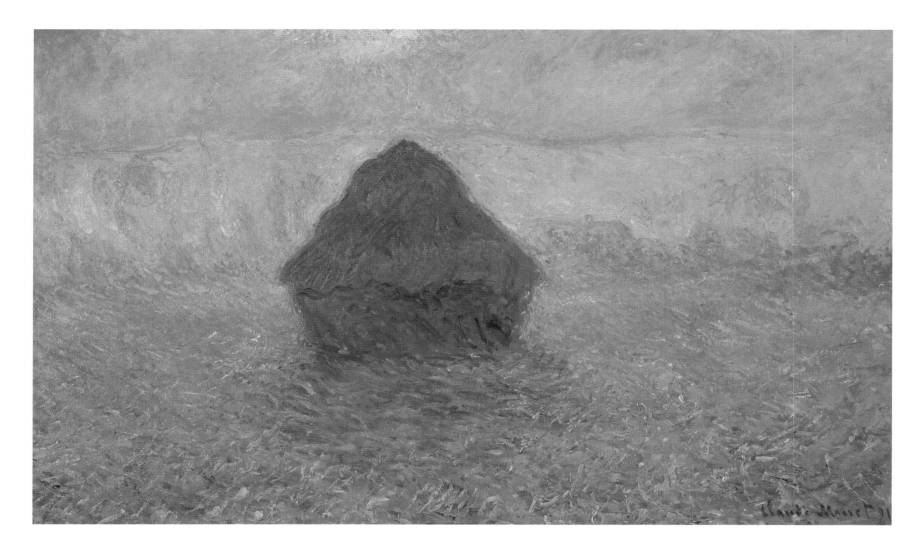

Everything he does goes off to America at prices of 4,000, 5,000 or 6,000 francs'. This was not true, but as Zola's novel *L'Argent* – just then appearing in serial form – showed, speculation flourishes on rumour as much as on truth. The *Stacks of wheat* sold for between 2,500 and 3,000 frs., over half of those exhibited were sold before and during the exhibition, most of the rest had been sold before the middle of the year, and at least fourteen went to the United States within two years. Most were bought by Durand-Ruel, Boussod & Valadon and Mrs Potter Palmer – nine went through her hands, some going backward and forward between her and Durand-Ruel, appreciating each time.[38] There was strong competition to acquire one of a restricted number of paintings of a single motif – clearly these embodiments of intensely individual perceptions of 'moments' of light in a deserted landscape were even more attractive as objects of speculation than had been the paintings of Antibes.

With the fifteen paintings of *Stacks of wheat*, Monet exhibited the two *Essais de figure en plein air* of 1886 and four paintings of the meadows full of flowers in spring and summer, thus representing the full cycle of seasons at Giverny. It is not known whether the *Stacks* were hung in temporal sequences, only that they were hung in one room with the *Essais de figure* above them. The catalogue titles indicate season, weather and time of day, without suggesting a chronological progression and, in fact, there were too many variables to do so. Nevertheless, the sense that there is such a chronology encourages the spectator to construct one, while the breaks in successive time made by the lack of correlation between the passage of light and the positions from which the stacks were viewed make this impossible. The struggle to fit the paintings into

some temporal structure does, however, force one to confront the uniqueness of each 'moment of landscape'.[39]

Articles in specialist journals and Geffroy's preface to the catalogue provided the élite who read such things with ample guidance as to how the series should be seen. Mirbeau had written before the exhibition opened:

A single motif – like the astonishing series of his *Stacks* in winter – is sufficient for [Monet] to express the manifold and so dissimilar emotions through which the drama of the earth passes from dawn to night.

For his part, Geffroy wrote in the preface:

These stacks in a deserted field are like transient objects on which are traced, as if on the surface of a mirror, the effects of their surroundings, atmospheric conditions, wandering breezes, sudden gleams of light.

Geffroy constructed a highly coloured narrative of the transformation of the stacks from their first appearance in summer, like 'gay little cottages' against the green trees, to autumn with its 'veiled days', or 'very clear weather where blue, already cold, shadows lengthen on the pink ground', and he wrote of the stacks of wheat at sunset:

At the end of lukewarm days, after the obstinate sun regretfully departing leaves a powdering of gold in the countryside; in the tumult of evening the stacks shine like piles of sombre jewels. Their flanks crack open and burn, giving glimpses of rubies, sapphires, amethysts and chrysolite. . . . Still later, under red and orange skies, the stacks become darker and glitter like burning furnaces. Tragic veils, blood red and funereal violet, trail around them. . . .[40]

Then comes winter, 'the snow lightened with pink, the shadows pure and blue, the menace of the sky, the white silence of space'. Others took

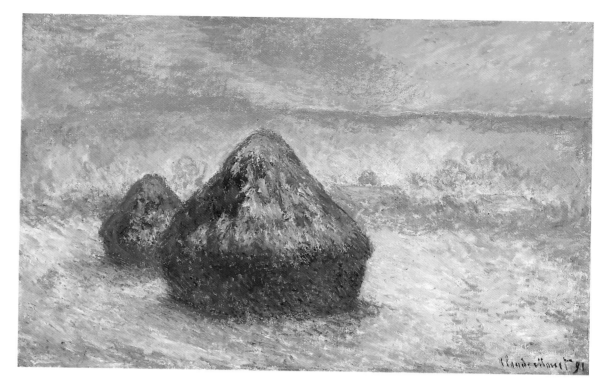

*Opposite:*

230  *Stack of wheat, sun in the mist* (W.1286), 1891,
60 × 116.2 (23⅝ × 45¾)

231  *Stacks of wheat, effect of snow, setting sun* (W.1278),
1891, 65 × 100 (25¼ × 39)

232  *Stacks of wheat, winter effect* (W.1279), 1891, 65 × 92
(25¼ × 36)

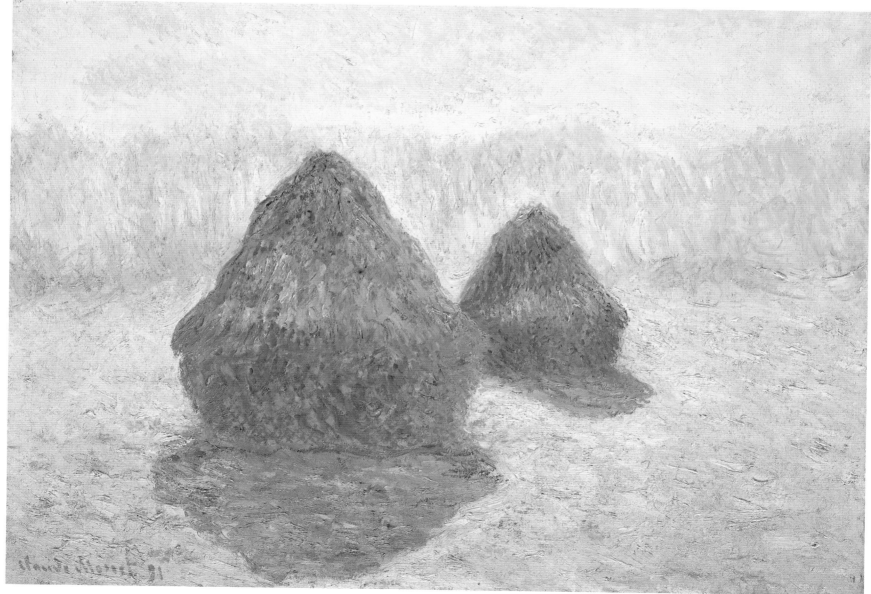

up Geffroy's rhetorical narrative of the passage of light through the day or seasons, and it became standard in reviews of the series.

The critics' response to the exhibition was more than favourable, probably because the repetition of simple shapes in all their polychromatic transformations invited them to speculate on the how and why of each variation on the theme. The astonishing colour combinations could never have been found in nature in so concentrated a form, yet no critic complained that they were untruthful, as they had complained so bitterly at more docile colours in the 1870s. This was probably because they had become accustomed to the general heightening of colour in most forms of contemporary art, and because every colour 'visibly' (to use a word favoured by both Mirbeau and Geffroy) plays a role in embodying Monet's experience.

No critic commented on the variations in composition which register Monet's small movements around the stacks. With the works exhibited together it could have been 'visible' that each painting was penetrated by Monet's consciousness of every other phase of his exploration of the motif; but, apart from his close friends, most writers were so convinced by the notion of his mechanistic recording of a succession of moments that they were uninterested in any aspect of his painting which might suggest the mind's experience of 'the moment of the landscape'.

The language of the Dutch writer Byvanck was influenced by that of Mirbeau and Geffroy, but he made it more concrete by analysing his response to the exhibition, describing how his initial distaste and disorientation at the paintings' 'showy colours, zigzagging lines' gave way to fascination. The agent of change was a single painting (probably *Stack of wheat, sunset*) in which 'an afternoon sun burnt the straw with its purple and gold rays', and which led him 'to recreate the vision of the painter by means of this motley of colours'. He then 'dared' to look at the other paintings:

I now felt a rare enjoyment in . . . the series of paintings . . . and the scale of colours which they displayed to me, from the scarlet purple of summer to the grey cold of the dying purple of a winter's evening.

Byvanck was finding pleasure in his deepening understanding of the relationship of the abstract scales of colour to particular effects, when Monet entered the gallery. In conversation, Monet asserted that the paintings 'acquire all their value only through the comparison and succession of the whole series'. His words suggest that he wanted the spectator to focus on the internal relationships among the works, whilst simultaneously being aware of their position in the passage of time. Byvanck concluded that the 'exact analysis' of the atmospheric effect which went into each work could be appreciated only when 'reunited with impressions of the same kind . . . Analysis acquires value only by the synthesis which the artist makes us make ourselves.'[41] In exhibiting the stacks as a series, Monet was depending on the intelligence of his spectators and their willingness to try to make sense of novel modes of notating perceptual experience, as he had done with his audiences in the 1870s; if in the '80s he had lost faith in the educability of the public, he was now both relying on and helping his more select audience to understand his work.

Fénéon was not won over by the formalization of phases of light in the series, although he clearly enjoyed evoking them:

In the evening sun, above all, the Stacks were exalted; in summer they were haloed with small purple flames; in winter, their phosphorescent shadows streamed over the soil; rose-pink, then gold, they sparkled against a sky enamelled blue by a sudden frost.

He found something lacking in Monet's willed subjection to the transitory. Nature, he wrote, 'is never so mobile, it sometimes stumbles, and we perhaps prefer painters who, less ready to serve its whims, co-ordinate its disparate aspects, recreate it in stable form and endow it with permanence'. Pissarro too was still worried by Monet's work. It is, he wrote, 'in the unity of execution that I find something needs to be re-thought, or rather in a way of seeing, which should be calmer, less ephemeral in certain parts'. But he concluded, 'It's all the same in the end, he's a great artist.'[42]

Science and subjectivism were curiously mingled in Mirbeau's and Geffroy's glittering evocations of the passage of hours and seasons. Geffroy described the series not only as an 'artistic demonstration' of ceaseless change in 'an apparently invariable spectacle', but as a representation of 'the faces of landscape, the expressions of joy or grief, of mystery and fatality with which we clothe everything which surrounds us'. Similarly, Mirbeau claimed that 'Monet's landscapes are . . . the revelation of the states of consciousness of the planet, and the super-sensory forms of our thought'. Such annexations of the objective processes of analysis by subjectivism or even spiritualism were common in the *fin de siècle*. The many different Symbolist sects shared a belief that appearances stood for deeper truths, which each sect interpreted in spiritualist terms according to its orientation; but, while Monet's closest friends employed much Symbolist terminology, their own faith was in a secular pantheism whose truth was confirmed by science, and whose role was to foster humanity's progress towards a just society. Mirbeau wrote to Monet in mid-1890:

While the natural sciences are discovering worlds and are going to disentangle the sources of life . . . [while] they are interrogating the infinity of space and the eternity of matter and are going to search the primeval depths of the sea for the primordial mucus from which we come, literature is still whining about one or two stupid, artificial and conventional sentiments . . . besotted by the false poetry of an idiotic and barbaric pantheism and cheapened by a sentimentalized anthropocentrism.

It is in this context that one should understand Geffroy's claim that Monet was 'a great pantheist poet', and Mirbeau's assertion that he 'knew how to express the inexpressible', and that he 'enchanted our dream with that dream which is mysteriously enclosed in nature, that dream which is mysteriously scattered in the divine light.'[43]

Monet had wanted Mirbeau to write the article on him in *L'Art dans les deux mondes*, thus implicitly accepting the secular mysticism which had pervaded the critic's 1889 articles. At the same time, he probably was concerned that his paintings might be seen as an expression of fashionable forms of mysticism. Monet always spoke of his paintings in straightforward terms: in the hundreds of letters in which he discussed his work, he wrote *only* about the beauties of what he saw and the difficulties of representing it, and he told Byvanck simply, 'above all, I wanted to be true and exact'. He would not have agreed with Pissarro's class analysis, but may well have sympathized with the latter's denunciation of current fads:

The bourgeoisie, anxious, surprised by the immense clamour of the disinherited masses . . . feels it necessary to bring the people back to superstitious beliefs; hence this confusion of religious symbolists, religious socialism, idealist art, occultism, Buddhism, etc. . . . The Impressionists have truth on their side, it's a healthy art based on sensations, and it's honest.[44]

Whether or not Monet had any real sympathy with the secular mysticism of his supporters, his practice of abstracting himself from the known forms of objects in order to paint light led to a suspension of

rational consciousness, and perhaps to a sense of oneness with light and, through it, with nature itself. At the same time, Monet's Realist training had instilled in him an intense consciousness of the externality of the objective world, which prevented any collapse of the self into a swooning oneness with the mystic 'other'.

Monet's laconic statement of his desire to embody 'instantaneity . . . the same light spreading everywhere' is obviously very different from Mirbeau's assertion that he was expressing 'that dream which is mysteriously scattered in the divine light', but the painter's statement may be amplified by his comment to Byvanck: 'For me, landscape does not exist at all as landscape, since its aspect changes at every moment, but it lives through what surrounds it, through light and air which change continuously.' With their clearly defined elements, the *Stacks of wheat* of 1888–9 and even those begun in the summer and autumn of 1890 can still be seen 'as landscape', but in the 1891 paintings the almost hypnotic repetition of the looming shapes and their perpetual threat of disintegration make them appear as only temporary concentrations of light; this undermines their traditional role as symbols of the fruitfulness of human labour, and makes it difficult to see them — like other late nineteenth-century representations of this theme — as representations of agricultural labour and embodiments of the wealth of their owners, as Herbert argues. Only one critic, Roger Marx (who had been one of the commissioners of the Exposition Centennale), referred to such aspects of the subject, but also claimed that Monet chose the stacks as a 'theme for demonstration' of his 'sole aim', that of 'establishing the variety of aspects taken by a single motif according to the different moments when it was observed'. The subject, Marx claimed, 'symbolizes ploughing, sowing, harvesting, all the hard struggle to make the soil fertile, all the harsh and superb work of the earth . . .'. He also said that the subject would 'be thought topical': he may have been referring to the recent State celebration of the return to France of Millet's *Angelus*, after the public outcry at its purchase in 1889 by the American dealer James Sutton. No other critic made any reference to this event — and it is possible that the avant-garde distanced itself from the sentimental nationalism which promoted *The Angelus* as an expression of the most fundamental value of France, its quasi-religious attachment to its soil. Mirbeau, for example, later claimed that *The Angelus* was so much repainted that it was no longer a Millet, and he dwelt on the 'marvellous irony' that at its sale, 'it was no longer a painting, but the very incarnation of the fatherland'.[45]

Geffroy wrote of 'these stacks in this deserted field', suggesting, even with the visible evidence of the cottages, that this was a dehumanized landscape, while Monet only casually mentioned the stacks of wheat when he wrote that he was painting 'a series of different effects (stacks)', and never once, in all his years at Giverny, represented those who worked its fields.[46] His emphasis was on 'the same light spreading everywhere' and the primary function of the stacks was to serve as a means of registering light. In so doing, they came to embody something more fundamental, the power of light to reveal form, to bring it to consciousness, and to create life and give it meaning.

In all the thousands of words of his letters, Monet never hinted at any emotional projection of himself into the 'moods' of nature, as Geffroy suggested, even though his perceptions were coloured by his subjective being. The emotion embodied in his paintings was not the 'sentimentalized anthropocentrism' denounced by Mirbeau, but one found in the discovery of a reality that is exterior to the self, although realized through the self. Byvanck quoted Monet as saying, 'one must

know how to seize the moment of the landscape, for that moment will never return, and one always wonders if the impression one received was the right one'. It is a strange remark, suggesting that he felt certain impressions were more true than others; but it may be elucidated by Mirbeau's interpretation of 'instantaneity' as a flash of awareness between the painter and 'the moment of the landscape', when the painter grasps both its specific character and its harmonic structure: a moment of such intensity that it overrides the logical contradictions at the heart of any representation of change. Monet agreed with Byvanck's suggestion that one painting in the series was 'perfectly realized' — not requiring comparison with the others — and he explained that this was 'perhaps because the landscape then gave all that it was capable of giving'.[47] His and Mirbeau's statements suggest a reciprocal exchange between artist and landscape so potent that the painter's expression of the landscape's externality was endowed with his own consciousness and the moment endowed with continuity.

Both Mirbeau and Geffroy stressed the prosaic, analytic aspects of Monet's practice as a necessary prelude to his grasp of the identity of the particular 'moment of the landscape' with the whole of nature — when, in Geffroy's words,

[He] gives the sensation of the ephemeral instant which has just been born, is dying and which will never return — and, at the same time, by density, by weight, by the force which comes from within and without, he evokes . . . in each of his canvases, the curve of the horizon, the roundness of the globe, the movement of time and space.[48]

Monet's procedures, like his words, were prosaic: they required infinitely painstaking observation of every change of light, and a no less painstaking search for the appropriate nuances of coloured pigment, for it was only through intense experience of the particular that he might break through to a more profound sense of the wholeness of being.

The mode of representation in which recognizable form emerged from a gradual accretion of touches of colour was shared by a number of avant-garde artists, ranging from Redon to Cézanne and Monet. Furthermore, Monet's attempt to see nature without knowing what it was he saw, and his representation of the stacks in a field in the middle of a populous village as if no human had ever trod there, partook of a general cultural tendency to escape what was seen as modern decadence by returning to the origins of vision, of language, of society and of art. Gauguin's retreat to the South Seas in search of a primitive garden of Eden, Mallarmé's ambition to write 'the Book, the Orphic explanation of the Earth', Redon's creation of the imagined first forms of life, Cézanne's struggle to give clear form 'to the confused sensations we have at birth', the anarchists' search for an innocent, uncorrupted society — all had something in common with Monet's search for a kind of primordial, pre-conceptual mode of seeing.[49]

The success of the exhibition confirmed Monet's strategies: he was now committed to solo exhibitions of serial works, with well-planned publicity to build up the expectations of his audience and to suggest ways in which they might experience the works. The profits from recent exhibitions meant that he could make his dealers compete with one another, telling Charles Durand-Ruel that 'competition is the best thing for you above all, as it is for me'. He could now exhibit when and how he pleased, releasing his works to eager buyers when he saw fit; and could afford to spend as long as he wished on a single painting or a whole series, stopping when the light changed, waiting for the effect to return, finishing the series in the studio over many months.[50] The Giverny

series provided an alternative to the profitable but superficial tourist series. Monet still sought to exclude memory from the painting process, but each 'moment of the landscape' came from a place so familiar to him that it was inevitably impregnated by memory – memory which had become internalized, quite different from the exteriorized *souvenirs* embodied in places he did not know well. With the *Stacks of wheat* Monet located his serial practice in his own *pays*, where he was to employ it for the next quarter of a century. Perhaps it was for such reasons that, as Pissarro wrote, 'these paintings breathe happiness'.[51]

The same could be said of Monet's next series, the 23 *Poplars on the banks of the Epte*. The poplars which lined the streams and acted as windbreaks in the meadows had been a favourite motif for Monet since his arrival at Giverny (and earlier at Argenteuil). As can be seen in the *Meadow with haystacks at Giverny* (ill.187) and *Morning Mist* (ill.217), the thin trunks and transparent foliage of the different varieties of poplar made them an ideal motif with which to express the density of light

between the painter and objects, for they articulate, but scarcely interrupt light. In earlier paintings, the delicate grid of horizontals and verticals was located in deep space, but in 1887 Monet brought it closer to the foreground, in a painting of Suzanne fishing (W.1134) below poplars whose trunks are reflected in the river. Probably after exploring the motif in drawings, Monet brought this structure still closer, reducing it to an interplay between the horizontals of the plane of water and bank and the verticals of the slender trees and their reflections, with a further dimension given by the zigzag of the distant trees which follow the unseen windings of the little river.

All except 4 of the 23 works were painted from a flat-bottomed boat moored below a group of poplars so that Monet had to look up sharply from the plane of the water below him to encompass the height of the trees. These disjunctive visual movements are embodied in the paintings, and are made more complex by the representation of the reflections as simple verticals whereas they in fact lie on the plane of

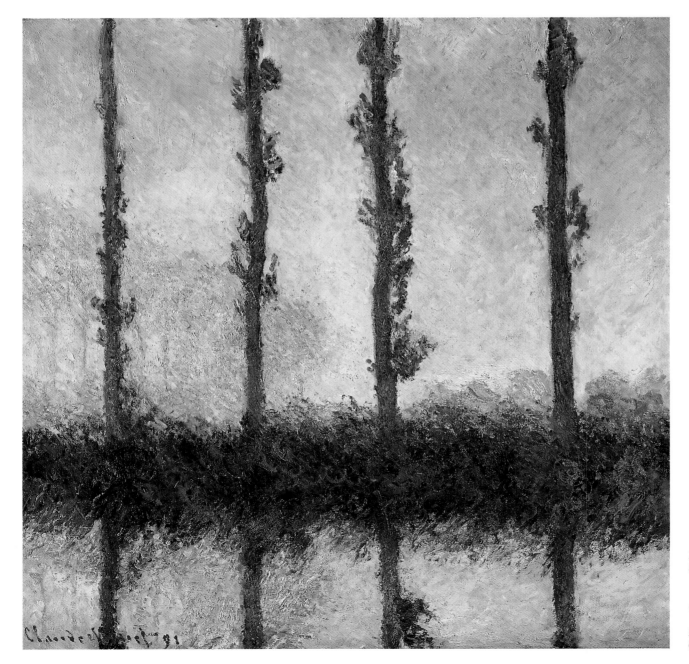

233   *The Four Trees* (W.1309), 1891, 82 × 81.5 (32 × 31¼)

*Opposite:*

234   *The Poplars, three pink trees, autumn* (W.1307), 1891, 92 × 73 (36 × 28½)

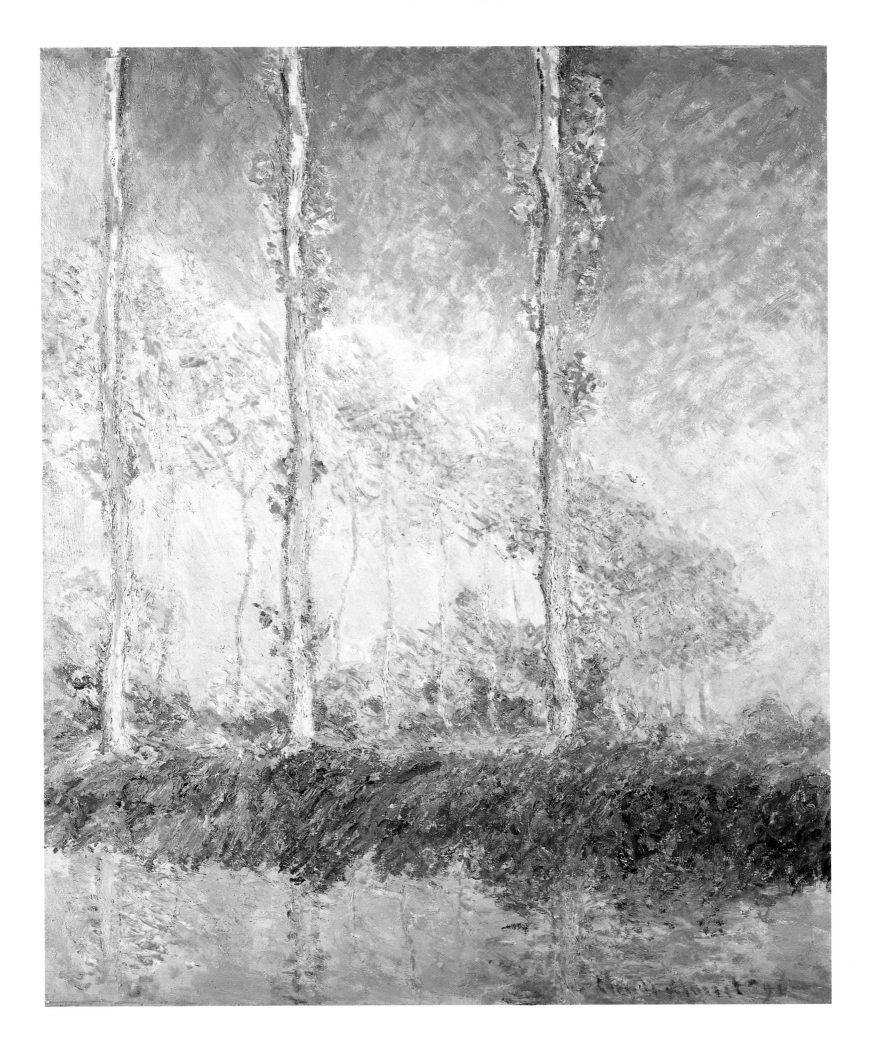

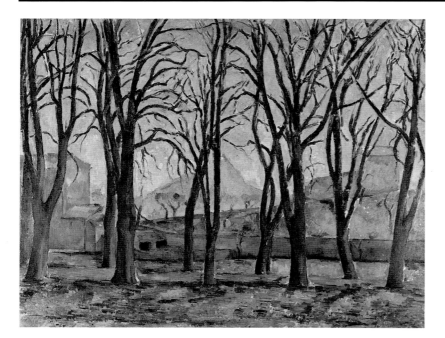

235    Paul Cézanne, *Chestnut trees at the Jas de Bouffan, c.* 1885–7, 73 × 92 (28¾ × 36¼)

water below the painter. Since these discontinuities make it impossible to see the painting in a momentary glance, they introduce another dimension of time into the 'moment of landscape'.

The *Poplars* were painted in what Geffroy called 'the soft seasons', between late spring and late autumn 1891, so the range of effects was not as extreme as in the *Stacks of wheat*, the first Giverny series. Anchored in the tranquil stream, Monet was disturbed only by the wind which fluttered the leaves and ruffled the water, and by gentle changes of light. The very subtlety of these effects demanded more delicate processes of representation than did the dramatic contrasts of effects represented in the *Stacks of wheat*, and most of the *Poplars* were so densely painted that they must have taken many sessions to complete. The hallucinatory *Four Trees* (ill.233) was built up from layer upon interwoven layer of tiny brushstrokes of colour, in nuances so complex that the original contours of the trees are sunk below the thick paint built up around them; and yet, despite its material density, this relief map of the painter's decisions evokes the golden glow of a twilight sky and the shadow of the trees silhouetted against it. Indeed, its rigid natural geometry intensifies the impression of the powdery vibration of coloured light by locking it in shallow space so that it is intensely present. In contrast to the painting of *Suzanne fishing* (W.1134), with its focus on human activity, this painting suggests something more elemental, perhaps because the forms are viewed from so close that their familiar reality disintegrates: Monet returned to a phenomenon which had fascinated him since the 1860s, and which he now brought right to the foreground – the juncture between a river bank and its shadowed reflection – but he made no distinction between the two (beyond the traces left by the horizontal and vertical brushstrokes of the preliminary sketching in of the composition). The 'moment' where solid becomes liquid is veiled in misty violet shadows which lure the spectator's gaze, promising a solution to the mystery whereby light reveals and paint creates form, and, just as insistently, evading any final definition.

Monet's processes of visualization now had much in common with those of Cézanne, whom he had come greatly to admire and who, like him, conceived of painting as a continuous 'research' into his perception of nature. They followed a similar process of working into the motif, each overlaying the broad 'first impression' with smaller strokes of colour which responded ever more precisely to 'the sensations of colour which give light', to use a phrase of Cézanne's which could have been Monet's.[52] Both scrutinized nature with such intensity that they were led to embody optical effects, like the visual fluctuation caused by changes from focused to peripheral vision which one can see in the shifting, breaking, re-asserted contours of the trunks in *The Poplars, three pink trees, autumn* (ill.234), as in Cézanne's *Chestnut trees at the Jas de Bouffan* of 1885–7. The concern with relativity of perception led Cézanne to create paintings which could never be 'finished', while Monet, who had a greater desire for decorative completeness, embodied that relativity in the theoretically infinite possibilities of the series.

Of greater significance to Monet was Cézanne's attempt to realize the enduring being of nature while trusting to individual perceptions which are subject to the relativity of time and space. That Monet was himself becoming conscious of a need to express more stable qualities at the heart of change is suggested by a comment he made in November 1891 when working on the *Poplars* in the studio:

I'm still struggling as well as I can with the admirable landscape motif which I've had to do in every weather in order *to make just one which would be of no weather, of no season,* and this comes down to a certain number of good intentions. Moral, one must do what one can, without giving a damn for anything else. . . .[53]

Did Monet hope that by representing a motif in all its aspects he could somehow express its essential, enduring being, or had his 'researches' helped him to realize the one work which – like the 'perfectly realized' *Stack of wheat, sunset* – could stand on its own within the series? The best candidate for such a work would be *The Four Trees* with its pure natural geometry and its still light, for despite its effect of truth to a moment of light, it seems more the quintessence of all moments when a landscape is lit by the low rays of the sun. Indeed, without knowledge of the alignment of the poplars in relation to the progression of the sun in the Giverny valley, and without comparing it with the rest of the series, one cannot know whether the painting represents the still, cool light and intense unearthly colours of dawn, or the still, warm light and intense, unearthly colours of the setting sun. Monet's comment remains mysterious, but it does suggest that he was no longer satisfied by the ever more precise, even mechanical, fragmentation of nature's light into finite moments.

Monet exhibited 15 of the *Poplars on the banks of the Epte* in Durand-Ruel's gallery in March 1892, his first exhibition of a single motif. Thirteen of the fifteen works belong to one of two variants (all in the same format) of a composition with a line of trees in the foreground and the zigzag of more distant trees in the background. *The Four Trees* is a slight but dramatic variant on this composition and format, achieved by Monet's turning slightly westwards and isolating the four tree trunks. The insistent repetition of the two compositional variants, the closely related, subtly inflected colour schemes, the emphatic flatness of the paintings, even the hint of the sinuosities of art nouveau in the curves of distant foliage, would have given the exhibition a more decorative character than that of the *Stacks of wheat*.

The series could be described as an arrangement in green, blue, violet, rose, yellow and white, whose dominants and intensities varied

in each work according to atmospheric effect: *The Four Trees* again stands out in the intensity of its colours, iridescent blues and violets silhouetted against a blaze of rose-gold; more saturated colours, in scales of interwoven yellows and orange-pinks dominating over softer violets and yellow-greens, suggest morning light in the *The Poplars, three pink trees, autumn.*

The subjects were dominated by autumnal, twilight and evening effects, and these, with their wistful associations of the fading of light and the passage of time, were the favourite hours and seasons of the Aesthetes, in particular of Monet's friend Whistler, who moved to Paris in November 1891. Whistler's exhibitions, with their carefully planned 'harmonies' of colours in which the décor of the rooms complemented the mood and colour of the paintings, could well have influenced Monet's conception of this series, but, however decorative Monet's paintings became, they were, unlike Whistler's, always based on the most intense scrutiny of nature. At the same time Monet constantly undermined any possibility that a painting might present a consistent illusion of nature: the paint is always paint, as even small details emphasize – for example, the bright red signature in the *The Poplars, three pink trees, autumn* creates a visual oscillation between its manifest flatness and the reading of the horizontal plane of water. Moreover the repetition of the motif undermines its reality as an object.

In the preface to the 1892 exhibition catalogue Geffroy described the series as 'the study of the same landscape in the soft seasons at different times of day', in which the passage of time was represented 'in nuanced phases which so closely follow one another, and are so unified that one has the sensation, through these 15 canvases, of a single work with inseparable parts'. Mirbeau put it more succinctly: 'this series, a work'. Geffroy again asserted the pantheistic unity of 'all things in the pure incandescence of solar light', making it precise in one telling phrase: 'the upper trunks are simultaneously gleams of light'.[54]

Some critics wrote of the series as an almost mechanistic record of a sequence of moments through the day. Similarly, the Symbolist critic Aurier – even while apostrophizing Monet as 'a lover of divine light' – employed language more reminiscent of the 1870s to deprecate 'the rudimentary nature of these instantaneous *pochades*'. He also used the word *'instantané'* with its associations with the snapshot.[55]

On the other hand Monet's expression of a form of time which is somehow more durable was also recognized: Geffroy wrote of his representation of 'the changing permanence of things', and Clément Janin evoked the 'science' which the painter used in order to make 'a purely transient phenomenon . . . give the sensation of duration and even Eternity'. Janin claimed that

despite all [the] elements which translate a particularly mobile state of matter and spirit, Monet suggests to us the idea of indestructibility, by means of something which one deduces beneath the essentially fugitive form of things: the presence of the first cause, of the force which will do again tomorrow . . . what it has done today.

Monet's landscapes, he said, 'summarize, in a chosen moment, all that nature can give, and they intensify with dreams'. They were thus not so much paintings of a specific tree or stack of wheat, as a 'tree idea', a 'stack idea'. To achieve this Monet had to be 'a decorator' – as he was, 'to a supreme degree'. Decoration, Janin explained, was more than 'décor', a superficially harmonious representation of objects; it consisted of 'the elimination in art of all that is specific and accidental, to leave only that which is characteristic of the species, diversified by indications of time and place'.[56]

Lecomte expanded these ideas in an important article, 'L'Art contemporain', in *La Revue indépendante*:

Finally the vigorous talent of M. Claude Monet, who for a long time restricted himself . . . to the rendering of rapid natural effects with their ephemeral intensity, seems more and more to abstract *the durable nature of things from complex appearances*, and, by means of a more synthetic and considered rendering, to accentuate *meaning* and *decorative beauty*.[57]

Until the series, the new avant-garde had believed Monet's art to be insufficiently decorative. Conservative critics had earlier condemned Monet's works as concerned primarily with the sensual qualities of painting, as opposed to its formal and intellectual ones; by the later 1880s, however, the 'decorative' had become a positive value both for the establishment and the avant-garde. In the last two decades there had been strong official emphasis on the necessity of reform of the decorative arts both to improve France's economic situation and to contribute to the regeneration of the French tradition. The avant-garde also laid increasing emphasis on such art, but in forms quite different from those promoted by the establishment. Within the avant-garde, there was what could be called an idealist conception of the decorative – expressed, for example, by Aurier – but opposed by Geffroy and Mirbeau, and, in a different way, by the Neo-Impressionists, all of whom believed that it was an embodiment of modern, progressive values. Pissarro – who had become disenchanted with Neo-Impressionism – was closely associated with Lecomte and may have helped him to understand that Impressionism's expression of perceptual experience in decorative form had profound meaning. Lecomte, like Pissarro and Mirbeau – anarchists all three – believed that appreciation of the decorative character of painting was a means of experiencing the reality of nature, the one true value on which human life in all its forms should be based. This 'CONCERN FOR DECORATIVE BEAUTY,' Lecomte wrote, 'must be the DISTINCTIVE MARK OF OUR EPOCH'. In 1895, after seeing Monet's *Cathedrals*, whose decorative unity he admired, Pissarro completed Lecomte's conception: 'Nature is our only hope of arriving at an art which is true and decorative'.[58]

Truth to nature was clearly not literal truth. In 'L'Art contemporain', Lecomte distinguished between the work of the Impressionists and Neo-Impressionists – which, however abstracted, derived from the study of nature – and 'the new painters conquered by literary Symbolism and fashionable mysticisms' who obtain their out-of-date beliefs 'from the Mont-de-Piété of the Absolute'. The modern epoch had, according to Lecomte, its own ideal: 'belief in the Individual, in the efficacity of the human struggle'. A truly modern art, he asserted, would be concerned not only with 'the grandeur of the human struggle and the justice of new social groupings', but with 'the magnificences of nature with their infinite poetry, mysterious but not mystic'. In his book, *L'Art impressionniste . . .*, published that same year, 1892, Lecomte claimed that certain works by Monet and Pissarro were 'as suggestive as they are representative. From their warm harmonies, Thought is released; dream takes wing. They render the great mystery of nature'. What he mistrusted in Symbolist painters was not their concern with dream or mystery, but 'their preconceived ideas', which he felt could lead them to 'an over-determined search for the Idea, at the expense of pure pictorial beauty'. 'Nature' – which the mid-century Realists had so confidently assumed they could master – had by the *fin de siècle* become something mysterious which could be approached by analysis and science, but, as Monet's closest associates believed, only understood in a moment of illumination, when rationality was suspended. Preconception, rationalist or mystic, could only obstruct this experience.[59]

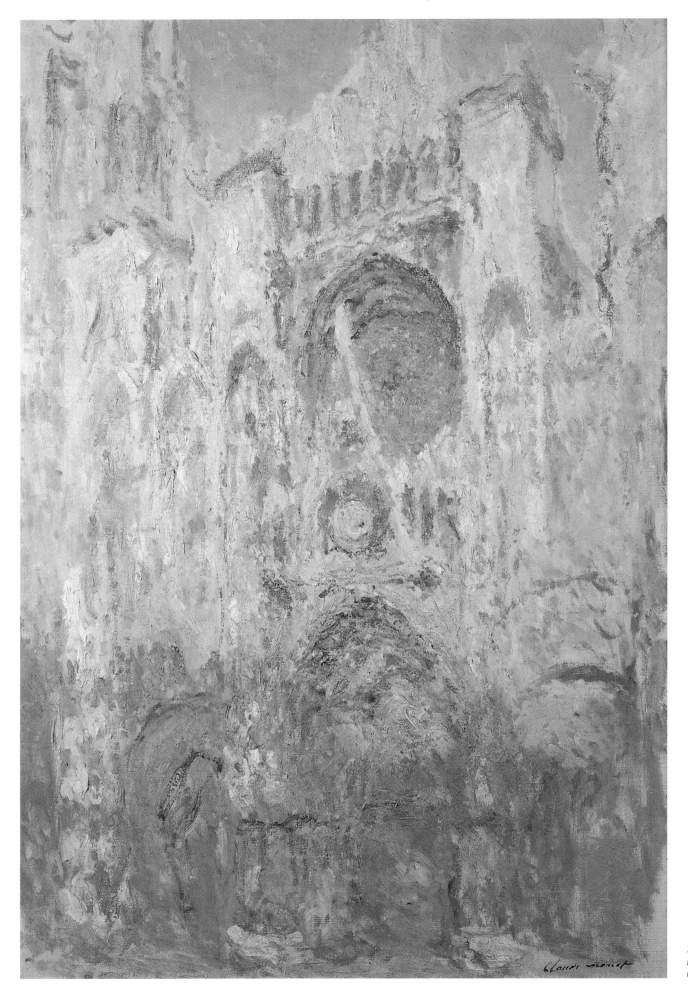

236 *Rouen Cathedral, sun effect, end of the day* (W.1327), 1892, 100 × 65 (39 × 25¼)

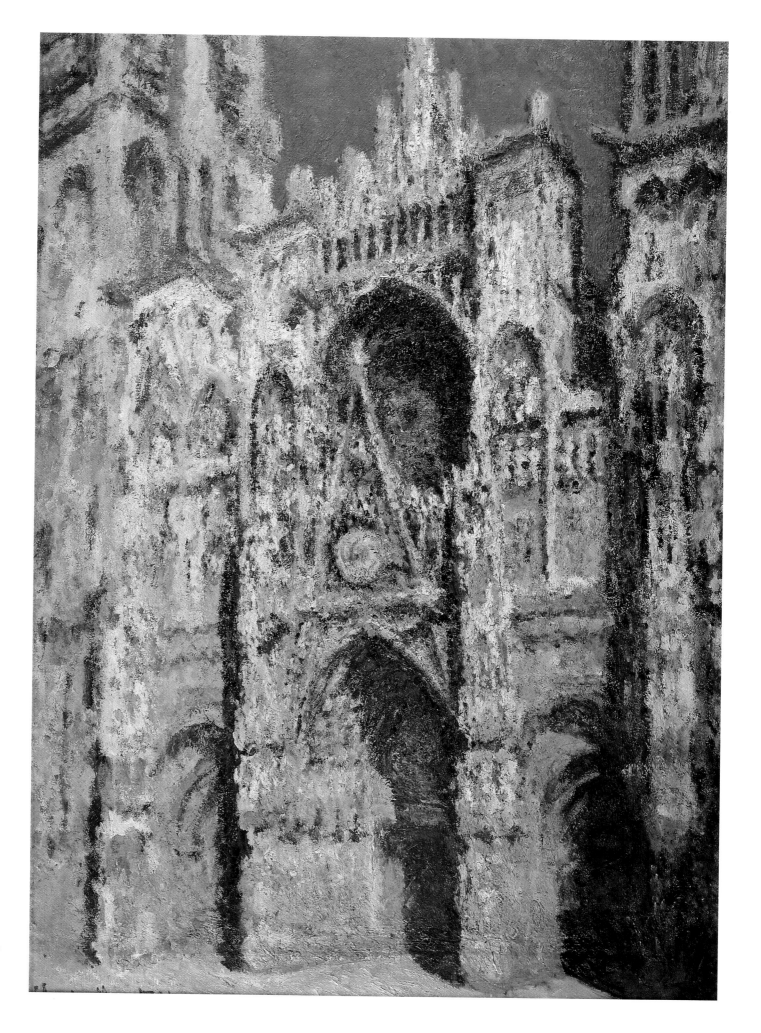

237 *Rouen Cathedral, the west portal and the Tour d'Albane, full sunlight* (W.1360), 1894, 107 × 73 (41¾ × 28½)

238    Monet in his dining-room at Giverny

The increasingly decorative character of Monet's series corres-
ponded to the increasing aestheticization of his environment, not only
fictively, through painting, but through the transformation of his
surroundings. Once the house at Giverny was his, he began planning a
more ambitious garden, perhaps inspired by those of Japan (he was
expecting the visit of a Japanese gardener in June 1891 when working
on the *Poplars*). Many members of the avant-garde believed it necessary
to create for themselves an ideal environment which would exclude a
vulgar materialist society, and in which they could cultivate their refined
sensibilities. Monet may have read one of the most notorious accounts
of such a setting, Huysmans's *A Rebours*, in 1884, but he is more likely to
have been impressed by European reports of the all-embracing nature of
Japanese design, and by the elegant simplicity and colour harmonies of
Whistler's London home and of his exhibitions, which may have
influenced the decoration of his own home. Monet's famous dining-
room, painted in two tones of yellow with yellow and white plates he
himself had designed, hung with predominantly blue Japanese prints,
and accented with bright green Japanese vases, could have been titled,
like one of Whistler's exhibitions, 'Harmony in yellow, blue and
green'.[60]

The decorative did not necessarily have anything to do with
decorative painting, in the sense of being designed for an architectural
setting or used to ornament furniture, but when the Impressionists did
such paintings — as in Monet's commissions for the Hoschedés, his
panels for doors in Durand-Ruel's salon, or his scenes of Etretat painted
on cupboard doors — there was real tension between the notion of
painting as a background to living, and painting which required the
utmost intensity of observation both to create and to appreciate.[61] The
context in which Monet made his bid for fashionable success in the
1890s favoured the development of what one might call 'background'
painting, which sat uneasily with Monet's fundamental commitment to
being true to his 'sensation of nature'.

The articles which the Symbolist writers Aurier and Mauclair
wrote on his 1892 exhibition are prime examples of the idealism which
Mirbeau and Geffroy, writers who believed in the reality and the
meaning of nature, feared might contaminate understanding of Monet's
art. Not without a certain irony, which enabled him to have his cake and
eat it, Aurier drew an extraordinary analogy between Monet and a
priest of Baal in his passionate love for 'his god, his Baal . . . his sun, his
divine sun'. According to Aurier, in Monet's experience, both matter
and idea were transformed into a new reality by the transcendant force
of light:

> The voluptuous passion which exalts him, the ineffable sensations which he
> experiences, free him from dreaming, thinking, almost from living. Ideas, beings, things
> no longer exist for him, fused as they are in the fiery breath of Baal.

Monet, Aurier claimed, chose

> insignificant pretexts, banal subjects to metamorphose these nothings into visions, into
> radiant poems for us; a stack of wheat, a ravine on the Creuse, some waves on the
> Mediterranean, some poplars on the banks of the Epte; it is enough to bathe these
> things in divine radiance . . . for despicable reality to be transformed into a delectable
> paradise flowered with jewels and with smiles.

Thus the humble tree, grown by the neighbouring commune for
sale as wood (and scorned by Hugo as 'the only tree which is stupid . . .
Like the Alexandrine, it is one of the classic forms of boredom'), was
transformed into the transcendental. Even so, Aurier felt that Monet's
painting should be 'less directly sensational . . . an art of more distant
dream and of the ideal'.[62] Mauclair evoked the 'apotheosis of light' by
this 'greatest of landscapists', but he did attend to the relationship
between the 'symbolic world', Monet's truth of observation and his use
of paint. The artist, he claimed, rendered 'realities' so faithfully:

> that these very realities . . . are suddenly doubled with a mysterious *sense* which
> instantly makes them participate in the symbolic world of which poets dream. Trunks of
> trees, those marvellous columns of poplars, grasses, shimmering water, lines of thin
> bushes, rose-coloured in the setting sun, are observed by an eye from which nothing
> real escapes; and seen closely, they appear only as an ocean of multicoloured
> brushstrokes in which one discovers relationships of colour and tone which are so
> unexpected that, from the very truth of the painter's vision, there arises this consoling
> certitude: that *the world is what we create*.[63]

Monet did create his own world in painting, but it lived off the world
external to it, and in whose reality he fervently believed.

## II

By the time Aurier's article appeared Monet had been working for some
weeks on a new series of paintings of the huge west façade of Rouen
cathedral. He may have chosen this uncompromising motif, which he
would find 'terribly hard and arid to do', in order to study an *unchanging*
motif, and he planned to paint it in a short period, probably so that the
sun would maintain more or less the same position in relation to the
motif. Thadée Natanson commented on Monet's choice of motif:

> If the artist . . . leaves trees and water, if he no longer has any natural phenomenon for
> which he must . . . create the form, if the landscape is restricted to a work of art, is it not
> so that he can devote himself further to light, a subject dominant in all his paintings till
> now, unique subject now?[64]

Confronted with this ready-made geometry, Monet had no need to
invent anything, and could concentrate exclusively on his own
perceptions and their transformation into paint. In no previous group of
works had Monet so clearly been engaged in a modernist project of
problem-solving, and he may have intended to intervene in a complex

contemporary debate by challenging the new avant-garde's denial of artistic meaning in what it conceived as simple-minded representations of external reality. It may have been no coincidence that while Monet was painting the unchanging geometry of the cathedral, Lecomte was noting his tendency to 'abstract the durable nature of things from complex appearances', for the cathedral façade could sustain the density of work *in time* which Monet needed to realize the 'more serious qualities' he now sought.[65] Yet while the form of the façade remained constant through every change of light, the repeated rendering of it profoundly undermined its reality, and its 'durable nature' became ambiguous, fugitive, fragmentary. The exceptionally long period over which the works were finished in the studio may have been determined by Monet's desire to reconstitute continuity, a continuity which could only be attained through painting, through what he had described as 'the comparison and succession of the whole series'.

The choice of the motif makes sense in the context of Monet's long exploration of the Seine valley. Rouen is at the centre of that valley, planted on its east–west axis, and the cathedral was used as another mode of registering its light, analogous to the station in the east whose glass vaults materialized light, to the river which reflected it, the stacks of wheat which measured its daily rise and decline, the screens of poplars which articulated it, and to the cliff on the Normandy coast which Monet showed as vibrating under its force. The motif would thus demonstrate the subjection of another form to the essential principle of nature, light, as it was perceived by Monet's 'unifying vision'. In this sense there was no essential difference between Monet's paintings of the cathedral and the Gare Saint-Lazare. Indeed, in the rhetoric of progress, the great railway stations were sometimes presented as the cathedrals of the nineteenth century, and, with other forms of iron and glass structures like Les Halles, as the highest examples of construction of their age as the cathedrals were of theirs.[66] There is a relationship between the geometry of the iron and glass structures and the composition which Monet found by focusing on the cliff-like façade of the cathedral, ignoring its great bulk, and treating it like a screen which, with the countless changes of surface created by its traceries, sculptures, pilasters, aedicules, its rose window and sunken portals, could receive and reflect light with infinitely greater complexity than could the great cliff-walls on the coast which also faced west.

In the contrast between the secular monument and the religious one, the station and the cathedral, one can observe the processes whereby Monet demonstrated the triumph of perception over association in such a way that Clemenceau could use it in his battle against clericalism. One of Monet's first depictions of an urban landscape centred on the late-Gothic façade of Saint-Germain-l'Auxerrois, shown sparkling in the sunlight in the heart of the new Paris, as part of the modern spectacle, and, although he eliminated any reference to modernity in the *Cathedrals*, the series was still subject to modern visual experience in that the object was used as a means of embodying an individual's consciousness, and, in the process, pulverized into 'a sort of universal palpitation of coloured molecules'.[67]

Rouen cathedral was not only a religious monument, but one that was deeply embedded in French history, so Monet, who rejected faith in the unseen and distrusted memory, had chosen to paint a building whose meaning was revealed through both. Although the image may have derived from a guidebook illustration, he painted it as if it were being seen for the first time, divested of any human reference (except for tiny figures in one painting, and picturesque old houses in four). At a

time when many were returning to the Church, and signs of spiritual allegiance were intently scrutinized, Monet obscured specifically Christian signs on the façade, blurring or simply cutting off the cross which surmounted it (it was also cut off in an illustration which may have been his source for the motif)[68] – but he also effaced the signs of modern time, the face of the clock.

The exponents of the new spiritualism either tended to dismiss Monet's art as obstinately materialist or interpreted it in their own terms, and Monet's decision to paint a religious monument in demonstrably secular terms could have been intended to challenge Symbolists such as Aurier and Mauclair, with their invocations of ancient sun-worship, who had characterized Monet as 'one of the unconscious inheritors of the ancient verities', celebrating 'the glorious Mass of light in a modern temple of the sun'.[69] Indeed the fervour of at least one of these devotees, Mauclair, withered before the *Cathedrals*.

Natanson pointed out how in these paintings 'the landscape has been restricted to the work of art', the cathedral. Geffroy had foreshadowed Monet's treatment of Rouen cathedral as landscape when he wrote in 1891 of Monet's desire to paint 'the cathedrals of France, high and beautiful like the rocks of promontories', and from this

239   *Rouen Cathedral*, wood engraving in *Rouen, Guide-Joanne*, 1891

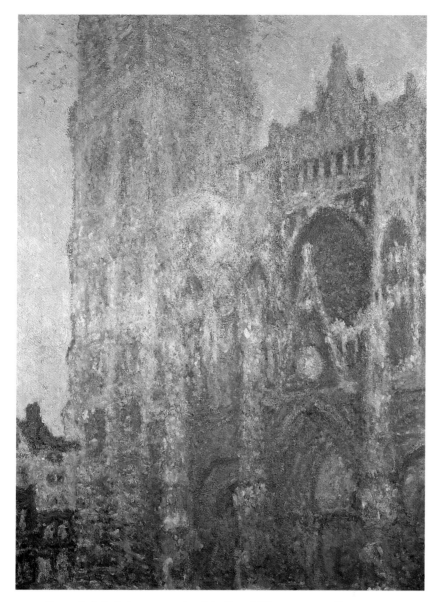

240    *Rouen Cathedral, the west portal and the Tour d'Albane, morning effect* (W.1346),
1894, 106 × 73 (41¼ × 28½)

perspective the village churches which Monet represented in many paintings after leaving Argenteuil were simply features of a man-made landscape which had become naturalized: the village of Vétheuil crowned by its church seems part of nature, while on the Normandy coast the little church of Varengeville appears to grow from the cliff.[70] At Rouen Monet severed the façade from the building, the building from its surroundings, and the cathedral from the meanings history had given it, so that it exists only in the present tense. Shortly before Monet exhibited the *Cathedrals*, Pissarro wrote of 'Nature, the good nature of French Gothic', and he, like many of his contemporaries, saw the Gothic as the highest expression of an art which is harmonious because it is founded on nature. Monet treated the man-made structure as a natural phenomenon shaped by time: Geffroy wrote of 'the portal hollowed like a sea cave, the stone worn by time, made gold and green by sun, mosses, lichens', and Monet exclaimed, 'Everything changes, even stone'.[71]

At this time of religious renewal, Monet's closest friends were forceful advocates of the laicization of French culture which others –

perhaps Alice Hoschedé-Monet herself – believed would destroy those qualities which had created French civilization. Thus the object which Monet had chosen to paint was 'saturated with symbolic meaning' of a kind which aroused contemporary passions.[72] The mode of representing and exhibiting this object meant, however, that any such symbolic meaning was undermined, as many commentators on the series were uneasily aware; indeed, the series is a daring assertion of the artist's power to transform the external world together with its meanings into the world of art.

One of Monet's sketch-books containing views of old Rouen suggests that he surveyed the cathedral in its context before 'finding' his motif, the west façade. The last of a sequence of drawings of the façade shows it at a slight angle, with the towers at left and right so sharply cut that the picture surface is filled by the cliff of masonry.[73] All the major elements of the final composition – the portals, rose window, Gothic arches, niches, tower and pilasters – are indicated by pure line, as usual without any shadow. Monet may have found his composition in the central section of a wood engraving in the *Guide-Joanne* to Rouen which shows the cathedral from the same angle. If he did, he cropped it so as to truncate the two towers, to eliminate all but slivers of the foreground plane and of the sky, and to cut off the uppermost cross above the rose window; he would also have reduced the complicated image to a linear skeleton which survives as the compositional structure repeated in all the paintings. In two seasons, from late winter to early spring in 1892 and again in 1893, Monet began 28 versions of this motif which differ only in different angles of the façade, and their inclusion of more or less of the cathedral and its surroundings. He then worked on the paintings at home between April 1893 and the opening of his exhibition two years later.[74]

This was Monet's first exhibition in three years, and as its long gestation shows, he was now conceiving his painting as an investigative process which had no end except that determined by his desire to present works for validation by his public. The process of realization was theoretically infinite, because Monet learnt to see through the act of painting:

I have now taken up so singular a way of working that I work vainly, it doesn't seem to advance at all, particularly since each day I discover things which I did not see the day before. I add and lose different things. In short, I seek the impossible.[75]

In these circumstances the short time Monet originally intended to spend in Rouen in February 1892 was prolonged into mid-April and was succeeded by a second visit covering the same period of 1893. From the beginning he was conscious that he had undertaken 'a hard task', particularly since he felt it was not his 'business to be in towns'. He sent Alice a stream of instructions about the Giverny garden, and got into an astonishing state over Suzanne Hoschedé's wish to marry an American, Theodore Butler, ostensibly because the man's antecedents were not known, and because he was a painter! 'It's impossible for me to stay any longer at Giverny', he wrote; 'I want to sell the house immediately.'[76] Although he calmed down and accepted the marriage, the incident is indicative of the intensity of his emotions in response to the least threat of disruption to his ideal family life, and perhaps suggests that Suzanne's role as his favourite model – sometimes paired with Jean Monet – was invested with an emotional significance beyond that of her being simply a pretty girl.

In Rouen he settled down to paint in improvised studios across the square from the cathedral; the first was directly opposite it, but the

second, a few doors away, enabled him – like most of his predecessors, including Turner – to view the façade at an angle. He worked all day from early morning to sunset, adding new canvases as the light changed, and reviewing his work each night in the hotel (François Depeaux, a major collector of Monet's work, provided him with a 'petrol lamp with a reflector' for this review, a porter to carry his canvases and a screen to shield him from the sight of the lady customers in the draper's shop where he worked). After three weeks he was working on nine canvases in a day, and becoming anxious about the changing weather; as the weeks passed, the rhythm of work accelerated and his emotional temperature rose, but he was discovering things he 'had not known how to see before'. Towards the end of his stay he felt that if the weather remained good, he could 'save' a number of works, but added, 'I'm broken. I can't do any more – this has never happened to me – my night was full of bad dreams: the cathedral fell on top of me, it seemed to be pink or blue or yellow'.[77] So much for the notion of Monet as the pitilessly analytic observer. He returned to Giverny 'absolutely discouraged', not wishing even to open the boxes to look at his paintings, and many months passed before he returned to them.[78]

The household was preoccupied by preparations for Suzanne's wedding, which was immediately preceded by Monet's own marriage to Alice Hoschedé on 16 July 1892. This event was made possible, after twelve years of living together, by the recent death of Alice's husband; it allowed Monet, as Suzanne's stepfather, to give the bride away.

The paintings which Monet brought back from Rouen in April 1892 probably included a group of nine which can be differentiated from those of 1893 by the gap of sky between the façade and the tower on the left (W.1321–1329; ills.236 and 242). Because the façade occupies almost the whole surface of each painting, and is at such a slight angle to it, it seems almost to be fused with that surface, so the contrast of dark and light hues which indicate its recessions and projections also model the picture surface, and echo from painting to painting.

An unfinished painting in which Monet depicted the upper part of the façade as golden in the late afternoon sun, and the lower part in violet shadow cast by the unseen houses on his side of the square, shows that these tones were developed from a linear structure which he carried through every phase of the painting. He forced the first thin smears of paint into the grain of the canvas, overlaying them with thick strokes of contrasting tones which map the major architectural shapes. Thus, quite early in the painting process, Monet had built up the image as a kind of crust of yellowed pinks and saturated violets, articulated by staccato accents in deep golden yellow and longer strokes of pale violet. These articulating tones are generally formed from lines of colour which mimic the architectural details, and which Monet repeatedly reinforced so that their form remains visible through layers of dry, scumbled paint. This painting was left unfinished after only a few sessions in front of the motif; it is more densely worked and correspondingly more precisely observed in certain areas (as in the complex build-up of strokes which suggest the vibration of reflected light in the shadows of the portal), but Monet failed here to create a unity from this sort of intense focusing, and the work does not convey the sense of cumulative perception, of perception which becomes more acute in time, that is found in more finished works like the *Rouen Cathedral, sun effect, end of the day* (ill.236). However, given the number of sessions Monet had spent on this unfinished *Cathedral*, the number of paintings he had begun, and his short stay in Rouen, it is quite probable that the works which he took back to Giverny were as incomplete as this.

241   *Rouen Cathedral, the west portal and the Tour d'Albane, harmony in blue* (W.1355), 1894, 91 × 63 (35½ × 24½)

On his second visit, precisely a year later so as to obtain the same effects of light, Monet returned to one of his first improvised studios, and found a new one from which he could view the façade at a sharper angle (W.1346–1348; ill.240). He also introducd a new factor into his serial painting, by bringing with him his 'effects of last year', telling Alice after three weeks that he had compared his new works with the earlier ones, something he had hitherto avoided, 'not wishing to fall prey to the same mistakes'.[79] Thus paintings representing past phases of consciousness were being brought into the process of expressing the perceptions of the moment. Monet felt that his first paintings had been 'ruined' because he had 'wanted to do too much', and since they are slightly more descriptive than the second group, he may have meant that he had painted them too quickly to allow the slow development of perception to take over from the notation of known forms.[80]

After five weeks in Rouen he was working on ten or twelve canvases a day, torn between his need to develop these and to create new ones to register new effects, as he did until a fortnight before the

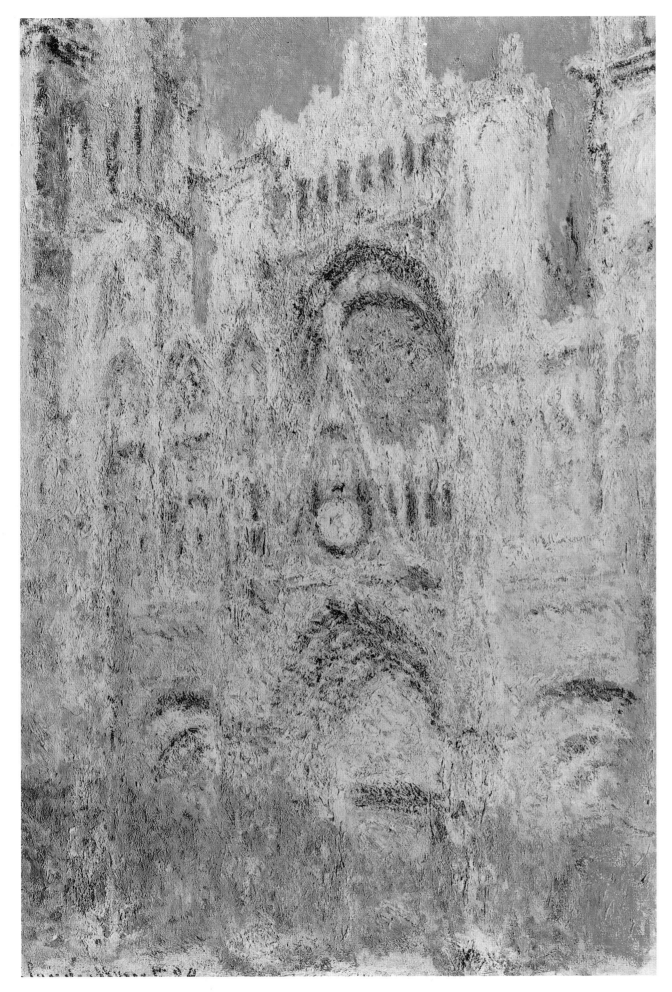

242   *Rouen Cathedral* (W.1326), 1894,
100 × 65 (39 × 25¼)

marked changes in seasonal light forced his departure. He yearned after the delights of painting in the country, and his constant thoughts as 'a prisoner' in the city were with his garden. Yet even his dreams of a water garden were frustrated, and he exploded in characteristic rage to Alice at the local opposition to his plans. 'I give up entirely,' he wrote. 'The water plants must be chucked into the river; they'll grow there. Don't, then, speak to me about it. I want to paint. Shit to the "naturals" of Giverny, the engineers'.[81]

'Fourteen canvases a day', he wrote after six weeks; 'such a thing has never happened to me.' He felt he was beginning to understand his subject, but was too exhausted to pursue it, while 'every day' the light became 'whiter' and fell 'more vertically', so that he was shocked by

the sight of my canvases which seemed to me atrocious, the lighting having changed. In short I can't achieve anything good, it's an obdurate encrustation of colours, and that's all, but it's not painting. . . .[82]

His phrase 'obdurate encrustation of colours' suggests that many of the paintings were very densely worked before he returned to the next phase of his work, the many months working on the series in the studio before his exhibition opened in May 1895. Naturally Monet did not spend the entire time reworking the *Cathedrals* – in both 1893 and 1894 he painted long-familiar motifs in the Giverny valley, a haystack, pollard willows, poplars in spring-green fields, misty reflections on the Seine, and six pictures of another Gothic building, the church at Vernon reflected in the Seine (ill.243).

During these months too Monet was creating the first stage of his water garden. The considerable sums he earned in 1892 enabled him to buy land across the road and the railway branch line from his flower garden, through which flowed a stream which formed a small pond where wild irises and water-lilies grew. In 1893 Monet obtained permission from the prefect of the department to erect a small sluice to divert the Epte, making a pool for water plants, and to build two small bridges, stating in his application that his aim was to create 'motifs for painting'. While he was working on the *Cathedrals*, he supplemented the established willows, poplars and alders with ash trees, flowering cherries, clumps of bamboo and thickets of rhododendron, and, in January 1895, was able to paint the pool with the little Japanese bridge that had been erected in place of the originally planned stone one.[83]

In 1895 he also went on a painting trip to Norway, and, as was characteristic of his representation of places he did not know well, he saw its landscape through other images: Mount Kolsaas made him 'dream of Fujiyama', while the village of Sandviken reminded him of a Japanese one. Indeed, although he painted *en plein air* – 'under the endlessly falling snow', he wrote to Geffroy, 'you would have laughed to see me completely white with my beard covered in icicles' – the planes of delicately tinted blues and pinks, and the little wooden bridge seem to derive as much from a print by Hiroshige as from nature. And as a reminder that he was still subject to modern time, one may note that he told his wife – without comment – that he had used the telephone.[84]

It is not possible to know how much time Monet spent on the *Cathedrals* at Giverny. The exhibition planned for early 1894 was postponed partly because he was unable to complete his work to his satisfaction, writing to Durand-Ruel, 'I have so much difficulty now in making anything and I take so long.' Ten years earlier he had told the dealer that 'retouching' was 'long and difficult', but, although it now took even longer, it seems still to have been a process of strengthening already existing effects,

rather than transforming them.[85] Possibly what took time was the review of the works together, learning to understand what differentiated them and what sequences of colours would further clarify individual effects. Monet would add veils of scumbled colour, webs of tiny strokes of colour, and would then have to reassert the articulating strokes, until the final surface of a painting became so dense that it was almost as much a material object as a pictorial image.

The work done in the studio also strengthened the decorative unity of the Rouen series. The almost invariable linear form expressed in consciously varied colour harmonies – essentially variants of creamy-ochres and mauve-blues with accenting strokes of gold, pink, orange and violet – suggests the notion of variations on a musical theme and may have been influenced by Whistler.[86] The cathedral was built of grey stone and was thus quite unlike Monet's previous motifs, which were either composed of colourless, reflective substances like water or snow, or had quite strong local colours. The colour schemes of the *Cathedrals* were, then, more obviously invented than those in any previous works; nevertheless once the colour harmony for a specific effect had been 'chosen' – the choice may not have been conscious, and would, as the series progressed, be increasingly dependent on previous choices – it would be as much responsive to perceived changes of light as would any more naturalistic code. Thus, however decorative the individual paintings and the series as a whole, one can always find a reason for each modulation of colour in the artist's perception of the motif. Indeed, given the Impressionists' confidence that the decorative was both 'natural' and 'true', there was no need to distinguish the origins of any colour choice.

The Musée d'Orsay with its five *Cathedrals* is the only place today where one can have any sense of how astonishing, how exhilarating and how demanding it must have been to see twenty in one exhibition. In comparing them, one can begin to appreciate how Monet's perception of the motif became more acute as he struggled to embody its transient moments in a form both stable and evanescent. *Rouen Cathedral, the west portal and the Tour d'Albane, morning effect* (ill.240) suggests the artist's perception of the *'enveloppe'* when the sun was behind the cathedral, with the façade in shadow and the upper part of the tower caught in a golden haze. The presence of warmer light in the upper air is suggested by the tremulous pinks lightly brushed on the shadowed side of the tower, while the colder light below is evoked by tiny strokes of infinitely varied blues, with colder and denser blues creating the deeper shadows of the rose window and portals where touches of warmer colour indicate the vibration of light reflected from the ground. Although the sun is still behind the cathedral and the sky less clear in *The west portal and the Tour d'Albane, harmony in blue* (ill.241), the narrowing of the shadows and the addition of strokes of golden yellow to the blue dominants of the *Morning effect* suggest that the sun is higher and that the light in front of the façade is becoming warmer; the changing colour relationships of *The west portal and the Tour d'Albane, full sunlight* (ill.237) suggest that the sun has moved just in front of the façade and that a clearer light has made the architectural tracery sharper.

When Monet's exhibition opened in Durand-Ruel's gallery in May 1895, it included, besides 20 *Cathedrals*, 8 paintings from Norway and 12 of the Giverny area, including 6 of the church at Vernon. It was, then, dominated by paintings of two Gothic churches, suggesting, on one level, an image of the traditional France entirely unaffected by the more ephemeral troubles of the modern capital. The most significant of these last were the anarchists' bomb attacks of 1892–4 and the

consequent government repression which was extended not only to the political anarchists but to their avant-garde sympathizers, whose reactions confirmed the darkest suspicions of *'honnêtes hommes'*. A day after one bombing, the anarchist journal *L'Endehors* published Mirbeau's impassioned article on the acquittal of Ravachol, one of the most notorious of the bombers:

I abhor the shedding of blood . . . I love life, and for me all life is sacred. This is why I am demanding from the anarchist ideal that which no form of government has been able to give me: love, beauty, peace between men. Ravachol does not frighten me. . . . He is the roll of thunder to which succeeds the joy of the sun and of calmed skies. After the sombre task, the dream of universal harmony will smile. . . .

Moreover, society is wrong to complain. It alone has engendered Ravachol. It has sown misery: it harvests rebellion.

More shocking was Laurent Tailhade's comment on the throwing of a bomb in the Chambre des Députés in December 1893: 'If the gesture is beautiful, what do the victims matter?' As was widely reported, this was said at the banquet of the Symbolist journal *La Plume*, the guests of which included Mallarmé, Fénéon, Zola and Rodin, so suspicion of the avant-garde spread. Monet's voluminous letters do not so much as hint at any concern over the events which touched friends and acquaintances so closely: the explosion of the bomb in the Chambre des Députés in 1892 and the assassination of President Carnot in 1894 led to waves of arrests, including those of Fénéon, Signac, Luce, and the threatened arrest of Pissarro, Lecomte and Mirbeau. Once again, Monet's sales seem to have been unaffected, although in 1894 Pissarro said that collectors were 'so disorientated by events that they don't want to hear about art', and Durand-Ruel asserted that the situation was 'disastrous for business'.[87] Monet was no anarchist, yet he could be tarred with the same brush as Pissarro, as he was in the scandal provoked by Caillebotte's bequest which left his Impressionist collection to the State in 1894. In an enquiry published in *Le Journal des artistes*, the academician Léon Gérôme wrote: 'For the State to have accepted such filth, there must be a really great moral decline. . . . There's anarchy everywhere and nothing is done to repress it.' What was at issue was power. 'It is we who represent the State' wrote Gérôme, while another painter, Charles Maignan, worried that the Impressionists might succeed 'in usurping authority'. That academic artists still had influence is suggested by the fact that it took three years before the State accepted the bequest – and then only part of it.[88]

After months of fear and after the acquittals in the Procès des Trente – the trial of those accused of complicity in the anarchists' bombings, at which Mallarmé testified on behalf of Fénéon – the political crisis subsided, and soon, as Pissarro wrote, 'all Paris' was talking about the struggle between Monet and Durand-Ruel over the prices of the *Cathedrals*. The dealer wished to buy the whole series, but Monet was asking 15,000 frs. for each, and the long period of preparation and postponements fed the rumours of his fabulous sales. Although he had to give way, he sold some before and during the exhibition at 12,000 frs. – between four and five times what he had obtained for any of the *Stacks of wheat*.[89] A fairly large number of the *Cathedrals* remained unsold, and this was probably a reflection not only of the high prices, but of the puzzlement and discomfort expressed by several critics and presumably felt by collectors. The exhibition was, however, a success: a journalist claimed that, with *Tannhäuser*, it was 'the event' of the Paris season. Wagner's opera had been revived for the first time since 1863, and was enthusiastically received by the avant-garde, while being attacked by nationalists as anti-French. The journalist stated

that those who had previously criticized Monet's work 'now met in a mêlée of enthusiastic adjectives, in an explosion of epithets'.[90]

A great deal was written about the *Cathedrals*, but if one excludes Geffroy's habitual lyrical effusion and Clemenceau's panegyric – spread across five columns on the front page of *La Justice* – most of the critics, while admiring Monet's virtuosity, were either uneasy about the 'truth' of this series, or were hostile to the application of this mode of painting to a religious monument. All agreed that there was special significance in the large group of works on a single motif, but some interpreted it in terms of the representation of phases of light, while others emphasized its abstract, musical, subjective character, and few found a relationship between the two. The 'decomposition' of light was easier to appreciate in paintings of mobile reflections and fluttering leaves than in ones of a massive stone building. Michel mocked those who claimed that Impressionism was 'truth itself': since the scale of values in painting is different from that in nature, he wrote, 'it is *impossible* to paint the real sun'. He therefore ridiculed accounts which suggested that Monet had 'to leap . . . from one canvas to another' as the effect changed. 'These acrobatics', wrote the critic, 'seem to me as puerile as they are vain', and asserted that 'this series could have been painted anywhere but at Rouen itself'. Describing the series as 'a suite of extraordinary variations on a given theme', Michel dared to write (as few others did) that Monet *'imagines* different effects', using 'the phantom of stone as a pretext . . . for his arbitrary and compelling dream', and he presented Monet's dissolution of 'defined forms' as the 'final exacerbated expression of sensation', the last throes of oil painting which 'has nothing left to say'.[91]

Whatever his views on the work, almost every critic used the series as a pretext to display his own stylistic virtuosity. Drawing on their lushest adjectives, their most dazzling metaphors, reviewer after reviewer counted out the phases of light which had passed over the cathedral – phases which seem as much the creations of their minds as of close observation of the paintings. Clemenceau was sufficiently carried away by the notion of chronological progress to rhapsodize that in place of twenty canvases of the cathedral Monet could have done 'as many as there are seconds in his life . . . and [for] each beat of his pulse he could fix on the canvas as many moments of the model', as many 'as man can make divisions of time'. Imagining himself at the centre of an exhibition arranged so as to reveal 'the perfect equivalence of art and phenomenon', the writer conceived 'a lasting vision not of twenty, but a hundred, a thousand, a million states of the eternal cathedral in the immense cycles of the sun'.[92]

Clemenceau, like other writers, regretted that the series would not be preserved as a unity, and called on the President of the Republic to buy the series for the State, because there had been no 'millionaire to understand even vaguely the meaning of these twenty cathedrals and to say: "I'll buy the lot", as he would have done with a packet of shares'. Clemenceau's choice of words raises the central issue of the relationship of these unique moments of individual sensibility to the market whose needs they served by establishing themselves as a commodity in short supply, but whose initial meaning was destroyed by fragmentation – a dilemma which Monet solved only at the end of his life when he presented the *Nymphéas* to the State.

Pissarro told his son that he was sorry that he had not seen the series before it was dispersed because

it's above all as an ensemble that it should be seen. It's much opposed by the young and even by admirers of Monet. I'm very excited by this extraordinary mastery. Cézanne . . . fully agrees with me that it's the work of a strong-willed, level-headed man, pursuing

the ungraspable nuances of effects which I don't see realized by any other artist. Some artists deny the necessity of this research; personally, I find any research legitimate if it's felt to this degree.

He found in the ensemble 'a superb unity' which he himself sought, and which he perhaps found in the monotonous facture, repetitive linear structure, even tonalities and closely related colour schemes of Monet's series.[93]

The whole series cannot have been hung as a chronological sequence of phases of light through a day, for there were a number of subgroups formed by slightly different viewpoints, each of which would have had its own sequence, and Monet may have juxtaposed closely related or contrasting effects in order to invite the spectator to make connections rather than passively following some suggested temporal sequence. There is, however, no evidence to prove this, and only Lecomte drew any comparisons among the works, pointing out that Monet had proved his command over drawing by first painting the cathedral 'without worrying' about its changing atmospheric states. He was probably referring to a relatively descriptive painting (W.1319) seen from directly in front (although begun from the usual angled viewpoint and subsequently modified to the frontal view); this work could have acted as a neutral statement of theme in relation to which all the atmospheric variations could be seen. In order fully to appreciate the precision of Monet's analysis of colour, Lecomte recommended 'that one examines in detail and compares' different atmospheric effects in terms of the unvarying architectural framework given by the rose windows, doors and porches. Both he and Geffroy emphasized the relationship between the changeless architecture and changing light, between stone and atmosphere, between a 'reality at once immutable and changing' as Geffroy put it.[94] These two were the only critics to write of the interlinked components at the core of the series: the single motif, 'abstract' colour harmonies and Monet's search for truth. The decorative ensemble was — as Pissarro also recognized — essential in the constitution of truth, so that, paradoxically, truth could be perceived as much by comparing the paintings one with another as by confronting them with the motif itself. Truth to nature could, then, to be experienced through art.

Monet claimed, 'everything changes, even stone'. The longer he painted a work, the more he saw, and the more he saw, the more he needed to paint, so that the painting became visually and materially ever more dense. He was, then, seeking to embody not only an external reality which was ceaselessly changing, but also a continuous perceptual experience of that reality,[95] and the more intensely he focused on changing light, the more the stable reality of the cathedral disintegrated. Michel's concern that Monet reduced everything to 'a sort of universal palpitation of coloured molecules' expresses something of Monet's inherently terrifying vision of reality, but no other writer except Clemenceau wished to see the paintings in such terms.

Most critics were simply puzzled by the difference between grey stone and Monet's iridescent colours and could see no raison d'être for the dense paint strata which they variously described as 'plaster-like', 'formless rough cast' or 'layers of rough cement'. Indeed, despite their dutiful litany of the moments of light which passed over the façade, few seemed to see any relationship between paint and the image of light — unless they retreated to a safe distance — and most writers felt the Cathedrals to be profoundly irreal.[96] Michel wrote of 'this series of . . . visions'; Renan called them 'twenty different mirages projecting on our retinas the image of the massive façade and the airy tower', and expressed the disquiet felt by many when he said that Monet's 'pictorial matter' had never been 'more strangely troubling'. In the fashionable Symbolist journal, La Plume, Eon wrote of the image of the cathedral in fog as 'a phantom-cathedral', of the shadowed portal as 'deserted, hermetically closed, mysterious and mute as a tomb forever sealed'; he welcomed the restoration of the legendary and fairy-tale to the Gothic, and claimed that 'the almost fantastic impression that Monet has been able to draw from the cathedral of Rouen adds a new and truly curious note of mysticism to his glory'. In Le Journal des artistes Denoinville apostrophized: 'Beautiful with a mystic beauty . . . Temples of Faith! . . . Basilicas of Love! . . . Magic Apotheosis of Religion and Dream!' Only Lumet wrote simply that the paintings were both 'true and unreal', as if one were the function of the other.[97]

Others were disturbed that Monet should paint a religious monument. In the influential Mercure de France, a former admirer, Camille Mauclair, praised Monet's 'prodigious' virtuosity, but was concerned that 'after a life of titillating sensualism', Monet should 'attempt to apply the most exclusively colouristic and orgiastic art to these heights of monochrome stone, to these linear theorems'. The paintings contained no 'intellectual emotion' responsive to that of the architecture, and Mauclair found that 'the very idea that the Gothic, the cerebral art par excellence, serves as a theme for this so superbly sensual a pagan is somewhat wounding'.[98] Monet's admirers defended the Cathedrals in secular, pantheist or anti-clerical terms. In his provocatively titled article, 'La Révolution des cathédrales', in La Justice, Clemenceau contrasted Monet's paintings of 'miraculous realities', movement, light, 'life itself', with the false miracles of Christianity. It was the artist, he maintained, not 'the feeble curé', who was the real conveyor of spiritual truths.[99] It was perhaps inevitable that Monet's Cathedrals should have been drawn into the religious polemics of the Third Republic, for those writers who had done most to bring him to public attention, Mirbeau, Geffroy and now Clemenceau, were notorious for their efforts to free consciousness from what they saw as the obscurantist hold of the Church, while their promotion of a secular religion based on science, reason, progress and nature seemed to be threatened by the Catholic revival of the 1890s.[100] Monet was also a free-thinker, but, as always, his paintings were mute in any explicit ideological sense; nevertheless by representing the cathedral simply as a form — or rather, as multiple forms — subjected to light, he ranged his painting with those who defended nature as the one true faith of modern society.

If Monet shared his friends' pantheism, his painting was still that of a passionately detached observer; if he reached self-forgetfulness in the process of observing each nuance of light, choosing each particle of colour, he was still confronted every day with 'obdurate encrustations' of colour. He never publicly contradicted the wilder flights of his admirers (and, indeed, sought Geffroy and Mirbeau as interpreters), but he himself spoke of his art in resolutely matter-of-fact terms. He sought new forms of consciousness, but he certainly did not think that he could find any short-cut by means of Symbolist notions of spiritualism or the ideal; he believed that if painting had any meaning beyond its immediate presence, this meaning could be achieved only by working through the material with the self-imposed, almost mechanical routines he employed towards — as Clemenceau later quoted him — 'a maximum of appearances in strict correlation with unknown realities'.[101]

In La Revue blanche Natanson introduced another aspect of the contemporary aesthetic debate, that which held that art was the only

source of sure values. Somewhat indirectly, he criticized the didacticism of the progressives, Clemenceau and Geffroy. One should not, he said, 'make the artist responsible for the interpretations of unthinking admirers'; nor should one blame 'the method' used in the series if certain writers disregarded the paintings and encumbered them 'with a sort of scientific conception, an educative purpose and with heaven knows what idea of progress'. Such a notion would be justified so long as it did not 'delude the artist himself . . . as it does certain spectators, and distract him from the task – which some wish were his only task – of composing paintings'. Natanson felt that Monet's preoccupation with 'the most fugitive impressions of light' might distract him from the real aims of painting, which he defined – in the terms one would expect from a close associate of the Nabis – as the creation of 'an object which derives its value only from its own qualities'. For Monet formal 'qualities' were a means of finding nature, rather than self-evident values, but he may have found Natanson's delicately expressed reservations about his 'construction of always thick, almost sculptural pastes' useful. Natanson wrote: 'one begins to prefer to the most unexpected, the most extraordinary of these realizations, a less fugitive form of expression, more ordinary, but more durable'.[102]

Monet himself had been thinking along these lines; indeed, his choice of the cathedral as motif may have been determined by his desire to create a work 'of no weather and no season', but once he started to paint he had again become totally absorbed in the representation of ephemeral effects. The 'terribly hard and arid' labour of the *Cathedrals* seems to have made him react against the more mechanistic aspects of the serial method, and to seek alternative modes of consciousness in which recourse to memory made the representation of the passage of light over a motif 'less fugitive . . . more ordinary . . . more durable'. While completing the *Cathedrals*, Monet had returned to a motif he had painted when he first arrived in Giverny, the church seen across the river at Vernon. The six paintings he did of another religious building bathed in light show clearly differentiated atmospheric effects, rather than the infinite succession of 'moments' of the *Cathedral* series. Instead of thick pastes, he used delicate, evanescent hazes of colour that fuse every form into a single luminous substance which somehow suggests a light existing in time rather than a fragment of its continuity as in the *Cathedrals*.

Monet painted few new works for ten months after his 1895 exhibition. He was finishing the remaining Norwegian paintings, defending common land in Giverny against industrial development and was 'living in anxiety' over the illness of Suzanne and his wife. He did paint two pictures of his water garden (W.1419, 1419 *bis*) with the Japanese bridge reflected perfectly in the pool.[103] As these show, the garden had taken shape by 1895, but Monet did not paint it intensively until the summers of 1896 and 1897, as if waiting for it to be enclosed in its layers of foliage. The water garden was never used as a setting for images of the family, as was the flower garden, and, like Monet's other paintings of the 1890s and the twentieth century, was devoid of any human figure.

Georges Truffaut – himself a well-known gardener – claimed that when the tree peonies and laburnum flowered next to the grove of bamboo in Monet's water garden 'one would think one was in a suburb of Yokohama', and others commented on the garden's Japanese characteristics. The Japanese influence went deeper than any question of style or detail. Monet's garden with its little bridge and 'Japanese' plants – bamboo, irises, peonies, willows, water-lilies – his huge collection of

Japanese prints, and the decoration of his house were specific manifestations of a totalizing vision, strongly influenced by the European concept of the Japanese environment as completely aestheticized, with the countryside shaped by the same aesthetic that shaped the arts, and the home as the crucial site of aesthetic experience. The Japanese, as Gonse described him, was 'a contemplative . . . he loves his home, his house, an exquisite and peaceful place, made to receive works of art'.[104] The Japanese home was completed by the garden, and was thus for Monet an image of his life-long aspirations.

Monet could have learnt about Japanese gardens from recent publications, from friends or acquaintances who knew Japan at first hand, such as Duret, Gonse, Bing and Hayashi, and from Japanese kakemonos which depict the curved banks, willows, bridges and irises found in his garden. He had been visited by a Japanese gardener in 1891, had probably seen the Japanese gardens at the Exposition Universelle of 1867 and of 1878, and perhaps also a private one constructed near Versailles by 1890, with a pavilion for contemplation of the garden, a pool with water-lilies, and a red lacquer bridge. Almost undoubtedly he had read Geffroy's article on Japanese landscapists, in Bing's *Le Japon artistique* in 1890, in which he described the Japanese garden as a microcosm:

Everything is represented in this confined space which can be crossed in a leisurely walk of a few steps. There is the strong and universal substance, earth. Shaped by tools which level and excavate it, this earth reproduces the rhythmic undulations of the soil, the upheavals of mountain chains, the unified surfaces of plains. There is the fluid and singing element, there is water . . . the narrow stream flows circuitously like a river bounded by sinuous banks, runs down a slope, spills over a waterfall, bubbles, splashes, then quietens and deepens in a miniature pool which simulates the tranquil lake and the secure bay. . . . At the same time as truth, the artificial triumphs. In order to possess the many essences and to create the imaginary forest, the dreamer, the patient gardener has violated nature. . . .

This 'artistic transposition', Geffroy claimed, reveals 'the changing spectacle of the universe' in all its seasons.[105]

Although Monet could have been influenced by the ways in which the Japanese gave their gardens the illusion of scale, he was too good a gardener to try to recreate a Japanese garden in a different landscape and climate.[106] Moreover, he had already developed the principles of composition of his Giverny gardens in his painted ones, in which he created the illusion of an enclosed, sensually concentrated world whose boundaries are obliterated by flowers and foliage, where paths turn back on themselves in limited space, and where even a distant river may be included in its ideal wholeness (W.693). Monet now brought water, his favourite motif, into the real garden as he had done into the painted one. The lush profusion of his garden was quite unlike the extreme refinement of Japanese ones, and it would be truer to say that rather than determining its style, the latter helped transform its function.

The French avant-garde was well aware that the Japanese garden was not simply a place of recreation, but of meditation on nature. Like Japanese paintings, in which a few brushstrokes can evoke a tree, rocks, eddies of water, it embodied the forces of nature in a concentrated, purified form which made them available for contemplation. Conceived in this way, Monet's garden was ultimately to provide a means of bringing nature back into the almost over-refined harmonies of his paintings of the 1890s and early 1900s. It gave him a place for continuous meditation on a small area of the physical world which was both natural and created, and would thus enable him to endow 'the moment of landscape' with continuity.

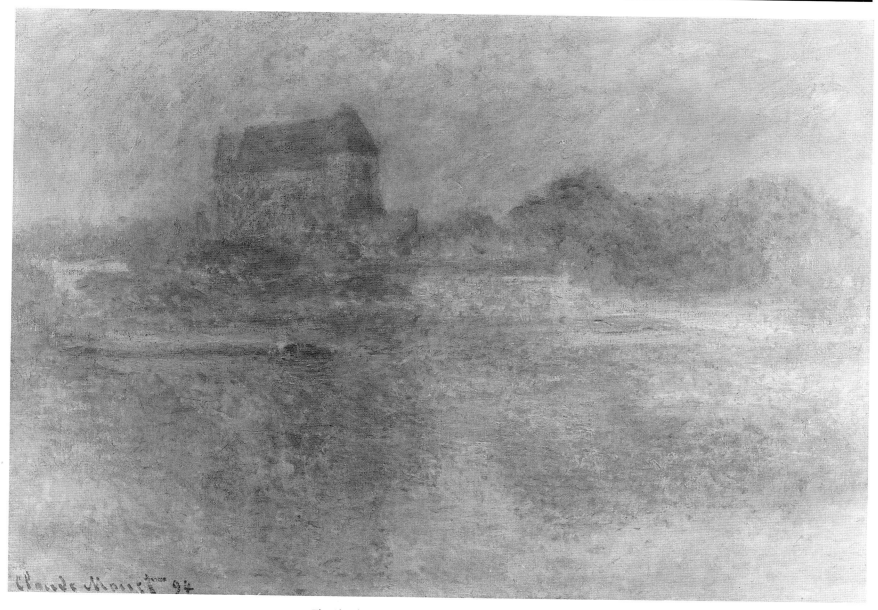

243    *The Church at Vernon, mist* (W.1390), 1894, 65 × 92 (25¼ × 36)

## III

Monet's stepson, Jean-Pierre Hoschedé, wrote of Monet's desire in the late 1890s to 'return to his first loves', and the journalist Thiébault-Sisson later described a plan Monet had when he was sixty to return to his old painting areas, in order to create, as he said, 'a kind of synthesis in one or sometimes two canvases of my earlier impressions and sensations'. He gave up the idea, since it would have required much travelling and much time 'to see . . . all the stations of my life as a painter and to verify my former emotions', but the six paintings of the church at Vernon were of this kind, as were works painted at Pourville and on the Seine in 1896–7 which went back to motifs painted thirteen or fourteen years earlier; the huge London series begun in 1899 had its origin in the small, naïve paintings of 1871, while the six views of Vétheuil of 1901 were inspired by memories twenty years old.[107] In each case Monet's alleged wish to create in one or two paintings a synthesis between past

and present experience gave way to his obsession with capturing ever more precise moments of *present* light by multiplying canvases.

Monet's long struggle to exclude memory from his painting so that the work would be a pure image of the 'moment' was unrealizable, if only because, once he adopted the practice of painting only so long as the light on his motif was constant, he was dependent on memory to verify the moment when he could return to it, for the earlier stages of the painting were inevitably generalized. Nevertheless, when Monet was painting, he was probably able to switch off any form of consciousness except that necessary to scrutinize each phase of light and to find its equivalent in pigment. Unlike the tourist paintings, the works painted at Giverny were based on knowledge of a landscape which had become internalized, and with the exception of the London series, the paintings of Monet's 'first loves' were of this latter kind.

There was much in the 1890s to encourage retrospection and interiority in Monet: the *fin de siècle* was itself retrospective, and there

was a general preoccupation with the processes of the mind. Many writers and artists were interested in Bergson's intensive exploration of the continuity of consciousness, and his insistence on the role of involuntary memory in installing the self in 'the fluid continuity of the real'. His distinction between the 'psychic' memory released unconsciously by intense perceptual experience and the mechanical, utilitarian memory which resurrects the past in a willed way, as *'souvenirs'* lacking essential life, has a relationship to Monet's struggle to bypass conceptual memory as a barrier to those perceptual experiences which can release more profound memories of the relationship between the 'moment of landscape' and the individual consciousness which – in Bergson's phrase – 'endures in time'.[108] There were also particular reasons why Monet should have become more receptive to the processes of memory: in early 1896, he helped organize a retrospective exhibition of the work of Berthe Morisot who had died in April 1895, while, in 1897, the exhibition of 16 of his own paintings of the years 1874–86, which the State had accepted from the Caillebotte bequest, would concretely have renewed the past. Moreover, the approach of his sixtieth birthday at the turn of the century seems to have disposed him to the idea of re-viewing his past as he had experienced it in painting.[109]

Corot's and Cézanne's retrospective exhibitions of 1895 were also influential. Corot's 150 works could have reminded Monet of the years he had considered him 'a good model to follow' and they strongly influenced his *Mornings on the Seine* series of 1896–7. Cézanne had not exhibited since the contemptuous reception of the few works he had shown in the Impressionist exhibitions of the 1870s, and even his old comrades, who had seen his works in his studio, experienced those shown in Vollard's gallery in November as a revelation.[110] The exhibition would have disclosed not only the duration and intensity of the Provençal painter's exploration of his *pays*, but his deepening consciousness of a motif in time. Cézanne's painting may have crystallized Monet's awareness of the way his own serial painting fractured perception into a sequence of isolated moments, transforming him into 'a machine for painting' who had to wait for nature to produce an effect resembling one he had already painted, and frustrating his 'researches' into his deepening consciousness of a reality external to himself but known only through himself, and endowed with its own continuities. Perhaps Cézanne's exhibition – which took place during a long pause in Monet's painting – gave Monet the idea of returning to Pourville to paint his real *pays*, an area infused with the memories of past experience. That his invoking of the past was deliberate is suggested by the fact that he used a sketch-book of the early 1880s, containing an 1882 drawing of Pourville, to do a sketch for his new works.[111]

In February 1896 Monet wrote from Pourville to Durand-Ruel's son, Joseph (who had joined the business), 'I needed to see the sea again, and am delighted to see again so many things that I did fifteen years ago', and he told Geffroy days later, 'I'm a bit timid and groping, but at last I feel I am *in my element'*.[112] This was not a phrase he would use lightly. His letters on this painting campaign were characterized by a nervous self-consciousness, 'an indecision, an extreme timidity', rather different from the exhilaration at the beginning of other painting trips, and despite his apparent intention to limit the number of works, he was still driven by his compulsion to produce more. 'I must resolve to begin canvases for every weather, every wind', he wrote; 'it's impossible for me to do a few things, and to stay with my arms folded when the effect isn't there.' His letters indicated that he was choosing his motifs even more carefully than before, positioning himself so as to obtain softly

flowing silhouettes, a delicate balance of volume and void, and vast light-filled space; and he very consciously chose motifs which he felt were appropriate for the exploration of different atmospheric effects.[113] Despite returning to sites which he had painted intensively 14 years before (for example, he began 11 views of the Customs-officers' cabin which he had painted 14 times in 1892), Monet still believed he needed 'months of apprenticeship', and he felt himself to be 'so clumsy, so long to see and *to understand* . . . I am not what I was. . . .' Rain and glacial wind were succeeded by sun, 'a time of unbelievable calm and beauty, but how much I walked to get to each motif in less than a moment!' Nature itself changed, making his motifs 'unrecognizable', and he was driven from Pourville by the frightful weather, determined to return the following year to finish his works, and concluding with unusual calm, 'Well, it's a queer job being a landscapist'.[114]

During the summer Monet probably began the *Morning on the Seine* series, 18 paintings of a backwater near Giverny (ills.251 and 253). This too was a return to an intensely familiar theme, for not only had Monet painted many works on this stretch of river, but the view up or down the Seine (he never painted such a view elsewhere), across a sheet of water bordered by trees which can scarcely be distinguished from their reflections, had been one of his most persistent themes at Argenteuil, Vétheuil and Giverny. A journalist, Maurice Guillemot, described how he accompanied Monet one August morning in 1897 at 3.30 a.m., passing through his garden with its awakening flowers and through the misty fields to the Seine near the Île des Orties where the family moored its boats, and where Monet worked from a flat-bottomed boat, changing his canvases as the sun dispersed the morning mist. Guillemot said that the 14 works which he saw Monet painting had all been started at the same time – presumably on a single morning – and that he had been working on them since the previous summer.[115] The weather had then been so bad that Monet had been unable to go on with these paintings of perfect summer mornings, and he may have had to leave them in the state indicated by two unfinished paintings of the Seine at Port-Villez (W.1379–1380), in which he painted the trees and their reflections as a single continuous shape like a vertical cut-out, with no indication of the horizontal plane of the water except for slight changes in the direction of the brushstrokes.

By late January 1897 he was back at Pourville 'visiting all my motifs'; the grass was greener than the year before, and one of his motifs – of which he had begun several canvases on his previous visit – was, he said, threatened with tourist development, so he had to work fast before the grasses were burnt and the 'beautiful movements of the ground' were levelled.[116] This was the site of seven views of the val Saint-Nicolas, looking towards Dieppe (W.1465–1471), a motif very similar to one Monet had painted at Fécamp in 1881 (W.653–654; ill.162). The weather in 1897 was even worse than the year before, and the grasses and the angle of light changed so quickly that by the end of his stay in late March, Monet had come to the conclusion that he should have begun a new work for each effect of light, rather than transforming paintings as effects changed, because he succeeded only 'in making bastardized, imprecise things . . .'.[117]

Nothing of Monet's anguish was expressed in the 40 calm and delicate paintings of Pourville which he probably worked on in the studio until mid-1898 when he exhibited 24 of them in 6 groups of motifs. Unlike the works of 1881–2, few of the later works represented rapidly changing light or weather, although Monet's letters were full of complaints about rain, hail and wind. Instead, most have a dreamlike

stillness, undisturbed by any human presence, and even the occasional white sail serves to accent the harmonies of soft colour, rather than to suggest modern recreation.

The light which pervades *At the val Saint-Nicolas, near Dieppe, morning* (ill.252) is like a light which will never end, while the broken colours, patches of sun and shadow of a similar motif in 1881 suggest a moment of rapidly changing light. The colours – iridescent greens, mauves, rose-tinted oranges – are now closer to the mother-of-pearl colours favoured by the *fin de siècle* than to the colours of nature, yet the fusion of the shimmering, evanescent colours with the looming bulk of the cliffs conveys the pervasive brilliance of coastal light more intensely than did the more descriptive earlier painting, and the subtlety with which it is suggested that the shadowed cliff face is radiant with reflected light, or that the grass catching the light is full of dew, makes the earlier work seem approximate, hasty and generalized.

Monet's return to Pourville was not just a return to particular painting sites, but to the coast of his childhood and to his 'element', yet his mode of painting allowed the effacement of conscious memory, in such a way that what he had previously known of this coast – as child and as painter – could unconsciously permeate his seeing. These paintings thus attain a form of continuity which is lacking in earlier ones, and they suggest a characteristic *fin de siècle* nostalgia for some lost past, dreamlike, distant, ungraspable.

The *Morning on the Seine* series to which Monet returned in the summer of 1897 seems like a tribute to the silvered harmonies of Corot's paintings of trees reflected in still water. Geffroy described Monet rowing up and down the river, searching 'with infinite slowness and care' for a motif which was itself 'decorative' so that nothing would distract from his contemplation of light.[118] Seen always in fine weather and from one unchanging viewpoint – looking east down a backwater of the Seine – no series had been more unified. The 14 paintings were begun at dawn and continued no later than early morning, so each phase of light would have melted into the next. It seems a crude irruption into this dreaming consciousness to mention that it was precisely at this time that the Lumière brothers were transforming the 'moment' of the photograph into the continuity of film by multiplying and fusing its successive phases. The two modes of expression were very different, but like many contemporary cultural forms, both aspired to the expression of temporal continuity.

The new paintings of the Seine share the dreamy, meditative character and the evanescent, almost precious colour schemes of those painted on the coast; the latter, however, combine warm and cool colour scales, while the river scenes are characterized by cool harmonies of green, blue, lavender, mauve and silvery white. Only occasionally are they warmed by hazes or touches of rose and gold, or sharpened by an orange-pink dawn sky or the brilliant blue of a daylight sky just freed from mist. Monet had never used such a consistently refined technique, with veils of thin paint, little impasto and relatively few discrete brushstrokes.

In what is perhaps the first canvas (ill.251), begun after dawn, the paint suggests that mist veils the scene so thickly that the trees and their reflections are like shadows in the haze of milky, opalescent lavender and saturated blue tinged with scarcely visible violet, green, blue and pink, and the only distinct brushstrokes are those which suggest leaves emerging to light and echoed in the reflections. In a slightly later 'moment' (ill.253) Monet depicted the surface of the river stirred by the faint breeze which comes with the warmth of the day; mist thins, and

trees begin to acquire form; on the left, solid is not yet distinguished from mist and reflection, and is fused with them in a violet-green haze. In successive paintings, forms become more clearly differentiated, more layers of foliage are revealed, reflections mirror more precisely the fusion of leaves and light above them. Perhaps no earlier series had more insistently involved the spectator in the poignancy of passing time, as seen in the dual continuities of nature and of the artist's perceiving consciousness.

Monet told Guillemot that he wanted to prevent the spectator from 'seeing how it's done', and if this is true of any of his works, it is true of this series: the paintings tempt one to forget that they were 'made with paste on a piece of canvas' (to quote Mirbeau), and to write such things as 'the stillness of dawn light is so fragile that one almost holds one's breath', as if confronted (again in Mirbeau's words) 'with nature itself', rather than the most intense and delicate artifice.[119] The sense of a transparent relationship between painting and nature derives from a profound concordance between the gradual revelation of form through light, and the processes by which Monet moved from generalized impressions to the most intense perceptual awareness: just as the rising sun made trees and water visible, so he developed his painting from undifferentiated areas of colour, using ever more precise brushstrokes to create images whose very structure conveys his processes of visualization.

The *Morning on the Seine* and the Pourville paintings, fragile evocations of a nature undisturbed by human concerns, were being finished at Giverny at the height of the Dreyfus Affair in which Monet's closest friends, Mirbeau, Geffroy and Clemenceau, were deeply involved. Monet wrote three letters to Zola, on trial for defamation of the Council of War which had condemned Dreyfus as a German spy, expressing his 'admiration for your courageous and heroic conduct', and his regret that, 'ill and surrounded by the ill', he could not come to the trial 'to shake your hand'. He signed one of the *'protestations des intellectuels'* published in *L'Aurore* in support of Zola's *'J'Accuse'*, his denunciation of the government and army machinations designed to conceal the truth. Monet refused, however, to sit on a pro-Dreyfus committee, because, he said, he was not 'a committee man'.[120] There is no trace of the passions unleashed by *'l'Affaire'* in the tranquil paintings of the late 1890s, and indeed, he was wrapping the protective screens of his own creation ever more securely around himself.

Guillemot commented that the motifs provided by the water-lily pool he visited with Monet in August 1897, were

the models for a decoration for which he has already done some studies, large panels which he later showed me in his studio. Imagine a circular room, the dado below the wall moulding entirely filled with a plane of water scattered with these plants, transparent screens sometimes green, sometimes almost mauve. The calm and silent, still waters reflecting the scattered flowers, the colours evanescent, with delicious nuances of a dreamlike delicacy.

Guillemot probably saw a group of works in which the artist painted the surface of the pool as if looking steeply down upon it, with only the membranes of the water-lily leaves to hint at the horizontal plane of water.[121] The entire surface of each painting is composed on a sheet of motionless water, painted in limpid greens or blues, and accented by pink or white water-lilies and their green and violet leaves (ill.244).

Having brought water into the enclosed world of his garden, Monet was now using it as another means of transforming external reality into the world of painting. Visitors commented that the artist

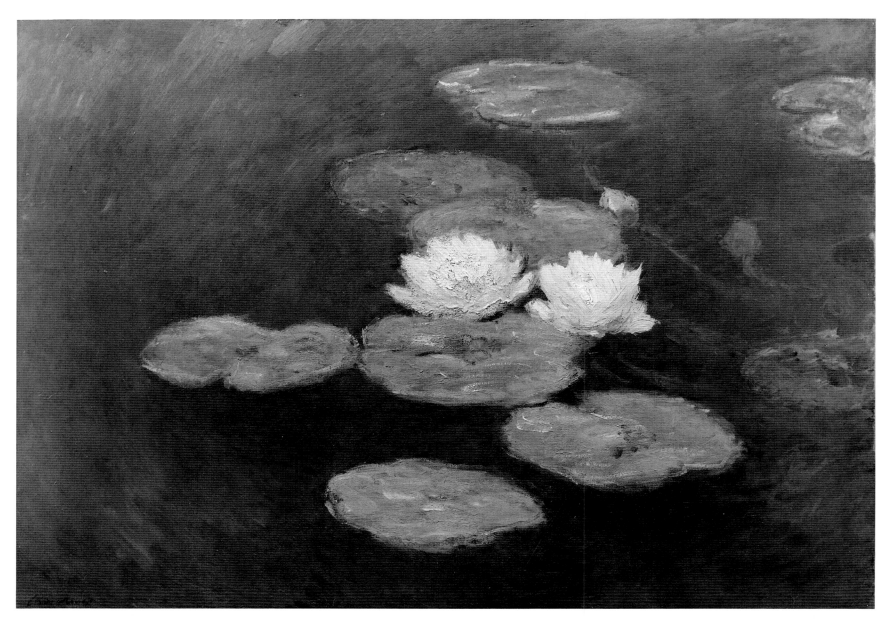

244　*Water-lilies, evening effect* (W.1504), *c.* 1897–8, 73 × 100 (28½ × 39)

composed his garden as he composed paintings. This was particularly true of his flower garden, where his wealth enabled him to employ gardeners to change the colour effects created by massed flowers according to the season – thousands of mauve irises, violets and violas would, for example, be set against red tulips, yellow roses and 'showers of golden *doronicus*'. The contrasts and harmonies of blocks of colour and flowers suspended in space on arches and pergolas had strong similarities to Monet's paintings with their rich encrustations of colour and linear articulations. The 'violent *polychromies*' of the flower garden were complemented by the softer colours of the water garden, with its harmonies of rose, white and mauve amid the many greens of trees and bushes, while at the centre 'the vast and palpable mirror' of the pool reflected willows, poplars, alders and ash trees, irises and pampas grasses.[122] The water garden was, then, a re-creation of that motif which had fascinated Monet for decades, a surface of water reflecting the trees and sky above it.

The notion of a painting designed for an architectural setting and almost entirely given over to the fragile, reflective surface of a pool goes back to one of the four decorations which Monet painted for the dining-room of the Hoschedé mansion in 1876. The earlier decorative schemes were composed of isolated panels, whereas that described by Guillemot was related to the contemporary fashion for integrated decorative schemes influenced by the rococo revival of the 1890s, such as the spectacular dining-room designed by Charpentier with decorative panels interlinked by carvings of the sinuous plants beloved of the late nineteenth century.[123] Although very different from the simple refinement of Monet's own yellow dining-room, the two schemes were based on the idea of creating a harmonious background for one of the chief pleasures of life.

The tension between '*décoration*' and '*décor*' was fundamental to late Impressionism. '*Décor*' had only a superficial relation to nature and amounted simply to pleasurable ornamentation, significant only so far as any cultivated sense-experience was significant. '*Décoration*' derived from what Pissarro called an 'intensely felt' enquiry into nature. It was pleasurable because it accorded with the essential harmonies of nature, but, by the same token, it was intensely demanding and could be profound. In 1892 Pissarro told his son about a conversation with Degas, who maintained that a '*décoration*' must be done 'for an

architectural ensemble', and that easel painting as a decoration was 'an absurdity': so Pissarro's excitement about Monet's *Cathedrals* ensemble may have been inspired by his realization that decorations could be created from an interrelated group of easel paintings derived from 'research' into nature. Clemenceau confirmed such a notion when he wrote of the *Cathedrals* as a sequence of transitions of light on four walls embraced by 'a sweeping circular gaze'.[124] Was it this which gave Monet the idea of a circular room, an idea which would now never leave him? If the dispersion of the *Cathedrals* had effectively destroyed their meaning, it may have seemed to him that the only way to ensure the expression of continuing consciousness through an ensemble of paintings was a permanent architectural installation, 'something durable' in a different sense.

Monet's imagery was closely related to that fashionable in the 1890s, when paintings of water-lilies in a pool or river, enclosed by foliage and fringed by reeds and water irises, abounded in the Salons (indeed, since the 1860s there had rarely been a Salon without such paintings; ill.247). The water-lilies appeared in both contemporary subjects, particularly of girls on the water's edge or in a boat, and in the infinite variations on the theme of nymphs of wood and water, of which Checa's *Nymphs* (Salon 1899), with its piled-up female bodies by a pool with water-lily pads and irises in 'the trembling shadow of the willows', was typical. These evocations of soft flesh, arranged according to the formulae of respectable eroticism, were used to symbolize the spirit of nature, yet with such artifice – the nymphs all look as if they came out of the same mould for the desirable body of the 1890s – that nature withers.[125] Their imagery of enclosed pools, water-lilies and willows emphasizes the radical emptiness of Monet's paintings, which allow the pool to be invested with desire, and which have a hold on the imagination all the more strong for being elusive.

One of the most complete of the *Nymphéas* paintings contains the image of a white water-lily doubled by its dark reflection (W.1505). When Monet was in Pourville earlier that year, 1897, Mallarmé had sent him a copy of *Divagations*, a collection of his prose writings, containing not only his 1876 essay, 'Manet and the Impressionists', and his preface for the catalogue of the commemorative exhibition of Morisot's works, but also 'Le Nénuphar blanc', which Morisot had illustrated in 1888–9. Monet promised Mallarmé he would read his book 'with all the care and the concentration it deserves', and may again have been inspired by the image of the water-lily – which wraps in its 'hollow whiteness a nothing made of intact dreams, of a happiness which will not take place' – to meditate on the potential of a painting marked by absence, and to consider the implications of Japanese art as one which 'evokes presence by a shadow, the whole by a fragment'.[126]

Although the Decadents (satirized by Mirbeau in his 1895 article 'Les lys, les lys!'), had appropriated the 'mystic lotus' of Japanese Zen Buddhism for their modish mysticism, Japanese Zen – extensively written about in contemporary texts – could have suggested to Monet a model of contemplation by which to attain direct communion with nature. By its means, the mind divests itself of conscious knowledge in ways which could have confirmed his desire to paint 'without knowing what he saw', so that his consciousness could open to the wholeness of being.[127]

Monet did not complete the decorative scheme he had discussed with Guillemot, perhaps because he could not reconcile the evanescence of the motif with an architectural setting – and when he returned to the theme in 1899, he painted a corner of the pool more descriptively, with

245   Gaston Bussière, *Iris*, from Armand Silvestre, *Le Nu au Salon de 1898*, 1898

246   Upiano Checa, *Nymphs*, from Armand Silvestre, *Le Nu au Salon de 1899*, 1899

more conventional compositional framing. Some of the paintings disappeared into his cellars where they were forgotten until he found them just before the 1914–18 war, when he was reviving the idea of a decorative scheme composed of paintings of his water-lily pool.

Guillemot's article was published in March 1898, and was probably intended to inform his readers how to look at the *Morning on the Seine* series in Monet's forthcoming exhibition at the Galerie Georges Petit, for he concluded:

if one did not know – through confidences in conversation – the length and the patience of the work, the conscientiousness of the research, the feverish obsession of this two years' work, one would be astonished at this desire: 'I would wish to prevent one from seeing how it was done'.[128]

Having let a journalist in on his secrets, it is, however, clear that Monet wanted the spectator both to be aware of his practice and to be prepared to suspend this awareness in contemplation of the unfolding effects, and that he sought to maintain the viewer's consciousness both of nature and of artifice.

The large number of articles on this exhibition joined in an almost unanimous chorus of praise. Geffroy found that the seven *Cathedrals* exhibited decisive examples of 'a meeting between and a penetration of the force of nature and of human work' – an observation deriving from his sense of pantheistic wholeness. Younger critics introduced a new emphasis on the temporal continuity of Monet's work: Roger-Milès noted briefly that Monet 'was not only content to observe things in the space of a landscape; he observes them in time . . .', while in *Le Mercure de France*, André Fontainas contrasted holiday-makers' conventional 'immobile' views of nature with the experience of the solitary landscapist who voluntarily deprives himself of the pleasures – even the intellectual pleasures – of the capital, and isolates himself in the country, attentive only 'to that which passes, has only one time and disappears'. He claimed that Monet saw and expressed 'the living element of a moment of nature', in this way suggesting that the moment was not isolated, but possessed a vital element which propelled it in time. Fontainas also extended his notion of the dynamism of Monet's work, claiming that he perceived the particles 'which form an impalpable atom' and imaged 'the multiform palpitation of the atmosphere'.[129]

All the critics commented on the ethereal softness of the 24 paintings of the coast and the 12 paintings of the Seine, and most noted the relationship of the latter to Corot's landscapes. Geffroy claimed, 'What is new is a sort of evaporation of things, a melting of colours, a delicious contact of surfaces with the atmosphere'; 'the vibrations seem to be softened; the prism has paled; gaudy brightness is succeeded by milky, caressing colouring', wrote the critic of the *Chronique des arts*. The latter was the only writer to have reservations about Monet's art, suggesting that its intensely personal character may have been 'the consequence of the spiritualist movement which agitates the present generation'.[130]

Late 1898 and early 1899 were marked by the deaths of Mallarmé, of Sisley and of Suzanne Hoschedé-Butler, for whom her mother's grief was long and intense. By now, Jean Monet and Jacques Hoschedé, Alice's elder son, had left home. Of the four sons of the Monet and Hoschedé families, only Jean-Pierre Hoschedé seems to have been able to lead a normal life; those of the others were perhaps stunted by the dominance of the patriarch Monet. Several of the children were unable to separate themselves from the double family, with some having almost incestuous relationships within it. Monet had raged at the

prospect of Suzanne's marriage to Theodore Butler; she had been paired with his son Jean in paintings of the 1880s, but it was Blanche Hoschedé who married Jean, her stepbrother, in 1897, while Marthe, the eldest Hoschedé daughter, took Suzanne's place after her death, marrying Butler, her widower, in 1900. Finally, after the deaths of her mother and husband, Blanche Hoschedé-Monet returned home in 1914 to keep house for her stepfather-cum-father-in-law. Something of the emotional intensity at the heart of this household is suggested by a passage in Alice Monet's diary, written four years after Suzanne's death, when she found Mirbeau's comments on the painting, *Suzanne with sunflowers*:

What more beautiful model could one have than you, my daughter, my supreme perfection. . . . 'She is of a delicate beauty (says Mirbeau's article) and sad, infinitely sad – (Did you see the future, that death which would bear you away from us all?) . . . Involuntarily one dreams of some delicate, ghostly and real, spectre of a soul!'
   Isn't that an extraordinary divination – Poor child![131]

There was, then, one person in Monet's entourage, the one closest to him, who seems to have believed in spiritualism.

Monet returned to the theme of water-lilies – which had had a special association with Mallarmé and perhaps with Suzanne, his favourite model in the late 1880s – in the spring and summer of 1899, when he painted the first of two series of his water-lily pool. It was now thickly overhung with willows and other trees and surrounded by clumps of water irises and grasses – although, as contemporary photographs show, it was never as densely enclosed as Monet represented it, and always allowed views to the meadows and hills beyond it. He painted the 11 works of the 1899 series from directly in front of the Japanese bridge, looking east into the little pool, taking up a position so close to the bridge and the screen of trees and bushes that nothing, not even the sky, could be seen beyond this world of water, foliage and flowers. *The Water-lily pool, harmony in green* (ill.248) gives a sense of the almost claustrophobic enclosure characteristic of the series: the long verticals of the willow fronds and their reflections penetrate the entire surface, and are woven in and out of the horizontal planes of the lily pads as if to lock every detail into stillness.

These works were painted more descriptively than any other series, almost as if Monet were making an inventory of what his garden could offer before beginning to paint it with the intensity of his other Giverny paintings. More literal than the *Nymphéas*, the series may have owed something to Helleu's paintings of a pool at Versailles which reflects trees and bushes on a surface strewn with leaves (Musée d'Orsay). Thus when Monet first introduced the fragmentation of time into paintings of his garden, he did so in over-controlled compositions which lock the spectator out. The rigidity of enclosure – which one could contrast with the idealized freedom of the image of Suzanne reflected in the Epte – reminds one of the many paintings in which Monet enclosed his family within the protective garden. Yet, while the theme of the water-lily may recall the paintings and drawings of Suzanne and her sisters boating in the late 1880s, unlike the unseen lady of Mallarmé's 'Le Nénuphar blanc', Suzanne had been real and was now dead, and this is perhaps felt in the unresonant emptiness of the 1899 paintings.

In 1898–9 Mirbeau, that other passionate gardener, wrote *Le Jardin des supplices*, a horrific evocation of a monstrously perverted garden, fertilized by the blood and flesh of those killed in the prison surrounding it, and filled with eroticized flowers and with instruments of torture 'so intimately mingled with the splendours of this orgy of

flowers . . . that they seem . . . the miraculous flowers of this soil, this light'. The garden in the novel must have been based on Monet's, for at its centre, reached by an avenue of dead trees which were hollowed out to hold bodies 'subjected to hideous and obscene tortures', is 'a vast pool' on to which open winding paths; it is crossed 'by the arch of a wooden bridge painted bright green', and planted with irises, arches of wistaria and water-lilies. The narrator, who is guided through these horrors by his lover, an Oriental *femme fatale*, sees the irises as 'diabolic flowers' with 'the colours of blood', the water-lilies as 'floating, decapitated heads', and the garden as symbolic of 'the universe . . . an immense, inexorable garden of tortures':

The passions, the appetites, the interests, the hatreds, the lies; and the law, social institutions, justice, love, glory, heroism, religion are the monstrous flowers and the hideous instruments of eternal human suffering. . . . And the individual-man and the crowd-man, and the beast, the plant, the elements, indeed all nature, impelled by the cosmic forces of love, throw themselves into murder, believing that it will thus find gratification for the raging forces of life. . . .[132]

It is possible that Mirbeau, profoundly shocked by the Dreyfus Affair, conceived the violated garden as a metaphor for the corruption of France, by which even nature was hideously polluted. It is hard, however, to imagine that Monet, the uxorious, family-centred, *bon bourgeois* lover of nature, could have appreciated his friend's transformation of a paradise garden so like his own into a place of disgusting cruelty; indeed it is hard to imagine how he could have continued to paint it. He must have had to struggle to preserve his created world from contamination by morbid, *fin-de-siècle* perversities, so that his pool could continue to act as a space of desire. Indeed, the rigid perfection of the *Japanese bridge* paintings of 1899 may reflect something of this struggle. His mode of painting involved forms of consciousness which empty the mind of literal associations, which play on absence, and which, of course, cannot be censored, and, after having read *Le Jardin des supplices*, it is almost impossible to see the naturalistically implausible and pictorially disturbing reds which stain the second group of pictures of the *Japanese bridge*, painted in 1900 (W.1509–1520), without speculating whether Monet's vision had been unconsciously influenced by Mirbeau's blood soaked garden.

In 1899 Monet was included in two important group shows, one organized by Durand-Ruel and another by Petit, with the orchestrated publicity which had by now become a feature of his exhibitions. In the Durand-Ruel exhibition, his 36 paintings were exhibited with those of Corot and his old comrades, Renoir, Pissarro and Sisley, each of whom had a room. Corot was at that time acknowledged as the greatest French landscapist of the nineteenth century, so the exhibition was probably intended to locate Impressionism in the national tradition. Recognizing that the show 'invited' the visitor to form a historical view, Natanson produced a torrent of generalizations on the 'French spirit', and concluded that the Impressionists now had an assured place in the Louvre. Leclercq agreed, maintaining that Impressionism was 'a glorious chapter to add to our history of French art'.[133] One cannot ignore a certain note of finality in this consigning of Impressionism to history in the last year of the nineteenth century.

The dealers may have arranged these displays to ensure that their artists would be adequately represented in the Exposition Centennale de la Peinture at the Exposition Universelle celebrating the first year of the new century. Monet and his friends refused to participate until they

were assured that their work would be adequately represented in a room of its own.[134] In contrast to the State's unwilling acceptance of the Caillebotte bequest only a few years before, the Exposition Centennale marked the official acceptance of Impressionism, with Monet recognized as its chief exponent: the director of the exhibition, Roger Marx, celebrated him as the equal of Corot and Turner, and the mass-circulation *Le Temps* decided that this was 'the moment' to make him known to its readers. Its critic, Thiébault-Sisson, gave wide currency to the myth of Monet being self-educated, to his 'years of trial' and his ultimate triumph, ending in a flurry of fashionable phrases – 'the most penetrating and the most true, the most poetic and the most moving of *décors* . . .'.[135]

Although extravagantly praised, Monet's painting did not go unchallenged, and perhaps the attempts to establish his position in the French tradition caused some conservative critics to make what was to be their last protest against what they saw as the anti-humanism of his modernist vision. Michel wrote that in Monet's earlier works,

it seems that the world appears in its first freshness still palpitating in the divine 'Let there be light'. But in *Vétheuil in summer*, in the shattering of this pink village which gives the impression of being dissolved, crumbled and pulverized in the wild palpitation of atoms, I fear a cataclysm. . . . I wish to go and restore my eyes with some nocturne, to go and meditate in front of a Cazin, to rest in front of a Corot . . . or even to reassure myself of the solidity of the world in front of . . . [a] Courbet. . . .

The critic of that bastion of conservative opinion, *La Revue des deux mondes*, Robert de Sizeranne, commented that although 'modernist theory' maintained that 'every modern form was aesthetic',

after having proved that a railway station was as worthy of representation as the ruins of Tivoli or the Temple of Vesta, the modernists have been able to paint a picture of it only by melting all line in clouds of luminous vapour – [so that] it no longer has anything more modern about it than the sun from which it receives all its beauty.[136]

De Sizeranne was writing of the two Gare Saint-Lazare paintings exhibited (W.440, 442), but his words apply more strongly to a series of paintings of the Thames which Monet had begun the previous autumn.

Monet's visit to London in September–October 1899 enabled him to fulfil a long-postponed desire to paint a 'series of London fogs'.[137] For more than a month he painted the view from his room in the Savoy Hotel – an appropriately more elevated location than that from which he painted *The Thames and the Houses of Parliament* in 1870–1 – returning to Giverny with what he called 'vague essays'. Even if they were, Durand-Ruel reserved eleven, and one was sold before Monet returned to London in February 1900 with at least some of the canvases he had promised the dealer. Arriving at the height of the Boer War, when there was a certain amount of anti-French feeling, he again took up residence in the Savoy, on a lower floor 'with a less plunging view', where he set up easels at the windows of two rooms so that he could move from canvas to canvas as the light changed. On this and on his next visit, early in 1901, he painted two motifs – looking to the south-east from the hotel to Waterloo Bridge and the South Bank, and west to Charing Cross Bridge and the Houses of Parliament. He also arranged to work from a terrace in the open air at St Thomas's Hospital directly across the river from the Houses of Parliament, going there daily at 4 p.m. to paint the sun setting behind the huge silhouette of the mock-Gothic building (having persuaded the hospital's almoner that his 'fever of commencements' should not be interrupted by cups of tea).[138]

Monet was fascinated by the ways light was made visible in the smoke, mist and fog of the poisonous London atmosphere which he

247    J. Ambroise, *Water-lilies*, 1896, from the *Catalogue illustré du Salon*, 1896

articulated with the metal scaffolding of the railway bridge, the stone arches of the road bridge, factory chimneys and the attenuated towers and pinnacles of the Houses of Parliament. When the series was exhibited in 1904, the titles of the works were listed under their motifs (for example, *Sun shining through a gap in the fog*, was listed under *The Houses of Parliament*), indicating that Monet wished his public to see the atmospheric effects as much as the only too well-known symbols of London. His daily letters to his wife give a vivid picture of his obsession with effects which changed so rapidly that he was forced to produce over 100 canvases, which marked the almost manic end of this kind of serialization. Once, he was interrupted three times in a day by changes of light so extreme that he could not work, so he seized the opportunity to write: he had been up at six to find 'a terrifying clarity'; then 'the sun rose with blinding light. . . . The Thames was nothing but gold. God, how beautiful it was; I began work in a frenzy, following the sun in all its sparkling on the water.' Kitchen fires were lit, smoke made the familiar fog, clouds came, and by 9 a.m. he had worked on four canvases. At 2.30 p.m. he was interrupted again, exclaiming at the 'fantastic day. So many marvellous things . . . but none lasting five minutes . . .'. It was so dark that he had to put on a light, 'But there's natural light again, I'll stop'. At 5 p.m., he ended for the day, having done in the interval 'the sketch of a marvellous effect'.[139]

This kind of experience is repeated in letter after letter as fog, mist, sun, snow, rain, hail succeeded one another, and, as the season advanced, the sun changed its course (in the *Houses of Parliament* motif, the sun reappeared after being obscured for days, only to be out of the picture!). At the end of two seasons Monet concluded that he could not finish his paintings in London, but, of his 100 canvases, some at least had been brought to that state of completion where studio work would consist of finishing touches, not major structural painting.[140] Throughout the months he spent in London, Monet oscillated between two solutions to the problem of changing light: he would paint a new canvas in response to every change of light and weather, presumably with the intention of doing major work on it at home, or perhaps of leaving it as an

impression; or he would try to match an effect to a previous picture, and when it was clear that 'the moment [would] never return', he would transform the painting. He later said that when an atmospheric effect changed he would search 'feverishly' through piles of roughly painted canvases (*ébauches*) for one 'which did not differ too much from what I saw; even then, I would modify it completely'.[141]

Monet's letters record the multiplication of canvases: in little over a fortnight, he had commenced 44; three days later he had just begun the 50th; shortly after, he wrote that he had so many canvases that he could not hope to finish them, and that he could spend only one or two sessions on some, but still worked eleven hours in one day. The next day he was pleased that he had 'boldly transformed' some *Houses of Parliament* canvases, but two days later he wrote:

Today was a day of terrible struggle. . . . All I lack is canvases; for it's the only way to arriving at something, to put as many in train as possible for every effect of weather, every harmony. . . . at the beginning one always believes one will find one's effect again and thus complete them; this belief inspires those unfortunate transformations which are useful for nothing.[142]

He then had 60 canvases, 'covered with colours'; two days later, after a terrible rage when he wished to give up the whole project, he decided he should simply wait 'with folded arms' for his effect. Just before he left London, he wrote that his developing understanding of the weather had led him to 'slash' at his 'canvases with heavy blows of the brush — canvases which had given me much trouble, and were nearly finished, but which were not sufficiently Londonian [this was his adjective] . . .'. He announced his return with 80 canvases 'which are only essays, researches, preparations . . . mad and useless researches'. Yet in the two months he had 'ceaselessly watched this Thames', he had seen beautiful things, and was determined to return at the same time the following year.[143]

He does not seem to have worked on the London canvases that year in Giverny, and worked instead 'in nature', painting the second group of pictures of *The Water-lily pool* (W.1509–1520), as well as his first sustained group of paintings of his flower garden and orchard.[144] When Monet exhibited 14 paintings of the *Water-lily pool* at Durand-Ruel's in December 1900, the Symbolist poet Verhaeren claimed that they evoked

the whole of nature. One intuits the entire garden in this simple display of water and grasses. One senses the subterranean life at the bottom of the pool; the thick growth of roots; the intertwining of the stems, of which the flowers, massed on the surface, are only the continuation. Monet will never succeed in restricting himself to the motif, because his strength will always push him beyond it.

Verhaeren said that Monet could be called a 'great poet'. Such a one is

condemned to remain grave, sincere and anguished before nature. Little by little, he comes alive in it, and, in its turn, nature comes alive in those parts of the brain which observe, study, admire and reproduce it. In hours when work is fruitful, the union is complete. Individual life and universal life fuse. The poet becomes the universe which he translates.[145]

When Monet returned to London in January 1901, he brought with him many of the 80 canvases he had previously painted, which meant that, despite his earlier resolutions, he was to continue the practice of 'transforming' canvases when effects of light changed.[146] He was pleased to find that the universal mourning black for the death of Queen Victoria did not affect his motifs, and regretted that he did not paint a sketch of her (more colourful) funeral procession, but was soon in the usual throes of frustration, excitement and despair — intensified this

248    *The Water-lily pool, harmony in green* (W.1515), 1899, 89 × 93 (34¾ × 36¼)

249   *Vétheuil, at sunset* (W.1644), 1901, 90 × 93 (35 × 36¼)

250    *Waterloo Bridge* (W.1568), 1903, 65 × 92 (25¼ × 36)

time by the depression of his wife, which elicited, besides deep concern, a very clear statement about the separation of his painting from his emotional concerns. He felt remorse that he was 'occupied in searching for pretty colours while you suffer', 'although that won't change anything', and a day later he wrote of his 'love for this damned painting'.[147]

His conclusion after six weeks' continuous painting in London was that:

This is not a country where one can finish anything on the spot; the effect can never be found twice, and I should have done nothing but sketches, real impressions. With them and drawings, I could have made the best of it, whereas I worked up to twenty times on canvases which I denatured each time, so that I end up with a mere sketch, which takes only a few instants. . . .

His strain and exhaustion were so great that he fell ill and was unable to work for a month, returning to Giverny with what he called 'studies, sketches, essays of every kind'.[148]

He did not begin work on them for some time, painting his water-lily pool and his flower garden, and returning to another of his 'first loves', Vétheuil, like some enchanted village depicted 14 times over, dissolved into multi-coloured particles as fluid and intangible as their reflections in the water below.[149] The square format of these paintings isolates the motif from its surroundings, an effect which may also have been influenced by the fact that Monet went to Vétheuil by car, which could have fragmented the continuity of his experience of the landscape. He had bought a car in 1901, partly to distract his wife from her grief, and he was to delight in the speed of the modern machine and the mobility it afforded him during his years of absolute concentration on his water-lily pool in the first quarter of the twentieth century.[150]

Monet was also occupied by the extensions to his water garden, and was constantly interrupted by family troubles, writing to Geffroy in late 1902, 'These emotions never cease . . . to dream, to paint, ah yes!' He had promised Durand-Ruel that he would work on 'some Londons', but

251 *Morning on the Seine* (W.1477), 1897,
81 × 92 (31½ × 36)

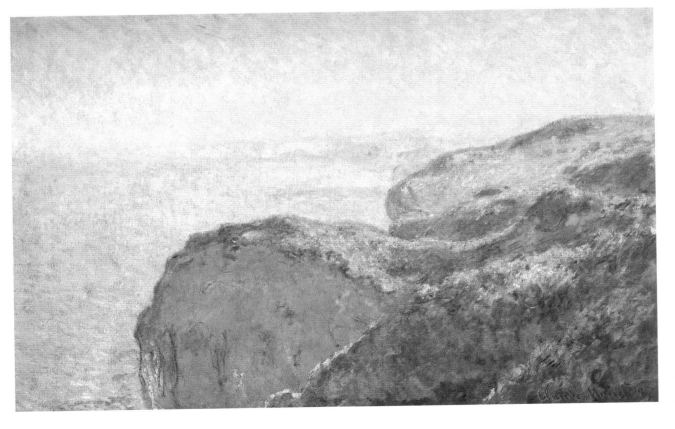

252 *At the val Saint-Nicolas, near Dieppe,
morning* (W.1466), 1897, 65 × 100
(25¼ × 39)

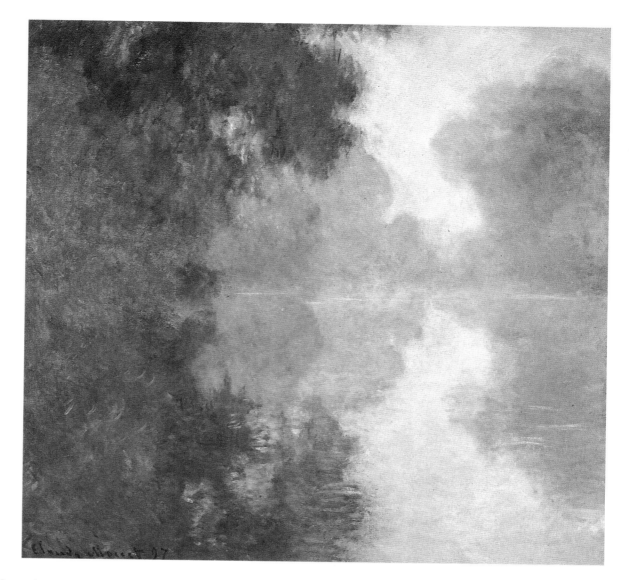

253 *Branch of the Seine, near Giverny, morning mist*
(W.1474), 1897, 89 × 92 (34¾ × 36)

does not seem to have started intensive work on them until nearly two years after his return from London, when he wrote to the dealer:

I cannot send you a single canvas of London, because, for the work I'm doing, it's indispensable for me to have them all under my eyes.... I develop them all — or at least a certain number — together ... and what I'm doing there is most delicate.[151]

This 'delicate' work resulted in the destruction of some paintings (generally only qualitatively), but, he wrote, 'I must go on to the end, ready to destroy them all', and he told Geffroy that he could not show incomplete works, but that he had 'lost good impressions. . . . I've retouched them all, all. . . .' In May 1903 he cancelled his exhibition in a rage, saying he never wanted to think of the paintings again; he spent the summer and autumn painting in nature, returning to the series in January, and working on the paintings until ready for his exhibition of 37 'Views of the Thames' which opened in early May 1904. By that time, as he wrote to Durand-Ruel, he had been working on his 'Londons' for nearly four years; he wanted the dealer to take most of the paintings, and told him that he was pleased that none of them had been seen, since 'the sight of the whole series will have a much greater importance'.[152]

One cannot be sure how much work Monet did on the 'Londons' in the studio. He had brought back to Giverny a number of sketches and studies on which he had spent only one or two sessions, and which he left in this condition as too rudimentary to continue; he was satisfied that the *Charing Cross Bridge, smoke in the fog, impression* (ill.256) gave a sufficiently vivid impression of a transient moment to be exhibited as

such, but did not exhibit *The Houses of Parliament, reflections on the Thames* (ill.254), with its long tentacular brushstrokes pulled across the stabbing horizontals of the water as if weaving a net of shadow. This may well have been the state of finish of many of the paintings which Monet brought back from England, before he decided which were sufficiently 'Londonian', and capable of sustained development.

Some works were painted entirely in the studio, but Monet's words for what he was doing ('retouched' and 'most delicate') still suggest the intensification of existing effects rather than major structural painting away from the motif, and it is probable that most work in the studio — where he could compare the works — was of this kind. In three paintings of *Waterloo Bridge* (ills.250, 257 and 258), in early morning, in brilliant misty sunlight, or swathed in fog but illuminated by a livid gleam of sun, the last layers of paint were composed of scales of colour applied in tiny flickering strokes, longer calligraphic ones, or in cloudy hazes which heighten, through repetition or contrast, the already established colours. The long strokes articulating the arches; the staccato ones suggesting reflections and shadows on the water; the more closely related tones and softer brushstrokes suggesting the immense complexity of buildings on the South Bank; the dots and dashes evoking the dense crowd of people and vehicles on the bridge; the different mauves and pinks smudged on to the smoke — all build up internally coherent scales of colour which both clarify the effect and strengthen the decorative unity of the group of motifs. Studio work took so long because it was not only a physical but a mental process, in

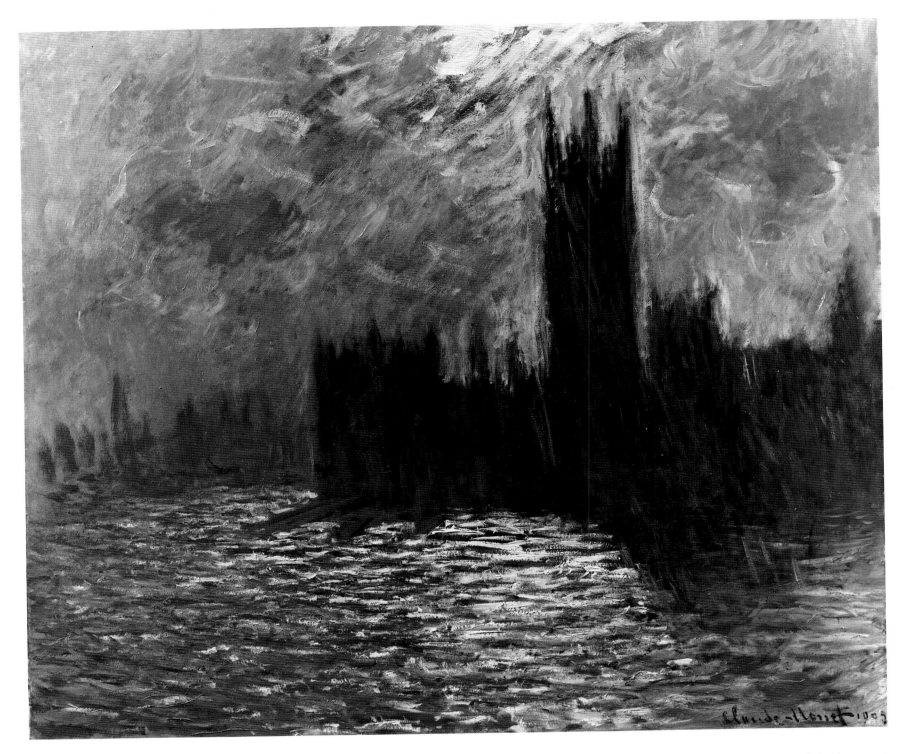

which each painting demanded more precise rememoration of the 'Londonian'. Thus he wrote to Durand-Ruel in 1903, 'No, I'm not in London, unless in thought'.[153]

The 'Londons' lay somewhere between the tourist series of the 1880s and his series of intimately known landscapes, for they were impregnated with time and with memory. The idea of painting them was probably influenced by Monet's desire to return to earlier motifs in order to create 'a kind of synthesis' in which he would sum up his 'earlier impressions and sensations' in 'one or sometimes two canvases'. The one or two canvases, of course, immediately proliferated, but, as late as 1901, he said he would be content to produce 'five or six works' – a fantastic expenditure of many months of 'researches'.[154]

The phases of intensive concentration on the motif interspersed by long pauses for reflection, and long periods of painting far from the motif, allowed a complex interplay between memory and the 'moment of the motif'. For example, Whistler's and Turner's paintings of the Thames are a visible presence in every one of Monet's 'Londons' – not as exemplars external to the painter, but inherent in his remembered perception of his motifs. Geffroy pointed out that, like Whistler, Monet 'painted harmonies, and like him, could have given his paintings titles according to their colour-dominants and nuances'. A work like *The Houses of Parliament, sun shining through a gap in the fog* (ill.259) could be called 'Harmony in red and violet' – but, significantly, Monet preferred the more descriptive title.[155] Whistler's 'composing' of the river by setting fluidity against the tension of the bridges, and his aesthetic placement of the smudgy accents of boatmen in shadowy boats had become part of Monet's process of seeing, and thus was perfectly compatible with Geffroy's insistence that Monet's colours derived from

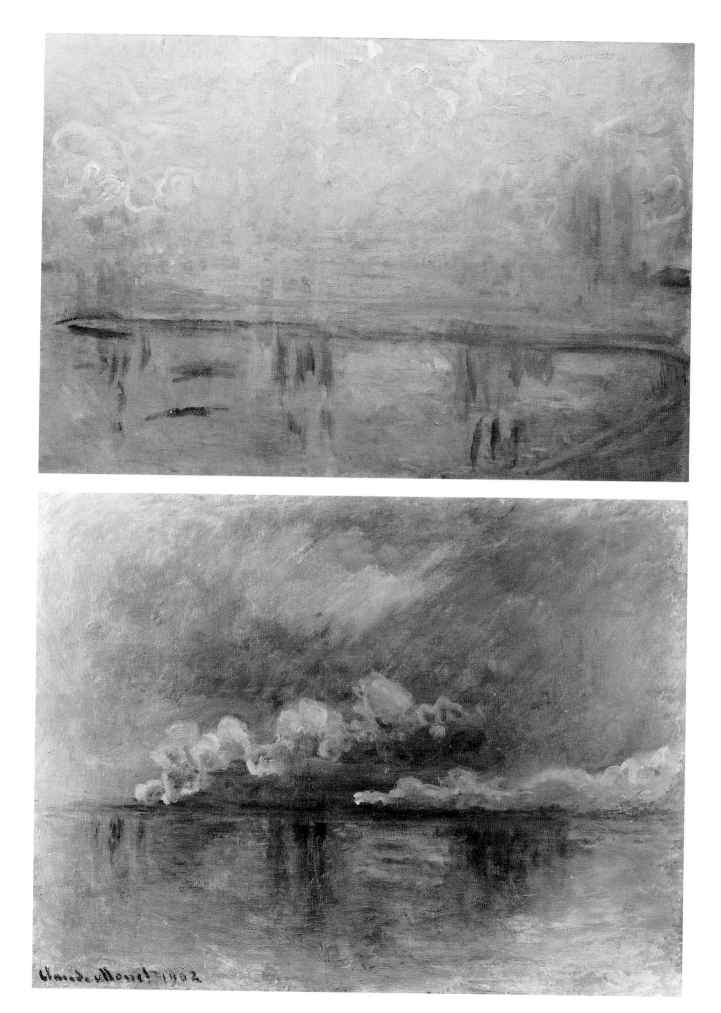

*Opposite:*

254    *The Houses of Parliament,
reflections on the Thames* (W.1606),
*c.* 1900–1, 81 × 92 (31½ × 36)

255    Sketch of *Charing Cross Bridge*
(W.1530), 1899–1901, 66 × 91
(25¾ × 35½)

256    *Charing Cross Bridge, smoke in
the fog, impression* (W.1535), 1902,
73 × 92 (28½ × 36)

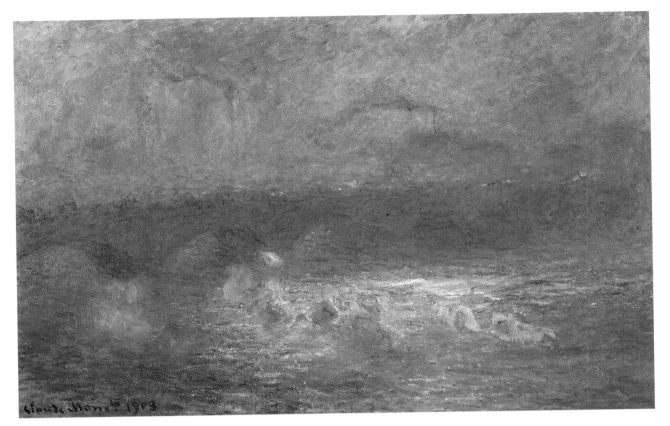

*Opposite:*

259   The Houses of Parliament, sun
shining through a gap in the fog (W.1610),
1904, 81 × 92 (31½ × 36)

257   Waterloo Bridge, sun effect with
smoke (W.1566), 1903, 65 × 100
(25¼ × 39)

258   Waterloo Bridge, effect of sunlight
(W.1588), 1903, 65 × 100 (25¼ × 39)

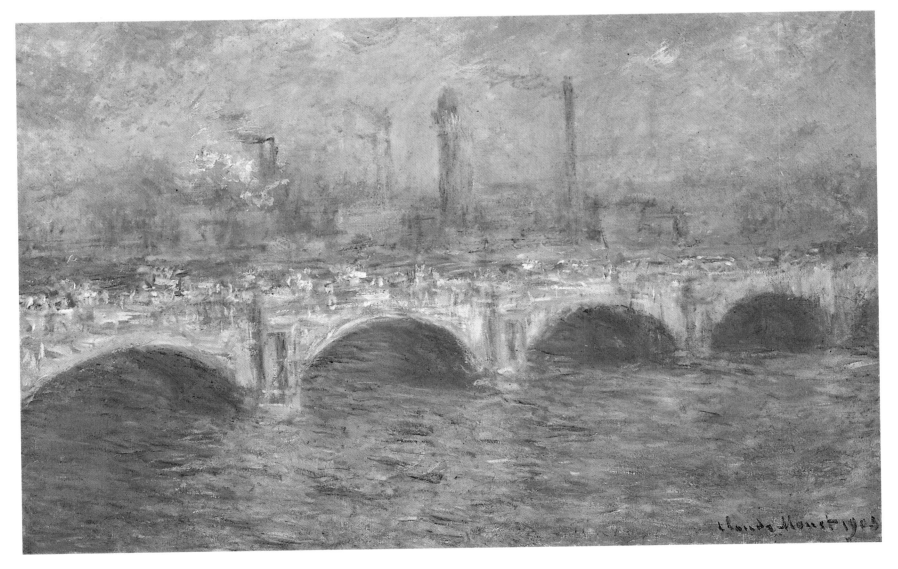

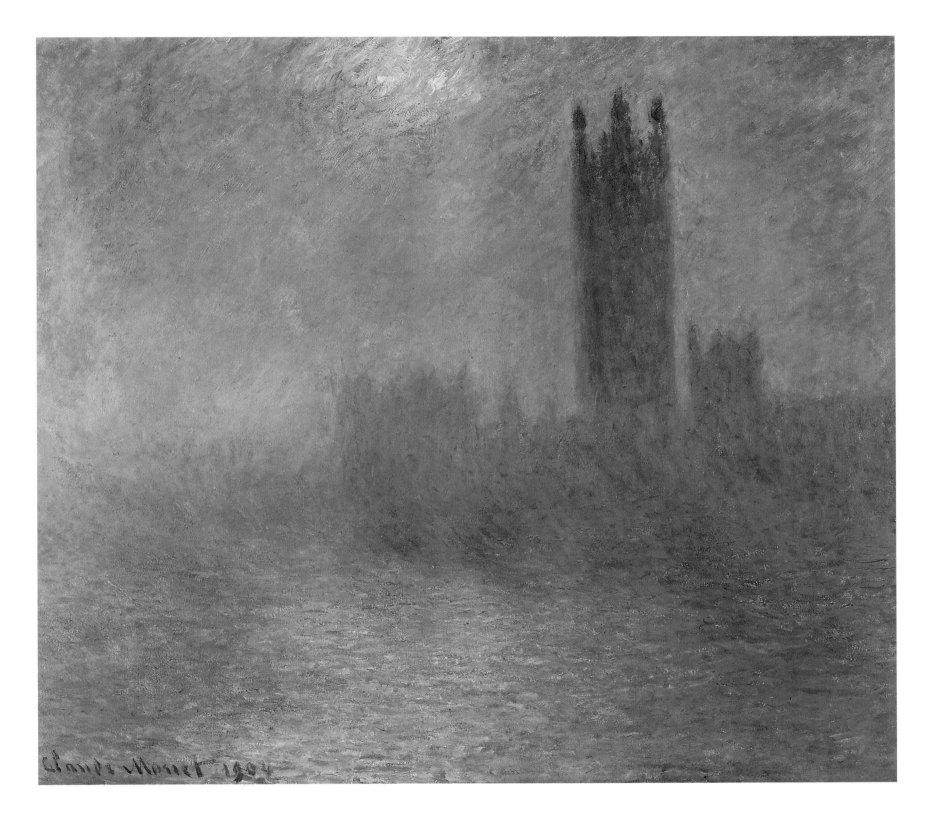

his experience of the motif. Turner's painting was more important, perhaps because the young Monet had found it necessary to reject it, so that it exerted a hidden, discontinuous influence, reappearing in isolated works like *Impression, sunrise* and *Sunset on the Seine, winter effect*. Turner's brilliant transparent hues and his evocations of storm, sunset and fire (in particular in his *Burning of the Houses of Parliament*, Philadelphia Museum of Art) could now have helped Monet realize these huge areas of light-filled space, and could have influenced his last representations of modern life as something both dreamlike and actual.[156]

Nevertheless the very real relationships between the two indicate just how deeply rooted were the 'Londons' in Monet's own painting. It was not only *The Thames and the Houses of Parliament*, nor the constant memory of *Impression, sunrise* with its orange disc emerging from smoky mist to reveal chimneys and docks, but the stretch of river at Argenteuil that was recreated on the scale of the great city: its road bridge and stark railway bridge with the plumes of smoke from passing trains; its factory chimneys and mock-château, all found their equivalents in Waterloo Bridge, Charing Cross Bridge and the Houses of Parliament. These motifs were now located in the heart of a modern city, which Monet had never painted so intensively, even at the height of his enthusiasm for the modern. Perhaps he could do so now because he could paint from his secured home, enclosed in the ideal garden he himself had created, and

could look at the greatest of modern cities as pure spectacle, transforming its poisonous fogs and foul smoke into rose, gold, blue or violet mists, its huge, anonymous crowds, its ceaseless traffic into myriads of sparkling, gaily coloured dots.[157] Monet's total concentration on his motif made possible the involuntary transformation of past experience into his perceptions of the moment, which was rich with accumulated experience. One has only to compare the more generalized effects of the little Thames pictures of 1870–1 with those of the turn of the century to realize how vividly specific the later paintings of the river are. Their brilliantly unreal colours are completely unlike the filthy greys of London fogs, yet they are intensely revealing of the effects which inspired them.

By comparison with the 74 paintings of bridges, those of the Houses of Parliament seem almost visionary. Monet painted the great towers from across the river with the light behind them, so that they are like screens capturing the shadowed and illuminated light which reflects off the great sheet of water. He painted the sun invisible in dense fog, diffuse in sunset mists; it gilds layers of fog or bursts through in sudden dramatic radiance, and its long trailing strokes suggest the myriad pulsating particles of light and dissolve the already fluctuating, attenuated towers and pinnacles. The paintings suggest childhood dreams of enchanted palaces glimmering in a light that never was, yet they are full of extraordinary perceptual revelations: in *The Houses of Parliament, sun shining through a gap in the fog*, thick impasto strokes of brilliant orange, red and yellow represent the sun's rays as a sudden turbulence in a livid red and violet sky; they are reflected on the water in a curiously cold blaze of red, and the great towers cast a shadow across the water like a huge veil filling space in indescribable layers of vermilion, mauve and violet.

The opening of the 1904 exhibition was a social event seen as competing successfully with the Salon, and was greeted with the customary torrent of laudatory prose. Monet himself remarked, somewhat ungraciously after the adulation of over a decade, 'This time the press has overwhelmed me with exaggerated praise'. The paintings sold more than well – Durand-Ruel bought 24 'Londons' at prices between 8,000 and 11,000 frs., for a total of 252,000 frs.[158] Although there was some confusion as to how to react to the evident fact of studio painting, the critics did see a relationship between the truth of Monet's effects and his abstract colour, and the role played by the series in establishing this truth. Gustave Kahn gave a particularly vivid account of the relationship between 'truth' and 'decoration':

Claude Monet has noted rare, perhaps unique, moments so adorned with beauty, diversity and luxury that they can for a moment seem unreal [. . .] and that, before these pyrotechnics of gold, of pink-pink, of pink-red, of pink touched with red, of purple, of grass-green, green which is golden or dark blueish, one might for a moment dream of believing that these visions – based on principles of polychrome ornamentation, rather than on an absolute obedience to nature – are harmonies on a theme given at the moment of the sketch by grace of the hour and its associated colours. . . .

This, Kahn said, would be a mistaken view: the paintings were not 'visions', but finished works 'developed from exact notations', and they embodied a 'struggle . . . with the proteanism of the day which at every

instant lets new adornments and veils of reflections fall into the death of time'.[159]

Mirbeau's preface to the catalogue suggests something of the embarrassment of Monet's supporters over how to discuss the work – and particularly the studio work – which went into his painting of 'moments'. 'These canvases', wrote Mirbeau, 'are the result of four years' reflective observation, of deliberate effort, of prodigious labour' – and then broke off to say that this was 'nobody's business' and that what counted was 'the end result'. Geffroy – who had heard endlessly about Monet's labours in the studio – claimed that the painter remained faithful to his method of work, 'accomplished strictly before nature', and relying on the return of fugitive moments. Admitting that there were other ways to paint masterpieces, Geffroy was emphatic that this was the only way 'to express the magnificent poetry of the moment which passes and the life which continues'.[160]

Monet himself told a journalist that, because he had spoiled so many canvases as a result of the changeable English weather, after 'four years of work and retouching on the spot, I had to resign myself to painting nothing but notes, and to finish here in the studio'. The inaccuracies in this account may have been due to the journalist's ignorance, but it is significant as Monet's first public acknowledgement that he worked in the studio. Although he reacted angrily to later speculation on this matter – 'whether my cathedrals', he wrote, 'whether my Londons or other canvases are painted from nature or not, is nobody's business, and has no importance' – this acknowledgement probably made his subsequent studio work more flexible and more creative.[161]

Mirbeau attacked the Symbolist critics Mauclair and Morice who, he said, demanded that nature should be 'regenerated, intellectualized, polished and cooked' in order to elevate it to 'the majesty of art'. Rejecting Mirbeau's criticism, Morice expressed not only his intense admiration for 'the miraculous precision of these apparitions of things', but also his sense that something was lacking in Monet's work: 'the master of Impressionism is unconscious of the movement of humanity, except in those forms which reduce it to the status of things: trains which cross, buses which pass'. It is difficult, however, to think how the scale of the great modern city and the vast anonymity of the urban crowd could have been evoked on a small canvas except as pure spectacle (within eight years the problem had led the Futurists and Simultanists to abstraction). Notwithstanding his own social commitment, Mirbeau rejected the notion that painting should 'solve the great social, moral, international, political, philosophical, psychological, scientific, esoteric and tetralogical problems'. It was enough for him that Monet's painting should express 'the inflexible laws of the cosmos'. Morice felt, however, that this was a 'perfect art – whose limits it is impossible not to feel', and asked, rhetorically, where was 'the fault' which might 'open the door on to the unknown, the desired unknown . . .?'[162]

Monet was to spend the next 22 years, the rest of his life, pursuing the effects of 'the inflexible laws of the cosmos' on the surface of his lily pool. It was at the heart of his intimately known landscape and was also to be the site of the 'desired unknown'.

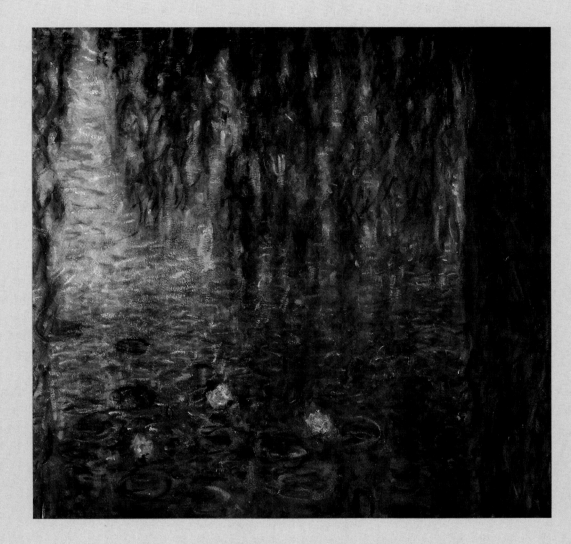

# PART THREE

*Le Temps retrouvé*

Giverny 1903-1926

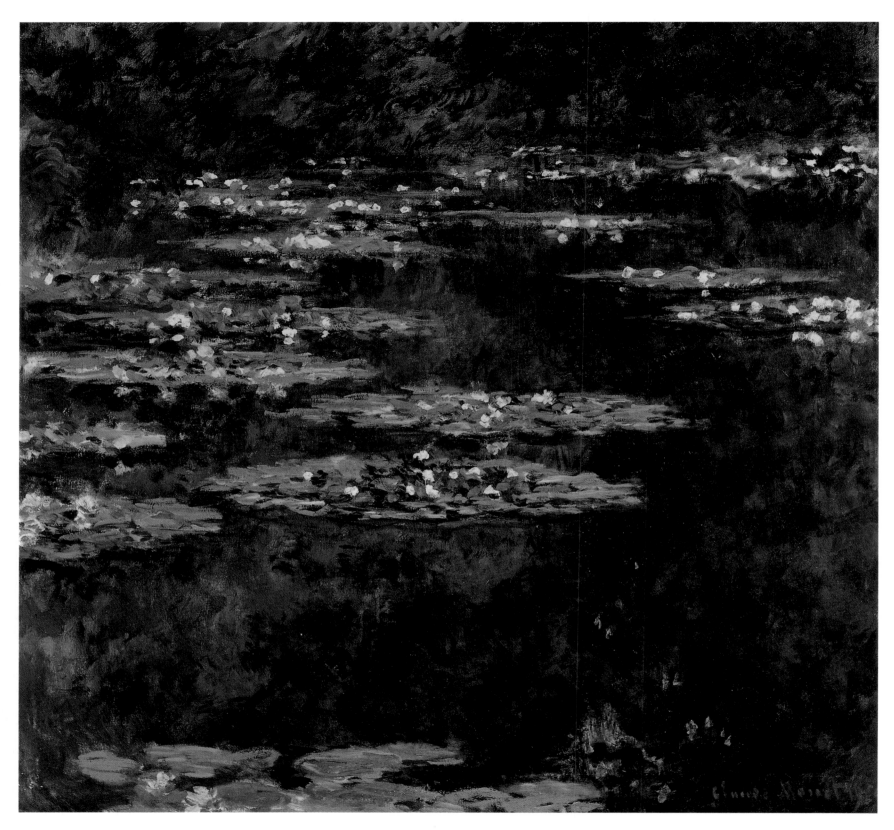

260    *Paysage d'eau, nymphéas* (W.1664), 1904, 90 × 93 (35 × 36¼)

# 6

# *The Nymphéas*

*I've begun working again; it's still the best way of not thinking of present sorrows, although I am rather ashamed of thinking about little researches into form and colour while so many suffer and die for us.*
MONET, 1914

*There is no document of civilization which is not at the same time a document of barbarism.*
WALTER BENJAMIN, 1940[1]

## I   The *Paysages d'eau*[2] 1903–1909

IN THE GREAT PAINTINGS OF HIS WATER-LILY POOL WHICH OCCUPIED THE last ten years of Monet's life and which culminated in the two huge cycles at the Orangerie in the Tuileries, the earlier 'moment of the landscape' gave way to a form of painting in which fugitive effects – light penetrating the depths of the water, or a slight breeze shirring its glassy stillness – are secured in a time which seems never to end. These huge, encircling expanses of paint bear all the marks of Monet's struggle to create a perfect, self-enclosing world, a struggle waged not only against death and blindness, but the disintegration of the world he had known.

When he began them, Monet was extremely wealthy and internationally famous; he had been, and continued to be, interviewed so often that his life had taken on mythic form; he was the genius, the *maître*, the self-taught artist who had triumphed over all obstacles to become the greatest French artist of his generation. He took refuge in the guise of the recluse of Giverny (though he rarely turned a journalist away and welcomed the visits of younger painters like Vuillard, Bonnard and Matisse); there, he created a form of painting which would transcend those monetary values which had worked so spectacularly for him.[3]

In the 1890s Monet sought to resolve the opposition between the moment and the temporal continuities of nature and of consciousness by trying to create a work 'of no weather and no season', by utilizing memory, and by bringing the phases of light on a motif closer and closer together as if trying to fuse them into a continuity; yet, as is seen most strikingly in the spectacle of Monet searching 'feverishly' through piles of paintings for a canvas that would correspond to a particular effect, the more responsive he became to infinitesimal changes of light, the less able he was to embody the continuity of experience. Monet's first paintings of his water-lily pool represented fragmentary 'moments' of light, but the indeterminacy of the motif – an area of water with no earth, no solids, no limits – and the notion of decoration led to a form of painting which embodied continuity: Monet multiplied and expanded canvases as if to make them infinite; he represented phases of light which seem paradoxically to last forever; and he embarked on a project which could have gone on indefinitely, and was indeed terminated only by his death.

Since Monet's studio and the water-lily pool were both located in his garden, a short distance from each other, studio painting could be integrated into the pictorial investigation of his perceptions of the motif in nature. Internalized memory also played a role: the theme of the *Nymphéas* was present in Monet's earliest paintings – the *Landscape at Rouelles* in the late 1850s and the *Farmyard in Normandy* of 1864 – and since then he had spent over forty years watching the reversed images of the natural world on the surface of still water, as it changed from dawn to dusk, through every weather and every season.

Monet gave up the idea of visiting his earlier painting sites to create a synthesis of past and present experience, when he realized he need go no further than his own garden. 'I have always loved sky and water, leaves and flowers', he once said; 'I found them in abundance in my little pool.' Almost as significant a theme for Monet as water, the garden had been both subject and context of his life as a painter – indeed, in the last year of his life he told an interviewer that gardening was 'a *métier* I learnt in my youth . . . when I was unhappy. . . . I perhaps owe it to flowers that I have been a painter'.[4] First represented as a protective enclosure for Camille and for his family in the late 1860s, the garden reappeared after the traumas of the invasion and civil war, when Monet began painting Argenteuil from the secure base of a fictionally enclosed garden; he had memorialized it as a place of legendary beauty from behind a barricade of flowers, as he did at Vétheuil where it surrounded his new family or embraced a glimpse of the Seine (W.693); and it was while he was transforming the fields of Giverny from an agricultural landscape to an aesthetic one that he executed his few paintings of members of his now secure family in the flower garden (W.1207). The intensity of his need to effect this transformation explains his excessive rages against the farmers and washerwomen who had used the village stream for generations and who opposed his plans to dam it.[5] Once Monet had integrated water into the nature which he had shaped according to his desires, he was to use it to effect a final closure, to exclude everything which might intrude upon or disturb the perfect harmony that he sought in painting. Everything, that is, except time.

After completing the descriptive and fragmentary paintings of the *Japanese Bridge* series, Monet probably decided that his pool did not provide enough motifs for him to realize the ideal of a continuous decoration of which he had spoken in 1897, for he purchased additional land, and despite further opposition from his neighbours, had the pool

enlarged from about 20 to about 60 metres (65½ to 197 feet) long. A small islet and a concrete basin for African water-lilies were also constructed, an arch for wistaria was added to the bridge, and more bamboo, rhododendron and Japanese apple and cherry trees were planted round the banks. These operations occupied 1901 and 1902, when Monet was working on the 'Londons' and on paintings of the flower garden; in these last the mauves and greens of the massed irises, the red-orange paths, the greens and pinks of the house, and greens and reds of the trees form a dense, airless, almost tapestry-like effect; but he did not resume painting the *Nymphéas* until the reconstructed pool had been transformed by new growth.[6]

Writers of the 1900s emphasized the interdependence of Monet's painting and garden even more strongly than had those of the 1890s: Alexandre claimed that it was the garden which taught Monet to 'dare effects which are so true that they seem unreal, but which charm us irresistibly like all truths of which we are unaware'. He stressed the artifice of the pool:

Damascened by the large round leaves of the water-lilies, encrusted with flowers like precious stones, the water seems, when the sun plays on its surface, the masterpiece of a craftsman who has created alloys of the most magical metals.

261   Monet by the water-lily pool, *c.* 1904

It was probably from such accounts, as well as from the paintings themselves, that Proust imagined Monet's garden, which he never visited, as

a garden of tones and colours rather than of flowers, a garden which must be less the old floral garden than a colour garden . . . flowers arranged in an ensemble which is not exactly that of nature, since they are planted in such a way that only those flowers whose nuances tone and harmonize in infinite variations come into bloom at the same time. . . . [This] pictorial intention . . . has dematerialized . . . everything which is not colour. Flowers of the earth and flowers of water, these tender *nymphéas* that the master has depicted in sublime canvases for which the garden (true transposition of art rather than model for painting, painting already executed as if it were nature . . .) is like a first and living sketch, at least the palette is ready-made, delectable, with prepared colour harmonies.[7]

The garden was nature as Monet desired it and as he had already created it in his paintings, and it says much for the strength both of his realism and of his need for the ideal, that rather than invent idealized pictorial forms, he had to grow a real garden before beginning to paint them. He employed gardeners to mass plants 'like colours on a palette', to wash the dust off the lily leaves and to remove flower heads as they died,[8] but in his art, he was not subject to such contingencies, as may be seen in the almost over-perfect paintings of the Japanese bridge, of the flower garden and some of the *Paysages d'eau*. Ultimately it was Monet's ruthless search for truth to his sensation which shattered the almost claustrophobic sweetness of his paradise garden.

Monet worked on the *Paysages d'eau, nymphéas* for six years, from 1903 to 1909 when he exhibited 48 in Durand-Ruel's gallery. He began painting them when he felt the need to work in nature in order not to 'think about' his 'Londons', and he spent the summer of 1903 on 'studies and researches'.[9] He continued to work on the Thames series for some 18 months, but thereafter he worked almost exclusively on this small area of water, painting on the motif in spring, summer and autumn, and in the studio in winter. He is said to have begun 150 *Paysages d'eau*, and he completed nearly 80. Monet had never worked with such concentration on a single motif, and he had great difficulty in completing the series, putting off planned exhibitions from year to year, refusing to part with any paintings before the series was ready for exhibition, and destroying many in rage and frustration.[10]

In the *Nymphéas* of the 1890s, Monet painted only a small area of the water surface, and in the *Japanese Bridge* series, he constructed a fairly conventional linear perspective which channels the eye into depth; but the reconstructed pool was so wide that Monet would have had constantly to shift his gaze to encompass its greater dimensions. Accordingly, in the *Paysages d'eau*, Monet came very close to the motif so that he could embody the experience of looking down on to the images of sky and trees which were above him, in reflections which appear vertical but which, of course, lay on the horizontal plane of the water below him. He thus reversed the dimensional relationships of the Western landscape tradition and destroyed the notion of the 'view'. He not only represented his simultaneous perception of the surface of the water and the depths below it, of light which reflects off it or light which penetrates its glassy depths, but chose a motif more changeable than any he had attempted, and of which he is quoted as saying:

The essence of the motif is the mirror of water whose appearance changes at every moment because areas of sky are reflected in it. . . . The passing cloud, the freshening breeze, the seed which is poised and then falls, the wind which blows and suddenly drops, the light which dims and then again brightens – all . . . transform the colour and disturb the planes of water.[11]

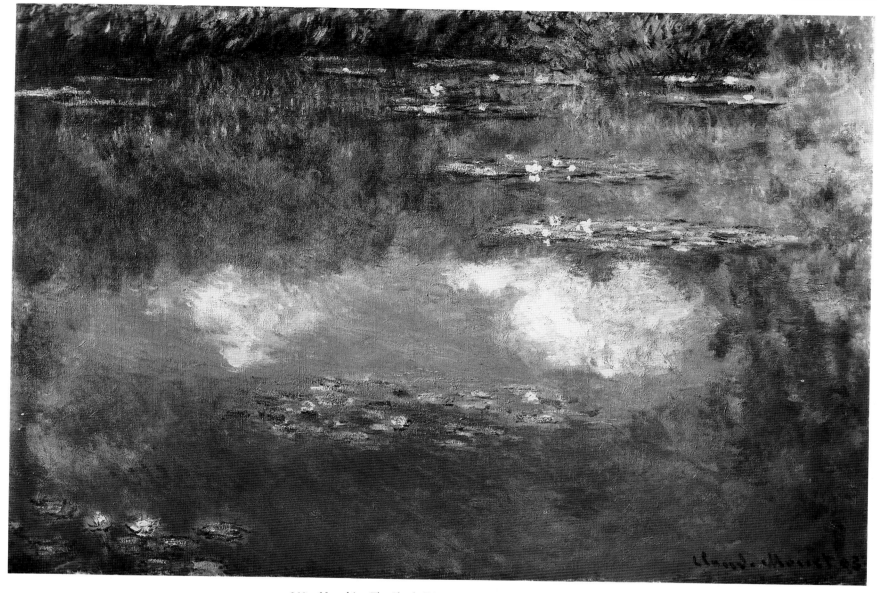

262    *Nymphéas. The Clouds* (W.1656), 1903, 73 × 100 (28½ × 39)

One of the earliest works in the group (W.1654) depicts a view across the pool, showing full-length reflections of trees, henceforth shown only in part, while on the bank the figures of two women recall *The Pool at Montgeron* (ill.133) and the *Corner of a garden at Montgeron* (ill.134), painted for the Hoschedés' dining-room nearly thirty years earlier, in which a woman, probably Alice Hoschedé, is represented both on the bank and reflected in the water.[12] *The Clouds* of 1903 shows the decisive shift from this relatively conventional view to a new kind of space which both lies below and spreads away from the spectator. As in other early paintings in the series, there is a narrow strip of ground across the top of the painting; in this it derives from a motif which had always fascinated Monet — the juncture between earth and water — but the bank here is summarily indicated, showing that his interest had shifted from the point of transposition between the material and the fluid to the surface of the water itself. *The Clouds* is descriptive in technique, with local colours and brushstrokes responding to different substances, so that the reflected clouds and trees partake more of their

reality as trees and clouds than as reflections, as if Monet were not yet able to dissociate his knowledge of their source in nature from his perception of the dematerialized colours of their images in water.

Each year from 1904 until 1908, Monet began a group of *Paysages d'eau* with a different viewpoint and format on which he continued to work in subsequent years. In 1904 he was seen working with twelve canvases within reach, changing them as the light changed,[13] and, in these, he adopted a slanting view up the pool to show a wider stretch of water than in *The Clouds*. Some of the 1904 group retain the descriptive techniques of the 1903 painting, but in the Le Havre *Nymphéas* (ill.260), for example, Monet emphasized the pictorial substance of each element, translating local colours into interacting scales of green, deep blue and violet, accented by rose-pink and yellow lilies. As a result the reflected trees are more successfully transposed into the fluidity of water, and the painting becomes a more self-contained construction; rather than referring directly to conventionally known forms, it demands a more active reading of the abstracted colour structure.

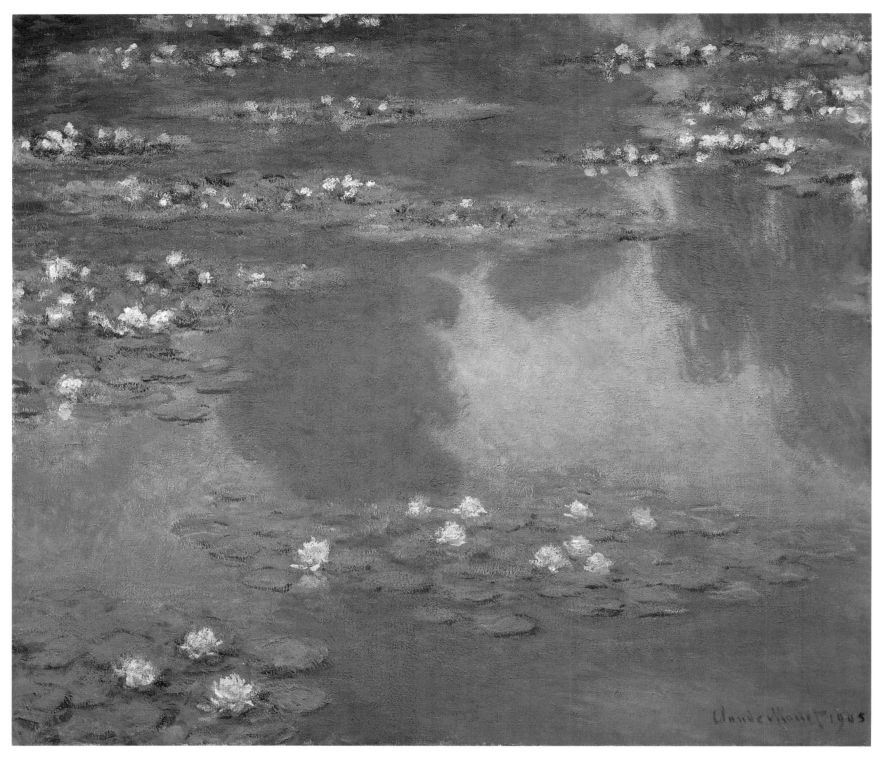

263   *Nymphéas* (W.1671), 1905, 90 × 100 (35 × 39)

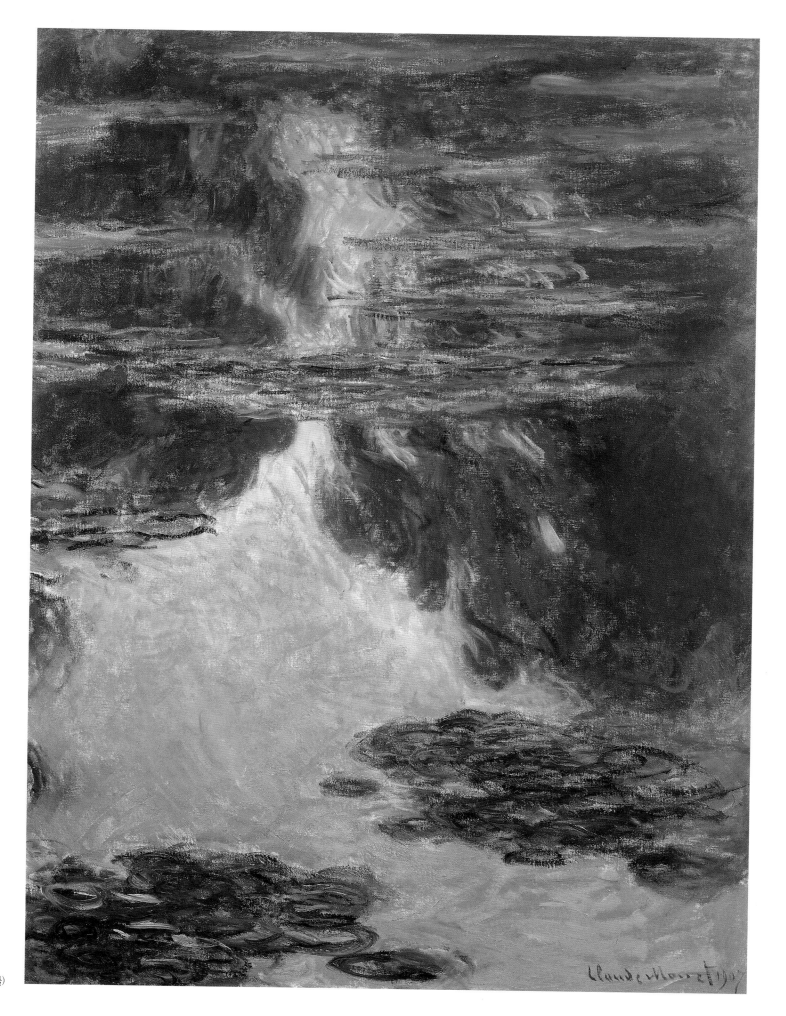

264 *Nymphéas,*
*sunset effect* (W.1714),
1907, 100 × 73 (39 × 28½)

265    Monet painting at Giverny, c. 1915

Thus, instead of the reflected clouds and trees being immediately identifiable, as they are in *The Clouds*, the lighter greens only gradually reveal themselves as the reflections of unseen trees; the darker reflections and shadows of the overhanging willow draw the eye lower and lower, until it recognizes with a delighted shock that the bright blue strokes at the base of the painting signify the sky that was above the painter.

As seen most strikingly in the paintings of ice-floes at Vétheuil, compositions based on a tension between vertical reflections and the horizontal plane of the water had a long history in Monet's *oeuvre*; the earlier works were still views, compositions which hold a fragment of nature separate and distant from the spectator. This relationship to nature began to change in the 1904 series, where the lily pads were cut by the lower edge of the canvas, suggesting that they were immediately below the painter; it was transformed in the series begun in 1905 (W.1671–1682) in which Monet eliminated the distant bank.

With the disappearance of this last vestige of terra firma, the only remaining material forms are the water-lilies, whose leaves are shown hovering above the water surface, resting on and tautening that surface, or partially submerged beneath it. When the bank is represented the spectator can still measure space, locating him- or herself in relation to the motif through reading the conventional signs of space – the foreshortening and the decreasing scale of the water-lily islands as they recede towards the far bank – but in the 1905 *Nymphéas* (ill.263), there is no means of measuring the distance between the lilies and the unseen limits of the pool, and thus of determining where one stands in relation to it. The material world is known only through its reflection, and space becomes limitless.

The abstract colour harmonies of the Le Havre *Nymphéas* were more consistently developed in the paintings of 1905, and the dense over-painting of the former suggests that its colour structure was realized as it was retouched in later years. The paintings begun in 1905 were also thickly painted with similar strong contrasts between layers of colour, but Monet now seems to have begun consciously exploiting the

possibilities of the layered painting which had resulted spontaneously from his struggles to realize his experience of the motif: in such paintings, the lower layers were painted in fairly dark tones with heavily striated brushstrokes, while succeeding layers were painted in lighter mauves, dusky pinks and greens, in broad strokes of dry paint which catch at the striations formed by the lower layers, and thus create an irregular, grainy surface which receives light at different angles so that the painting itself seems to vibrate. The different layers of colours suggest the permeability of the water surface and the depth beneath it – effects emphasized by the thick purplish lines painted below the lower curve of some of the leaves, which suggest shadows *in* the water below them. Dense mauve and lavender paint below thin and irregular layers of green and violet suggest the depth of water seen from directly above, while the more dense lavender- and rose-tinted white painted over the dark mauves in the middle of the pool represents not only the reflection of a brighter area of sky, but also the way light from it seems to refract from rather than sink into the water.

By 1906, having developed ways of registering such complex visual experience, Monet was able to achieve similar effects with less heavily worked surfaces (W.1683–1691), and was writing of his joy in his work. Soon, however, he became worried that he could not complete the series in time for an exhibition the next spring – and then spent two months working on two still lifes of eggs (W.1692–1693) which curiously reverse the structures of the *Paysages d'eau*, as if he sought relief from years of painting the fluid and the formless.[14] In April 1907 he told Durand-Ruel that he would postpone his exhibition, for he had completed only 5 or 6 paintings of more than 40 he had begun, and the others needed re-working from nature, and, since only some were worth developing, he had just destroyed 30 canvases. As usual, he emphasized that the works would be best exhibited as a group, so he would release none, particularly since he wished to compare the finished paintings with those he planned to do; he regretted that he had sold one, *The Clouds*, which he felt should have been destroyed.[15] Comparison between *The Clouds* (ill.262) and the works which Monet preserved shows that he wished to obliterate a form of painting in which the picture plane could be conceived as a window through which one looks at a distanced scene. The upside-down reflections of *The Clouds* do not fundamentally disturb the gravitational structures of the European landscape tradition, and it remains a fragmentary view of a pool which will exist when the light has changed and the clouds have moved on. This view can be grasped in the instant, but because of their multi-dimensional space the *Paysages d'eau* of 1905–6 and thereafter reveal themselves only in time.

In the series begun in 1907 and 1908, Monet represented more extreme effects of light, employed unusual formats and forced the tensions between the different dimensions. An unfinished painting (opposite, ill.266) suggests that Monet would begin each one of the *Paysages d'eau* with bold contours indicating the position and the foreshortening of the lily pads and the outlines of the reflected trees, and would then roughly scrub in areas of colour for the islands of leaves and the reflections of trees and sky. He did nothing, however, to indicate the water surface. As more complete paintings show, the contradictions between the verticality of the reflections and the horizontal recession of the lily pads were resolved only after much work had been carried out to establish the continuity of the water surface. The tension between the thin membrane of the water-lily leaves and the verticality of the reflections was crucial in establishing the new, multi-dimensional space.

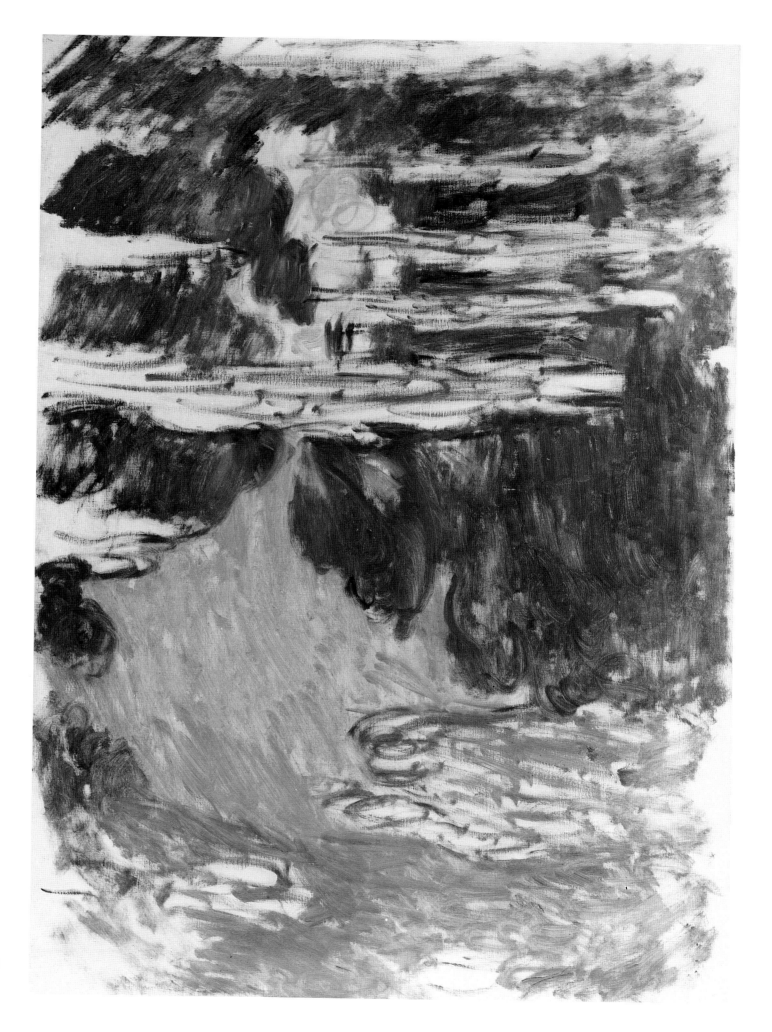

266   *Nymphéas* (unfinished)
(W.1717), 1907, 105 × 73
(41 × 28½)

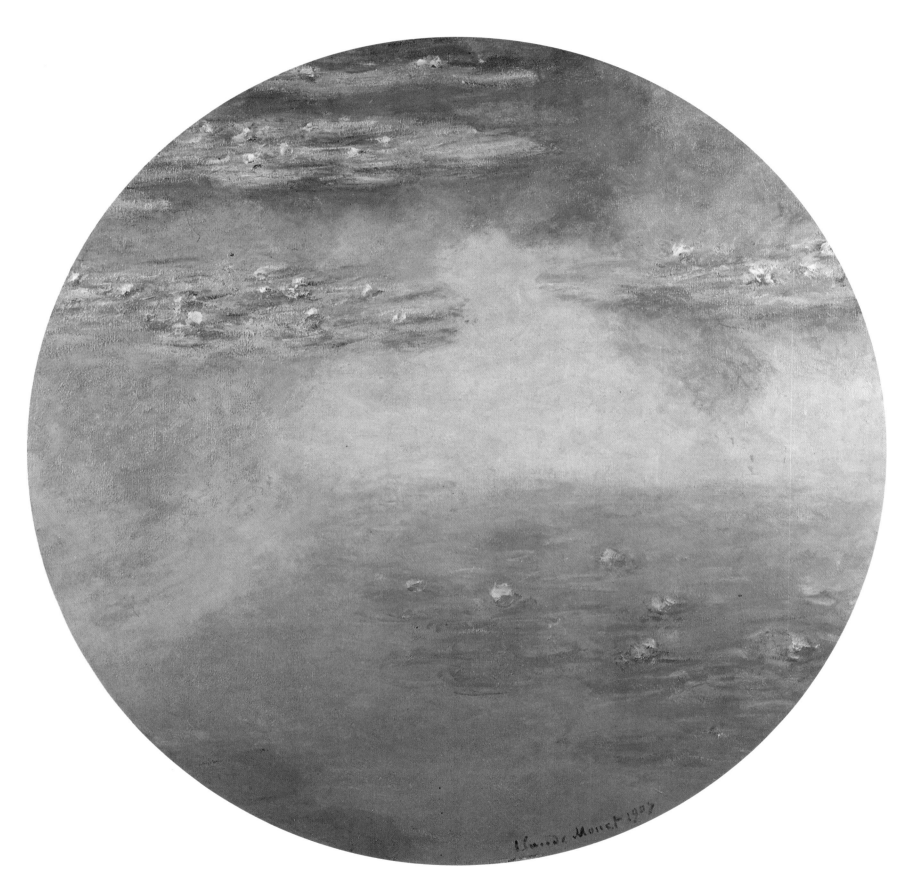

267   *Nymphéas* (W.1702), 1907, 81 (31½) diameter

*Opposite:*

268   *Nymphéas* (W.1732), 1908, 100 × 81 (39 × 31½)

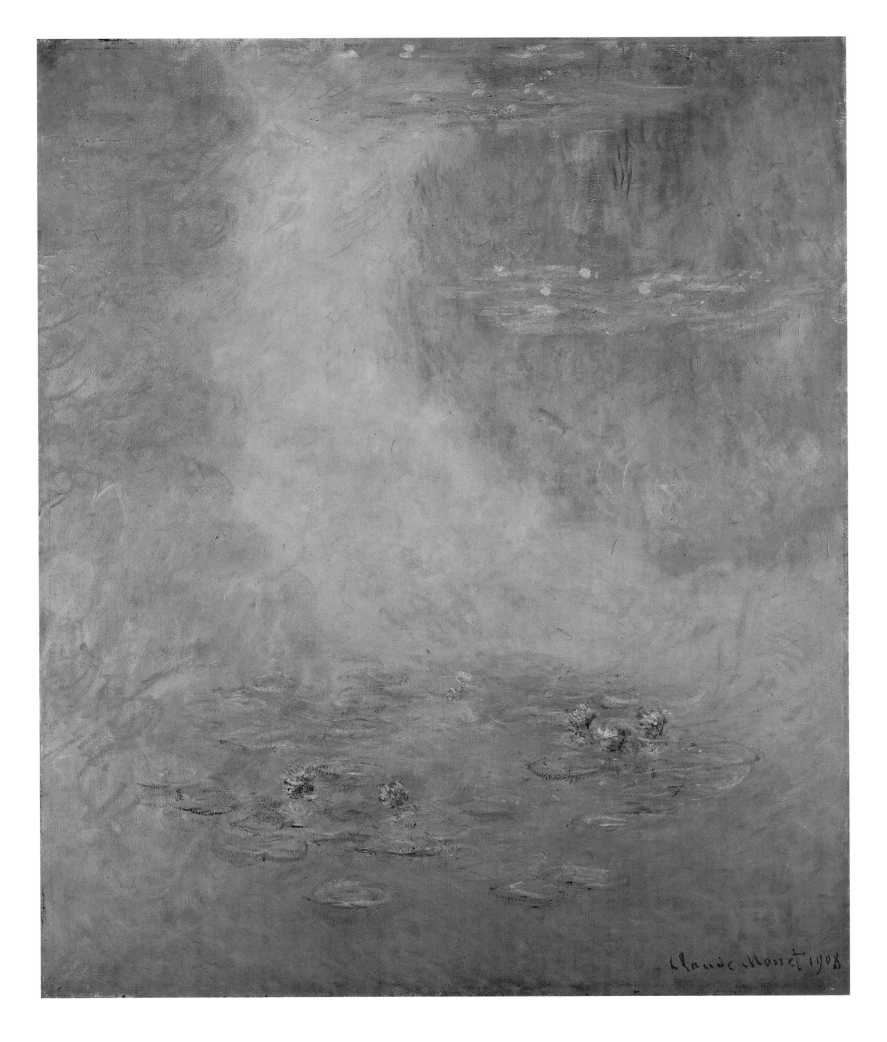

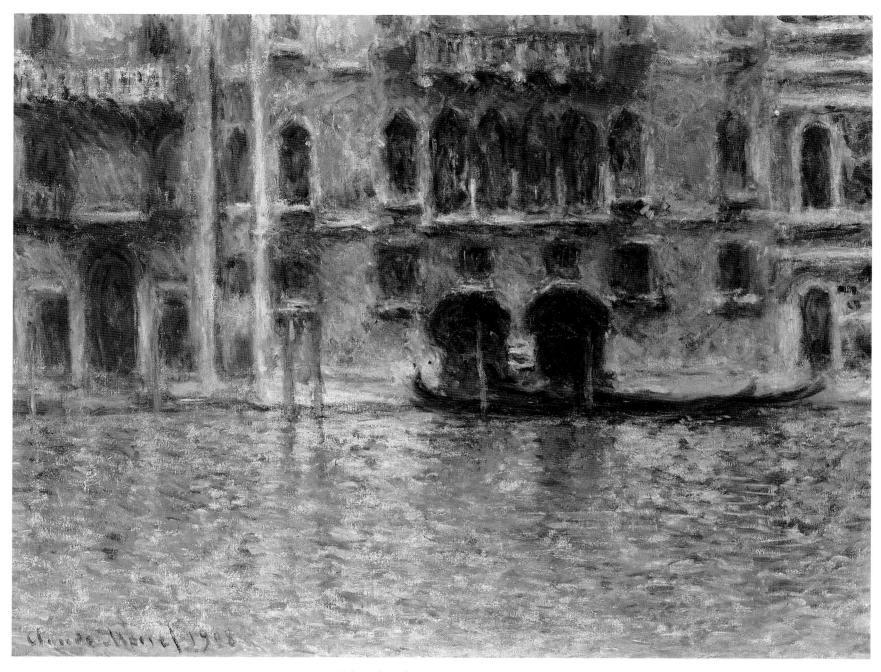

269    *Palazzo da Mula* (W.1764), 1908, 62 × 81 (24 × 31½)

The 'grasses undulating in the depths' represented in *The Empty Boat* of *c.* 1890 (ill.221) indicate the dimension of depth, but nothing establishes the recessive dimension; in the *Nymphéas* of *c.* 1896–7, depth is suggested by the stems of the lily buds and the darkening contours below the leaves, and recession is signalled by the foreshortening of the leaves; the painting, however, lacks the structuring tension introduced by the reflections.

A completed painting of this vertical motif, *Nymphéas, sunset effect* (ill.264), shows how Monet brought these complex dimensions into equilibrium: he painted transparent layers of colour over the roughly brushed areas in order to establish the continuous 'skin' of the water, and while developing complex effects of reflected light, he also strengthened the cursive lines of the lily pads and reflected willows, as if to intensify the tension between the different dimensions. The painting is an astonishing visualization of reflected light so bright that it seems to

ignite the reflected trees, while the islands of leaves in the centre of the painting seem on the point of breaking forward from the blazing depths of the pool with a dizzying, hallucinating intensity in which one's sense of ordered dimensions and bodily stability seems almost to disintegrate.

In 1907 and 1908 Monet began four paintings of water-lilies on circular canvases (W.1701–1702, W.1724–1729), which detach the motif from its immediate dependence on the prosaic dimensions of the pool, and which, more than any other works in this series, fulfil his desire to create a perfect, self-contained world, a world which forever turns in on itself, yet which is formed from a transient moment of light.

As Monet struggled to register such elusive effects, he found in 1908 that his sight was failing. 'I see less clearly', he wrote; 'It's been better for two days, but I saw the moment when I was going to be forced to stop all work.' His wife attributed his condition to his anxieties about the exhibition planned for that spring and, after having failed to

persuade Durand-Ruel to buy up to 16 *Nymphéas* at 13,000 to 15,000 frs. each, he renounced his exhibition 'forever' in April 1908.[16]

Monet's sense of the 'impossible labour' of bringing the formless to form may have been affected by the growing criticism of his work. In reviews of two exhibitions of his earlier works, that May, he was compared unfavourably with Cézanne, criticized for 'the vicious empiricism of his method' and for being 'too passive, letting himself be too distracted by spectacles, scarcely intervening intellectually, except in matters of practical execution'. The recently dead Cézanne was promoted as an intellectual artist who opened the way to the future, while Monet was seen to have a reactionary influence; thus Morice claimed that 'the unconquerable stupidity of the majority already erects this delectable *oeuvre* into a wall against the future'.[17]

Despite his renunciation of the *Nymphéas*, Monet continued to work on them, writing in August:

These landscapes of water and reflections have become an obsession. It's beyond my strength as an old man, and yet I wish to succeed in rendering that which I feel. I've destroyed some . . . I've begun them again. . . .

He was still working on canvases which he had begun as much as five years earlier, some of which, he admitted, were over-worked with 'three or four paintings on one canvas', yet his determination to render his experience forced him to continue.[18] He was, however, also beginning the most lyrical and assured works in the whole series, a group depicting the motif he had painted in the vertical canvases of 1907 (W.1703–1717), looking west along the pool to the channel of reflected light between the reflected trees. In this group (W.1721–1723, 1725–1726, 1730–1732; ill.268) Monet used closely related scales of mother-of-pearl blue, lavender, pink and yellow, applied in delicate glazes to suggest early sunlight warming the morning mists and suffusing the reflected trees with delicate nuances of sharp gold. These abstract colour harmonies embody intensely observed effects: slight inflections of violet around the lowest island of leaves – which seems to be coming to form in the thinning mist – suggest the translucent depths of the water, while the different intensities of colour are evocative of the different densities of mist in shadow, in the golden reflections or under the open sky. The tones are more closely related and the paint surface more unified than in the earlier works, so that the shifting viewpoints melt one into another, rather than displacing one another. Monet had thus created a new, multi-dimensional pictorial space which only gradually reveals itself in time. No longer a view of distanced nature, it acts as an equivalent to the visual experiencing of the sheen, the unbroken tension of water which holds in its depths images of the unseen material world.

Monet himself was so dissatisfied with these paintings that he broke his five years' concentration with a short visit to Venice. He intended to paint only a few canvases 'to preserve its *souvenir*', but was soon 'ravished' by it, once again 'possessed by work', obsessed by 'this unique light', and regretful that he had not come to Venice when he was younger and 'dared everything!' Monet was not to return to Venice as he had planned, but he did work on the Venetian paintings until he was able to exhibit 29 of them in 1912. For the time being, however, these paintings of façades reflected endlessly in the canals of the historic city enabled him to return to the paintings of his intimately known pool 'with new eyes', and to put the final touches to them before the often postponed exhibition, *Paysages d'eau. Nymphéas*, opened in Durand-Ruel's gallery in May 1909.[19]

It was five years since his last solo exhibition and, with the expectations raised by the postponements and the many earlier articles on Monet's water garden and water-lily paintings, it is small wonder that it attracted a great deal of critical attention. No visitor could have been prepared for the impact of 48 paintings on a single motif, and most critics revelled in the variety of effects, which ranged from the misty tranquillity of dawn to fiery sunset, from clear sunlight to threat of rain, from relatively descriptive works to the most refined abstract harmonies. Henri Ghéon commented on their virtuosity:

And one by one the material of these stupefying morsels is revealed to us, all glossy with glazes, all granular and porous, all broken up by impastos, and the suggestion of a flower on the water is conjured up with an assured thick touch, by a subtle colour wash, by a random splash or by a curiously expressive nervous flourish.[20]

The catalogue listed the works according to the year in which they were commenced (each year having been characterized by a different format and viewpoint), and they may have been hung in this order. The paintings were rarely completed in the year in which they were begun, and the earlier ones embody the cumulative experience of several years, so if the exhibition was hung in chronological groups, the developing complexity of the new pictorial space and subtlety of effects of light would have been manifest. Monet also included a more conventional view of the pool and the Japanese bridge (W.1668), dated 1905, which a critic described as 'a connecting link between past and present', and which the artist may have intended as an aid to reading works with no fixed frame of reference and which deny conventional modes of representing landscape.[21]

Nearly all the critics felt that through his exclusive emphasis on the visual, Monet was penetrating to other orders of experience, and only Morice repeated the belief held earlier, that Monet's paintings 'in no way aim at our mind, they stop at our eyes'.[22] It was an old criticism, but one which was to acquire new force in the next few years when the avant-garde was dominated by Cubism, first exhibited in 1909.

Fourcaud extended the notion of the structural relationship between the artist's garden and his painting by emphasizing that Monet shaped 'natural forces' so that they would develop as material for painting, 'with a special sumptuousness in a framework delicately arranged for them'. In this way the motif was simultaneously internalized as a desire and as a reality external to Monet, a reality which would endlessly challenge him with the previously unseen. In his long article, 'L'Epilogue de l'impressionnisme', Gillet related the physical paradoxes of these 'upside-down' paintings – in which light which had always been represented at the top of the painting was now depicted at its base – to the change from the Western notion of man 'as the centre of the world' on which the system of linear perspective depended, to 'oriental [self]-effacement and impersonality'. Gillet referred to Monet's depiction of the 'large lotus with the sacred flowers, the blue lotus of the Nile, the yellow lotus of the Ganges', and thus raised the possibility of Monet's interest in Oriental religions, which certainly preoccupied many of his contemporaries, in particular Odilon Redon.[23] Monet's relationship to Eastern thought should not, however, be too easily assumed, and would have derived more from a sympathy with, for example, Japanese attitudes to gardens than from any particular dogma. 'Self-effacement and impersonality' had been inherent in his approach to the motif, but these qualities had co-existed with a European emphasis on the expression of personal sensations and on modernist artistic innovation.

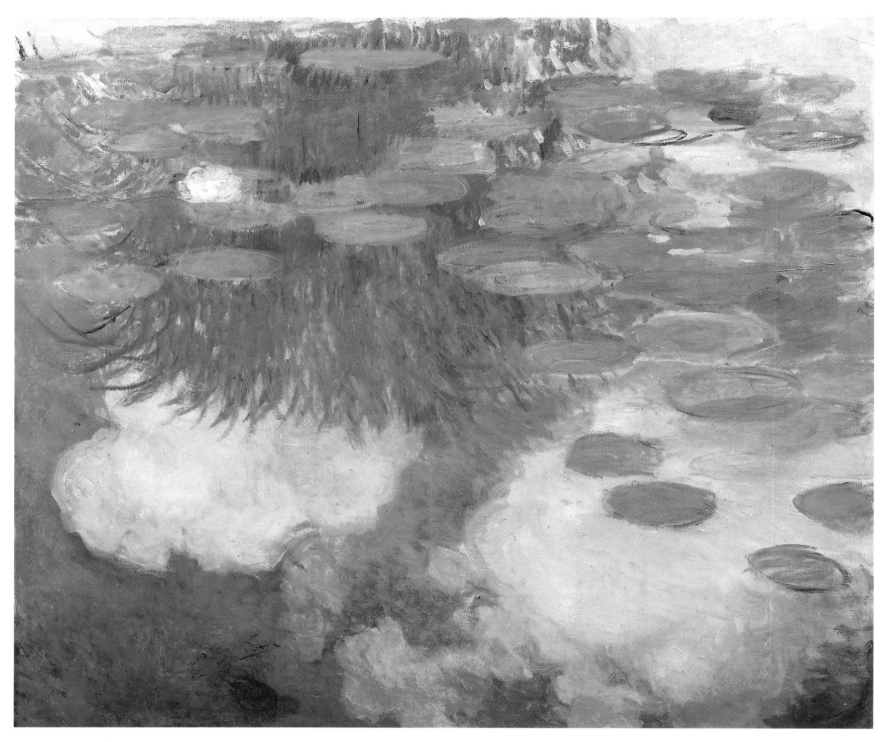

270   *Nymphéas* (W.1783), *c.* 1914, 130 × 150 (50¾ × 58½)

Moreover what Monet said (or appeared to have said) about this was more prosaic: it was in an imaginary interview that Roger Marx had Monet say that he approved the Japanese aesthetic which 'evokes presence by a shadow, the whole by a fragment'.[24] This notion has an obvious relationship to Monet's use of reflections on a fragment of a pool to suggest the earth, its plants, and the limitless, light-filled sky; but, as usual, Monet implied no more than he said. His knowledge of Japanese paintings may have helped him realize multi-dimensional space, for those paintings depend, not on a unifying linear perspective, but on perspectival fragments which establish space around themselves, much as do the water-lily islands of the *Nymphéas*. Gillet's comments on the destruction of perspectival space are pertinent, for Monet's spatial structures make it impossible for the spectator to find a secure position in relation to the painting. In this way, he or she may lose a sense of the presentness of the individual body and so, in a sense, be absorbed in the otherness of the painting – and may thus attain something of the spiritual experience implied by Gillet.

Monet's painting continued to be interpreted in pantheistic terms: Verhaeren had claimed that, in the *Japanese Bridge* paintings, the artist 'becomes the universe which he translates. The cosmic force is there brought to consciousness, and thanks to this consciousness is endowed with beauty'. In Roger Marx's imaginary dialogue, 'Monet' protested at idealistic interpretation of his work, asserting that he simply submitted to instinct and absorbed himself in creation. The phrase makes no distinction between artistic creation and nature's 'creation', but it was completed by the statement, 'I have no other desire than to merge myself more intimately with nature'.[25]

Ghéon wrote that 'other painters painted in space, he . . . in time', and most of the critics emphasized the continuity of the series, asserting that the many paintings formed 'one work', and regretting that they would be dispersed. 'They will', Fourcaud wrote, 'be scattered to the four corners of the world, exquisite but each giving up only a part of the secret of the whole', and Gillet warned of the loss of 'the most powerful attempt ever made to give decorative value to the intimate landscape, to the painting of the [private] interior, and to make the experience of continuity enter painting'.[26] Roger Marx and Alexandre both suggested that Monet had not forgotten his 'dream' of creating a form of painting which would entirely surround the spectator. Alexandre wrote:

The painter would have liked to have a circular room of modest, well-calculated dimensions to decorate. Around it, to half-human height, there would have extended a painting of water and flowers passing through every possible modulation. . . . Nothing else. No furniture. Nothing but a central table in this room which would be a dining-room, surrounded by these mysteriously seductive reflections.

Echoing Clemenceau thirteen years earlier, Alexandre asked why there was no millionaire to commission such a work. In words which recall those of Matisse published in 1908, Roger Marx 'quoted' Monet:

For a time I was tempted to use the theme of the *nymphéas* for the decoration of a salon . . . enveloping all the walls with its unity, it would have given the illusion of an endless whole . . . nerves strained by work would have relaxed there, in accord with the calming influence of these sleeping waters. . . .

Since the compositions had no boundaries, it was not difficult to imagine how they might be extended, and photographs of canvases hung side by side in Monet's studio in 1908 suggest that he was thinking of ways in which different phases of light could be modulated in a horizontal frieze of 'half-human height'. Yet both Roger Marx and Alexandre wrote of his project as if it were a dream which he had given up.[27]

Perhaps this was because he had found the representation of reflections in changing light so demanding that he was daunted by the problem of realizing such complex 'moments' of perception on an extended surface. He also did not continue to paint circular formats – Gillet said they would make 'the most perfect boudoir since Fragonard' – perhaps because they were too decorative to allow experience to develop. Monet never gave up the idea of a circular room, but the *Nymphéas* painted in the last decade of his life lost their character as a background to the good life, and became, despite their sensuousness, so austere, so intense, and so demanding that the idea of dining in their presence is unthinkable.

Gillet described the pool represented in the *Paysages d'eau* as the 'lake where the divine galley of the *Embarkation for Cythera* should glide'. It has been suggested that the Watteau (ill.272) may have influenced Monet's last paintings of Argenteuil, and of Jean and Suzanne in the twilight fields. Comparison of the *Paysages d'eau* with these earlier works suggests the significance in these waterscapes of the traces of human presence which are felt through absence. The pool created by Monet at the heart of his familial landscape was heavily impregnated with memories of other such landscapes, and perhaps of Watteau's painting of embarkation for the island of love; the *Paysages d'eau* were, then, paintings of a place of sublimated desire, a place which embodied 'something unexpected and desired, intimately poetical and absolutely real'.[28]

The months following the exhibition were unproductive. Monet found it impossible to work on the Venice paintings he had promised to Georges and Joseph Bernheim-Jeune, who had become as important purchasers of his work as the Durand-Ruels, and by early January 1910 he was once again telling Geffroy that he saw 'everything black'.[29] Then, less than a year after the exhibition of his paintings of the peaceful surfaces of his pool, it was submerged repeatedly for over two months by the raging waters of the Seine, in one of its worst recorded floods. Alice Monet wrote to her daughter Germaine that Monet 'does not speak, but moans', and as the waters rose from the water garden to the flower garden, sometimes 'with waves so high that it is almost impossible to steer a boat', she commented, 'Monet's despair, like the Epte, will not abate'. His ready pessimism would have inclined him to echo Mirbeau's ironic comment on the endless rain: 'I begin to believe in the end of the world'; he lamented to his wife that 'everything is lost . . . business will never improve, we will have to sell everything, the house, the car . . .' – an extraordinary recurrence of his old nightmare of being once again 'without a sou'. In mid-March, the receding waters left devastation and the 'awful stench of slime'; but three months later Alice could write that the garden 'is paradise, everything is in bloom, the irises, the poppies, the azaleas, the roses', and her husband took advantage of the damage to the pool to have its rather straight banks refashioned in more intricate curves. Since he had told Roger Marx a few months earlier that he dreamed of making 'a decoration with these same *Nymphéas* as its theme, [a] project which I will one day realize . . .', these changes were probably designed to give Monet more motifs than the straight-sided pool would allow.[30]

Although nature had proved its powers of regeneration, the flood had made it clear that Monet's sanctuary was not inviolate, and this message was reinforced over and over in the following years. Alice Monet had become ill before the flood abated; by April 1910, Monet had to admit that there was little hope for her life, and, within a year of

her delight at the restoration of the garden as 'paradise', she was dead. She had been Monet's 'adored companion' for over thirty years, and had shared in the creation of that secure, sheltered, familial world which both shaped and was shaped by his painting, and which he felt was now shattered.[31] Monet felt himself 'annihilated', 'lost, finished'; he spent months reading his wife's letters and 'reliving almost all our life'. He wrote to Rodin, 'I ought to be able to work to conquer my grief, but I cannot', and, although he returned to his pictures of Venice by the end of the year, he said he would give up painting, since he was merely spoiling works which he should have left as they were, 'as a *souvenir* of such happy days passed with my dear Alice'.[32] The Venetian paintings, beautifully coloured images of untransformed tourist sights, remained *souvenirs*, 'dead façades'. Although their exhibition in May 1912 was greeted with enthusiasm, even by young avant-garde critics like Apollinaire, Monet said that he was 'indifferent to the praise of idiots, snobs and traffickers'.[33]

A few weeks after that exhibition, he confided to Geffroy his fears that his eldest son, Jean, who had long been ill, would lose his mind; and then, just over a fortnight later, Monet encountered a threat even more fundamental to his being than the disintegration of his family: blindness. He wrote to Geffroy:

Three days ago, as I was setting to work, I realized with terror that I could see nothing with my right eye. . . . a specialist. . . . told me that I had a cataract and that the other eye was also slightly affected. It's in vain that they tell me it's not serious, that after the operation I'll see as before. I'm very disturbed and anxious.[34]

Alice Monet had believed that the 'giddiness and blurred sight' he had experienced in 1908 were caused by his worries about his *Paysages d'eau*

271    Monet retouching
*The Flowering Arches*, 1913

272    Jean-Antoine Watteau,
*The Embarkation for the island of Cythera*, 1717, 129 × 194
(50¼ × 75¾)

*Opposite:*

273    *The Flowering Arches*
(W.1779), 1913, 81 × 92
(31½ × 36)

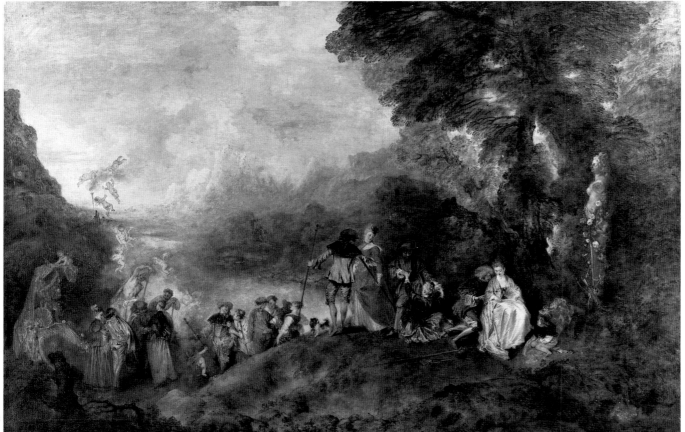

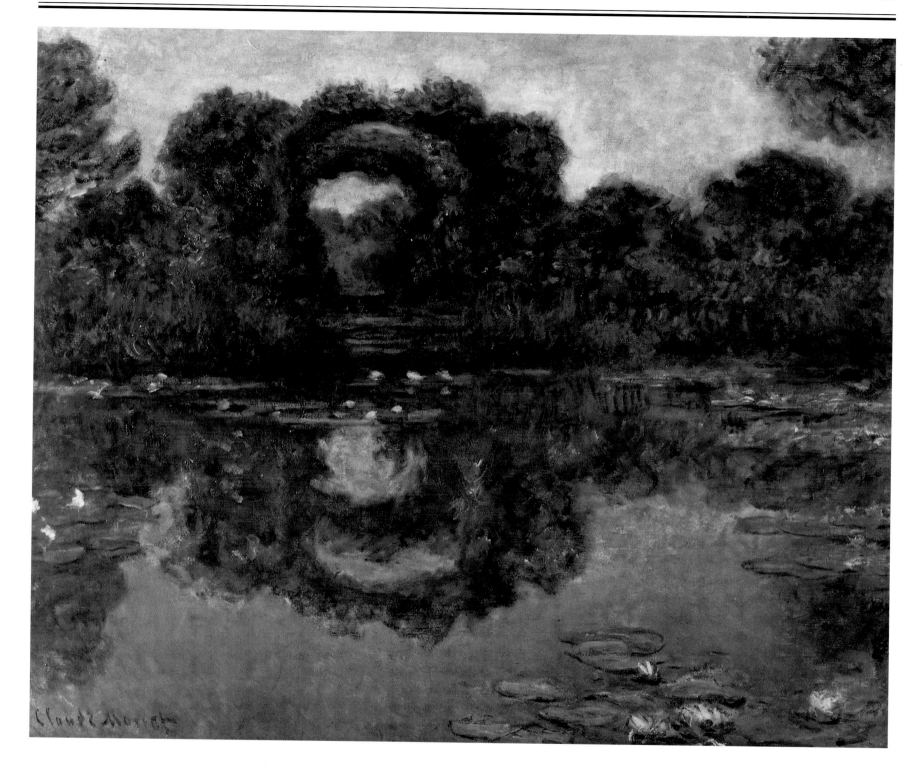

and, for a man of Monet's nervous temperament, whose sense of his own being was dependent on visual creation, such a connection between eyesight and mental state is more than probable. In 1912, the situation was like a nightmare unravelling of that time in 1867 when, intensely worried about Camille and the impending birth of Jean, he became temporarily blind, and feared he would not be able to paint outdoors again. Clemenceau, once a doctor, assured Monet that *'You don't in the least risk losing your sight. . . .* One must hope that the cataract in the bad eye will soon be at the stage where one can operate . . . the continuity of sight is *assured'*. But Monet could not believe that his sight

would be unaffected, telling one of the Bernheim-Jeunes that Jean was 'seriously ill', and that

I now see with only one eye. It's a cataract. . . . I'm following a treatment to delay an operation and to avoid it if possible. The operation is nothing, but afterwards my sight will be totally changed, and this is crucial for me. . . . As a final blow, a frightful cyclone made havoc in my garden. My weeping willows of which I was so proud, devastated, with branches torn off . . . a real grief for me.

More than ever, and despite my poor sight, I need to paint, and to paint without ceasing.[35]

Monet managed both to continue painting and to postpone an eye

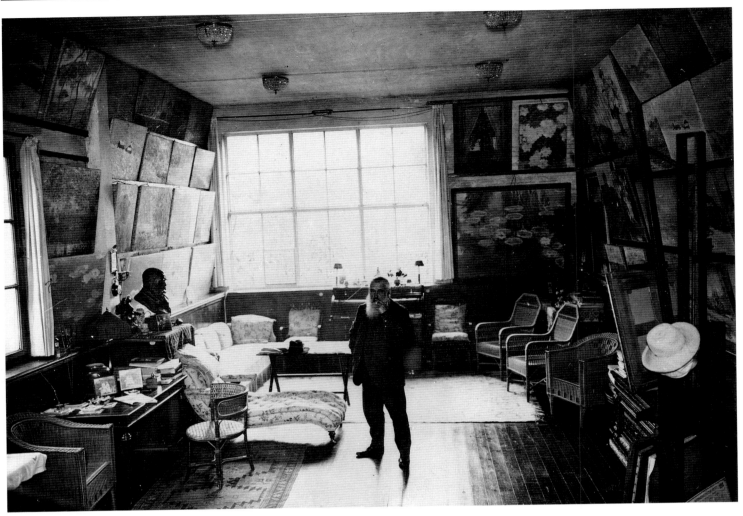

274   Monet in his
salon-atelier, 1913–14,
in *Je sais tout*,
15 January 1914

operation until 1923, and it is clear that he preferred what he called 'my sight', however defective, to something unknown. It should also be noted that, in all his many letters from mid-1913 to early 1919, Monet – who was never reticent about his own sufferings – did not once complain of his sight.[36]

Monet painted at least two works in the open air during the summer of 1912 (W.1777–1778), and, in view of the continuing threats to his family and garden, it was probably no coincidence that these were the first paintings of his house seen from near by, and surrounded by flowers. In June 1913, he resigned himself to the cataract operation, but a month later he told Geffroy that, although he did not 'see very well', his eyes seemed to be 'getting better'. It was perhaps at this time that he created the three tranquil paintings of *The Flowering Arches* (ill.273).[37] One, painted at dusk with the reflections of the arches of roses suggesting a path into the light-filled depths of the pool beneath the white water-lilies, recalls Watteau in its poetic artifice and delicate melancholy.

Jean Monet died a few months later, in February 1914, and his father wrote in answer to a letter of condolence, 'I will always be happy to welcome you to what you call my paradise. Alas!' Despite – or perhaps because of – his grief, he began painting his garden again, telling Geffroy on 30 April:

As for me, I'm feeling marvellous and am obsessed by the desire to paint. . . . I even intend to undertake some large things, for which you will see some old trials which I found in a cellar. Clemenceau saw them and was amazed.

By June he could write to Paul Durand-Ruel: 'I've gone back to work . . . getting up at four in the morning, I slave away all day . . . my eyesight is at last good. Thanks to work, the great consoler, all is well.'[38] He had rediscovered the tangible reminders of his 'old dream', the *Nymphéas* he had painted *c*. 1896–7 in preparation for a decoration for a dining-room, two of which appear in a photograph of his studio published in January 1914. Monet had decided he was too old to undertake a great decorative cycle – he was in his seventy-fifth year – but Clemenceau persuaded him to accept the challenge.

From this time on Blanche Hoschedé-Monet, Jean's widow, took over her mother's role in structuring Monet's domestic life – after Monet's death, Clemenceau said that Blanche 'cared for him, coddled him . . . watched over him like her child. She worked on his canvases. She did the grounds [of his paintings] for him'. Clemenceau took Mirbeau's place in providing Monet with the constant bracing, commonsensical moral support he required for his painting, and which was to be crucial in the 1920s when Monet fought against blindness, architecture, bureaucrats and his own perfectionism to complete what he called the *Grande Décoration* or simply '*mes Décorations*'.[39]

## II  The Evolution of the *Grandes Décorations* 1914–1926

It is not known whether Monet began his scheme with the notion of great stretches of painting above normal human height, or whether he was still thinking in terms of a dado composed of panels about 'half-human height'; but his use of terms like *'un grand travail'* and *'grandes choses'* suggests that he was thinking on a large scale from the beginning. This was certainly so by 1915:

... I'm pursuing my idea of a *Grande Décoration*. It's a huge thing that I've undertaken, above all, at my age ... it's a question of the project which I have had for a long time now: water, water-lilies, plants, but on a very large area.[40]

Monet had not painted on this scale since his first youthful bid for fame with the unfinished *The Picnic* of 1865–6, a large fragment of which occupied a prominent place in his second studio; but since 1900 he had had encouragement to produce large-scale decorative painting. André Michel wrote in that year: 'If I were a millionaire – or minister for the Arts – I would ask M. Claude Monet to decorate for me some immense ceremonial room in a Palace of the People'; and in 1912 Gustave Kahn stated that Impressionism had not had the opportunity 'of affirming its compositional qualities and its decorative capacities on the great walls of a palace of State'.[41] The possibility of State support for the project was probably influential in the transformation of the decorations from something appropriate to a private room to something grander and less intimate.

Monet may also have known of other large-scale decorative paintings, in particular those of Vuillard, Bonnard (with whom he was friendly) and Redon; would have seen many *fusamas*, the painted Japanese screens, in French collections and domestic interiors, and would have known of their use as walls and sliding doors in Japanese dwellings.[42] Since they often brought nature life-sized into the interior, they may well have influenced the scale and composition of the *Grande Décoration*. Scale could also have been influenced by Monet's composing of his own garden: until now, he had shrunk nature to the size appropriate for the bourgeois interior, but now he developed a close relationship between the size of the natural forms represented and their image, so that he could convey a sense of immense space by representing the sky in a painted pool which aspires to the size of that pool. His failing sight probably also demanded that he paint on as broad a scale as possible. Monet's visit to Venice may have been more significant than the somewhat disappointing Venetian paintings, for he

saw there literally miles of reflections, as well as paintings on a scale which he could scarcely have imagined – and he brought back to Giverny photographs of Tintoretto's vast hymn to the divine light, the *Paradiso* in the Palazzo Ducale.[43]

Monet told Thiébault-Sisson that he 'waited until the idea [of the *Grande Décoration*] had taken shape, [and] the arrangement and composition of the motifs had gradually inscribed themselves on my mind', before having a huge studio built in which he could paint it. A number of drawings in a sketch-book, executed very freely with bold, shadowless, curving lines, probably represent early compositional explorations, and already foreshadow several of the Orangerie compositions (ills.276 and 277).[44] Several were developed in sweeping abstract lines across two pages suggesting long horizontal compositions with the banks of the pool running across the base or the top of the image which is articulated by the trunks and fronds of willows and by tufts of grass. Other drawings show compositions consisting of nothing but water, whose presence is signified only by scrawls of interlinked ovals representing the rhythmic distribution of the lily pads. Several of the sketches were drawn over drawings of girls boating executed between 1887 and 1890.

In July 1914 Monet invited Geffroy to see the beginning of his *'grand travail'*, the product of working 'two months without stopping', and which probably included images of water-lilies, reflected clouds, willow fronds and reeds pictured fairly descriptively with light colours, and resembling the recently rediscovered *Nymphéas* of c. 1896–7.[45]

Monet's excitement at the possible realization of his dream was shattered, like countless other dreams, by the declaration of war on 1 August 1914. His house emptied, his friends seemed to disappear, and his sense of the disintegration of his world would have been intensified by the exodus of thousands of Parisians along the roads of the Seine valley, and by the counter-movement of refugees. He began to worry about the security of his collection and his own paintings, but also wrote to Geffroy:

Many of my family have left ... a mad panic has possessed all this area. ... As for me, I'll stay here all the same, and, if these savages must kill me, it will be in the midst of my canvases, in front of my life's work.

He had recently seen Mirbeau who was, he wrote, 'so isolated, in good health, but alas so pessimistic!' Heart-broken at the destruction of his dreams of internationalism and of progress towards a just society, Mirbeau resolved not to write again until the tragedy was over; but he was to die before that happened.[46] Clemenceau, on the other hand,

275  Kano Eitoku, *The Four Seasons*, c. 1566: sliding doors, each 175.5 (68½) high, extending 18 m (59 ft) on three walls

276 Preliminary drawing for the *Grande Décoration* (sketchbook MM.5129, 17 verso — 18 recto)

277 Preliminary drawing for the *Grande Décoration* (sketchbook MM.5129, 12 verso — 13 recto)

threw himself into the prosecution of the war with all his strength: he was an implacable upholder of *'guerre à l'outrance'*, war to the death, while Monet was working more single-mindedly than ever before to create his ideal world.

In October Monet wrote that the wounded were 'everywhere even in the smallest villages', and news of the wounding of Renoir's son intensified his fears for Jean-Pierre Hoschedé, who was at the front, and for his own son Michel, who was soon to be called up, leaving only Blanche with him. The battle of the Marne secured the front for the time, and the armies settled into the interminable, unknown nightmare of trench warfare. In December Monet wrote to Geffroy:

I've begun working again; it's still the best way of not thinking of present sorrows, although I'm rather ashamed of thinking about little researches into forms and colours while so many suffer and die for us.[47]

Monet's need to create a perfect world existed in intolerable contradiction to facts which he could not shut out now that he was painting in the face of death, not only personal deaths, but the deaths of untold numbers. The war was presented as a life-and-death struggle between the forces of good and evil, light and darkness, French culture and German barbarism, creation and destruction, and Monet accepted this dualism, allowing his name to be used in connection with a book called *Les Allemands, déstructeurs des cathédrales et des trésors du passé*, and believing that both he and his painting were directly menaced by the German offensives.[48]

In painting, Monet had always literally turned his back on anything disturbing, but this fundamental attitude now took a different form. For about two decades his need to arrest time had co-existed with an increasingly strong imperative to endow it with continuity: the great

*Nymphéas* painted during the war were conceived as a huge cycle in which constantly changing moments of light were fused into an endless whole. By the time the *Grandes Décorations* were completed, however, the destructive effects of time had become part of their very structure: they were affected by external constraints and Monet's age and blindness, but their character was also determined by his desire to absorb himself so intensely in his painting that he would not have to 'think too much about this terrible, frightful war'.[49]

Monet's output in these years was prodigious. In December 1920 he said he had painted between 40 and 50 panels, most of them substantially executed during the war. They were all 2 metres (6½ feet) high by 4.25 metres (14 feet) long (except for 3 which were 6 metres [19 feet, 8 inches] long), and were grouped to form larger compositions. He also painted at least 60 large – up to 2 metres (6¼ feet) square – studies related to the *Décorations*, and did a number of easel paintings. Some of the panels for the *Grande Décoration* were under way as early as June 1915 when, six weeks after the first use of blinding poison gas on the western front, the Goncourt dinner was held in Monet's home, and Lucien Descaves reported seeing in Monet's second studio 'vast canvases of about 2 metres (6½ feet) high by 3 to 5 metres (10 to 16½ feet) long. He had already covered some, and he was having a studio built specifically for the series . . .'. Despite the shortage of manpower, by August the huge studio – 23 metres (74 feet) long and 12 metres (39 feet) wide – was sufficiently advanced for Monet to lament its ugliness, in a letter to Jean-Pierre Hoschedé. In the same letter he said that, although he was 'working enormously', bad weather would prevent him from realizing what he wanted to do that year, adding, 'I speak as if I have a lot of time, which is pure folly, as it is to have undertaken such a task at my age . . .'. By September he was exhausted by months of uninterrupted painting and, in late October, he was able to move into the new studio where he could 'finally judge' what he had been doing.[50] He could now spend the winter working on the *Décorations*, using the warm months to study his motifs *en plein air*. His huge paintings were placed on wheeled chassis so that he could push them together to create continuous stretches of painting that would entirely surround him.

Some of the 60 large paintings of the pool and its flowered bank which Monet painted in these years can be called studies, in that he used them to explore certain effects and to examine the decorative possibilities offered by the pool: water-lilies seen through a screen of willow fronds; the vigorous willow trunks framing the water; the bank curving round coves full of lilies, reflecting open sky or shadowed by unseen trees and overhanging grasses; agapanthus, irises and day lilies silhouetted against the water.

The studies for the *Nymphéas* can be distinguished from the 1903– 9 series in that they focus on a fragment of the pool seen very close, whereas the earlier works represent it as if it were at some distance, with the islands of lilies in the front plane seemingly very small. Even in the earliest studies – such as the *Nymphéas* with willow fronds – the water-lilies and reflected clouds seem to be at one's feet in an almost dizzying disruption of pictorial dimensions which makes *The Clouds* of 1903 seem almost conventional.

The sense of closeness to the motif was retained even when a larger stretch of water was represented, as in a group of paintings of water-lilies on the open pool in which the lily pads closest to the spectator are not sharply foreshortened, as in the earlier series, so that they seem to be viewed from above and from near by. The close motif allowed Monet to look into the depths of the water rather than at its

reflective surface, as had been his primary concern in the *Paysages d'eau*. The composition also emphasized the flatness appropriate for wall painting, for space is suggested not through the abrupt foreshortening of the earlier series, which would illusionistically have destroyed the sense of the wall's vertical surface, but by slower transitions of scale which preserve that surface. This was one of the few dated *Nymphéas*, painted in 1916 when Monet was working with great intensity, congratulating himself that his sight still made this possible; but although he was more than ever conscious that he was working against time, and had not 'a moment to lose', he was able to endow the painted water with a glassy stillness.[51]

There are no painted compositional studies for the *Décorations*. This suggests that Monet took small nodal areas of pictorial activity depicted in the individual studies, setting these against the expanses of water for which there were no studies. This form of composition, influenced by Japanese screen painting and developed in the earlier *Nymphéas*, was now used to animate vast sheets of empty water on which Monet could materialize the myriad phases of light.

The studies were painted with huge scribbles of the brush animated by the rhythms of the reflected forms; the areas of water were scrubbed in with wide brushstrokes which left blank the places for material forms like willow fronds or the islands of lilies, which were mapped in with rapid loops of paint. Monet paid little attention to the representation of the water surface, but concentrated on the depths of water below the water-lilies and on the reflections of trees, grasses, clouds or patches of open sky which read as vertical shapes. In the *Paysages d'eau* he had worked towards taut, reflective, continuous surfaces, but in the studies the surface appears only at certain points

278  Monet painting by the water-lily pool, 8 July 1915

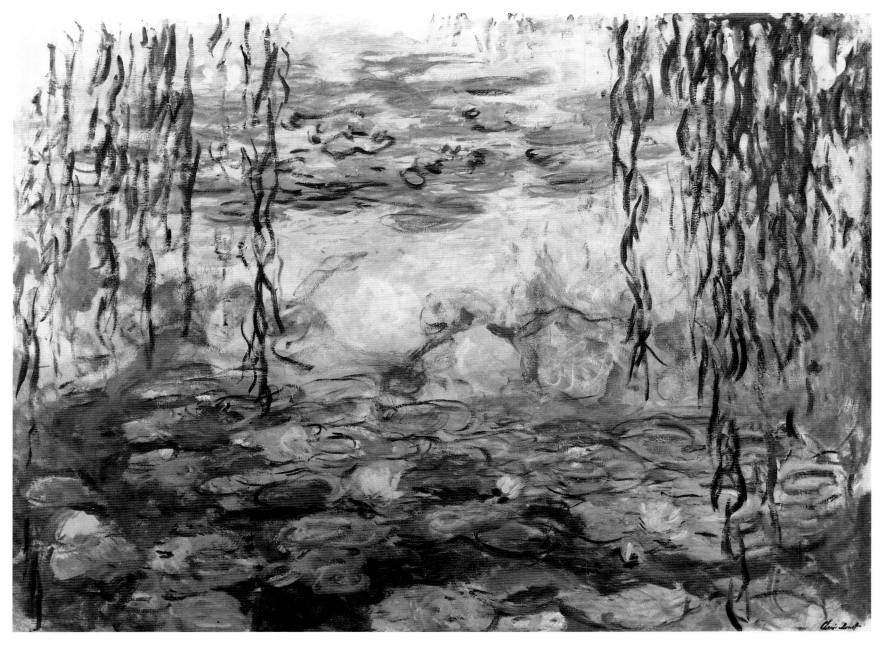

279    *Willow Fronds, nymphéas and clouds* (W.1852), *c.* 1914–17, 150 × 197 (58½ × 77)

(where willow frond meets its reflected image, for example; ill.287), and is not sustained across the painting; this can be seen in another painting in which there is no continuity between the water at the base of the painting and that in the second plane, where the reflected clouds are so bright that the water appears to bulge forward in front of the foreground plane. Photographs of the studio suggest that Monet used the large-scale studies there as *aides-mémoires*,[52] but since they registered only the depths of the water, the vertical reflections and the horizontal space indicated by the lily pads, the imaging of the surface which mediates between these different visual experiences must have evolved during the long months when Monet worked in the studio on the dense layers of paint of the *Décorations*. Despite having painted the pool for over twenty years, Monet continued to scrutinize and to contemplate it every day, but by now his knowledge of its every aspect was so deeply internalized that the distinction between observation and memory had become almost meaningless. Nevertheless the extraordinary freshness of observation both in the studies and the great panels suggests that the

*plein-air* studies continued to have a role in helping him to see what he had not seen; in this sense they should be viewed as 'researches' used by Monet in the ceaseless process of challenging his own preconceptions of form. Finally, they had a role in helping him to know what he could still do, at a time when his sight was inexorably weakening.

The '2 metres high by 3 to 5 metres long' canvases begun by June 1915 could have included the four panels of a composition entitled *Three Willows*, used in the Orangerie, and which were photographed in November 1917 (ills.295–7). In drawings for the *Willows* composition (ills.276–7), the trunks of the willow are represented by vigorous curved lines which are used more sparingly in the fronds, and are counter-pointed by the continuous loops and curves of the water-lily pads. The same mobile linearism is found in the painted studies, for example in a study of willows (ill.279), where the fronds and their reflections weave in and out of the brilliant violet-blues of the water, as they modulate from dark but brilliant green in the shadow to yellowed green when caught by light. Monet did not locate the fronds in space, or stabilize the

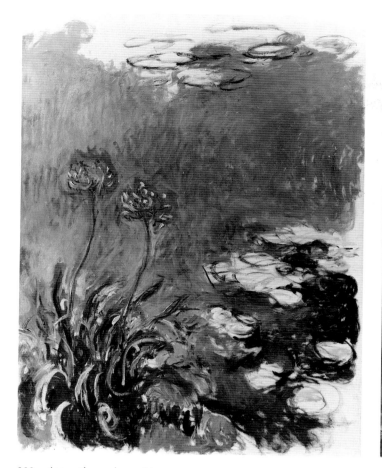

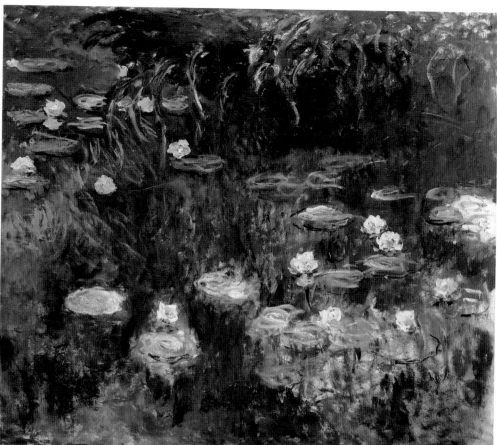

280   *Agapanthus and nymphéas*
(W.1820), *c.* 1914–17,
200 × 150 (78 × 58½)

*Above right:*

281   *Yellow and mauve*
*nymphéas* (W.1804), *c.* 1914–17,
200 × 215 (78 × 84)

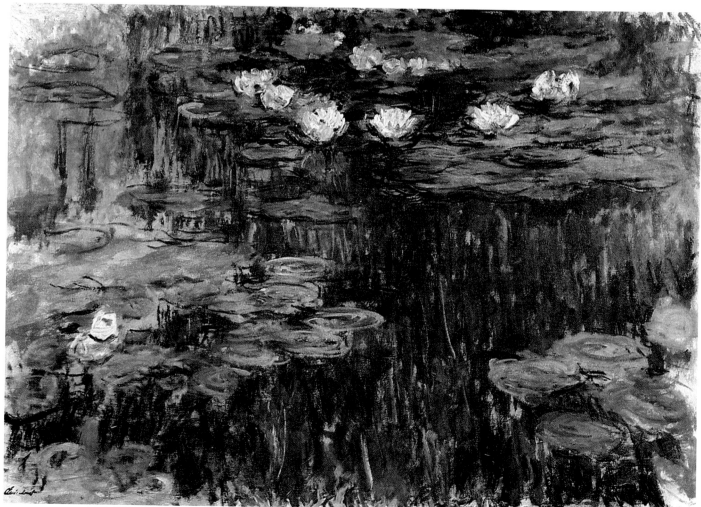

282   *Nymphéas* (W.1791),
*c.* 1914–17, 150 × 200
(59 × 78¾)

lily leaves, some of which detach themselves from the water surface and appear to float in front of the willows. It is a sparkling impression of a complex visual moment, which he transformed into something more grave and distant during the long months of working on the great panel.

The two 4-metre- (13-feet-) long panels of the *Green Reflections* used in the Orangerie (ill.294), and probably completed by late 1918, evolved from a group of studies probably painted in the summer of 1915, in which Monet represented the depths of the water below the islands of white water-lilies and the reflected fronds of a willow on the other side of the water. He was photographed painting this motif, with greenish violet lilies, by the side of the pool in July 1915 (ill.278). In a variant with white water-lilies, the grey-green, blue-green elliptical leaves detach themselves from the dark vertical streaks which suggest reflections penetrating ever deeper into the unseeable depths of the pool.[53] The following year Monet expanded the motif to include a larger stretch of water in a 2-metre- (6½-feet-) square painting, in certain areas of which he suggested the silky, taut surface of the water but did not fuse these into a continuous surface, so the lily islands seem to float, unrelated, on different planes (ill.288). In the *Green Reflections*, Monet opened out the composition so as to suggest limitless space, and he painted layer upon layer of colour, making the surface of the pool suggest a continuous substance which allows depth and breadth ceaselessly to fluctuate into one another.

As the war became darker, Monet continued 'this immense work' despite crises of discouragement, and fears for his son who survived 'three terrible weeks at Verdun'. It was in this year that he painted one of his most sombre panels, *Reflections of willows* (ill.305), a version of which was used in the Orangerie. One cannot read Monet's reaction to war into his painting, for he was seeking an alternative to horror, and he could write (when thanking the Bernheim-Jeunes for their good wishes for his seventy-seventh year), 'I am more and more ardent at my work... my greatest joy is to paint and to enjoy nature'. He was not only covering huge new canvases, but was transforming earlier ones, getting 'in a vile humour', because he had 'lost things which were quite all right and which I wanted to make better, and which I must at any cost find again'.[54] Loss could be experienced in painting, and there recuperated.

By early 1917 over a million of Monet's countrymen had died in the carnage. As always, he saw the wider tragedy as it affected his art:

I no longer have the courage for anything, saddened by this appalling war first of all, by my anxiety for my poor Michel who risks his life at every moment, and finally, and as a consequence, I'm disgusted by what I'm doing, and I see I will never come to the end of it.

Three weeks later came the long-expected death of Mirbeau. A short time before, a right-wing journal, *Le Petit Parisien*, had published what was alleged to be his '*Testament politique*', repudiating the internationalist, anti-militarist principles which had governed his life; but those close to him believed this to be a fake, sharing Tailhade's view that Mirbeau's 'entire work, with its cries, its tears, its gnashing of teeth, its furies ... is simply an appeal for Justice, a long cry of distress for Pity, Tenderness and Love'. There was little enough of that in 1917. Monet attended the funeral and there, Lecomte wrote, 'this harsh man sobbed. . . . overwhelmed with grief'.[55]

Two incidents which occurred early in 1917 suggest that Monet's confidence in continuing his huge scheme may have been sustained by some sort of commitment from the State to acquire the *Grande*

*Décoration*. Through Geffroy, who was administrator of the Manufacture Nationale des Gobelins, Monet tried to interest the Minister of Commerce and Industry in the manufacture of a carpet he had designed for the *Décoration*. The Minister, Etienne Clémentel, and the Under-Secretary of the Ministry of Fine Arts visited Monet and proposed that he should go to Reims to paint the cathedral, terribly damaged by

283    Monet on the wistaria-covered Japanese bridge at Giverny, *c. 1920*

*Opposite:*

284    *The Japanese Bridge* (W.1916), 1919, 65 × 107 (25⅝ × 42⅛)

German bombardment. The choice of France's most prestigious artist and painter of Rouen cathedral was an obvious one, but, although Monet accepted the commission and did visit Reims, he did not do the painting. He was, however, able to keep his car when others were being requisitioned, and to get petrol.[56]

In November, Clemenceau, who had ceaselessly and virulently denounced the conduct of the war, and those who sought or were believed to seek a negotiated peace with Germany, was made Premier and Minister of War. The armistice which the Germans signed with the new Soviet government in December enabled them to concentrate their forces on the western front, and, at this desperate time, Monet was making demands on the government which were quite astonishing, even for someone with his egotism. For example, in January 1918 when France was bracing itself for the German offensive, he wrote to Clémentel almost demanding that the Minister provide him with 'the necessary authorization' to override the refusal of the railway to transport the large chassis and canvases which he had ordered. He was, he wrote, 'in a great hurry'.[57]

Even if Monet had received some assurance that the State would accept his *Grande Décoration*, there was something excessive in these demands, and in the fact that he kept creating new works, far more than could be used in any feasible decorative scheme. By February 1918, he had completed 8 of the 12 panels that he had decided would constitute the *Grande Décoration* and was working on the last 4, which he believed he would finish that year, so long as his eyes 'did not play any more tricks'; but by the end of the war, he may well have completed nearly four times that number, perhaps including 3 canvases each 6 metres (19

feet, 8 inches) long.[58] Monet's fever of work was not confined to the 'grandes machines', for at the end of April 1918 he ordered 20 chassis of $2 \times 1$ metres ($6\frac{1}{2} \times 3$ feet), some of which he presumably used that spring, when, at the height of the German offensive, he reported that he was 'still working, still struggling with nature'. He feared a German breakthrough, and the possibility of having 'to abandon everything, as had so many others', but in response to Gaston Bernheim-Jeune's offer to get his canvases to safety, he wrote, 'I don't want to believe I should ever have to leave Giverny; as I have written, I still prefer to perish here amidst what I've done.'[59] Indeed, the Germans had broken through south of Amiens, about 60 kilometres ($37\frac{1}{4}$ miles) from Giverny, before the Allies began the counter-offensive which was to lead in November to victory in an exhausted, devastated Europe.

On the day after the Armistice, Monet wrote to Clemenceau:

Dear and great friend, I am on the eve of finishing two decorative panels which I wish to sign on the day of Victory, and am asking you to offer them to the State. . . . it's not much, but it's the only way I have of taking part in the victory.[60]

Monet told the Bernheim-Jeunes of the good beginning to his seventy-ninth year, 'first . . . this beautiful victory . . . and the visit of the great Clemenceau . . . it was his first free day, and he came to see me'. He informed them about his offer to the State, but asked them to keep it to themselves. He and Clemenceau may have had a more ambitious plan – the gift of the 12 panels, to be housed in a specially designed building which would involve the State in great expense, to which the Premier could not commit it without parliamentary consent. Clemenceau's promotion of the Décoration was intimately bound up with his faith in a

France which, after four years of destruction, had redeemed the humiliating defeat of 1870–1. He had long considered Monet's art as the exemplum of the moral supremacy of French culture, and, I think, wished to present it to the nation in this light. But the proposed gift raised issues which involved money, the bureaucracy and politics, and which led to months of uncertainty and to changes of plan that affected the final form of the Grandes Décorations.[61]

In 1919 Monet took a rest from the Décorations, and worked with great exhilaration en plein air on a group of easel paintings of the Japanese Bridge (W.1911–1933) and perhaps of willows and other parts of the pool. He intended to return to the Décorations in winter, but his sight suddenly worsened. For the next three years Monet fought to continue painting while his vision steadily deteriorated, and he stubbornly resisted an operation, preferring even to give up work rather than risk losing his sight.[62]

Clemenceau's probable commitment of the government to accept the Grande Décoration, to provide it with an appropriate home and to purchase the Women in the garden for a very large sum, as 'compensation' for the gift, was jeopardized by his defeat in the presidential elections in January 1920 and his subsequent retirement from public life.[63] But he continued to play a crucial role in persuading Monet to fulfil his commitment 'to France'. Monet was fighting to have the paintings housed exactly as he wanted, but he obviously did not want to let his great paintings go, or at least to do so before they were perfect – which meant, of course, that he could never finish them.

The press played a major role in the negotiations on the Grandes Décorations; four writers sought to play their part in history not only by

becoming Monet's biographer, but by ensuring that the offer of the *Nymphéas* to France would become a reality.[64] In April Elder gave an account of the great paintings which became familiar through the press, while Monet steadfastly refused to let any of them be seen in public. He described the studio as so full of sets of huge canvases arranged in a great oval that Monet had to replace them one after another, showing Elder paintings of 'dawn, the colour of absinthe, fusing the water-lilies and the misty water; there, the clear mirror of water . . . there, more distant, a carpet of precious stones . . .'.[65]

In June 1920 Monet wrote to Thiébault-Sisson, whom he used as an intermediary with the new Premier, Millerand, spelling out the conditions for his gift. These conditions were to determine the difficult future of the project. Monet stipulated that he would keep his canvases 'until the end', and that he would 'separate' himself from them 'only when I have seen the place where they will be placed, and that according to my instructions. This', he said, 'is for me an *absolute decision*'. About a fortnight later, however, he begged the journalist not to 'follow up the matter in any way . . . I don't want to hear anything more about it'. Such 'disturbances', Monet claimed, 'compromise my work and . . . I now have no time to lose'. Yet within a week he was writing to Clémentel to ensure his supply of coal for the winter, claiming, 'if the State wants me to work for it, it must give me the means'.[66]

Although Monet told Geffroy in June 1920 that his sight prevented him from working in nature, he did return to the motif, continuing the group of 23 paintings of the *Japanese Bridge* which was probably begun in 1919, and perhaps commencing the *Path with roses* group (W.1934–1940). He worked on these easel paintings in the summers so as 'to reserve my strength in order to continue work on my *Décorations* when the heat is not too strong in my studio'.[67]

Meanwhile the government entrusted negotiations to Alexandre, despite Monet's attempts to put them off and to postpone the visit of Paul Léon, Director of the Ministry of Fine Arts, on the grounds that he was 'struggling with nature'. By late September 1920 it was agreed in principle that the government would build a pavilion for the *Grande Décoration* in the grounds of the Hôtel Biron, which Monet's old friend Rodin had left to the State as a museum for his work, and the architect Louis Bonnier began to develop plans for it. Monet wanted an elliptical room, but, finding that too expensive, and believing that it gave unsatisfactory angles from which to view the longer paintings, Bonnier proposed a circular room in a polygonal building, with the four panels of the *Three Willows* facing the diptych, *Green Reflections*, and two triptychs, *The Clouds* and *Agapanthus*, facing each other (ill.289).[68]

News of the donation was leaked by Thiébault-Sisson, who wrote that the 12 panels of the *Grande Décoration*

would be distributed end to end along the walls in such a fashion as to give the spectator the impression of a single canvas composed of series. The series will be separated at intervals by relatively narrow passages symmetrically disposed . . . as entrance and exit. . . .

He also reported that Monet intended to have paintings of wistaria above each doorway, and that he would decorate a vestibule with a large composition.[69]

Of the articles appearing in the press once the news was out, Monet told Alexandre that he preferred his because it addressed the 'question of art', and Alexandre probably gave the most precise account of the original scheme. He described how the multi-canvas compositions – each characterized by a different colour-dominant – would be arranged so as to 'form an uninterrupted spectacle of water, reflected sky and vegetation', articulated by willow trees, clumps of irises and islands of water-lilies. The diptych 'in blue major' (probably the *Green Reflections*, which is as much blue as green), 'spontaneously offered to commemorate the victory', would, he wrote, be placed at one end of an elliptical room facing a three-canvas composition 'dominated by molten gold', probably the *Agapanthus* (W.1975–1977). On the longer sides of the ellipse, a composition with the heavy trunks of willow trees – probably the four-canvas *Three Willows* (ultimately made into two compositions) – would face a composition 'tinted with silver and pink with all the most tender freshness of morning', and perhaps related to *The Two Willows*. Alexandre said that

These decorations, placed very low, will seem to rise from the ground, and the spectator will . . . be placed not only in the centre of the water-lily pool, but also plunged into the passion of colour and into the multiple dream of the great artist.[70]

The different accounts of the titles, subjects and arrangement of the *Décorations* indicate that Monet had more compositions than he

285    The *grande allée* vaulted by rose trellises in Monet's garden

*Opposite:*

286    *Path with roses, Giverny* (W.1934), 1920–2, 89 × 100 (34¾ × 39)

intended to offer, so that he could continue to plan new combinations as freely as he could rearrange the panels in his studio. His changes caused Bonnier to comment, 'Monet has a new idea every day – Perhaps he wished [merely] to make the gesture', and he added sarcastically, 'The State would be really embarrassed at refusing a gift which could cost a million'.[71] Monet was over-optimistic in his belief that parliamentary approval of the project was almost a formality, for the post-war economy was in crisis, and costs of nearly 1 million frs. for unfinished works of art would have been hard to justify. As late as 1921, there was still uncertainty as to whether credits for the project would be voted.[72] But Japanese and American buyers were expressing an interest in the *Grande Décoration*, and the loss of the paintings to foreigners would have been an embarrassment, as Monet's art was being promoted in the press

as quintessentially French, and the government was seeking to institutionalize it.[73]

The Duc de Trévise visited Monet on his eightieth birthday in November 1920 (ill.312), and saw 'vast and disconcerting studies' for the *Grande Décoration* painted on the spot 'during these last summers. Tangled skeins of closely related colours, which no other eye had unravelled, bizarre mixtures of immaterial wools . . .'. Perhaps he was referring to works like *Reflections of willows* (ill.305) – though this was probably not painted outdoors. De Trévise describes how Monet several times changed 'the fabulous partition with which he surrounded me. Now the crepuscular bronze of a cloud served as a theme, now the calm of clouded azure'. Monet told him that he even painted at night, for he dreamed of his paintings. Alexandre made a similar point:

It is literally true that the painter was so dominated by his task . . . that he was unable to stop. . . . He told us that at certain of the most intense periods of his work, through the night in dreams, he continued to spread colours on the canvases, descending lower, ever lower. . . .

'Never', wrote Alexandre, 'has anyone abandoned himself to his dream with such freedom. . . . There is such joy in this exaltation of colour that he seems unable to stop'.[74]

In February 1921, Monet finally rejected Bonnier's plan for a circular room, objecting that it would be too regular, 'like a circus', and proposing to reduce his gift from twelve to ten or eight panels so that he could have an elliptical room created at less expense than estimated by Bonnier.

287    *Willow Fronds and nymphéas* (W.1850), 1914–17, 200 × 180 (78 × 70¼)

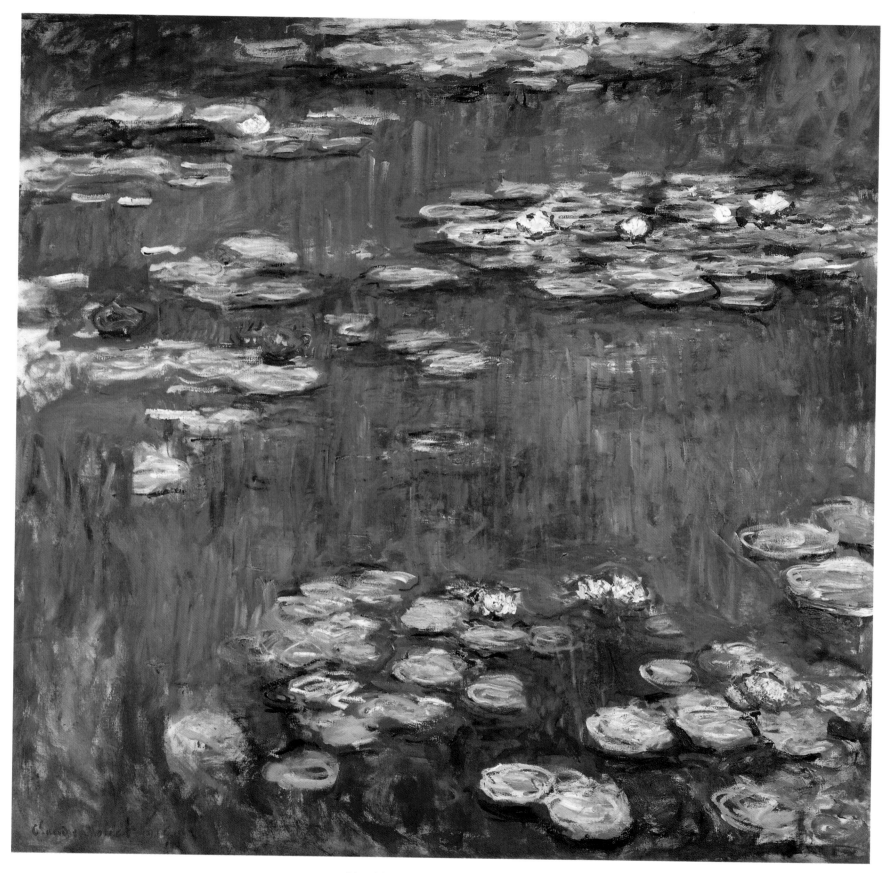

288  *Nymphéas* (W.1800), 1916, 200 × 200 (78 × 78)

In March Clemenceau and Léon sought a less expensive solution in the adaptation of either the Jeu de Paume or the Orangerie in the Tuileries; Monet rejected the first, and then decided that the second was so narrow that he would have to show his works 'absolutely straight' rather than curved, and since this would 'denature' what he was 'trying to do', he threatened once more to withdraw his gift altogether. He had, however, already been paid the 200,000 frs. for the *Women in the garden*, so his threat was probably a means of ensuring that he would get what he wanted, and he went on making subtle calculations about the relationship between specific paintings and the curve of the walls, and of the angle and distance from which they could be viewed. By June 1921 he was considering offering enough panels for two rooms.[75]

Monet had insisted on the *Grande Décoration* being housed in the centre of Paris, with the curious phrase, 'if not, why not in the slaughter yards?' It is difficult to imagine a more appropriate location than this peaceful back-water on the central axis of the city. The Orangerie was opposite the site of the old Salon which – as Monet never failed to remind those who interviewed him – had rejected the *Women in the garden* half a century ago. It was located by the Seine which, as Monet said, he had painted all his life, 'at every hour, in every season, from Paris to the sea'.[76] Its east–west orientation echoes that of the rising and setting sun which had governed his life as a painter, and may have influenced the choice of paintings for the end walls of the ellipse, with sunset and darkness on the west wall and dawn on at least one of the east walls. Finally the orientation and shape of what were to become two great elliptical rooms of paintings echo those of the pool at Giverny.

Although his eyes were becoming weaker 'by the day', Monet worked outdoors in the garden throughout the summer and autumn of 1921, writing exultantly to his friends about his hard work. The weather was good, he felt he had made progress and he hoped 'to be [there] next year to continue my researches despite my bad sight'. His exhilaration is understandable in relation to the dramatic sunset effects of the *Japanese Bridge* series, but is difficult to relate to the choked surfaces and, at first sight, chaos of multi-coloured brushstrokes of the *Path with roses* (W.1934–1940; ill.286). Nevertheless some were intensely observed: one suggests the dappled light on the path and the differences between the shadowed layers of leaves and flowers on the arches and the more luminous foliage above. Although the dull scales of colour are much further from the expected than in earlier works, comparison among paintings shows that Monet retained the intensity of his perception of tonal relationships, so that – as he told journalists – he could rely on the labels of his paint tubes and on the unvarying layout of colours on the palette to realize equivalents to nature even when his sight was much diminished. Nevertheless the muddied colours of the group suggest that he may have continued to paint them through 1922, when his sight was at its worst and he saw 'everything in a complete fog'. The ones which he left as wild swirls of paint suggest a despairing response to the fading motif and to his dying sight.[77]

The tactful mediation of Alexandre and Clemenceau enabled Monet to solve the problem of the Orangerie site, 'keeping the oval form' he had always wanted, and in November 1921, he told Léon he would offer 18 panels forming 8 compositions for two rooms, in place of his original offer of 12 panels for one room. The change in the number of panels meant that elliptical rooms could be constructed within the narrow rectangle of the Orangerie. Two diptychs, *Green Reflections* and *Agapanthus*, would face each other at the two ends of the first room, and would be flanked by two triptychs, *Clouds* and *Morning*; in the second room, the four-panel *Three Willows* would face the diptych, *Reflections of trees*, and they would be flanked by two 6-metre stretches of painting. These may have been the 'new canvases' which Bonnier saw in the studio at this time. Believing he would have to complete all the parts of the new scheme by the spring of 1922, Monet went back to work:

I closed my door to everyone all through the winter . . . I wanted to use what little remained of my sight to complete certain of my *Décorations* . . . in the end, I had to recognize that I was ruining them, and that I was no longer capable of doing anything good. And I destroyed several of my big panels.[78]

He also continued to change his mind about the scheme – plans submitted in January 1922 by a new architect, Lefevre, indicate an increase from 18 to 20 panels (including two diptychs 12 metres [39 feet] long in the second room); there was another scheme in March, which included four 6-metre-long panels – but the Act of Donation at last drawn up on 22 April 1922 was similar to the January scheme (although the 6-metre-long *Setting Sun* had replaced the *Agapanthus* diptych, and the diptychs in the second room were separated into four 6-metre panels). Monet did not confine himself to the terms of the legal agreement – the installation in the Orangerie has 22 panels, and the arrangement of the second room was radically changed. The contract of 22 April stipulated that the State should not alter the installation of the panels from that given in Lefevre's final plan; should not place any other work of art in the two rooms; and should never have the panels varnished. The alterations to the Orangerie were to be completed within two years. Because of his eyesight, Monet would not guarantee the quality of his panels. Although not mentioned in the contract, it had been decided that the paintings would be fixed permanently to the walls by *marouflage* which would enable one canvas to be joined almost invisibly to the next, if – as Monet planned – he wished to retouch them once they were in place.[79]

Monet had never given finite form to his 'old dream', but he had now to adapt his works to a real setting where they would be immobilized forever. Instead he kept his great canvases in his studio, arranging and rearranging them as he desired. Agathe Rouart-Valéry, who visited Giverny as a young girl, described how Blanche Hoschedé-Monet would 'tackle the weighty easels and close them around us. . . . From one visit to the next their number and diversity intrigued us more and more'.[80] The studio gave Monet the freedom to shape his own dream world, and the *Grandes Décorations* did not leave it until after his death. A few weeks after the drawing up of the contract, he wrote that as he was 'almost blind', he would have to give up all work: 'It's hard, and really sad, but there it is', and a month later, he begged Léon to hurry the work on the Orangerie, for he feared that his deteriorating sight would prevent him from overseeing the installation of his paintings.[81]

Yet the old man who could now paint only by relying on the labels of his colour tubes and on his lifelong experience of how tangles of colour would look when viewed at an appropriate distance, simply could not stop painting what he himself had called 'an obsession'. In early 1922, he may momentarily have dreamed of producing four or five 6-metre-long canvases, and he may at least have begun *The Setting Sun*, an extraordinary blaze of colour of expressionistic force.[82] He spent the summer painting outdoors. 'I'm working hard', he wrote, 'and would like to paint everything before being unable to see anything any more'. He no doubt went back to his paintings of *The Japanese Bridge* and *Path with roses* which he wished 'to see again from nature', and it was no doubt the latter which Joseph Durand-Ruel described as 'dark and sad'.

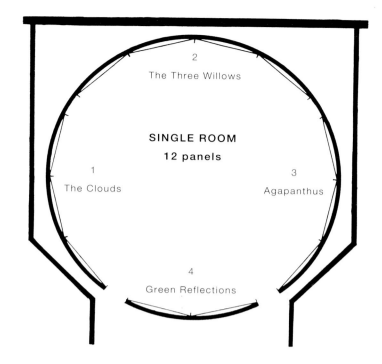

289 Louis Bonnier's project for a building for the *Grande Décoration* at the Hôtel Biron, 9 December 1920

290 Above, diagram of the *Grandes Décorations* in the Orangerie of the Tuileries according to the Act of Donation of 12 April 1922, and below, as installed in 1927. The four 6-metre paintings of *Morning* (Room 2) may have been intended to be separate panels, not 12-metre diptychs (see note 82, p. 333)

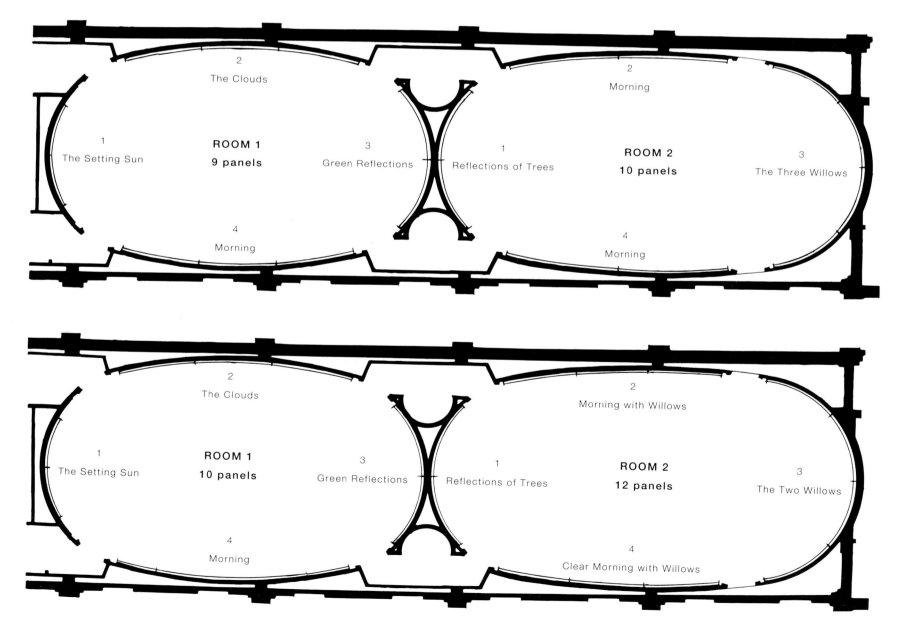

291  *The Grandes Décorations. The Setting Sun,* 200 × 600 (78 × 234), Room 1, wall 1, Musée de l'Orangerie, Paris

292  *The Grandes Décorations. Morning,* four canvases, two 200 × 212.5 (78 × 83), two 200 × 425 (78 × 166), Room 1, wall 4, Musée de l'Orangerie

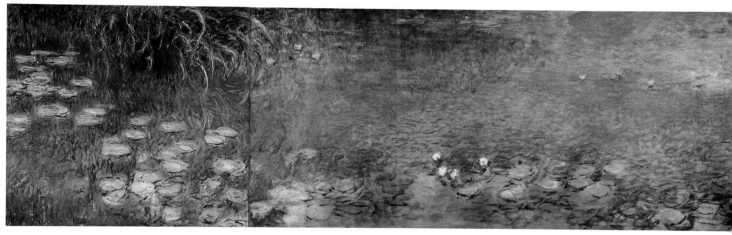

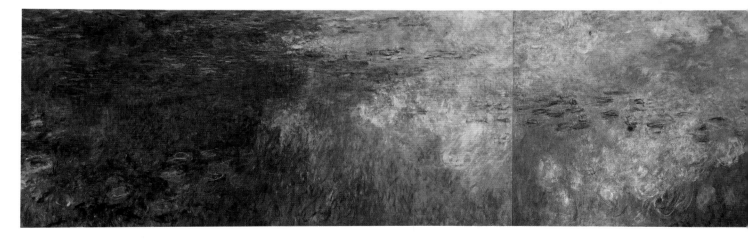

293  *The Grandes Décorations. The Clouds,* three canvases, each 200 × 425 (78 × 166), Room 1, wall 2, Musée de l'Orangerie

294  *The Grandes Décorations. Green Reflections,* two canvases, each 200 × 425 (78 × 166), Room 1, wall 3, Musée de l'Orangerie
*Overleaf:*

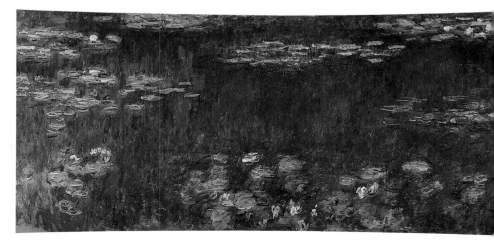

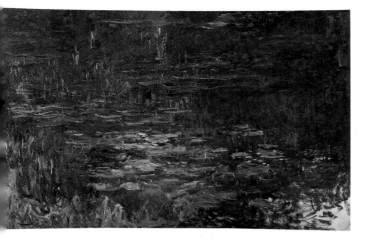

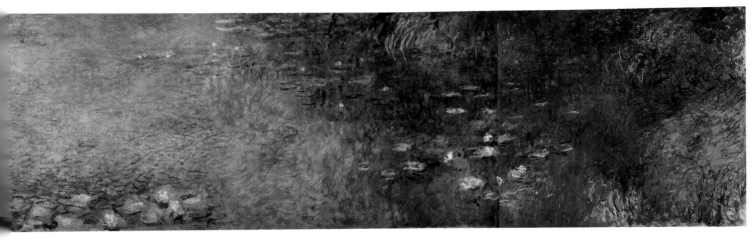

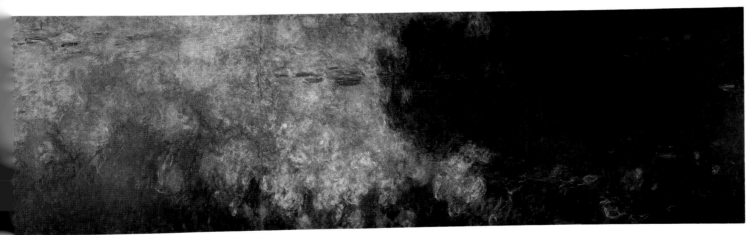

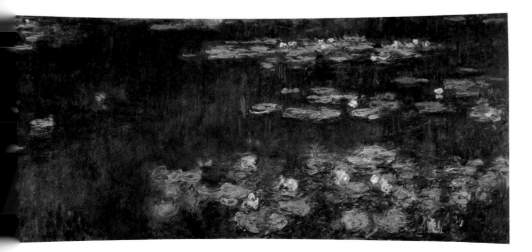

He also returned to an earlier motif, his house seen from the garden (W.1944), painted in a cacophony of hot oranges, yellows, pinks and livid greens, with the forms of the house and trees almost lost in the tossing brushstrokes. This was a subject of deep personal meaning to which he probably turned in his fear at the loss of sight and, through that, the loss of self.[83]

In September 1922 the ophthalmologist, Dr Coutela, recommended an operation to Monet's right eye, which was virtually blind, while the other had only 10 per cent vision. Treatment temporarily enabled him to paint 'passable canvases instead of crusts which I struggled to do without seeing anything there but fog', and he asked his doctor if he could continue the treatment in order to do what was 'most pressing'.[84] Two operations in January 1923 for the removal of the cataract in the right eye were only partially successful, perhaps because of Monet's unusually acute nervous reaction, and then his rage and despair that he was not immediately cured; another and more painful operation in July did not immediately improve things and his first spectacles were a disappointment: 'all is deformed, everything is doubled, and it becomes impossible to see'; 'I still see what is green as yellow and the rest as more or less blue . . .'; 'deformations and exaggerated colours drive me absolutely mad . . . if I have always to see nature as I see it now, I would prefer to be blind and to keep the memory of the beauties which I've always seen'.[85]

In September 1923 Coutela found that Monet had near-perfect vision in his right eye for things seen close, and adequate long sight if he wore his glasses, that he could see his palette and paint strokes, but could not judge the results when he retreated 4 to 5 metres (13 to 16½ feet), which was, according to Coutela, his practice. He no longer saw double, and deformations were minimal, but 'he sees everything much too yellow'. In view of these improvements and to rectify Monet's distance vision, Coutela proposed to operate on the left eye, and was energetically supported by Clemenceau, who urged Monet to decide quickly so that he could complete the 'rectifications' to the *Décorations* by April. Thrown into a panic, Monet refused unless he could find a painter whose sight had survived the experience, preferring to continue experimenting with glasses; in October he recognized that new glasses had improved his perception of colour. 'I again see green, red', he wrote, 'and at last the blue is diminishing'. He seems not to have painted until late autumn, writing to Clémentel in November: 'These badly written words will show you that things are going better, and moreover, that I am working . . . and that I want to finish my decorations by the date fixed'; and ten weeks later, 'I'm possessed by work and faced with great difficulties. . . . A painter's vision is difficult to restore . . .'.[86]

Monet was determined that the *Décorations* be exhibited only as a cycle, and insisted that one of them – the *Reflection of a willow*, the only one sold in his lifetime – be withdrawn from a major retrospective of his work held in January 1924 to aid the victims of the great Japanese earthquake. The completion of the cycle was, however, becoming more remote: Clemenceau commented sourly that Monet painted 'as if he had eternity before him', and that they would need to have a serious talk, while Monet told the Bernheim-Jeunes that he had to work without a break because it was nearly time to deliver the panels, but that the condition of his eyes made him 'often spoil that which was nearly good'.[87]

After the signing of the contract in 1922, Monet had two years to accomplish three major and ultimately incompatible tasks: firstly, to complete the paintings as laid down in the contract; secondly, to ensure that the panels of the different compositions would appear as one when they were attached to the walls, and that there would be some relationship between compositions; thirdly, to make the canvases true to his vision of light materialized in water, a vision made profoundly ambiguous by his defective sight.

The contract committed Monet to five 6-metre-long canvases, but the final installation contains only one, *The Setting Sun*, and it was possibly only this turbulent work, rather than any of the contemplative ones, which was begun after 1920.[88] Monet would not have the time or strength to paint all the large panels specified in the contract; moreover he probably could not find a way in which his 6-metre canvases could relate to a scheme which he seems to have been evolving in response to the alignment of the Orangerie, with compositions representing early morning light in the east and relative darkness in the west. Large isolated panels on the long side walls would focus attention on themselves rather than contribute to the vast panoramas which Monet desired.

He therefore added two panels to the *Three Willows* to form two triptychs, nearly 13 metres (42½ feet) in length, for the long side walls of the second room, each containing an open expanse of water flanked by the heavy trunks of willow trees whose fronds form a delicate screen in front of the luminous water. The *Three Willows* composition was to have gone at the east end of the ellipse, and Monet replaced it by four panels, probably begun during the war, which form the composition 17 metres (55 feet, 9 inches) long called *The Two Willows*. In the first room, there was only one change from the contract: the *Morning* was to have been a triptych of 4.25-metre (14-feet) panels, but Monet flanked two panels of this size with two paintings half that length, which are so different in handling from the central panels as to suggest that they were specially painted for the Orangerie, and which frame the large open plane of water with curving banks and overhanging grasses. He thus structured every composition – except for the two representing dark waters – in such a way that the most radiant part of the pool is at the centre both of the composition and of the curved wall.

Monet also began to develop relationships between compositions, suggesting connections of scale, perspective and tone between the water, lily pads and grasses at the ends of adjacent compositions. He could not, however, really work on such connections until he was certain which works he would use, and how he would arrange them, and then the trauma of his loss of sight in 1922–3 prevented him from fully developing his compositions as cycles in space.

He also continued what he called his 'transformations' so that his paintings would more precisely and subtly materialize his vision of light. Given his damaged sight, he must have been painting his memories of light, drawing on the accumulated, internalized experience of over sixty years of painting, and using the long-remembered gestures of embodying that experience. He was probably also painting his dream of light, a vision of unattainable perfection. Fully realizing memory or dream within the prosaic limitations imposed by the contract was to prove impossible, yet although he was painting what he could see only in his mind, on canvases which he could see only when he was close to them, the clarity of Monet's imaging of light is extraordinary. Maurice Denis wrote in his journal in February 1924:

Astonishing series of the great *Nymphéas*. This little man of eighty-four years . . . sees with only one eye with glasses, the other blocked with darkened lens. And these colour-tones are more exact and true than ever.

While Clemenceau responded to Monet's constant need for reassurance:

You decided that your work, interrupted when you were at the end of your journey, would be resumed with half-sight. And you found means to produce a consummate masterpiece (I speak of the panel of the cloud) and some marvellous preparations. . . .

In your last panels, I've found the same *creative* power perhaps even on a higher level.[89]

Clemenceau obtained a postponement for the submission of the paintings, advising Monet 'quietly . . . to get hold of yourself, and accept that you are only a man of mixed strength and weakness. (You are only a man . . . and this makes me joyful for if you were the good God you'd be really irritating.)' Monet's sight was improving, but he had repeatedly tried different glasses without giving his eyes time to adjust, so that his vision was in a state of constant change: in May he complained of 'the exaggeration of blues and yellows', and a month later he is reported to have told a second specialist, Dr Mawas:

I see blue, I no longer see red, I no longer see yellow. . . . I know that these colours exist, because I know that on my palette there is red, yellow, a special green, a certain violet; I no longer see them as I once did, and yet I remember very well the colours which this gave me.

Newly prescribed glasses were 'perfect', and he was able to work in the garden, but once again he found he was seeing less well, and matters seemed to go seriously wrong.[90] Louis Gillet wrote to Monet in October:

I think it imprudent to go back, with this fiery art [perhaps that of *The Setting Sun*], to canvases already executed in another technique. . . . I have a real fear that you might burn those beautiful, grandiose, mysterious, savage things which you showed me.

Clemenceau was outraged when Monet told him he might break the contract:

First you wanted to finish the incomplete parts. . . . Then you conceived the absurd idea of improving the others. Who knows better than you that the painter's impressions change at every moment? . . . You made new canvases of which most were and are masterpieces, if you haven't ruined them. Then you wanted to create super-masterpieces with sight which you yourself wished [to keep] imperfect. . . . at your request a contract was drawn up between you and *France*, and the State has fulfilled all its commitments. . . . You must then conclude, artistically and honourably. . . .[91]

Clemenceau did recognize some benefits in Monet's stubbornness: he had begged him to stop reworking a painting of reflected clouds, and, between his visits, 'some laboured effects where the brush had lingered obstinately, had become miraculously full of air'. The painting may have been *The Two Willows* or *The Clouds*, the central panel of which is most certainly 'full of air', while the heavy and inert right-hand panel is one of those which Monet had not succeeded in 'transforming'. Clemenceau quotes Monet:

I knew that this water was pastey. . . . The whole composition of the light needed to be re-done. I didn't dare. . . . You were frightened that I would destroy my painting. And so was I. But then some confidence came to me in my misfortune and, despite my veiled sight, I saw so well what was necessary in order to continue the chain of relationships that I was sustained by that confidence.[92]

Another visitor who had seen the paintings two years earlier said, when he saw them again in 1924, 'Far from having spoiled them, the old master . . . has developed them further'. Comparison between photographs taken in the studio and finished paintings shows that the 'transformations' consisted partly of layers of translucent paint which built up more subtle relationships between the receding surface of the water and its reflections and depths. For example, in the *Clear Morning*

*with willows*, Monet created luminous sparkling shadows across the base of all three panels, aerated the water, softened and diminished the far-off lily islands so that they suggest infinite distance; he subtly altered the curves of the trunks to frame the luminous space, blurred the fronds so as to suggest the breeze, and added delicate accents of clear colour so that the whole painting seems to vibrate with light.[93]

At the end of 1924 Monet was working on *The Setting Sun*, but suddenly informed Léon that he would not honour the contract. Clemenceau's long patience snapped. No man, he wrote, 'however old or ill, whether artist or not, has the right to break his word of honour — especially when that word was given to France'. He described Monet's offer to pay damages to the State as 'shabby', and continued:

If your sight is weak, this is because you wished it by allowing the condition of the eye which had been operated on to get worse and, like a bad child, refusing to have an operation on the other. Then, however, there was a real miracle. You were able to paint and you painted with more grandeur and beauty than ever. . . .

And now you are possessed by the frenzy of a spoilt child. You decided that your painting was worth nothing, and, although everyone who saw the panels declared them to be incomparable masterpieces, *although, at our last interview, you were very happy with them*, you now cynically break your word. . . . If I loved you, it was because I gave myself to the *you* whom I saw you were. If you are no longer this *you*, I will remain the admirer of your painting, but my friendship will have nothing more to do with this new *you*.

Monet did return to his huge task, and the two old men made tentative gestures towards one another, until a reconciliation took place at Giverny three months later.[94]

With new glasses and his unoperated eye blocked with a darkened lens, Monet was working in the garden 'with unequalled joy . . . I am content with what I do, and if the new glasses are even better, then my only wish will be to live to a hundred'. Exhilarated that he could still confront the weather, he was painting his last images of his house, described by Paul Valéry, who visited him that summer, as 'Strange tufts of pink seized beneath a blue sky. A sombre house'. Valéry also noted his glasses, 'a black lens, the other tinted'.[95] These were strangely echoed in the windows of the house in the picture.

That autumn, Monet told Elder:

You know that I have at last regained my true sight, that for me this is like a second youth, that I then returned to work outdoors with unequalled joy, and that at last I'm giving the finishing touches to my *Décorations*. I don't want to lose an instant until I have delivered my panels.[96]

It may have been in the joy of *vision retrouvée* that Monet painted the last scumbles of rose- and blue-tinted whites which dematerialize the watery clouds of *The Two Willows*; that he smudged on the blues which blur the falling leaves in the *Clear Morning with willows*; added to the layers of paint which soften the banks of *Morning*; and brushed in the streaks of yellow and vermilion that burn into the reflections of the willows in *The Setting Sun*.

By February 1926, Monet told Clemenceau that he was waiting only for the paint of the first set of panels to dry before despatching them to Paris, but in April, Clemenceau, who had gone to Giverny to tell him of Geffroy's death, wrote, 'He is stoic and even gay at moments.

*Overleaf*:

Detail of *The Grandes Décorations. The Setting Sun*, Room 1, Musée de l'Orangerie (ill.291)

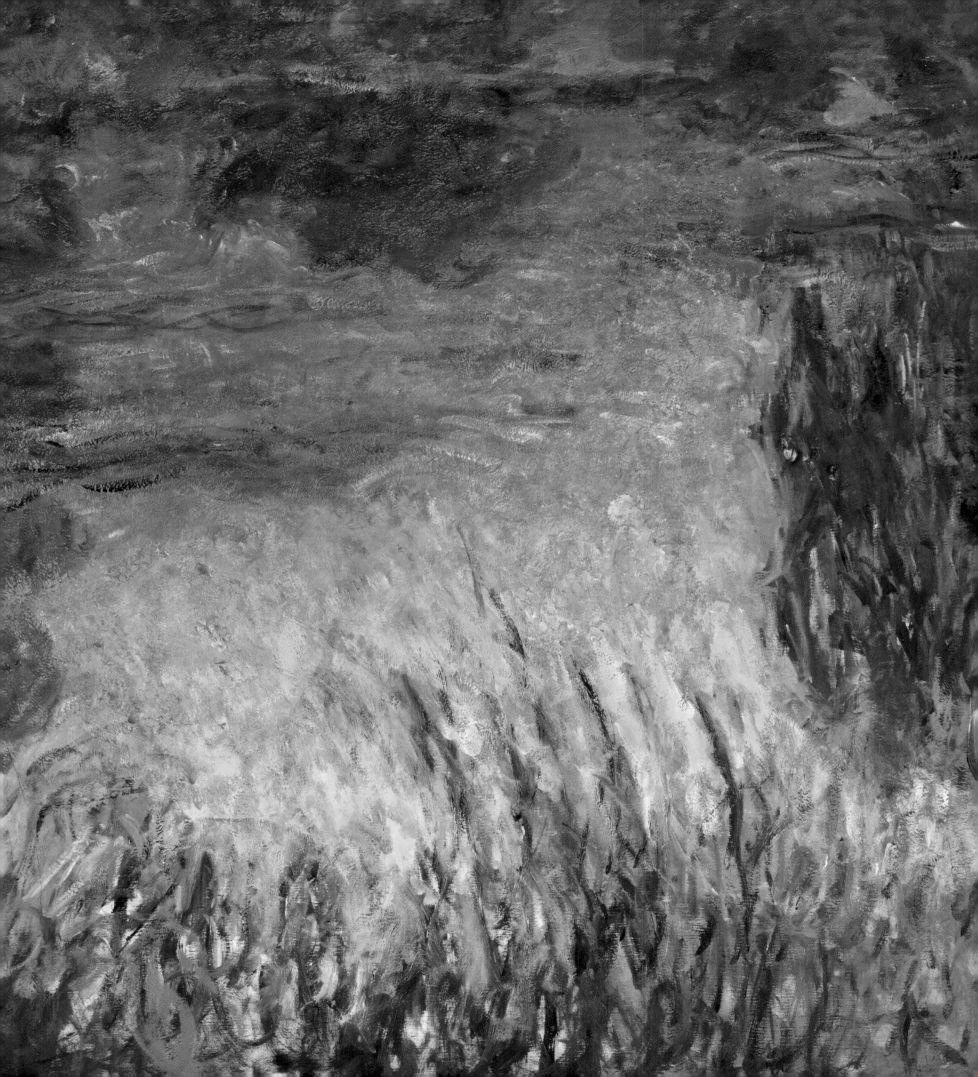

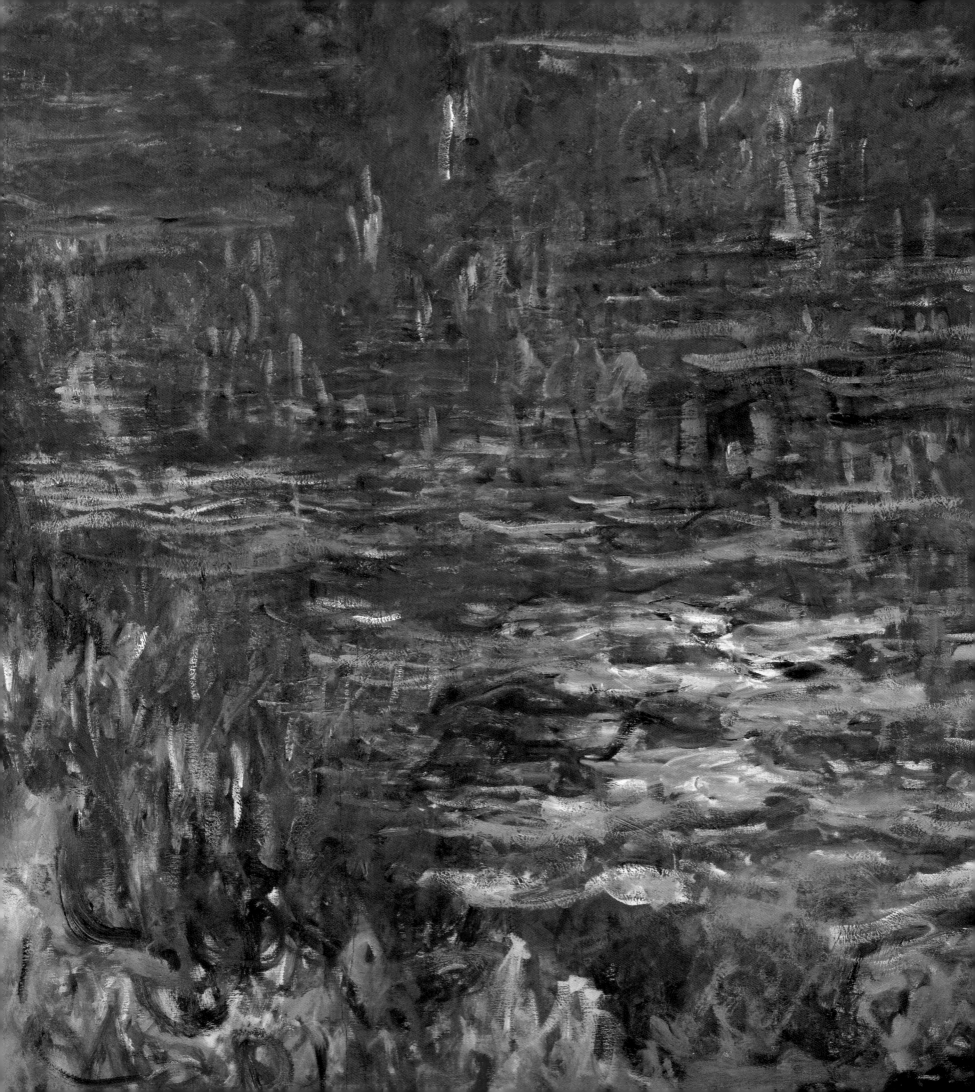

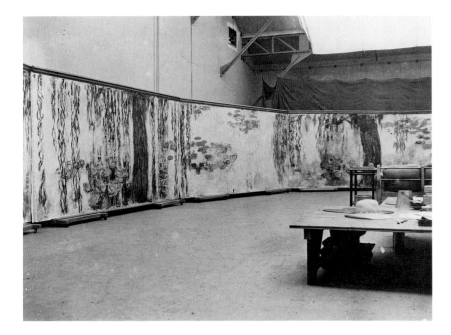

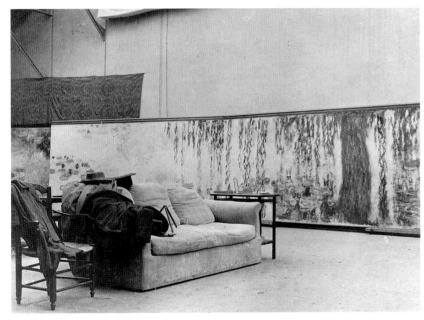

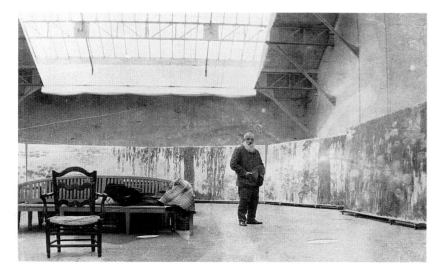

His panels are finished and won't be touched again. But it's beyond his strength to separate himself from them.'[97] In August the reason for the painter's growing weakness was diagnosed as sclerosis of the lung. He was not told of this, and he still struggled to continue work on the *Nymphéas*, writing to Clemenceau in September that he had felt well enough to

think of preparing palette and brushes to start work again, but relapses and renewals of pain prevented me. I don't lose courage for all that and am busy with big changes to my studio and with projects to perfect my garden. . . .

Finally, understand that if my strength does not return sufficiently for me to do what I desire to my panels, I have decided to give them as they are, or at least in part.

Three weeks later, in early October, he told Léon that he had been so ill that summer that he could not paint, but that he was getting better, 'and despite my weakness, I've gone back to work, though in small doses'. After this he painted no more, and spoke 'only of his flowers and his garden'.[98]

Claude Monet died on 5 December 1926. Before the funeral procession walked the half-mile to the village churchyard, Clemenceau insisted that the black cloth customarily covering the bier should be replaced by a floral one. The modern world reasserted itself as the mourners gathered round the grave, and film camera-men appeared 'in this marvellous silence which was strangling us and which was about to be broken by the clicking of the machines'.[99]

Only after Monet's death were the *Nymphéas* taken from the studio to be glued on to the walls of the Orangerie, making permanent that which an anguished sense of impermanence had condemned to incompletion. The *Grandes Décorations* which Monet had painted 'as if he had eternity before him' were opened to the public on 16 May 1927. Monet had preferred to die before these paintings, initially conceived as part of his home, were made public on the terms he had chosen, in the heart of the modern city.

The greatest of nineteenth-century landscapes, conceived in the 1890s, were first seen by the public after a quarter of the twentieth century had passed, and the many books and articles on Monet's life and art and on the *Grandes Décorations* which then came off the presses paid tribute to a cultural monument of a lost age, but did not engage with them as recent paintings which might generate new meanings. In June 1928 Clemenceau, who had made the *Grandes Décorations* possible, said, 'I went to the Orangerie. There was absolutely no one there. During the day there came, I think, forty-six men and women, forty-four of whom were really lovers seeking a private place'.[100]

295 The *Three Willows* polyptych (three panels and part of a fourth), in Monet's third studio, November 1917

296 Two panels of the *Three Willows* polyptych, November 1917

297 Monet standing in front of three panels of the *Three Willows* polyptych, after 1923(?)

*Opposite*:

Detail of *The Grandes Décorations. Clear Morning with willows*, Room 2, Musée de l'Orangerie (ill.299)

*Overleaf*:

Details of *The Grandes Décorations. Morning*, Room 1, Musée de l'Orangerie (ill.292)

Detail of *The Grandes Décorations. The Clouds*, Room 1, Musée de l'Orangerie (ill.293)

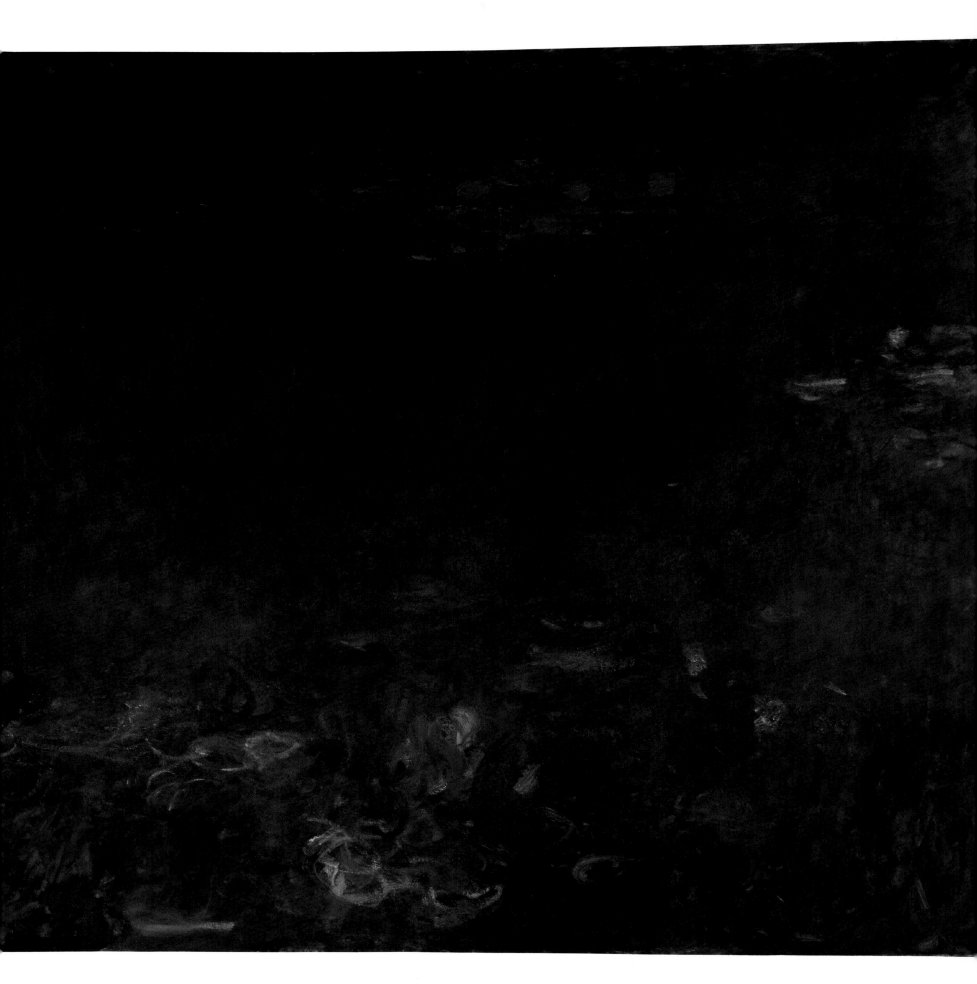

*Overleaf*: Details of *The Grandes Décorations. Green Reflections*, Room 1, Musée de l'Orangerie (ill.294)

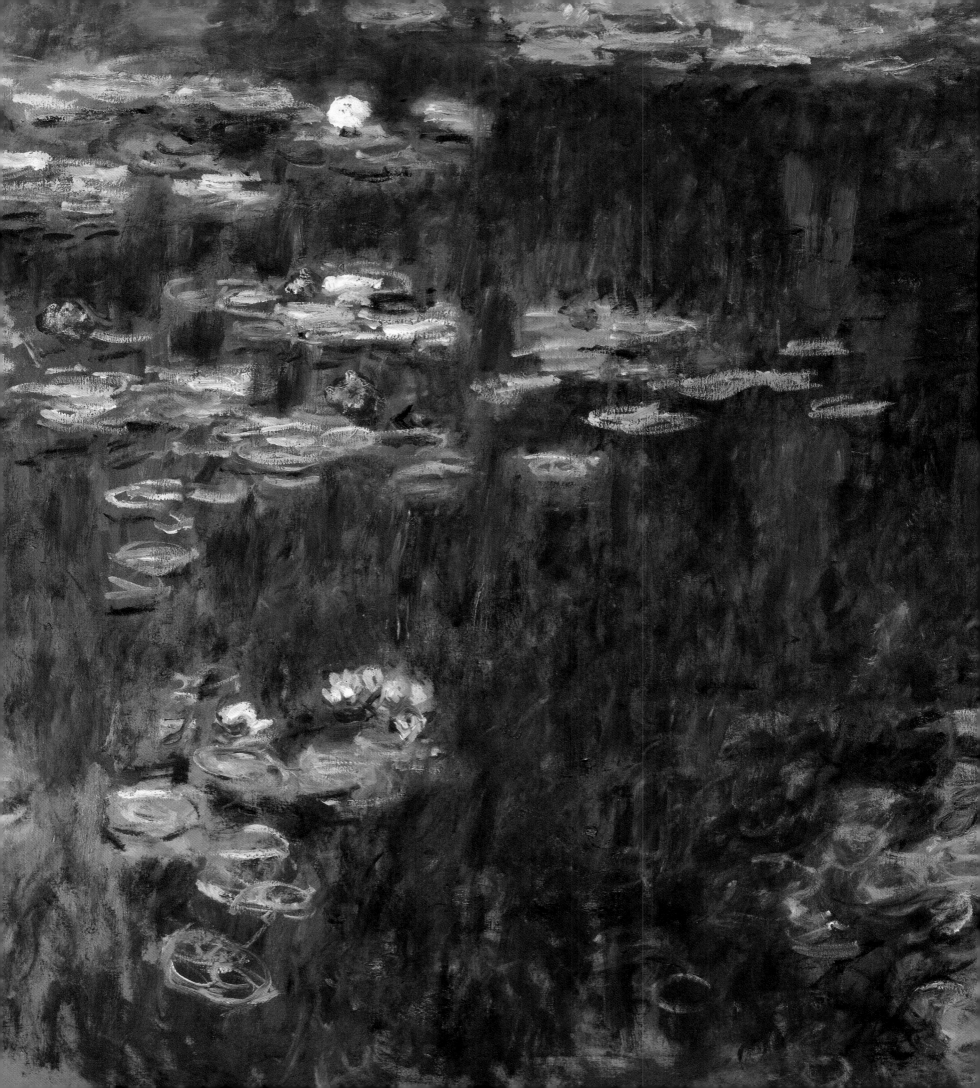

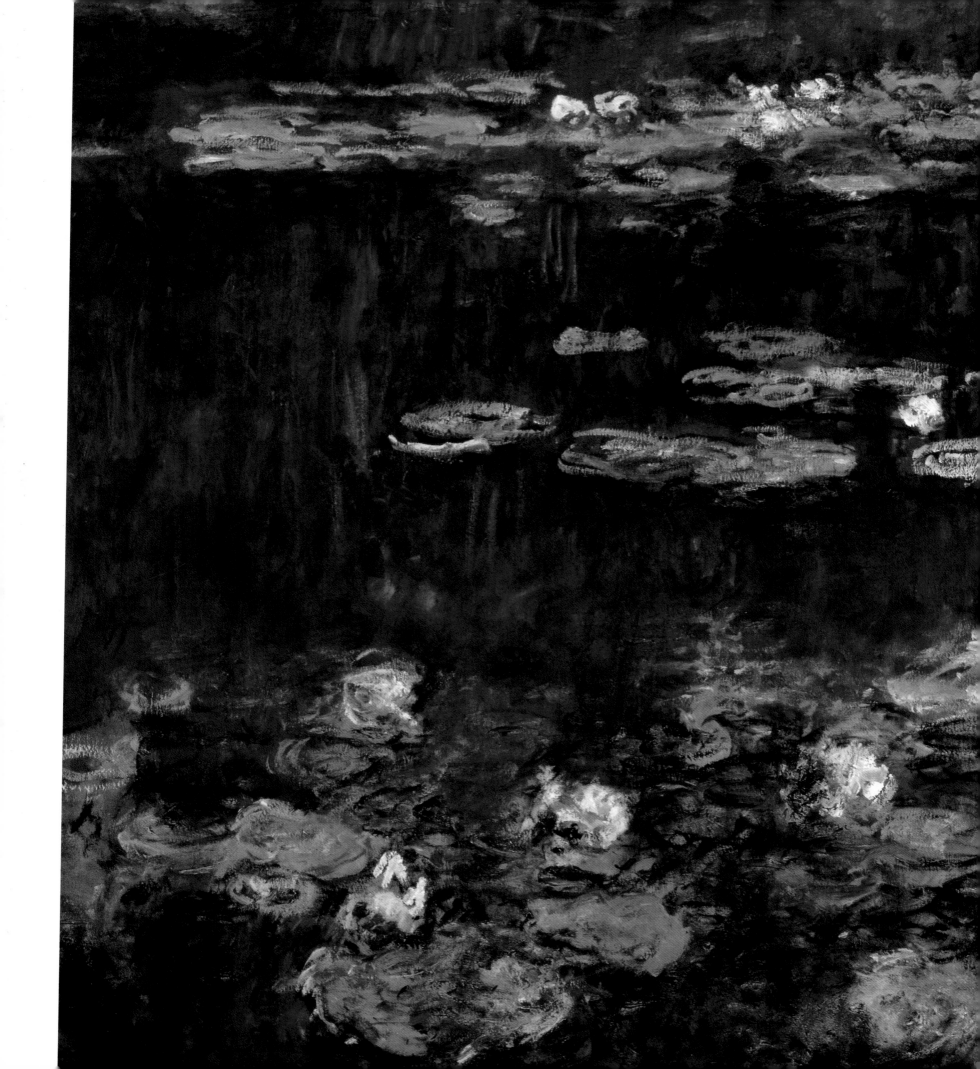

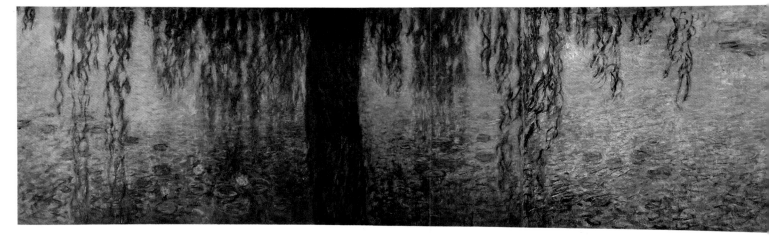

298    *The Grandes Décorations. Reflections of trees*, two canvases, each 200 × 425
(78 × 166), Room 2, wall 1, Musée de l'Orangerie

299    *The Grandes Décorations. Clear Morning with willows*, three canvases, all 200 × 425
(78 × 166), Room 2, wall 4, Musée de l'Orangerie

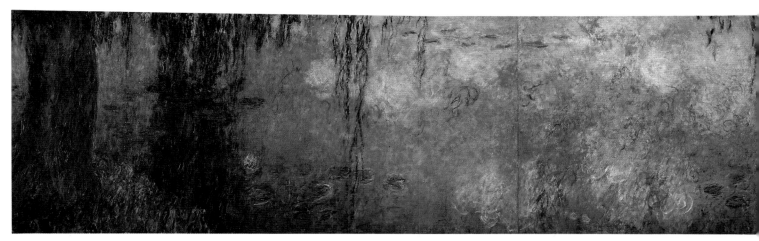

300    *The Grandes
Décorations. Morning with
willows*, three canvases, all
200 × 425 (78 × 166), Room
2, wall 2, Musée de
l'Orangerie

301    *The Grandes
Décorations. The Two Willows*,
four canvases, each
200 × 425 (78 × 166), Room
2, wall 3, Musée de
l'Orangerie

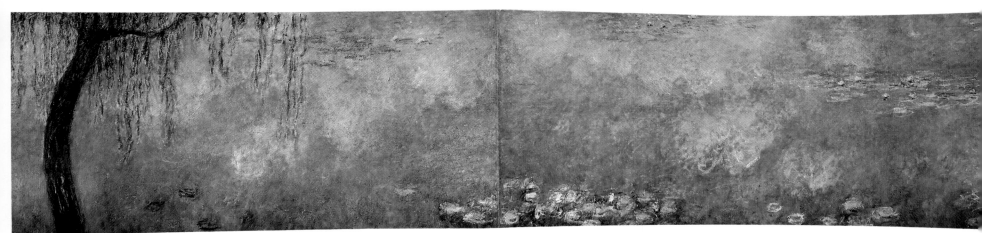

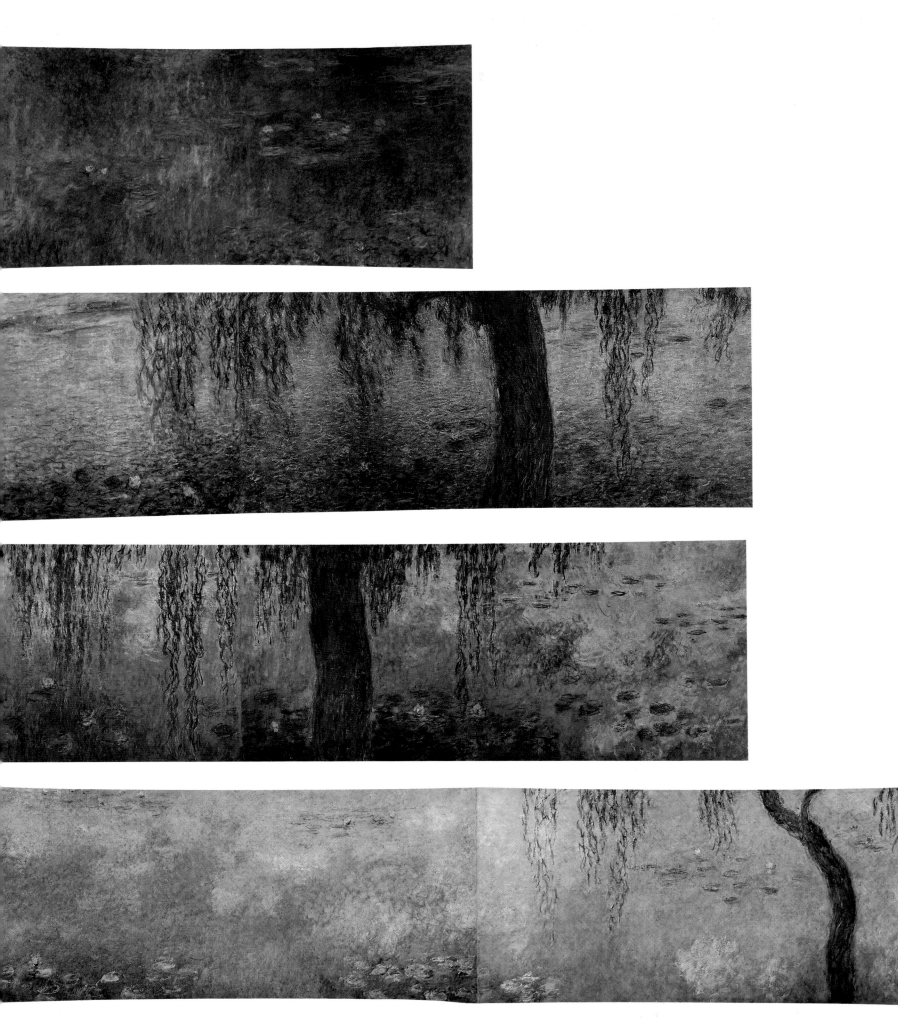

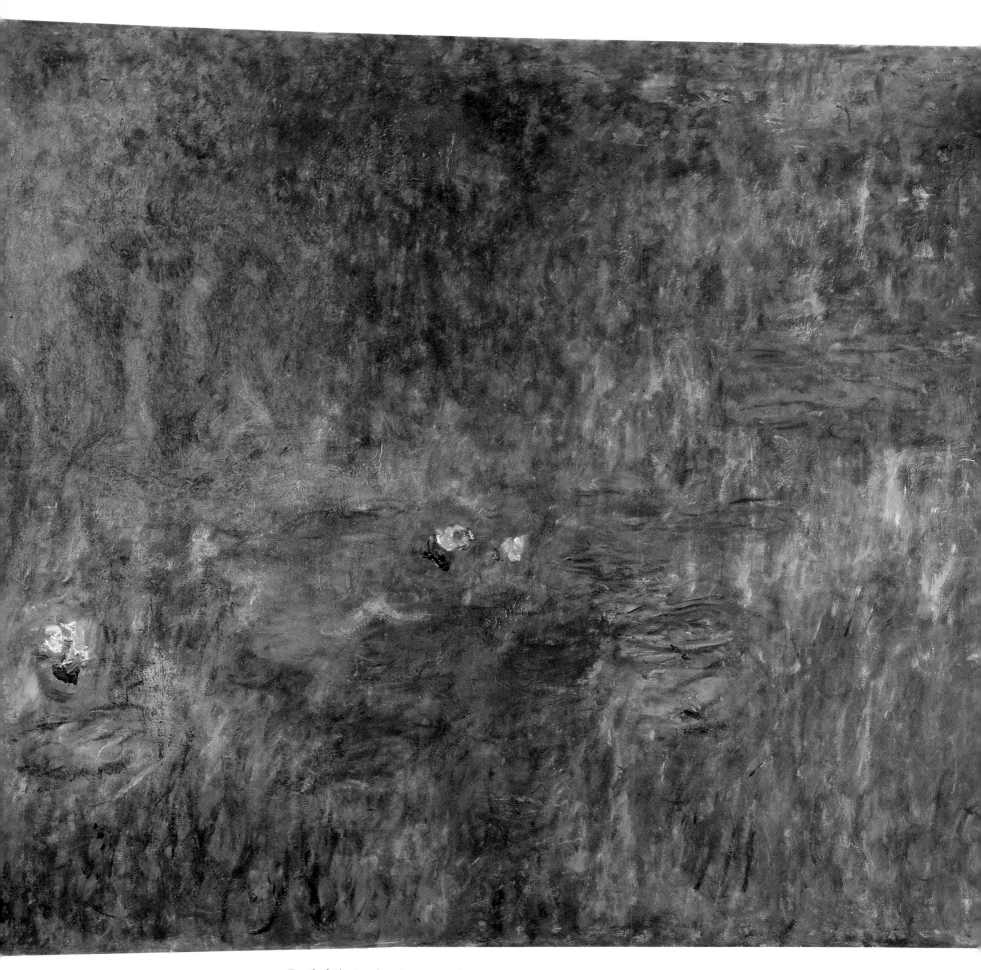

Detail of *The Grandes Décorations. Reflections of trees*, Room 2, Musée de l'Orangerie (ill.298)

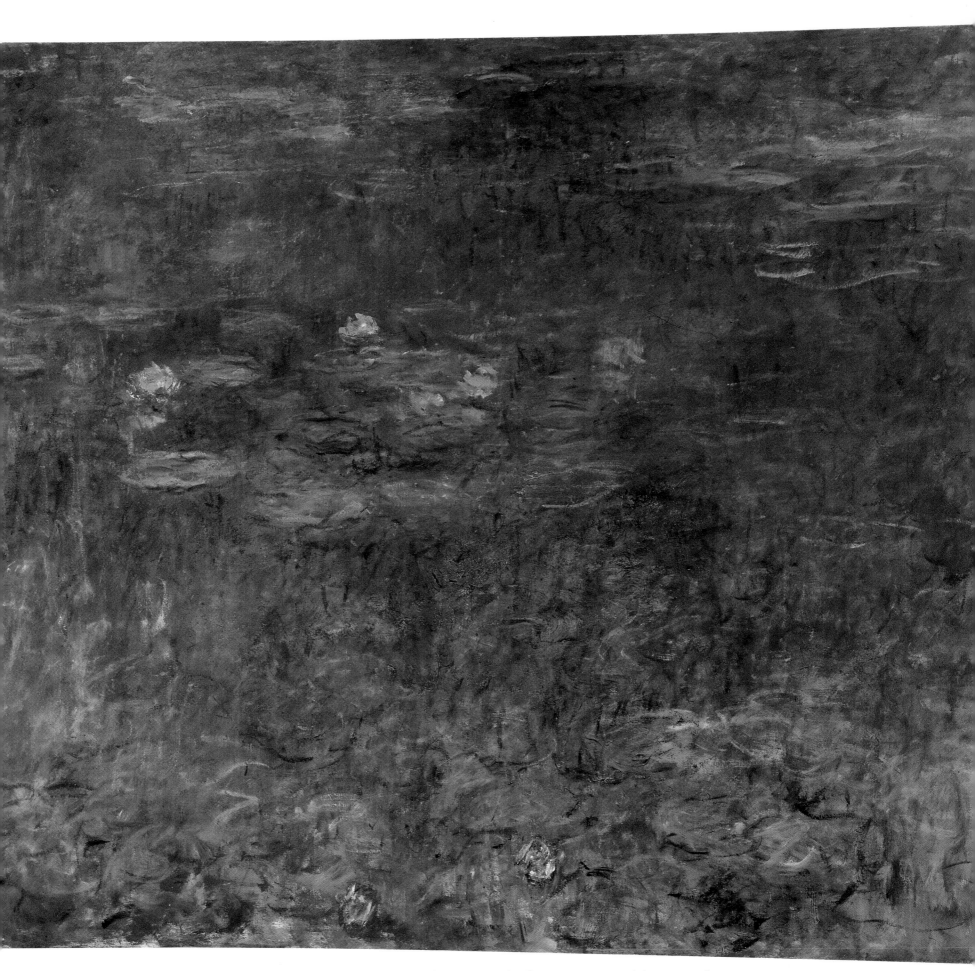

*Overleaf*: Details of *The Grandes Décorations. Clear Morning with willows*, Room 2, Musée de l'Orangerie (ill.299)

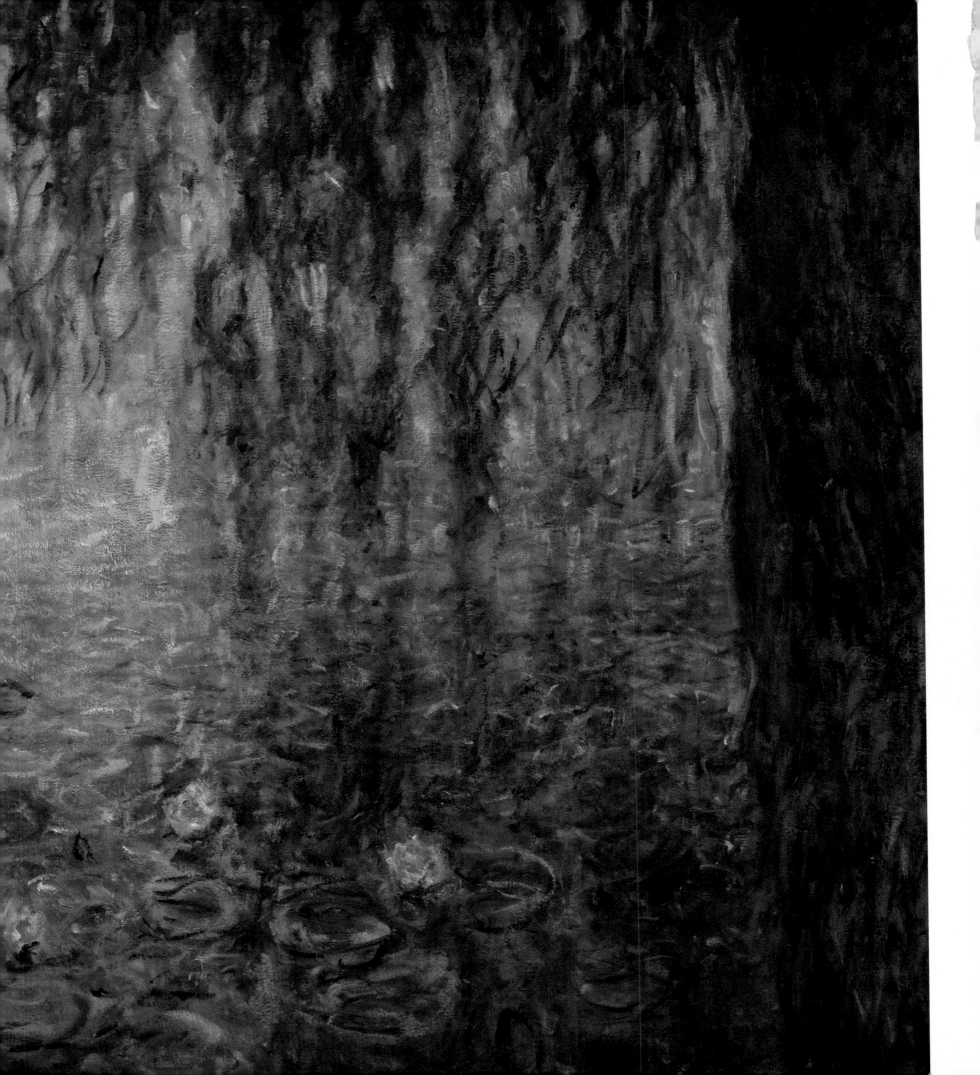

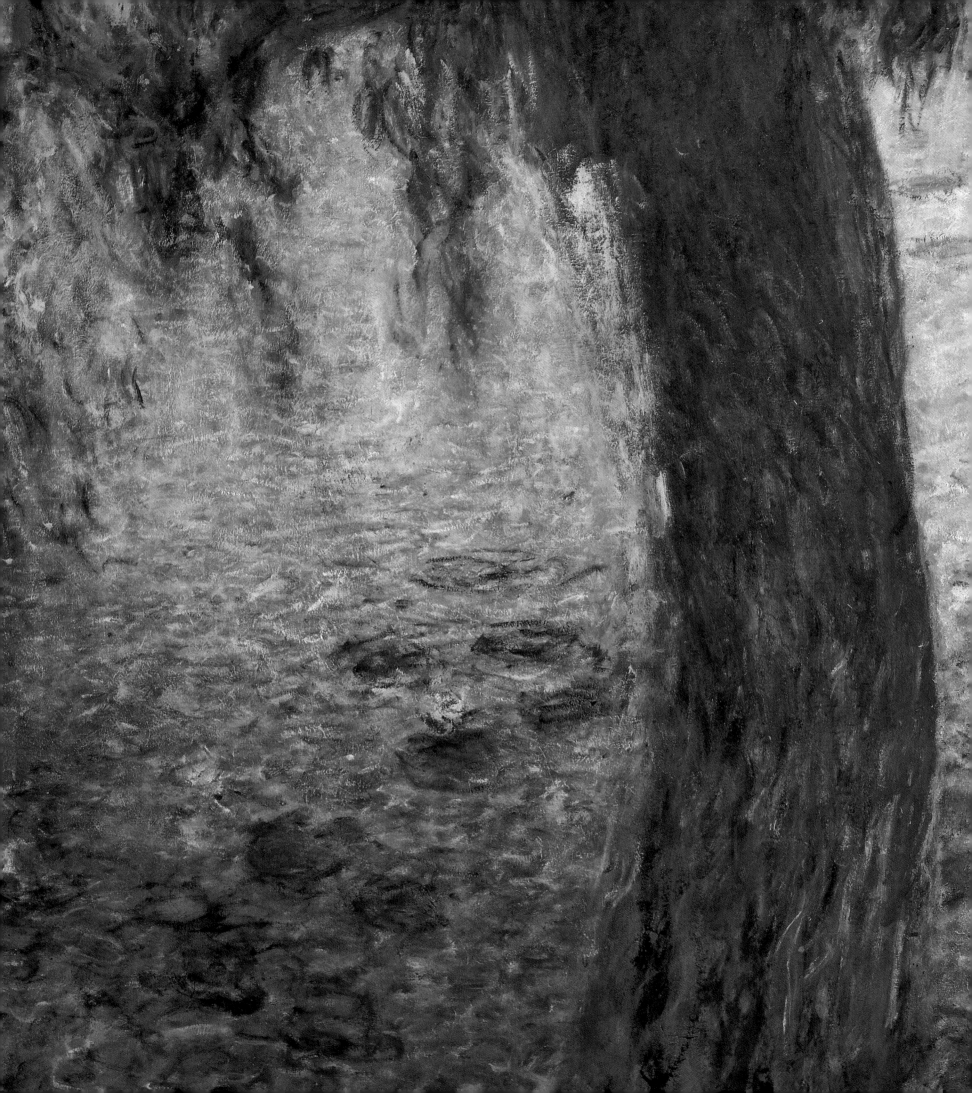

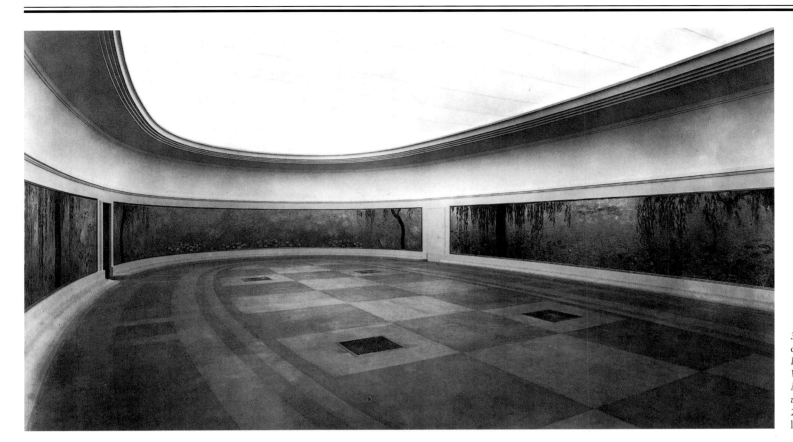

302   Photograph of *The Grandes Décorations. The Two Willows* and *Clear Morning with willows*, 1927, Room 2, Musée de l'Orangerie

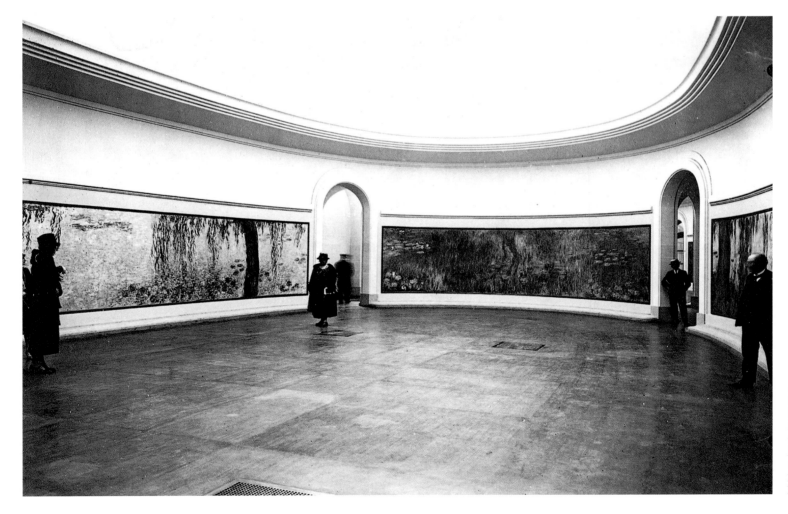

303   Photograph of *The Grandes Décorations. Clear Morning with willows* and *Reflections of trees*, 1927, Room 2, Musée de l'Orangerie

# III   The *Grandes Décorations* in the Orangerie

Monet's original idea for an antechamber to the *Grande Décoration* would have freed the visitor from the fret and noise of modern Paris. Today, the first room fulfils this function. One enters through an indeterminate space to be confronted by the deeply curved *Green Reflections*, flanked by the longer, shallower curves of *The Clouds* and *Morning*, and it is only when one has advanced to the centre of the room that one can see that it is completed by the 6-metre- (19 feet, 8 inches-) long *Setting Sun*, and that one begins to become absorbed in the huge expanses of light which is water, water which is paint.

Markedly different in character, the curving compositions invite one to seek their interconnections, and, in this way, to complete one's encirclement. Their subtleties of observation entice one to approach and to grasp the moment where illusion becomes paint, and paint illusion, and as one seeks to do so, the concave paintings seem to retreat and to draw one further into their depths, where they stretch beyond one's field of vision and become infinite. . . . The image of the external world then disintegrates into huge scribbles, dabs, smears, and crusts of paint, and the lilies, reflected clouds and willows, the glassy or broken surfaces of the water and its translucent depths disappear into a chaos of desiccated pigment (Monet sought to preserve the dryness of the paint by stipulating in the contract that the panels would not be varnished, and by using big sheets of blotting paper to absorb oil from the paint).[101] If one retreats to the point where illusion re-emerges, one can look at the wall of paint as if one were looking into the depths or across the surfaces of the pool, but even then, awareness of the paint does not dissipate, and the semblances of the natural world fluctuate before the viewer's remembering gaze.

The paintings are, in this way, a realization of Baudelaire's preference, expressed in 1859 – the year Monet arrived in Paris – for the illusions imposed on him by the 'brutal and enormous magic' of theatre scenery or dioramas.[102] Because of the consubstantiality of visible artifice and illusion, neither the individual compositions nor the cycle reveal themselves in the instant. They exist only in time, and only gradually install themselves in the consciousness of the visitor who, forgetting all, ceases to be a visitor and becomes a creator of this enclosing world.

This slow process may be observed in the case of the *Green Reflections* (ill.294), seemingly the diptych offered to France to commemorate the 1918 victory. Painted in dark, bright greens, deep blues and violets, it suggests the glassy stillness of shadowed water beneath the willows, perhaps before its surface is disturbed by the dawn breeze. On the left side of the composition nothing disguises the big scrawls of paint which take the form of the reflected willow fronds, but its centre has the multi-layered, granular surface characteristic of the works which Monet found most difficult to resolve. It is scarred by one of those slashes with which Monet, desperate that he could not realize his vision of light, would attack his own canvas. And yet it was repaired, and the dense build-up of paint continued, creating those dry, choked surfaces from which the most subtle moments of observation come improbably to form: a tangle of lighter greens summons up the interaction between a fugitive gleam of direct light and hazy, indirect light in the depths of the water; curved brushstrokes of light blue-violet beneath the lily leaves suggest the shadows they cast below them, while similar curves in light greens or darker blues, which link leaf to leaf, island to island, allow one simultaneously to distinguish the leaves

which hover above the water, those which lie upon it, and those which are partially submerged by it.

The *Green Reflections* suggest that if the *Décorations* were called into being by Monet's dream of an ideal enclosure, their scale was made necessary by his need for sufficient space to embody the ways in which sight takes possession of the physical world. The apparently contradictory scale and foreshortening of the islands of lilies show that this was not the finite world given by linear perspective, but one which changes according to perception in time and space. The island of lilies in the centre of the pool is, for example, smaller than one would expect from its position in space, but it is painted in firmer strokes of clearer colour than those surrounding it. If one focuses on it – as Monet would have done while painting it – the other islands of leaves loom and expand at the edges of one's gaze, but if one shifts that gaze across the water surface to focus on other islands, the central one maintains its radiance. The *Green Reflections* is one of the smallest of the *Grandes Décorations*, yet the imaging of the phases of light reflecting from the surfaces of the pool or diffused in its depths is infinitely complex. These phases are no longer severed one from the other, but coalesce in the watery element in such a way that consciousness of them becomes both continuous and cumulative.

The expression of light in time is yet more complex in the 13-metre (42$\frac{1}{2}$-feet) stretches of the two paintings flanking the *Green Reflections, Clouds* and *Morning* (ills.292 and 293). Monet's insistence on an elliptical arrangement of his *Décorations* meant that the maximum distance from which a painting could be viewed was shorter for the paintings on the long walls of the first room than for the smaller ones at each end. The spectator is then forced into a more active role in experiencing the effects of light in both space and time – for, even from the other side of the room, there is no moment when one can grasp the phases of light which play over the extended surfaces.

The four-panel composition of *Morning* owes much to the long-assimilated mobile space of Japanese screen paintings. The final abandonment of a unified system of perspective frees the spectator from his or her role as a detached observer viewing the world from a fixed position at a fixed moment in time, and makes it necessary for one to wander the length of the painting, exploring its multiple effects both successively and simultaneously, as they co-exist on the canvas and in one's mind. One may look down to the lilies on the water 'below' one, or 'across' the open water, where the sudden diminution of scale of the lily islands, and the modulation of blue-violet to more roseate tints, suggest an infinite, luminous watery space; one may pause on the bright reflections on the left, where the grasses are caught by the slanting rays of the early sun and where, in the transparent shadows, tiny concentric lines suggest 'the seed which falls'; one may move along the painting, past the central area of luminous violet-blues which, sharply accented by brilliant blues, suggest clear water ruffled by ripples, to the darker section of the painting on the right, where the grasses are rendered smudgily, as if to suggest still-lingering mist in which one only slowly comes to see the reflection of a willow made transparent by the light beyond it.

*Overleaf*:

Details of *The Grandes Décorations. The Two Willows* (left) and *Morning with willows* (right), Room 2, Musée de l'Orangerie (ills.301 and 300)

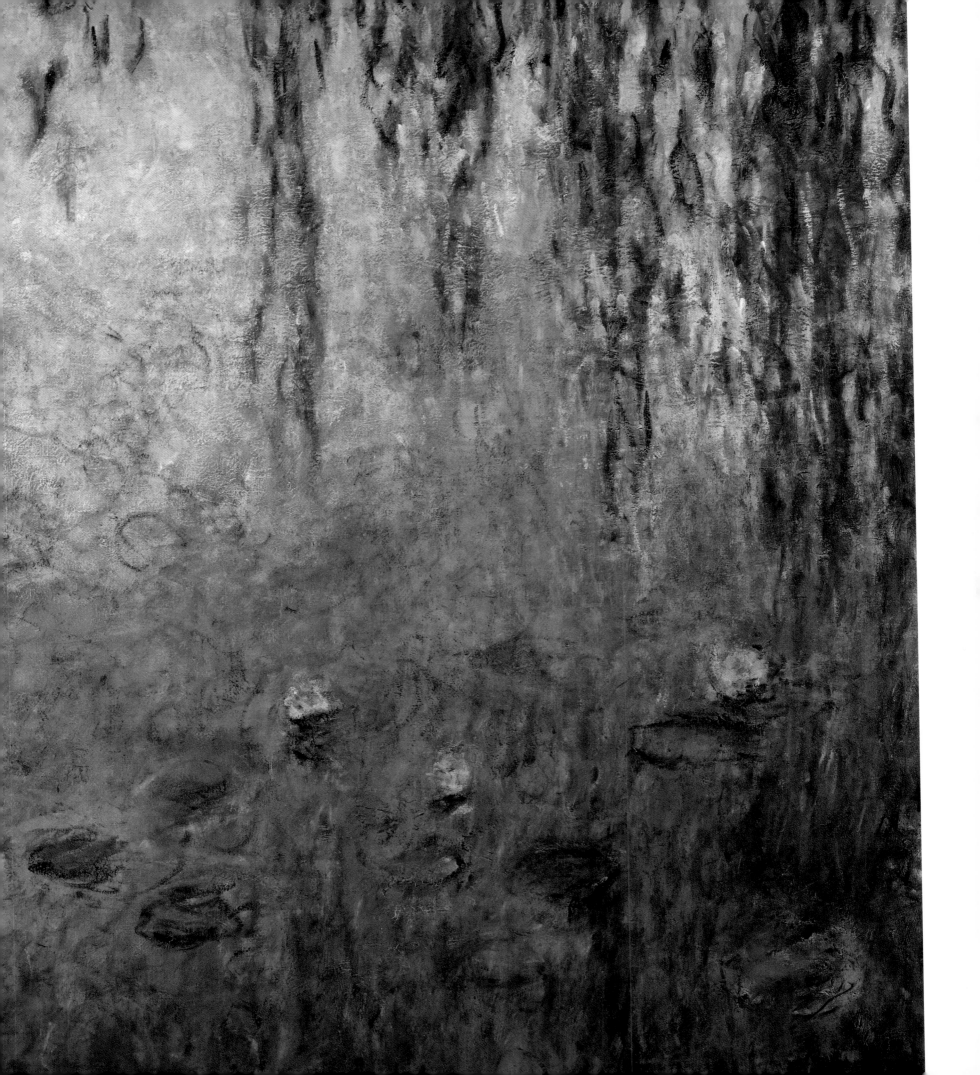

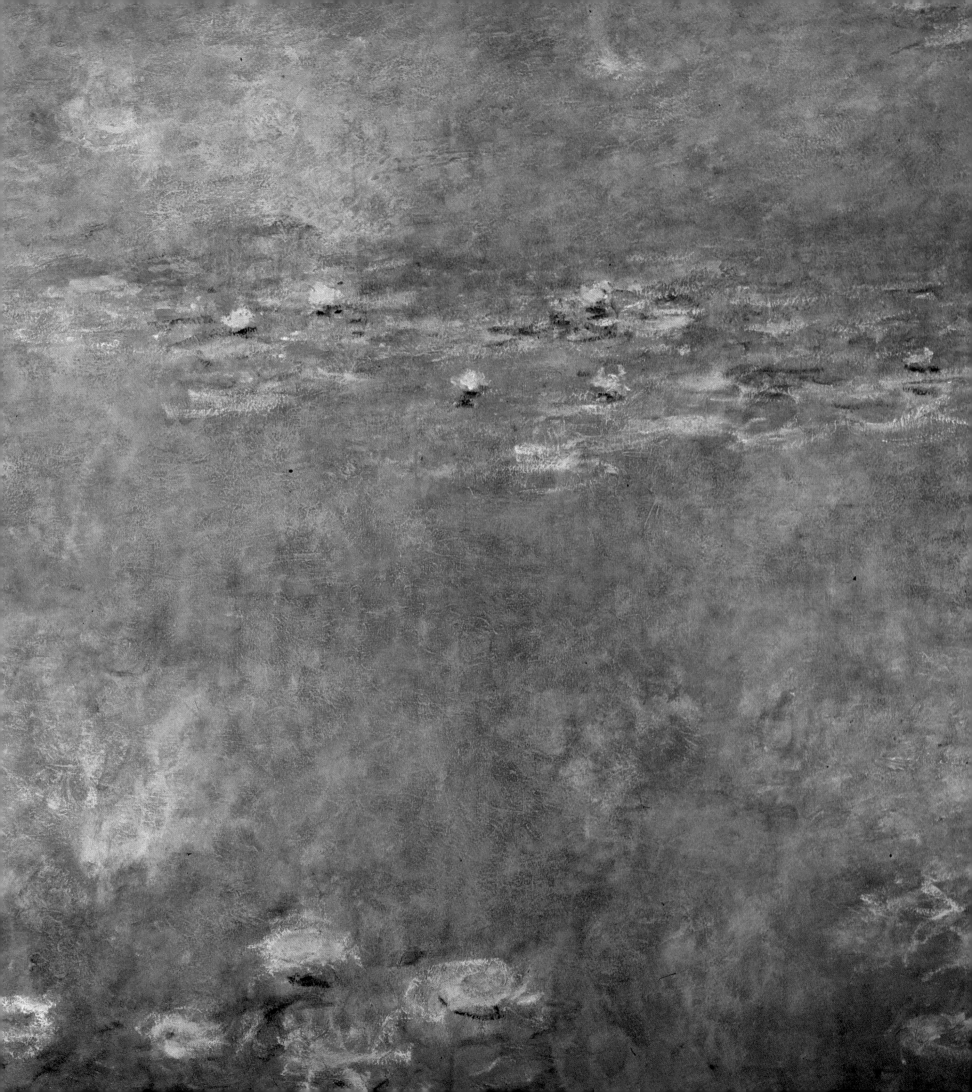

Between *The Clouds* and *Morning* lies the 6-metre-long *Setting Sun* (ill.291), in which a flame of golden light blazes in the darkening shadows of the pool. The painting re-enacts the visual experience when eyes, adjusting to blinding light, begin to discern form: ghostly leaves and grasses seem to emerge from the glare, while the fiery sky burning through the willow fronds appears in the shadowy 'depths' of the pool. Yet these recognitions do not stabilize, for, as one struggles to secure one's sense of the reality of what one sees, the great flare of yellow paint irresistibly draws the eye to it, and seems to open a chasm in the pool which disrupts all other relationships and dimensions.

The paintings bear the marks of Monet's difficulties in adapting his 'dream' to a finite architectural setting: in the *Morning*, he had not been able to reconcile the colours of the left-hand panels; the lily leaves were only roughly sketched in, and do not flow from panel to panel, and the irises which have been painted out remain visible; the dark reflections in *The Clouds* were not resolved and simply read as dead paint; *The Setting Sun* is so roughly sketched that bare canvas shows; the surfaces of *Green Reflections* and *Morning* are scored, scratched and even slashed. Yet these unresolved areas involve the spectator in the processes of completion, and reveal something of the ways in which sensations were brought to form as images.

Perhaps influenced by the way the scenes painted on Japanese screen-walls were sometimes continued across the gap of a doorway, Monet seems to have tried to create continuities between the canvases by using the spaces between them as imaginary fields of activity – which would allow, as an example, the light-filled shadows on the left of *Clouds* to modulate into those of the adjacent *Setting Sun*, while the scale, perspective and distribution of the lily leaves also establish relationships across the imagined continuity of the doorway. Similar connections are suggested between the grasses on the bank on the right of *Morning* and those in the foreground of *The Setting Sun*. The divergences between the compositions were too great to be resolved in the time Monet had available to him, but such is the suggestiveness of the great ellipse that the spectator strives endlessly to construct some continuum from fragmentary clues.

The cyclic arrangement of the paintings invites interpretation in conventional terms as a cycle of light from dawn through the day to darkness; but when Monet painted the *Décorations* he could no longer paint in full sunlight, so that, instead of the spatial and temporal continuity promised by the room, there is duality: notions of light and the extinction of light, of dawn and sunset, day and night ceaselessly oscillate in the mind, and the promised cycle breaks down into huge fragments of time and of space united, precariously, only by the spectator's remembering consciousness.

The paintings are not *views* of something outside themselves from which one is separate. This is not only because one is embraced by the painted space, but also because there is no moment when illusion is intact or the cycle of paintings complete; no moment, then, when one is released from the desire to resolve them as the perfect enclosures which Monet sought. The room gradually absorbs the spectator in its endless presentness, in which memories of the external world fade. It thus acts as an ante-room for the second cycle, yet, even in so doing, it preserves its duality, for as one walks through the doorway into the second room, one shatters the illusion of continuity that the paintings have invited one to create.

In the second room, complex phases of light are distilled into a single essence, an intense, luminous, unearthly blue. It is only when one

reaches the centre of this encircling blueness, and looks back at the fourth painting, *Reflections of trees* (ill.298), that one sees the ethereal blue extinguished in sombre blues and dark violets.

The astonishing clarity of vision manifested in the paintings is impossible to reconcile with one's knowledge of Monet's darkening sight, just as it seems inconceivable that their piercing calm is engendered by a cycle which has loss built into its very structure. More strongly than those in the first room, the four great expanses of painted water impose the notion of a cycle of light, from dawn on the eastern wall to darkness on the western one – yet here too, the cycle is flawed.

Perhaps finding the almost visionary intensity of *The Two Willows* too much to contemplate when they enter the huge room, most visitors first turn to the two triptychs, *Morning with willows* (ill.300) and *Clear Morning with willows* (ill.299). In both, the heavy trunks of the willows frame the open water at the centre of the shallowly curved wall, with their subtly varied counterpoint of veils of leaves, interlinked chains or islands of water-lilies, reflected clouds, and willows painted in ever-changing harmonies of blue, blue-green, blue-violet, blues tinted with mauve and pink, blues saturated with white. The long stretches of painting synthesize complex phases of light: the *Morning with willows* ranges from dark but brilliant blue shadows at the end nearest to the sombre *Reflections of trees*, to a warmer light at the far end; its unified surfaces, brushed by dark pinks, suggest an overcast sky, while the sparkling broken surface of the *Clear Morning with willows* suggests brilliant, breezy light. On the right, the trailing fronds are smudged as if by the breeze, while those on the left hang heavy, and the bright deep blues and greens suggest still shadowed water; but the broken strokes of brighter blue, with touches of warmer colours catching on the striations of the darker strokes, register the first quivering movement of the breeze, while a seemingly casual stroke captures the moment when a willow leaf grazes the water and becomes reflection.

The remote, ethereal beauty of *The Two Willows* (ill.301) stretches for 17 metres (55 feet, 9 inches) on the deep curve between the two paintings of *Morning with willows*. Except for the over-elegant signs for willows – like the silhouetted trees in some *fusamas* – nothing can be seen but water. The water makes visible a measureless sky of radiant blueness, softened by the gently moving summer clouds, and accented by constellations of pale blue-green lily leaves and white and pink flowers which melt into a dreamlike distance. Delicate modulations of colour suggest light in or reflected off the water, while the haziness of the lilies hints also at the vibration of light suspended in the air between spectator and pool, sky and water. Clarity of vision is sustained, from the materialization of the hugeness of space to the smallest details – as in the flecks of near-white paint, further lightened by scratches made by the point of the brush, which conjure up the way in which ripples in the translucent depths capture light as would a liquid crystal.

This is, however, paint: countless brushstrokes, broad dry strokes, scribbles, and scumbles; layer upon layer of coloured paste forming dry, heavily striated, encrusted surfaces. This materiality images immaterial light; this opacity transparent water; this density vibrating air. The huge gestures are those of an old man threatened with blindness, but they convey the sense of a vision so fresh that it recalls Baudelaire's assertion that the artist has something of the child 'who sees everything new'.[103]

The abrupt change of scale between the water-lilies at the base of the painting and those in the middle and far distance gives the sensation of space without end, and, as one approaches the painting, its deep curves entirely enclose one's field of vision, drawing one into the

304   Kaihō Yushō, *Pine and plum by moonlight*, second half 16th century, six-panel screen, ink and colour wash on paper, 168.9 × 353 (66½ × 139)

painting itself. The iridescent blue energies of the willows then become little more than images on the edge of sight or memory, and the forms whose reality one seeks to grasp dissolve into veil upon veil of thick, pastey pigment. Without any clues to physical location, one's sense of bodily autonomy dissolves, just as one's mind seems able to accept dissolution in the all-embracing light, which becomes paint before one's eyes. When one draws away to contemplate the leaves and flowers floating on the aqueous sky, the memory of their non-form is insistent, and they recall the symbolism of Mallarmé's water-lilies which enclose 'in their hollow whiteness a nothing, made of intact dreams . . .'.

As one turns away, it is a shock to see the extinction of light in the *Reflections of trees* on the opposite wall of the ellipse. Monet had never seriously painted darkness before, and the heavy layers of paint (as well as the several studies) show that he found it difficult to establish the surface plane of the water or its lower depths. Trying to paint what he could see in darkness was not only difficult, but was profoundly alien to all that he had sought in his painting.

Like the four paintings in the first room, those in the second invite the spectator to complete them as a cycle by trying to follow up the hints suggested, by the relationship between the darker shadows at the adjacent sides of *Morning with willows* and *Reflections of trees*, or the luminosity of the sides of the two *Mornings with willows* which are closest to *The Two Willows*. One's sense that such relationships exist cannot be sustained, for time is represented not as continuous throughout the day but as an opposition between light and darkness mediated by the *Morning with willows* paintings. Moreover, while each of the multiple phases of light is intensified by one's consciousness of the others, each renders the temporal specificity of the others ambiguous: Is either of the two *Mornings with willows* earlier than the other? Does the

stiller pink light of the one precede the morning breeze in the other, or is it merely a different effect? Do the glimmers in the darkness of the *Reflections of trees* signify the last light of an evening sky, the luminosity of the night sky, or the lightening of the sky at dawn? Can one relate phases of light to the fact that — as Monet pointed out to his visitors — the lily flowers open with the light and close as twilight falls?[104] At first, both *The Two Willows* and *Reflections of trees* have a strong enough presence for each to extinguish consciousness of the other, and to suggest that the final dissolution of the self is in the luminous essence of the former or in the dark waters of the latter. The presence of the two *Mornings* disrupts this simple dualism, and insists on the interpenetration of every phase of light in one's consciousness: darkness is thus latent in one's experience of the measureless light of *The Two Willows*, and light is like a memory in the darkness of the *Reflections of trees*.

◆◌◆◌◆◌◆◌◆

A visitor to Monet's studio in 1918 wrote, 'We seem to be present at one of the first hours in the birth of the world.'[105] Monet rejected any metaphysical interpretation of his work, insisting to the end of his life that he sought only to be true to his sensation of nature, but his obsession with the natural elements, light and water, which are so essential to life that they are deeply embedded in language, memory and culture, inevitably evoke associations of this kind. They arise irresistibly from experience of the *Grandes Décorations* in the way in which form emerges from and dissolves into undifferentiated matter. This double experience of form suggests a state of consciousness which perceives the world as fluid, and not solidified into the static shapes of everyday recognition and functional thought.

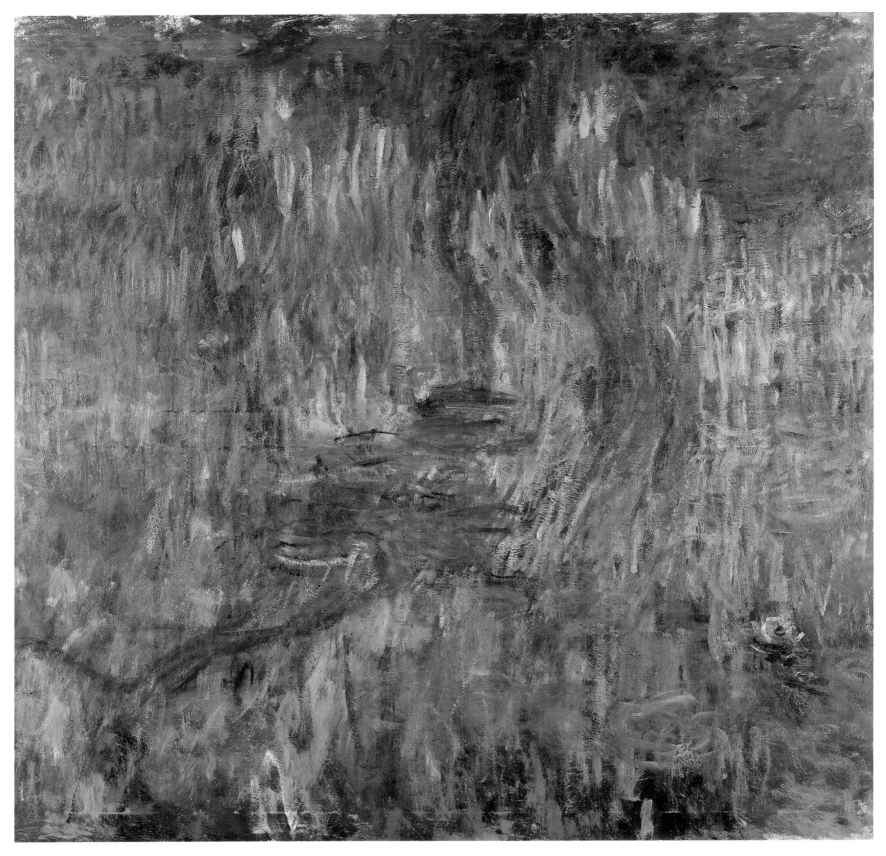

305   *Nymphéas. Reflections of willows* (W.1862), 1916–19, 200 × 200 (78 × 78)

*Opposite:*

306   *Camille Monet on her death-bed* (W.543), 1879, 90 × 68 (35 × 26½)

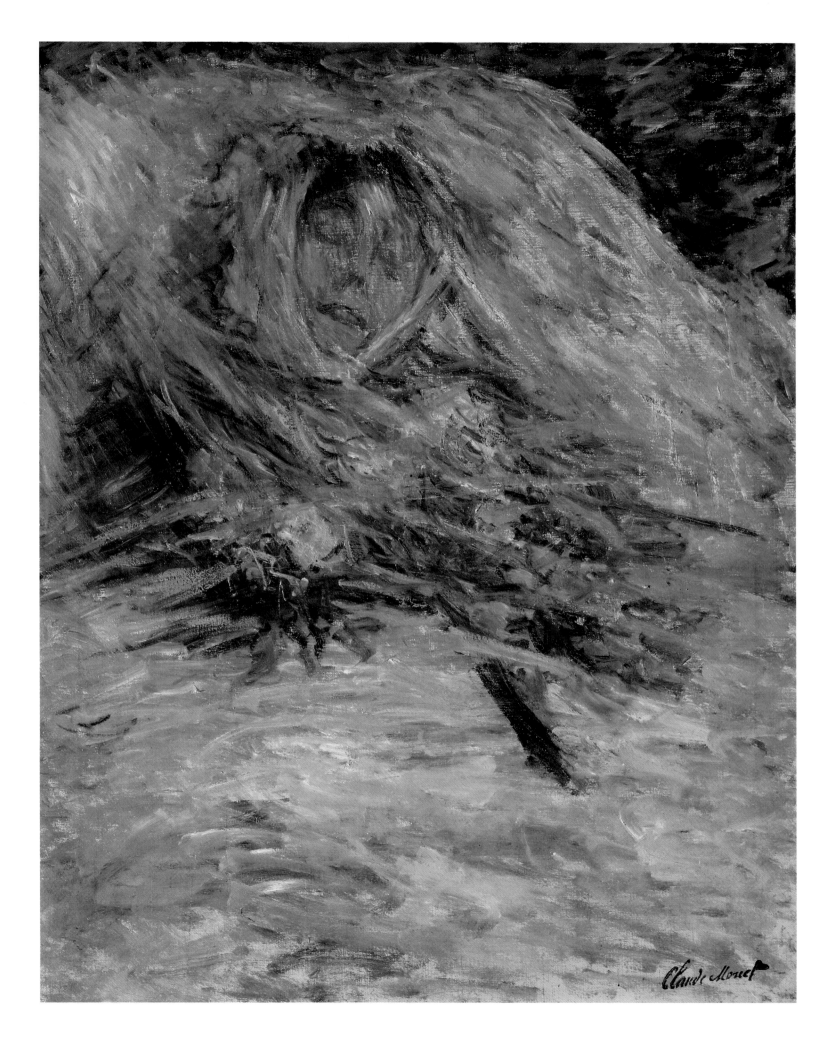

Monet's desire to paint without 'knowing what he saw' was impossible fully to realize; nevertheless, while painting he had been able to transcend the practical faculty of identification, and to scrutinize his field of vision in terms of 'sensations of colour which give light'. This mode of seeing resulted in images composed of constantly shifting webs of colour whose temporary stabilization into recognizable forms is dependent only on the spectator's desire for the known.[106] Such images, as Clemenceau claimed, had significant analogies with the hypotheses of contemporary physics and with contemporary theories about the nature of consciousness – in which contemporary painters like the Orphists and Futurists were interested.[107] For Monet and Cézanne, who believed in the all-sufficiency of nature, painting suggestive of unformed matter evolved from their 'researches' into their own sensations of the external world; but other artists of the late nineteenth and early twentieth centuries used inherited literary sources to express their preoccupation with the formless. Redon did several pictures of Oannès, one of which was inscribed, 'I, the first consciousness of chaos: I arose from the abyss to harden matter, to regulate form'; in a characteristically literal way, Moreau painted a number of pictures of Narcissus, ranging from elaborate allegories to oil sketches where the body of the youth seems about to melt into the watery landscape.[108] The meaning of these works is accessible through their sources, but that of Monet's paintings remains in the pre-verbal realm of sensation. Geffroy described the *Décoration* as 'a great pantheist poem', suggesting an aspiration towards the dissolution of the self in the wholeness of nature. Sometimes in his later years, as his sight declined, Monet saw nature as undifferentiated matter which he could bring only painfully and fitfully to form – as can be seen in the *Path with roses* or *The Setting Sun* – and, even when his sight was at its clearest, when working on his great panels, he would have been so close to them that any specific forms would be invisible in the tangles of paint before him. Yet the gestures which create form had

308   Monet, Germaine Hoschedé-Salerou and Blanche Hoschedé-Monet in his third studio with self-portrait (now destroyed), *c.* 1917

307   Gustave Moreau, *Narcissus*, 1890, 53 × 61 (20¾ × 23¾)

long been internalized, and through using them on the huge expanse of painting which stretched beyond his sight, Monet may have had the experience of being merged 'more intimately with nature'.[109]

Narcissus' vain attempt to grasp his own reflection is curiously evoked in a photograph which Monet took of his own shadow in the water-lily pool. In 1917 he painted no less than four self-portraits (W.1843–1844), his first paintings of a human face since 1890; one of these appears in a photograph of his studio, propped up on a painting of the surface of the pool in almost the same position as in the photograph. It is significant that Monet destroyed three of the self-portraits, and only saved the fourth by giving it to Clemenceau, for his scrutiny of the self had always been sublimated into scrutiny of the external world, and his self-realization could be accomplished only through attempting to grasp the reality of that world, a reality which eluded him as tantalizingly as did Narcissus' mirrored face. Even though the artist's own image is absent, that of Narcissus keeps coming awkwardly to mind in Monet's endlessly repeated attempt to seize the reflections in his pool; likewise,

Between *The Clouds* and *Morning* lies the 6-metre-long *Setting Sun* (ill.291), in which a flame of golden light blazes in the darkening shadows of the pool. The painting re-enacts the visual experience when eyes, adjusting to blinding light, begin to discern form: ghostly leaves and grasses seem to emerge from the glare, while the fiery sky burning through the willow fronds appears in the shadowy 'depths' of the pool. Yet these recognitions do not stabilize, for, as one struggles to secure one's sense of the reality of what one sees, the great flare of yellow paint irresistibly draws the eye to it, and seems to open a chasm in the pool which disrupts all other relationships and dimensions.

The paintings bear the marks of Monet's difficulties in adapting his 'dream' to a finite architectural setting: in the *Morning*, he had not been able to reconcile the colours of the left-hand panels; the lily leaves were only roughly sketched in, and do not flow from panel to panel, and the irises which have been painted out remain visible; the dark reflections in *The Clouds* were not resolved and simply read as dead paint; *The Setting Sun* is so roughly sketched that bare canvas shows; the surfaces of *Green Reflections* and *Morning* are scored, scratched and even slashed. Yet these unresolved areas involve the spectator in the processes of completion, and reveal something of the ways in which sensations were brought to form as images.

Perhaps influenced by the way the scenes painted on Japanese screen-walls were sometimes continued across the gap of a doorway, Monet seems to have tried to create continuities between the canvases by using the spaces between them as imaginary fields of activity – which would allow, as an example, the light-filled shadows on the left of *Clouds* to modulate into those of the adjacent *Setting Sun*, while the scale, perspective and distribution of the lily leaves also establish relationships across the imagined continuity of the doorway. Similar connections are suggested between the grasses on the bank on the right of *Morning* and those in the foreground of *The Setting Sun*. The divergences between the compositions were too great to be resolved in the time Monet had available to him, but such is the suggestiveness of the great ellipse that the spectator strives endlessly to construct some continuum from fragmentary clues.

The cyclic arrangement of the paintings invites interpretation in conventional terms as a cycle of light from dawn through the day to darkness; but when Monet painted the *Décorations* he could no longer paint in full sunlight, so that, instead of the spatial and temporal continuity promised by the room, there is duality: notions of light and the extinction of light, of dawn and sunset, day and night ceaselessly oscillate in the mind, and the promised cycle breaks down into huge fragments of time and of space united, precariously, only by the spectator's remembering consciousness.

The paintings are not *views* of something outside themselves from which one is separate. This is not only because one is embraced by the painted space, but also because there is no moment when illusion is intact or the cycle of paintings complete; no moment, then, when one is released from the desire to resolve them as the perfect enclosures which Monet sought. The room gradually absorbs the spectator in its endless presentness, in which memories of the external world fade. It thus acts as an ante-room for the second cycle, yet, even in so doing, it preserves its duality, for as one walks through the doorway into the second room, one shatters the illusion of continuity that the paintings have invited one to create.

In the second room, complex phases of light are distilled into a single essence, an intense, luminous, unearthly blue. It is only when one reaches the centre of this encircling blueness, and looks back at the fourth painting, *Reflections of trees* (ill.298), that one sees the ethereal blue extinguished in sombre blues and dark violets.

The astonishing clarity of vision manifested in the paintings is impossible to reconcile with one's knowledge of Monet's darkening sight, just as it seems inconceivable that their piercing calm is engendered by a cycle which has loss built into its very structure. More strongly than those in the first room, the four great expanses of painted water impose the notion of a cycle of light, from dawn on the eastern wall to darkness on the western one – yet here too, the cycle is flawed.

Perhaps finding the almost visionary intensity of *The Two Willows* too much to contemplate when they enter the huge room, most visitors first turn to the two triptychs, *Morning with willows* (ill.300) and *Clear Morning with willows* (ill.299). In both, the heavy trunks of the willows frame the open water at the centre of the shallowly curved wall, with their subtly varied counterpoint of veils of leaves, interlinked chains or islands of water-lilies, reflected clouds, and willows painted in ever-changing harmonies of blue, blue-green, blue-violet, blues tinted with mauve and pink, blues saturated with white. The long stretches of painting synthesize complex phases of light: the *Morning with willows* ranges from dark but brilliant blue shadows at the end nearest to the sombre *Reflections of trees*, to a warmer light at the far end; its unified surfaces, brushed by dark pinks, suggest an overcast sky, while the sparkling broken surface of the *Clear Morning with willows* suggests brilliant, breezy light. On the right, the trailing fronds are smudged as if by the breeze, while those on the left hang heavy, and the bright deep blues and greens suggest still shadowed water; but the broken strokes of brighter blue, with touches of warmer colours catching on the striations of the darker strokes, register the first quivering movement of the breeze, while a seemingly casual stroke captures the moment when a willow leaf grazes the water and becomes reflection.

The remote, ethereal beauty of *The Two Willows* (ill.301) stretches for 17 metres (55 feet, 9 inches) on the deep curve between the two paintings of *Morning with willows*. Except for the over-elegant signs for willows – like the silhouetted trees in some *fusamas* – nothing can be seen but water. The water makes visible a measureless sky of radiant blueness, softened by the gently moving summer clouds, and accented by constellations of pale blue-green lily leaves and white and pink flowers which melt into a dreamlike distance. Delicate modulations of colour suggest light in or reflected off the water, while the haziness of the lilies hints also at the vibration of light suspended in the air between spectator and pool, sky and water. Clarity of vision is sustained, from the materialization of the hugeness of space to the smallest details – as in the flecks of near-white paint, further lightened by scratches made by the point of the brush, which conjure up the way in which ripples in the translucent depths capture light as would a liquid crystal.

This is, however, paint: countless brushstrokes, broad dry strokes, scribbles, and scumbles; layer upon layer of coloured paste forming dry, heavily striated, encrusted surfaces. This materiality images immaterial light; this opacity transparent water; this density vibrating air. The huge gestures are those of an old man threatened with blindness, but they convey the sense of a vision so fresh that it recalls Baudelaire's assertion that the artist has something of the child 'who sees everything new'.[103]

The abrupt change of scale between the water-lilies at the base of the painting and those in the middle and far distance gives the sensation of space without end, and, as one approaches the painting, its deep curves entirely enclose one's field of vision, drawing one into the

304   Kaihō Yushō, *Pine and plum by moonlight*, second half 16th century, six-panel screen, ink and colour wash on paper, 168.9 × 353 (66½ × 139)

painting itself. The iridescent blue energies of the willows then become little more than images on the edge of sight or memory, and the forms whose reality one seeks to grasp dissolve into veil upon veil of thick, pastey pigment. Without any clues to physical location, one's sense of bodily autonomy dissolves, just as one's mind seems able to accept dissolution in the all-embracing light, which becomes paint before one's eyes. When one draws away to contemplate the leaves and flowers floating on the aqueous sky, the memory of their non-form is insistent, and they recall the symbolism of Mallarmé's water-lilies which enclose 'in their hollow whiteness a nothing, made of intact dreams . . .'.

As one turns away, it is a shock to see the extinction of light in the *Reflections of trees* on the opposite wall of the ellipse. Monet had never seriously painted darkness before, and the heavy layers of paint (as well as the several studies) show that he found it difficult to establish the surface plane of the water or its lower depths. Trying to paint what he could see in darkness was not only difficult, but was profoundly alien to all that he had sought in his painting.

Like the four paintings in the first room, those in the second invite the spectator to complete them as a cycle by trying to follow up the hints suggested, by the relationship between the darker shadows at the adjacent sides of *Morning with willows* and *Reflections of trees*, or the luminosity of the sides of the two *Mornings with willows* which are closest to *The Two Willows*. One's sense that such relationships exist cannot be sustained, for time is represented not as continuous throughout the day but as an opposition between light and darkness mediated by the *Morning with willows* paintings. Moreover, while each of the multiple phases of light is intensified by one's consciousness of the others, each renders the temporal specificity of the others ambiguous: Is either of the two *Mornings with willows* earlier than the other? Does the

stiller pink light of the one precede the morning breeze in the other, or is it merely a different effect? Do the glimmers in the darkness of the *Reflections of trees* signify the last light of an evening sky, the luminosity of the night sky, or the lightening of the sky at dawn? Can one relate phases of light to the fact that – as Monet pointed out to his visitors – the lily flowers open with the light and close as twilight falls?[104] At first, both *The Two Willows* and *Reflections of trees* have a strong enough presence for each to extinguish consciousness of the other, and to suggest that the final dissolution of the self is in the luminous essence of the former or in the dark waters of the latter. The presence of the two *Mornings* disrupts this simple dualism, and insists on the interpenetration of every phase of light in one's consciousness: darkness is thus latent in one's experience of the measureless light of *The Two Willows*, and light is like a memory in the darkness of the *Reflections of trees*.

<div align="center">◆◖◗◆◖◗◆◖◗◆</div>

A visitor to Monet's studio in 1918 wrote, 'We seem to be present at one of the first hours in the birth of the world.'[105] Monet rejected any metaphysical interpretation of his work, insisting to the end of his life that he sought only to be true to his sensation of nature, but his obsession with the natural elements, light and water, which are so essential to life that they are deeply embedded in language, memory and culture, inevitably evoke associations of this kind. They arise irresistibly from experience of the *Grandes Décorations* in the way in which form emerges from and dissolves into undifferentiated matter. This double experience of form suggests a state of consciousness which perceives the world as fluid, and not solidified into the static shapes of everyday recognition and functional thought.

305 *Nymphéas. Reflections of willows* (W.1862), 1916–19, 200 × 200 (78 × 78)

*Opposite:*

306 *Camille Monet on her death-bed* (W.543), 1879, 90 × 68 (35 × 26½)

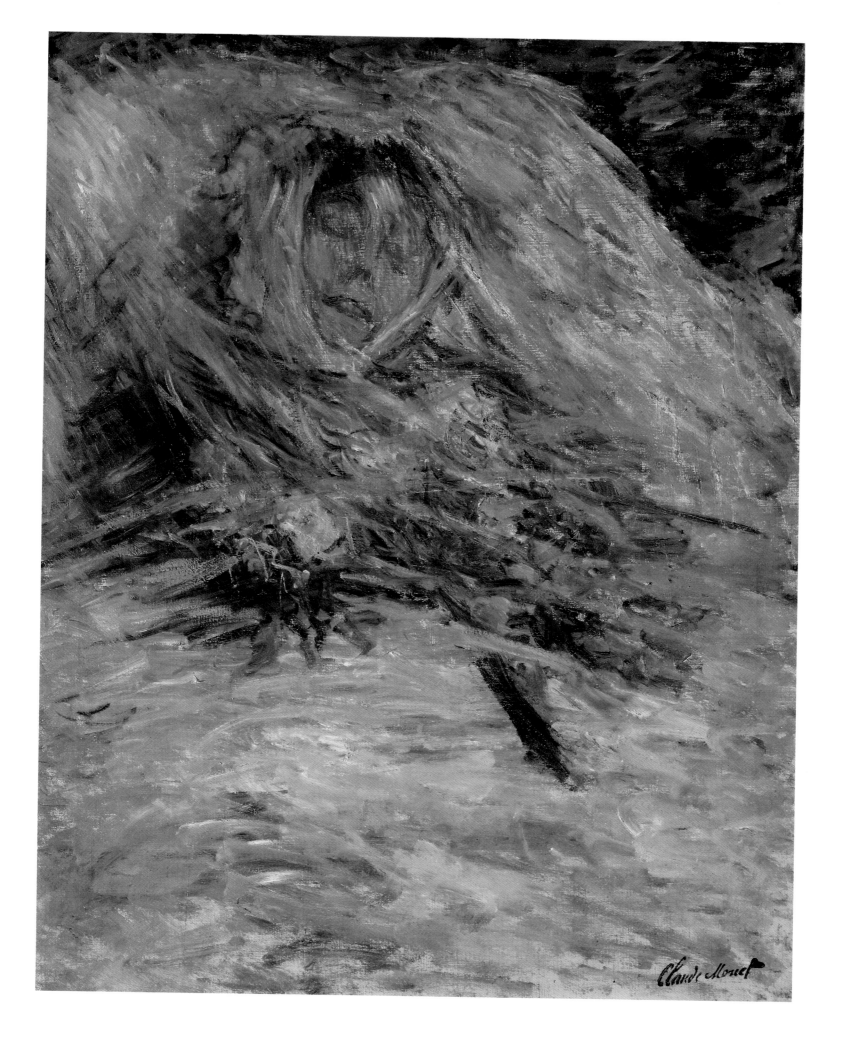

Monet's desire to paint without 'knowing what he saw' was impossible fully to realize; nevertheless, while painting he had been able to transcend the practical faculty of identification, and to scrutinize his field of vision in terms of 'sensations of colour which give light'. This mode of seeing resulted in images composed of constantly shifting webs of colour whose temporary stabilization into recognizable forms is dependent only on the spectator's desire for the known.[106] Such images, as Clemenceau claimed, had significant analogies with the hypotheses of contemporary physics and with contemporary theories about the nature of consciousness – in which contemporary painters like the Orphists and Futurists were interested.[107] For Monet and Cézanne, who believed in the all-sufficiency of nature, painting suggestive of unformed matter evolved from their 'researches' into their own sensations of the external world; but other artists of the late nineteenth and early twentieth centuries used inherited literary sources to express their preoccupation with the formless. Redon did several pictures of Oannès, one of which was inscribed, 'I, the first consciousness of chaos: I arose from the abyss to harden matter, to regulate form'; in a characteristically literal way, Moreau painted a number of pictures of Narcissus, ranging from elaborate allegories to oil sketches where the body of the youth seems about to melt into the watery landscape.[108] The meaning of these works is accessible through their sources, but that of Monet's paintings remains in the pre-verbal realm of sensation. Geffroy described the *Décoration* as 'a great pantheist poem', suggesting an aspiration towards the dissolution of the self in the wholeness of nature. Sometimes in his later years, as his sight declined, Monet saw nature as undifferentiated matter which he could bring only painfully and fitfully to form – as can be seen in the *Path with roses* or *The Setting Sun* – and, even when his sight was at its clearest, when working on his great panels, he would have been so close to them that any specific forms would be invisible in the tangles of paint before him. Yet the gestures which create form had

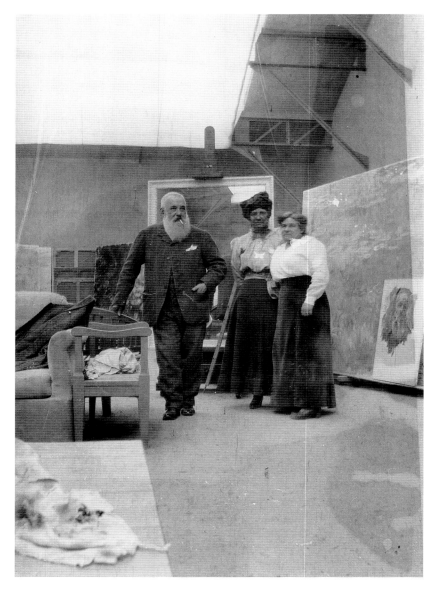

308   Monet, Germaine Hoschedé-Salerou and Blanche Hoschedé-Monet in his third studio with self-portrait (now destroyed), *c.* 1917

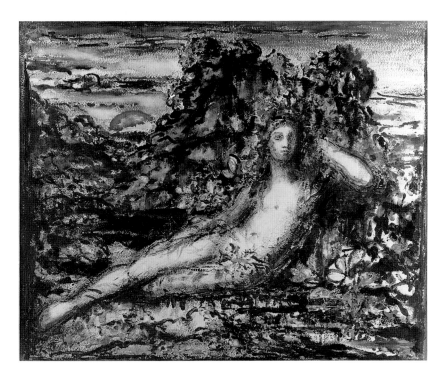

307   Gustave Moreau, *Narcissus*, 1890, 53 × 61 (20¾ × 23¾)

long been internalized, and through using them on the huge expanse of painting which stretched beyond his sight, Monet may have had the experience of being merged 'more intimately with nature'.[109]

Narcissus' vain attempt to grasp his own reflection is curiously evoked in a photograph which Monet took of his own shadow in the water-lily pool. In 1917 he painted no less than four self-portraits (W.1843–1844), his first paintings of a human face since 1890; one of these appears in a photograph of his studio, propped up on a painting of the surface of the pool in almost the same position as in the photograph. It is significant that Monet destroyed three of the self-portraits, and only saved the fourth by giving it to Clemenceau, for his scrutiny of the self had always been sublimated into scrutiny of the external world, and his self-realization could be accomplished only through attempting to grasp the reality of that world, a reality which eluded him as tantalizingly as did Narcissus' mirrored face. Even though the artist's own image is absent, that of Narcissus keeps coming awkwardly to mind in Monet's endlessly repeated attempt to seize the reflections in his pool; likewise,

309   Monet's photograph of his own shadow in the water-lily pool

when Mallarmé endowed the unseen lady of 'Le Nénuphar blanc' with the willow-shaded stream as 'her inner mirror', he impregnated the water with her absent being, an image with a nagging insistence similar to that of Narcissus. Gillet's association of the pool of the *Paysages d'eau* with the lake of Watteau's *Embarkation for Cythera* suggests that the earlier paintings of the water-lily pool retained a human presence, perhaps recalling the images of a woman – probably Alice Hoschedé – absorbed in the water of the pool at Montgeron in paintings of 1876, or the paintings of the girls boating, with their reflections in the water beneath them, as seen in a painting still hanging in Monet's studio in 1920, next to *The Empty Boat*.[110] The *Grandes Décorations* are significantly different. Monet's long dedication to Realism still had its effect, in that it placed him in a precarious relationship to the world he represented, and of which he wished to be part. This can be seen in a more obvious way in the *Luncheon*, from which, although his place is shown, he had been absent as an observer of the scene represented, but omnipresent as creator of a new reality which exists only in the painting.

The *Grandes Décorations* were permeated by Monet's sixty years' experience as a painter, and were expressive of his intense desire for wholeness, but a wholeness in which any human associations were made grandly impersonal.

*Reflections of willows* (ill.305), a large study related to the *Reflections of trees*, and painted in 1916, the year of Verdun, indicates that the substructure of the *Reflections of trees* was composed of an almost undifferentiated substance of long trailing strokes in blues and violets in which all dimensions are fused.[111] These strokes engulf the lily leaves which had been previously sketched in, and even submerge one of the two flowers. The leaves were re-asserted, the violets of the reflected tree trunks strengthened, but their existence is fragile, ephemeral, unstable, and they seem to be there and not there, as if they are melting back into the sweeping brushstrokes. The paint structure of this work is curiously similar to that of the painting of *Camille Monet on her death-bed* (ill.306), where the long brushstrokes fluctuate over forms that one knows to be solid, submerging the flowers on Camille's breast (like the lilies painted

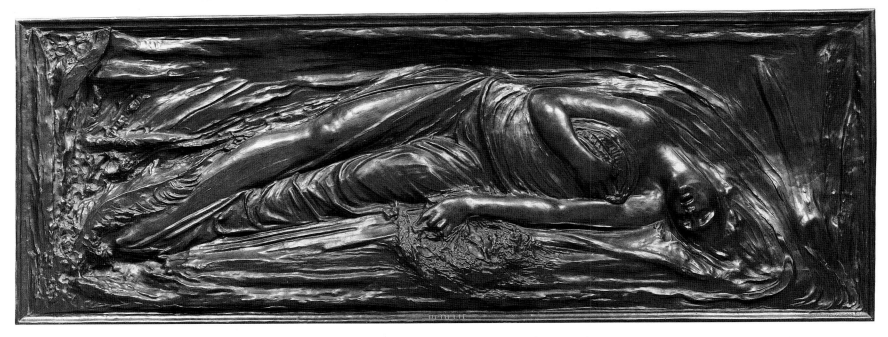

310 Augustin Préault, *Ophelia*, bronze relief of a plaster cast shown at the 1876 Salon, 75 × 200 (29½ × 78)

311 *Girl in a Boat, c.* 1887, pencil drawing (sketchbook MM.5129, 9 recto)

out in *Reflections of trees*), as if imaging a sense of death as a return to non-form.

The relationship between the two paintings recalls the age-old association between water and death which has entered the language in the French phrase for 'still water', *'les eaux mortes'*, and which Bachelard discusses in *L'Eau et ses rêves* in terms of the unconscious desire for or dread of re-integration in the primal element, so profound that it recurs constantly in myth and in more conscious cultural forms.[112] One such recurrent image was that of the drowned woman floating in a stream, seen most poignantly in the figure of Ophelia. It is no more likely that Monet should have represented Ophelia than that he should have figured Narcissus, but it is possible that the natural element which fascinated him all his life could have aroused associations with the many paintings of Ophelia's death showing her 'in the weeping brook', where a willow 'shows his hoar leaves in the glassy stream', floating in the water 'like a creature native and indu'd/Unto that element'. Préault's bronze relief of Ophelia exhibited in the Exposition of 1900 shows her draperies and hair dissolving the body into eddies of the water in a way which relates to the associational processes by which, in Monet's sequence of drawings of a girl in a boat, the lines indicating her presence in the boat gradually fade away so that, in the final drawing, there is only a trace of her body, and attention is transferred to the 'grasses waving in the depths'.[113] The drawing was not only a preliminary to *The Empty Boat*, in many ways very similar to the *Reflections of willows*, but was curiously related to the great *Nymphéas*, in that an early drawing for the *Décoration* was superimposed on it in such a way that the multiple waving lines had the double role of suggesting water weeds in one drawing and reflections of willow fronds in the other. There is a similar sense of a figure which is both there and not there, present and absent, in the two paintings of the pool at Montgeron, in which the reflected image of Alice Hoschedé – if it is she – is broken into mobile planes of colour and fused with the shimmering forms of the two reflected trees which are not unlike the pair in the *Reflections of trees*.

The little that Monet said about water, one of the elements he had spent his life painting, suggests that his feelings for it were complex: when he returned to paint the Normandy coast of his childhood, he said that he felt 'in his element', while in his eighties he told of his wish to be buried at sea, and more than one of his close friends wrote of his passionate love for it. There was also the curious incident in 1868 when he threw himself in the Seine; he was a strong swimmer, so he was not at risk, but the very excessiveness of the act indicates that his impulse to lose himself in water had little to do with reality.[114] This incident occurred at Bennecourt shortly after Monet had depicted Camille on the river bank with an empty boat moored below her, as if looking at the reflection of the sky and the landscape in the still water — the first time he painted the motif which foreshadowed the *Nymphéas*.

The *Reflections of trees* is a painting of darkness, but the darkness of blindness and of death itself could never have been far from Monet's mind as he painted not only this sombre painting, but the brilliant light of the *Three Willows* or the *Agapanthus*, during the most sombre years of the war. Death would have been constantly in his mind as he painted his *Décorations*: personal deaths, the deaths of millions. When Renoir died in December 1919, Monet wrote to Fénéon:

You understand what grief the disappearance of Renoir is for me; he takes with him a part of my life. For three days, I have ceaselessly re-lived the years of struggle and hope of our youth. . . . It's hard to remain alone, not for long certainly . . .[115]

He had survived all the painters with whom he had discovered the resources of his art in the 1860s; as he thought of Renoir, he may have

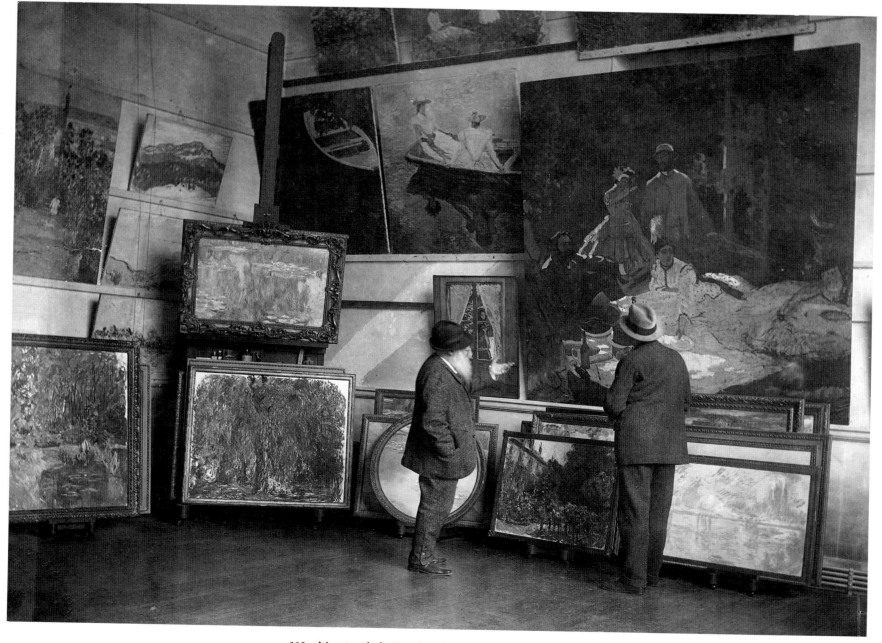

312   Monet with the Duc de Trévise in his second studio, 1920

remembered Manet, news of whose death reached him the day he arrived in Giverny, and Bazille, killed in that other invasion of France, and recalled those who had supported him morally and materially, Caillebotte, Mirbeau, and Durand-Ruel, as well as the women who had played a central role in his art, encouraging him, creating an environment for his work, or shaping it as subjects: his mother, Louise Justine Monet, his wives, Camille and Alice, and Alice's daughter, Suzanne. Only Blanche remained in their place. Photographs show that Monet lived surrounded by his own paintings, image after image of moments of light, images of his family in their different gardens, images of those he had loved, now long dead, but vividly alive in those layers of paint which summon up dreams of summer days in gardens and flowered fields, on rivers and streams. What those images meant to him is suggested by his saying that when the *Women in the garden* – with Camille as model – left his studio, he felt it 'a small heart-break' because of 'the many memories it contains for me'. In his bedroom, together with works by Morisot, Cézanne, Renoir, Caillebotte, Pissarro, Degas, Manet, Boudin and Jongkind, were three portraits of Camille Monet by Renoir, including one of her and Jean in the garden at Argenteuil. 'I assure you', Monet said to Gimpel in 1920, 'that it's agreeable to see these beautiful paintings by all my good friends when I go to bed.' Somewhere else in the house was the painting of Camille dead, as well as paintings of Suzanne, and of Jean whose death preceded Monet's decision to embark on the *Grande Décoration* by less than two months. The great cycle of *Nymphéas* too was a world where, in Gillet's words, 'the things of life no longer exist except as images, as memories'.[116]

These had been natural deaths; the millions being killed in the war were not. During and after the war Monet insisted that he had 'wished to shut myself up, with work, in order not to think any more of the horrors endlessly being committed'. Yet horror could not be shut out; his son was at Verdun, and other members of the family were at the front; the road which he crossed to get to his water garden was sometimes filled with convoys of wounded men; the sound of the guns from the battles near Amiens could be heard in his peaceful garden; there was a danger that Giverny might be overrun, and that even the paintings with which he had tried to secure his domestic paradise might be destroyed. Monet read the newspapers every evening, and the accounts of the death of thousands in blood-stained trenches, the destruction of cities and the devastation of northern France, the threat to Paris, and the terrifying new weapons – above all, perhaps, the horrors of gas which blinded thousands – only reaffirmed his sense that, as Alexandre quoted him as saying, 'to work was again to defend France and to defend his own life at the same time'. Monet could write of dying among his paintings, but fundamentally he seems to have had a stronger if desperate belief in the reparative value of his work, and his dream of creating a great circle of painting 'to defend France' was an assertion of the regenerative power of art and of nature.[117] Only such a belief can explain his demands at a time of crisis that priority should be given to the transport of his canvases.

The need for reparation did not end with the war which, it was soon clear, had brought peace in only one sense, and had destroyed the old world: it had killed a generation of young men, and left Europe devastated, with millions of people displaced and at the mercy of disease and famine, and the economies of the warring nations in ruins. The situation in France – where revolution, after that in Russia, seemed possible – may have aroused memories of 1871, and of the reparative paintings which Monet had executed in 1872.[118] In his painting Monet

had never, with the exception of the picture of the dead Camille, confronted loss, violence, destruction, death, or even ugliness and imperfection, any more than he could bear dead flowers in his garden. This may have been the reason why he did not fulfil the commission to paint the devastated Reims cathedral, and why he so ferociously destroyed paintings, slashing them to shreds and, in the autumn of 1925, 'burning six canvases at the same time as the dead leaves from my garden'.[119] Painting, however, kept Monet alive. Having told Gimpel that, with Renoir gone, he 'no longer had much time to live', he said that he would work on his *Nymphéas* 'until my death; this will help me pass my life; the work has already helped me pass the difficult years of the war'. 'This life', he added, 'preserves me': his huge studio ensured he got exercise; he ate less, but drank 'a great deal' and smoked 'from morning to night'; and finally, 'work on these huge canvases impassions me'.[120]

Monet might exclude such things from the charmed circle of his garden and his painting, but they could not be without their effect, for, just as his relationship to the social world had shaped his sight – his habit, that is, of seeing the external world as object – so his sight had shaped his vision of the world. He had wished to create a world protected from the threat of time, of modern life, but the breakdown of his sight, coinciding with the horrors brought by war, made this desire more than ever unattainable. His weakening sight and his constant fear of total blindness brought darkness into his work, and made it impossible for him to create a perfect cycle of light.

Monet maintained that there was no black in nature, but when he was unable to realize his image of nature he often said that he saw 'everything black' or was 'in the black', and on one occasion at least there may have been emotional reasons for an attack of blindness. Evidently the blindness of his later years had physical causes, but its emotional effects were extremely complex. It must have made him consider his desire to have been born blind and then to have acquired sight, so that he could paint without knowing what he saw, for when his sight was really at risk, he was forced to become aware how intimately that sight was part of his being. His curiously detached phrase, 'what will Monet be without his sight', is suggestive of the fusion of the intimate and the impersonal, the subjective and the objective in his processes of vision.[121] The painting *The Setting Sun* can be seen as an analogy of Monet's sight when he was threatened with an existence without light after a lifetime searching for equivalents, not only for what the sun revealed, but for its processes of revelation. His declining sight had remissions, and even at its worst, he seems to have known what gestures to make in order that his paintings should be filled with light. Operations, eye-drops and spectacles gradually gave him 'new' sight which he recognized as his own, and he painted light until the end, but once he had admitted darkness into his painting, in the *Reflections of trees*, he did not exclude it from his cycle as he could have done by using existing paintings.

Monet said in 1925, 'I would not wish to die before having said all that I had to say, or at least having tried to say it'. As a free-thinker, he believed in no life beyond this one, so if the paintings of *Camille Monet on her death-bed* and the *Reflections of willows* and his wish to be buried at sea suggest a return to a watery element, they suggest nothing more than that.[122] What Monet had to say concerned this world. It is in this sense that one should understand that, while he was painting not only through the day 'but through the night in dreams', into the depths of his being, the world without light, he was continuing his struggle to realize his two great cycles dominated by light. At this time, in 1924, the Surrealists launched their first manifesto announcing their determination

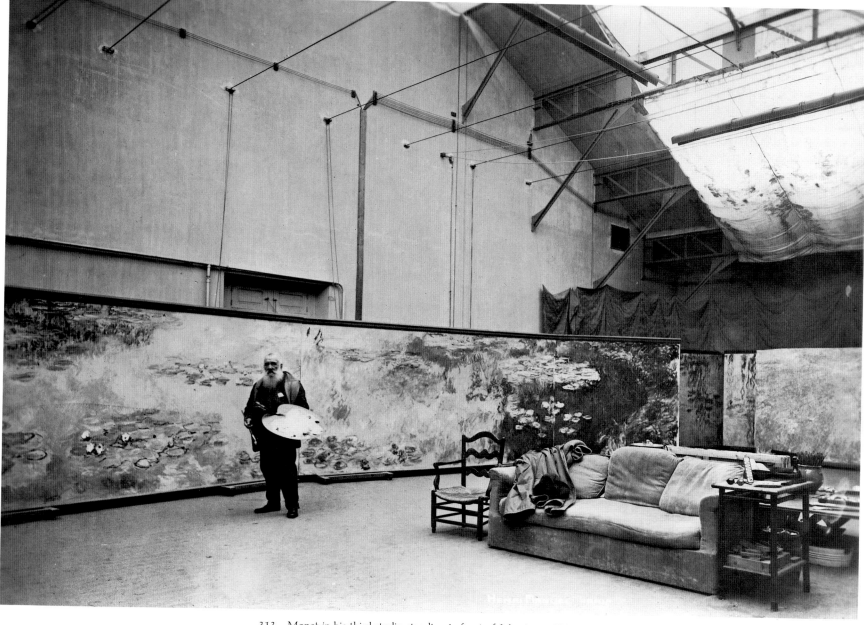

313  Monet in his third studio standing in front of *Morning*, c. 1924–5

to create a sur-reality in which 'dream and reality are one'. If the Paris of the Surrealist sects seems another world from that of Monet, the aspiration was not. The paintings of his 'immense circle of dreams' (as Gillet called it) are not views of a reality 'out there', but expressions of an anguished desire for an ideal dream-state where the real could be rendered perfect and secure. They were intensely self-referential and shaped by profoundly internalized memory, but were also flawed and given life by Monet's insistent need for truth to external reality.[123]

Monet had begun the *Paysages d'eau* with the realization that he could find the things he loved, 'sky and water, leaves and flowers', in his pool. Having painted them all his life, from his first landscape with its reflected trees and sky in the late 1850s, and the first garden paintings in the 1860s, they were not *souvenirs*, relics of past moments, but so deeply

interiorized that the movements of the brush could still create their semblance when sight was nearly gone. Thus it was that Monet's pool, 'this crystal', acted as his 'interior mirror' in the most profound sense. His comment that he preferred to be blind than to have distorted sight, for he could live with his memory of beauty, indicated that he was as much concerned with desire and memory as with the immediate experience of nature, essential as that remained.[124]

Long before, Monet had accepted the challenge of modern life, and accepted subjection to the 'shocks' of reified time. His sight too had taken that form, so that when it engaged with nature, that nature was experienced as countless shocks of fragmented sensations. Accepting this, Monet also sought to re-establish the continuity of memory and of desire in his consciousness. Nevertheless his equally strong commit-

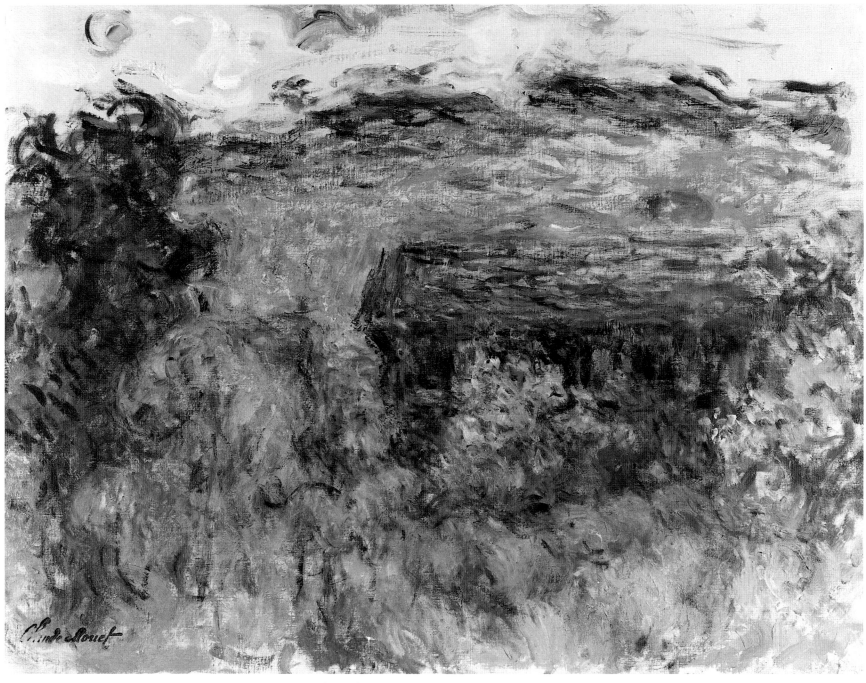

314 *The Garden at Giverny* (W.1959), 1925–6, 66 × 82 (26 × 32¼)

ment to the real condemned him to the world ruled by time, the resistant, contradictory world which, when he first shaped his great cycles, was engaged in its own destruction, yet which he struggled to heal until the very end of his life.

Monet's last easel paintings were those of his house from the rose garden, first represented in the summer after Alice Monet's death. In one, the house is like a dream image with the floating pinks of the rose garden in a vortex around the darkened window of Monet's bedroom, like a mirror image of his occluded eye, or an echo of the house in the family garden painted at Vétheuil nearly half a century earlier and still in Monet's studio, or even further back to one of his very earliest drawings which united a house with a darkened window and a pool. In this last painting, the ideal unity of house and garden is on the point of dissolution into fitful skeins of colour, and reveals the tenacity of what Geffroy once called his 'anxious dream of happiness'.[125]

◆◇◆◇◆◇◆◇◆

However long one may dream in the unearthly blueness of the second room of the Orangerie, however long one may absorb oneself in its time, in its timelessness, one must in the end leave. As one goes, one must pass the sombre *Reflections of trees* which, at the point where form struggles to emerge from darkness, has been scarred by a shell-burst from the next 'Great War'.[126] Today, when the destruction of all that Monet had loved, 'sky and water, leaves and flowers', has become possible, the meaning of his two flawed cycles has a new urgency.

As one leaves the *Grandes Décorations*, one must see last of all the unfinished painting of the setting sun in which traces of deeply known forms are consumed in the last blaze of light which itself is about to be extinguished by the darkening shadows.

And then, in a thinner light, the roar of traffic in today's Paris.

NOTES

BIBLIOGRAPHY

LIST OF ILLUSTRATIONS

INDEX

# Notes

## Abbreviations and Short Forms

W = Daniel Wildenstein *et al.*, *Claude Monet. Biographie et catalogue raisonné*, 4 vols. (Lausanne/Paris, 1974–85): vol. I: 1840–81 (1974); vol. II: 1882–6 (1979); vol. III: 1887–98 (1979); vol. IV: 1899–1926 (1985). Vols. I–IV contain a catalogue of Monet's paintings, numbered consecutively, a biographical account and documents covering the years indicated; a fifth volume, in preparation, will include a catalogue of Monet's watercolours, pastels and drawings. So complete is the documentation in this invaluable work that any facts on Monet's life and work which are not given sources here can be found in it. It has three major faults: the first 4 volumes have no index; no justification is given for the dating of undated works, and the authors dwell almost obsessively on Monet's acts of meanness; their relevance is never made apparent.

Monet's paintings are referred to in the following notes, as in the text, by their Wildenstein catalogue numbers (e.g., W.349). His letters are cited by recipient and date, followed by the Wildenstein volume and letter number (e.g. W IV, L.1597 [Wildenstein vol. IV, letter no. 1597]); letters and documents other than by Monet are cited as '*pièces justificatives*' [p.j.] with their Wildenstein number in square brackets, together with the volume and page reference (e.g., p.j. [49], W III. 454).

Articles in periodicals, and contributions to modern collectivities and to exhibition catalogues are cited in full at the first instance (in the form in which they appear in the Bibliography at p. 335), and thereafter in short form, the former with an identifying date, and the latter with an abbreviated reference to the volume in which the article appears.

The place of publication is Paris unless otherwise stated; translations are my own unless otherwise attributed.

## Introduction

1   Ambroise Vollard, *En écoutant Cézanne, Degas, Renoir* (1938), 55.
2   Cited by Georges Clemenceau, *Claude Monet: Les Nymphéas* (1928), 21–2. Clemenceau probably made Monet's words more 'literary' than they were – he gave a simpler account in conversations with Jean Martet (*M. Clemenceau peint par lui-même* [1929], 273).
3   Louis Gillet, 'L'Epilogue de l'impressionnisme. Les *Nymphéas* de M. Claude Monet', *La Revue hebdomadaire*, 21 Aug 1909, 403. The 'lived experience of shock' as shaped by the modern city is one of the major themes of Walter Benjamin's writings on Baudelaire and Paris; see 'The Paris of the Second Empire in Baudelaire' (1938), and 'Some Motifs in Baudelaire' (1939), in Benjamin, *Charles Baudelaire: A Lyric Poet in the Era of High Capitalism*', trans. Harry Zohn (London, 1973).
4   Monet to Bazille [Etretat, Dec 1868] (W I, L. 44).
5   Judith Wechsler, *A Human Comedy: Physiognomy and Caricature in 19th Century Paris* (London, 1982); T. J. Clark, *The Painting of Modern Life: Paris in the Art of Manet and his Followers* (London, 1984): this brilliant book was unfortunately not yet published when my earlier chapters were written.
6   Charles Baudelaire, 'Le Peintre de la vie moderne', *Le Figaro*, 26, 29 Nov, 3 Dec 1863, repr. *L'Art romantique* (1869), in *Oeuvres complètes*, Pléiade edn (1964), 1161.
7   Emile Zola, *L'Argent* (1890), vol. V in *Les Rougon-Macquart. Histoire naturelle et sociale d'une famille sous le Second Empire*, Pléiade edn (1967), 398.

8   Armand Silvestre, preface to *Recueil d'estampes gravées à l'eau forte*, Galerie Durand-Ruel, Paris (1873), in Lionello Venturi, *Les Archives de l'impressionnisme* (Paris/New York, 1939; cited hereafter as *Archives*), II, 285–6. 1939.
9   Emile Zola, 'Mon Salon: les actualistes', *L'Evénement illustré*, 24 May 1868, in *Mon Salon. Manet. Ecrits sur l'art*, ed. Antoinette Ehrard (1970; cited hereafter as *Ecrits sur l'art*), 152.
10   Gillet, 'L'Epilogue de l'impressionnisme' (1909), 402.
11   *Tintamarre Salon. Exposition des Beaux-Arts de 1868*, ill. Chassagnol-Neveu [Félix Régamey] (1868) (see ill. 49).
12   Renoir to Monet, 23 Aug 1900, in Gustave Geffroy, *Claude Monet, sa vie, son oeuvre* (1922; 1980 edn), 286; Jean Renoir, *Pierre-Auguste Renoir, mon père* (1968; 1981 edn), 12 (the son's book was written some fifty years after the conversations on which it is based). John Rewald, *The History of Impressionism*, 4th edn rev. (New York, 1973), 226; A. André, *Renoir* (1928), 60.
13   André Wormser, 'Claude Monet et Georges Clemenceau: une singulière amitié', in *Aspects of Monet: a Symposium on the Artist's Life and Times*, ed. John Rewald and Frances Weitzenhoffer (New York, 1984); (cited hereafter as *Aspects*), 190–216. Octave Mirbeau, 'Lettres à Claude Monet', *Cahiers d'aujourd'hui*, 29 Nov 1922.
14   Claire Joyes *et al.*, *Monet at Giverny* (London, 1975), 22–3, 31–2; Maurice Kahn, 'Le Jardin de Claude Monet', *Le Temps*, 7 June 1904; Monet to Alice Monet, 6 Feb 1901 (W IV, L.1597).
15   Camille Pissarro, *Correspondance*, ed. J. Bailly-Herzberg (1980 ff.).
16   Clemenceau, who adulated Monet, was shocked by his neglect of Blanche Hoschedé-Monet's welfare (Martet, *M. Clemenceau peint par lui-même*, 52–3).
17   Maurice Rollinat to Monet, 25 May 1889; Rodin to Monet, 22 Sept 1897: both in Geffroy, *Claude Monet*, 207, 359.
18   Gillet, 'L'Epilogue de l'impressionnisme' (1909), 406 (he may have been writing about landscape; the passage is ambiguous); Charles Bigot, 'Causerie artistique. L'Exposition des "impressionnistes"', *La Revue politique et littéraire*, 28 Apr 1877, 1047.
19   'Qui aimes-tu le mieux, homme énigmatique, dis? ton père, ta mère, ta sœur ou ton frère? / – Je n'ai ni père, ni mère, ni sœur, ni frère. / – Tes amis? / – Vous vous servez là d'une parole dont le sens m'est resté jusqu'à ce jour inconnu. / – Ta patrie? / – J'ignore sous quelle latitude elle est située. / – La beauté? / – J'aimerais volontiers, déesse et immortelle. / – L'or? / – Je le hais comme vous haïssez Dieu. / – Eh! qu'aimes-tu donc, extraordinaire étranger? / – J'aime les nuages . . . les nuages qui passent . . . là-bas . . . les merveilleux nuages!' – Baudelaire, 'L'Étranger', *Le Spleen de Paris* (1869), in *Oeuvres complètes*, 231; trans. Louise Varèse, in Charles Baudelaire, *Paris Spleen, 1869* (New York / London, 1951); repr. in Charles F. Stuckey (ed.), *Monet. A Retrospective* (New York, 1985), as from an article by Henry Vidal in *La France de Marseille*, 19 Feb 1947. I have been unable to locate this journal.
20   John House (*Monet. Nature into art*, New York/London, 1986) analyses the changes which Monet made to many of his motifs. The book is crucial for the understanding of Monet's pictorial practice. I wish I had made more use of it.
21   Guy de Maupassant, 'Mouche. Souvenir d'un canotier' (1890), in *Contes et nouvelles*, ed. Louis Forestier, Pléiade edn (1979), II. 1169–70.
22   Gustave Geffroy, 'Les Meules de Claude Monet', preface, exh. cat., Paris (1891), in *La Vie artistique*, 1ère série (1892), 27. (It was Geffroy's practice to re-use his earlier articles; he used this one three times.)
23   Walter Benjamin, 'Theses on the Philosophy of History', in *Illuminations*, ed. Hannah Arendt, trans. Harry Zohn (London, 1973), 258.

## Chapter 1

1   Monet, letter to Bazille [Dec 1868], (W I L.44); Zola, 'Mon Salon. Les actualistes' (1868), in *Ecrits sur l'art*, 152. Monet always emphasized that he was 'a Parisian of Paris' ([François] Thiébault-Sisson, 'Claude Monet: Les années d'épreuves', *Le Temps*, 26 Nov 1900, 3). Thiébault-Sisson interviewed Monet, who also sent him information (letter, 19 Nov 1900 [W IV, L.1577]).
2   Théophile Béguin-Billecocq, unpub. journal, 1853, cited Wildenstein I. 3. Monet's stepson, Jean-Pierre Hoschedé (*Claude Monet, ce mal connu. Intimité familiale d'un demi-siècle à Giverny de 1883 à 1926* [1960], I. 75–80), shows that he maintained similar domestic pleasures all his life.
3   Hugues Le Roux, 'Silhouettes parisiennes. L'Exposition de Claude Monet', *Gil Blas*, 3 Mar 1889.
4   Thiébault-Sisson, 'Claude Monet: Les années d'épreuves' (1900).
5   Duc de Persigny, 'Extrait du *Moniteur* du 20 juillet 1852', repr. in *Catalogue du Salon des Beaux-Arts de 1853*, Paris (1853), 8.
6   Thiébault-Sisson, 'Claude Monet: Les années d'épreuves' (1900); René Gimpel, *Journal d'un collectionneur, marchand de tableaux* (1963), 178 (9 Oct 1920).
7   Marc Elder, *A Giverny, chez Claude Monet* (1924), 55.
8   Wildenstein (I.5) dates Monet's meeting with Boudin to 1858 (as does G. Jean-Aubry, *Eugène Boudin d'après des documents inédits, L'homme et l'oeuvre* [1922; 2nd edn, with R. Schmit, Neuchâtel, 1968], 27), noting that in his application of 21 Mar 1859 to the city of Le Havre for a scholarship for his son to study painting in Paris, Monet's father added Boudin's name to those of the two teachers – Ochard and Wissant – he had listed in an earlier application (6 Aug 1858). Neither application was successful (Wildenstein I. 6 and n. 28); in the session of the town council on 16 May 1859, it was questioned whether Monet's facility as a caricaturist might not keep 'the young artist from the more serious and less gratifying studies which alone have the right to municipal liberalities'. John House ('The New Monet Catalogue', *Burlington Magazine*, Oct 1978, 678–9) suggests that Boudin and Monet may have met as early as 1856 (on the grounds that Monet's mother, who was said to have disapproved of Boudin, died in January 1857, and that the *Landscape at Rouelles* [W.1], exhibited in 1858, was not the work of a beginner). In a letter to Geffroy (8 May 1920 [W IV, L.2348]), Monet said he was fifteen or sixteen when he met Boudin. See also Joel Isaacson, *Claude Monet: Observation and Reflection* (Oxford, 1978), fig. 4.
9   The first account of this incident was by Philippe Burty, 'Les Paysages de M. Claude Monet', *La République française*, 27 Mar 1883; Thiébault-Sisson, 'Claude Monet: Les années d'épreuves' (1900); André Arnyvelde, 'Chez le peintre de la lumière', *Je sais tout*, 15 Jan 1914, 32. Monet, letter to Boudin, 22 Aug 1892 (W III, L.1162).
10   Duc de Trévise, 'Le Pèlerinage à Giverny: I' [1920], *La Revue de l'art ancien et moderne*, Jan 1927, 48. Monet told Thiébault-Sisson ('Claude Monet: Les années d'épreuves' 1900) that Boudin taught him to understand nature, and that as a consequence of the older artist's teaching he 'analysed its forms through drawing and studied its colorations'.
11   Geffroy, *Claude Monet*, 13; Maxime Du Camp, *Paris, ses organes, ses fonctions et sa vie dans la seconde moitié du XIXᵉ siècle* (1869–75) VI. 253, cited Benjamin, 'Paris of the Second Empire', in *Charles Baudelaire*, 86.
12   Emile Zola, *L'Oeuvre* (1886), vol. IV in *Les Rougon-Macquart* (1966), 72–5, 79. Monet and Zola had not met before 1866 (Zola, 'Mon Salon: Les réalistes du Salon', *L'Evénement illustré*, 11 May 1866, in *Ecrits sur l'art*, 74).

13 Edouard Gourdon, *Le Bois de Boulogne*, (1861), trans. in Paul Hayes Tucker, *Monet at Argenteuil* (New Haven/London, 1982), 31–2; Edmond and Jules de Goncourt, *Journal: Mémoires de la vie littéraire*, ed. Robert Ricatte (Monaco, 1956–9), I. 835 (18 Nov 1860).

14 Benjamin, 'Paris of the Second Empire', in *Charles Baudelaire*, 35–66; for Adorno's criticism of Benjamin's assertions about the role of sight as 'behaviourist', see French edn, Benjamin, *Charles Baudelaire: un poète lyrique à l'apogée du capitalisme*, ed. and trans. Jean Lacoste (1982), 258.

15 Jean Renoir, *Renoir, mon père*, 71–2; also 21, 53, 57. See also Zola, 'Lettres parisiennes [Le nettoyage de Paris sous Haussmann]', *La Cloche*, 8 June 1872, in *Oeuvres complètes*, ed. Henri Mitterand (1969), XIV. 79–80.

16 Note the rebuilding of the law courts and central police station on the Île de la Cité. Michel Foucault, 'The Eye of Power', conversation with Jean-Pierre Barou and Michelle Perrot, in Foucault, *Power/Knowledge: Selected Interviews and Other Writings 1972–1977*, ed. Colin Gordon, trans. C. Gordon *et al.* (New York, 1980), 146–65; Benjamin, 'Paris of the Second Empire', in *Charles Baudelaire*, 47–8.

17 Goncourt, *Journal*, I. 41; Walter Benjamin, 'Paris – the Capital of the Nineteenth Century', in *Charles Baudelaire*, 173–5.

18 Zola, *L'Oeuvre*, 62–4.

19 Zola, *La Curée* (1871), vol. I in *Les Rougon-Macquart* (1960), 387–90. One of the two novels of the cycle begun during the Second Empire, in which it was set, *La Curée* is pervaded by metaphors of light and shadow; for example, the ostentatious visibility of the new rich is contrasted with the sober values of the old bourgeoisie living in a shadowy *hôtel* on the untransformed Île Saint-Louis.

20 'The Empire was like . . . those unfortunate women who wear a silk dress and who have dirty petticoats. . . . Its dream was to do up the town, to straighten it up, to dress it up in fancy clothes, prepared to leave its feet bare and to hide each tear, each grease-stain under knots of lace. . . . To clean the town, they began by blotting out the old Paris, the Paris of the people . . .' (Zola, 'Lettres parisiennes [Le nettoyage de Paris]' [1872], in *Oeuvres complètes*, XIV. 77–9.

21 Baudelaire, 'Le Peintre de la vie moderne' (1863), in *Oeuvres complètes*, 1177–85.

22 Geffroy, *Claude Monet*, 14.

23 Letter to Boudin, 3 June 1859 (W I, L.2).

24 Albert Boime, 'The Second Empire's Official Realism', in *The European Realist Tradition*, ed. G.P. Weisberg (Bloomington, Ind., 1982), 31–110, esp. 96–101. Boime exaggerates the Imperial favouring of Realism as against other styles, for the government's policies were more eclectic – see Patricia Mainardi, 'The Political Origins of Modernism', *Art Journal*, Spring 1985, 11–17.

25 Willem Bürger [Théophile Thoré], 'Salon des Réprouvés', 1863, in *Salons de W. Bürger: 1861 à 1868* (1870), I. 415.

26 Letters to Boudin, 19 May, 3 June 1859 (W I, L.1–2). Corot exhibited mainly historical landscapes, but did show an *Etude à Ville d'Avray*; among Delacroix's entries, the most interesting work for Monet may have been *Ovide en exile chez les Scythes*; Monet mentioned neither Breton's *The Recall of the Gleaners* (which won a First Class medal and was purchased by the Imperial government), nor Millet's *Woman grazing her cow*.

27 Letter to Boudin, 20 Feb [1860] (W I, L.3: Monet here expresses his contempt for Couture); Thiébault-Sisson, 'Claude Monet: Les années d'épreuves' (1900).

28 Albert Boime, *The Academy and French Painting in the Nineteenth Century* (London, 1971). (Boime overemphasizes the relationship between Impressionist techniques and official teaching methods.)

29 Firmin Maillard, *Les derniers Bohèmes: Henri Mürger et son temps* (1874); in a letter to Geffroy (21 Feb 1921 [W IV, L.2408]) Monet said he once knew Firmin Maillard 'very well'; Wildenstein (I. 11) suggests the harm was caused by '*les belles filles*' but gives no evidence. A letter to Amand Gautier (11 Aug 1860 [W I, L.5]) shows that Monet continued to do caricatures (for *Charivari*, *Le Gaulois* and *Diogène*).

30 Jules Vallès, *Les Réfractaires* (1865) (based on a series of newspaper articles); (developed as *Le Bachelier*; 1974 edn, ed. J.-L. Lalanne). See Benjamin, 'The *Bohème*: Paris of the Second Empire', in *Charles Baudelaire*, 11–34; T. J. Clark, *The Image of the People: Gustave Courbet and the 1848 Revolution* (London, 1973), 33–4.

31 Wildenstein I. 10–11; Marcel Crouzet, *Un Méconnu du réalisme: Duranty (1833–1880)* (1964), 475–92, 515–20.

32 Baudelaire praised Boudin's watercolours in his 'Salon de 1859', *Revue française*, 10, 20 June, 1, 20 July 1859, repr. *Curiosités esthétiques* (1868), in *Oeuvres complètes*, 1081–3. *Le Courrier du dimanche*, 29 Jan 1861, quoted in Jack Lindsay, *Gustave Courbet, his Life and Art* (Bath, 1973), 171–2.

33 Jacques Salomon, 'Chez Monet, avec Vuillard et Roussel', *L'Oeil*, May 1971, 24.

34 Letter to Boudin, 20 Feb [1860] (W I, L.3).

35 Boudin's first modern-life painting was seemingly the tiny *Celebration of 14 July. Port of Le Havre* of 1858 (Robert Schmit, *Eugène Boudin 1824–1898* [1973–84], I, cat. no. 191).

36 Wildenstein I. 12–21; Thiébault-Sisson, 'Claude Monet: Les années d'épreuves' (1900); letter to Geffroy, 8 May 1920 (W IV, L.2348). Monet told Le Roux ('Silhouettes parisiennes' [1889]) that North Africa had 'completed his education as a colourist' and taught him 'to look into shadows', but he continued to paint grey for at least two years after his return.

Wildenstein (I. 21–5) is scornful about the stories of Monet's almost immediate rejection of Gleyre's teaching, yet Monet began to shape the myth of his self-education quite early (shown in his refusal in Salon catalogues to acknowledge himself as Gleyre's pupil, as was the custom); the myth would then in turn have shaped the image of himself and his development. Monet probably shared Bazille's view (to his father, letter 22 in J. Patrice Marandel and François Daulte, *Frédéric Bazille and Early Impressionism*, exh. cat., Art Institute of Chicago [1978; cited hereafter as Marandel and Daulte]) that 'What M. Gleyre teaches me – the craft of painting – can be learned anywhere. If I ever do accomplish anything, I hope to do so without having copied anyone'. But this was a view held by Gleyre himself (Albert Boime, 'The Instruction of Charles Gleyre and the Evolution of Painting in the Nineteenth Century', in *Charles Gleyre ou les illusions perdues*, ed. René Berger *et al.*, exh. cat., Musée Cantonal des Beaux-Arts, Lausanne [1974], 102–14; determined to do justice to Gleyre, Boime succumbs to a unilinear model of artistic development).

37 Jean Renoir, *Renoir, mon père*, 122 (Monet wore lace cuffs all his life – see Salomon, 'Chez Monet' [1971], 21, and other late interviews). Renoir told his son that when he and Monet shared a studio in the rue Visconti, from July 1866 to December 1867, one of the *petits commerçants* for whom they painted paid them with bags of beans, and that all their money went on rent, models' fees and coal – to keep the model warm and cook the beans. 'I've never been happier in my life', he said (*Renoir, mon père*, 124–5).

38 See letters to his parents in Marandel and Daulte, *passim*. Considerably better-off than his friends, Bazille spent more than they on clothes and food, but his more onerous expenses seem to have been studio rent and 'enormous' fees for models (see below, n. 121).

39 Olivier Merson, *La Peinture en France* (1861), 190–1, cited Boime, 'Second Empire's Official Realism' (1982), 89. Boime ('Instruction of Charles Gleyre' [1974], 104, 106) suggests that the elegant paintings of bourgeois life by Gleyre's successful pupils Toulmouche, Heilbuth and Firmin-Girard 'made possible the candour of the Impressionists'.

40 Bazille to his father, letter 6, [March] 1863 (the dates given these letters are quite unsatisfactory; alternatives are suggested in square brackets), Marandel and Daulte, 192; Jean Renoir, *Renoir, mon père*, 113; Ambroise Vollard, *Auguste Renoir* (1920), 26.

41 Thiébault-Sisson, 'Claude Monet: Les années d'épreuves' (1900), and other interviews with minor variants. Boime ('Instruction of Charles Gleyre' [1974], 102) says that Gleyre encouraged his students to express natural attitudes; this is not apparent in his own drawings. Bazille to his parents, Marandel and Daulte, letter 10, 1863 (about painting 'figures in sunlight'); letter 35, [July] 1864 (about a life-size study of a woman); letter 50 [late 1865] ('the living model' in Monet's studio); letter 55 [late 1865–early 1866] (the nude model). Gleyre insisted that it was necessary for his pupils to work in their own studios as well as at the teaching one (Boime, *Academy and French Painting*, 59).

42 Courbet made an analogy between the way he worked from the darkest to the lightest tones and the way objects 'scarcely perceptible' 'before the first glimmers of dawn' are gradually revealed and brought to plenitude of form by the rising sun: 'I proceed in my paintings, as the sun acts in nature' (quoted by Théophile Silvestre, *Histoire des artistes vivants* [1856], 270).

43 Several *habitués* of the Lejosnes' salon attended a performance of *La Tour de Nesle* – in which Bazille acted – in Gleyre's studio: *Le Boulevard*, 8 Feb 1863 (ill. Wildenstein I. 17); Monet had met Benassit, caricaturist for *Le Boulevard*, at the Brasserie des Martyrs.

Letter to Mme Lejosne, 2 Apr 1924 (W IV, L.* 2556); Monet spoke of his 'very precise' memory of a dinner at the Lejosnes', when 'we had the joy of meeting Manet', but he did not say when.

44 Baudelaire, 'Salon de 1859', in *Oeuvres complètes*, 1085.

45 [Jules-Antoine] Castagnary, 'Salon de 1864', *Courrier du dimanche* 15 May–3 July 1864, in *Salons (1857–79)* (1892), I. 188.

46 Boime, 'Second Empire's Official Realism' (1982), 108–10; Lindsay, *Courbet*, 182–4, 227–8, 243–5.

47 Baudelaire, 'Le Peintre de la vie moderne' (1863), in *Oeuvres complètes*, 1155, 1166–7.

48 Le comte de Nieuwerkerke (1849–70); speech at Salon of 1863, in *Catalogue du Salon des Beaux-Arts de 1864* (1864), xiii–xiv; see also Boime, 'Second Empire's Official Realism' (1982), 45–6.

49 Burty ('Les Paysages de M. Claude Monet [1883]') said this 'revelation' was in Manet's studio, which Monet would not have visited until later (see n. 43); the comment was repeated forty years later in Elder, *A Giverny*, 37. Baudelaire, 'Le Peintre de la vie moderne' (1863), in *Oeuvres complètes*, 1186. Renoir recalled that when he first met Bazille – probably late in 1862 – he was thinking of painting the animated Luxembourg gardens (*Renoir, mon père*, 115); Manet's paintings of modern life were not publicly visible before March 1863, but Bazille may have seen studies in Manet's studio. Monet told Louis Vauxcelles ('Un après-midi chez Claude Monet', *L'Art et les artistes*, Nov 1905) that he went to the Café Bade to hear Manet talk to Baudelaire – who left France in April 1864.

50 Castagnary, 'Salon de 1859', in *Salons* I. 159.

51 Castagnary, 'Salon des Refusés', *L'Artiste*, 1, 15 Aug, 7 Sept 1863, in *Salons* I. 167. Compare in particular Monet's *Road under trees* (W.58) of 1863 and Corot's *Ville d'Avray, entrance to a wood* (National Galleries of Scotland).

52 Letter to Amand Gautier, 23 May 1863 (W I, L.6). I have not sufficiently acknowledged Millet's influence on Monet in his early years (see esp. Monet's *Faggot-gatherers in the forest of Fontainebleau*, W.18).

53 Frequent changes of lodgings and seizure of his paintings for debt wreaked their toll; Monet told Thiébault-Sisson that he had lost 200 works in six years, and since he was always prolific, and since this figure would have included many studies, this is quite possible (Wildenstein I, 35–6, n. 246).

54 Monet first painted coastal resorts in 1867, six years after Boudin's first sea-side canvas, the *Beach Scene at Trouville* (Schmit, *Eugène Boudin*, I, cat. no. 254); his subjects followed Boudin's so closely and were so much larger and more daringly painted that Boudin would have had reason to wonder whether Monet was not demonstrating his mastery of him: Monet's paintings of shipping around Le Havre took up a Boudin theme; his *Jetty at Le Havre* (rejected, Salon 1868) was a subject Boudin exhibited in 1867 and 1868 (Schmit, I, nos. 407 and 436); he painted at Boudin's preferred beach at Trouville in 1870; in the early 1870s he echoed Boudin's two paintings of 1866 of figures and regattas at Argenteuil (Schmit, I, nos. 391–392). Monet took up the same close relationship with Jongkind's and Daubigny's subjects and compositional types.

55 Bazille to his father (letter 20), to his mother (letter 34), Marandel and Daulte; Monet, letter to Bazille, 26 Aug 1864 (W I, L.9).

56 Letter to Bazille, 15 July [1864] (W I, L.8), my italics.

57 Arsène Alexandre, *Claude Monet* (1921), 33 (Monet's claim to complete acceptance of the motif accords with the self-generated myth of the purity of his *pleinairisme*).

58 Paul Mantz, 'Salon de 1865: II', *Gazette des Beaux-Arts*, July 1865, 26.

59 The confusion between 'Manet' and 'Monet' may have occurred not only at the Salon of 1865 but at that of 1866: Elder [*A. Giverny*, 38] places the incident in the Salon of 1865; in 1900 Thiébault-Sisson ['Claude Monet: Les années d'épreuves'] states 1866, but in 1926 ['Cl. Monet'. *Le Temps*, 7 Dec 1926], he puts it in 1865. See also n. 86.

60 Elder, *A Giverny, chez Claude Monet*, 27; Monet praised Courbet's works in the 1860 exhibition (letter to Boudin, 20 Feb 1860 [W I, L.3]); Bazille told his parents of a projected visit in 1863, letter 10 [autumn] 1863, Marandel and Daulte.

Wildenstein dates *The Pavé de Chailly* (W.19) to 1864, but it was first exhibited in the Salon of 1866, and probably painted in summer 1865 along with other less bold paintings of the same motif.

61 Elder, *A Giverny*, 64. Monet said he was sixteen when he discovered Japanese prints, and that they cost 'a few sous'. This would have been 1856–7, which is very unlikely since the first

Franco-Japanese commercial treaty was signed only in Oct 1858. In 'L'Exposition universelle. Le Japon à Paris: I', *Gazette des Beaux-Arts*, Sept. 1878, 385–6, Ernest Chesneau noted that a painter – Whistler or Stevens – found such prints in Paris in 1862 in a consignment from Le Havre.
My discussion of the Japanese influence on Monet is influenced by an early version of David Bromfield's article, 'Japanese Art, Monet and the Formation of Impressionism' (to be published, with other papers from the conference, 'Europe and the Exotic', Humanities Research Centre, Canberra, 1987, in a volume ed. C. Andrew Gerstle and Tony Milner). Bromfield established a chronology for Monet's acquisition of his large collection of prints (Geneviève Aitken and Marianne Delafond, *La Collection d'estampes japonaises de Claude Monet à Giverny* [1983]; cited hereafter as Aitken and Delafond). Bromfield suggests that the first prints to arrive in France after the Franco-Japanese Commercial treaty of 1858 were contemporary ones, while earlier ones, including those of Hiroshige and Hokusai, arrived later.
Shinsai's print, illustrated in the text, was in Wakai's collection, so Monet would not have acquired it until later (Aitken and Delafond, cat. no. 81).

**62** Beatrice Farwell, *The Cult of Images*, exh. cat., Univ. of Calif., Santa Barbara Art Museum (1977), ill. 39, 72–3; Anne Coffin Hanson, *Manet and the Modern Tradition* (New Haven/London, 1977), 94–5.

**63** Bazille to his brother, letter 52 [late 1865–early 1866], Marandel and Daulte. The bulky figure of a bearded man substituted in the final painting for the slighter man in the sketch was probably Courbet. By mid-1866, Monet was on terms of some familiarity with Courbet (letter to Amand Gautier, 3 July [1866] [W I, L.27]).

**64** After reforms to the Salon regulations in 1864, three-quarters of the jury were elected from among artists who were members of the Institut, or had received the Légion d'honneur or a medal; one quarter were appointed by the government. Liberalization of these regulations in 1868 did not substantially alter the composition of the jury. Elizabeth Gilmore Holt, *The Art of All Nations 1850–1873* (New York, 1981), 492, 545. Monet's *Women in the garden* (W.67) and *The Port of Honfleur* (W.77) were rejected in 1867; his *Jetty at Le Havre* (W.109) in 1868; his *Magpie* (W.133) and *Fishing Boats at sea* (W.126) in 1869; his *Luncheon* (W.132) and perhaps *La Grenouillère* (W.136, now lost) in 1870. Monet's accounts of the works shown in dealers' windows (and of the hostility shown them by Corot or Daumier or Manet) vary – see Wildenstein I. 36. He showed four works (W.65, 77, 94, 109) in the 'Exposition Maritime Internationale du Havre' in 1868 – see Wildenstein I. 40, n. 295.

**65** Jean Renoir, *Renoir, mon père*, 117.

**66** Clark, *Image of the People*, 133–54; *Painting of Modern Life*, ch. 2: 'Olympia's Choice', 79–146.

**67** Joel Isaacson, *Monet: 'Le Déjeuner sur l'herbe'* (London, 1972), 39 and fig. 21.

**68** Baudelaire, 'Le Peintre de la vie moderne' (1863), in *Oeuvres complètes*, 1155.

**69** Wildenstein (I. 30, n. 204) does not think Monet painted Camille Doncieux in *The Picnic*, but the female figure at the far left has her distinctive hair and bearing.
Pierre-Joseph Proudhon, *Du Principe de l'art et de sa destination sociale* (1865), cited *Realism and Tradition in Art. 1848–1900*, ed. Linda Nochlin (Englewood Cliffs, NJ, 1966), 50.

**70** Castagnary, 'Salon de 1863', in *Salons* I. 140.

**71** Monet later said that this was the painting he would choose from the Louvre (Clemenceau, *Claude Monet*, 92–3). Boudin made a copy of the painting in 1853–4, and perhaps adapted it to his modern beach scenes (Schmit, *Eugène Boudin*, I, cat. no. 279).

**72** Emile Zola, 'Aux champs' (first pub. in Russian, 1878); *Le Figaro*, 25 July 1881, and in *Le Capitaine Burle* (1883), in *Contes et nouvelles*, Pléiade edn (1976), 665. (Zola also discusses the painters of the *banlieue parisienne*, 668.) See also 'Lettres parisiennes [Une promenade à travers les ruines de Paris]', *La Cloche*, 13 June 1872, in *Oeuvres complètes* XIV. 85. Zola's account of the *petit bourgeois* occupation of the suburban countryside displays little of the contempt expressed by most contemporary writers.

**73** Georges Riat, *Gustave Courbet, peintre* (1906), 150, 158; Castagnary, 'Philosophie du Salon de 1857' (1858), in *Salons* I. 29–30 (that Courbet had opened 'a back door from Saint-Lazare [the prostitutes' prison] on to the flowery fields'); Louis Etienne, *Le Jury et les exposants – Salon des Refusés* (1863), 30, and Ernest Chesneau, *L'Art et les artistes modernes en France et en Angleterre* (1864), 188–9, both cited Françoise Cachin, Charles S. Moffett et al., *Manet 1862–*

*1883*, exh. cat., Grand Palais, Paris (1983), 165–6.

**74** Isaacson, *Monet, 'Le Déjeuner sur l'herbe'*, 45 ff. (for discussion of fashion plates); Edmond and Jules de Goncourt, *Gavarni. L'homme et l'oeuvre (1822–96)* (1879), cited Wechsler, *Human Comedy*, 107. Baudelaire wrote in 'Le Peintre de la vie moderne' (1863) (in *Oeuvres complètes*, 1164): 'every age has its bearing, its look, its gesture'. In his pamphlet, *La Nouvelle Peinture* (1876), in Charles S. Moffett et al., *The New Painting: Impressionism 1874–1886*, exh. cat., Fine Arts Museum of San Francisco [1986; cited hereafter as *New Painting*] (477–84; transl. 37–47), Duranty wrote (481–2), that painting should express 'the particular mark of a modern individual': 'With a back we wish that a temperament, an age, a social situation will be revealed . . .', etc.

**75** Jean Renoir, *Renoir, mon père*, 82.

**76** Delacroix's influence on Monet's handling of colour was more profound than I have acknowledged. On Delacroix's *Journals* as Monet's favourite reading, see Introd., p. 11 and n. 14.

**77** Paul Mantz, 'Salon de 1863', *Gazette des Beaux-Arts*, 1 Apr 1863.

**78** Bromfield, 'Japanese Art, Monet and Impressionism'; compare Monet's portrait of Jacquemart (W.54) and Yoshitomi's *England* (Aitken and Delafond, no. 176).

**79** Zola, *L'Oeuvre*, 79; Anon., *Rouchon. Un Pionnier de l'affiche illustré*, Musée de l'Affiche et de la Publicité, Paris (1983); Rouchon produced posters between 1846 and 1865. Paul de Saint-Victor's comment that Manet's painting 'flays the eyes, just as fairground music makes the ears bleed' ('Beaux-Arts', *La Presse*, 27 Apr 1863) is suggestive of the concern raised by popular art forms.

**80** [François] Thiébault-Sisson, 'La Vie artistique. Claude Monet', *Le Temps*, 6 Apr 1920.

**81** Paul Mantz, 'Le Salon de 1865: I', *Gazette des Beaux-Arts*, June 1865, 515–16.

**82** Thoré wrote of Courbet's 'unanimous success . . . accepted, bemedalled, decorated, glorified, embalmed' ('Salon de 1866', in *Salons de W. Bürger* II. 275–6).

**83** Mainardi, 'Political Origins of Modernism', 11–17. Castagnary included Monet in 'the battalion of new recruits all more or less attached to naturalist doctrines': 'Salon de 1866', in *Salons* I. 224, 240; Thoré, 'Salon de 1866', in *Salons de W. Bürger* II. 286; Zola, 'Mon Salon', *L'Evénement*, 27 Apr–20 May 1866, in *Ecrits sur l'art*, 49–89; A. J. du Pays, 'Salon de 1866' (3e article), *L'Illustration*, 2 June 1866, 342.

**84** Bazille to his family [May-June 1866], p.j. [12], W I. 444; E. d'Hervilly, 'Les poèmes du Salon: Camille', *L'Artiste*, 15 June 1866, 207; Thoré, 'Salon de 1866', in *Salons de W. Bürger* II. 285–6; Charles Blanc, 'Salon de 1866', *Gazette des Beaux-Arts*, June 1866, 519. 'Camille' may have signified a prostitute (see Léon Billot, 'Exposition des Beaux-Arts', *Journal du Havre*, 9 Oct 1868, cited Wildenstein I. 40: 'from the provocative way she walks the pavement, one guesses without difficulty that Camille is not a woman of the world, but a "Camille" ').

**85** Zola, 'Mon Salon. Les réalistes au Salon' (1866), in *Ecrits sur l'art*, 75.

**86** André Gill, 'Le Salon pour rire', *La Lune*, 13 May 1866, in Jacques Lethève, *Impressionnistes et Symbolistes devant la presse* (1959), 37. For Monet's meeting with Manet in 1866: see Elder, *A. Giverny*, 37–9; Arnyvelde, 'Chez le peintre de la lumière' (1914), 34. In 1900 Monet told Thiébault-Sisson ('Claude Monet: Les années d'épreuves') that he met Manet in 1869. This is quite improbable; as late as 1868, however, Duranty wrote that Manet was 'tortured by his competitor and near-namesake' (Crouzet, *Un Méconnu du réalisme*, 232).

**87** Thiébault-Sisson, 'Claude Monet: Les années d'épreuves' (1900).

**88** Letter to Amand Gautier, 22 May 1866 (W I L.26). Because the big paintings would simply make him 'eat money' (letter to Gautier [Apr 1866] [W I, L.25]), Monet had decided to 'leave aside' those on which he was working; the restoration of his allowance seems to have changed his mind. Zola, 'Edouard Manet', *La Revue du XIXe siècle*, 1 Jan 1867, in *Ecrits sur l'art*, 107.

**89** Boudin, notes from sketchbooks, quoted Rewald, *History of Impressionism*, 4. The painting was finished in the studio (letter from Dubourg to Boudin, Honfleur, 2 Feb 1867, p.j. [13], W I. 444).

**90** Zola, 'Mon Salon: les actualistes' (1868), in *Ecrits sur l'art*, 152.

**91** In *La Curée* (412–13), Zola evoked Worth's role in the transformation of women into objects through the object of their desire, fashion. See Benjamin on the *flâneur* and 'the intoxication of the commodity': 'Paris of the Second Empire', in *Charles Baudelaire*, 54–6.

**92** Kermit Champa, *Studies in Early Impressionism* (New Haven/London, 1973), 11 and fig. 14. The use of tinted grounds (see Anthea Callen, *Techniques of the Impressionists* [London, 1982], 60–3) emphasized the 'sign' value of the brushstroke which tended to stand independent on the picture surface rather than to cohere with it.

**93** Elder, *A Giverny*, 29 (Monet's precise recollection of Breton's words must be doubted, but he never forgot this exclusion; see below, Ch. 6, p. 280 and n. 76); Nieuwerkerke, speech at Salon of 1852, reported in *Catalogue du Salon des Beaux-Arts de 1853*, 12; Jules Breton, *Un Peintre paysan* (1896), 111. As the opposition to the Caillebotte bequest shows, the hostility of some traditionalists to Monet's painting was implacable (see below, Ch. 5, p. 230 and n. 88).

**94** Baudelaire, 'Salon de 1859', in *Oeuvres complètes*, 1085.

**95** Bazille to his mother, letter 76 [April 1867], Marandel and Daulte; he thought they would be joined by Courbet, Corot, Diaz and Daubigny; in letter 77 [May 1867], he wrote that the 2,500 frs. they had collected was not enough for the exhibition.

**96** The highest price Monet obtained was 2,500 frs. for the *Women in the garden*, towards which Bazille paid 50 frs. a month. Giraud's 4-metre-(13-feet-)long *Slave Market* was purchased for 6,000 frs. from the Salon of 1867. Highly detailed works attracted particularly high prices: Worms, *Romance à la mode* (Salon 1868), set in the Empire, fetched 4,000 frs. from the Salon of 1868, while Meissonier was paid a staggering 50,000 frs. for the *Battle of Solferino* (Salon 1864). The most expensive state purchase of a landscape – which was really a genre scene in a wide landscape – was Chenu's *The Stragglers; snow effect* (Salon 1870), 8,000 frs. (details from Geneviève Lacambre, *Le Musée du Luxembourg en 1874*, exh. cat., Grand Palais, Paris [1974]). Monet is known to have sold *Still Life*, 1862–3 (W.13), *Fishing Boats*, 1866 (W.74), *Red Mullet*, 1869 (W.140), all to Edmond Maître, friend of Bazille; *Road to the farm, Saint-Siméon;* 1864 (W.30, to Gaudibert?); *Farm near Honfleur*, 1864 (W.36, to Louveau, friend of Boudin); *Oak at Bas-Bréau*, 1865 (W.60: seized 1866–7, though slashed by Monet; sold to nephew of Martin?); *Women in the garden*, 1867 (W.67, to Bazille, 2,500 frs.); *Camille*, 1866 (W.65, to Houssaye, 800 frs.); *Camille* (replica), 1866 (W.66, to Cadart et Luquet); *Port of Honfleur*, 1866 (W.77: seized by creditors, auctioned, bought by Gaudibert, apparently at 84 frs. for it and the *Jetty at Le Havre*, Boudin to Martin, 25 Apr 1869, p.j. [25], W I. 445); *Saint-Germain-l'Auxerrois*, 1867 (W.84, to Astruc, before 1870?); *Quai du Louvre*, 1867 (W.83, to Latouche, mid-1867); *Terrace at Sainte-Adresse*, 1867 (W.95, to Frat, friend of Bazille, probably before 1870); *Still Life*, 1867 (W.103, to Lejosne, early 1868, through Bazille); *Jetty at Le Havre*, 1868 (W.109: see *Port of Honfleur*, above); commissioned portraits of the Gaudibert family (W.120–123, 1868); *Stranded Boat*, 1869 (W.117, to Manet, before 1870?); *La Grenouillère*, 1869 (W.134, to Manet?); *Road, winter effect, sunset*, 1869 (W.142, to Amand Gautier, before 1870?); *Soldiers of the guard on the banks of the river*, 1869 (W.149, to Lindner); *Bridge at Bougival*, 1870 (W.152, to Martin, for 50 frs. plus a small Cézanne). Many paintings would have been sold and lost, and for many there are no early records of sale. To put these prices in some sort of perspective: the rent of Monet's studio at Pigalle in 1866 was 800 frs. p.a. (Wildenstein I. 31). The costs of Bazille's *Girl at the piano* (2 × 1.3 m [6⅝ × 4¼ ft]): model – 60 frs. for two weeks (more time was needed); canvas – 70 frs.; frame for Salon – 150 frs.; hire of dress and rugs – unspecified amount (letter 54 [early 1866]); when working on this painting, Bazille wrote to his parents that Monet had 'sold thousands of francs' worth of paintings in the last few days' (letter 53 [early 1866], Marandel and Daulte – perhaps this was to encourage his parents!). Monet claimed he sold 800 frs.' worth of paintings as a result of the success of *Camille* (letter to Gautier, 22 May 1866 [W I, L.25]).

**97** Letter to Bazille [Dec 1868] (W I, L.44), on the closing of his account; in *Le Bachelier*, Vallès wrote of the effects of insecure accommodation and on the high cost of buying one egg at a time. Frédéric Le Play. 'Les Ouvriers européens (1855), 274 (my translation), cited Benjamin, 'Paris of the Second Empire', in *Charles Baudelaire*, 20, n. 25.

**98** See n. 88.

**99** Thiébault-Sisson, 'La Vie artistique. Claude Monet' (1920); he concluded 'And that's how I bungled my career'. Maurice Kahn ('Le Jardin de Claude Monet' [1904]) quoted Monet: 'At the beginning, I had no money. And models, that was expensive. So I began to paint models which cost nothing.'

**100** Bromfield ('Japanese Art, Monet and Impressionism') discusses the ideas of a number of early collectors of and

commentators on Japanese prints who were also concerned with problems of Realism (e.g. the Goncourts, Duret, Burty, Duranty, Zola, Chesneau, Manet, Tissot, Fantin, Bracquemond, Monet, Degas).

**101** Billot, 'Exposition des Beaux-Arts' (1868), cited Wildenstein I. 38. Wildenstein dates the *Cart, road under snow, near Honfleur* (W.50) to 1865, but it was probably painted in the winter of 1866–7 (like W.79–82) (p.j. [13], W I. 444).

**102** Victor Fournel, 'Voyage à travers l'Exposition universelle. Notes d'un touriste: I', *Le Correspondant*, Apr 1867, 971–86. Bazille described the park as 'frightful . . . full of plaster shanties' (letter 77, Marandel and Daulte). Corot shared artists' and intellectuals' contempt; on a visit to the Exposition he allegedly said, 'this new Paris bores me. All this ordered luxury will kill everything, painters first of all' (Armand Silvestre, 'Le Salon de 1873', in *Corot raconté par lui-même et par ses amis*, ed. Pierre Cailler [Vezenay/Geneva, 1946], 112–13).

**103** Monet was critical of both exhibitions: letter to Bazille, 25 June 1867 (W I, L.33).

**104** Boudin to Martin, 18 Jan 1869 (p.j. [23], W I. 445). Monet's memory of Daumier's criticism was still intense over half a century later (Elder, *A Giverny*, 155–6); c.p. Rewald, *History of Impressionism*, 152 and n. 20).

**105** Wildenstein I. 37 and letters to Bazille (W I, L.32–35).

**106** Letter to Bazille (W I, L.45); House, 'New Monet Catalogue', 681.

**107** Théodore Duret, *Les Peintres impressionnistes* (1878), 13–14.

**108** Letter to Bazille, 25 June 1867 (W I, L.33); see Wildenstein (I. 46) on Camille Doncieux's dowry of 1870, which was never paid in full. See Theodore Zeldin on the role of the dowry as a means of social consolidation (*France 1848–1945* [Oxford, 1973–7], I. 287–91). Duranty, in 'L'Atelier' and 'La Simple vie du peintre Louis Martin' (*Le Siècle*, 13–16 Nov 1872, repr. *Le pays des arts* [1881]), located the artists' lives in bourgeois society rather than on its bohemian margins; for the artist Jourdain, in 'L'Atelier', 'marriage is, above all, a good business affair' (Crouzet, *Un Méconnu du réalisme*, 514–15).

**109** Letter to Bazille, 3 July 1867 (W I, L.34).

**110** Letters to Bazille, 12 Aug 1867 (W I, L.37), Jan 1868 (W I, L.39). Bazille and Julie Vellay, Pissarro's future wife, became Jean's godparents in April 1868.

**111** See n. 54. On 3 Sept 1868, Boudin wrote to his friend Martin: 'The peasants have their painters . . . but do not those middle-class people strolling on the jetty towards sunset, have the right to be fixed upon canvas, *to be brought to light*? [Boudin's emphasis] . . . they are often resting from hard work, those people who leave their offices, consulting rooms. If there are some parasites among them, are there not also those who have fulfilled their task?' (Jean-Aubry, *Eugène Boudin*, 72).

**112** Boudin to F. Martin, 18 Jan 1869 (p.j. [23], W I, 445); Holt, *Art of All Nations*, 460–1; Castagnary, 'Salon de 1868', in *Salons* I. 251–5.

**113** Zola, 'Mon Salon: les actualistes' (1868), in *Ecrits sur l'art*, 153; Zacharie Astruc, 'Salon de 1868', *L'Etendard*, 27 June 1868, cited *Archives* II. 282.

**114** Baudelaire, 'Le Peintre de la vie moderne' (1863), in *Oeuvres complètes*, 1155; Zola, 'Edouard Manet', *L'Evénement illustré*, 10 May 1868, in *Ecrits sur l'art*, 143; Ernest Chesneau (*Les Nations rivales en l'art* [1868], 220–1) wrote that today's purchaser 'wants his money's worth . . . and finds more value in the work the more minute details, seen very close, he can count').

**115** A. J. Du Pays, 'Exposition: Des Ouvrages des artistes vivants, au palais des Champs-Elysées,' *L'Illustration*, 16 Apr 1859. Castagnary ('Salon de 1863', in *Salons* I. 100) stated that the Salon was a fair 'in the diversity of its products, not in its pecuniary results; the great fairs of France leave more money in the safe of a single merchant than a whole Salon often leaves in the collective pockets of all artists'.

**116** Karl Marx, *Critique of the Gotha Programme* (1875; London, 1933 edn), 21, quoted by Benjamin, 'Paris of the Second Empire', in *Charles Baudelaire*, 71.

**117** Letter to Bazille, 25 June [1867] (W I. L.33) (Monet described the ship as 'very strange'); Wildenstein I. 38; *Entrance to the port of Le Havre* (W.87) could have been a study for *Ships leaving the jetties of Le Havre*.

**118** Meyer Schapiro, 'Courbet and Popular Imagery. An Essay on Realism and Naïveté', *Journal of the Warburg and Courtauld Institutes*, Apr–June 1941, repr. Schapiro, *Modern Art: 19th and 20th Centuries* [Selected Papers, vol. II] (New York, 1978), 47–86.

**119** Gaudibert had decided to buy *The Jetty at Le Havre* on condition it was shown at the Salon (Martin to Boudin, 4 May 1868, p.j. [19], W I. 444); he did, however, purchase it cheaply later (Boudin to Martin, 25 Apr 1869, p.j. [25], W I. 445).

**120** Wildenstein I. 140 and II. 47. Zola's painter hero has the same first name as Monet, but this was also Zola's own pen-name in some of his early art criticism; like Christine and Claude in the novel, but unlike Zola and his mistress, Claude Monet and Camille Doncieux were accompanied by their baby who, in *L'Oeuvre*, is seen as a rival to Claude's painting. Rodolphe Walter ('Critique d'art et vérité. Emile Zola en 1868', *Gazette des Beaux-Arts*, Apr 1969, 227–8) suggests that Zola could have been there when Monet painted *On the bank of the river, Bennecourt*.

**121** Bazille frequently referred to the expense of models (to his parents, letters 47, 68, 71, 83, 85, Marandel and Daulte).

**122** Letters to Bazille, 29 June, [late Oct–early Nov 1868] (W I, L.40, 43); Martin to Boudin, 6 Oct 1868 (p.j. [22], W I. 445). Wildenstein I. 40–1.

**123** Letter to Bazille [Dec 1868] (W I, L.44, my emphases). Monet used the verb '*ressentir*' (and was to do so throughout his life); it implies that his experience of nature was as much subjective as objective. In this context I should have made more use of Richard Shiff's 'The End of Impressionism: A Study in Theories of Artistic Expression', *Art Quarterly*, Autumn 1978, repr. *The New Painting*, 61–89.

**124** Letter to Bazille, 15 July [1864] (W I, L.8).

**125** Manet, preface to catalogue of his exhibition, Place de l'Alma, 24 May 1867, in *Realism and Tradition in Art*, ed. Nochlin, 81. Letter to Bazille [20 May 1867] (W I, L.32).

**126** Zola, 'Mon Salon. Les réalistes du Salon' (1866), in *Ecrits sur l'art*, 77.

**127** Quoted Wildenstein, I. 42 and n. 320. Monet stayed with Bazille; see letter 62 [5 Apr 1869], Marandel and Daulte.

**128** Boudin to Martin, 25 Apr 1869 (p.j. [25], W I. 445).

**129** Bazille to his father, letter 74, [April] 1869, Marandel and Daulte. Bazille's *Fisherman* was rejected; the 1869 Salon jury included Gérôme, Cabanel, Gleyre, Stevens, Daubigny.

**130** Monet to Arsène Houssaye, 2 June 1869 (W I. L.49); to Bazille, 9 Aug 1869 (W I. L.50); Renoir to Bazille, summer 1869, cited Gaston Poulain, *Bazille et ses amis* (1932), 155–6. Monet's isolation in the country meant that his relations with his few Parisian patrons were less close than were Renoir's (the prince Bibesco, whom Renoir met through Bazille, befriended him, and said 'There comes a moment when one must become polished': Jean Renoir, *Renoir, mon père*, 130); in 1870 Renoir had a commission for a portrait from the publisher Georges Charpentier, in whose salon he had met Arsène Houssaye and Théophile Gautier.

**131** Joel Isaacson, 'Impressionism and Journalistic Illustration', *Arts Magazine*, June 1982, 95–7, 100.

**132** Letter to Bazille, 25 Sept 1869 (W I. L.53).

**133** Edmond Viellot, 'L'Île de la Grenouillère', *La Chronique illustré*, 1 Aug 1869, in Isaacson, 'Impressionism and Journalistic Illustration', 102 and n. 40.

**134** Maupassant, 'Yvette' (1884), in *Contes et nouvelles*, Pléiade edn II. 264–5. Mme Morisot, 19 Aug 1867, in *Correspondance de Berthe Morisot avec sa famille et ses amis*, ed. Denis Rouart [1950], 19–20. Bazille and Tiburce Morisot were typical of those who took 'the elegancies of high society' to the river; Bazille won first prize in the Bougival regattas of 1865.

**135** Wildenstein (I. 46) assumes that Jean Ravenel ('Préface au Salon de 1870', *Revue internationale de l'art et de la curiosité*, 15 Apr 1870, 320–3) was referring to a painting of La Grenouillère (W.136; lost), when the critic commented on the exclusion from the Salon of 'a landscape'. Jules Claretie, 'Léon Gambetta. Amateur d'art', *Gazette des Beaux-Arts*, Feb 1883, 124.

**136** The relationship between sketch and finished picture is discussed intensively in House, *Monet. Nature into Art*. This book was published after most of my text was written, and I was not able to profit by its analysis of Monet's processes of creation. Throughout his life Monet did sketches for works painted in the studio, and, far more frequently, finished works there. He tended, however, to bring together on one canvas those phases of work which academic painters had isolated in separate works (broadly painted sketches, detailed studies, finished work, i.e., *pochades, esquisses, études, tableaux*). One can sometimes distinguish Monet's studies from his finished works, but generally they range across a spectrum in which different degrees of 'finish' are seen as appropriate to the expression of different effects.

**137** See n. 96. Chenu's painting is in the Musée d'Orsay.

**138** Boudin to Martin, 29 May 1870 (p.j. [28], W I. 445). For an account of the controversy, see Wildenstein (I. 45–6) and Rewald, *History of Impressionism*, 239–40; since all artists who had exhibited could now vote, there was an attempt to elect a reform jury of Corot, Daubigny, Millet, Courbet, Daumier, Manet, Bonvin and Amand Gautier; only Corot and Daubigny were elected, but they were on the official list as well. Monet acknowledged Daubigny's support in a letter to Moreau-Nélaton (15 Jan 1925 [W IV, L.2587]).

**139** Houssaye wrote that *Camille*, which he owned, would go into the Musée du Luxembourg: Karl Bertrand, 'Le Salon de 1870', *L'Artiste*, 1 June 1870, in *Archives* II. 283; Castagnary ('Salon de 1870', in *Salons* I. 390, 392) claimed that there were few exclusions, that the growing number of artists 'coincides with the progress of our young democracy', that 'the impartiality of the judges . . . attests to the doctrines of liberty', but that artists elected 'old names', who were still 'the creatures of the administration' and who still had their victims, including Monet.

**140** Compare Monet's modest and intimate painting and Duranty's descriptions of bourgeois interiors in 'Le Salon bourgeois', *La Rue*, 13 July 1867; see Crouzet, *Un Méconnu du réalisme*, 490–1, n. 62.

The positioning of the mother, child and servant, and of the table in a corner by a window, are so similar to the composition of Boucher's *Luncheon* (1739) that it seems probable that Monet had seen the painting, or a copy or engraving of it. It was then in a private collection. When sold at the Hôtel Drouot in 1878, it was thought to be Boucher's family (Alastair Laing *et al.*, *François Boucher*, exh. cat., Metropolitan Museum of Art, New York [1986], no. 33).

**141** Letter 85 (dated 26 May 1870, but referring to events occurring in Jan 1870, Marandel and Daulte. Rochefort was editor of the radical *La Lanterne* and deputy for Paris.

**142** Wildenstein I. 46.

**143** Wildenstein I. 51–2.

**144** Letter to Pissarro, 27 May 1871 (W I, L.56).

**145** Elder, *A Giverny*, 25.

**146** Alexandre, *Claude Monet*, 53 (Alexandre's phrase, 'Faire un retour sur lui-même', has the sense of self-examination.

**147** Bracquemond showed an etching after Turner's *Rain, Steam and Speed* in the first Impressionist exhibition in 1874.

**148** In his paintings of Holland Monet again followed Boudin, Jongkind and Daubigny, and painted motifs very similar to theirs, but not on the grand scale which characterized his earlier versions of their themes.

**149** Letter to Pissarro, 17 June [1871] (W I, L.59); Wildenstein I. 56–7.

*Chapter 2*

**1** Duret, *Les Peintres impressionnistes*, 16; Pissarro to Duret, 2 May 1873, *Correspondance* I, L.21, 79; Silvestre, preface to *Recueil d'estampes* (1873), in *Archives* II. 285–6.

**2** Charles Bigot, 'Causerie artistique: L'Exposition des Mirlitons – L'exposition des "Intransigeants"', *La Revue politique et littéraire*, 8 Apr 1876, 350–1.

**3** This chapter owes much to Tucker's *Monet at Argenteuil* (1982), which initiated the detailed analysis of the social context of Impressionism based on study of municipal records and other contemporary sources.

**4** Zola, 'Mon Salon: les actualistes' (1868), in *Ecrits sur l'art*, 152.

**5** Paul Lidsky, *Les Ecrivains contre la Commune* (1970); 'L'Enquête des conseillers municipaux sur l'état de la main d'oeuvre de la capitale', Oct 1871: see Georges Soria, *Grande Histoire de la Commune* (1971), I. 47 ff. An analysis of the nearly 40,000 arrests included 48 'artist-painters', 863 house painters: Soria, *Grande Histoire*, V. 167–75.

Théodore Duret (*Histoire des quatre ans 1870–1873* [1876–80], III: *La Commune* [1880], 254–5): 'the slightest expression of pity' had to be hidden since it 'would put the life of anyone who indulged it in immediate peril'. Duret himself was imprisoned by the Versaillais (III. 252).

Paul Tucker, 'The First Impressionist Exhibition in Context', in *The New Painting*, 93–117. My chapter was completed before I read this article, which puts a stronger emphasis on the effects of the Franco-Prussian war than on the trauma of the Commune. The latter was equally significant in shaping French bourgeois culture; it posed insoluble dilemmas which could not be 'spoken', while the French

nation could plan revenge for the Prussian defeat. See also Stephen F. Eisenman, 'The Intransigent Artist or How the Impressionists Got Their Name', in *The New Painting*, 31–59.

6   Alexandre Dumas fils, *Une Lettre sur les choses du jour* (1871), 26–7. Paul de Saint-Victor stated that 'like the Last Judgement', recent events divided 'the elect of order, duty, integrity and the public peace' from 'the damned of brigandry and anarchy': 'L'Orgie rouge', 13 June 1871, in *Barbares et bandits – La Prusse et la Commune* (1872), 253.

7   Zola, 'Lettres de Paris', *Le Sémaphore de Marseille*, 3 June 1871, cited Lidsky, *Les Ecrivains contre la Commune*, 52; he returned to this hideous idea a year later in 'Lettres parisiennes', *La Cloche*, 25 Oct 1872, in *Oeuvres complètes* XIV. 194–6. The Goncourts believed that the 'brutal' solution based on 'pure force' would give society twenty years of peace.

8   Zola, letter to Cézanne, 4 July 1871, *Correspondance*, ed. H. B. Bakker (Montreal, 1978 ff.), II. 293–4. Duranty too wrote, 'We are the seekers into the future and so must be confident, for everything tells us that our hour of success is near': 'La Mer parisienne', *La Vie parisienne*, 9 Mar 1872. On the other hand he was so affected by *l'année terrible* that he seems to have considered suicide (Crouzet, *Un Méconnu du réalisme*, 307–9); Manet and Duret too became deeply depressed.

9   Théophile Gautier, *Tableaux de siège Paris 1870–1871* (1872), 352, cited Lidsky, *Les Ecrivains contre la Commune*, 73.

10  Wildenstein I. 57–8; Manet, letter to Duret, in Adolphe Tabarant, *Manet et ses oeuvres* (1947), 191; Mme Morisot wrote to Berthe (5 June 1871, *Correspondance*, 58) that her son had met 'two Communards at the time when they were all being shot, Manet and Degas! Even now they criticize the energetic means of repression. I think them mad, and you?'

11  Dumas fils, *Une Lettre sur les choses du jour*, 16; Leconte de Lisle to J.-M. de Heredia, 22 June, 29 May 1871, cited Lidsky, *Les Ecrivains contre la Commune*, 59. Courbet's activities were documented in Alfred Darcel's seven articles, 'Les Musées, les arts et les artistes pendant la siège et pendant la Commune', *Gazette des Beaux-Arts*, Sept 1871–June 1872; see esp. Jan 1872, 41–65 (on the Fédération des Artistes), and Feb 1872, 146–50 (on the Colonne Vendôme).

12  Those elected to the Fédération des Artistes included Manet, Daumier, Amand Gautier, Corot, Bonvin, Millet, Courbet, Pichio, Bracquemond and Ottin (the last two were to exhibit in the Société Anonyme exhibition), and Feyen-Perrin, who was to be a non-exhibiting member of the Société Anonyme. All those elected to the Fédération were Realists, though not all of them had agreed to serve.

13  Lidsky, *Les Ecrivains contre la Commune*, 53–6, 83–5. Those who opposed the Provisional Government's continuing repression centred on Victor Hugo and his journal *Le Rappel*, which supported an amnesty for the Communards (Victor Hugo, *Choses vues 1870–1885*, ed. Hubert Juin [1972]). Manet, Duret, Duranty, Castagnary, Pissarro, Renoir and Zola had some sympathies with the defeated Communards (though see Pissarro, *Correspondance* I, L.11 [draft] and n. 1; II, L.419 and n. 2).

14  Ernest Feydeau, *Consolation* (1872), 112, cited Lidsky, *Les Ecrivains contre la Commune*, 80.

15  Dated 1871 by Wildenstein (W.193); others date it to 1872, like Renoir's lively painting of the same motif (e.g. Theodore Reff, *Manet and Modern Paris*, exh. cat., National Gallery of Art, Washington, DC [1982], no. 6). Cp. Tucker's interpretation ('The First Impressionist Exhibition and Monet's *Impression, Sunrise*: A Tale of Timing, Commerce and Patriotism', *Art History*, Dec 1984, 472) of *The Pont-Neuf* as a homage to the past and an expression of faith in the future.

16  'Apart from informers and policemen/One no longer sees in the streets/Anyone but old people sad to the point of tears/Widows and orphans': J.-B. Clément, *Chansons* (1887).

17  Tucker, *Monet at Argenteuil*, 58–62, 71. Here and in 'The First Impressionist Exhibition in Context' (see n. 5), Tucker interprets Monet's participation in reconstruction in terms of conscious patriotic – and commercial – intent. For example, he suggests that works like *The Goods train* 'reveal the presence of industry and progress in the landscape, as if Monet was presenting a Saint-Simonian utopian world as a logical choice for his defeated country'. Monet's way to a bourgeois Utopia was through personal need rather than political concern. Of course, this need would be served by paintings which would sell – but it was mainly the legitimist Durand-Ruel who bought.

18  Eugène Spuller, cited Jean-Marie Mayeur, *Les débuts de la III*

*République 1871–1898* (1973), 11. Spuller, a friend of Gambetta, was a radical deputy for Paris from 1876; his portrait by Renoir was shown in the 1876 Impressionist exhibition.

19  A. de Pontmartin, 'Salon de 1872: I', *L'Univers illustré*, 11 May 1872, 295. Poets and painters are in the plural, while 'the peasant' and 'the workman' are in the singular, thus denying any significance to class or collectivity; nurses take the place of real beggar-women.

20  Zola, 'Lettres parisiennes', *La Cloche*, 12 May 1872, in *Ecrits sur l'art*, 200.

21  T. Gautier, 'La Sculpture au Salon', *L'Artiste*, June 1872, 263; Paul de Saint-Victor, 'Les Tableaux de style au Salon', *L'Artiste*, June 1872, 247–8; de Pontmartin, 'Salon de 1872: I', 294–5. The last two articles inveighed against the influence of dealers on contemporary art; recent high prices included 18,200 frs. for Breton's *Gleaners* and 13,100 frs. for Rousseau's *Banks of the Oise* at the Pereire sale.

22  Castagnary, 'Salon de 1872', *Le Siècle*, in *Salons* II. 3–7.

23  Cham [Amédée Noé], *Le Salon pour rire 1872* (1872).

24  Castagnary, 'Salon de 1872', in *Salons* II. 11–14. In 1875 Zola wrote: 'Courbet, who committed the unpardonable stupidity of compromising himself at the time of the insurrection which had nothing to do with him, no longer exists, so to speak' ('Exposition de tableaux à Paris', *Le Messager de l'Europe*, June 1875 [trans. from the Russian], in *Ecrits sur l'art*, 217); for Manet, see n. 10.

25  Zola, 'Lettres parisiennes' (12 May 1872), in *Ecrits sur l'art*, 198. Edmond About ('Deux Refusés qui n'ont dit rien', *L'Artiste*, May 1872, 220–1) wrote that the paintings of Prussian atrocities by Detaille and Ulmann were excluded because they might cause demonstrations and retard the Prussian withdrawal, and that he would say what the art world was whispering so that Courbet could hear. The Salon contained 38 subjects directly related to the war and siege; 11 watercolours or prints on the Commune; 14 Alsatian subjects; and a number of indirect or allegorical references, such as several Joans of Arc and Louis Janmot's *In hoc signo vinces*, described in the *Catalogue du Salon de 1872*: 'France, Religion, Liberty and Justice. – Two figures, symbolizing Demagogy and Despotism, submerged in a river of blood. God blesses France and those who died for her.'

26  Zola, 'Causerie du dimanche', *Le Corsaire*, 3 Dec 1872.

27  Henri Vigne, 'Les Bas-fonds parisiens', *L'Illustration*, 26 Aug 1871. On 2 Sept 1871 an article in the series, on hunger and criminality, referred to a Ministry of Justice report numbering 'the army of those in open revolt against society' as '200,000'.

28  Paintings of beggary in the 1872 Salon included Hublin's *Breton Beggar-women* and Firmin-Girard's *The Favourite*, both illustrated in *L'Univers illustré*, 13 July 1872, 441. In 'Les Bas-fonds parisiens' (*L'Illustration*, 11 Nov 1871), beggary was shown as sinister and threatening. Duranty, *La Nouvelle Peinture*, in *New Painting*, 482.

29  De Pontmartin, 'Salon de 1872: I', 295.

30  'Tout renaît/Sur nos morts, longtemps sans sépulture,/Le linceul odorant des fleurs s'est refermé,/Et le printemps revient, doux, charmant, enbaumé:/Tant nos deuils sont légers à ton âme, ô Nature!' Jules Claretie ('L'Art français en 1872. Revue du Salon', in *Peintres et sculpteurs contemporains* [1874], 314) described the painting; repr. *Gazette des Beaux-Arts*, Feb 1872, facing p. 467. For Feyen-Perrin, see n. 12.

31  *L'Illustration* 1871: 7 Oct, sea-bathing and reviews of histories of the Commune; 18 Nov, review of Mangin's *L'Homme et la bête* ('if one re-reads the history of the last nine months, lions or hyenas would seem gentle in comparison to men'); 25 Nov, races at Longchamp; 16 Dec, illustrations of 'Prisoners of the Commune at Versailles', winter fashions, Bayard's two drawings. Claretie ('Deux Dessins de M. Bayard', in *Peintres et sculpteurs contemporains*, 362–5) noted that the drawings had been prepared in photographs.

32  Monet to Bazille [Dec 1868] (W I, L.44).

33  See n. 21. In February 1873 Durand-Ruel paid 2,000 frs. for a painting of La Grenouillère (probably W.136; now lost); Wildenstein I. 87, n. 612. A book of advice for workers on budgeting (H. Leneveux, *Le Budget du foyer* [1872]) itemizes a salary of 2,339.60 frs. for a factory worker, supplemented by work done at home by his wife and daughters.

34  *La Cloche*, 14 Apr 1871, cited Bernard Noël, *Dictionnaire de la Commune* (1971), I. 76; Maxime Du Camp, *Les Convulsions de Paris*, 7th edn (1889), II. 61–2. Arsène Houssaye, owner of Monet's *Camille*, who specialized in novels on the erotic life of the boulevardier, wrote in his novel *Le Chien pendu et la femme fusillée* (1872), I. 239: 'Not one of these women had a human face; it was the image of crime and vice . . . bodies without souls which

deserved death a thousand times over, even before having touched petrol' (cited Lidsky, *Les Ecrivains contre la Commune*, 64, 115). The tenacity of the bestial image of working-class women is evidenced in Zola's *Germinal*, written more than a decade later.

35  Soria, *Grande Histoire de la Commune*, V. 120–4; [Louis] Uhlbach, 'Justice', editorial, *La Cloche*, 29 May 1871; Lidsky, *Les Ecrivains contre la Commune*, 127–32, citing Alphonse Daudet's 'Monologue à bord', *Contes du lundi* (1876).

36  Jules Janin, *Voyage de Paris à la mer* (1847): vignette on map of Seine railway in Seine valley to Rouen, facing p. 18; illustrations on pp. 19, 21–2, 44, 89, 91, 94, facing pp. 98 and 112, 152, facing p. 156. The same illustrations were used in Janin's *La Normandie* (1862, 3e edn), chs. XV–XVI (both books contain an engraving of the façade of Rouen Cathedral which Monet would paint in the 1890s). One could imagine that Janin's guide – which included an account of the inaugural trip in 1843 – was owned by Monet's family, and that it fanned boyhood dreams about the route between his home and Paris.

37  See Tucker, *Monet at Argenteuil*, passim, esp. ch. 1.

38  Despite the rhetoric of work, it was generally its material results rather than its actual processes which were represented in contemporary painting; there were few depictions of work in the Salons (except that in fishing villages and in a seemingly changeless countryside).

39  Stéphane Mallarmé, 'The Impressionists and Edouard Manet', *Art Monthly Review* (London), 30 Sept 1876 (unpub. in French until 1968); repr. *The New Painting*, 28–34.

40  Tucker, *Monet at Argenteuil*, 67–8.

41  Pissarro to Duret, 2 May 1873 (see epigraph p. 69, and n. 1). Duret had just criticized Monet's and Sisley's landscapes as 'without soul, without sentiment': Pissarro, *Correspondance* I, L.21 and n. 1, 79.

42  Mayeur, *Les débuts de la III*[e] *République*, 26.

43  Duret, *Les Peintres impressionnistes*, 19.

44  Silvestre, preface, *Recueil d'estampes* (1873), and see below, p. 92.

45  Benjamin, 'Paris of the Second Empire', in *Charles Baudelaire*, 37.

46  Monet to Pissarro, 22 Apr 1873 (W I, L.64). For the evolution of the private exhibition, see Wildenstein I. 65–70; Tucker, 'First Impressionist Exhibition in Context', in *New Painting* 93–4, 104–6.

47  *Reproduction photographique des principaux oeuvres*, Salons des Beaux-Arts, 1872–7 (Goupil, Paris): Cabinet des Estampes, Bibliothèque Nationale, Paris.

48  Paul Alexis, in *L'Avenir national*, 'Paris qui travaille. III: Aux peintres et sculpteurs', 5 May 1873; 'Aux peintres, et sculpteurs. Une lettre de M. Claude Monet', 12 May 1873 (for Monet's letter, see also W I, L.65). Alexis's suspicion of dealers, which was also expressed by other journalists, probably reflected their increasing influence. See n. 21.
Zola too had advocated that artists should form 'a corporation like simple workers' to escape the interference of the State: 'Lettres parisiennes', *La Cloche*, 13 July 1872, in *Ecrits sur l'art*, 203.

49  Silvestre, preface, *Recueil d'estampes* (1873).

50  Pissarro to Duret, 5 May 1874, *Correspondance* I, L.36, 93. Duret had advised Pissarro to continue trying to succeed through the Salon (letter, 15 Feb 1874, in Rewald, *History of Impressionism*, 310).

51  Excavations for Sacré-Cœur, cover illus., *L'Univers illustré*, 9 May 1874. H. le Pène, editorial *Paris-Journal*, 7 May 1874; Ernest Chesneau, 'A côté du Salon: II – Le plein air. Exposition du boulevard des Capucines', *Paris-Journal* (and *Le Soir*), 7 May 1874, in Hélène Adhémar et al., *Centenaire de l'Impressionnisme*, exh. cat., Grand Palais, Paris (1974; cited hereafter as *Centenaire*), 268–70.

52  A. de Pontmartin, 'Salon de 1874', *L'Univers illustré*, 2 May, 16 May 1874, 278, 310–11.

53  Castagnary, 'L'Exposition au boulevard des Capucines', *Le Siècle*, 29 Apr 1874, in *Centenaire*, 265 (*Le Siècle* published the rumours of the Comte de Chambord's presence at Versailles). Emile Blémont, editorial, *La Renaissance littéraire et artistique*, 18 Jan 1874.

54  Pierre Albert, *Histoire de la presse politique nationale au début de la troisième république (1871–1879)* [thèse, Université de Paris IV, 1977] (1980). No Catholic or legitimist journal commented on Impressionism in 1874, but there was an article on the exhibition in the *Paris-Journal*, which supported the *septennat* (the seven-year presidency), in the hope it might lead to a monarchist or Bonapartist solution.

55  Georges Rivière, 'Aux femmes', *L'Impressionniste*, 21 Apr 1877, in *Archives* II. 322.

**56** Jean Renoir, *Renoir, mon père*, 270–1; Armand Silvestre, 'Chronique des beaux-arts: Physiologie du refusé – L'exposition des révoltés', *L'Opinion nationale*, 22 Apr 1874.

**57** Louis Leroy, 'L'Exposition des impressionnistes', *Le Charivari*, 25 Apr 1874; Emile Cardon, 'L'Exposition des révoltés', *La Presse*, 29 Apr 1874; Chesneau, 'A côté du Salon': all in *Centenaire*, 259–61, 262–3, 259; A.L.T., 'Chronique', *La Patrie*, 16 May 1874, cited Jean Renoir, *Renoir, mon père*, 180. On Chesneau, see Boime, 'Second Empire's Official Realism', 47–9 and n. 51. For the *septennat*, see n. 54, above.

**58** [Philippe Burty], 'Exposition de la Société anonyme des artistes', *La République française*, 25 Apr 1874; [Ernest d'Hervilly], 'L'Exposition du boulevard des Capucines', *Le Rappel*, 17 Apr 1874: both in *Centenaire*, 261–2, 256–7. Burty wrote mainly for the left-wing Republican press, but also contributed to conservative journals like *La Presse*; he had attended the first meeting of the Commune's Fédération des Artistes in April 1871; d'Hervilly was an habitué of the Charpentiers' Gambettist salon. The involvement of journals in the political debate conducted through art was depicted in Pabst's *La Lecture du journal*, in the 1872 Salon, which showed an Alsatian girl reading (according to de Pontmartin, 'Salon de 1872: II', *L'Univers illustré*, 18 May 1872 [210]) '*la République française*, journal de M. Gambetta!' The critic claimed that 'the profession of political faith can only weaken the sympathetic effect. Are we not sufficiently divided?'

**59** In his 'Salon de 1872' (*Salons* II. 7–8), Castagnary cited the 'two systems' of liberty and protectionism; the origins of the second were despotic: it fixed the artist's attention on the 'central power', and was governed by academies, regulations, juries, prizes, while the origins of liberty were municipal: its ideal was 'the glorification of humanity', and it took 'public opinion as judge'. The anonymous author of *Aux artistes-peintres. A propos du Salon de 1872* (1872) sought alternatives to subjection to the State and to dealers. Silvestre, 'L'exposition des révoltés' (1874). Duranty said that if vitality in the arts was desired, artists should be left alone, '*laissez-faire . . . Laissez-les combattre ensemble*' (15 June 1872; quoted Crouzet, *Un Méconnu du réalisme*, 312). For Alexis, see p. 92 and n. 48.

**60** Cardon, 'L'Exposition des révoltés' (1874); Philippe de Chennevières, *Souvenirs d'un Directeur des Beaux-Arts* (1879), IV. 91 (his proposal failed because it was opposed by artists who, as the author of *Aux artistes-peintres* claimed [287], had been accustomed to state tutelage since 1791).

**61** Ph.B. [Philippe Burty], 'Chronique du jour', *La République française*, 16 Apr 1874; Castagnary, 'L'Exposition au boulevard des Capucines'; Marc [Marie-Amélie Chartroule] de Montifaud, 'Exposition du boulevard des Capucines', *L'Artiste*, 1 May 1874; Chesneau, 'A côté du Salon': all in *Centenaire*, 264–5, 256, 266–8, 269.

**62** Mallarmé, 'Impressionists and Edouard Manet', in *New Painting*, 33. Feydeau, *Consolation*, 77, cited Lidsky, *Les Ecrivains contre la Commune*, 84. *Le Siècle* opposed Versailles's policy of repression and supported the idea of amnesty for Communards.

**63** De Pontmartin, 'Salon de 1874', *L'Univers illustré*, 2 May 1874, 279; Francis Aubert, 'Le Salon: IX', *La France*, 26 May 1874. Lindsay, *Gustave Courbet*, 244.

**64** Stéphane Mallarmé, 'Impressionists and Edouard Manet' (1876) and 'Le Jury de Peinture pour 1874 et M. Manet', *La Renaissance littéraire et artistique* 12 Apr 1874, in *Oeuvres complètes*, ed. H. Mondor and G. Jean-Aubry, Pléiade edn (1945), 695–700. De Pontmartin, 'Salon de 1874', *L'Univers illustré*, 16 May 1874, 310.

**65** *Journal Officiel*, 15 Apr, 10 May 1871, in Darcel, 'Les Musées, les arts et les artistes . . . pendant la Commune', Jan 1872, 47–50, 59–60.

**66** Duranty, 3 July 1872, quoted Crouzet, *Un Méconnu du réalisme*, 312.

**67** Monet to Duret, 8 Mar 1880 (W I, L.173).

**68** [Burty], 'Exposition de la Société anonyme des artistes' (1874), in *Centenaire*, 261. Zola ('Lettre de Paris', *Le Sémaphore de Marseille*, 3–4 May 1874, in *Ecrits sur l'art*, 206) pointed out that in the 1874 Salon, the works were hung on two levels only, making eighty rooms! – 'a kilometre of violent colours . . . shrieking out the most abominable cacophony in the world'.

**69** Benjamin, 'Paris of the Second Empire' and 'Paris – the Capital of the Nineteenth Century', in *Charles Baudelaire*, 54–5, 165–6. 'Open' Salons pre-dated bazaars and department stores (see Bernard Marey, *Les Grands Magasins des origines à 1939* [1979]), but their spectacular expansion during the Second Empire coincided with a growing concern that the Salon would be contaminated by commercial principles (see above, p. 321, n. 115).

**70** Th. de Langeac, 'Bulletin', *L'Univers illustré*, 9 May 1874, 290; de Pontmartin, 'Salon de 1872: III', *L'Univers illustré*, 6 July 1872 (the 'austere lesson of adversity' had been learnt by Tassaert, whose suicide was reported by de Langeac). Anon., *Aux artistes-peintres*, 26–7.

**71** Hélène Adhémar and Sylvie Gache, 'L'Exposition de 1874 chez Nadar', in *Centenaire*, 223–54. Cals showed paintings of fisherfolk, Brandon paintings of Jewish life, Ottin sculptures of classical subjects – and a bust of Ingres!; Chesneau, 'A côté du Salon: II' (1874) in *Centenaire*, 268.

**72** De Montifaud, 'Exposition du boulevard des Capucines'; Chesneau, 'A côté du Salon: II' (both 1874), in *Centenaire*, 266, 257. Tucker gives an excellent analysis of the modern iconography of *Impression, sunrise* in 'The First Impressionist Exhibition and Monet's *Impression, sunrise*' (1984), 473–4, and suggests that it was surprising that no one saw Monet's painting in terms of post-war reconstruction. Monet's brushstrokes probably asserted themselves against any such reading.

**73** Mallarmé, 'Le Jury de Peinture pour 1874 et M. Manet' (1874), in *Oeuvres complètes*, 696.

**74** [Burty] 'Exposition de la Société anonyme'; Cardon, 'L'Exposition des Révoltés (both 1874), in *Centenaire*, 261, 263.

**75** Castagnary, 'L'Exposition au boulevard des Capucines' (1874), in *Centenaire*, 265.

**76** [d'Hervilly], 'L'Exposition du boulevard des Capucines'; Chesneau, 'A côté du Salon: II' (both 1874), in *Centenaire*, 257, 269. Enthusiasm from a Bonapartist may be explained by the fact that liberal members of the Bonapartist establishment believed more strongly in free-enterprise progress than did many Republicans in these uneasy years.

**77** Leroy, 'L'Exposition des impressionnistes'; Cardon, 'L'Exposition des Révoltés' (both 1874), in *Centenaire*, 260, 263.

**78** De Pontmartin, 'Salon de 1874: IX. La sculpture', *L'Univers illustré*, 27 June 1874, 407. The exhibition of the competition for the design of Sacré-Cœur opened in July 1874.

**79** Castagnary, Chesneau, Burty (all 1874 as cited above), in *Centenaire*, 265, 270, 262. Durand-Ruel purchased *Poppies at Argenteuil* (W.274) in Dec 1873.

**80** Tucker, *Monet at Argenteuil*, 176–81.

**81** Jean-Baptiste Faure may have purchased two versions of yachts and the villa at Argenteuil in 1876 (W.368–369); Ernest Hoschedé and Georges de Bellio each bought three of the *Gare Saint-Lazare* series in 1877.

**82** Gambetta, speech at Lille, Aug 1877, *Discours et plaidoyers choisis de Léon Gambetta* (1909), 254.

**83** Duret (*Les Peintres impressionnistes*, 9) lists some of Monet's collectors; see also Merete Bodelsen, 'Early Impressionist Sales 1874–94', *Burlington Magazine*, June 1968, 331–40. Other purchasers included Comte Jean de Rasti (*La Japonaise*, 1877), and the dealers, paint merchants and framers Portier, Dubourg, Petit and Hagerman. Artists who owned Monet's works included Manet, Michel Levy, Caillebotte, Gonzalès (?), Morisot (?), de Nittis, Duez, Meixmoron de Dombasle. The writers Arsène Houssaye, Ernest Feydeau, Duret, Zola, Chesneau and Blémont [Léon-Emile Petitdidier] owned works (some could have been gifts, as Monet later made presents of paintings to the critics Burty and Mirbeau). Two musicians also bought works: the singer Faure's collection was the most adventurous, and the composer Chabrier showed an early understanding of Monet's work (*Archives* I. 39–44). Paintings of figures in the countryside, in the garden, and the house sold most consistently; of 35 such works painted in 1872–6, at least 21 were sold by the end of 1878.
Wildenstein I. 62–4, 71, 74, 79. Letter to Manet, 28 May [1874] (W I, L.86).

**84** Tucker, *Monet at Argenteuil*, ch. 3, 'Bridges over the Seine', 57–87.

**85** A drawing for the *Picnic* of 1865–6 suggests that Monet added a river to the earlier forest setting; since this was in the same sketch-book as some Argenteuil drawings (Musée Marmottan sketch-book MM. 5130), he may have added it at the time he did those.

**86** Maupassant, 'Mouche', in *Contes et nouvelles* II. 1169, quoted Tucker, *Monet at Argenteuil*, 181.

**87** Aitken and Delafond, cat. nos. 56–67, 114, 131, 138, 141, 155, 157–8. Bromfield ('Japanese Art, Monet and Impressionism') suggests dates at which Monet may have acquired these prints: Hiroshige: cat. nos. 155, 157–8 (before 1867); 138–41 (before 1873); 114, 131 (before 1878); Hokusai: cat. nos. 56–67 (before 1883).

**88** Mallarmé, 'Impressionists and Edouard Manet', in *New Painting*, 31.

**89** Details in this and the following paragraph, discussed by Tucker in *Monet at Argenteuil*, 48–52.

**90** See Theodore Reff, *Degas: The Artist's Mind* (New York, 1976), 164–9.

**91** Geffroy (*Claude Monet*, 367) cites Georges Lafenestre, writing in 1899: 'The silhouettes take on a demoniac and fantastic aspect against a melancholic background of a landscape crossed by an iron arch like a bridge to hell'.

**92** Courbet's *Stone-breakers* was re-sold to a private collector in 1871; it was exhibited in April–May 1877. Bromfield (see above, n. 87) suggests that Monet bought the Hiroshige print (Aitken and Delafond, cat. no. 139) before 1873.

**93** Mallarmé, 'Impressionists and Edouard Manet', in *New Painting*, 33, 34.

**94** Anon., 'Faits. Paris. Vente Morisot, Monet, Renoir et Sisley', *L'Echo universel*, 23 Mar 1875; Anon. [Léon Mancino], 'Chronique de l'Hôtel Drouot', *L'Art*, I (1875), 336; both in *Archives* II.300–1; 'Masque de fer' [Albert Wolff], in *Le Figaro*, 24 Mar 1875 (*Le Figaro* was 'the sharpshooter of the conservative press': Albert, *Histoire de la presse politique nationale* II. 916 ff.); [Burty], preface to catalogue, *Vente du 24 mars 1875. Tableaux et aquarelles par Cl. Monet, B. Morisot, A. Renoir, A. Sisley* in *Archives* II. 290; [Burty], 'Chronique du jour', *La République française*, 23, 26 Mar 1875; 'Un Passant' [d'Hervilly], 'Les on-dit', *Le Rappel*, 20, 26 Mar 1875. The 'vulgar speculators' included Hecht, Débrousse, Dollfuss and perhaps Dalloz (see pp. 100–1 and n. 83).

**95** Théodore Véron praised Baader's work for its elevated ideas ('De l'Art et des artistes de mon temps. Salon de 1875', in *Mémorial de l'art et des artistes de mon temps* [1876], 43); de Chennevières's comment cited Adrian Rifkin, 'Cultural Movements and the Paris Commune', *Art History*, June 1979, 207.

**96** Letters to Manet, 28 June [1875], 8 July 1875, and undated [1875] (W I, L.81–83). Manet proposed to Duret that they should secretly take up Monet's offer of ten to twenty works at 100 frs. apiece, 'despite the repugnance one might have, making an excellent deal, and at the same time doing a service to a man of talent' (quoted Geffroy, *Claude Monet*, 73). The deal did not come off.

**97** *Mémoire sur l'avant projet de déviation des eaux d'égout de la ville de Paris*, Saint-Germain-en-Laye (1876), 45; cited Tucker, *Monet at Argenteuil*, 149–52.

**98** Tucker, *Monet at Argenteuil*, ch. 5, 'Monet and his Garden', 125–53. Zola, 'Mon Salon: les actualistes' (1868), in *Ecrits sur l'art*, 152; Jean Prouvaire [Pierre Toloza], 'L'Exposition du boulevard des Capucines', *Le Rappel*, 20 Apr 1874, in *Centenaire*, 258.

**99** Compare Manet's more prosaic painting of the Monet family in their garden (Metropolitan Museum, New York).

**100** Letter to Chocquet, 4 Feb 1876 (W I, L.86); Wildenstein I. 72.

**101** Tucker, *Monet at Argenteuil*, 138–9; Isaacson, *Claude Monet*, 205–6.

**102** Prouvaire, 'L'Exposition du boulevard des Capucines' (1874), in *Centenaire*, 259.

**103** In the *Oarsmen at Chatou* (W.324). In 'Mouche', Maupassant evokes the casual sexuality in the life of such oarsmen (*Contes et nouvelles* II. 1169–76).

**104** See n. 83.

**105** See also Aitken and Delafond, cat. nos. 87–8. Bromfield, 'Japanese Art, Monet and Impressionism'. Emile Blémont ('Les impressionnistes', *Le Rappel*, 9 Apr 1876, cited Geffroy, *Claude Monet*, 81–3) and Alexandre Pothey ('Chronique', *La Presse*, 31 Mar 1876; *Archives*, II, 302) were the only critics to note the masquerade.

**106** Armand Silvestre, 'Exposition de la rue le Peletier', *L'Opinion nationale*, 2 Apr 1876 (cited Steven Z. Levine, *Monet and his Critics* [New York, 1976], 25); Simon Boubée, 'Beaux-Arts. Exposition des impressionnistes', *Gazette de France*, 5 Apr 1876, cited Wildenstein I. 80. A similar innuendo was made by Emile Porcheron ('Promenades d'un flâneur. Les impressionnistes', *Le Soleil*, 4 Apr 1876, cited Geffroy, *Claude Monet*, 94): 'the painter has perhaps found it good taste to drape her in such a way that a portion of the robe on which is embroidered a warrior's head, is applied precisely on the part of the body entrusted to the care of Dr Purgon'. Monet wrote to Gustave Manet (7 May 1876, W I, L.88) enjoining silence 'au sujet de la Japonaise'. Gimpel, *Journal d'un collectionneur*, 68 (19 Aug 1918).

**107** Monet to Burty, 10 Oct 1875 (W I, L.84); Bigot, 'Causerie artistique' (1876).

**108** A. de L. [Alfred de Lostalot], 'L'Exposition de la rue le Peletier', *Chronique des arts et de la curiosité* (weekly supplement to the *Gazette des Beaux-Arts* described by Burty in 1876 as 'the organ of the purest academical doctrines'), 1 Apr 1876, cited Levine, *Monet and his Critics*, 25–6; Pierre Dax, 'Chroniques', *L'Artiste*, 1 May 1876, 347 (repr. of Georges Rivière, 'Les intransigeants de la peinture', *L'Esprit moderne*, 13 Apr 1876); Léon Mancino, '2ème exposition de peintures, dessins, gravures, faite par un groupe d'artistes', *L'Art*, V (1876), 36–7.

**109** Bigot, 'Causerie artistique' (1876); Castagnary, 'Salon de 1876', in *Salons* II, 213–14.

**110** *Correspondance de Berthe Morisot*, 94.

**111** Albert Wolff, 'Le Calendrier parisien', *Le Figaro*, 3 Apr 1876, cited Geffroy, *Claude Monet*, 86–8.

**112** Georges Maillard, 'Chronique: Les impressionnalistes', *Le Pays*, 4 Apr 1876, cited Geffroy, *Claude Monet*, 88–9; [Marius Vachon], 'Carnet de la journée', *La France*, 4 Apr 1876; note in *Le Figaro*, cited Geffroy, *Claude Monet*, 86.

**113** Bertall [Charles-Albert d'Arnoux], 'Exposition des impressionnalistes, rue Lepeletier', *Le Soir*, 15 Apr 1876, cited Geffroy, *Claude Monet*, 89–91; Emile Blavet, 'Avant le Salon. L'exposition des réalistes', *Le Gaulois*, 31 Mar 1876; Bigot, 'Causerie artistique' (1876). Underlying their accusation of madness was suspicion of the collectivity of the group, expressed by Wolff (see p. 116 above, and n. 111), 'the mutual admiration of their shared lunacy'.

**114** Daniel Halévy, *La République des ducs* (1937; 1972 edn), 206; *Courbet raconté par lui-même et par ses amis*, ed. Pierre Cailler (Geneva, 1951), II. 159.

**115** Louis Enault, 'Mouvement artistique: L'Exposition des intransigeants dans la galerie de Durand-Ruelle [sic]', *Le Constitutionnel*, 10 Apr 1876, cited Geffroy, *Claude Monet*, 92. That critics instinctively read political signs in the Impressionists' paintings is shown by Enault's comment that in *La Japonaise*, 'by force of habit', Monet had transformed the silk of the robe into peasants' wool or cotton, which Enault advised them not to wear when they went near their bulls because 'these reactionary animals don't like any reds'. Maillard wrote that the group raised 'some revolutionary banner'; two other critics noted that the Japonaise carried a tricolour fan, which a writer in the centre-left *L'Evénement* said was 'flattering for France' (Geffroy, *Claude Monet*, 83). One should recall the passions aroused by the white, red and tricolour flags between 1870 and 1876 (rejecting the Bourbons' white flag in July 1871, Falloux claimed that the tricolour had 'through opposition to the bloody standard of anarchy', become the flag of social order': cited Mayeur, *Les débuts de la III* République*, 15–16. See p. 92, n. 51).

**116** Editorial, *Le Rappel*, 25 Mar 1876; Hugo, *Choses vues*, 379–80; he also spoke on 22 May 1876 (*Choses vues*, 383).

**117** Bigot, 'Causerie artistique' (1876); he also stated that the artists had not created 'a revolution', and were simply producing *esquisses* and *ébauches*. The radical Alfred Naquet spoke in favour of amnesty in the Chambre des Députés in May 1876.

**118** Blémont, 'Les Impressionnistes' (1876). Blémont had dined with Hugo in 1873 when the writer read his *L'Année terrible* to his guests (*Choses vues*, 319).

**119** Editorial, *Le Soleil*, 4 Apr 1876; Anon., 'Revue des journaux: Revue littéraire et anecdotique', *Le Moniteur universel*, 11 Apr 1876 (incl. partial repr. of Blémont, 'Les Impressionnistes', 1876).

**120** Mancino, '2ème exposition de peintures, dessins, gravures' (1876); Lidsky, *Les Ecrivains contre la Commune*, 49, 59, 73, 92, 157. An anonymous writer in *L'Illustration* (3 June 1871) had commented that Paris must be saved from 'complete destruction by bandits whom one can compare only with Attila's hordes'.

**121** Porcheron, 'Promenades d'un flâneur' (1876); Geffroy, *Claude Monet*, 93; Bigot, 'Causerie artistique' (1876). The colours mentioned in these and other articles undermine the thesis expressed in Oscar Reuterswärd's article, 'The "Violettomania" of the Impressionists', *Journal of Aesthetics and Art Criticism*, Dec 1950, 106–10.

**122** Silvestre, 'Exposition de la rue le Peletier'; Blavet, 'Avant le Salon. L'exposition des réalistes'; Blémont, 'Les impressionnistes'; Enault, 'Mouvement artistique' (all 1876).

**123** Duranty, *La Nouvelle Peinture*, in *New Painting*, 481.

**124** Pothey ('Chronique', 1876) stated that the grouping of works by individual artists enabled the spectator 'to go from details to the whole, and to judge them with a thorough knowledge of the matter.' Bigot, 'Causerie artistique' (1876).

**125** Mallarmé, 'Impressionists and Edouard Manet', in *New Painting*, 33.

**126** According to Georges Rivière (*Renoir et ses amis* [1921], 89–90), when Renoir asked *La République française* to insert a favourable note on their 1877 exhibition, Gambetta laughed and said, 'You are Revolutionaries? Well then! what are we!' Monet, letters to Charpentier, 2, 12 July 1876 (W I, L.91–2).

**127** Among Monet's expedients was a loan of 1500 frs. guaranteed by a fictive sale of 15 works, valued at 100 frs. each; see Wildenstein I. 80. The highest price paid by de Bellio was the 400 frs. for *The Promenade* (W.381). *Correspondance de Berthe Morisot*, 94–5.

**128** The Palace of the Tuileries remained in ruins for twelve years before being fully demolished: Jacques Hillairet, *Le Palais royal et impérial des Tuileries et ses jardins* (1965).

**129** On Camille Monet's illness, see Wildenstein I. 88; but cf. p. 138, on the inadvisability of reading over-precise meanings into avant-garde Realist figure paintings.

**130** Letter to de Bellio, 25 July 1876 (W I, L.95).

**131** Wildenstein (I. 83) implies that their liaison began at Montgeron.

**132** The first Gare Saint-Lazare was illustrated in Janin's *Voyage de Paris à la mer* (1847) and in his *La Normandie* (1862, 3e edn). See p. 80 and n. 133.

**133** Drawings for the Gare Saint-Lazare, Musée Marmottan sketchbook MM 5128. Frederick Chevalier, 'Les Impressionnistes', *L'Artiste*, 1 May 1877, 332.

**134** Letter to Duret [Mar 1877] (W I, L.104).

**135** [Emile Zola], 'Une Exposition. Les peintres impressionnistes', *Le Sémaphore de Marseille*, 19 Apr 1877, in *Ecrits sur l'art*, 283; Georges Rivière, 'A. M. le rédacteur du *Figaro*', *L'Impressionniste*, 6 Apr 1877, in *Archives* II. 306–8; Jacques [pseud.], 'Menus propos. Salon impressionniste', *L'Homme libre*, 11 Apr 1877; Bigot, 'Causerie artistique. L'Exposition des "impressionnistes"' (1877), 1045–7.

**136** Alexandre Pothey 'Beaux-Arts', *Le Petit Parisien*, 7 Apr 1877, cited Levine, *Monet and His Critics*, 28; *Le Siècle* (5 Apr 1877, cited Lethève, *Impressionnistes et symbolistes*, 83) noted the number of visitors in 'elegant clothes' who admired the paintings.

**137** Roger Ballu, 'L'Exposition des peintres impressionnistes', *La Chronique des arts et de la curiosité*, 14 Apr 1877, 147–8; Baron Grimm [Albert Milhaud], 'Lettres anecdotiques du Baron Grimm. Les impressionnistes', *Le Figaro*, 5 Apr 1877; Georges Maillard, 'Chronique: Les impressionnistes', *Le Pays*, 9 Apr 1877; Cham [Amédée Noé], caricature in *Le Charivari*, 16 Apr 1877.

**138** Chevalier, 'Les impressionnistes' (1877), 332.

**139** Bigot, 'Causerie artistique' (1877); Paul Mantz, 'L'Exposition des peintres impressionnistes', *Le Temps*, 22 Apr 1877.

**140** Ph.B. [Philippe Burty], 'Exposition des impressionnistes', *La République française*, 25 Apr 1877; Marc de Montifaud [Marie-Amélie Chartroule], 'Salon de 1877', *L'Artiste*, 1 May 1877, 337. *L'Assommoir* was published as a book in Feb 1877, after being serialized in 1876; it went through 38 impressions by the end of the year: F.W.J. Hemmings, *Emile Zola* (Oxford, 1970), 120–1.

**141** Paul Sébillot ('Exposition des impressionnistes', *Le Bien public*, 7 Apr 1877) said that he thought only a decorative art could emerge from Impressionism; Mantz, 'L'exposition des peintres impressionnistes'; Bigot, 'Causerie artistique' (both 1877); Mallarmé, 'Le Jury de Peinture pour 1874 et M. Manet' in *Oeuvres complètes*, 695–700; Georges Rivière, 'L'Exposition des impressionnistes', *L'Impressionniste*, 14 Apr 1877, in *Archives* II. 308–9.

**142** 'Un peintre' [Pierre-Auguste Renoir], 'L'Art décoratif et contemporain', *L'Impressionniste*, 28 Apr 1877, in *Archives* II. 327.

**143** Baron Schop [Théodore de Banville], 'La Semaine parisienne. Les bons jeunes gens de la rue Le Peletier', *Le National*, 13 Apr 1877, quoted by Oscar Reuterswärd, 'The Accentuated Brush Stroke of the Impressionists', *Journal of Aesthetics and Art Criticism*, Mar 1952.

**144** *Salon de 1877. Reproduction photographique des principaux oeuvres . . .*, Goupil (1877) contains photographs of paintings of croquet, picnics, sea-bathing, fashionable promenades, etc.

**145** Baron Grimm, 'Lettres anecdotiques'; Rivière, 'L'exposition des impressionnistes'; Jacques [pseud.], 'Menus propos. Salon impressionniste' (all 1877); [Zola], 'Une exposition. Les peintres impressionnistes' (1877), in *Ecrits sur l'art*, 282.

**146** Georges Rivière, 'Les Intransigeants et les impressionnistes. Souvenirs du Salon libre de 1877', *L'Artiste*, 1 Nov 1877, 302; Arthur Baignières, 'Exposition de peinture par un groupe d'artistes. Rue le Peletier, 11', *L'Echo universel*, 13 Apr 1876, in *Archives* II. 305; Bigot, 'Causerie artistique' (1877). Rivière expressed his under-

standing of the change from an anthropocentric art in a different way, stating that Monet 'gave to inanimate objects . . . the life which others give to people'.

**147** Mayeur, *Les débuts de la III* République*, 119–20.

**148** In November 1877 Rivière wrote ('Les intransigeants et les impressionnistes') that in Renoir's *Swing*, 'one recognizes something of the *Voyage to Cythera* with a particular accent of the nineteenth century'.

**149** Letter to Murer, 11 Apr 1878 (W I, L.130).

**150** Letter to Manet [probably 1877] (W I, L.98); to de Bellio [June 1877?] (W I, L.107); to Zola [June 1877] (W I, L.108). Wildenstein I. 87–8.

**151** Wildenstein I. 89, 91–2.

**152** Pissarro to Caillebotte [Mar 1878], *Correspondance* I. L.53. Ronald Pickvance, 'Contemporary Popularity and Posthumous Neglect', in *The New Painting*, 243–6.

**153** Duret, *Les Peintres impressionnistes*, 17–18; Charles Ephrussi, 'Bibliographies. *Les Peintres impressionnistes* . . . par Théodore Duret', *La Chronique des arts et de la curiosité*, 18 May 1878, 158.

**154** Anon., 'Chronique parisienne', *Le Figaro*, 30 June 1878; 'La Fête du 30 juin', *Le Figaro*, 1 July 1878.

**155** Duret, *Les Peintres impressionnistes*, 16.

**156** A. Picard, *L'Exposition universelle internationale de 1889, Paris, Rapport général* (1891), I. 235, extract in Yvonne Brunhammer et al., *Le Livre des expositions universelles, 1851–1989*, Musée des arts décoratifs (Paris, 1983), 76. Auguste Vacquerie, editorial, *Le Rappel*, 10 Apr 1876.

**157** Halévy, *La République des ducs*, 323, citing Wolff. An article in *Le Rappel* (8 Jan 1878, cited Halévy, 317) discussed recent inventions which could have confirmed Monet's intuitions about the material world, including the liquefaction of oxygen and liquid air.

**158** Hébrard (probably Adrien Hébrard, *directeur* of *Le Temps*, or his brother Jacques, editor of the same paper) quoted by Halévy, *La République des ducs*, 331. Courbet's death on the last day of 1877 would also have helped lay these bad dreams to rest. Halévy (312–15) discusses the effacing of the past, observing that 'at the horizon of every French person there was the work chosen as a vocation, the home possessed, the family founded'.

**159** Pissarro to Murer [mid-1878], *Correspondance* I, L.70.

**160** Paul Mantz, 'La Peinture française', in *Exposition Universelle de 1878. Les Beaux-Arts et les arts décoratifs*, ed. Louis Gonse (1879), vol. I: *L'Art moderne*, 22.

**161** Rivière, 'L'Exposition des impressionnistes' (1877).

**162** Pissarro to Murer [mid-1878], *Correspondance* I, L.70.

**163** Silvestre, preface, *Recueil d'estampes* (1873).

*Chapter 3*

**1** Letter to Duret, 9 Dec 1880 (W I, L.203; in the same letter Monet wrote of plans to paint in London); letters to Durand-Ruel, 6, 7 Mar 1883 (W II, L.337–8).

**2** Gambetta, speech of 21 June 1880, *Discours et plaidoyers choisis*, 320.

**3** Wildenstein I. 92–4; letter to Duret, 8 Feb 1879 (W I, L.149); letter to Durand-Ruel, 18 May 1884 (W II, L.496).

**4** See esp. Joel Isaacson, *The Crisis of Impressionism 1878–1882*, exh. cat., Univ. of Michigan Museum of Art (Ann Arbor, 1980).

**5** See n. 38, below. Monet did paint portraits of his sons (W.504, 632–633), and of Jean-Pierre and Blanche Hoschedé (W.503, 619); he also had an unusual number of commissions for small portraits.

**6** Letter to Murer, 1 Sept 1879 (W I, L.136); Wildenstein I. 92.

**7** One can only speculate on the relationship between Monet and Alice Hoschedé at this stage. If they were consciously drawn to each other, it seems unlikely that they would have sought the claustrophobic domesticity of the set-up at Vétheuil. See Wildenstein I. 100, 108, 119–20; and see below, n. 30.

**8** Musée Marmottan sketch-books MM. 5130, MM. 5131.

**9** Wildenstein I. 93, 95–6; letter to de Bellio, 10 Mar 1879 (W I, L.155); Monet's request that Duret send him a cask of cognac (8 Feb 1879 [W I, L.154]) shows that he was keeping up bourgeois standards.

**10** Pissarro to Murer [mid-1878], *Correspondance* I, L.66; to Caillebotte [May 1878], *ibid*, I, L.53, 109–10; Monet to Murer, 25 Mar 1879 (W I, L.156). On the fourth Impressionist exhibition, see Pickvance, 'Contemporary Popularity and Posthumous Neglect', in

*New Painting*, 243–65. Caillebotte to Monet [late Mar 1879], in Marie Berhaut, *Caillebotte, sa vie, son oeuvre* (1978), L.15.

**11** Georges Lafenestre, 'Les expositions d'art: les indépendants et les aquarellistes', *Revue des deux mondes*, 15 May 1879, 479–82. There was a growing consensus that 'true' Impressionists – generally *pleinairistes* and colourists – could be distinguished from Degas and his followers, who were generally Realist figure painters of urban subjects.

**12** Bertall [Charles-Albert Arnoux], 'Exposition des indépendants: Ex-impressionistes, demain intentionistes', *L'Artiste*, 1 June 1879, 396–8; Armand Silvestre, 'Le Monde des arts. Les indépendants . . .', *La Vie moderne*, 24 Apr 1879, 38; Edmond Duranty, 'La quatrième exposition faite par un groupe d'artistes indépendants', *La Chronique des arts et de la curiosité*, 19 Apr 1879, 126–8; Charles Tardieu, 'La Peinture au Salon de Paris 1879', *L'Art*, II (1879), 202.

**13** Lafenestre, 'Les expositions d'art: les indépendants et les aquarellistes' (1879); Ph.B [Philippe Burty], 'L'exposition des artistes indépendants', *La République française*, 16 Apr 1879; Silvestre, 'Le Monde des arts. Les indépendants' (1879).

**14** Paul Sébillot, 'Revue artistique', *La Plume*, 15 May 1879; Albert Wolff, 'Les indépendants', *Le Figaro*, 11 Apr 1879.

**15** Zola, 'Nouvelles artistiques et littéraires' (trans. from the Russian), *La Revue politique et littéraire*, 26 July 1879, in *Ecrits sur l'art*, 320; Duret, *Les Peintres impressionnistes*, 17–18; Ephrussi, 'Bibliographies. Les Peintres impressionnistes' (1878), 158; Monet to Ernest Hoschedé, 14 May 1879 (W I, L.158).

**16** Letter to de Bellio, 17 Aug 1879 (W I, L.161).

**17** Letter to Hoschedé, 14 May 1879 (W I, L.158): Ernest Hoschedé to his mother, 16 May 1879, cited Wildenstein I. 97; Monet to de Bellio, 17 Aug 1879 (W I, L.161).

**18** De Bellio to Monet, 25 Aug 1879, cited Wildenstein I, 97, n. 725. De Bellio's apparent callousness did not prevent Monet from asking him for money to redeem a medallion of Camille's which had been pawned and which he wished to have buried with her (letter to de Bellio, 5 Sept 1879 [W I, L.163]).

**19** Clemenceau, *Claude Monet*, 21–2. See Introd., n. 2.

**20** Alice Hoschedé to Ernest Hoschedé, Nov and Dec 1879, cited Wildenstein I. 100, n. 761, 105, n. 765. For Mme Hoschedé's dowry, see Wildenstein I. 81.

**21** See also Isaacson, *Crisis of Impressionism*, cat. no. 29: *Still life with melon* (W.544). Obviously Monet painted many still lifes without such associations.

**22** Cp. Wildenstein (I. 106–7), who suggests that Monet had only four or five days after the thaw on 5 January 1880 to paint the freed ice-floes.

**23** William C. Seitz, *Claude Monet* (New York 1960), 29. Alice Hoschedé to Ernest Hoschedé, Dec 1879, cited Wildenstein I. 100, 105. Monet earned a substantial 12,500 frs. in 1879, but his earnings were swallowed up by his debts; Monet to de Bellio, 8 Jan 1880 (W I, L.170); Wildenstein I. 107.

**24** Wildenstein (W.511) dates this work to the winter of 1878–9; it has a close compositional relationship to works of that time, but its more assured handling and use of colour relates it more closely to the paintings of snow-covered landscapes in the winter of 1879–80.

**25** Goncourt, *Journal*, 31 Oct, 6 and 28 Nov 1878, 1267–72. That same year Chesneau listed Monet as a collector of Japanese art along with Manet, Degas, Bracquemond, the Goncourts, Zola, Burty, Charpentier and Duret ('L'Exposition universelle. Le Japon à Paris: I', *Gazette des Beaux-Arts*, Sept 1878, 387; II, Nov 1878, 844–6).
Monet to Durand-Ruel, 8 Mar 1883 (W II, L.339). The catalogue of the 'Exposition Retrospective de l'Art Japonais', organized by Louis Gonse, Galerie Georges Petit, March 1883, lists several hundred works loaned by Bing, Gonse Burty, Duret, Wakai and other private collectors; these include paintings by major Japanese artists from the fifteenth to the nineteenth century, including [names in their French transliterations] Sesshiu, Soami, Itshio, Josetsou, Gheami, Korin, Sotatsu, Sansetsu, Seisen, Okio, Sosen, Sessai, Tanyo, Hokusai; a mountain landscape by Sesshiu (owned by Bing) and a *kakemono* by Bountshio of mountains and a waterfall in mist and clouds (Montefiore collection) were illustrated. Monet owned a *kakemono* (Joyes, *Monet at Giverny*, 36).

**26** Silvestre, 'Le monde des arts. 'Les indépendants' (1879).

**27** Letter to Duret, Mar 1880 (W I, L.173). The 1880 Salon jury was the first, under the new regulations, to be chosen by artists rather than controlled by the government.

**28** There was a very large number of Japanese paintings in Paris

collections in the last quarter of the century, but without extensive research, it is difficult to identify them; illustrations in this book do not, therefore, represent works which Monet is known to have seen.

**29** Philippe de Chennevières, 'Le Salon de 1880', *Gazette des Beaux-Arts*, July 1880, 44. Zola made the same point.

**30** Ph.B [Philippe Burty], 'Le Salon de 1880', *La République française*, 19 June 1880; Zola, 'Le Naturalisme au Salon', *Le Voltaire*, 18–22 June 1880, in *Ecrits sur l'art*, 341 (Monet, in fact, never exhibited *esquisses*). In mentioning 'personal considerations', Zola was probably referring to a disagreeable article in *Le Gaulois* ('La Journée parisienne. Impression d'un impressionniste', 24 Jan 1880), with a funeral announcement occasioned by Monet's 'loss' to Impressionism, with innuendoes about his relationship with Mme Hoschedé (Wildenstein I. 107–8). In the context of the recent death of Monet's wife, the malice of the article reveals the depth of feeling aroused by his possible defection from the Impressionist group.

**31** Although the liberalization of the government made possible the posthumous rehabilitation of Courbet through his exhibition at the Ecole des Beaux-Arts in 1882, there were still scars (see de Chennevières, *Souvenirs d'un directeur des Beaux-Arts* II. 51–2). A number of works on the Commune were published in 1879–80, including Zola's 'Jacques Damour' (1880, serialized in *Le Figaro* 27 Apr–2 May 1883; repr. in *Naïs Micoulin* [1884]: see Zola, *Contes et nouvelles* [Pleiade edn], 891–929); Maxime Du Camp's 4-vol. *Les Convulsions* (1878–80); Duret's *La Commune* (1880), the third volume of his *Histoire des quatre ans 1870–1873* (published by Charpentier).

**32** Letters to Duret, 19 May–4 June 1880 (W I, L.179–184). The paintings included the *Cabin at Sainte-Adresse*, 1867 (owned by Duret; W.94); *Boats at Argenteuil, Gare Saint-Lazare*, and the *Rue Montorgueil* (W.469). If *Sunset on the Seine, winter effect* was exhibited, it was probably catalogued as *After the thaw. Winter of 1879–80*; the title is similar to that of the studio painting, *Ice-floes. Winter of 1879-80*, and the two large, formal works could well have been shown together. Joel Isaacson ('The Painters Called Impressionists', in *The New Painting*, 385) believes that this *Sunset on the Seine* was shown only in the sixth Impressionist exhibition, in 1882; but a painting which an anonymous writer in *La Vie moderne* (19 June 1880) praised as 'a very important painting which could not be more decorative,' *The Thaw at Sunset* [*Le Dégel au soleil couchant*], is the only work with such a subject which could have been so characterized.

**33** Degas's comment cited *Archives* I. 146. Emile Taboureux, 'Claude Monet', *La Vie moderne*, 12 June 1880, 380–2. An anonymous notice, 'Notre Exposition: Claude Monet', *La Vie moderne*, 19 June 1880, 400, stated that the exhibition had had 'a very great success with the Parisian art-loving public and most of the canvases were bought on the first day' (this was untrue; most of the works were loaned).

**34** Théodore Duret, *Le Peintre Claude Monet: Notice sur son oeuvre, suivi du catalogue de ses tableaux exposés dans la galerie du journal illustré, 'La Vie moderne'* (1880). Taboureux, 'Claude Monet' (1880).

**35** Monet's *Camille and Jean Monet in the house at Argenteuil*, 1875 (ill. 127), was painted in the family interior.

**36** [Burty], 'Le Salon de 1880' (1880); the 'establishment' critic, Alfred de Lostalot, did, however, write in 'Concours et expositions' (*La Chronique des arts et de la curiosité*, 12 June 1880) that Monet had 'rare talent as a landscapist'. Taboureux, 'Claude Monet' (1880).

**37** Letter to Mme Charpentier, 27 June 1880 (W I, L.186); to Duret, 5 July 1880 (W I, L.191). Ephrussi also bought a painting from the exhibition (letter, 30 June [W I, L.188], perhaps *Path in the poppies, Île Saint-Martin* [W.592], for 400 frs.).

**38** Wildenstein and the *Exposition Claude Monet–Auguste Rodin* (Galerie Georges Petit, Paris [1889]) date *The Meadow* (W.535) to 1879, but it is closer in style to dated works of 1880 (e.g. W.592); the smallest child is presumably Michel Monet, who would have been only just over a year old in the spring and early summer of 1879, and appears older here. The painting could have been painted in May 1880, just before the exhibition.

**39** Ernest Hoschedé, letter to his mother, 25 Sept 1878 (Wildenstein I. 92–3, n. 681).

**40** Wildenstein I. 108. Alice Hoschedé made sure that Camille and Claude Monet, who had had only a civil marriage ceremony, now had a Catholic one so that Camille could receive the last rites. Mme Hoschedé's position exposed her to malicious gossip; see above, n. 30.

**41** Letter to Duret, 9 Dec 1880 (W I, L.203). For Monet's

finances before Durand-Ruel's purchases in 1881, see Wildenstein I. 100, 105, 109, 112, 115–17.

**42** Letters to Durand-Ruel, 23 Mar, 18 June 1881 (W I, L.212, 221), characterize Monet's transactions with the dealer over the years (e.g. his use of advances and of Durand's support in being able to refuse lower offers). Wildenstein I. 117–18, 119–20; *Archives* I. 56–8. Isaacson ('Painters Called Impressionists', in *New Painting*, 337 and n. 34) points out that the dealer bought at least 30 works by Monet in 1881, 40 in 1882, 30 in 1883.

**43** A letter written to Zola (24 May 1881 [W I, L.218]) shows that by the spring of 1881 Monet was thinking of leaving Vétheuil; the rent on the house had not been paid since January 1880, and the lease expired in October. In a letter to her husband [c. 1 June 1881], Alice Hoschedé wrote, 'You reproach me for not being alone at Vétheuil; the situation is still the same and you accepted it previously; your absences have become longer and longer. Whose fault is that?' (Wildenstein I. 119).

**44** *Nasturtiums at Vétheuil* (W.693). Monet told Durand-Ruel (letter, 1 Oct 1881 [W I, L.223]) that he had begun a big canvas and that he wanted to paint many things before leaving Vétheuil. Alice Hoschedé had told her husband she would return to him in Paris in October (letter cited, n. 43). *The Artist's Garden at Vétheuil* remained in Monet's collection until his death, suggesting that it had private significance.

**45** Wildenstein I. 119–20, nn. 909, 921.

**46** Letter to Alice Hoschedé, 15 Feb 1882 (W II, L.242).

**47** Letter to Durand-Ruel, 10 Feb 1882 (W II. L.238). My account of this exhibition owes much to Isaacson, 'Painters Called Impressionists', in *New Painting*, 373–418.

**48** Letters to Durand-Ruel, 23, 24 Feb 1882 (W II, L.249, 250). J.-K. Huysmans, 'Appendice', in *L'Art moderne* (1883; 1975 edn), 259–60; *Correspondance de Berthe Morisot*, 110.

**49** Ph.B. [Philippe Burty], 'Les Aquarellistes, les indépendants et le Cercle des arts libéraux', *La République française*, 8 Mar 1882; Jules Claretie, 'Les Indépendants', *Le Temps*, 3 Mar 1882. *The Artist's Garden at Vétheuil* was probably the painting shown as *Coin d'un jardin à Vétheuil* (W.685).

**50** *Archives* II. 119–22. In his draft, Renoir said that the sole aim of his life was 'to make the price of my canvases rise', and that those connected with 'le social' would make him lose what he had gained in the Salon. The letter he sent to Durand-Ruel was less forceful. Cp. Pissarro's letter to Monet [c. 24 Feb 1882], *Correspondance* I. 98.

**51** Charles Bigot, 'Beaux-arts'. Les petits Salons. L'exposition des artistes indépendants', *La Revue politique et littéraire*, 4 Mar 1882, 281; Albert Wolff, 'Quelques expositions', *Le Figaro*, 2 Mar 1882. Wolff maintained that Degas had left the group because it was no place for an artist 'of his rank' while Raffaelli had done so after having been 'the principal attraction' of the Intransigents 'for several years'.

**52** Letter to Durand-Ruel, 23 Feb 1882 (W II, L.249).

**53** Armand Silvestre, 'Le monde des arts. Expositions particulières. Septième exposition des artistes indépendants', *La Vie moderne*, 11 Mar 1882, 150–1. The 'Willows' was perhaps W.611.

**54** Huysmans, 'Appendice', in *L'Art moderne*, 267; Ernest Chesneau, 'Groupes sympathiques. Les peintres impressionnistes', *Paris-Journal*, 7 Mar 1882; Fichtre [Gaston Vassy], 'L'actualité. L'exposition des peintres indépendants', *Le Réveil*, 2 Mar 1882; Anon., 'L'exposition des impressionnistes', *La Patrie*, 2 Mar 1882, cited Wildenstein II. 5.

**55** Huysmans, 'Appendice', in *L'Art moderne*; Alexandre Hepp, 'Impressionnisme', *Le Voltaire*, 3 Mar 1882; Chesneau, 'Groupes sympathiques' (1882); Mallarmé had, glancingly, made a similar point when he wrote of the Impressionists' 'real or apparent promptitude of labour': 'The Impressionists and Edouard Manet', in *New Painting*, 32.

**56** Jean de Nivelle [Charles Canivet], 'Les peintres indépendants', *Le Soleil*, 4 Mar 1882, cited Isaacson, 'Painters Called Impressionists', in *New Painting*, 403; Huysmans, 'Appendice', in *L'Art moderne*, 268; Chesneau, 'Groupes sympathiques' (1882).

**57** Emile Hennequin, 'Beaux-arts. Les expositions des arts libéraux et des artistes indépendants', *La Revue littéraire et artistique* (1882), 154–5; Fichtre, 'L'actualité' (1882), cited Isaacson, 'Painters Called Impressionists', in *New Painting*, 404.

**58** Letter to Durand-Ruel, 14 Mar 1882 (W II, L.254). Chesneau, 'Groupes sympathiques' (1882).

**59** Monet to Bazille, 15 July [1864], [Dec 1868] (W I, L.8, 44). For discussions of the subjectivity of Impressionism, see Shiff, 'End of Impressionism', and Isaacson, 'Painters Called Impressionists', both in *New Painting*, 61–89, 382–3 and nn. 61–4.

**60** The domination of the scientific, positivistic interpretation is made clear in the writings cited by Levine in *Monet and His Critics*. Levine emphasizes the importance of 'the decorative' in Monet criticism, but it was not of central significance until the 1890s.

**61** Huysmans, 'Appendice', in *L'Art moderne*, 268; Monet to Alice Hoschedé [17 Mar 1882] (W II, L.255 *bis*); Hepp, 'Impressionnisme' (1882).

**62** *Correspondance de Berthe Morisot*, 102; letter to Durand-Ruel, 25 Mar 1882 (W II, L.260).

**63** Letters to Alice Hoschedé, 11, 7, 6, 4 Apr 1882 (W II, L.270, 266, 264, 263 *bis*). (To avoid proliferation of notes, references to Monet's correspondence will be grouped thus hereafter.)

**64** Musée Marmottan sketch-books MM. 5131 (12r–14v), 5134 (35r).

**65** Wildenstein II. 6.

**66** Monet did other 'pairs' of landscapes with and without figures, as if speculating on the difference made by the presence or absence of spectator figures (W.757–758, W.777–778, W.781–782).

**67** Letter to Durand-Ruel, 28 June 1882 (W I, L.278); to Pissarro, 16 Sept 1882 (W I, L.287); to Durand-Ruel, 18, 26 Sept 1882 (W II, L.288, 290).

**68** Wildenstein II. 9 and n. 101 (Monet received 31,241 frs. including advances, so that by the end of 1882 he was in debt to the dealer, and had to make up the balance by the delivery of more paintings); letter to Durand-Ruel, 10 Nov 1882 (W II, L.300); Gauguin to Pissarro, cited Wildenstein II. 9, n. 102.

**69** See, for example, House, *Monet. Nature into Art*, 24–5, and Tucker, *Monet at Argenteuil*, for guidebooks and press illustrations related to 1870s motifs.

**70** Musée Marmottan sketch-books MM.5131 (30v); 5135 (5v, 22r, 24r, 25r–28v). Letter to Alice Hoschedé, 1 Feb [1883] (W II, L.312). The Courbet exhibition contained at least seven of his Etretat paintings; others were in the collections of Durand-Ruel, Faure and Hecht.

**71** Letter to Alice Hoschedé, 19 Feb [1883] (W II, L.334).

**72** Letters to Durand-Ruel, 27 July, 26 Aug, 6 Nov 1883 (W II, L.367, 371, 380); in the last he warned that the paint was still 'a bit wet'.

**73** Letter to Alice Hoschedé, 3 Feb 1883 (W II, L.314).

**74** Wildenstein II. 13, n. 145 (some lenders were apparently creditors, or lent under a pseudonym, so it cannot be assumed that the 26 Pourville works exhibited had all been purchased); there were a few uncatalogued works, including *Low tide at Varengeville* (W.722).

**75** Camille Pissarro to his son Lucien [3 Mar 1883] (he wrote on 15 Mar 1883 that the exhibition had 'not made a sou from entries'; however, by 15 Apr he had concluded that Monet's and Renoir's exhibitions had both been successful): *Correspondance* I, L.122, 125, 138. Monet to Durand-Ruel, 5, 6, 7 Mar 1883 (W II, L.336–8).

**76** Dargenty [Arthur d'Echerac] ('Exposition des oeuvres de M. Monet', *Le Courrier de l'art*, 15 Mar 1883, 126–7, cited Levine, *Monet and His Critics*, 59–60), denounced Monet's incorrect drawing, childish 'babbling', and 'debauches' as a danger to French painting.

**77** Gustave Geffroy, 'Claude Monet', *La Justice*, 15 Mar 1883 (largely repr. in Geffroy, *La Vie artistique*, 3ᵉ série [1894]; his articles on Monet repr. in whole or in part in this 8-vol. collection [1892–1903], will be cited in full at the first instance, and thereafter in short form with both the date of original publication and that of the reprint).

**78** Armand Silvestre, 'Le Monde des arts. Exposition de M. Claude Monet, 9 boulevard de la Madeleine', *La Vie moderne*, 17 Mar 1883, 177.

**79** [Burty], 'Les Paysages de M. Claude Monet' (1883), *La République française* (recognized as the major 'opportunist' newspaper), 27 Mar 1883. Monet offered the critic a painting a few days before the article appeared (letter to Burty, 22 Mar 1883 [W II, L.342]).

**80** See below, Ch. 4, n. 26.

**81** Alfred de Lostalot, 'Exposition des oeuvres de M. Claude Monet', *Gazette des Beaux-Arts*, Apr 1883, 342–8. De Lostalot extended the analogy between painting and music by suggesting that since the former cannot attain the brilliance of natural light, it can be only a transposition of nature like a melody which 'does not change if it is lowered a tone'.

**82** E.g. W.724, 734, 808. Monet exhibited two other recent paintings with figures, *Fishermen at Poissy* (W.748) and *Low Tide at Pourville* (W.776), and the portrait *Le Père Paul* (W.744).

**83** [Burty], 'Les Paysages de M. Claude Monet' (1883); Geffroy, 'Claude Monet' (1883/1894). Durand-Ruel felt that the Republican government opposed him because of his Catholicism: *Archives* II. 210.

## Chapter 4

**1** Octave Mirbeau, 'Claude Monet', in *Exposition Claude Monet – Auguste Rodin*, exh. cat., Galerie Georges Petit, Paris (1889), 16. Letter to Durand-Ruel, 27 Apr 1884 (W II, L.489).

**2** Letter to Durand-Ruel, 15 Apr 1883 (W II, L.346).

**3** Pissarro mentions Alice Hoschedé's income (letter to Lucien, 13 Apr 1891, *Correspondance* III, L.653), and see below, p. 238. Charles Durand-Ruel in conversation with Gimpel (*Journal d'un collectionneur*, 348) implied that Monet's art suffered because he married a 'society lady'; Forain told Gimpel (386) that Alice's fortune had supported both the Monet/Hoschedé household and Ernest Hoschedé for ten years when Monet was doing his 'most interesting researches' into colour.

**4** Octave Mirbeau, *Contes de ma chaumière* (1886; 1923 edn), 5–6 (Mirbeau wrote weekly 'Lettres de ma chaumière' for *La France* in the summer and autumn of 1885; the passage quoted here was added to the collected edition).

**5** Letter to Alice Hoschedé [19 Feb 1888] (W III, L.840). Pissarro told Monet (12 June 1883, *Correspondance* I, L.158) that some dealers, collectors and speculators had given Durand-Ruel's business only eight days to survive, but it had lasted several months.

**6** Jean Bouvier, *Les Deux scandales de Panama* (1964), *passim*. And see below, n. 107.

**7** Octave Mirbeau, 'Prélude', *Le Figaro*, 14 July 1889, cited Reg Carr, *Anarchism in France: The case of Octave Mirbeau* (Manchester, 1977), 28.

**8** Gustave Geffroy, dedication to Michelet, in *La Vie artistique*, 4ᵉ série (1895), x–xviii.

**9** Thadée Natanson, 'Sur des traits d'Octave Mirbeau', *Les Cahiers d'aujourd'hui*, no. 9 (1922), 115–16.

**10** On Fénéon's criticism of Monet, see below, p. 174 and n. 53, p. 178 and n. 70.

**11** Letter to Durand-Ruel, 27 Apr 1884 (W II, L.489). Gillet, 'L'Epilogue de l'impressionnisme' (1909), 403–5. Gillet continued, 'Does one find in this native of Le Havre that profound sense of the country which marks the charm of Millet?'; he implied that Monet's attitude to nature was that of a gardener. Jules Laforgue, 'L'Impressionnisme' [Berlin, 1883], in *Mélanges posthumes* (1903; 1979 facsimile), 143–4.

**12** Letter to Duret, 13 Aug 1887 (W III, L.794).

**13** Letter to Durand-Ruel, 1 Dec (W II, L.383).

**14** Letter to Durand-Ruel, 3 July 1883 (W II, L.362).

**15** Letter to Durand-Ruel, 12 Jan 1884 (W II, L.388).

**16** Letter to Durand-Ruel, 23 Jan 1884 (W II, L.391); to Alice Hoschedé, 6 Feb, 5 Mar, 26 Jan, 11 Feb 1884 (W II, L.409, 438, 394, 415).

**17** Letter to Alice Hoschedé, 29 Jan 1884 (W II, L.398); to Duret, 2 Feb 1884 (W II, L.403); to Alice Hoschedé, 15 Feb, 22 Mar, 28 Mar 1884 (W II, L.419, 454, 465). Monet received 34,541 frs. in payments and advances from Durand-Ruel in 1883, and delivered *c.* 29,000 frs.' worth of paintings (Wildenstein II. 21, n. 213).

**18** House, *Monet. Nature into Art*, 24–5.

**19** Gillet, 'L'Epilogue de l'impressionnisme' (1909), 404.

**20** Letter to Durand-Ruel, 27 Apr 1884 (W II, L.489); see Wildenstein II. 30, 32.

**21** Letter to Alice Hoschedé [10 Mar 1884] (W II, L.441). He began, 'I did lots of bad paintings [*croûtes*] at the beginning but now I have it, this enchanted country, and it's exactly this wondrous side which I try so hard to render'.

**22** Laforgue, 'L'Impressionnisme' (1883), in *Mélanges posthumes*, 143–4. Letter to Duret, 2 Feb 1884 (W II, L.403).

**23** Wildenstein II. 31–2; letter to Alice Hoschedé, 13 Feb 1884 (W II, L.417); letters to Durand-Ruel, 21 July, 18 May, 2 Oct 1884 (W II, L.510, 496, 521). Pissarro to Monet, 13 May, [second half May 1884], *Correspondance* I, L.235, 238 (the first letter discusses the arrangements whereby Durand-Ruel would pay off his creditors; the second the belief that the dealer was 'absolutely lost'). Gauguin told Pissarro (*Correspondance* I. 302, n. 1) that Durand-Ruel 'should have warned you long ago [about his financial

difficulties] . . . but those types are nothing but speculators, and deceive you shamefully . . .'.

**24** Letter to Pissarro, [late Nov] 1884 (W II, L.534); to Durand-Ruel, 24 Oct, 3 Nov 1884 (W II, L.526, 527). To maintain prices, it was necessary to keep up appearances: Monet told Durand-Ruel, 'I absolutely concealed my – as well as your – financial difficulties from [Faure]' (6 Sept 1884 [W II, L.518]). Wildenstein II. 30 and n. 311.

**25** Letter to Durand-Ruel, 5 June 1883 (W II, L.356).

**26** Letter to Durand-Ruel, 23 Dec 1882 (W II, L.305) (he added 'We're well enough known today, it's time to strike a firm blow . . . it's essential to act with daring'); to Durand-Ruel, 30 May 1885 (W II, L.567). In a letter to Monet of 12 June 1883, stating that Durand-Ruel was 'too much a shopkeeper', Pissarro asserted: 'Since what we produced was not understood by the general public, it should be shown, if not with pomp, at least with a certain special taste, a certain mystery which would give the thing attraction' (*Correspondance* I, L.158).

**27** Letters to Pissarro, 11 Nov, [late Nov] 1884 (W II, L.531, 534); to Zola, 24 Feb 1885 (W II, L.552). Wildenstein II. 36–7, 39 and n. 398, 48; III. 19. The Café Riche dinners went back to 1877 (letter to Zola [March 1877] [W I, L.105]).

**28** Letter to Pissarro [mid-Dec 1884] (W II, L.538) (see Pissarro's correspondence with Huysmans on *L'Art moderne*, *Correspondance* I, 9 May, 15 May 1883, L.144 and n. 1, L.146); to Zola, 24 Feb, 28 Feb 1885 (W II, L.552, 553). Octave Mirbeau, 'Emile Zola et le naturalisme', *La France*, 11 Mar 1885, 2. The paintings described as requiring 'a palette of gold and jewels' (see p. 167 and n. 22 above) were those of Bordighera, on which Monet worked throughout 1884.

**29** Letter to Durand-Ruel, 10 Nov 1884 (W II, L.529); Pissarro to Monet [late Nov 1884], *Correspondance* I, L.258; letter to Pissarro, [late Nov] 1884 (W II, L.534); de Bellio to Monet, 29 Nov 1884, cited Wildenstein II. 33–4 and n. 357. Carr, *Anarchism in France*, 3–6.

**30** Octave Mirbeau, 'Notes sur l'art. Claude Monet', *La France*, 21 Nov 1884. The same issue reported on wars in China and India, the Congo conference, de Lesseps' projects for the Panama Canal, plans for the Exposition Universelle of 1889, strikes in Paris, and the invention of the phonograph.

**31** Mirbeau to Monet, 30 Dec 1884 (p.j. [87], W II, 293) (see W.739).

**32** Octave Mirbeau, 'Chroniques parisiennes', *La France*, 27 Oct 1885; Carr, *Anarchism in France*, 1–13.

**33** The 19 French exhibitors included Béraud*, Besnard, Bonnat*, M. Cazin*, Mme Cazin, Gervex* (those with an * were decorated); the foreigners, Liebermann, Raffaelli, Sargent, Stevens. Alfred de Lostalot, 'Exposition internationale de peinture (Galerie Georges Petit)', *Gazette des Beaux-Arts*, June 1885, 529–32. For works shown by Monet, see Wildenstein II. 38, n.392.

**34** The *Meadow with haystacks* is analysed by Robert L. Herbert, 'Method and Meaning in Monet', *Art in America*, Sept 1979, 90–108. Although he is right about the extraordinary complexity of Monet's paint structures, I think Herbert exaggerates the role of conscious decisions during Monet's working process.

**35** Laforgue, 'L'Impressionnisme' (1883), in *Mélanges posthumes*, 137, 139–40.

**36** Musée Marmottan sketch-book MM. 5131.

**37** Letter to Alice Hoschedé, [27 Nov] 1885 (W II, L.631).

**38** Guy de Maupassant, 'La Vie d'un paysagiste', *Gil Blas*, 28 Sept 1886.

**39** Letters to Alice Hoschedé, 24, 31 Oct [1885] (W II, L.597, 604). Monet added that Maupassant liked his '*effet de pluie*', probably *Rain at Etretat* (W.1044), which the writer would have seen as an immediate response to an effect, though it was probably mediated by Japanese prints. Octave Maus appreciated the reasons for Monet's repetition of a motif: 'the grandeur of the drawing and of the composition, the shape of each canvas, the smoothness or the impetuosity [varied] according to whether it was a question of representing an effect of calm weather or a storm' ('Les Impressionnistes', *La Vie moderne*, 15 Mar 1885, 85).

**40** See below p. 172 and n. 43.

**41** Letter to Durand-Ruel [12 Sept 1886] (W II, L.684); see also letter to Charpentier, 27 Oct 1885 (W II, L.600).

**42** Letter to Durand-Ruel, 27 May 1885 (W II, L.566).

**43** Letters to Alice Hoschedé [22, 24 Feb 1886] (W II, L.656, 658). Wildenstein II. 46. In this context the personal symbolism of the two paintings, *L'Aiguille seen through the Porte d'Aval* (W.1049–1050), may be obvious.

**44** The painting of Suzanne in the orchard (W.1065) was offered to Durand-Ruel (11 Aug 1886 [W II, L.678]) for 1,000 frs.

**45** Pissarro to Monet, 29 Oct 1885, *Correspondance* I, L.292, 353, n. 4; Monet to Alice Hoschedé, 30 Oct [1885] (W II, L.603); to Pissarro, 9 Nov 1885 (W II. L.616); to Durand-Ruel, 28 July, 10, 17 Dec 1885 (W II, L.578, 638, 642). Wildenstein II. 44.

**46** Letter to Durand-Ruel, 7 Apr 1886 (W II, L.665).

**47** Frances Weitzenhoffer, 'The Earliest American Collectors of Monet', in *Aspects*, 72–91.

**48** 'The Impressionists', *Art Age*, Apr 1886, 166, cited Weitzenhoffer, 'Earliest American Collectors', in *Aspects*, 76.

**49** Letter to Zola, 5 Apr 1886 (W II, L.664); to Pissarro (W II, L.667); Pissarro to Monet [April 1886]; to Lucien [8 May 1886], *Correspondance* II, L.326, 334. Zola's novel was serialized in *Gil Blas*, 27 Dec 1885–27 Mar 1886.

**50** Other works exhibited incl. W.889(?), 1044, 1067, 1070; see Wildenstein II. 48, n. 502. Letter to Durand-Ruel, 30 Apr 1886 (W II, L.671); to Durand-Ruel, 11 Aug 1886 (W II. L.678).

**51** M. Fouquier, 'L'Exposition internationale,' *Le XIXᵉ Siècle*, 17 June 1886, cited Wildenstein II. 49; Albert Wolff, 'Exposition internationale', *Le Figaro*, 19 June 1886 (the painting praised was probably *Yachts in the sea near L'Aiguille*, W.1032).

**52** See Martha Ward, 'The Rhetoric of Independence and Innovation', in *New Painting*, 421–2.

**53** Félix Fénéon, 'VIIIᵉ Exposition impressionniste', du 15 mai au 15 juin, rue Laffitte, 1', *La Vogue*, 13–20 June 1886; repr. (with 'Vᵉ Exposition Internationale du 15 juin au 15 juillet, rue de Sèze, 8', *La Vogue*, 28 June–5 July 1886), as a pamphlet, *Les Impressionnistes en 1886* (1886); in Félix Fénéon, *Oeuvres plus que complètes*, ed. Joan U. Halperin (Geneva/Paris, 1970), I. 29–37.

**54** Letters to Morisot and Duret [late July/end Aug 1886] (W II, L.676, 677). Wildenstein II. 47–8.

**55** Hoschedé, *Claude Monet, ce mal connu*, II. 126. This anecdote undercuts Wildenstein's innuendos about Alice Hoschedé's 'censorship' of Camille Monet (I. 99). The house at Giverny was full of images of Camille, including three portraits by Renoir (Geffroy, *Claude Monet*, 448).

**56** Wildenstein dates this painting (W.846) 1883, but gives no reason. Michel Monet who is seated at the table was born in early 1878; he appears older than five, and closer to the age of the little boy in the *Evening landscape with figures*. The strong calligraphic handling of *Luncheon under the awning* relates it to the *Essais de figures en plein air* of 1886. Rewald reproduces a painting of this subject by Sargent (*History of Impressionism*, 552), but the attribution is doubted by Richard Ormond, *John Singer Sargent* (London, 1970), 41, n. 90.

**57** Willem G.L. Byvanck, *Un Hollandais à Paris en 1891. Sensations de littérature et d'art* (1892), 176. In his 1889 retrospective exhibition Monet exhibited 4 other paintings under the heading *Essais de figures en plein air* (see p. 199).

**58** Monet later asked Mallarmé for a copy of the poem (which had been illustrated by Manet) (letter, 5 June 1889 [W III, L.894]).

**59** Morisot, quoted in Elizabeth Mongan et al., *Berthe Morisot: Drawings, Pastels, Watercolours, Paintings*, exh. cat., Museum of Fine Arts, Boston (1960–1), 16.

**60** Letters to Morisot, 30 Mar, 8 Aug, [Nov] 1884 (W II, L.467, 515, 530); to Pissarro, 22 Aug 1885 (W II, L.581); Puvis de Chavannes to Morisot, 5 June 1885, *Correspondance de Berthe Morisot*, 124; letter to Morisot, 8 Dec 1886 (W II, L.761).

**61** Hoschedé, *Claude Monet, ce mal connu*, I. 100; letter to Durand-Ruel, 13 May 1887 (W III, L.788).

**62** In his novel *Grave Imprudence* (1880), 135, Burty wrote of the desire of his hero – based partly on Monet – to paint the female nude in the sunlight, but asserted: 'This vision of the real is forbidden to the modern artist . . .' (quoted in *Archives* II. 296). For Monet's study of the nude in the 1860s, see Ch. 1, p. 24 and n. 41, and p. 54. Manet abandoned the subject after the *Déjeuner sur l'herbe*; Cézanne painted nudes in the landscape all his life (Monet owned one of his paintings of female bathers: Geffroy, *Claude Monet*, 447); Morisot began to explore the theme in drawings in the late 1880s; Pissarro did etchings, lithographs and paintings of the nude in 1894–5. Thus, apart from Sisley, Monet was the only Impressionist not to paint the nude. Alexandre (*Claude Monet*, 44) states that when Monet was asked why he had never painted the nude he replied, 'I never dared'. Gimpel said that, about 1889, Mme Hoschedé threatened to leave if he brought a model into the house (*Journal d'un collectionneur*, 348); this typical Gimpel anecdote is unlikely, since in his household Monet's needs as an artist always had primacy.

**63** Monet said he met Sargent and Helleu in about 1876 (letter to Charteris, in Evan Charteris, *John Sargent* [London, 1927], 130); the first reference to Monet's friendship with Helleu occurs in an account of Helleu's visit to Giverny in Feb 1885 (Wildenstein II. 37, n. 378). Sargent was one of the few painters (apart from Blanche Hoschedé) whom Monet allowed to work with him after the mid-1870s; they probably painted together in the summer of 1887 (Warren Adelson et al., *Sargent at Broadway. The Impressionist Years* [New York/London, 1986], 25–6 and n. 4). Sargent painted Monet's portrait *c.* 1883–4 (Wildenstein II. 31) and *c.* 1887 (Adelson, *Sargent at Broadway*, 60, n. 4); they both exhibited in the 'Exposition Internationale' of 1885.

**64** Clark, *Painting of Modern Life*, passim; see esp. 23–30.

**65** Letter to Alice Hoschedé [5 Oct 1886] (W II, L.705).

**66** Steven Z. Levine, 'Seascapes of the Sublime: Vernet, Monet, and the Oceanic Feeling', *New Literary History* 16, no. 2 (Winter 1985), 377–8.

**67** Gauguin to Van Gogh (Gauguin's italics) (Sept 1888); to Schuffenecker (Feb 1888), cited Fred Orton and Griselda Pollock, 'Les Données Bretonnantes: la Prairie de Représentation', *Art History*, Sept 1980, 320.

**68** Letter to Caillebotte, 11 Oct 1886 (W II, L.709); to Durand-Ruel, 28 Oct 1886 (W II, L.727); to Alice Hoschedé, 23 Oct [1886] (W II, L.721).

**69** Letter to Alice Hoschedé, 30 Oct [1886] (W II, L.730).

**70** Félix Fénéon, 'L'Impressionnisme aux Tuileries' [the Salon des Indépendants], *L'Art moderne*, 19 Sept 1886, in *Oeuvres plus que complètes* I. 52–3, 58.

**71** Letters to Alice Hoschedé, 1, 10, 14 Nov [1886] (W II, L.732, 742, 746).

**72** Letter to Durand-Ruel, 17 Oct 1886 (W II, L.715); to Alice Hoschedé [17 Oct 1886] (W II, L.714); Levine, 'Seascapes of the Sublime', 379–80, 390. On Levine's interpretation: see Ch. 6, n. 114.

**73** Geffroy, *Claude Monet*, 1–5, 184–5 (note made at Belle-Île, Sept 1886). Wildenstein (II. 57) quotes a contemporary account of Monet painting in the storm (*Le Phare de la Loire*, 6 Nov 1886); the author may have been Geffroy, for he too alludes to Vernet (Levine, 'Seascapes of the Sublime', 380–5); Monet sent the article to Alice Hoschedé, with stories by Tolstoy (9 Nov [1886] [W II, L.740]).

**74** Letter to Alice Hoschedé, 19 Nov 1886 (W II. L.752).

**75** Mirbeau to Rodin, *c.* 20 Nov 1886, quoted Wildenstein II. 57, n. 597.

**76** Letters to Duret, 28 Mar, 22 April [1877] (W III, L.780, 783); to Rodin [Mar 1887], (W III, L.774); to Durand-Ruel, 13 May 1887 (W III, L.788). Monet may have shared Mirbeau's contempt for some of the fashionable writers and artists with whom he associated (Mirbeau, 'Lettres à Claude Monet' [1922], 161, 164); other diners at Les Bons Cosaques included the writers Hervieu and Richepin, and several Salon painters. Wildenstein III. 1–3.

**77** John Rewald, 'Theo van Gogh, Goupil, and the Impressionists: I', *Gazette des Beaux-Arts*, Jan 1973, 1–64. Wildenstein III. 1–2; letter to Pissarro, 3 Mar 1887 (W III, L.775); to Morisot [early Mar 1887] (W III, L.777); Pissarro to Monet, 7 Mar 1887, *Correspondance* II, L.402 (cp. letter to Lucien [10 Jan 1887], *Correspondance* II, L.375).

**78** Octave Mirbeau, 'Exposition internationale de la rue de Sèze: I', *Gil Blas*, 13 May 1887.

**79** For works shown in the 1887 exhibition, see Wildenstein III. 2, n. 621. Gustave Geffroy, 'Salon de 1887 – Hors du Salon: Cl. Monet', *La Justice*, 25 May and 2 June 1887, largely repr. *La Vie artistique*, 3ᵉ série (1894).

**80** For Monet and Whistler, see letters to Duret, 12 Mar, 9, 22 Apr 1887 (W III, L.778, 781, 783); to Petit, 7, 13 Mar 1887 (W III, L.776, 779). Alfred de Lostalot, 'Exposition Internationale de peinture et de sculpture (Galerie Georges Petit)', *Gazette des Beaux-Arts*, June 1887, 523–4.

**81** J.-K. Huysmans, 'Le Salon de 1887 – L'Exposition Internationale de la rue de Sèze', *La Revue indépendante*, June 1887, 352.

**82** Pissarro to Lucien [10 Jan, 14 May 1887], *Correspondance* II, L.375, 423. Mirbeau ('Exposition internationale de la rue de Sèze' [1887]) made a similar point: Monet could draw 'elegant forms' from nature which were the only 'real ones', despite what 'naturalist theoreticians' said.

**83** Letter to Durand-Ruel, 13 May 1887 (W III, L.788). John Rewald, 'Theo van Gogh: I' (1973), 10, 26; 'Theo van Gogh': II', *Gazette des Beaux Arts*, Feb 1973, 74–5. Pissarro to Lucien, 8 May [15, 16 May] 1887, *Correspondance* II, L.421, 423–424. See Wildenstein II, catalogue entries.

**84** Pissarro to Lucien, 13 Jan, 4 Feb, 30 Apr 1887, *Correspondance* II, L.379, 394, 418.

**85** *Le Correspondant*, 25 July 1887, cited Mayeur, *Les débuts de la IIIᵉ République*, 171.

**86** Letters to Duret, 25 Oct, 13 Aug 1887 (W III, L.797, 794); to Helleu (19 Aug 1887 [W III, L.795]): 'I've undertaken some figures in the open air which I wish to finish in my own manner, in the way I finish a landscape'.

**87** Mirbeau, 'Claude Monet', exh. cat. (1889).

**88** Wildenstein dates W.1330 to 1892, and identifies the painter in the background as the American Theodore Butler, whom Suzanne Hoschedé met in 1892 and married in 1893. No evidence is given, and since the work is similar in style and subject to those of *c.* 1887, it is more likely that it was painted in the late 1880s; see also John House ('Monet in 1890', in *Aspects*, 125 and n. 5), referring to this work and *Monet's Garden at Giverny* (W.1420). Compare the figure in the background with fig. 6, in Ormond, *John Singer Sargent*. Monet encouraged Blanche Hoschedé to paint seriously (letter to Alice Hoschedé [22 Apr 1888], [W III, L.877]; see also L.808, 811, 849–850, etc.)

**89** Only one of the boating paintings (W.1150–1154, 1249–1250), the large *Girls in a boat* (W.1152), is dated – 1887. Since it is similar in conception and mood to *In the 'norvégienne'* (W.1151) and the *Blue boat* (W.1153), they may date from the same year. The three paintings can be distinguished from the *Pink boat* and *Boating on the Epte* (W.1249–1250) in that they have a reflecting water surface, while the latter two show the depths of the water; Wildenstein dates W.1249–1250 to 1890 because Monet said he had returned to painting 'water with grasses waving in its depths' (letter, 22 June 1890 [W III, L.1060]); however, in answer to a questionnaire of Geffroy's in 1920–1, Monet said that *Boating on the Epte* was painted 'in '87 or '88' (W IV, 105, n. 950).

**90** Mirbeau to Monet [Jan–Feb 1888], 'Lettres à Claude Monet' (1922), 164.

**91** Letter to Duret, 13 Aug 1887 (W III, L.794). Théodore Duret, 'Whistler et son oeuvre', *Les Lettres et les arts*, I (1888), 215–26 (reissued as a pamphlet, 1888); Stéphane Mallarmé, *Correspondance*, ed. Henri Mondor and Lloyd James Austin (1959–85), vol. III (1969), 174; letters to Mallarmé [8 Jan], 5 June 1888 (W III, L.803, 894). James Abbott McNeill Whistler, 'Le "Ten O'Clock"', trans. S. Mallarmé, *La Revue indépendante*, May 1888, in *Oeuvres complètes*, 569–83.

**92** Mallarmé to Verhaeren, 15 Jan 1888, *Correspondance* III. 161–3. In Dec 1887, Morisot invited Mallarmé to dine with herself and Renoir, who were both 'bewildered' by the project (*Correspondance de Berthe Morisot*, 133). Monet, letter to Mallarmé, 12 Oct 1889 (W III, L.1007); they may have discussed the project at the meeting with Whistler in January 1888. Mallarmé to Morisot, 17 Feb 1889, *Correspondance* III. DCCLI, 290 ('Monet que le nénuphar blanc, aux fameux trois crayons, a charmé').

**93** '. . . végétations dormantes d'un toujours étroit et distrait ruisseau . . . Sans que le ruban d'aucune herbe me retînt devant un paysage plus que l'autre chassé avec son reflet en l'onde par le même impartial coup de rame, je venais d'échouer dans quelque touffe de roseaux . . . au milieu de la rivière: où tout de suite élargie en fluvial bosquet, elle étale un nonchaloir d'étang plissé des hésitations à partir qu'a une source'./'Tant d'immobilité paressait que frôlé d'un bruit inerte où fila jusqu'à moitié la yole, je ne vérifiai l'arrête qu'à l'étincellement stable d'initiales sur le bois, ce qui me rappela à mon identité mondaine'./'. . . de leur creuse blancheur un rien, fait de songes intacts, du bonheur qui n'aura pas lieu . . .'. Stéphane Mallarmé, 'Le Nénuphar blanc', *L'Art et la Mode*, 22 Aug 1885, in *Oeuvres complètes* (1945), 283–6; trans. Keith Bosley, in *Mallarmé. The Poems*, bilingual edn (Harmondsworth, 1977), 236–43.

**94** M.L. Bataille and G. Wildenstein, *Berthe Morisot. Catalogue des peintures, pastels, et aquarelles* (1961), nos. 146–147 (1884), 185 (1885), 754 (1887), etc.

**95** Illustration to Mallarmé, 'Le Nénuphar blanc', *L'Art et la Mode*, 22 Aug 1885. I thank Christopher Yetton who drew my attention to this.

**96** The Princesse de Polignac (née Winnaretta Singer) bought *In the 'norvégienne'*; the dealers Boussod & Valadon bought *Landscape with figures* (W.1204) in Dec 1888 and sold it to Sargent in 1889; Durand-Ruel bought *Promenade, grey weather* (W.1203) in 1891.

**97** Letter to Duret, 7 Nov 1887 (W III, L.799).

**98** Information derived from a lecture given at the Auckland City Art Gallery, May 1985, by Richard R. Brettell.

**99** Letter to Duret, 10 Mar 1888 (W III, L.855); Baudelaire,

'L'Invitation au voyage' (Les Fleurs du mal), in Oeuvres complètes, 51–2: 'Les soleils couchant/Revêtent les champs,/Les canaux, la ville entière/D'hyacinthe et d'or;/Le monde s'endort/Dans une chaude lumière/Là, tout n'est qu'ordre et beauté/Luxe, calme et volupté' ('By late afternoon/the canals catch fire/as sunset glorifies the town;/the world turns to gold/as it falls asleep/in a fervent light./All is order there, and elegance,/pleasure, peace, and opulence'. Trans. Richard Howard).

**100** Letter to Alice Hoschedé [3 Feb 1888] (W III, L.827); to Geffroy, 12 Feb 1888 (W III, L.836); to Alice Hoschedé [1 Feb 1888] (W III, L.824); to Helleu [10 Mar 1888] (W III, L.854); to Alice Hoschedé [13, 16 Apr 1888] (W III, L.871, 873).

**101** For the planned Petit exhibition, see esp. letters to Alice Hoschedé [7 Apr], [11 Apr 1888] (W III, L.865, 869); to Durand-Ruel [c. 11 Apr 1888] (W III, L.868). For Monet's reference to contemporary politics, letter to Alice Hoschedé [23 Apr 1888] (W III, L.878); Mallarmé voted for Boulanger: letter to Morisot, 17 Feb 1889, Correspondance III. DGCLI, 291.

**102** Gustave Geffroy, 'Chronique: Dix tableaux de Cl. Monet', La Justice, 17 June 1888 (repr. L'Art moderne, 24 June 1888), largely repr. in La Vie artistique, 3e série (1894), 81, 78.

**103** G.J. [Georges Jeanniot], 'Notes sur l'art. Claude Monet', La Cravache parisienne, 23 June 1888; Félix Fénéon, 'Dix marines d'Antibes, de M. Claude Monet', La Revue indépendante de littérature et d'art, July 1888, in Oeuvres plus que complètes I. 113.

**104** Morisot to Monet [after 15 June 1888], Correspondance de Berthe Morisot, 135; Mallarmé to Monet [18 June 1888], Correspondance III. 212 (addressed to: 'Monsieur Monet que l'hiver ni/L'été sa vision ne leurre/Habite en peignant Giverny/Sis auprès de Vernon, dans Eure'). Pissarro to Lucien, 10, 8 July 1888, Correspondance II. 495, 492.

**105** Jeanniot, 'Notes sur l'art' (1888); Geffroy, Claude Monet, 445–6 (the latter's 'Mme Monet' and 'stepchildren' were premature – Monet and Mme Hoschedé were not yet able to marry). Monet had a second studio built in a separate building in 1899 (Wildenstein IV. 9; letter to Deconchy, 5 Aug 1899 [W IV, L.2632]). It is unlikely that a 'barn' with earth floors could be the 'salon–atelier'; Michel Hoog (Les Nymphéas de Claude Monet au Musée de l'Orangerie [1984], 11) notes that when Monet bought the Giverny house in November 1890, it had four rooms on the ground floor, four on the first floor, a cellar and attic, and to the west 'a sort of barn which Monet made into his studio'. Julie Manet (Growing Up with the Impressionists: The Diary of Julie Manet, trans. and ed. Rosalind de B. Roberts and Jane Roberts, London, 1987) notes (30 Oct 1893) that Monet had recently had his bedroom built over the studio; he may then have had his studio restructured when he had his house decorated in the early 1890s, and Geffroy may have been wrong in dating this recollection of the 'salon-atelier' to 1886.

**106** Letter to Jeanniot, 1 Oct 1888 (W III, L.905).

**107** Of the 36 Antibes paintings, Monet judged about 28 of a quality to be sold (figures are approximate because of problems of identification). Boussod & Valadon bought 10 in June 1888 for 11,900 frs. and 6 in subsequent months; 7 were sold in 1888 (3 to Durand-Ruel and Petit). Petit bought 4 in 1888–9, and had sold 3 by 1890. Durand-Ruel, whose financial position had improved, was now actively competing for Monet's paintings; he bought 7 Antibes works and sold c.4 between 1890 and 1892. At least 7 were in American collections by the end of 1891. At the Cap d'Antibes (W.1193) changed hands four times between mid-1888 and late 1891 (Boussod & Valadon – Petit – Boussod & Valadon – de la Rochefoucauld). Only 2 works were not bought through dealers (see Wildenstein III. 9 and n. 704): Rewald, 'Theo van Gogh: I,' (1973), 23. Bouvier (Les Deux Scandales de Panama, 110–12) mentions P. Aubry, Ernest May, and Ephrussi et Cie as having benefited from irregular profits, as well as two Ellisens perhaps related to a purchaser from the 1888 exhibition.

**108** See Degas's comment (c. 1856–7, quoted in Rewald, History of Impressionism, 27–8) that in Paris 'pictures are produced like stock-exchange prices by the friction of people eager to gain; there is as much need of the mind and ideas of one's neighbour in order to produce . . . as businessmen have need of other people's capital in order to profit in speculation'. Monet mentioned his shares to Alice Hoschedé [27 Feb 1888] (W III, L.844), raising the question of selling them to sustain prices in a forced sale of the Leroux collection. Gauguin to Schuffenecker [June 1888], quoted Rewald, 'Theo van Gogh: I', (1973), 2; Pissarro to Lucien, 12 July, 26 Apr 1888, Correspondance II. L.496, 479 (see also [10 Jan 1887], II. L.375). Pissarro later told Lucien (13 Apr 1891, Correspondance III. L.653) about Sisley's claim that Monet had succeeded in raising his prices,

despite Durand-Ruel's opposition, by relying on Theo van Gogh's purchases for Boussod & Valadon and on Mme Hoschedé's income. Pissarro commented that, once Durand-Ruel had a stock of Impressionist paintings, he had every interest in keeping their prices low. Being 'ready to leave our canvases to his children', the dealer was, according to Pissarro, acting like 'a modern speculator, for all his angelic sweetness'.

**109** Letter to Alice Hoschedé [28 Jan 1888] (W III, L.820); to Geffroy [20 June 1888] (W III, L.*1425); to Mallarmé, 5 June 1888 (W III, L.894) (see p. 176 and n. 58).

**110** Gustave Geffroy, 'Paysages et figures', La Justice, 28 Feb 1889, partially repr. in La Vie artistique, 3e série (1894), 81–7.

**111** The view that Monet was indifferent to the human presence in his paintings is implicit in many critiques, and explicit in, for example, Bigot's 'Causerie artistique. L'Exposition des "impressionnistes"' (1877) and, thirty years later, in Gillet's 'L'Epilogue de l'impressionnisme' (1909), 402–3. Lilla Cabot Perry, 'Reminiscences of Claude Monet from 1889 to 1909', American Magazine of Art, Mar 1927, 123; repr. in Impressionism in Perspective, ed. Barbara Ehrlich White (Englewood Cliffs, NJ, 1978), 14.

**112** Both Wildenstein (III. 12–13) and Herbert ('Method and Meaning in Monet' [1979], 106), emphasize that Monet was not painting stacks of hay, as he had done earlier in the 1880s, but more structured stacks of sheaves of wheat, piled up for the winter, before threshing. These should not, then, be called 'haystacks'; it is equally inaccurate to call them 'stacks of grain', as Herbert does, since grain is extracted by threshing.

**113** Letter to Morisot, 8 Apr 1889 (W.L.942); to Alice Hoschedé, 4, 7 Apr 1889 (W III, L.937, 940).

**114** Letters to Alice Hoschedé, 8, 12 Apr, 8, 9 May 1889 (W III, L.942, 947, 975–6); see W. 1229–1232.

**115** The February-March 1889 exhibition had no catalogue; its contents are partly known through Geffroy's article, 'Paysages et figures'. It has been suggested that Monet showed some of the Giverny boating pictures; there is no evidence for this, and he seems to have included only the two paintings of the children in the meadows. On attendance at the exhibition: see letter to Alice Hoschedé [18 Mar 1889] (W III, L.919).

**116** Letter to Boudin, 28 Mar 1889 (W III, L.931); Geffroy, 'Paysages et figures' (1889/1894).

**117** Octave Mirbeau, 'Claude Monet', Le Figaro, 10 Mar 1889; repr. in Mirbeau, Des Artistes, 2 vols. (1922/1924; 1986 edn, 1 vol.), 88–96.

**118** Le Roux, 'Silhouettes parisiennes. L'exposition de Claude Monet', 1889. On Vétheuil in the mist: see House, 'Monet in 1890', in Aspects, 130–2.

**119** Letter to Morisot, 15 Feb 1889 (W III, L.910); Octave Mirbeau, 'L'Avenir', Le Figaro, 5 Feb 1889.

**120** For the planning of the Petit exhibition, see Wildenstein III. 19, 21–3, and esp. letter to Rodin, 28 Feb, 12 Apr 1889 (W III, L.912, 949). Monet's March exhibition had been transferred to the Goupil Gallery, London; his three paintings in the Exposition Centennale de l'Art Français were Vétheuil (W.539), The Tuileries (W.401), the Church at Vernon (W.843).

**121** The unidentified Meadow at Giverny; misty weather, shown in the exhibition, may have been one of the 1888 paintings of poplars in the mist (W.1194–1199). Cp. Wildenstein III. 21, n. 825.

**122** J. le Fustec, 'Au Jour le jour', La République française, 28 June 1889; A. de Calonne, 'L'art contre nature', Le Soleil, 23 June 1889: both cited Wildenstein III. 22. A letter from Mirbeau to Rodin [c. 29 June 1889] suggests that Petit paid critics for favourable reviews (Mirbeau said he would do an article for Le Figaro, but not if paid by Petit: 'I do not wish my name to be mixed up with a commercial affair' [Wildenstein III. 22, n. 836]); the Le Roux interview had been 'placed' as advance publicity. Pissarro (21 Jan 1887, Correspondance II, L.385) wrote of a painter paying for favourable articles.

**123** Monet was disappointed in the exhibition, as it did not attract large audiences (see Mirbeau, letter to Monet, c. 6 July 1889, cited Wildenstein III. 23). Forty works of all periods changed hands in the next four years, often from dealer to dealer, or from dealer to private collector to dealer who was frequently the original seller. Pissarro told Lucien on 13 Sept 1889 that Theo van Gogh had sold a work of Monet's for 9,000 frs. to an American: Correspondance II, L.541, n. 1; this was the Stacks of wheat, white frost effect (W.1215): see Rewald, 'Theo van Gogh: I' (1973), 42). Purchased by van Gogh for 6,000 frs., it was sold to Stany Oppenheim, bought back by van Gogh and sold to Alfred Atmore Pope, USA, for 10,350 frs. between June and October 1889 (p.j. [117], 28 Nov 1889, W III. 299).

**124** Exposition Claude Monet–Auguste Rodin, Galerie Georges Petit, Paris (1889). Monet to Durand-Ruel, 1 May 1889 (W III, L.969).

**125** Mirbeau, 'Claude Monet', in Exposition (1889), 7–8, 21–2, 10.

**126** Ibid, 12–13.

**127** Ibid, 15–16. There is remarkable consistency among the accounts of Monet's procedures by Duret and Taboureux (1880), Geffroy (1887), Jeanniot (1888), Mirbeau (1889) and Guillemot (1898). Mirbeau acknowledged Duret's study. Their accounts were accepted until the 1970s. Perry ('Reminiscences of Claude Monet') noted the time of working as fifteen minutes.

**128** Mirbeau, 'Claude Monet', in Exposition (1889), 16, 18; the 'life of meteors' probably meant the influence of the sun and moon on the earth.

**129** Monet's letters about later exhibitions show that printers of the day were able to produce catalogues at a very late stage.

**130** Mirbeau, 'Claude Monet', in Exposition (1889), 25.

**131** Mirbeau, 'Emile Zola et le naturalisme' (1885); Geffroy, dedication of La Vie artistique, 4e série (1895), xviii.

*Chapter 5*

**1** Quoted by Byvanck, Un Hollandais à Paris, 177; letter to a painter, Nov 1891 (W III, L.1124). Although I saw Paul Hayes Tucker's magnificent exhibition, Monet in the '90s. The Series Paintings, it came too late for this chapter; the catalogue (Museum of Fine Arts, Boston [1989], Royal Academy, London [1990], revised), helped sharpen some points in extremis.

**2** Raymond Bouyer, 'Le Paysage contemporain: III – Claude Monet et le paysage impressionniste', La Revue d'histoire contemporaine, 2 May 1891, in Levine, Monet and his Critics, 166; Clemenceau, Claude Monet, 146. And see below, n. 102.

**3** Wildenstein III. 42, n. 1042; IV. 40–1, n. 274; Vauxcelles, 'Un après-midi chez Cl. Monet' (1905), 90; Joyes, Monet at Giverny, passim; Hoschedé, Claude Monet, ce mal connu I. 88.

**4** Geffroy deplored the self-interest disguised by 'solemn patriotic declarations' about France's 'civilizing mission' revealed in artists' quarrels over the prizes awarded at the Exposition Centennale; he felt they displayed an 'irritating chauvinism, more out of place than ever' ('Salon de 1890 aux Champ-de-Mars: VI – Deuxième vernissage', La Justice, 14 May 1890, in La Vie artistique. 1ère série [1892]). For their views on the social role of art, see: Octave Mirbeau, 'Ravachol!', L'Endehors, 1 May 1892; Gustave Geffroy, 'Le Musée du soir', in La Vie artistique. 4e série (1895), xi–xviii (though Monet wrote to Alice Monet on 8 Mar 1896 [W]III, L.1331, 'I'm afraid that Geffroy is becoming dull and only begins to write well again when it's a question of an artist coming out on the side of the people').

**5** Félix Fénéon, 'Certains', Art et critique, 14 Dec 1889, in Oeuvres plus que complètes I. 171.

**6** Julien Leclercq, 'Le Bassin aux Nymphéas de Claude Monet', La Chronique des arts et de la curiosité, 1 Dec 1900, 363.

**7** Wildenstein III. 23–4, 27–33; letters, 22 June 1889–23 May 1890 (W III, L.1000–1058; see esp., letter to Armand Fallières, 7 Feb 1890 [W1032]); Zola to Monet, 23 July 1889, Correspondance, in Oeuvres complètes XIV. 1472. Geffroy, Claude Monet, 222–58.

**8** Geffroy, 'Claude Monet' (1883/1894), 64–5; Félix Fénéon, 'Exposition de M. Claude Monet', La Vogue, Sept 1889, in Oeuvres plus que complètes I. 162–3.

**9** Gustave Geffroy, 'Salon de 1890 aux Champs-Elysées et aux Champ-de-Mars: VIII – Les Paysagistes', La Justice, 21 May 1890, in La Vie artistique. 1ère série (1892), 185–90. There is no real English equivalent for the word 'pays': 'native place' would be closest.

**10** Letter to Geffroy, 22 June 1890 (W III, L.1060).

**11** For dating of the boating pictures, see Ch. 4, n. 89. Letter to Alice Hoschedé, 13 Apr 1889 (W III, L.950); House, 'Monet in 1890', in Aspects 125–6; Mirbeau ('Lettres à Claude Monet' [1922], 167–8): 'As for this filthy, this horrible weather . . . we have the right to curse it. But to infer from that that you are artistically finished because it's rainy or windy, or because the grasses of the river have been raked, is sheer madness; you reason like a theologian or a spiritualist philosopher who believes in final causes. . . . As I am a man of science, I wouldn't think of accusing anything but nature. . . .'

**12** Octave Mirbeau, 'Claude Monet', L'Art dans les deux mondes, 7 Mar 1891, 184–5.

13   Roger Marx, 'Les *Nymphéas* de M. Claude Monet', *Gazette des Beaux-Arts*, June 1909, 528.

14   See Ch. 4, p. 190 and nn. 92–3. Monet attended Mallarmé's lecture on Villiers de l'Isle-Adam at the Morisot/Manet house, 27 Feb 1890 (*Correspondance de Berthe Morisot*, 151); on 13 July 1890 he was visited by Mallarmé and Morisot so that the poet could choose a *pochade* as compensation for the drawing Monet had failed to do; Mallarmé chose a completed painting (W.912): Mallarmé, *Correspondance* III. 363; IV. 123–4. See Mallarmé's two poems on fans, published 1886 and 1891, in *Oeuvres complètes*, 57–8.

15   Geffroy, 'Les Meules de Claude Monet' (1891/1892), 27.

16   Letter to Morisot, 11 July 1890 (W III, L.1064); to Geffroy, 21 July 1890 (W III, L.1066). See n. 11.

17   Georges Clemenceau, 'La Révolution des cathédrales', *La Justice*, 20 May 1895, largely repr. in Clemenceau, *Claude Monet*, 114–27.

18   Letter to de Bellio, 24 Aug 1890 (W III, L.1069).

19   Herbert, 'Method and Meaning in Monet' (1979), 106. See Ch. 4, n. 112. Bromfield ('Japanese Art, Monet and Impressionism') suggests the influence of Hokusai's *Thirty-six Views of Mount Fuji* – of which Monet owned nine prints – on the increasing profundity of the *Stacks of wheat*. Edmond de Goncourt said that this album, which sought 'to approach the colours of nature under every effect of light', inspired Impressionist landscape painting: *Hokusai* (1896), cited Aitken and Delafond, 70–1. In 1900 Leclercq ('*Le Bassin aux Nymphéas*', 364) mentioned Hokusai's changing view-point of a single motif.

20   Mirbeau wrote to Monet c. 1894–5 ('Lettres à Claude Monet' [1922], 172) – in terms suggesting a continuing discussion – that Gauguin 'was tormented to know what you think of his evolution, towards complication of the idea through simplification of form'. Mirbeau told Gauguin that Monet admired his *Vision after the Sermon*. In interviews of the 1900s, Monet was always very critical of Gauguin, but he may have been interested in the broad tendency towards simplification of form, which was promoted by Gauguin, the Nabis and the Synthetists in the late 1880s and early 1890s.

21   Letter to Morisot, 22 Sept 1890 (W III, L.1074). On the dating of the series: House, 'Monet in 1890', and Charles S. Moffett, 'Monet's Haystacks', both in *Aspects*, 128, 142; Wildenstein III. 37–8, 40. Letter to Geffroy, 7 Oct 1890 (W III, L.1076). George Heard Hamilton, *Claude Monet's Paintings of Rouen Cathedral* (London, 1960), 18.

22   Geffroy, 'Salon de 1890' (1890/1892), 186. In 1889 ('Silhouettes parisiennes. L'exposition de Claude Monet'), Le Roux wrote, 'what is called in studio slang, the atmosphere, the envelope'.

23   Chesneau, 'A côté du Salon' (1874); Levine, *Monet and his Critics*, 464–5. Fénéon: 'Vᵉ Exposition internationale' (1886) and 'Exposition de M. Claude Monet' (1889) in *Oeuvres plus que complètes* I. 41, 51, 162.

24   Mirbeau, 'Claude Monet', in *Exposition* (1889), 24, 17 (his italics).

25   The eight pictures are W. 1266–1273. House, 'Monet in 1890', in *Aspects*, 128 and nn. 18, 20. The Duc de Trévise ('Le Pèlerinage à Giverny: II', *La Revue de l'art ancien et moderne*, Feb 1927, 126) reported Monet as saying in 1920 that he originally planned two canvases to represent the stacks, one for 'grey weather', one for 'sun', but that as the light changed, he repeatedly sent Blanche Hoschedé to bring new canvases. If this occurred, it was probably with the 1888–9 *Stacks of wheat*, since he painted nine versions of one motif at La Creuse – before he began the series of stacks in 1890–1.

26   Mirbeau, 'Claude Monet', in *Exposition* (1889), 15.

27   Ibid. Mirbeau suggested that Monet could spend up to sixty sessions on a single work. If a 'session' sometimes consisted of only a few strokes, 'sixty sessions' may well have been spent on the most densely painted *Stacks of wheat*.

28   Byvanck, *Un Hollandais à Paris*, 177.

29   Letter to Durand-Ruel, 27 Oct 1890 (W III, L.1079).

30   Letter to Durand-Ruel, 23 Mar 1891 (W III, L.1102). Hoschedé was buried, by his children's wish, in the Giverny churchyard.

31   Wildenstein dates the portrait of Suzanne (W.1261) to 1890; Lilla Cabot Perry ('Reminiscences of Claude Monet' [1927], 123) saw it being painted, probably after her first visit to Giverny in 1889, when she lived next door to Monet. Mirbeau, 'Claude Monet' (1891), 185 (he also wrote of Suzanne in the *Essais de figure en plein air*, 'She has, in her modernity, the distant grace of a

dream . . .'). Vincent van Gogh to Theo, [Aug 1888], *Complete Letters of Vincent van Gogh* (London, 1958), III. L.526; a dead sunflower was used on the cover of the catalogue to the Van Gogh exhibition held in Amsterdam in 1894. Jean Paris, 'Le Soleil de van Gogh', in *Miroirs sommeil soleil espaces* (1973), 125. Pissarro to Lucien, 18 Oct 1890, *Correspondance* II, L.393, n. 1.

32   Mirbeau, 'Claude Monet' (1891), 183.

33   Letter to Mallarmé, 28 July 1891 (W III, L.1121).

34   For dating of *Monet's Garden at Giverny* (W.1420), see Ch. 4, n. 88.

35   Wildenstein III. 38; letters to Durand-Ruel, 3, 14 Dec 1890, 4, 21 Jan 1891 (W III, L.1082, 1085, 1093, 1096).

36   Mirbeau, 'Claude Monet' in *Exposition* (1889), 23.

37   One such drawing is repr. in Mirbeau, 'Claude Monet (1891), 183.

38   Pissarro to Lucien, 9, 3 Apr 1891, *Correspondance* III, L.652, 650. By mid-1891 Monet had sold 8 *Stacks of wheat* to Boussod & Valadon, 12 to Durand-Ruel; at least 7 were in the USA before the end of the year; Paul Gallimard was one of the 4 French purchasers (see Wildenstein, catalogue entries).

39   Moffett ('Monet's Haystacks', in *Aspects*, 152–3) attempts to construct a chronological sequence, but in addition to the changes of hour there are those of weather and season, as well as variations in angle of vision, closeness to the motif, number of stacks, etc. Roger Marx ('Les Meules de M. Claude Monet', *Le Voltaire*, 7 May 1892) blames the 'gaps' in the temporal sequence on the depredations of American collectors.

40   Mirbeau, 'Claude Monet' (1891), 184; Geffroy, 'Les Meules de Claude Monet' (1891/1892), 24 (he seems to have confused the sunset in the snow paintings with autumn ones); in 'L'Exposition Claude Monet – Durand-Ruel', *La Revue indépendante*, May 1891, 268, Camille Mauclair followed Geffroy in evoking the phases of the 15 *Stacks of wheat*.

41   Byvanck, *Un Hollandais à Paris*, 176–8.

42   Fénéon, 'Oeuvres récentes de Claude Monet', *Le Chat Noir*, 16 May 1891, in *Oeuvres plus que complètes* I. 191; Pissarro to Lucien, 5 May 1891, *Correspondance* III. L.658.

43   Mirbeau, 'Lettres à Claude Monet' (1922), 169; 'Claude Monet' (1891), 183–4; Geffroy, 'Les Meules de Claude Monet' (1891/1892), 26.

44   Byvanck, *Un Hollandais à Paris*, 177. Pissarro to Lucien, 13 May 1891, *Correspondance* III, L.661; another letter (5 May 1891, *Correspondance* III, L. 658), contrasts with Monet's unproblematic relationship with the capitalist dealer system: Pissarro and the painter Maximilien Luce had been discussing 'the meaning of the work of artists with absolute liberty without the terrible impediments of messieurs the capitalists, art collectors, speculators and dealers . . .'; they were planning an article on the artist's role in an anarchist society, to be written by Lecomte. This was the letter in which Pissarro praised the *Stacks*.

45   Cp. Herbert ('Method and Meaning in Monet' [1979], 106), who suggests not only that the stacks of wheat display 'the wealth of its owners', but that they are the 'simulacrum of a man's house'. In 1921 Alexandre (*Claude Monet*, 94–5) pointed out that Poussin and Millet had represented wheat as 'the supreme evocation of the fruits of the earth', but that Monet painted 'the edifice of the labourer . . . like a monument, almost like a being'. Monet's attitude was, however, probably closer to the non-anthropomorphic philosophy favoured by Mirbeau. This is not to suggest that the paintings were self-contained pictorial exercises, as suggested in House's comment: 'Looking at the picture is now an experience absolutely different from and divorced from the experience of looking at nature' ('Monet in 1890', in *Aspects*, 135). Marx, 'Les Meules de M. Claude Monet' (1892); Mirbeau, 'Un Tableau par la fenêtre!', *Le Gaulois*, 22 Sept 1896, in *Des Artistes*, 232–3.

46   Geffroy, 'Les Meules' (1891/1892), 26; letter to Geffroy, 7 Oct 1890, W III, L.1076. See Hoschedé (*Claude Monet, ce mal connu* I, 45–50) on the tensions between Monet, the 'horzin' – the foreigner – and the 'cultivants', the farmers of Giverny.

47   Geffroy, 'Les Meules' (1891/1892), 26; Monet, quoted by Byvanck, *Un Hollandais à Paris*, 177.

48   Geffroy, 'Les Meules' (1891/1892), 28.

49   Mallarmé, 'Autobiographie', letter to Verlaine, 16 Nov 1885, in *Oeuvres complètes*, 663; Cézanne to Henri Gasquet, 3 June 1899, in *Paul Cézanne: Letters*, trans. John Rewald (Oxford, 1976), 271.

50   Letter to Charles Durand-Ruel, 30 June 1891 (W III, L.1116). According to Wildenstein (III, n. 1042), Monet's account books from 1889 to 1897 are missing, but Durand-Ruel paid him 77,000

frs. in 1891 (almost double the 40,000 frs. paid in 1890); Boussod & Valadon, 20,000 frs. (from whom in 1887 and 1888, he earned 28,962 and 44,500 frs.: Wildenstein IV. 10, n. 70). Maurice Joyant replaced Theo van Gogh at Boussod & Valadon's in 1891 (Rewald, 'Theo van Gogh, Goupil and the Impressionists: II', 72–3, states that van Gogh had bought 73 Monets; that Joyant sold 16 of the 24 unsold in 1891, but bought 16 more; he sold 9 works before the exhibition, 25 during the year). In several interviews, Monet emphasized that wealth created a situation where he 'thought more, painted less' (see, for example, Arnyvelde, 'Chez le peintre de la lumière' [1914], 36–7).

51   Pissarro to Lucien, 5 May 1891, *Correspondance* III, L.658.

52   Cézanne to Emile Bernard, 23 Oct 1905, *Letters*, 316. Monet said Cézanne was 'a real painter' (letter to Geffroy, 23 Nov 1894, W III, L.1256). In Nov 1894, Cézanne visited Monet at Giverny, and later told him (6 July 1895, *Letters*, 242) that his 'moral support' stimulated his painting. Maurice Denis wrote in 1906 (*Journal*, 1884–1943 [1957–9], vol. II [1957], 46), 'Monet is working desperately. . . . His wife takes great care to cover the Cézannes because if he sees them at those moments, he wouldn't paint any more. . . .'

53   Letter to a painter, Nov 1891 (W III, L.1124) [my emphasis].

54   Geffroy, preface, 'Série des peupliers des bords de l'Epte, Galeries Paul Durand-Ruel', exh. cat., Mar 1892, repr. in *La Vie artistique*, 3ᵉ série (1894) as 'Les Peupliers', 90–1, 93; Mirbeau, 'Lettres à Claude Monet' (1922), [15 Feb 1892], 170.

55   Anon., 'Chez les peintres', *Le Temps*, 1 Mar 1892; G.-Albert Aurier, 'Claude Monet', *Mercure de France*, Apr 1892, 302–5.

56   Geffroy, 'Les peupliers' (1892/1894), 94; Clément Janin, 'Claude Monet', *L'Estafette*, 10 Mar 1892, 1–2.

57   Georges Lecomte, 'L'Art contemporain', *La Revue indépendante*, Apr 1892, 10 (my emphasis); (extensive extracts in French in Robert L. Herbert, 'The Decorative and the Natural in Monet's Cathedrals', in *Aspects*, 176–7).

58   The 'decorative' is discussed by Levine, *Monet and his Critics*, 463, and by Herbert, 'Decorative and Natural in Monet's Cathedrals', in *Aspects*, 162–74. Pissarro, 8 Apr, 23 May 1895, *Lettres à son fils Lucien*, ed. John Rewald (1950), 375, 381. Lecomte, 'L'Art contemporain' (1892), 4–5 (his emphasis). See also, Silvestre, 'Exposition de la rue le Peletier' (1876), in *Archives* II, 286; and Ch. 2, p. 117.

59   Georges Lecomte. 'L'Art contemporain' (1892), 22, 25, 28–9; *L'Art impressionniste d'après la collection privée de M. Durand-Ruel* (1892), 260 (Lecomte also used the phrase beginning 'From their [warm] harmonies, thought is released . . .' in 'L'Art contemporain', 12–13 – where it refers only to the Neo-Impressionists).

60   Letter to Helleu, 9 June 1891 (W III, L.1111 bis). In her account of her visit to Giverny with her mother on 30 Oct 1893 Julie Manet (*Growing Up with the Impressionists*) mentions that since their last visit the rooms had been painted in yellows, violets and blues; she also refers to the Japanese bridge. This suggests that the decoration of the house and the making of the water garden proceeded together between 1891 and 1893. Louis Gonse, 'L'Art japonais et son influence sur le goût européen', *Revue des arts décoratifs*, VIII (1898), 97–116; Gonse – who owned Monet's *Bay of Antibes* (W.1161) – wrote of Japan, 'Nature becomes the principal factor in this tendency to see the object of art in terms of its decorative character', and described Japanese art as 'a permanent décor' (100–1).

61   W.857, W.919–954, W.1041, 1043a. The landscapes used as decorations tended to be larger paintings done in the studio from *plein-air* studies, but Monet made no attempt in them to achieve mural 'flatness'; letters to Morisot, 30 Mar, c. 10 Nov 1884 (W II, L.467, 530).

62   Aurier, 'Claude Monet' (1892), 304–5. Hugo's aphorism was quoted – in relation to the *Poplars* – by Maurice Guillemot in 'Claude Monet', *La Revue illustrée*, 15 Mar 1898 (n.p.).

63   Camille M[auclair], 'Exposition Claude Monet', *La Revue indépendante*, Apr 1892, 418 (my emphasis).

64   Thadée Natanson, 'Expositions. I: M. Claude Monet', *La Revue blanche*, 1 June 1895, 522.

65   Letter to Alice Monet, 15 Mar [1893] (W III, L.1188). Theodore Robinson, unpub. journal, 3 June 1892 (MS Frick Art Reference Library, New York), cited House, 'Monet in 1890', in *Aspects*, 133 and n. 30; Lecomte, 'L'Art contemporain' (1892), 10.

66   A wood-engraving of the façade of Rouen Cathedral, seen from the angle painted by Monet, can be found in Janin's *Voyage de Paris à la mer* (1847) and in his *La Normandie* (1862, 3ᵉ edn). For the possible role of Janin's books in Monet's exploration of the Seine

valley, see p. 213 and n. 36 and p. 239, n. 132. Théophile Gautier described railway stations as the 'cathedrals of a new humanity', quoted in *All Stations*, ed. Jean Dethier (London, 1981), 6.

**67** André Michel, *Notes sur l'art moderne (peinture)* (1896), 290; on Michel's comments, see Levine, *Monet and his Critics*, 195–9.

**68** See below, n. 74.

**69** Aurier, 'Claude Monet' (1892), 302–3; see also 'the embrace of the soul' experienced by Léon Maillard before the 'luminous researches' of Monet's friend Helleu, whose paintings of Chartres, he claimed, expressed 'the mysticism of Christian cathedrals' ('Salon de la Société nationale des Beaux-Arts', *La Plume*, 1 July 1892, 311).

**70** Natanson, 'Expositions. I' (1895), 522; Geffroy, 'Les Meules de Claude Monet' (1891/1892), 21. Monet used a sketch-book with drawings of Varengeville to do drawings of Rouen cathedral (Musée Marmottan MM. 5134).

**71** Pissarro, 8 Apr 1895, *Lettres à Lucien*, 375; Geffroy, 'Claude Monet', *Le Journal*, 7 June 1898, repr. in *La Vie artistique*, 6e série (1900), 168; letter to Alice Monet [5 Apr 1893] (W III, L.1208).

**72** Hamilton, *Claude Monet's Paintings of Rouen Cathedral*, 19; Herbert, 'Decorative and Natural in Monet's Cathedrals', in *Aspects*, 168–71.

**73** Sketch-book, Musée Marmottan MM. 5134.

**74** Hamilton, *Claude Monet's Paintings of Rouen Cathedral*, 22–3, figs 4, 9; Wildenstein III. 50, 52, 55.

**75** Letter to Alice Hoschedé [9 Apr 1892] (W III, L.1151).

**76** Letters to Alice Hoschedé [12 Feb, 10 Mar 1892] (W III, L.1132, 1139).

**77** Letters to Alice Hoschedé [8], 31, [18], 30 Mar 1892 (W III, L.1137, 1144, 1140, 1143); 2, [3] Apr 1892 (W III, L.1145–1146).

**78** Letter to Durand-Ruel, 13 Apr 1892 (W III, L.1153). Monet's correspondence between his return to Giverny in April 1892 and his second visit to Rouen in Feb 1893 does not mention any 'retouching' of his *Cathedrals*.

**79** Letter to Alice Monet [9 Mar 1893] (W III, L.1186).

**80** Letter to Durand-Ruel, 13 Apr 1892 (W III, L.1153).

**81** Letters to Alice Monet, 23, 24, 29 Mar 1893 (W III, L.1196, 1198, 1203); 15 Mar, [20 Mar] (W III, L.1188, 1193).

**82** Letters to Alice Monet, 29 Mar, [4 Apr] 1893 (W III, L.1203, L.1207).

**83** Letters to the Préfet de l'Eure, 17 Mar, 17 July 1893 (W III, L.1191, 1219); to Alice Monet [20, 21 Mar 1893] (W III, L.1193, 1195). Monet earned 113,100 frs. in 1892. See W.1392.

**84** W.1406–1418; W.1397–1399. Letter to Blanche Hoschedé, 1 Mar [1895] (W III, L.1276); to Geffroy, 26 Feb 1895 (W III, L.1274); to Alice Monet, 23 [Mar 1895] (W III, L.1287).

**85** Letter to Durand-Ruel, 12 Apr 1894 (W III, L.1236); see also 20 Feb, 20, 26 Apr 1894 (W III, L.1232, 1237, 1239).

**86** Michel, *Notes sur l'art moderne (peinture)*, 290–1; A.R. [Ary Renan], 'Cinquante tableaux de M. Claude Monet', *La Chronique des arts et de la curiosité*, 18 May 1895, 186. The temporal structure of the paintings was interpreted in musical terms, as theme and variations; or in poetic terms by Renan, 'Cinquante tableaux', and Louis Lumet, 'Sensations d'art (Claude Monet)', *L'Enclos*, May 1895, 44.

**87** Mirbeau, 'Ravachol!' (1892). Tailhade explained his widely reported comment in a letter to *Le Temps*, 16 Dec 1893: unaware of the nature of the attack, he had wished to indicate 'that, for us contemplatives, disasters of this kind, have no interest other than the Beauty which sometimes derives from them'; yet, accidentally injured in another bombing a year later, he declared his readiness to die, if this would help realize the anarchist ideal (letters repr. in Mme Laurent Tailhade, *Laurent Tailhade intime* [1924], 172–3). Pissarro to Lucien: 28 Apr 1894 (Fénéon's arrest; the *Cathedrals*); 29 Apr (Mirbeau's article supporting Fénéon); 15 July (the arrest of Luce; business bad because of the crisis); 30 July (Mirbeau had fled France; Pissarro on a visit to Belgium felt it safer to stay there); 9 Aug (Durand-Ruel on business crisis), *Correspondance* III, L.1002, 1003, 1022, 1024, 1028.

**88** Léon Gérôme in *Le Journal des artistes*, 8, 15 Apr 1894, cited Wildenstein III. 57, n. 1183; Lethève, *Impressionnistes et Symbolistes devant la presse*, 148; Pissarro to Lucien, 29 Apr 1894, *Correspondance* III, L.1003. See below, p. 234 and n. 109.

**89** Pissarro to Lucien, 21 Oct (also 14 Oct) 1894, *Correspondance* III, L.1059, 1056. On Monet's negotiations with Durand-Ruel and Joyant, Apr–Oct 1894, see Wildenstein III. 58–9.

**90** Anon., 'Exposition Claude Monet', *L'Art moderne*, 26 May 1895, 164, cited Levine, *Monet and his Critics*, 182 (in the May issue of *L'Enclos* with the review of Monet's exhibition, it was said that

*Tannhäuser* was acclaimed by those 'abominable brutes' who had condemned it 34 years before).

**91** Michel, *Notes sur l'art moderne (peinture)*, 260–2, 290–3.

**92** Clemenceau, 'La Révolution des cathédrales' (1895). For other evocations of the phases of light on the façade, by Michel, Eon, Thiébault-Sisson, see Levine, *Monet and his Critics*, 198, 202, 215.

**93** Pissarro, 26 May and 1 June 1895, *Lettres à Lucien*, 381, 382.

**94** Georges Lecomte, 'Les Cathédrales de M. Claude Monet', *La Nouvelle Revue*, 1 June 1895, 672; Geffroy, 'Claude Monet' (1895/1900), 167.

**95** Letter to Alice Monet [5 Apr 1893] (W III, L.1208). Hamilton (*Claude Monet's Paintings of Rouen Cathedral*, 18–19) wrote, 'the instant had come to count less as a chronological moment and more as an extended perceptual experience reaching more widely through time and more deeply . . . into the psychological structure of life'. No one has improved upon his account (in a lecture in 1959) of Monet's perceptual experience, but he perhaps underestimated the temporal breaks, the 'shocks' which formed part of this experience.

**96** In 'Sensations d'art' (1895), Lumet did, however, assert that Monet evoked rather than represented light.

**97** [Renan], 'Cinquante tableaux de M. Claude Monet' (1895); Henry Eon, 'Les Cathédrales de Claude Monet', *La Plume*, 1 June 1895, 259; Georges Denoinville, 'Les Salons. Les Cathédrales', *Le Journal des artistes*, 19 May 1895, cited Wildenstein III. 68; Lumet, 'Sensations d'art' (1895).

**98** Camille Mauclair, 'Choses d'art', *Mercure de France*, June 1895, 357. Since his unqualified praise for Monet in 1892 (see n. 63), Mauclair had become concerned about the loss of the intellectual element in a decadent art of immediate gratification (see his 'Destinées de la peinture française 1865–1895', *La Nouvelle Revue*, 15 Mar 1895, 376: 'An art limited to virtuosity of representation is essentially corrupt . . . Monet, Turner and Monticelli have souls; but they are in no way the soul of a Corot or a Puvis de Chavannes . . .').

**99** Clemenceau left out this passage when incorporating most of the rest of the article in his book on Monet; extract in Herbert, 'Decorative and Natural in Monet's Cathedrals', in *Aspects*, 170 and n. 28. Herbert discusses (168–71, nn. 24–5) the ideas of Léon Bazalgette, who wrote in 'Les Deux cathédrales. Claude Monet et J.-K. Huysmans', in his book *L'Esprit nouveau* (1898), that Christian dogma isolated the individual from nature, but that the new secular individual felt 'no antagonism between his own being and the world's being' and must therefore 'plunge, to the depths of his soul, into this fountain of life, into this ocean of nature'; Bazalgette evoked 'a new pantheism wholly impregnated with reality and science . . . from which the painter of the *Cathedrals* has sprung'.

**100** See Mirbeau's novel, *L'Abbé Jules* (1888).

**101** Clemenceau (*Claude Monet*, 145–6) quoted Monet: 'While you seek philosophically the world in itself . . . I simply direct my efforts to a maximum of appearances in strict correlation with unknown realities. . . . Your error is to wish to reduce the world to your own measure, while, by increasing your knowledge of things, your knowledge of yourself will increase.' If Monet did say something like this, the wording is probably Clemenceau's.

**102** Natanson, 'Expositions. I' (1895), 522–3.

**103** Letter, 20 Nov 1895 (W III, L.1319); Wildenstein III. 69–70 (Monet gave the commune 5,500 frs. to protect the *marais* of Giverny).

**104** Georges Truffaut, 'Le Jardin de Claude Monet', *Jardinage*, Nov 1924; Vauxcelles, 'Un après-midi chez Claude Monet' (1905), 86; Joyes, *Monet at Giverny*, 33–5, 37–8. Gonse, 'L'art japonais et son influence sur le goût européen' (1898), 101. See p. 224 and n. 60.

**105** Gustave Geffroy, 'Les Paysagistes japonais', in *Le Japon artistique*, ed. S. Bing (1888–91), III. 92. Aitken and Delafond (16–24) detail Monet's connections with Gonse, Bing and Hayashi, and list some of the books he owned on Japanese art by Duret, Goncourt, Migeon, etc. See n. 60.

**106** John House, 'Monet: le jardin d'eau et la 2e série des *Nymphéas* (1903–9)', in Jacqueline and Maurice Guillaud, *Claude Monet au temps de Giverny*, exh. cat., Centre Culturel du Marais, Paris (1983); cited hereafter as Guillaud, 152.

**107** Hoschedé, *Claude Monet, ce mal connu*, I. 125–7; [François] Thiébault-Sisson, 'Un nouveau musée parisien. Les *Nymphéas* de Claude Monet à l'Orangerie des Tuileries', *La Revue de l'art ancien et moderne*, June 1927, 48 (based on interviews of 1918 and 1920, but not published until after Monet's death, probably because Monet

came to distrust the interviewer). Natanson ('Expositions. I' [1895], 521) stated that in his 1895 exhibition Monet showed an earlier painting of the church at Vernon whose *naïveté* contrasted with the more 'learned' ones of 1894.

**108** See esp. Henri Bergson, *Matière et mémoire* (1896). In his two 1889 articles on Monet, Mirbeau used this terminology but in a contradictory way: in 'Claude Monet' (*Le Figaro*, 10 Mar 1889) he referred to Monet's attempt to rid himself of 'external *souvenirs*' of earlier painters, but in 'Claude Monet', in the June catalogue (*Exposition*, p. 9), he changed the phrase to 'involuntary *souvenirs*'.

**109** For the exhibition of the Caillebotte Bequest in 1897, see Wildenstein III. 77–8; for an amusing account of the hanging of Morisot's exhibition by Monet, Renoir, Degas and Mallarmé, see Julie Monet, *Growing Up with the Impressionists*, 2, 3, 4 Mar 1896.

**110** Pissarro (21 Nov 1895, *Lettres à Lucien*, 388–90) said that Monet had bought some 'astounding things' by Cézanne and discussed 'this nature of refined savagery'.

**111** Musée Marmottan sketch-books, MM. 5134, 41 recto (drawing for *At the val Saint-Nicolas*, W. 1466); 28 verso, drawing of the Pourville cliffs in 1882; MM. 5131 contains other drawings of the early 1880s.

**112** Letter to Joseph Durand-Ruel, 25 Feb 1896 (W III, L.1324); letter to Geffroy, 28 Feb 1896 (W III. L.1327) (Monet's emphasis).

**113** Letters to Alice Monet [8, 14, 18 Mar 1896] (W III, L.1331, 1336, 1337).

**114** For the 1882 paintings of the customs-officers' cabin, W.730–743; for those of 1896–7, W.1447–1458. Letters to Alice, [18, 11, 19 Mar], 25 Mar 1896 (W III, L.1337, 1332, 1338, 1340).

**115** Guillemot, 'Claude Monet' (1898).

**116** Letters to Alice Monet [18 Jan, 6, 21 Feb] 1897 (W III. L.1358, 1367, 1373).

**117** Letters to Alice Monet [4, 29, 30 Mar 1897] (W III, L.1377, 1386, 1387).

**118** Geffroy, 'Claude Monet', *Le Journal*, 7 June 1898, repr. *Le Gaulois*, 16 June 1898 (supplement), in *La Vie artistique*, 6e série (1900), 168–74.

**119** Guillemot, 'Claude Monet' (1898); Mirbeau, 'Claude Monet', in *Exposition* (1889), 25.

**120** Letters to Zola, 3 [Dec] 1897, 14 Jan, 24 Feb 1898 (W III. L.1397, 1399, 1402); letters to Geffroy, 15, 25 Feb 1898 (W III. L.1401, 1403); letter to anon., 3 Mar 1898 (W III, L.1404). Monet gave Clemenceau *Le Bloc* (W.1228) to honour his role in '*L'Affaire*' (letter to Geffroy, 15 Dec 1899 [W IV, L.1482]); Clemenceau, letter to Monet, 23 Dec 1899 (p.j. [133], W III. 300–1).

**121** Wildenstein's identification of this group (W.1501–1508) is convincing, as the works correspond closely to Guillemot's description (although W.1503 seems more closely related to the *Nymphéas* of 1914–17: see W.1785–1806).

**122** Guillemot ('Claude Monet' [1898]) said the garden 'was composed like a palette'; Truffaut, 'Le Jardin de Claude Monet' (1924); Joyes, *Monet at Giverny*, 33–5 (plan of garden).

**123** The 1897 *Water-lilies* were similar in scale to the four *Chrysanthemums* (W.1495–1498) which were taking up 'all' Monet's time in Nov 1896 (letter to Paul Durand-Ruel [W III, L.1354]), and Monet may have considered a 'decoration' with panels of different flowers. He could have been influenced by Hokusai's prints of flowers: see letter to Joyant, 8 Feb 1896 (W III, L.1322), and Hokusai, 'Chrysanthemums and bee', from the *Great Flowers* series, Aitken and Delafond, no. 69. An immediate inspiration may have been Caillebotte's paintings of orchids and chrysanthemums, used to decorate doors: Berhaut, *Caillebotte, sa vie, son oeuvre*, nos. 464–474. Alex Charpentier and Adrien Besnard, dining-room for the Villa Champrosay, c. 1900–1, Musée d'Orsay; its panels are animated by intertwining branches of wistaria, roses, blackberries, convolvulus, irises, and passion flowers so that it is completely enclosed by the curving forms. See Pissarro (3 Jan 1896, *Lettres à Lucien*, 394) for comments on decorative interiors at Bing's gallery.

**124** Pissarro to Lucien, 2 Oct 1892, *Correspondance* III, L.819; 26 May, 1 June 1895, *Lettres à Lucien*, 294, 381, 382; Clemenceau, 'La Révolution des cathédrales' (1895), in *Claude Monet*, 127.

**125** Checa's *Nymphs* was reproduced in Armand Silvestre's *Le Nu au Salon* (1899); the illustrations were accompanied by lines of prose or verse of a revoltingly coy 'poetic' kind. The 1898 book included works on similar subjects by Foubert, Brillaud, Buissière, Alleaume. The 1899 volume illustrated works with such themes by Triquet, Hodebert; Le Quesne's *The Reeds* bore the lines: 'And while pink reflections/Pass over the mother-of-pearl of their flanks/The golden eye of morose water-lilies/Droops at the sight of their

white bodies'). The *Salon illustré* reproduced numerous landscapes of pools and rivers with wild irises, water-lilies and contemporary figures by Allouard, Matthieu, Son, Sain, *et al*. See also Camille Mauclair's poem 'La Baigneuse aux cygnes' (dedicated to Besnard), *La Revue indépendante*, Apr 1892, 308–11.

**126** Mallarmé, 'Le Nénuphar blanc' (see Ch. 4, p. 190 and n. 94); letter to Mallarmé, 27 Jan 1897 (W III, L.1364 *bis*); comment attributed to Monet by Roger Marx, 'Les *Nymphéas* de M. Claude Monet' (1909), 528.

**127** Raymond Régamey in his *Promenades japonaises* (1878) discusses the Zen lotus and describes a tea house by a pool with water-lilies and a bridge. One of the clearest accounts of the relationship between Zen and landscape painting in Japan was given by Emile Hovelaque ('Les Arts à l'Exposition Universelle de 1900. L'Exposition retrospective du Japon: III', *Gazette des Beaux-Arts*, Feb 1901, 110–12). In Zen Buddhism, according to Hovelaque, 'the parallelism between man and nature is total' and 'Art becomes the religion of landscape'. Degas attended lectures on Zen Buddhism at the Musée Guimet in the 1880s (information from Dr David Bromfield). Mirbeau's article, 'Les lys, les lys!' (*Le Journal*, 7 Apr 1895), was praised by Pissarro (8 Apr 1895, *Lettres à Lucien*, 375).

**128** Petit could have 'placed' the Guillemot article as he had tried to do for Monet's June 1889 exhibition (see Ch. 4, n. 122). The large press coverage in 1898 included a special supplement in *Le Gaulois*, 16 June 1898, printed at the Imprimerie Georges Petit.

**129** Geffroy, 'Claude Monet' (1898/1900); L. Roger-Milès, 'Claude Monet', *L'Eclair*, June 1898, repr. *Le Gaulois*, 16 June 1898 (supplement); André Fontainas: 'Claude Monet', *Mercure de France*, July 1898, 160, 164–5; 'Galerie Georges Petit: Exposition Claude Monet – Galerie Durand-Ruel: Exposition d'oeuvres de MM. Claude Monet, Renoir, Degas, Pissarro, Sisley, Puvis de Chavannes', *Mercure de France*, July 1898, 279.

**130** Anon., 'Exposition d'oeuvres de M. Claude Monet', *La Chronique des arts et de la curiosité*, 15 June 1898, 212.

**131** Monet told Durand-Ruel that Alice's grief would be long to heal (17 Mar 1899 [W IV, L.1445]), and indeed it lasted for years (see letters to Alice Monet, 17 Feb 1901, and to Germaine Hoschedé, 3 July 1901 [W IV, L.1608a, 1638]). Alice Monet, journal, 9 Jan 1903 (p.j. [142], W III. 301). Mirbeau, 'Claude Monet' (1891), see p. 212, n. 31. Monet helped organize an exhibition for the benefit of Sisley's children (Wildenstein IV. 2–3).

**132** Octave Mirbeau, *Le Jardin des supplices* (1899; 1986 edn), 192, 187–8, 254–7, 262–3. Carr, *Anarchism in France*, 104–7.

**133** Thadée Natanson, 'Spéculations sur la Peinture, à propos de Corot et des Impressionnistes', *La Revue blanche*, 15 May 1899, 123–33; Julien Leclercq, 'Galerie Durand-Ruel', *La Chronique des arts et de la curiosité*, 15 Apr 1899, 130–1. The Petit exhibition contained works by Cazin, Besnard and Thaulow, as well as Sisley; Wildenstein IV. 3–6. The French frequently acknowledged Turner as Corot's equal.

**134** Letters to Roger Marx, 9 Jan ('we have lived too much outside any officiality to lend ourselves to this'), 22 Jan, 21 Apr 1900 (W IV, L.1491, 1496, 1552); letters to Paul Durand-Ruel, 15, 16 Jan 1900 (W IV, L.1492–1493). Wildenstein IV. 11, 19–21.

**135** Roger Marx, 'Un Siècle d'art' (1900), in *Maîtres d'hier et d'aujourd'hui* (1914), cited Levine, *Monet and his Critics*, 252; Thiébault-Sisson, 'Claude Monet: Les années d'épreuves' (1900).

**136** André Michel, 'Les Arts à l'Exposition Universelle de 1900. L'Exposition Centennale: La Peinture francaise: V', *Gazette des Beaux-Arts*, Nov 1900, 478 (referring to W. 534, 1879); Robert de Sizeranne, 'L'Art à l'Exposition de 1900: II – Le Bilan de l'Impressionnisme', *Revue des deux mondes*, 1 June 1900, 634.

**137** Wildenstein IV. 10; letter to Duret, 25 Oct 1887 (W III, L.797).

**138** Letters to Alice Monet [11, 10 Feb 1900], 14, 16 Feb 1900 (W IV, 1504, 1503, 1507–1508).

**139** Letter to Alice Monet, 3 Feb 1901 (W IV, L.1593).

**140** Letters to Alice Monet, 7, 9 Mar 1900, 10 Mar 1901 (W IV, L.1525, 1527, 1616).

**141** Cited by de Trévise, 'Le Pèlerinage à Giverny: II' (1927), 126.

**142** Letter to Alice Monet, 1 Mar 1900 (W IV, L.1521); to Blanche Hoschedé-Monet, 4 Mar 1900 (W IV, L.1522); to Alice Monet, 14, 16, 18 Mar 1900 (W IV, L.1529–1530, 1532).

**143** Letters to Alice Monet, 20, 25, 28 Mar 1900 (W IV, L.1534, 1539, 1543); to Durand-Ruel, 10 Apr 1900 (W IV, L.1549).

**144** Letter to Geffroy, 25 May 1900 (W IV, L.1557); to Julie Manet, 29 May 1900 (W IV, L.1560).

**145** Emile Verhaeren, 'L'Art moderne', *Mercure de France*, Feb 1901, 544–6.

**146** Since his cases of canvases were delayed he did pastels – 'which make me see what I must do' – and read 'mon Delacroix'; letters to Alice Monet [26 Jan 1901], 1 Feb [1901] (W IV, L.1588, 1591).

**147** Letters to Alice Monet [25 Jan], 2, 6, 7 Mar 1901 (W IV, L.1587, L.1592, 1613, 1614).

**148** Wildenstein IV. 25; letter to Alice Monet 10 Mar 1901 (W IV, L.1616); to Geffroy, 15 Apr 1901 (W IV, L.1632).

**149** Letter to Durand-Ruel, 19 Oct 1901 (W IV, L.1644). André Fontainas wrote in 'Claude Monet et Pissarro' (*Mercure de France*, April 1902, 247) that the new Vétheuil paintings expressed 'a penetrating, warm sensibility whose contagion makes me drunk and carries me away'.

**150** For Monet and cars, see letter to Alice Monet [18 Feb 1901] (W IV, L.1607); Hoschedé, *Claude Monet, ce mal connu*, I. 84–6; Joyes, *Monet at Giverny*, 31–2 (Monet had a chauffeur).

**151** Wildenstein IV. 26, 29; letter to Geffroy, 6 Dec 1902 (W IV, L.1676); to Durand-Ruel, 23 Mar 1903 (W IV, L.1690).

**152** Letters to Geffroy, 10, 15 May 1903 (W IV, L.1691–1692); to Durand-Ruel, 10 May 1903, 2 Mar 1904 (W IV, L.1693, 1712).

**153** Letter to Durand-Ruel, 23 Mar 1903 (W IV, L.1690).

**154** Thiébault-Sisson, 'Un nouveau musée parisien. Les *Nymphéas* de Claude Monet' (1927), 48; letter to Alice Monet, 17 Feb 1901 (W IV, L.1606a). In 1903, Monet planned to exhibit only 15 works (letter to Durand-Ruel, 23 Mar 1903 [W IV, L.1690]).

**155** Gustave Geffroy, 'La Tamise' (1904), repr. in Geffroy, 'Claude Monet', *L'Art et les artistes*, Nov 1920; and in Geffroy, *Claude Monet*, 390.

**156** A number of critics of the late 1890s and 1900s suggested a relationship between Turner and Monet; see esp. Gustave Kahn, 'L'Exposition Claude Monet', *Gazette des Beaux-Arts*, July 1904, 82, 84.

**157** He had done something similar in the *Terrace at Sainte-Adresse*; see Ch. 1, pp. 48–9. Octave Mirbeau, 'Claude Monet. Série de vues de la Tamise à Londres', preface to exh. cat., Galeries Durand-Ruel, Paris (1904), repr. *L'Humanité*, 8 May 1904 (extract in Geffroy, *Claude Monet*, 395–6).

**158** Letter to Geffroy, 4 June 1904 (W IV, L.1732). Wildenstein IV. 39–42. The Paris exhibition was followed by successful ones in London, Boston and Berlin.

**159** Kahn, 'L'Exposition Claude Monet' (1904), 83–4 (he also gave an unusually detailed analysis of the relationships among the groups of motifs, and among similar effects in different motifs, 85–8).

**160** Mirbeau, 'Claude Monet. Série de vues de la Tamise' (1904); Geffroy, *Claude Monet*, 389–90.

**161** Maurice Kahn, 'Le Jardin de Claude Monet' (1904); letter to Durand-Ruel, 12 Feb 1905 (W IV, L.1764) (some artists in London had accused Monet of using photographs for his Thames series).

**162** Charles Morice, 'Vues de la Tamise à Londres, par Claude Monet', *Mercure de France*, June 1904, 795–7.

## Chapter 6

**1** Letter to Geffroy, 1 Dec 1914 (W IV, L.2135); Walter Benjamin, 'Theses on the Philosophy of History', in *Illuminations*, 258.

**2** 'Les Nymphéas. Série de Paysages d'eau' was the title of Monet's exhibition at Durand-Ruel's gallery in 1909; he used the title *Grande Décoration* or '*Décorations*' for his large project of 1914–26. I have used *Nymphéas* as a general title; *Paysages d'eau* for the works painted 1903–9; *Grande Décoration* for the scheme as conceived from 1914/15 to 1921; *Grandes Décorations* for the two rooms of the Orangerie as conceived between 1921 and 1926. *Décorations* is used as a general title as Monet used it.

**3** In 1899 Monet earned 227,400 frs. from his paintings; in 1901 he sold 17 canvases for 127,500 frs.; in 1902 his earnings from paintings were 105,000 frs. He also had a large investment income, so in 1903 he did not sell any works. In 1912 his income from paintings was 369,000 frs.; by 1918–19, he had securities worth 1 million frs., earning 40,000 frs. in interest (Wildenstein IV. 10, 25, 34, 77, 90).

**4** For the 1904 *Nymphéas* see W.1662–1667; Thiébault-Sisson, 'Un nouveau musée parisien, Les *Nymphéas* de Claude Monet' (1927), 48; René Delange, 'Claude Monet', *L'Illustration*, 15 Jan 1927, 54.

**5** Letter to Alice Monet, 20 Mar 1893 (W III, L.1193); to the Préfet de l'Eure, 17 July 1893 (W III, L.1219); Guillemot, 'Claude Monet' (1898).

**6** W.1624–1626. Wildenstein IV. 26, 29.

**7** Arsène Alexandre, 'Le Jardin de Monet', *Le Figaro*, 9 Aug 1901; Marcel Proust, '*Les Eblouissements*', par la comtesse de Noailles', *Le Figaro*, 15 June 1907, in *Contre Sainte-Beuve*, précédé de *Pastiches et mélanges* et suivi de *Essais et articles*, ed. Pierre Clarac and Yves Sandre, 1971. 539–40.

**8** Guillemot, 'Claude Monet' (1898); Elder, *A Giverny*, 35; de Trévise, 'Le Pèlerinage à Giverny: I' (1927), 47.

**9** Letter to P. Durand-Ruel, 5 Nov 1903 (W IV, L.1699).

**10** House, 'Monet: le jardin d'eau', in Guillaud, 152–4.

**11** Thiébault-Sisson, 'Un nouveau musée parisien' (1927), 44.

**12** Morosov bought *The Pool at Montgeron* from Ambroise Vollard in 1907.

**13** M. Kahn, 'Le Jardin de Claude Monet' (1904).

**14** Letters to P. Durand-Ruel, 28 Sept, 28 Dec 1906, 21 Feb 1907 (W IV, L.1811, 1818, 1826).

**15** Letters to P. Durand-Ruel, 8, 27 Apr 1907 (W IV, L.1831, 1832); House, 'Monet: le jardin d'eau', in Guillaud, 154, 158, citing an article in *The Standard* (London), 20 May 1908.

**16** Letter to P. Durand-Ruel, 7 Apr (W IV, L.1848). Alice Monet to Germaine Salerou (*née* Hoschedé), 30 Mar 1908, in Guillaud, 270. Letters to Durand-Ruel, 20, 24, 30 Mar, 3, 7, 23, 29 Apr 1908 (W IV, L.1844–1850).

**17** Pierre Hepp, 'Fleurs et natures mortes (Galeries Durand-Ruel)', and 'Exposition de paysages par Claude Monet et Renoir', *La Chronique des arts et de la curiosité*, 9, 30 May 1908, 183, 214–15; Charles Morice, 'Exposition Monet et Renoir', *Mercure de France*, 16 June 1908, 734.

**18** Letter to Geffroy, 11 Aug 1908 (W IV, L.1854). House, 'Monet: le jardin d'eau', in Guillaud, 154, 158.

**19** Letter to P. Durand-Ruel, 19 Oct 1908 (W IV, L.1861); to Clemenceau, 25 Oct 1908 (W IV, L.1863); to Geffroy, 7 Dec 1908 (W IV, L.1869); to P. Durand-Ruel, 28 Jan 1909 (W IV, L.1875).

**20** H.G. [Henri Ghéon], 'Les *Paysages d'eau* de Claude Monet', *La Nouvelle Revue française*, 1 July 1909, 533.

**21** Marx, 'Les *Nymphéas* de M. Claude Monet' (1909), 524–5.

**22** Charles Morice, 'L'Exposition d'oeuvres de M. Claude Monet', *Mercure de France*, 16 July 1909, 347.

**23** [Louis de] Fourcaud, 'M. Claude Monet et le Lac du Jardin des Fées', *Le Gaulois*, 22 May 1909; Gillet, 'L'Epilogue de l'impressionnisme' (1909), 1525–6.

**24** Marx, 'Les *Nymphéas* de M. Claude Monet' (1909), 524–8 (Marx's version of Monet's speech is more 'literary' than anything the painter wrote – see letter to Marx, 1 June 1909 [W IV, L.1893]).

**25** Verhaeren, 'L'Art moderne' (1901), 544–5; Marx, 'Les *Nymphéas* de M. Claude Monet' (1909), 529.
The vitalistic first Futurist manifesto was published in the same year of 1909.

**26** H.G., 'Les *Paysages d'eau* de Claude Monet', 534; Fourcaud, 'M. Claude Monet et le Lac du Jardin des Fées'; Gillet, 'L'Epilogue de l'impressionnisme', 414 (all 1909).

**27** Arsène Alexandre, 'Un paysagiste d'aujourd'hui', *Comœdia*, 8 May 1909; Marx, 'Les *Nymphéas* de M. Claude Monet' (1909), 529. Cp. Henri Matisse's comment that his art 'might be for every mental worker . . . like . . . a mental soother' ('Notes d'un peintre', *La Grande Revue*, 25 Dec 1908), in Alfred H. Barr, *Matisse: his Art and Public* (New York 1951), 122. Both Marx and Gillet refer to des Esseintes, hero of Huysmans's *A Rebours*, and his creation of an ideal, self-contained environment. For photographs of Monet's studio in 1908: Wildenstein IV. 51 and W.1659, 1663, 1677.

**28** Gillet, 'L'Epilogue de l'impressionnisme' (1909), 413; Clemenceau, *Claude Monet*, 68; Fourcaud, 'M. Claude Monet et le Lac du Jardin des Fées' (1909).

**29** Letter to P. Durand-Ruel, 29 Dec 1908 (W IV, L.1872); to Geffroy, 7 Dec 1909, 4 Jan 1910 (W IV, L.1908, 1911).

**30** Alice Monet to Germaine Salerou, 28 Jan, 2, 3 Feb, 12, 14 Mar, 2 June 1910, in Guillaud, 275–6; Mirbeau to Monet, *c.* 14 Feb–5 Mar 1910, cited Wildenstein IV. 70; letter to Roger Marx, 1 June 1909 (W IV, L.1893).

**31** For the illness and death of Alice Monet, Wildenstein IV. 72–4; letter to Julie Manet-Rouart, 19 Apr 1910 (W IV, L.1919); to Geffroy, 19 May 1911 (W IV, L.1966).

**32** Letters to Geffroy, 29 May, 11 July, 7 Sept 1911 (W IV, L.1968, 1971, 1977); to Rodin, 16 July 1911, (W IV, L.1972); to Germaine Salerou, 19 Nov 1911 (W IV, L.1986); to Blanche Hoschedé-Monet, 4 Dec 1911 (W IV, L.1989). Only Michel Monet

still lived at home, but Marthe Hoschedé-Butler, her husband Theodore Butler and her step-children lived at Giverny until the war.

**33**  Geffroy, *Claude Monet*, 419; Monet saw the paintings as *souvenirs*: see letter to G. or J. Bernheim-Jeune, 1 Apr 1912 (W IV, L.2001b). Guillaume Apollinaire, 'Claude Monet', *L'Intransigeant*, 31 May 1912, in Apollinaire, *Chroniques d'art 1902–1918*, ed. L.-C. Breunig (1960), 250; letter to Signac, 5 June 1912 (W IV, L.2014). The Futurists – who demanded the draining 'of the canals of Venice' ('Contro Venezia passatista', 10 Apr 1910) – had exhibited in the Bernheim-Jeune gallery in February.

**34**  Letters to Geffroy, 6 and 26 July 1912 (W IV, L.2019, 2023). When Jean Monet's illness became really severe, he and Blanche moved back to Giverny (letter to P. Durand-Ruel, 10 Apr 1913 [W IV, L.2062]); he had a venereal disease.

**35**  See Ch. 1, p. 49 and n. 109. Letter to P. Durand-Ruel, 7 Apr 1908 (W IV, L.1848); p. 262–3 and n. 16. Clemenceau to Monet, 28 July 1912 (his emphasis), Wildenstein IV. 77, n. 701; letter to G. or J. Bernheim-Jeune, 5 Aug 1912 (W IV, L.2024a).

**36**  Letter to Koechlin, 1 May 1916 (W IV, L.2180) (his sight is good enough for him to work well); to J. Bernheim-Jeune, 5 Mar 1919 (W IV, L.2306). Thiébault-Sisson ('Un nouveau musée parisien' [1927], 45–6, 48) reports a conversation with Monet about his blindness, its remission and the ways in which he attempted to adapt his modes of painting to his sight. The article is not entirely convincing, perhaps because, while it claims to recount a visit made in 1918, it seems to incorporate memories of other visits made up to the autumn of 1920; the journalist refers to 25 to 30 works in which 'the notations of colour . . . were odiously false', but those works were probably painted after 1918 (Wildenstein IV. 94, n. 866); Thiébault-Sisson's 'La Vie artistique. Claude Monet', published in *Le Temps* in 1920, seems more specific to that year, and states only that Monet's sight was weakened, affecting his perception of details from a distance, but not that of atmospheric and tonal values. In his detailed account of two visits to Giverny in 1918, Gimpel makes no mention of Monet's impaired vision (even when the subject of Cassatt's blindness was brought up), (*Journal d'un collectionneur*, 65–9, 87–90).

**37**  Letter to Geffroy, 30 Apr; to Koechlin, 1 June; to the Bernheim-Jeunes, 5 June; to Geffroy, 18 July, all 1913 (W IV, L.2066, 2069, 2072, 2074).

**38**  Letter to Thérèse Janin, 24 Feb 1914 (W IV, L.2109); to Geffroy, 30 Apr 1914 (W IV, L.2116); to P. Durand-Ruel, 29 June 1914 (W IV, L.2123).

**39**  Martet, *M. Clemenceau peint par lui-même*, 52–3. Clemenceau's role in persuading Monet to begin work on the *Grande Décoration* may have been exaggerated by post-war political allegiances (see below p. 275, n. 61; p. 276, n. 72), but the letter to Geffroy of 30 Apr (see n. 38 above) suggests that he was already influential.

**40**  Letter to Koechlin, 15 Jan 1915 (W IV, L.2142).

**41**  Michel, 'Les Arts à l'Exposition universelle de 1900', 479–80; Gustave Kahn, 'Les Impressionnistes et la composition picturale', *Mercure de France*, 16 Sept 1912, 430. Monet's thinking about the fragmentation inherent in the *Paysages d'eau* could have been influenced by a comment Fénéon made in 1889, that a Monet landscape 'never really properly develops a natural theme and seems simply one of twenty rectangles which one could cut out of a panorama of 100 square metres' ('Certains', *Art et critique*, 14 Dec 1889, in *Oeuvres plus que complètes* I. 172). Fénéon was now artistic director for Bernheim-Jeune.

**42**  For example, Redon's *Night* and *Day*, two four-panel compositions, each 6.5 m (21½ ft) long, painted in 1910–11 for the Abbaye de Fontfroide (Roseline Bacou, *Odilon Redon* [Geneva 1956], I. 213, 215); he also painted 18 panels of 2.5 × 1.6 m (8 × 4½ ft) for the Château Domecq in 1900–3. The most relevant *fusamas* or *kakemonos* were those of the Kano school, with their typical iconography of willows, pine trees, irises, often framing a central area of water which comes down to the base of the painting. The Japanese section at the 1900 Exposition, organized by Monet's friend Hayashi, contained many (apparently uncatalogued) *kakemonos* from Japanese collections, offering, said Emile Hovelaque, 'a unique opportunity' to study Japanese painting 'since its origins' ('Les Arts à l'Exposition Universelle. L'Exposition retrospective du Japon: II, III', *Gazette des Beaux-Arts*, Jan 1901, Feb 1901, 110–12). See also Ch. 3, n. 25.

**43**  Charles F. Stuckey, 'Monet's Art and the Art of Vision', in *Aspects*, 118. Louis Gillet ('Après l'Exposition Claude Monet. Le testament de l'impressionnisme', *Revue des deux Mondes*, 1 Feb

1924, 673) relates the *Nymphéas* to the paintings in the Palazzo Ducale.

**44**  Thiébault-Sisson, 'Un nouveau musée parisien' (1927), 48; Musée Marmottan, MM. 5128, 5129. The drawings foreshadow certain of the *Grandes Décorations: Morning with willows, Reflections of trees, Morning* and *Green reflections*.

**45**  Letter to Geffroy, 6 July 1914 (W IV, L.2124). Wildenstein dates W.1852 and works like it to 1916–19, but as it is similar in colouring, handling of inverted space, etc., to W.1783, it was probably painted *c*. 1914.

**46**  Letter to Geffroy, 1 Sept 1914 (W IV, L.2128); Mirbeau, 'A nos Soldats', *Le Petit Parisien*, 28 July 1915; Carr, 'The Pity of War (1914–17)', *Anarchism in France*, 156–63.

**47**  Letter to J. Durand-Ruel, 9 Oct 1914 (W IV, L.2129); Alexandre, *Claude Monet*, 118; letter to Geffroy, 1 Dec 1914 (W IV, L.2135).

**48**  Letter to a committee, 16 Jan 1915 (W IV, L.2143). Monet's name appeared (with those of Matisse, Bonnard, *et al.*) on the list of sponsors when *Les Allemands, destructeurs des cathédrales et des trésors du passé* was published in Paris in 1915. Monet shared the xenophobia of the time, and wrote that he had been lucky not to have put himself into the hands of 'a Boche doctor' who might have blinded him (letter to Koechlin, 1 May 1916 [W IV, L.2180]).

**49**  Letter to G. or J. Bernheim-Jeune, 16 Feb 1915 (W IV, L.2145).

**50**  Lucien Descaves, 'Chez Claude Monet', *Paris-Magazine*, 25 Aug 1920; letter to J.-P. Hoschedé, 19 Aug 1915 (W IV, L.2155); to Geffroy, 24 Oct 1915 (W IV, L.2160).

**51**  Letter to G. or J. Bernheim-Jeune, 16 June 1916 (W IV, L.2188).

**52**  See photograph of Clemenceau and Monet in the third studio (Wildenstein IV. 95, upper left); the panel on the right is W.1811.

**53**  The photograph shows W.1795.

**54**  Letters to Geffroy, 11 Sept 1916, 25 Jan 1917 (W IV, L.2193, 2210); to G. and J. Bernheim-Jeune, 15 Nov 1916 (W IV, L.2201); to Sacha Guitry, 14 Dec [1916] (W IV, L.2208).

**55**  Georges Lecomte, 'Claude Monet ou le vieux chêne de Giverny', *La Renaissance de l'art français et des industries de luxe*, Oct 1920, 408, cited Wildenstein IV. 86; Carr, *Anarchism in France*, 161–2; Laurent Tailhade, *Les Livres et les hommes 1916–1917* (1917), 273, cited Carr, 163.

**56**  Letters to Geffroy, 26 Apr, 1 May 1917 (W IV, L.2228, 2230); to Clémentel, 23 July 1917 (W IV, L.2235a); to J. Durand-Ruel, 14 Oct 1917 (W IV, L.2243); to Albert Dalimier, 1 Nov 1917 (W IV, L.2249). Michel Hoog, 'La Cathédrale de Reims de Claude Monet ou le tableau impossible', *Revue du Louvre*, Feb 1981, 22–4.

**57**  Letters to Clémentel, 21 May 1917, 26 Jan 1918 (W IV, L.2232a, 2260).

**58**  Thiébault-Sisson, 'Un nouveau musée parisien' (1927), 41, 49; in a letter to Alexandre (6 Dec 1920 [W IV, L.2391]), Monet said he had completed 48 to 50 large panels, including 3 of 6 metres (19½ feet) in length. Wildenstein lists 42 2-m (6½-ft) high panels; 27 or 28 were 4.25 m (13¾ ft) long; 7, 3 m (10 ft) long; 2, 2.25 m (7¼ ft) long; 5, 6 m (19½ ft) long. Most would have been painted during the war (since Monet did easel paintings in 1919 and 1920 and his sight became very bad in late 1919).

**59**  Letter to Mme Barillon, 30 Apr 1918 (W IV, L.2271); to J. Durand-Ruel, 25 May, 15 June 1918 (W IV, L.2273, 2275); to G. Bernheim-Jeune, 21 June 1918 (W IV, L.2277) (the works of art of the Rouen museum had been taken to safety).

**60**  Letter to Clemenceau, 12 Nov 1918 (W IV, L.2287). Monet at this time intended the paintings to go to the Musée des Arts Décoratifs; the terms of his offer appear to contradict my suggestion that Monet believed the government had made some commitment to housing the *Décoration*, but they may have been a means of embarking on official negotiations – as opposed to unofficial commitments by Clemenceau and his ministers.

**61**  Letter to the Bernheim-Jeunes, 24 Nov 1918 (W IV, L.2290) (Monet said he offered one decorative panel and a *Weeping Willow* from his last series [W.1868–1877]). Geffroy ('Claude Monet', *L'Art et les artistes* [1920], 80–1) suggested some commitment to a larger project. Thiébault-Sisson ('Un Don de M. Claude Monet à l'Etat', *Le Temps*, 14 Oct 1920), stated that the project was Clemenceau's, and that it required only the government's signature to be realized; Marcel Pays ('Un Grand Maître de l'impressionnisme – Une visite à M. Claude Monet dans son ermitage à Giverny', *L'Excelsior*, 26 Jan 1921) reported that Monet said Clemenceau had encouraged him to give the 12 works to the State. In 1895, in 'La Révolution des cathédrales', Clemenceau had called on President Faure to consider that 'you represent France' and to

'give France' the 20 Rouen *Cathedrals* 'which, united . . . represent a moment of art, that is a moment of the man himself, a revolution without a gunshot'.

**62**  Letter to G. and J. Bernheim-Jeune, 25 Aug 1919 (W IV, L.2319). Wildenstein suggests that the 1 × 2 m (3¼ × 6½ ft) paintings of *The Japanese Bridge* (W.1911–1933) date to 1918, perhaps because Monet had ordered canvases of that format in April 1918; however, the clarity of vision revealed in the group of paintings of open water, of this format, which Gimpel saw in mid-1918 (see below, n. 105), compared with the choked surfaces of the bridge paintings, suggests the latter were begun in 1919 when Monet again began to complain about his sight. For Monet's sight in 1919–20, see Wildenstein IV. 90; letter to Clemenceau, 10 Nov 1919 (W IV, L.2324).

**63**  Gimpel, *Journal d'un collectionneur*, 179 (Oct 1920). See n. 76 below.

**64**  The writers were Geffroy, Thiébault-Sisson, Alexandre and Elder; Monet was most helpful to Alexandre, but treated his old friend Geffroy shabbily over his biography, perhaps because he did not like the way he assembled his books from previously published articles. After initially cordial relations with Thiébault-Sisson, Monet grew to dislike his activities, and refused to see him after the autumn of 1920, so he did not publish his account until after Monet's death.

**65**  Marc Elder, 'Une Visite à Giverny chez Claude Monet', *Excelsior*, Jan 1921; the 'absinthe'-coloured paintings of dawn were probably the *Agapanthus* panels, a triptych (W.1975–1977), perhaps related to W.1958 (National Gallery, London), whose right side links with the left of W.1975 (Cleveland).

**66**  Letters to Thiébault-Sisson, 4 Apr, [*c*. 27 June] (Monet's emphasis), [8 July 1920] (W IV, L.2342, 2358, 2359); to Clémentel, 12 July 1920 (W IV, L.2362). Monet was anxious lest Thiébault-Sisson disclose a letter revealing that Clemenceau had committed the government to the project.

**67**  Letter to Geffroy, 11 June 1920 (W IV, L.2355). Monet worked on paintings of the *Japanese Bridge* (W.1911–1933) both before and after his cataract operations in 1923 (Wildenstein IV. 296). See n. 62 above.

**68**  Letters to Alexandre, 31 Aug, 10 Sept 1920 (W IV, L.2366, 2367); Wildenstein IV. 94–9. Monet and Rodin, who had exhibited together in 1889, had come to be regarded as respectively the greatest painter and sculptor of their generation; they were born on the same day. Wildenstein IV. 94, 96–7, 318–19; Bonnier to Monet, 5 Oct 1920, p.j. [297a], W IV. 431 (enclosing a drawing for an elliptical scheme).

**69**  Thiébault-Sisson ('Un don de M. Claude Monet à l'Etat', in *Le Temps*) and *Le Petit Parisien* leaked news of the donation on 14 Oct 1920, to the annoyance of the Bernheim-Jeunes' *Bulletin de la vie artistique*, where an anonymous article ('Le Précieux Don de Claude Monet') appeared on 15 Oct. Others were by Georges Grappe, 'Chez Claude Monet', *L'Opinion*, 16 Oct (Monet wrote to thank him, ironic that he had reported the donation as '163 metres of painting': letter, 24 Oct 1920 [W IV, L.2380]); Arsène Alexandre, 'L'Epopée des *Nymphéas*', *Le Figaro*, 21 Oct; and Geffroy, in the special issue of *L'Art et les artistes*, published for Monet's eightieth birthday in November 1920.

**70**  Letter to Alexandre, 22 Oct 1920 (W IV, L.2378). Monet criticized other articles as 'shocking in their useless gossip'. Wildenstein (IV. 96, and n. 885) calls Alexandre's 'L'Epopée des Nymphéas' 'more "poetic" than exact', partly because he assumes that Alexandre identified the diptych with *The Clouds: The Clouds* is, however, a triptych, and the diptych then being offered was probably the *Green reflections*. The *Agapanthus* panels repr. together in Daniel Wildenstein *et al.*, *Monet's Years at Giverny: Beyond Impressionism*, exh. cat. Metropolitan Museum, New York (1978) (cat. nos. 76–78). Alexandre mentions only two tree trunks in the 'silver and pink' morning composition, and this suggests that it was an early phase of *The Two Willows*. Monet probably showed him and other visitors different combinations of panels in the studio. See below, n. 88.

**71**  Louis Bonnier, unpub. notes, 10 Oct 1920 (Wildenstein IV. 97, n. 887). True to form, Wildenstein (IV. 98–100) interprets Monet's treatment of Bonnier as simple meanness. However Monet was determined to ensure that the compositions could be viewed from carefully calculated variable angles, and the architect perhaps insisted overmuch on regularity (p.j. [297a, b, 298], W IV. 431–2).

**72**  Bonnier's first estimate for an oval room had been 790,000 frs., reduced for a revised form of the circular project to 626,000 frs.

in Dec 1920 (Wildenstein IV. 98, n. 902, and 99, n. 912); 200,000 frs. was to be paid for the *Women in the garden.* Durand-Ruel advised Monet (letter, 10 Nov 1920, cited Charles F. Stuckey and Robert Gordon, 'Blossoms and Blunders: Monet and the State: I', *Art in America*, Jan–Feb 1979, 112–13), that it was sensible to have allies like Thiébault-Sisson writing for *Le Temps*, 'a serious and semi-official newspaper', at the time of the parliamentary debates on the necessary credits; Pays ('Un Grand Maître de l'impressionnisme') stated that the scheme was too expensive at a time when economies were necessary; even in March 1922 Monet told Clemenceau (W IV, L.2487) that the Ministry of Fine Arts could not afford the scheme – this was after the credits seem to have been 'fixed' (Clemenceau to Monet, 14 Dec 1921, in Hoog, *Les Nymphéas*, 108).

**73** On American and Japanese interest: Pays, 'Un Grand maître de l'impressionnisme'; letter from J. Durand-Ruel to Monet, 2 June 1920, in Stuckey and Gordon ('Blossoms and Blunders: I', 110, n. 32). As examples of Monet's institutionalization: the Reims cathedral commission; the proposed visit of the President of the Council of Ministers, Georges Leygues, for his eightieth birthday; the offer of a '*fauteuil*' in the Institut de France in Dec 1920 (which he refused, to the indignation of patriots [Wildenstein IV. 97 and n. 897]). Thiébault-Sisson wrote in *Le Temps* ('La vie artistique' [1920]) that the assembling of the *Nymphéas* in the Grand Palais 'would increase the prestige of France throughout the world'.

**74** De Trévise, 'Le Pèlerinage à Giverny: II' (1927), 130; Alexandre, *Claude Monet*, 120.

**75** Wildenstein IV. 98–100. The Conseil des Bâtiments Civils rejected Bonnier's modern pavilion as 'not sufficiently Louis XV' for the Hôtel Biron: Bonnier, notes, cited Wildenstein IV. 98 and n. 905. Anon., 'Le Musée des *Nymphéas*', *Bulletin de la vie artistique*, 15 Apr 1921; letters to Léon, 11 Feb, 17 and 25 Apr 1921 (W IV, L.2406, 2422, 2426); to Alexandre, 1 June 1921 (W IV, L.2437). Stuckey and Gordon ('Blossoms and Blunders: I' [1979], 114–15) regret the loss of the 'sophisticated program' of the circular Hôtel Biron scheme, and assert that Monet had to struggle to adapt a scheme conceived as 'continuous' to groups of self-contained compositions. The evidence suggests however that Monet always preferred an elliptical scheme, and had recognized the need for doorways and other separations between the compositions which he need not have in the infinitely flexible world of the studio; perhaps this is why he considered making his home the site for the donation (Anon., 'Echos et nouvelles: La donation Cl. Monet', *Bulletin de l'art ancien et moderne*, 25 Oct 1920). Clemenceau resolved the question of doorways by suggesting a lift (Descaves, 'Chez Claude Monet' [1920]).

**76** De Trévise, 'Le Pèlerinage à Giverny': II' (1927), 131–2; Elder, *A Giverny*, 35. Monet felt the purchase of the *Women in the garden* was some recompense for its devastating rejection from the Salon, yet he felt it was 'a small heartbreak' when it left his studio: letters to Alexandre, 28 Jan, 2 Feb 1921 (W IV, L.2400, 2402; to Léon, 2 Feb 1921 (W IV, L.2403).

**77** Letter to the Bernheim-Jeunes, 17 Sept 1921 (W IV, L.2448a); to Alexandre, 24 May, 19 June, 6 July 1921 (W IV, L.2435, 2442, 2446); to Clemenceau, 6 Sept 1921 (W IV, L.2447); to G. or J. Bernheim-Jeune, 11 Aug 1921 (W IV, L.2504a).

**78** Letter to Clemenceau, 31 Oct 1921 (W IV, L.2458); to Léon, 9 Nov 1921 (W IV, L.2463); Bonnier, notes, 8 Nov 1921, Wildenstein IV. 100, n. 929; letter to Elder, 8 May 1922 (W IV, L.2494).

**79** The contract of Apr 1922 and related documents are reprinted in Hoog, *Les Nymphéas*, 113–15; Hoog reproduces alternative plans done in January and March (42–3); letter to Léon, 23 Mar 1922 (W IV, L.2490).

**80** Agathe Rouart-Valéry, quoted in Guillaud, 244.

**81** Letter to Elder, 8 May 1922 (W IV, L.2494); to Léon, 27 June 1922 (W IV, L.2501).

**82** *The Setting sun*, most incomplete of the *Décorations*, was not mentioned before Apr 1922; it can be seen in a photograph of the studio taken in July 1922 (Wildenstein IV. 95). Monet did five 6-m long canvases (*The Setting sun* and W.1980–1983); in 1920, in a letter to Alexandre (W IV, L.2391), he said that he had done three, and since *The Water-lily pool with irises* (W.1980) is essentially a huge sketch, it may have been one of the two 6-m long canvases begun after this date. (In his Nov 1921 letter to Léon [W IV, L.2463], he mentioned two such canvases.) The Jan 1922 plan included two unnamed diptychs, each composed of two 6-m panels, in Room 2, but since four of the five 6-m long canvases are of the same centralized motif, it is unlikely that Monet would have

combined them as diptychs. Even he probably realized that he could not embark on the four new 6-m panels required for such diptychs, and this is probably why he decided to use the existing ones separately, as in the March plan (with four separate 6-m canvases among seven compositions in Room 1), and in the April contract which stipulated *The Setting sun* in Room 1 and four separate 6-m canvases, all called *Morning*, in Room 2 (compare Wildenstein IV.327, where it is suggested that these panels formed diptychs).

**83** Letter to J. Durand-Ruel, 7 July 1922 (W IV, L.2503); J. Durand-Ruel to his son, 19 Oct 1922 (Wildenstein IV. 108, n. 1002).

**84** For the operations and treatment by Dr Charles Coutela, Wildenstein IV. 106–16, 118–19; letter to Dr Coutela, 13 Sept 1922 (W IV, L.*2649); other letters to Dr Coutela (W IV, Addenda, 13 Sept 1922–4 Jan 1926).

**85** Letters to Dr Coutela, 27 Aug, 14 Sept 1923 (W IV, L.*2659, *2662; to Clemenceau, 30 Aug 1923 (W IV, L.2529). Clemenceau to Monet, 1 Sept 1923, cited Wildenstein IV. 114. George H. Hamilton, 'The Dying of the Light: the Late Work of Degas, Monet and Cézanne', in *Aspects*, 227–9.

**86** See Wildenstein IV. 114–55 (citing esp. letters from Coutela to Clemenceau, 6, 13 Sept, and Clemenceau to Monet, 17 Sept 1923); Monet to Clemenceau, 22 Sept 1923 (W IV, L.2535); to Besnard, 20 Sept 1923 (W IV, L.2534); to Coutela, 21 Oct 1923 (W IV, L.*2664); to Clémentel, 7 Nov 1923, 26 Jan 1924 (W IV, L.2541, 2547). Clemenceau always heard the worst, but also invited this by relaying Coutela's professional opinions to Monet, mingling them with his own concern about the *Décorations*.

**87** The retrospective held in the Galerie Georges Petit, 4–18 Jan 1924, included 20 works from the Matzukata collection, one of which was one of the great panels related to the *Grandes Décorations* (W.1971) (Wildenstein IV. 116–17). The exhibition, appropriate in view of all Monet owed Japanese art, can be seen as another example of the reparative nature of his art. Clemenceau to Blanche Hoschedé-Monet, 19, 20 Jan 1924, cited Wildenstein IV. 117; J. to G. Durand-Ruel, 6 Mar 1924, cited Wildenstein IV. 118, n. 1106; Monet to G. or J. Bernheim-Jeune, 2 Mar 1924 (W IV, L.2553); to Elder, 6 Oct 1924 (W IV, L.2678).

**88** Monet did some new panels for the Orangerie (Clemenceau, letter to Monet, 8 Oct 1924; see below, p. 285 and n. 91), but it is difficult to know how many, particularly since he seems to have begun some which were not finally used for the project. Monet said he had painted 48 to 50 panels by Dec 1920; 42 exist today, and evidence suggests that most of the panels used in the Orangerie were substantially complete before he began to plan for it in 1921: perhaps only *The Setting sun* (see n. 82, above), and the side panels of *Morning* were begun specifically for it (both *The Setting sun* and the left-hand panel of *Morning* appear in a photograph of the studio in summer 1922: Wildenstein IV.95). There are no clearly identifiable photographs of *The Two Willows* before 1927, but the composition seems to have been described by Alexandre in 1920 ('L'Epopée des *Nymphéas*'; see p. 276 and n. 70), and two of its four panels (those without trees) may have been photographed in Feb 1921 (Wildenstein IV. 318–9, B-J 1), before being transformed through overpainting; Monet was presumably working on the right-hand and the centre panels of the *Morning with willows* which appear in a photograph taken after Monet's 1923 operation (see his remedial glasses on the table: Wildenstein IV.95). On the destruction of canvases, Monet to Elder, 8 May 1922 (see p. 280 and n. 78); Elder (*A Giverny*, 81–2) describes the shreds of canvas hanging from stretchers.

**89** Maurice Denis, *Journal* III. 17 Feb 1924, 40; Clemenceau to Monet, 1 Mar 1924, in Hoog, *Les Nymphéas*, 109–10. See below, n. 93.

**90** Letter to Dr Coutela, 9 May 1924 (W IV, L.*2674); recollections of Dr Jacques Mawas, June (?) 1924, cited Wildenstein IV. 120; letters to André Barbier, 5 Aug and 5 Oct 1924 (W IV, L.2572, 2577).

**91** Gillet to Monet, 2 Oct 1924, cited Wildenstein IV. 123; Clemenceau to Monet, 8 Oct 1924, in Hoog, *Les Nymphéas*, 110–12.

**92** Clemenceau, *Claude Monet*, 41–2 (the account he gave to Martet [*M. Clemenceau peint par lui-même*, 30] was far simpler). One wonders why the triptych, *The Water-lily pool, reflections of clouds* (Museum of Modern Art, New York, W.1972–1974) was not used in the Orangerie; it is more resolved than the triptych of the same theme and size which was used.

**93** H.S. Ciowalski, 24 Oct 1924, cited Wildenstein IV. 124.

Photographs taken for Durand-Ruel in 1917 and Bernheim-Jeune in Feb 1921, ill. Wildenstein IV. 317–9.

**94** Clemenceau to Monet, 7 Jan 1925, in Hoog, *Les Nymphéas*, 111; Joyes, *Monet at Giverny*, 36, 40 and n. 59; Hoschedé, *Claude Monet, ce mal connu* II. 14.

**95** Letter to Barbier, 17 July 1925 (W IV, L.2609); to Geffroy, 11 Sept 1925 (W IV, L.2611). Paul Valéry, *Cahiers* (1974), II, 7 Sept 1925.

**96** Letter to Elder, 16 Oct 1925 (W IV, L.*2683); see also letters to Dr Coutela, 27 July 1925 (W IV, L.*2682); to G. Bernheim-Jeune, 6 Oct 1925 (W IV, L.2612).

**97** Clemenceau to Monet, 8 Feb 1926, in Hoog, *Les Nymphéas*, 112; letter to Barbier, 28 Feb 1926 (W IV, L.2619); Clemenceau to Mme Baldensperger [5 Apr 1926], *Lettres à une amie 1923–1929*, ed. Pierre Brive (1970), 266.

**98** Letter to Clemenceau, 18 Sept 1926 (W IV, L.*2685); to Léon, 4 Oct 1926 (W IV, L.2630). Wildenstein IV. 138–40.

**99** Wildenstein IV. 143–4; Salomon, 'Chez Monet, avec Vuillard et Roussel' (1971), 24. Monet shared the tomb with Alice and her first husband, Ernest Hoschedé, Jean Monet and Suzanne and Marthe Hoschedé-Butler.

**100** Clemenceau, in Martet, *M. Clemenceau peint par lui-même*, 89–90. Levine (*Monet and his Critics*), 393–417. After the many books and articles published immediately after Monet's death (Wildenstein IV. 334), silence fell over the *Nymphéas*, which were mentioned only cursorily until their 'rediscovery' by the Abstract Expressionists in the 1950s (see Clement Greenberg, 'The Later Monet', *Art News Annual*, 1957); in the same decade there were short articles by Bachelard and by Masson; short essays by Butor and by Seitz were the only significant contribution in the 1960s; in the 1970s and '80s, the *Décorations* were discussed mainly in monographs, or books on the Giverny gardens; an inadequately researched catalogue by Rouart and Rey appeared in 1972, followed in 1979 by Stuckey's and Gordon's heroic attempts to unscramble this complex history, and Wildenstein's magisterial compendium in 1985.

**101** Hoschedé, *Claude Monet, ce mal connu* II. 25–6; Salomon, 'Chez Monet, avec Vuillard et Roussel' (1971).

**102** Baudelaire, 'Salon de 1859', in *Oeuvres complètes*, 1085.

**103** Baudelaire, 'Le Peintre de la vie moderne' (1863), in *Oeuvres complètes*, 1159.

**104** Vauxcelles, 'Un après-midi chez Claude Monet' (1905), 86; Elder, *A Giverny*, 9.

**105** Gimpel, *Journal d'un collectionneur*, 66 (19 Aug 1918). Gimpel states that the paintings were 1 m (3 ft) high × 2 m (6½ ft) wide; he could have been mistaken, but Monet did paint at least 14 works of this size after April, 1918 (W. 1886–1887, 1890–1901). There is, however, no evidence that Monet ever showed these works in a circle; indeed, this is unlikely since they were all of the same motif–reflections of the sky and willows to the west of the pool.

**106** Perry, 'Reminiscences of Monet' (1927), in *Impressionism in Perspective*, ed. White, 14; Cézanne to Bernard, 23 Oct 1905, *Letters*, 316.

**107** Clemenceau (*Claude Monet*, 154) claimed that Monet's painting 'was a great step towards the emotive representation of the world and its elements by the distribution of light corresponding to the vibrating waves which science has uncovered for us'. His comments were intended as a refutation of the 'metaphysics' of Louis Gillet's *Trois Variations sur Claude Monet* (1927); see Levine, *Monet and his Critics*, 396–8.

**108** Klaus Berger, *Odilon Redon, Fantasy and Colour* (London, 1965), cat. no. 57, c. 1905–6, The Hague (see also nos. 76–78).

**109** Geffroy, 'Claude Monet', *L'Art et les artistes* (1920), 81; Roger Marx, 'Les *Nymphéas* de M. Claude Monet' (1909), 529. See also Gillet, 'Après l'exposition Claude Monet' (1924), 673.

**110** Mallarmé, 'Le Nénuphar blanc', see Ch. 4, p. 190; Gillet, 'L'Epilogue de l'impressionnisme' (1909), 413. Clemenceau's comment that 44 of the 46 who visited the Orangerie in a day (p. 288, n. 100) were lovers suggests a new Cythera.

**111** Gillet ('Après l'exposition Claude Monet' [1924], 671) pointed out that the *Reflections of trees* (W. 1971) (the only panel related to the *Grandes Décorations* to be dated) 'carries the date of the year of Verdun'. There are two drawings in the Musée Marmottan sketch-books (MM.5129) related to this work.

**112** Gaston Bachelard, *L'Eau et ses rêves. Essais sur l'imagination de la matière* (1942), esp. chs. 2 and 3.

**113** Shakespeare, *Hamlet* iv. vii. 167–83 (the French, 'Comme un être . . . Dans son propre élément', recalls Monet's 'je me sens dans

mon élément' (Ch. 5, p. 234, n. 112). E.L. Delabarre, *Nymphs receiving Ophelia* (*Salon illustré*, 1899, no. 349), also shows Ophelia's floating hair taking on the rhythms of the current and the water plants; in *Le Panorama. Salon 1899*, the illustration of A.C.-E. His's *Ophélie* was similar.

**114**  Letter to Geffroy, 28 Feb 1896 (W III, L.1327); Elder, *A Giverny*, 9; Marthe de Fels, *La Vie de Claude Monet* (1929), 15; Levine ('Seascapes of the Sublime' [1985], 390) suggests that Monet wrote of the sea 'in an emotional language of love and violence that often seems to overflow the strict bounds of discursive sense'. Monet's language does not quite sustain this interpretation, but water certainly had profound emotional meaning for him.

**115**  Letter to Fénéon, mid-Dec 1919 (W IV, L.2329).

**116**  See n. 76. Geffroy, *Claude Monet*, 447–8 (he lists over 50 works in Monet's bedroom); Gimpel, *Journal d'un collectionneur*, 155 (1 Feb 1920). Gillet, 'Après l'exposition Claude Monet' (1924), 671–2.

**117**  Elder, *A Giverny*, 79; letter to J.-P. Hoschedé, 8 Feb 1916 (W IV, L.2170); Alexandre, 'L'Epopée des *Nymphéas*' (1920).

**118**  Mirbeau expressed his faith in post-war reparation: 'I firmly believe that . . . once peace is reconquered, men will be more just and more wise. I believe that ideas of liberty and justice will spread everywhere after the war', *Le Petit Parisien*, 28 July 1915, cited Carr, *Anarchism in France*, 159.

**119**  Delange, 'Claude Monet' (1927), 54. Monet also destroyed paintings because he wished to control the quality of the works he would leave behind at his death (de Fels, *La Vie de Claude Monet*, 199).

**120**  Gimpel, *Journal d'un collectionneur*, 154 (1 Feb 1920).

**121**  Among many examples, Monet to Bazille [1868] (W I, L.43); to Geffroy, 21 July 1890 (W III, L.1066), 28 June 1917 (W IV, L.2235). See also p. 267 and n. 35, concerning possible emotional causes for earlier episodes of blindness.

One might compare Monet's *Reflections of trees* with another painting executed during the war by another painter of light, the

*Window* (1914), in which Henri Matisse blacked it out.

**122**  Cited by Delange, 'Claude Monet' (1927), 54. See Jacques-Emile Blanche's account of Monet's funeral, 'without bells, or prayers, or incense; melancholy end of a lonely unbeliever' (W IV. 144, n. 1346).

Clemenceau's comment that Monet feared death and 'nothingness' (Martet, *M. Clemenceau peint par lui-même*, 53) makes the evolution of the *Grandes Décorations* all the more poignant: Monet could not die before realizing his dream of light, but finishing the cycle could have meant only death.

**123**  Alexandre, *Claude Monet*, 120; Gillet, 'Après l'exposition Claude Monet' (1924), 671.

**124**  Thiébault-Sisson, 'Un nouveau musée parisien' (1927), 48; letter to Clemenceau, 30 Aug 1923 (W IV. L.2529).

**125**  Geffroy, 'Les Meules de Claude Monet' (1891/1892), 27.

**126**  Hoog, *Les Nymphéas*, 61 (five shells fell into the two rooms in the Orangerie during the battles for the liberation of Paris in 1944).

# *Bibliography*

This bibliography owes a great deal to Steven Z. Levine's pioneering work in *Monet and his Critics* (New York, 1976), and to the listing of reviews of the Impressionist exhibitions in Charles S. Moffett *et al.*, *The New Painting. Impressionism 1874–1886*, exh. cat., Fine Arts Museum of San Francisco; National Gallery of Art, Washington, D.C. (1986).

Square brackets around an entry indicate significant books or articles which my distance from Europe and the USA or publication after completion of my writing prevented me from using. The place of publication is Paris unless otherwise indicated.

*Unpublished*

Photographs of selected works from the Salon des Beaux-Arts, 1860s and 1870s, in albums issued by Goupil *et Cie* and by E. Boetzel (Cabinet des Estampes, Bibliothèque Nationale, Paris).

*Published*

About, Edmond, 'Deux refusés qui n'ont dit rien', *L'Artiste*, May 1872

Adelson, Warren, *et al.*, *Sargent at Broadway. The Impressionist Years* (New York/London, 1986)

Adhémar, Hélène *et al.*, *Hommage à Claude Monet (1840–1926)*, exh. cat., Grand Palais, Paris (1980)

—— *Centenaire de l'Impressionnisme*, exh. cat., Grand Palais, Paris; Metropolitan Museum, New York (1974–5; English edn 1975)

[Adler, Kathleen, and Tamar Garb, *Berthe Morisot* (Oxford, 1987)]

Aitken, Geneviève, and Marianne Delafond, *La Collection d'estampes japonaises de Claude Monet à Giverny* (1983)

Albert, Pierre, *Histoire de la presse politique nationale au début de la troisième république (1871–1879)* (thèse, Université de Paris IV, 1977) (1980)

Alexandre, Arsène, 'Paysages de M. Claude Monet', *Le Figaro*, 3

June 1898

—— 'Le Jardin de Monet', *Le Figaro*, 9 August 1901

—— 'Les *Nymphéas* de Claude Monet', *Le Figaro*, 7 May 1909

—— 'Un paysagiste d'aujourd'hui', *Comœdia*, 8 May 1909

—— 'L'Epopée des *Nymphéas*', *Le Figaro*, 21 October 1920

—— *Claude Monet* (1921)

Alexis, Paul, 'Paris qui travaille: III – Aux peintres et sculpteurs', *L'Avenir national*, 5 May 1873

—— 'Aux peintres et sculpteurs: Une lettre de M. Claude Monet', *L'Avenir national*, 12 May 1873

Allem, Maurice, *La Vie quotidienne sous le Second Empire* (1968)

A.L.T., 'Chronique', *La Patrie*, 16 May 1874

André, A., *Renoir* (1928)

Anon., *Aux artistes-peintres. A propos du Salon de 1872* (1872)

—— 'Notre Exposition. Claude Monet', *La Vie moderne*, 19 June 1880

—— 'L'exposition des impressionnistes', *La Patrie*, 2 March 1882

—— [Gustave Geffroy?], 'Morbihan', *La Phare de la Loire*, 6 November 1886

—— 'Chez les peintres: Claude Monet – Albert Besnard', *Le Temps*, 1 March 1892

—— 'Exposition Claude Monet', *L'Art moderne*, 26 May 1895

—— 'Le Legs Caillebotte', *La Chronique des arts et de la curiosité*, 25 June

—— 'Exposition d'oeuvres de M. Claude Monet', *La Chronique des arts et de la curiosité*, 15 June 1898

—— 'La *Venise* de Claude Monet (Galerie Bernheim)', *La Chronique des arts et de la curiosité*, 15 June 1912

—— 'Le Précieux don de Claude Monet', *Bulletin de la vie artistique*, 15 October 1920

—— 'Echos et nouvelles. La donation Cl. Monet', *Bulletin de l'art ancien et moderne*, 25 October 1920

—— 'Le Musée des *Nymphéas*', *Bulletin de la vie artistique*, 15 April 1921

—— *Rouchon. Un Pionnier de l'affiche illustré*, Musée de l'Affiche et de la Publicité (1983)

Apollinaire, Guillaume, 'Claude Monet', *L'Intransigeant*, 31 May 1912, in Apollinaire, *Chroniques d'art 1902–1918*, ed. L.-C. Breunig (1960)

Arnyvelde, André, 'Chez le peintre de la lumière', *Je sais tout*, 15 January 1914

Astruc, Zacharie, 'Salon de 1868', *L'Etendard*, 27 June 1868

Aubert, Francis, 'Le Salon: IX', *La France*, 26 May 1874

Aurier, G.-Albert, 'Claude Monet', *Mercure de France*, April 1892

Bachelard, Gaston, *L'Eau et ses rêves. Essais sur l'imagination de la matière* (1942)

—— 'Les Nymphéas ou les surprises d'une aube d'été', *Verve* nos. 26–7 (1952)

Bacou, Roseline, *Odilon Redon*, 2 vols. (Geneva, 1956)

Baignières, Arthur, 'Exposition de peinture par un groupe d'artistes, rue le Peletier', *L'Echo universel*, 13 April 1876

—— '5e exposition de peinture, par MM. Bracquemond, Caillebotte, Degas, etc.', *La Chronique des arts et de la curiosité*, 10 April 1880

Banville, Théodore de, *see* Schop, Baron

Ballu, Roger, 'L'exposition des peintres impressionnistes', *La Chronique des arts et de la curiosité*, 14 April 1877

Barr, Alfred H., *Matisse: his Art and Public* (New York, 1951)

Bataille, M.-L., and Georges Wildenstein, *Berthe Morisot, catalogue des peintures, pastels et aquarelles* (1961)

Baudelaire, Charles, *Oeuvres complètes*, ed. Y.-G. Le Dantec and Claude Pichois [Pléiade edn] (1964)

—— *The Painter of Modern Life and Other Essays*, trans. and ed. Jonathan Mayne (London, 1964)

—— *Art in Paris 1845–1862: Salons and other Exhibitions*, trans. and ed. Jonathan Mayne (London, 1965)

Bénédite, Léonce, 'La Collection Caillebotte au Musée du Luxembourg', *Gazette des Beaux-Arts*, March 1897

Benjamin, Walter, *Charles Baudelaire: A Lyric Poet in the Era of*

*High Capitalism*, trans. Harry Zohn (London, 1973); French edn, *Charles Baudelaire: un poète lyrique à l'apogée de capitalisme*, trans. and ed. Jean Lacoste (1982)

—— *Illuminations*, ed. Hannah Arendt, trans. Harry Zohn (London, 1973)

Berger, Klaus, *Odilon Redon, Fantasy and Colour* (London, 1965)

Berger, René, *et al.*, *Charles Gleyre ou les illusions perdues*, exh. cat., Musée cantonal des Beaux-Arts, Lausanne (1974)

Bergson, Henri, *Matière et mémoire* (1896)

Berhaut, Marie, *Caillebotte, sa vie, son oeuvre. Catalogue raisonné des peintures et pastels* (1978)

Bertall [Charles-Albert d'Arnoux], 'Exposition des impressionnalistes, rue Lepeletier', *Paris-Journal*, 15 April 1876 (repr. in *Le Soir*, same date)

—— 'Exposition des impressionnistes', *Paris-Journal*, 9 April 1877

—— 'Exposition des indépendants', *Paris-Journal*, 14 May 1879 (repr. as 'Exposition des indépendants: Ex-impressionnistes, demain intentionistes', *L'Artiste*, 1 June 1879)

Bertrand, Karl, 'Le Salon de 1870', *L'Artiste*, 1 June 1870

Bigot, Charles, 'Causerie artistique. L'exposition des Mirlitons – L'exposition des "intransigeants"', *La Revue politique et littéraire*, 8 April 1876

—— 'Causerie artistique. L'exposition des "impressionnistes"', *La Revue politique et littéraire*, 28 April 1877

—— 'Beaux-arts. Les petits Salons: L'exposition des artistes indépendants', *La Revue politique et littéraire*, 4 March 1882

[Billot, Léon, 'Exposition des Beaux-Arts', *Journal du Havre*, 9 October 1868]

Bing, Samuel, ed., *Le Japon artistique*, 3 vols. (1888–91)

Birkett, Jennifer, *The Sins of the Fathers. Decadence in France 1870–1914* (London, 1986)

Blanc, Charles, 'Salon de 1866', *Gazette des Beaux-Arts*, June 1866

Blanche, Jacques-Emile, *Propos de peintre, de Gauguin à la Revue nègre* (1928)

Blavet, Emile, 'Avant le Salon: L'exposition des réalistes', *Le Gaulois*, 31 March 1876

Blémont, Emile [Emile Petitdidier], 'Les impressionnistes', *Le Rappel*, 9 April 1876 (extract in Anon., 'Revue des journaux: Revue littéraire et anecdotique', *Le Moniteur universel*, 11 April 1876)

—— editorial, *La Renaissance littéraire et artistique*, 18 January 1874

Bodelsen, Merete, 'Early Impressionist Sales 1874–94 in the light of some unpublished "procès-verbaux"', *Burlington Magazine*, June 1968

Boime, Albert, 'The Salon des Refusés and the Evolution of Modern Art', *Art Quarterly* 32 (Winter 1969)

—— *The Academy and French Painting in the Nineteenth Century* (London, 1971)

—— *Thomas Couture and the Eclectic Vision* (New Haven/London, 1980)

Boubée, Simon, 'Beaux-Arts: Exposition des impressionnistes chez Durand-Ruel', *La Gazette de France*, 5 April 1876

Boussel, Patrice, *Histoire des vacances* (1961)

Bouvier, Jean, *Les Deux scandales de Panama* (1964)

Bouyer, Raymond, 'Le Paysage contemporain: III – Claude Monet et le paysage impressionniste', *La Revue d'histoire contemporaine*, 2 May 1891

Bowness, Alan, John House and MaryAnne Stevens, *Post-Impressionism*, exh. cat., Royal Academy of Art, London; National Gallery of Art, Washington, D.C. (1979–80)

Braudel, Fernand, and Ernest LaBrousse, *Histoire économique et sociale de la France. III: L'Avènement de l'ère industrielle (1789-années 1880)*, 2 vols. (1977)

Breton, Jules, *Un Peintre paysan* (1896)

[Brettell, Richard, *et al.*, *A Day in the Country. Impressionism and the French Landscape*, exh. cat., Los Angeles County Museum of Art (1984)

Bromfield, David, 'Japanese Art, Monet and the Formation of Impressionism: an enquiry into some conditions of cultural exchange and appropriation in later nineteenth-century European art' (paper from the conference, 'Europe and the Exotic', Humanities Research Centre, Canberra 1987, forthcoming [1990] in a volume ed. C. Andrew Gerstle and Tony Milner)

Brunhammer, Yvonne, *et al.*, *Le Livre des expositions universelles 1851–1989*, Musée des Arts décoratifs, Paris (1983)

Buchloch, Benjamin H.D., *et al.*, eds., *Modernism and Modernity*

(Halifax, Nova Scotia, 1983)

[Bürger, Wilhelm], *see* Thoré, Théophile

[Burty, Philippe], 'Chronique du jour', *La République française*, 16 April 1874

—— 'Exposition de la Société anonyme des artistes', *La République française*, 25 April 1874

—— (as 'Ph.B.'), 'Chronique du jour', *La République française*, 23, 26 March 1875

—— (as 'Ph.B.'), 'Chronique du jour', *La République française*, 1 April 1876

—— (as 'Ph.B.'), 'Exposition des impressionnistes', *La République française*, 25 April 1877

—— (as 'Ph.B.'), 'L'exposition des artistes indépendants', *La République française*, 16 April 1879

—— 'Le Salon de 1880', *La République française*, 19 June 1880

—— 'Grave imprudence' (1880)

—— 'Les aquarellistes, les indépendants et le Cercle des arts libéraux', *La République française*, 8 March 1882

—— 'Les Paysages de M. Claude Monet', *La République française*, 27 March 1883

Butor, Michel, 'Claude Monet ou le monde renversé', *L'Art de France* I (1963) (trans. *Art News Annual*, 1968)

Byvanck, Willem G.C., *Un Hollandais à Paris en 1891: Sensations de littérature et d'art* (1892)

Cachin, Françoise, Charles S. Moffett *et al.*, *Manet 1832–1883*, exh. cat., Grand Palais, Paris; Metropolitan Museum, New York (1983)

Callen, Anthea, *Techniques of the Impressionists* (London, 1982)

Calonne, A. de, 'L'art contre nature', *Le Soleil*, 23 June 1889

Cardon, Emile, 'L'exposition des révoltés', *La Presse*, 29 April 1874

Carr, Reg, *Anarchism in France: The case of Octave Mirbeau* (Manchester, 1977)

Castagnary, Jules-Antoine, 'L'exposition du boulevard des Capucines: Les impressionnistes', *Le Siècle*, 29 April 1874

—— *Salons (1857–79)*, 2 vols. (1892)

*Catalogue du Salon*, Salon des Artistes français, Paris 1667–1880, 60 vols.; facsimile, compiled by H.W. Janson (London/New York, 1977) [consulted vols. for 1859–80]

*Catalogue illustré du Salon des Beaux-Arts*, Salon de la Société nationale des Beaux-Arts, Champs-Elysées, Paris [consulted vols. 1889–1904]

*Catalogue illustré du Salon*, Salon du Champ de Mars, Paris [consulted vols. 1889–1904]

Catinat, Maurice, *Les Bords de la Seine avec Renoir et Maupassant: l'école de Chatou* (Chatou, 1952)

Cézanne, Paul, *Letters*, ed. and trans. John Rewald, 4th edn (Oxford, 1976)

Cham [Amédée Noé], *Le Salon pour rire 1872* (1872)

Champa, Kermit, *Studies in Early Impressionism* (New Haven/London, 1973)

Champfleury [Jules Husson or Fleury], *Le Réalisme*, ed. Geneviève and Jean Lacambre (1973)

Charteris, Evan, *John Sargent* (London, 1927)

Chennevières, Philippe de, 'Le Salon de 1880', *Gazette des Beaux-Arts*, July 1880

—— *Souvenirs d'un Directeur des Beaux-Arts* (1883–9; 1979 edn)

Chesneau, Ernest, *Salon de 1859* (1859)

—— *L'Art et les artistes modernes en France et en Angleterre* (1864)

—— *Les Nations rivales en l'art* (1868)

—— 'A côté du Salon: II – Le plein air: Exposition du boulevard des Capucines', *Paris-Journal*, 7 May 1874 (repr. in *Le Soir*, same date)

—— 'Exposition Universelle: Le Japon à Paris', *Gazette des Beaux-Arts*, September–November 1878

—— 'Groupes sympathiques: Les peintres impressionnistes', *Paris-Journal*, 7 March 1882

Chevalier, Frédéric, 'Les impressionnistes', *L'Artiste*, 1 May 1877

Chisburō, Yamada, ed., *Japonisme in Art, an international symposium* (Tokyo, 1980)

Claretie, Jules, *Peintres et sculpteurs contemporains* (1874)

—— *La Vie à Paris*, III (1882)

—— 'Léon Gambetta: Amateur d'art', *Gazette des Beaux-arts*, February 1883

Clark, T.J., *The Image of the People: Gustave Courbet and the 1848 Revolution* (London, 1973)

—— *The Painting of Modern Life: Paris in the Art of Manet and his Followers* (London/New York, 1984)

Clemenceau, Georges, 'La Révolution des Cathédrales', *La*

*Justice*, 20 May 1895

—— *Claude Monet: Les Nymphéas* (1928; 1965 edn: *Claude Monet. Cinquante ans d'amitié* [Paris/Geneva])

—— *Lettres à une amie 1923–1929*, ed. Pierre Brive (1970)

Clément, Charles, *Gleyre, Etude biographique et critique* (1886)

Clément, J.-B., *Chansons* (1887)

Cooper, Douglas, *The Courtauld Collection* (London, 1954)

[Corot, Jean-Baptiste-Camille], *Corot raconté par lui-même et par ses amis*, ed. Pierre Cailler, 2 vols. (Vesenay/Geneva, 1946)

[Courbet, Gustave], *Courbet raconté par lui-même et par ses amis*, ed. Pierre Cailler, 2 vols. (Geneva, 1951)

Crespelle, Jean-Paul, *La Vie quotidienne des impressionnistes* (1981)

Crouzet, Marcel, *Un Méconnu du réalisme: Duranty (1833–1880)* (1964)

Darcel, Alfred, 'Les Musées, les arts et les artistes pendant le siège et pendant la Commune', *Gazette des Beaux-Arts*, September 1871–June 1872

Dargenty [Arthur d'Echerac], 'Exposition des oeuvres de M. Monet', *Le Courrier de l'art*, 15 March 1883

Daudet, Alphonse, 'Monologue à bord', *Contes du lundi* (1873)

Daulte, François, *Frédéric Bazille et son temps* (Geneva, 1952)

—— *Alfred Sisley, catalogue raisonné de l'oeuvre peint* (Lausanne, 1959)

—— *Auguste Renoir, catalogue raisonné de l'oeuvre peint, I: Figures 1860–1890* (Lausanne, 1971)

Daumard, Adeline, *Les Bourgeois de Paris au XIXᵉ siècle* (1970)

Dax, Pierre, 'Chroniques', *L'Artiste*, 1 May 1876 (repr. of Georges Rivière, 'Les intransigeants de la peinture', *L'Esprit moderne*, 13 April 1876)

Delacroix, Eugène, *Journal*, ed. André Joubin, 3 vols. (1960)

Delange, Réné, 'Claude Monet', *L'Illustration*, 15 January 1927

Denis, Maurice, *Journal (1884–1943)*, 3 vols. (1957–9)

Denoinville, Georges, 'Les Salons: Les Cathédrales', *Le Journal des artistes*, 19 May 1895

Descaves, Lucien, 'Chez Claude Monet', *Paris-Magazine*, 25 August 1920

Du Camp, Maxime, *Paris: ses organes, ses fonctions et sa vie dans la seconde moitié du XIXᵉ siècle*, 6 vols. (1869–76)

—— *Les Convulsions de Paris*, 4 vols. (1878–80; 7th edn, 1889)

Dumas fils, Alexandre, *Une lettre sur les choses du jour* (1871)

Du Pays, A.J., 'Exposition: Des ouvrages des artistes vivants, au palais des Champs-Elysées', *L'Illustration*, 16 April 1859

—— 'Salon de 1866: III', *L'Illustration*, 2 June 1866

Duranty, Edmond, 'Le Salon bourgeois', *La Rue*, 13 July 1867

—— 'La Mer parisienne', *La Vie parisienne*, 9 March 1872

—— *La Nouvelle peinture. A propos du groupe d'artistes qui expose dans les galeries Durand-Ruel*, Paris (1876); repr. in Moffett, Charles S., et al., *The New Painting. Impressionism 1874–1886* (1986), q.v.

—— 'La quatrième exposition faite par un groupe d'artistes indépendants', *La Chronique des arts et de la curiosité*, 19 April 1879

—— *Le Pays des arts* (1881)

Duret, Théodore, *Histoire des quatre ans 1870–1873*, 3 vols. (1876, 1880)

—— *Les Peintres impressionnistes. Claude Monet, Sisley, C. Pissarro, Renoir, Berthe Morisot* (1878); repr. in *Critique d'avant-garde* (1885)

—— *Le Peintre Claude Monet. Notice sur son oeuvre, suivie du catalogue de ses tableaux exposés dans la galerie du journal illustré, 'La Vie moderne'* (1880)

—— *Critique d'avant-garde* (1885)

—— *Whistler et son oeuvre* (1888)

—— *Histoire des peintres impressionnistes, Pissarro, Claude Monet, Sisley, Renoir, Berthe Morisot, Cézanne, Guillaumin* (1906)

'E. d'H.', *see* Hervilly, Ernest d'

Elder, Marc, 'L'Exposition universelle: Le Japon à Paris', *Gazette des Beaux-Arts*, September 1878

—— 'Une visite à Giverny chez Claude Monet', *Excelsior*, January 1921

—— *A Giverny, chez Claude Monet* (1924)

Elderfield, John, 'Monet's Series', *Art International*, November 1974

Enault, Louis, 'Mouvement artistique: L'exposition des intransigeants dans la galerie de Durand-Ruelle' [*sic*], *Le Constitutionnel*, 10 April 1876

Eon, Henry, 'Les Cathédrales de Claude Monet', *La Plume*, 1 June 1895

Ephrussi, Charles, 'Bibliographies. Les Peintres impressionnistes

. . . par Théodore Duret', *La Chronique des arts et de la curiosité*, May 1878

Etienne, Louis, *Le Jury et les exposants. Salon des refusés* (1863)

Evett, Elisa, 'The Late Nineteenth Century European Critical Response to Japanese Art: Primitivist Leanings', *Art History*, March 1983

Farwell, Beatrice, *The Cult of Images*, exh. cat., University of California, Santa Barbara Art Museum (1977)

Fels, Marthe de, *La Vie de Claude Monet* (1929)

Fénéon, Félix, *Oeuvres plus que complètes*, ed. Joan U. Halperin (Geneva/Paris, 1970)

Feydeau, Ernest, *Consolation* (1872)

Fichtre [Gaston Vassy], 'L'actualité: L'exposition des peintres indépendants', *Le Réveil*, 2 March 1882

Fields, Barbara, *Jean-François Raffaelli (1850–1926): The Naturalist Artist* (Ann Arbor [University Microfilms], 1979)

Flood, Phylis, 'Documentary Evidence for the Availability of Japanese Imagery in Europe in Nineteenth Century Public Collections', *Art Bulletin*, March 1986

Fontainas, André, 'Galerie Georges Petit: Exposition Claude Monet. Galerie Durand-Ruel: Exposition des oeuvres de MM. Claude Monet, Renoir, Degas, Pissarro, Sisley, Puvis de Chavannes', *Mercure de France*, July 1898

—— 'Claude Monet', *Mercure de France*, July 1898

Foucault, Michel, *Power/Knowledge: Selected Interviews and Other Writings 1972–1977*, ed. Colin Gordon, trans, C. Gordon *et al.* (New York, 1980)

Fouquier, M., 'L'Exposition internationale', *Le XIXᵉ Siècle*, 17 June 1886

Fourcaud, Louis de, 'L'Exposition universelle: La Peinture: I – L'Ecole française', *La Revue de l'art*, September 1900

—— 'M. Claude Monet et le Lac du Jardin des Fées', *Le Gaulois*, 22 May 1909

Fournel, Victor, 'Voyage à travers l'Exposition universelle. Notes d'un touriste; I', *Le Correspondant*, April 1867

Francastel, Pierre, *L'Impressionnisme: Les origines de la peinture moderne de Monet à Gauguin* (1937)

Franklin, Ursula, *An Anatomy of Poesis: The Prose Poems of Stéphane Mallarmé* (Chapel Hill, 1976)

Fustec, J. le, 'Au Jour le jour', *La République française*, 28 June 1889

Gambetta, Léon, *Discours et plaidoyers choisis de Léon Gambetta* (1909)

Gastineau, Benjamin, *Histoire des chemins de fer* (1963)

Gautier, Théophile, 'La Sculpture au Salon', *L'Artiste*, June 1872

—— *Tableaux du siège de Paris 1870–1871* (1872)

Geffroy, Gustave, 'Claude Monet', *La Justice*, 15 March 1883; largely repr. in Geffroy, 'Histoire de l'impressionnisme', *La Vie artistique*, 3ᵉ série (1894)

—— 'Salon de 1887 – Hors du Salon: Cl. Monet', *La Justice*, 25 May and 2 June 1887; largely repr. in Geffroy, 'Histoire de l'impresionnisme: II. Claude Monet', *La Vie artistique*, 3ᵉ série (1894)

—— 'Chronique: Dix tableaux de Cl. Monet', *La Justice*, 17 June 1888; repr. in *L'Art moderne*, 24 June 1888; largely repr. in Geffroy, 'Histoire de l'impressionnisme: II. Claude Monet', *La Vie artistique*, 3ᵉ série (1894)

—— 'Paysages et figures', *La Justice*, 28 February 1889; largely repr. in Geffroy, 'Histoire de l'impressionnisme: II. Claude Monet', *La Vie artistique*, 3ᵉ série (1894)

—— 'Chronique: l'exposition Monet-Rodin', *La Justice*, 21 June 1889; largely repr. in Geffroy, 'Histoire de l'impressionnisme: II. Claude Monet', *La Vie artistique*, 3ᵉ série (1894)

—— 'Salon de 1890 aux Champs-Elysées et au Champ-de-Mars', *La Justice*, 7 April 7, 11, 13–4, 20–1 May 1890; repr. in Geffroy, *La Vie artistique*, 1ᵉʳᵉ série (1892)

—— *Exposition d'œuvres récentes de Claude Monet dans les galeries Durand-Ruel*, exh. cat., May 1891; repr. as 'Les meules de Claude Monet' in Geffroy, *La Vie artistique*, 1ᵉʳᵉ série (1892)

—— *Série des peupliers des bords de l'Epte*, exh. cat., Galeries Paul Durand-Ruel, March 1892; repr. as 'Les Peupliers' in Geffroy, 'Histoire de l'impressionnisme: II. Claude Monet', *La Vie artistique*, 3ᵉ série (1894)

—— 'Claude Monet', *Le Journal*, 10 May 1895; repr. in Geffroy, *La Vie artistique*, 6ᵉ série (1900)

—— 'Claude Monet', *Le Journal*, 7 June 1898; repr. *Le Gaulois*, 16 June 1898 (supplement) and in Geffroy, *La Vie artistique*, 6ᵉ série (1900)

—— *La Vie artistique*, 8 vols. [called 'séries'] (1892–1903):

collections of his essays on art published intermittently; they include his essays on Monet which were sometimes slightly revised and cut

—— 'La Tamise' (1904); repr. in 'Claude Monet', *L'Art et les Artistes*, November 1920 (special no.)

—— *Claude Monet, sa vie, son oeuvre*, 2 vols. (1924; 1-vol. edn, 1980). This book reprints – sometimes with excisions and additions – most of Geffroy's articles on Monet, which he collected in *La Vie artistique* and in *L'Art et les artistes* (1920)

Georgel, Pierre, 'Monet, Bruyas, Vacquerie et le Panthéon Nadar', *Gazette des Beaux-Arts*, December 1968

[Ghéon, Henri] (as 'G.H.'), 'Les Paysages d'eau de Claude Monet', *La Nouvelle Revue française*, 1 July 1909

Gill, André, 'Le Salon pour rire', *La Lune*, 13 May 1866

Gillet, Louis, 'L'Epilogue de l'impressionnisme: Les *Nymphéas* de M. Claude Monet', *La Revue hebdomadaire*, 21 August 1909

—— 'Après l'exposition Claude Monet: Le testament de l'impressionnisme', *Revue des deux mondes*, 1 February 1924

—— *Trois variations sur Claude Monet* (1927)

Gimpel, René, *Journal d'un collectionneur, marchand de tableaux* (1963)

Goldwater, Robert, 'Symbolic Form: Symbolic Function', in *Acts of the Twentieth International Congress of the History of Art* (Princeton, 1963)

Goncourt, Edmond and Jules de, *Manette Salomon* (1867)

—— *Gavarni: L'homme et l'œuvre (1822–96)* (1879)

—— *Journal: Mémoires de la vie littéraire*, ed. Robert Ricatte, 4 vols. (Monaco, 1956–9)

Goncourt, Edmond de, *L'Art japonais au XVIIIᵉ siècle: Outamaro* (1891)

—— *Hokousai* (1896)

Gonse, Louis, *L'Art japonais* (1883)

—— *Catalogue de l'exposition rétrospective de l'art japonais organisée par Louis Gonse*, Galerie Georges Petit, Paris (1883)

—— 'L'Art japonais et son influence sur le goût européen', *Revue des arts décoratifs*, April 1898

Gordon, Robert and Andrew Forge, *Claude Monet* (New York, 1983)

Gourmont, Remy de, 'Notes sur Claude Monet', *L'Art moderne*, 28 July 1901

Grappe, Georges, 'Chez Cl. Monet', *L'Opinion*, 16 October 1920

Greenberg, Clement, 'The Later Monet', *Art News Annual* (New York, 1957)

Grimm, Baron [Albert Millaud], 'Lettres anecdotiques du Baron Grimm: Les impressionnistes', *Le Figaro*, 5 April 1877

Guillaud, Jacqueline and Maurice, *Claude Monet au temps de Giverny*, exh. cat., Centre Culturel du Marais, Paris (1983; English edn, same date, pagination)

Guillemot, Maurice, 'Claude Monet', *La Revue illustré*, 15 March 1898

Halévy, Daniel, *La République des ducs* (1937; 1972 edn)

Hamilton, George Heard, *Claude Monet's Paintings of Rouen Cathedral* (1959 Charlton Lecture, Newcastle-on-Tyne), (London, 1960)

—— *Manet and his Critics*, 2nd edn (New York, 1969)

Hanson, Anne Coffin, *Manet and the Modern Tradition* (New Haven/London, 1977)

Hefting, Victorine, *Jongkind, sa vie, son œuvre, son époque* (1975)

Hemmings, F.W.J., *Emile Zola* (Oxford, 1970)

Hennequin, Emile, 'Beaux-arts: Les expositions des arts libéraux et des artistes indépendants', *La Revue littéraire et artistique*, 1882

Hepp, Alexandre, 'Impressionnisme', *Le Voltaire*, 3 March 1882

Hepp, Pierre, 'Fleurs et natures mortes (Galeries Durand-Ruel)', *La Chronique des arts et de la curiosité*, 9 May 1908

—— 'Exposition de paysages par Claude Monet et Renoir', *La Chronique des arts et de la curiosité*, 30 May 1908

Herbert, Eugenia W., *The Artist and Social Reform: France and Belgium 1885–1898* (New Haven, 1961)

Herbert, Robert L., 'Method and Meaning in Monet', *Art in America*, September 1979

—— [*Impressionism: Art, Leisure, and Parisian Society* (New Haven/London, 1988)]

Hervilly, Ernest d', 'Les poèmes du Salon. Camille', *L'Artiste*, 15 June 1866

—— (as 'E. d'H.'), 'L'exposition du boulevard des Capucines', *Le Rappel*, 17 April 1874

—— ('Un Passant'), 'Les on-dit', *Le Rappel*, 20, 26 March 1875

—— ('Un Passant'), 'Les on-dit', *Le Rappel*, 2 April 1876

—— 'Exposition des impressionnistes', *Le Rappel*, 11 April 1879

Hillairet, Jacques, *Le Palais royale et impériale des Tuileries et ses jardins* (1965)

Holt, Elizabeth Gilmore, *The Art of All Nations 1850–1873* (New York, 1981)

Hoog, Michel, 'La Cathédrale de Reims de Claude Monet ou le tableau impossible', *Revue du Louvre*, February 1981

—— *Les Nymphéas de Claude Monet au Musée de l'Orangerie* (1984)

Hoschedé, Jean-Pierre, *Claude Monet, ce mal connu. Intimité familiale d'un demi-siècle à Giverny de 1883 à 1926*, 2 vols. (Geneva, 1960)

House, John, 'The New Monet Catalogue', *Burlington Magazine*, October 1978

—— *Monet: Nature into Art* (New Haven/London, 1986)

House, John, Anne Distel *et al.*, *Renoir*, exh. cat., Hayward Gallery, London; Grand Palais, Paris; Museum of Fine Arts, Boston (1985–6)

House, John, and Virginia Spate, *Claude Monet – Painter of Light*, exh. cat., City Art Gallery, Auckland; Art Gallery of New South Wales, Sydney; National Gallery of Victoria, Melbourne (1985–6)

Houssaye, Arsène, *Le Chien pendu et la femme fusillée* (1872)

—— *Confessions; souvenirs d'un demi-siècle (1830–1880)*, 4 vols. (1885)

—— *Souvenirs de jeunesse 1850–1870* (1890)

Hovelaque, Emile, 'Les Arts à l'Exposition Universelle de 1900. L'Exposition retrospective du Japon', *Gazette des Beaux-Arts*, October 1900, January, February 1901

Hugo, Victor, *Choses vues 1870–1885*, ed. Hubert Juin (1972)

Huysmans, Joris-Karl, *L'Art moderne* (1883; 1975 edn: *L'Art moderne/Certains*)

—— *A Rebours* (1884)

—— 'Le Salon de 1887. L'exposition internationale de la rue de Sèze', *La Revue indépendante*, June 1887

—— *Certains* (1889)

—— *La Cathédrale* (1898)

Isaacson, Joel, *Monet. Le Déjeuner sur l'herbe* (London, 1972)

—— *Claude Monet: Observation and Reflection* (Oxford/New York, 1978)

—— 'Impressionism and Journalistic Illustration', *Arts Magazine*, June 1982

—— *et al.*, *The Crisis of Impressionism 1878–1882*, exh. cat., University of Michigan Museum of Art, Ann Arbor (1979–80)

Jacques [pseud.], 'Menus propos. Salon impressionniste', *L'Homme libre*, 11 April 1877

Janin, Clément, 'Claude Monet', *L'Estafette*, 10 March 1892

Janin, Jules, *Voyage de Paris à la mer*, 1847

—— *La Normandie* (1981, facsimile of 3ᵉ edn, 1862)

Jean-Aubry, G., *Eugène Boudin, d'après des documents inédits. L'homme et l'oeuvre* (1922; 2nd edn [with R. Schmit], *Eugène Boudin, La vie et l'oeuvre d'après les lettres et les documents inédits* [Neuchâtel, 1968]; English trans. [London, 1969], same pagination)

Jeanniot, Georges (as 'J. G.'), 'Notes sur l'art: Claude Monet', *La Cravache parisienne*, 23 June 1888

Joanne, Adolphe, *Les Environs de Paris illustrés* (1868)

—— *Rouen* (Guides-Joanne), 1887, 1891

Jones, Elizabeth H., *et al.*, *Monet Unveiled: A New Look at Boston's Paintings*, exh. cat., Museum of Fine Arts, Boston (1977)

Joyes, Claire, *et al.*, *Monet at Giverny* (London, 1975)

Kahn, Gustave, 'L'exposition Claude Monet', *Gazette des Beaux-Arts*, July 1904

—— 'Les Impressionnistes et la composition picturale', *Mercure de France*, 16 September 1912

Kahn, Maurice, 'Le jardin de Claude Monet', *Le Temps*, 7 June 1904

Karr, Alphonse, *Le Canotage en France* (1858)

Kracauer, Siegfried, *Offenbach and the Paris of His Time* (London, 1937)

Kravis, Judy, *The Prose of Mallarmé* (Cambridge, 1976)

Lacambre, Geneviève, *Le Musée du Luxembourg en 1874*, exh. cat., Grand Palais, Paris (1974)

—— [*et al.*, *Le Japonisme*, exh. cat., Grand Palais Paris; National Museum of Western Art, Tokyo (1988)]

Lafenestre, Georges, 'Les expositions d'art: les indépendants et les aquarellistes', *Revue des deux mondes*, 15 May 1879

Laforgue, Jules, *Mélanges posthumes* (1903; facsimile, 1979)

Laing, Alastair, J. Patrice Marandel and Pierre Rosenberg, *François Boucher 1703–1770*, Metropolitan Museum, New York; Detroit Institute of Art; Grand Palais, Paris (1986–7)

Langeac, Th. de, 'Bulletin', *L'Univers illustré*, 9 May 1874

Leclercq, Julien, 'Galerie Georges Petit', *La Chronique des arts et de la curiosité*, 25 February 1899

—— 'Galerie Durand-Ruel', *La Chronique des arts et de la curiosité*, 15 April 1899

—— 'Le Bassin aux Nymphéas de Claude Monet', *La Chronique des arts et de la curiosité*, 1 December 1900

Lecomte, Georges, 'L'Art contemporain', *La Revue indépendante de littérature et d'art*, April 1892

—— *L'Art impressionniste, d'après la collection privée de M. Durand-Ruel* (1892)

—— 'Les Cathédrales de M. Claude Monet', *La Nouvelle Revue*, 1 June 1895

—— 'Claude Monet ou le vieux chêne de Giverny', *La Renaissance de l'art français et des industries de luxe*, October 1920

Leneveux, H., *Le Budget du foyer* (1872)

Le Play, Frédéric, *Les Ouvriers européens* (1855)

Le Roux, Hugues, 'Silhouettes parisiennes. L'Exposition de Claude Monet', *Gil Blas*, 3 March 1889

Leroy, Louis, 'L'exposition des impressionnistes', *Le Charivari*, 25 April 1874

Lethève, Jacques, *Impressionnistes et symbolistes devant la presse* (1959)

Levine, Steven Z., 'Monet's Pairs', *Arts Magazine*, June 1975

—— *Monet and his Critics* (New York, 1976)

—— 'Décor/Decorative/Decoration in Claude Monet's Art', *Arts Magazine*, February 1977

—— 'The Window Metaphor and Monet's Windows', *Arts Magazine*, November 1979

—— 'Instant of Criticism and Monet's Critical Instant', *Arts Magazine*, March 1981

—— 'Seascapes of the Sublime: Vernet, Monet, and the Oceanic Feeling', *New Literary History* 16, no. 2 (Winter 1985)

Lidsky, Paul, *Les Ecrivains contre la Commune* (1970)

Lindsay, Jack, *Gustave Courbet, his Life and Art* (Bath, 1973)

Lloyd, Christopher, *Pissarro* (Oxford/New York, 1979)

—— et al., *Camille Pissarro 1830–1903*, exh. cat., Hayward Gallery, London; Grand Palais, Paris; Museum of Fine Arts, Boston (1981)

Lora, Léon de [Félix Pothey], 'Petites nouvelles artistiques: Exposition libre des peintres', *Le Gaulois*, 18 April 1874

[Lostalot, Alfred de] (as 'A. de L.'), 'L'exposition de la rue le Peletier', *La Chronique des arts et de la curiosité*, 1 April 1876

—— 'Concours et expositions', *La Chronique des arts et de la curiosité*, 12 June 1880

—— 'Exposition des œuvres de M. Claude Monet', *Gazette des Beaux-Arts*, April 1883

—— 'Exposition internationale de peinture (Galerie Georges Petit)', *Gazette des Beaux-Arts*, June 1885

—— 'Exposition internationale de peinture et de sculpture (Galerie Georges Petit)', *Gazette des Beaux-Arts*, June 1887

Lukacs, Gyorgy, 'Narrate or Describe' (1936), in *Writer and Critic*, trans. Arthur Kahn (London, 1970)

Lumet, Louis, 'Sensations de l'art (Claude Monet)', *L'Enclos*, May 1895

Maillard, Firmin, *Les derniers Bohèmes: Henri Mürger et son temps* (1874)

Maillard, Georges, 'Chronique: Les impressionnalistes', *Le Pays*, 4 April 1876

—— 'Chronique: Les Impressionnistes', *Le Pays*, 9 April 1877

Maillard, Léon, 'Salon de la Société nationale des Beaux-Arts', *La Plume*, 1 July 1892

Mainardi, Patricia, 'Edouard Manet's View of the Universal Exposition of 1867', *Arts*, January 1980

—— 'The Political Origins of Modernism', *Art Journal*, Spring 1985

—— [*Art and Politics of the Second Empire. The Universal Expositions of 1855 and 1867* (New Haven/London, 1987)]

Mallarmé, Stéphane, 'Le Jury de peinture pour 1874 et M. Manet', *La Renaissance littéraire et artistique*, 12 April 1874

—— 'The Impressionists and Edouard Manet', *The Art Monthly Review*, 30 September 1876; repr. in Charles S. Moffett *et al.*, *The New Painting. Impressionism 1874–1886* (1986), q.v.

—— *Oeuvres complètes*, ed. Henri Mondor and G. Jean-Aubry [Pléiade edn] (1945)

—— *Correspondance*, ed. Henri Mondor and Lloyd James Austin, 11 vols. (1959–85)

—— *Mallarmé. The Poems* (bilingual edn), trans. Keith Bosley (Harmondsworth, 1977)

Mancino, Léon, '2ème exposition de peintures, dessins, gravures, faite par un groupe d'artistes', *L'Art* 5 (1876)

Manet, Julie, *Growing Up with the Impressionists. The Diary of Julie Manet*, trans. and ed. Rosalind de Boland Roberts and Jane Roberts (London, 1987)

Mantz, Paul, 'Salon de 1863', *Gazette des Beaux-Arts*, 1 April 1863

—— 'Salon de 1865', *Gazette des Beaux-Arts*, June, July 1865

—— 'L'exposition des peintres impressionnistes', *Le Temps*, 22 April 1877

—— 'La Peinture française', in *Exposition universelle de 1878. Les Beaux-arts et les arts décoratifs*, ed. Louis Gonse, vol. I: *L'Art moderne* (1879)

Marandel, J. Patrice, and François Daulte, *Frédéric Bazille and Early Impressionism*, exh. cat., Art Institute of Chicago (1978)

Marey, Bernard, *Les grands magasins des origines à 1939* (1979)

Martet, Jean, *M. Clemenceau peint par lui-même* (1929)

Marx, Karl, *The Critique of the Gotha Programme* (1875; London, 1933 edn)

Marx, Roger, 'Les Meules de M. 'Claude Monet', *Le Voltaire*, 7 May 1891

—— 'Les Nymphéas de M. Claude Monet', *Gazette des Beaux-Arts*, June 1909

—— *Maîtres d'hier et d'aujourd'hui* (1914)

Masson, André, 'Monet le fondateur', *Verve*, nos. 27–8 (1952)

Matsugata, M., ed., *Le Japon à l'Exposition universelle de 1878*, vol. II (Commission impériale japonaise, 1878)

Matyjaszkiewicz, Krystyna, *James Tissot*, exh. cat., Barbican Art Gallery, London (1984)

Mauclair, Camille, 'L'Exposition Claude Monet – Durand-Ruel', *La Revue indépendante de littérature et d'art*, May 1891

—— (as 'Camille M.'), 'Exposition Claude Monet', *La Revue indépendante de littérature et d'art*, April 1892

—— 'La Baigneuse aux cygnes' (dedicated to Besnard), *La Revue indépendante de littérature et d'art*, April 1892

—— 'Destinées de la peinture française 1865–1895', *La Nouvelle Revue*, 15 March 1895

—— 'Choses d'art', *Mercure de France*, June 1895

—— 'Critique de la peinture', *La Nouvelle Revue*, 15 September 1895

—— 'La Réforme de l'art décoratif en France', *La Nouvelle Revue*, 15 February 1896

Maupassant, Guy de, 'La Vie d'un paysagiste', *Gil Blas*, 28 September 1886

—— *Contes et nouvelles*, (Pléiade edn), 2 vols. ed. Louis Forestier (1979)

Maus, Octave, 'Les Impressionnistes', *La Vie moderne*, 15 March 1885

—— 'Claude Monet – Auguste Rodin', *L'Art moderne*, 7 July 1889

Mayeur, Jean-Marie, *Les débuts de la IIIe République 1871–1898* (1973)

Mellerio, André, *L'Exposition de 1900 et l'impressionnisme* (1900)

Melot, Michel, 'Camille Pissarro in 1880: an Anarchist Artist in Bourgeois Society', *Marxist Perspectives*, Winter 1979–80

Merson, Olivier, *La peinture en France* (1861)

Michel, André, *Notes sur l'art moderne (peinture)* (1896)

—— 'Les Arts à l'Exposition Universelle de 1900: L'Exposition Centennale: La Peinture française': V', *Gazette des Beaux-Arts*, November 1900

Millaud, Albert, *see* Grimm, Baron

Miller, Michael, *The Bon Marché: Bourgeois Culture and the Department Store 1869–1920* (Princeton, 1981)

Mirbeau, Octave, 'Notes sur l'art. Claude Monet', *La France*, 21 November 1884

—— 'Emile Zola et le naturalisme', *La France*, 11 March 1885

—— 'Chroniques parisiennes', *La France*, 27 October 1885

—— *Contes de ma chaumière* (1886; 1923 edn)

—— 'Exposition internationale de la rue de Sèze', *Gil Blas*, 13 and 14 May 1887

—— *L'Abbé Jules* (1888)

—— 'L'Avenir', *Le Figaro*, 5 February 1889

—— 'Claude Monet', *Le Figaro*, 10 March 1889, repr. in Mirbeau, *Des Artistes* (1922/1986)

—— 'Prélude', *Le Figaro*, 14 July 1889

—— 'Claude Monet', in *Exposition Claude Monet – Auguste Rodin*, Galerie Georges Petit, Paris (1889); repr. in Jacques Villain *et al.*, *Claude Monet – Auguste Rodin. Centenaire de l'exposition de 1889* (1989–90), q.v.

—— 'Claude Monet', *L'Art dans les deux mondes*, 7 March 1891

—— 'Ravachol!', *L'Endehors*, 1 May 1892

—— 'Des lys! Des lys!', *Le Journal*, 7 April 1895; repr. in Mirbeau, *Des Artistes* (1924; 1986)

—— 'Un Tableau par la fenêtre!', *Le Gaulois*, 22 Sept 1896; repr. in Mirbeau, *Des Artistes* (1924/1986)

—— *Le Jardin des Supplices* (1899);

—— *Claude Monet. Série de vues de la Tamise à Londres*, preface to exh. cat., Galeries Durand-Ruel, Paris (1904); repr. *L'Humanité*, 8 May 1904

—— *Claude Monet, Venise*, pref. to exh. cat., Galerie Bernheim-Jeune, Paris (1912)

—— 'A nos Soldats', *Le Petit Parisien*, 28 July 1915

—— 'Lettres à Claude Monet', *Cahiers d'aujourd'hui*, 29 November 1922

—— *Des artistes*, 2 vols. (1922, 1924; 1986 edn)

Moffett, Charles S., *et al.*, *The New Painting. Impressionism 1874–1886*, exh. cat., Fine Arts Museum of San Francisco; National Gallery of Art, Washington, D.C. (1986)

Mondor, Henri, *Vie de Mallarmé* (1941)

Mongan, Elizabeth, *et al.*, *Berthe Morisot: Drawings, pastels, watercolours, paintings*, exh. cat., Museum of Fine Arts, Boston; Charles E. Slatkin Galleries, New York; California Palace of the Legion of Honor, San Francisco; Minneapolis Institute of Fine Arts (1960–1)

Montifaud, Marc de [Marie-Amélie Chartroule de Montifaud], 'Exposition du boulevard des Capucines', *L'Artiste*, 1 May 1874

—— 'Salon de 1877', *L'Artiste*, 1 May 1877

Morice, Charles, 'Vues de la Tamise à Londres, par Claude Monet', *Mercure de France*, June 1904

—— 'Exposition Monet et Renoir', *Mercure de France*, 16 June 1908

—— 'L'Exposition d'œuvres de M. Claude Monet', *Mercure de France*, 16 July 1909

Morisot, Berthe, *Correspondance de Berthe Morisot avec sa famille et ses amis* (1950), ed. Denis Rouart; trans. and ed. Kathleen Adler and Tamar Garb, *The Correspondence of Berthe Morisot* (London, 1986)

Moulin, Jean-Marie, Anne Pingeot, Joseph Rishel *et al.*, *The Second Empire 1852–1870. Art in France under Napoléon III*, exh. cat., Philadelphia Museum of Art; Detroit Institute of Arts; Grand Palais, Paris (1978–9)

Natanson, Thadée, 'M. Claude Monet', *La Revue blanche*, 1 June 1895

—— 'Speculations sur la Peinture, à propos de Corot et des Impressionnistes', *La Revue blanche*, 15 May 1899

—— 'Sur des traits d'Octave Mirbeau', *Les Cahiers d'aujourd'hui* no. 9 (1922)

—— *Peints à leur tour* (1948)

Nivelle, Jean de [Charles Canivet], 'Les peintres indépendants', *Le Soleil*, 4 March 1882

Nochlin, Linda, ed., *Realism and Tradition in Art. 1848–1900* (Englewood Cliffs, NJ, 1966)

Noël, Bernard, *Dictionnaire de la Commune* (1971)

Ormond, Richard, *John Singer Sargent* (London, 1970)

Orton, Fred, and Griselda Pollock, 'Les Données Bretonnantes: la Prairie de Représentation', *Art History*, September 1980

[Paradise, Jo-Anne, *Gustave Geffroy and the Criticism of Painting* (London/New York, 1985)]

Paris, Jean, 'Le Soleil de van Gogh', in *Miroirs sommeil soleil espaces* (1973)

Pays, Marcel, 'Un grand maître de l'impressionnisme. Une visite à M. Claude Monet dans son ermitage à Giverny', *L'Excelsior*, 26 January 1921

Perrot, M., *Le Mode de vie des familles bourgeoises* (1961)

Perry, Lilla Cabot, 'Reminiscences of Claude Monet from 1889 to 1909', *The American Magazine of Art*, March 1927.

'Ph.B.', *see* Burty, Philippe

Picard, A., *L'Exposition universelle internationale de 1889, Paris. Rapport générale* (1891)

Pierrot, Jean, *The Decadent Imagination 1880–1900*, trans. Derek Coltman (Chicago/London, 1981)

[Piguet, Philippe, *Monet et Venise* (1986)]

Pinkney, David H., *Napoleon III and the Rebuilding of Paris*

(Princeton, 1956)

Pissarro, Camille, *Lettres à son fils Lucien*, ed. John Rewald (1950)

—— *Correspondance*, ed. J. Bailly-Herzberg, 3 vols. [to 1894] (1980–8)

Plessis, Alain, *De la fête impériale au mur des fédérés 1852–1871* (1973)

Pontmartin, A. de, 'Salon de 1872: I–IX', *L'Univers illustré*, 11 May–6 July 1872

—— 'Salon de 1874: I–X', *L'Univers illustré*, 2 May–4 July 1874

Porcheron, Emile, 'Promenades d'un flâneur: Les impressionnistes', *Le Soleil*, 4 April 1876

Pothey, Alexandre, 'Chronique', *La Presse*, 31 March 1876

—— 'Beaux-Arts', *Le Petit Parisien*, 7 April 1877

Poulain, Gaston, *Bazille et ses amis* (1932)

Poulet, Georges, *Etudes sur le temps humain* (Edinburgh, 1949)

Proudhon, Pierre-Joseph, *Du principe de l'art et de sa destination sociale* (1865)

Proust, Marcel, 'Les Eblouissements, par la comtesse de Noailles', *Le Figaro*, 15 June 1907; repr. in *Contre Sainte-Beuve*, précédé de *Pastiches et mélanges* et suivi de *Essais et articles*, ed. Pierre Clarac et Yves Sandre (1971)

Prouvaire, Jean [Pierre Toloza], 'L'exposition du boulevard des Capucines', *Le Rappel*, 20 April 1874

Ravenel, Jean, 'Préface au Salon de 1870', *Revue internationale de l'art et de la curiosité*, 15 April 1879

Rearick, Charles, *Pleasures of the Belle Epoque* (New Haven/ London, 1985)

Rébérioux, Madeleine, *La République radicale? 1898–1914* (1975)

Reff, Theodore, *Degas: The Artist's Mind* (New York, 1976)

—— *Manet and Modern Paris*, exh. cat., National Gallery of Art, Washington, D.C. (1982)

[Renan, Ary] (as 'R.A.'), 'Cinquante tableaux de M. Claude Monet', *La Chronique des arts et de la curiosité*, 18 May 1895

Renoir, Jean, *Pierre-Auguste Renoir, mon père* (1962; 1981 edn)

[Renoir, Pierre-Auguste] (as 'Un peintre'), 'L'Art décoratif et contemporain', *L'Impressionniste*, 21 April 1877

Reuterswärd, Oscar, 'The "Violettomania" of the Impressionists', *Journal of Aesthetics and Art Criticism*, December 1950

—— 'The Accentuated Brush Stroke of the Impressionists', *Journal of Aesthetics and Art Criticism*, March 1952

Rewald, John, 'Theo van Gogh, Goupil, and the Impressionists', *Gazette des beaux-Arts*, January, February 1973

—— *The History of Impressionism*, 4th edn rev. (New York, 1973)

—— *Post-Impressionism from van Gogh to Gauguin*, 3rd edn (New York, 1978)

Rewald, John, and Frances Weitzenhoffer, eds., *Aspects of Monet: a Symposium on the Artist's Life and Times* (New York, 1984)

Rey, Jean Dominique, *Berthe Morisot* (Paris/New York, 1982)

Riat, Georges, *Gustave Courbet, peintre* (1906)

Richards, Jeffrey, and John M. MacKenzie, *The Railway Station* (Oxford, 1986)

Richardson, Joanna, *La Vie parisienne* (London, 1971)

Rifkin, Adrian, 'Cultural Movements and the Paris Commune', *Art History*, June 1979

Rivière, Georges, 'Les intransigeants de la peinture', *L'Esprit moderne*, 13 April 1876 (repr. in Pierre Dax, 'Chroniques', *L'Artiste*, 1 May 1876)

—— 'A. M. le rédacteur du Figaro', *L'Impressionniste*, 6 April 1877

—— 'L'exposition des impressionnistes', *L'Impressionniste*, 6 and 14 April 1877

—— 'Aux femmes', *L'Impressionniste*, 21 April 1977

—— 'Les intransigeants et les impressionnistes, souvenirs du Salon libre de 1877', *L'Artiste*, 1 November 1877

—— *Renoir et ses amis* (1921)

Robida, Michel, *Le Salon Charpentier et les impressionnistes* (1958)

Roger-Milès, Léon, 'Claude Monet', *L'Eclair*, June 1898

Rouart, Denis, and Jean-Dominique Rey, *Monet, Nymphéas ou le miroir du temps* (incl. catalogue raisonné by Robert Maillard) (1972)

R.Y., 'Notes d'art', *La Plume*, 15 November 1891

Sabbrin, C., *Science and Philosophy in Art* (Philadelphia, 1886)

Saint-Victor, Paul de, 'Beaux-Arts', *La Presse*, 27 April 1863

—— 'Salon de 1872: I', *L'Univers illustré*, 11 May 1872

—— 'Les Tableaux de style au Salon', *L'Artiste*, June 1872

—— *Barbares et bandits – la Prusse et la Commune* (1872)

Salomon, Jacques, 'Chez Monet, avec Vuillard et Roussel', *L'Oeil*, May 1971

Saunier, Charles, 'L'Art impressionniste', *La Plume*, August 1892

Schapiro, Meyer, *Modern Art. 19th and 20th Centuries. Selected Papers* (New York, 1978)

Schmit, Robert, *Eugène Boudin. 1824–1898* (catalogue raisonné), 4 vols. (1973–84)

Schop, Baron [Théodore de Banville], 'La semaine parisienne: Les bons jeunes gens de la rue Le Peletier. Taches et couleurs. Le brouillard lumineux. Manet condamné par Manet', *Le National*, 13 April 1877

Sébillot, Paul, 'Exposition des impressionnistes', *Le Bien public*, 7 April 1877

—— 'Revue artistique', *La Plume*, 15 May 1879

[Seigel, Jerrold, *Bohemian Paris. Culture, Politics and the Boundaries of Bourgeois Life 1830–1930* (New York, 1986)]

Seitz, William C., *Claude Monet* (New York, 1960)

—— *Claude Monet: Seasons and Moments*, exh. cat., Museum of Modern Art, New York (1960)

Sennett, Richard, *The Fall of Public Man* (New York, 1977)

Shiff, Richard, 'The End of Impressionism: A Study in Theories of Artistic Expression', *Art Quarterly*, Autumn 1978, in Charles S. Moffett *et al.*, *The New Painting. Impressionism 1874–1886* (1986), q.v.

—— [*Cézanne and the End of Impressionism* (Chicago, 1984)]

Silvestre, Armand, preface to *Recueil d'estampes gravées à l'eau-forte. Galerie Durand-Ruel* (1873)

—— 'Chronique des beaux-arts: Physiologie du refusé. L'exposition des révoltés', *L'Opinion nationale*, 22 April 1874

—— 'Exposition de la rue le Peletier', *L'Opinion nationale*, 2 April 1876

—— 'Le monde des arts: Les indépendants. Les aquarellistes', *La Vie moderne*, 24 April 1879

—— 'Le monde des arts: Expositions particulières: Septième exposition des artistes indépendants', *La Vie moderne*, 11 March 1882

—— 'Exposition de M. Claude Monet, 9 boulevard de la Madeleine', *La Vie moderne*, 17 March 1883

—— *Le Nu au Salon*, annually from 1889 to 1899

Silvestre, Théophile, *Histoire des artistes vivants* (1856)

Singer-Kérel, Jeanne, *Le Coût de la vie à Paris de 1870 à 1954* (1961)

Sizeranne, Robert de, 'L'Art à l'Exposition de 1900: II. Le bilan de l'impressionnisme', *La Revue des deux mondes*, 1 June 1900

Soria, Georges, *Grande histoire de la Commune* (1971)

Spate, Virginia, 'Arcady or Utopia? Figures in the Landscape in Late Nineteenth Century French Painting', in *Utopias*, papers from the annual symposium of the Australian Academy of the Humanities, ed. Eugene Kamenka (Melbourne, 1987)

Stuckey, Charles F., 'Blossoms and Blunders: Monet and the State, II', *Art in America*, September 1979

Stuckey, Charles F. and Robert Gordon, 'Blossoms and Blunders: Monet and the State, I', *Art in America*, January–February 1979

[Stuckey, Charles F., William P. Scott and Suzanne G. Lindsay, *Berthe Morisot. Impressionist*, exh. cat., Mount Holyoke College Art Museum; National Gallery of Art, Washington, D.C. (1987–8)]

[Stuckey, Charles F., ed., *Monet. A Retrospective* (New York, 1985)]

Tabarant, Adolphe, *Manet et ses œuvres* (1947)

Taboureux, Emile, 'Claude Monet', *La Vie moderne*, 12 June 1880

Tailhade, Laurent, *Les Livres et les hommes 1916–17* (1917)

Tardieu, Charles, 'La Peinture au Salon de Paris 1879', *L'Art*, vol. II (1879)

Thiébault-Sisson, [François], 'Claude Monet: Les années d'épreuves', *Le Temps*, 26 November 1900

—— 'Choses d'art: Claude Monet et ses vues de Londres', *Le Temps*, 19 May 1904

—— 'Claude Monet', *Le Temps*, 6 April 1920

—— 'Un don de M. Claude Monet à l'Etat', *Le Temps*, 14 October 1920

—— 'Cl. Monet', *Le Temps*, 7 December 1926

—— 'Un nouveau musée parisien. Les *Nymphéas* de Claude Monet à l'Orangerie des Tuileries', *La Revue de l'art ancien et moderne*, June 1927

[Thoré, Théophile], *Salons de W. Bürger: 1861 à 1868, avec une préface de T. Thoré*, 2 vols. (1870)

*Tintamarre Salon, Exposition des Beaux-Arts de 1868* (1868)

Trévise, Duc de, 'Le Pèlerinage à Giverny', [1920], *La Revue de l'art ancien et moderne*, January, February 1927

Truffaut, Georges, 'Le jardin de Claude Monet', *Jardinage*, November 1924

Tucker, Paul Hayes, *Monet at Argenteuil* (New Haven/London, 1982)

—— 'The First Impressionist Exhibition and Monet's *Impression, Sunrise*: A Tale of Timing, Commerce and Patriotism', *Art History*, December 1984

—— [*Monet in the '90s. The Series Paintings*, exh. cat. Museum of Fine Arts, Boston (1989), Royal Academy, London (1990, revised edn)]

Uhlbach, [Louis], 'Justice', *La Cloche*, 29 May 1871

[Vachon, Marius], 'Carnet de la journée', *La France*, 4 April 1876

Vacquerie, [Auguste], editorial, *Le Rappel*, 10 April 1876

Valéry, Paul, *Cahiers*, vol. XI: 1925 (1974)

Vallès, Jules, *Les Réfractaires* (1865)

—— *L'Enfant* (1879)

—— *Le Bachelier* (1881; 1974 edn, ed. Jean-Louis Lalanne)

—— *L'Insurgé* (1886)

Van Gogh, Vincent, *The Complete Letters of Vincent van Gogh*, 3 vols. (London, 1958)

Varnedoe, J. Kirk T., 'The Artifice of Candor: Impressionism and Photography Reconsidered', *Art in America*, January 1980

—— [*Gustave Caillebotte* (New Haven/London, 1987)]

Varnedoe, J. Kirk T., and Thomas P. Lee, *Gustave Caillebotte: A Retrospective Exhibition*, exh. cat., Museum of Fine Arts, Houston (1976)

Vauxcelles, Louis, 'Un après-midi chez Claude Monet', *L'Art et les artistes*, November 1905

Venturi, Lionello, *Les Archives de l'impressionnisme*, 2 vols. (Paris/ New York, 1939)

Verhaeren, Emile, 'L'Art moderne', *Mercure de France*, Feburary 1901

Véron, Théodore, *Mémorial de l'art et des artistes de mon temps*, 2e annuaire (1876)

Viellot, Edmond, 'L'Ile de la Grenouillère', *La Chronique illustré*, 1 August 1869

Vigne, Henri, 'Les bas-fonds parisiens', *L'Illustration*, 26 August 1871

[Villain, Jacques, *et al.*, *Claude Monet – Auguste Rodin. Centenaire de l'exposition de 1889*, exh. cat., Musée Rodin, Paris (1989–90)]

Vollard, Ambroise, *Auguste Renoir* (1920)

—— *En écoutant Cézanne, Degas, Renoir* (1938)

Walter, Rodolphe, 'Critique d'art et vérité. Emile Zola en 1868', *Gazette des Beaux-Arts*, April 1969

—— 'Claude Monet as a Caricaturist: a Clandestine Apprenticeship', *Apollo*, June 1976

Wechsler, Judith, *The Human Comedy. Physiognomy and Caricature in Nineteenth Century Paris* (London, 1982)

Weisberg, Gabriel P., ed., *The European Realist Tradition* (Bloomington, Ind., 1982)

White, Barbara Ehrlich, ed., *Impressionism in Perspective* (Englewood Cliffs, NJ, 1978)

White, Harrison and Cynthia, *Canvases and Careers: Institutional Change in the French Painting World* (New York, 1965)

Wildenstein, Daniel, *et al.*, *Claude Monet. Biographie et catalogue raisonné*, 4 vols. (Lausanne/Paris, 1974–85)

Wildenstein, Daniel, *Monet's Years at Giverny: Beyond Impressionism*, Metropolitan Museum, New York (1978)

Williams, Raymond, *The Country and the City* (London, 1973)

Wolff, Albert, 'Le calendrier parisien', *Le Figaro*, 3 April 1876

—— 'Les indépendants', *Le Figaro*, 11 April 1879

—— 'Quelques expositions', *Le Figaro*, 2 March 1882

—— 'Exposition internationale', *Le Figaro*, 19 June 1886

Zeldin, Theodore, *France 1848–1945*, 2 vols. (Oxford, 1973)

Zola, Emile, *Les Rougon-Macquart, Histoire naturelle et sociale d'une famille sous le Second Empire*, ed. Henri Mitterand, 5 vols. (1960–8)

—— *Oeuvres Complètes*, ed. Henri Mitterand, 15 vols. (1966– 70); incl. political and social journalism

—— *Mon Salon. Manet. Ecrits sur l'art*, ed. Antoinette Ehrard (1970)

—— *Contes et nouvelles*, ed. Roger Ripoll [Pléiade edn] (1976)

—— *Correspondance*, ed. B.H. Bakker, 6 vols. to 1880 (Montreal, 1978 —)

# List of Illustrations

# *Index*

Compiled by Isabel Hariades

LA MANCHE

Pourville

Varengeville

DIEPPE

Fécamp
Grainval
Etretat

Les Petites Dalles

Cap de la Hève · Ste Adresse
LE HAVRE

BAIE DE LA
SEINE

Honfleur

Trouville

Seine

ROUEN

NORMANDIE

GIVE

Vernon
Bennecourt

Orne

Eure

0 ———————————————— 50 MIS
0 ———————————————— 80 Km